the
black arts
movement

THE JOHN HOPE FRANKLIN SERIES

IN AFRICAN AMERICAN HISTORY AND CULTURE

Waldo E. Martin Jr. and Patricia Sullivan, editors

810.9896
S3686

22.46

San Diego Christian College
2100 Greenfield Drive
El Cajon, CA 92019

the
black arts
movement

Literary Nationalism in the 1960s and 1970s

James Edward Smethurst

THE UNIVERSITY OF NORTH CAROLINA PRESS

Chapel Hill and London

© 2005
The University of North Carolina Press
All rights reserved
Designed by Rebecca Giménez. Set in Adobe
Minion by Tseng Information Systems, Inc.
Manufactured in the United States of America

The paper in this book meets the guidelines
for permanence and durability of the Committee
on Production Guidelines for Book Longevity
of the Council on Library Resources.

Library of Congress
Cataloging-in-Publication Data
Smethurst, James Edward.
The Black Arts Movement : literary nationalism
in the 1960s and 1970s / James Edward Smethurst.
p. cm. — (The John Hope Franklin series in
African American history and culture)
Includes bibliographical references and index.
ISBN-13: 978-0-8078-2934-9 (cloth : alk. paper)
ISBN-10: 0-8078-2934-x (cloth : alk. paper)
ISBN-13: 978-0-8078-5598-0 (pbk. : alk. paper)
ISBN-10: 0-8078-5598-7 (pbk. : alk. paper)
1. American literature — African American
authors — History and criticism. 2. Black
nationalism — United States — History — 20th
century. 3. African Americans — Intellectual
life — 20th century. 4. African Americans in
literature. 5. Black nationalism in literature.
6. Black Arts movement. I. Title. II. Series.
PS153.N5S56 2005
810.9'896073 — dc22 2004027170

Portions of Chapters 2 and 3 were pub-
lished in different form in "Pat Your Foot
and Turn the Corner: Amiri Baraka, the
Black Arts Movement, and the Poetics of a
Popular Avant-Garde," *African American
Review* 37.2–3 (Summer/Fall 2003).

Portions of Chapter 3 were also pub-
lished in different form in "Poetry and
Sympathy: New York, the Left, and the
Rise of Black Arts," in *Left of the Color
Line: Race, Radicalism, and Twentieth-
Century Literature of the United States*,
edited by Bill V. Mullen and James
Smethurst (Chapel Hill: University of
North Carolina Press, 2003); and "'Don't
Say Goodbye to the Porkpie Hat': Lang-
ston Hughes, the Left, and the Black Arts
Movement," *Callaloo* 25.4 (Fall 2002).

Portions of Chapter 4 were published in
different form in "The Origins of the Black
Arts Movement in Chicago and Detroit,"
Contours 2.1 (Spring 2004).

Portions of Chapter 5 were published
in different form in "Remembering When
Indians Were Red: Bob Kaufman, the
Popular Front, and the Black Arts Move-
ment," *Callaloo* 25.1 (Winter 2002).

Portions of Chapter 6 were published in
different form in "The Black Arts Move-
ment and Historically Black Colleges and
Universities," in *New Thoughts on the
Black Arts Movement*, edited by Lisa Gail
Collins and Margo Crawford (New Bruns-
wick: Rutgers University Press, 2005).

cloth 09 08 07 06 05 5 4 3 2 1
paper 10 09 08 07 06 6 5 4 3 2

contents

Acknowledgments ix

Abbreviations xiii

Introduction 1

1. Foreground and Underground: The Left, Nationalism, and the Origins of the Black Arts Matrix 23

2. Artists Imagine the Nation, the Nation Imagines Art: The Black Arts Movement and Popular Culture, History, Gender, Performance, and Textuality 57

3. New York Altar City: New York, the Northeast, and the Development of Black Arts Cadres and Ideologies 100

4. Institutions for the People: Chicago, Detroit, and the Black Arts Movement in the Midwest 179

5. Bandung World: The West Coast, the Black Arts Movement, and the Development of Revolutionary Nationalism, Cultural Nationalism, Third Worldism, and Multiculturalism 247

6. Behold the Land: Regionalism, the Black Nation, and the Black Arts Movement in the South 319

Conclusion 367

APPENDIX 1. Birth Dates of Selected Black Arts and Black Power Figures 375

APPENDIX 2. Time Line of the Early Black Arts and Black Power Movements 377

Notes 381

Bibliography 429

Index 459

illustrations

Cover of an early issue of *Umbra* 40

Saxophonist Ornette Coleman on
the cover of *Liberator* 67

Cover of the first issue of *Soulbook* 67

Cover of *Black Theatre* portraying
Otis Redding as a Christ 70

Cover of *Black America* featuring a
watercolor by Muhammad Ahmad 78

Cover of a 1971 women's group
pamphlet 88

First page of Marvin X's ritual drama
The Resurrection of the Dead 98

acknowledgments

This project owes so much to so many people who have generously helped in so many ways that I am sure I will miss somebody or forget some invaluable assistance rendered me. So please forgive me in advance if I overlook someone or fail to recall something. Just because I am absentminded does not mean that I am not grateful. In any event, whatever worth this project may have is largely due to everyone who has guided, informed, corrected, and encouraged me. And, of course, the shortcomings of this study are solely my own.

In the first place, I would like to thank everyone who allowed me to interview them or who answered written questions at length (in some cases more than once): Muhammad Ahmad, Abdul Alkalimat, Ernest Allen Jr., Amina Baraka, Amiri Baraka (still my poet laureate), Grace Lee Boggs, Herb Boyd, John Bracey Jr., Ed Bullins, Sam Cornish, Jayne Cortez, Ebon Dooley, Dan Georgakas, Calvin Hicks, Esther Cooper Jackson, James Jackson, Maulana Karenga, Woodie King Jr., Haki Madhubuti, Marvin X, Ron Milner, Sterling Plumpp, Kalamu ya Salaam, Sonia Sanchez, Budd Schulberg, John Sinclair, A. B. Spellman, Edward Spriggs, Nelson Stevens, William Strickland, Michael Thelwell, Lorenzo Thomas, Askia Touré, Jerry Ward, and Nayo Watkins.

I am also deeply indebted to the many people who answered questions, gave me leads, shared their research, read larger or smaller portions of this study, and encouraged me in ways large and small: Shawn Alexander, Michael Bibby, Melba Joyce Boyd, Wini Breines, Randall Burkett, Lisa Collins, Margo Crawford, Maria Damon, Gary Daynes, Angela Dillard, Alan Filreis, Barbara Foley, Chris Funkhouser, Ignacio Garcia, Barry Gaspar, Henry Louis Gates Jr., John Gennari, Der-

rick Ibrahim Mussa Gilbert, Van Gosse, Cheryl Greenberg, Farah Jasmine Griffin, Phillip Brian Harper, William Harris, Juan Felipe Herrera, Fred Ho, Gerald Horne, Geoffrey Jacques, Meta Du Ewa Jones, Stetson Kennedy, Kathryne Lindberg, John Lowney, Waldo Martin, William Maxwell, Dan McClure, Jeffrey Melnick, James Miller, Bill Mullen, Donna Murch, Cary Nelson, Richard Newman, Aldon Nielsen, MaryLouise Patterson, Rachel Peterson, Arnold Rampersad, Howard Ramsby, Eugene Redmond, Rachel Rubin, Mike Sell, Archie Shepp, Josh Sides, Judy Smith, Werner Sollors, Mark Solomon, James Spady, Michelle Stephens, Patricia Sullivan, W. S. Tkweme, Jarvis Tyner, Alan Wald, Stephen Ward, Val Gray Ward, Mary Helen Washington, Komozi Woodard, and Ahmos Zu-Bolton.

I also wish to express my gratitude to the faculty and staff of the English Department at the University of North Florida for their support, collegiality, and friendship during my time there. While everyone at UNF showed me nothing but kindness, Richard Bizot, Sam Kimball, Nancy Levine, William Slaughter, Brian Striar, Michael Wiley, and Mark Workman in particular made my life there a pleasure professionally and socially. Similarly, I wish to thank Dean Lee Edwards of the College of Humanities and Fine Arts and my colleagues in the W. E. B. Du Bois Department of Afro-American Studies at the University of Massachusetts for their intellectual and emotional support: Ernest Allen Jr., John Bracey Jr., Richard Hall, Manisha Sinha, Nelson Stevens, William Strickland, Esther Terry, Michael Thelwell, Steven Tracy, and Robert Wolff. The chair of the department, Esther Terry, has helped me and made me feel welcome in every way imaginable. As can be seen from my list of interviewees, my study would have been vastly different (for the worse) without the expertise of my colleagues. Ernest Allen Jr., John Bracey Jr., William Strickland, and Michael Thelwell have been particularly invaluable to this project, generously critiquing and encouraging my work, providing information, stories, and innumerable research leads, passing on materials out of their own collections, and sharing their own inspirational scholarship. Thanks also to Tricia Loveland for answering many, many questions.

I am also grateful to the W. E. B. Du Bois Institute at Harvard University, the University of North Florida, and the National Endowment for the Humanities for providing support for this project during its early stages.

I want to acknowledge the help I received from the staffs of the W. E. B. Du Bois Library at the University of Massachusetts, the Woodruff Library at Clark Atlanta University, the Woodruff Library at Emory University, the Mugar

Library at Boston University, the Northeastern University Libraries, the Littauer and Schlesinger Libraries at Harvard University, the Walter P. Reuther Library at Wayne State University, the George A. Smathers Libraries at the University of Florida, the Beineke Library at Yale University, the Main Research Branch and the Schomburg Center for Research in Black Culture of the New York Public Library, the Tamiment Institute Library and Robert F. Wagner Labor Archives at New York University, the John Hay Library at Brown University, the Dodd Research Center at the University of Connecticut, the Moorland-Springarn Research Center at Howard University, and the Archives of American Art at the Smithsonian Institution.

I want to thank also the editorial and production staff at the University of North Carolina Press, especially Chuck Grench, Amanda McMillan, and Pam Upton, for all their help—and for making such great-looking books. I am also grateful for the incisive comments of the two anonymous readers who evaluated the manuscript for the Press.

My deepest thanks are to my complicated but extraordinarily supportive extended family: William Smethurst, Ludlow Smethurst, Richard Smethurst, Mae Smethurst, Andrew Smethurst, Alejandra Ramirez, Katie Smethurst, Tony Schlein, Silvie Schlein, Thea Schlein, Jeff Melnick, Rachel Rubin, Jesse Rubin, Merle Forney, Margaret Forney, and, especially, my son, Jacob Smethurst Rubin. This book is dedicated to Carol Forney for her love and for the many hours she has spent trying to clean up the mess of the world's worst proofreader.

abbreviations

AAA	Afro-American Association
AACM	Association for the Advancement of Creative Musicians
AAHA	Afro-American Heritage Association/African-American Heritage Association
AFL	American Federation of Labor
AFRI-COBRA	African Commune of Bad Relevant Artists
ALSC	African Liberation Support Committee
AMSAC	American Society for African Culture
BAG	Black Artists Group
BARTS	Black Arts Repertory Theatre and School
BAW	Black Arts/West
BCP	Black Communications Project
BPP	Black Panther Party for Self-Defense
BSU	Black Students Union
CAP	Congress of African People
CCCO	Coordinating Council of Community Organizations
CFUN	Committee for a Unified Newark
CIO	Committee for Industrial Organization/Congress of Industrial Unions
CORE	Congress of Racial Equality
CPUSA	Communist Party of the United States of America
CRC	Civil Rights Congress
DRUM	Dodge Revolutionary Union Movement

ELSFA	Elma Lewis School of Fine Arts
FAP	Federal Art Project
FST	Free Southern Theater
FTP	Federal Theatre Project
FWP	Federal Writers Project
GOAL	Group on Advanced Leadership
HUAC	House Un-American Activities Committee
HWG	Harlem Writers Guild
IBW	Institute of the Black World
ILWU	International Longshoremen's and Warehousemen's Union
JBP	*Journal of Black Poetry*
LRBW	League of Revolutionary Black Workers
MFY	Mobilization for Youth
NAACP	National Association for the Advancement of Color People
NAG	Nonviolent Action Group
NBT	National Black Theatre
NCAAA	National Center of Afro-American Artists
NEC	Negro Ensemble Company
NMU	National Maritime Union
NNC	National Negro Congress
NNLC	National Negro Labor Council
NOI	Nation of Islam
NSA	Negro Students Association
NSM	Northern Student Movement
OBAC	Organization of Black American Culture
OGFF	On Guard for Freedom
PL	Progressive Labor Movement/Progressive Labor Party
RAM	Revolutionary Action Movement
RNA	Republic of New Africa
SBCA	Southern Black Cultural Alliance
SCEF	Southern Conference Educational Fund
SCHW	Southern Conference for Human Welfare
SCLC	Southern Christian Leadership Conference
SDS	Students for a Democratic Society
SLANT	Self Leadership for All Nationalities Today
SNCC	Student Nonviolent Coordinating Committee

SNYC	Southern Negro Youth Congress
SP	Socialist Party
SWP	Socialist Workers Party
UAW	United Automobile Workers
UGMA/UGMAA	Underground Musicians Association/Union of God's Musicians and Artists Ascension
UNIA	Universal Negro Improvement Association
WP	Workers Party
WPA	Works Progress Administration

introduction

In earlier drafts of this introduction, I began by suggesting that African Ameri-
can studies, Chicana/o studies, Asian American studies, and other fields broadly
constituting the somewhat nebulous universe of ethnic studies were haunted
by the ethnic or racial nationalisms that in their various manifestations flour-
ished in the United States from about 1965 to 1975. I based this observation on
the fact that, even though relatively little scholarly work had been done on the
Black Power movement and other political nationalist movements and even less
on the Black Arts movement and its Chicana/o, Asian American, and Puerto
Rican analogues, the departments, degree-granting committees, research cen-
ters, institutes, and so on of the above listed fields owed their inception in large
part to the institutional and ideological spaces carved out by the Black Power,
Chicano, Asian American, and other nationalist movements.[1] Indeed, many of
these departments, programs, and committees (and publishers, book imprints,
academic book series, art galleries, video and film production companies, and
theaters) were the direct products of 1960s and 1970s nationalism. As I began
to write, a number of the institutions of ethnic studies, often under the rubric
of "Africana studies," still presented themselves as nationalist or Afrocentric,
say, Temple University's Africana Studies Department, preserving a relatively
untroubled sense of connection to earlier nationalist institutions and ideolo-
gies. Others, including my own W. E. B. Du Bois Department of Afro-American
Studies at the University of Massachusetts–Amherst, displayed a general stance
toward the Black Arts and Black Power movements that might be described as
critical support. However, many of the most high-profile institutions and schol-

ars of African American studies and ethnic studies maintained a far more ambivalent, if not hostile, relationship to the Black Power movement, the Black Arts movement, and other forms of political and artistic nationalism of the 1960s and 1970s. For instance, Harvard's Henry Louis Gates Jr. provocatively derogated the Black Arts movement in the pages of a 1994 *Time* magazine article, declaring, "erected on the shifting foundation of revolutionary politics, this 'renaissance' was the most short-lived of all."[2] Typically for such attacks, Gates's piece was not primarily about the Black Arts movement but instead discussed what the author saw as a contemporary "renaissance" of African American art, with Black Arts invoked and then dismissed with minimal description as a sort of nonmovement against which the new black creativity could be favorably judged. Such invocations and shorthand dismissals were (and still are) common. Yet this persistent referencing of the Black Power and Black Arts movements evinced an unquiet spirit that haunted even the most ambivalent or hostile present-day African Americanists, who must admit that their place in the academy was largely cleared for them by the activist nationalism of the 1960s and 1970s — however narrow that nationalism might seem to them now (or seemed to them then).

Until recently, what longer works we had for the most part were memoirs or biographies of individual participants in the various movements rather than historical analyses of the broader movements themselves. For example, the 1990s saw a number of often lurid biographies and autobiographies of former Black Panthers, such as Elaine Brown's *A Taste of Power* (1992), David Hilliard and Lewis Cole's *This Side of Glory* (1993), and Hugh Pearson's *The Shadow of the Panther: Huey Newton and the Price of Black Power in America* (1994), but no serious academic history of the BPP.[3] These works have been generally aimed at a popular audience for whom Black Power, especially the BPP, remains a fascinating subject.

This fascination with the BPP and other Black Power and Black Arts activists serves as a reminder that outside academia the Black Power, Black Arts, Chicano, Nuyorican, and Asian American movements never really disappeared enough to be called hauntings.[4] The continuing influence of African American, Chicana/o, and Asian American nationalism can be seen in literature produced since 1975. On some writers, such as Alice Walker, Cherie Moraga, and Sherley Anne Williams, the influence was in large part negative, as they reacted against what they saw as the sexism and homophobia of 1960s and 1970s nationalisms — though a vision of community descended from the Black Arts and Black Power

movements often remained. Others, notably Amiri Baraka, Frank Chin, and Sonia Sanchez, moved away from nationalism toward a "Third World Marxism," or some other sort of activist politics at odds with their earlier positions but acknowledged a positive, nationalist legacy while critiquing what they saw as the limitations of the Black Arts and Black Power movements, such as an underestimation of the impact of class on the African American liberation movement. Still other artists, such as Alurista and Toni Morrison (Chloe Wofford), continued to embrace what was essentially a nationalist stance in their work long after 1975.

More recently, editors have assembled anthologies of African American writing, such as Keith Gilyard's *Spirit and Flame* (1996), Kevin Powell's *Step into a World* (2000), and Tony Medina, Samiya A. Bashir, and Quraysh Ali Lansana's *Role Call* (2002), which look back to the key nationalist anthologies, particularly LeRoi Jones (Amiri Baraka) and Larry Neal's *Black Fire* (1968), for inspiration. Finally, the Black Arts movement made a considerable impression on artists and intellectuals too young to remember its events firsthand. Many of the more explicitly political hip-hop artists owe and acknowledge a large debt to the militancy, urgent tone, and multimedia aesthetics of the Black Arts movement and other forms of literary and artistic nationalism. The phenomenal growth of hip-hop–inflected performance poetry and poetry slam events and venues, often run by African Americans, recalls the Black Arts movement in both popularity and geographical dispersion. As with the theaters, poetry readings, workshops, and study groups of the Black Arts era, it is a rare city or region today that does not boast some regular series of performance poetry or poetry slams. When I lived in Jacksonville, Florida, in the late 1990s, one could attend such events three or four nights a week. At least two of the regular venues were in or very near historically black communities and were substantially run by young African American poets. Many of the black fans and performers in these poetry venues (and not a few white, Asian American, and Latina/o participants) looked back to the Black Arts movement as one of their chief inspirations. Such a sense of ancestry can be seen also in the lionization of Amiri Baraka, Nikki Giovanni, Sonia Sanchez, and the Last Poets on Russell Simmons's four-part Def Poetry Jam spoken-word series hosted by rapper Mos Def that debuted on the HBO television network in 2002.

Yet despite the continuing presence of the Black Power and Black Arts legacies, whether positive or negative, in academia and cultural expression, there was, until comparatively recently, little sustained scholarly attention to either the

political or cultural sides of the nationalist movements of the 1960s and 1970s. Even now, academic assessments of the Black Arts and Black Power movements are frequently made in passing and generally seem to assume that we already know all we need to know about these intertwined movements and their misogyny, homophobia, anti-Semitism, and eschewal of practical politics for the pathological symbolic. Less often, other commentators attempt to flatten out the contradictions and what might now be perceived as the extremism of the movements, pointing out, for example, echoes of the Declaration of Independence in the early BPP's Ten-Point Program and ignoring the plan's invocation of the Bolshevik slogan of "Land, Peace, and Bread."

However, it seems to me that there is currently such an upsurge in the recovery, revaluation, and rethinking of the Black Power and Black Arts movements that the haunting metaphor does not entirely serve. Komozi Woodard's *A Nation within a Nation* (1999) signaled the beginning of a new scholarly moment in its efforts to ground its examination of a single figure (Amiri Baraka) within the context of a detailed portrait of Black Power in a local community (Newark, New Jersey) and its relation to the broader movement. The year 1999 also saw the publication of Rod Bush's *We Are Not What We Seem*, which also engaged Black Power with a new seriousness—if on a more general level than Woodard's study. This scholarly rethinking of Black Power and its legacy has become even more pronounced more recently. The appearance of the autobiography of Kwame Turé (Stokely Carmichael), *Ready for Revolution* (2003), written with Michael Thelwell, has also dramatically changed the historiographical landscape of Black Power. Scot Brown's account of the Us organization founded by Maulana Karenga (Ronald Everett), *Fighting for us* (2003), too, marks a new era in the study of Black Power, with far more attention to the specifics of how the movement worked on the ground in particular places and much more extensive and careful use of primary sources than had been the case before. And it needs to be noted that important new studies of major Black Power figures, organizations, regional activities, and/or institutions by such scholars as Matthew Countryman, Peniel Joseph, Donna Murch, Stephen Ward, and Fanon Che Wilkins have appeared as dissertations or will appear in the near future (as of this writing) in book form. Much remains to be done (and is being done), particularly with respect to providing a broad overview of Black Power that records and respects the movement's ideological and regional variations. Still, it is clear

that, rather than a haunting presence invoked and then dismissed, Black Power has become a major area of active and open investigation and debate.

Until recently, scholars have devoted even less attention to the Black Arts as a national movement with significant regional variations than to Black Power. A similarly narrow focus on a few individual figures with little consideration of institutions can be particularly seen in many academic investigations of the art and literature of 1960s and 1970s nationalism, especially of what were the dominant literary genres of the Black Arts movement, poetry and drama. Few book-length studies since Stephen Henderson's *Understanding the New Black Poetry* (1972) have attempted to assess the characteristics and development of the literary Black Arts movement.[5] There are a number of valuable memoirs by leading literary figures of the era, such as Amiri Baraka's *The Autobiography of LeRoi Jones* (first published in 1984 and reprinted with substantial revisions in 1997) and *Somethin' Proper* (1998) by Marvin X (Marvin Jackmon). There are also a handful of often brief studies of various circles like the Umbra Poets Workshop and OBAC, institutions like Broadside Press, or individuals, usually Baraka (e.g., Werner Sollors's *Amiri Baraka/LeRoi Jones: The Quest for a Populist Modernism* [1978], Jerry Watts's *Amiri Baraka: The Politics and Art of a Black Intellectual* [2001], and William Harris's *The Poetry and Poetics of Amiri Baraka: The Jazz Aesthetic* [1985]). While valuable, the few published book-length considerations of the Black Arts movement and the culture of Black Power that existed until recently, most notably William Van Deburg's important *New Day in Babylon* (1992), basically investigated general aspects of these movements synchronically, without much effort to delineate historical and geographical specifics. In short, there seemed to be an assumption that, as with the Black Power movement, the basic shape of the Black Arts movement, its development, and its regional variations were somehow known.

It is true that the wide stylistic, thematic, and ideological range of Black Arts writers and artists make it difficult in a broad study like this to pay close attention to the local variations of the movement. But one could say the same about twentieth-century American modernism, which has been the subject of many general or comparative scholarly projects. Even the best study of the formal characteristics of post–World War II African American poetry, Aldon Nielsen's groundbreaking *Black Chant* (1997), only tentatively and suggestively points to some possible influences on and origins of the formally and politically radical

African American avant-garde of the 1950s, 1960s, and 1970s. For example, he alludes to Russell Atkins's argument for an African American avant-garde tradition descending from Langston Hughes without elaborating on how that tradition might be drawn and from where it might have come in the 1950s.[6] Similarly, Nielsen makes a claim for a certain kinship between "experimental" poetry by black and white authors, but there is not much concrete consideration of the relationship of the work of the black avant-garde of the 1950s through the 1970s to that of their white, Chicana/o, and Nuyorican counterparts—or to the development of the Black Arts as a cultural and political movement. This observation is not intended to diminish Nielsen's achievement in opening up poets and poetic formations to literary scholarship—not to mention his acumen in the reading of this body of work. As Nielsen himself mentions in the acknowledgments section of *Black Chant*, he was forced to prune much material due to the exigencies of academic publishing.[7] My critique of Nielsen is only meant to suggest how much more new critical work is needed.

And this work is beginning to be done. As with the study of the Black Power movement, a new scholarship examining Black Arts literature and art has started to flourish in work by such scholars as Melba Joyce Boyd, Kimberly Benston, James Sullivan, James C. Hall, David Lionel Smith, Lorenzo Thomas, Mike Sell, Michael Bibby, Kalamu ya Salaam (Val Ferdinand), Daniel Widener, Cynthia Young, Howard Ramsby, and Bill Mullen. Thomas, along with Nielsen, particularly charted the way for a rethinking of radical black poetry and drama in the 1960s and 1970s. Of course, Thomas has been doing this sort of thing for years, but his work took on a new prominence with the publication of his collection of essays on modern African American poetry, *Extraordinary Measures* (2000). Boyd's study of Dudley Randall, Broadside Press, and the Black Arts movement in Detroit, *Wrestling with the Muse* (2003), is a model of what an engaged study of the local manifestations of the movement might be.

These scholars need to be congratulated for beginning a vital intellectual conversation, a conversation that has taken on a new urgency with various popular culture and "high" culture representations and interpretations of the legacy of 1960s and 1970s nationalism, such as Mario Van Peebles's film *Panther*, Spike Lee's *Malcolm X*, Danzy Senna's popular novel *Caucasia*, and even the film *Forrest Gump*. This conversation takes up the questions, to paraphrase Harry Levin, What was the Black Arts movement? What were its sources? What were its re-

gional variations and commonalities? This book also echoes the set of questions that scholars of the New Negro Renaissance have raised since the 1980s: Was the movement a "failure" in something other than the sense that all cultural movements (whether British Pre-Raphaelite, Russian futurist, German expressionist, U.S. abstract expressionist, or Brazilian tropicalian) ultimately "fail" to achieve their most visionary aims—and simply end? Who says so? And why do they say it?

The Black Arts Movement, then, enters an intellectual conversation already in progress—though it is a conversation that was hardly more than a whisper in academia at the end of the twentieth century. It undertakes to map the origins and development of the different strains of the 1960s and 1970s Black Arts movement with special attention to the its regional variations while delineating how the movement gained some sense of national coherence institutionally, aesthetically, and ideologically, even if it never became exactly homogeneous. It is not an attempt to write an exhaustive history of the entire movement—a subject that seems to me beyond the scope of a single book. For reasons having to do with my particular interests and intellectual background as well as with the character of the Black Arts movement itself, there is a special, though not exclusive, emphasis on what was sometimes known as the "New Black Poetry" in this study.

The beginnings of the Black Arts movement are seen against the interrelated rise of the "New American Poetry" (as largely codified by Donald M. Allen's 1960 anthology of the same name) and postwar, avant-garde theater in the United States (and such groups as the Living Theater, the San Francisco Mime Troupe, and El Teatro Campesino) and the subsequent emergence of the literary activities connected to the Chicano movement, the Nuyorican writers, the circle of Asian American writers associated with the seminal 1975 anthology *Aiiieeeee!*, and what would become known as the multicultural studies movement. This examination considers the published and unpublished works of the writers in question as well as the institutional contexts in which the works were produced.

I also pay particular attention to the way the nascent Black Arts movement negotiated the ideological climate of the Cold War, decolonization, and the re-emergent civil rights movement, particularly the black student movement that began in 1960. As James Hall observes, "while accounts of African-American literary battles of the sixties often appropriately detail attitudes toward cultural nationalism and black power, too often cold war (and prior) ideological orien-

tations are placed to one side."[8] What Hall calls "prior ideological orientations" and their institutional expressions are crucial in understanding the political and cultural matrix in which the Black Arts grew. As Robert Self argues:

> Mid-century black communities embraced multiple political crosscurrents, from ideologies of racial uplift and integrationism to Garveyite nationalism and black capitalism to workplace-based black power (as in the BSCP [Brotherhood of Sleeping Car Porters]) and, especially in the East Bay, radical laborite socialism and communism. These crosscurrents produced a lively and productive debate over the future of African American neighborhoods and the cities in which they were situated. This rich political tradition belies a facile integration/separation or civil rights/Black Power dichotomy in black politics, which are inadequate frameworks for understanding the range of African American responses to the changing face of urban life either before or after 1945.[9]

While Self might underestimate the disruptive impact of Cold War repression (and Cold War ideological disenchantment) on some of the "crosscurrents" he enumerates, even in the East Bay, his basic point is well taken and can be equally applied to black cultural politics. To that end, I trace the continuities as well as the ruptures between the Old Left (and what could be thought of as the old nationalism) and the new black political and cultural radicalisms, much as Maurice Isserman and some other "revisionist" historians of the Left have done for the organized political movements of the 1960s. I note, for instance, many well-known dramatic gestures by African American artists and intellectuals that symbolically signaled a break with older literary politics and aesthetics, such as the vitriolic debate in the Umbra group in 1963–64 after John F. Kennedy's assassination over whether to publish a poem by Ray Durem attacking Kennedy; Amiri Baraka's move to Harlem and the founding of BARTS in 1965 (allegedly catalyzed by Malcolm X's assassination); and the transformation of the Watts Writers group's Douglass House into the House of Respect in 1966.

It is important to recall, though, that these dramatic moments not only indicate rejections of older political and cultural radicalisms by black artists and intellectuals but also stand as signposts alerting us to the very existence of organic links to older political and cultural movements that the continuing power of gestures of generational disaffiliation might cause us to miss or underestimate. Take the way in which Langston Hughes served as a bridge between different

generations of radical black artists. His generosity in encouraging, promoting, and mentoring younger black writers is well-known. Nonetheless, speaking personally, it was a revelation to me while undertaking this project to discover the crucial role that Hughes played in the emergence of the Black Arts movement in so many cities (New York, Detroit, Cleveland, Chicago, New Orleans, and on and on). Instances of Hughes's contributions to the movement are scattered throughout this study.

David Lionel Smith argues with respect to the Black Arts movement that "it must be understood . . . as emanating from various local responses to a general development within American culture of the 1960s."[10] In this spirit, while always attempting to place these local responses within a larger context, *The Black Arts Movement* is organized regionally for the most part to look at how connections between different groups of black artists and intellectuals took place on a grassroots level and to get a sense of the significant regional variations of the movement. My approach resembles Kalamu ya Salaam's local/national/local model of Black Arts movement development in his (as of this writing) unpublished introduction to the movement, *The Magic of Juju*. According to Salaam, the movement started out as disparate local initiatives across a wide geographic area, coalescing into a national movement with a sense of a broader coherence that, in turn, inspired more local, grassroots activities.[11] I would add that there was a continuing, bidirectional interplay between the national and the local in which the national inspired the local, even as the local confirmed and deepened a sense of the national as truly encompassing the nation — both in the geographical sense of covering the United States and in the ideological sense of engaging the entire black nation. BARTS and the work of Amiri Baraka, for instance, may have helped stimulate the development and shape of BLKARTSOUTH in New Orleans, but the growth of radical Black Arts groups and institutions in New Orleans, Houston, Miami, Memphis, Durham, Atlanta, and other cities in the South confirmed to activists in centers more commonly the focus of accounts of the movement (e.g., New York, Newark, Chicago, Detroit, San Francisco, Oakland, and Los Angeles) that it really was nation time.

Lorenzo Thomas's path-breaking discussions of African American Left and nationalist subcultures in the emergence of the Black Arts movement in New York City also significantly informs how I come at this dialectic of local and national. Keeping Thomas's work in mind, it should be recalled that there were already transregional and even international networks in place, particularly those

of various Left and nationalist (and Left nationalist) groups and their support-
ers, before the creation of BARTS in 1965. These networks were media of inter-
change between proto–Black Arts individuals and organizations in different
cities. In other words, the movement was always local and always national.

This impossibility of completely separating the local and the national dictates
that this study cannot be entirely regional in organization and that there will be
a certain overlap between chapters. Cultural and political styles (and cultural
and political activists) circulated widely and constantly in the Black Arts and
Black Power movements (and their immediate forerunners). As a result, cer-
tain issues and phenomena, such as Black Arts and Black Power conceptions of
history, the relationship between the visual and the oral (and between text and
performance) in Black Arts literature, and the connection between the Black
Arts, Black Power, and other nationalist political and cultural movements, were
significantly transregional. The Chicano movement, for example, was not only
a phenomenon of the West and the Southwest (and the South, depending on
how one categorizes Texas) but also of many midwestern cities where there had
long been significant Chicana/o communities. When Chicago BPP leader Fred
Hampton called for "Brown Power for Brown People" (basically meaning Chi-
cana/o and Puerto Rican power), he was not speaking abstractly but was making
a statement rooted in local Chicago politics. Similarly, as Michelle Joan Wilkin-
son notes, "Neorican" or "Chicagorican" writers in the Midwest were an impor-
tant strain of the larger Black Arts–influenced movement of writers of Puerto
Rican descent on the mainland often grouped under the rubric of "Nuyori-
can."[12] As a result, I take up some discussions of transregional phenomena in
the more general and thematically organized Chapters 1 and 2. However, other
transregional subjects are considered in chapters focusing on the areas with
which the subjects were most associated. For example, I take up the connection
between the Black Arts and Chicano movements at greatest length in the sec-
tion of the book devoted to the West Coast.

The first chapter of this study outlines the state of American culture and poli-
tics, particularly African American art and literature (and its critical and institu-
tional contexts during the age of the Cold War, civil rights, and decolonization
in the 1950s) and the rise of the New American Poetry. In this regard, I look at
the ascendancy of the New Critical and New York Intellectual models of poetic
excellence that privileged a streamlined and restrictive neomodernist aesthetic.
As a corollary to this ascendancy, I detail the character, influence, and eventual

isolation or destruction (by external and internal forces) of Popular Front aesthetics and the Popular Front institutions that played a large role in the artistic and intellectual life of the United States in the 1930s and 1940s. The first chapter also notes the development of distinct, though interconnected schools of New American Poetry (or postmodern poetry, if you will) that received such names as the "Beats," the "New York school," the "California Renaissance," and the "Black Mountain poets," in which many early Black Arts writers found a temporary home to one degree or another.

The opposition of all these countercultural schools to the New Criticism and their more murky relationship to the New York Intellectuals will be a special concern in the first chapter. The focus of this part of the study is the revival of Popular Front poetics within these various "schools" and the transformation of the cultural politics of the Popular Front by the still potent domestic and international Cold War as well as by the liberationist rhetoric of the civil rights, anticolonialist, and nonaligned movements. This tracing of the legacy of the Popular Front includes the issues of the relationship of popular culture to poetic practice, the interpretation of the heritage of European modernism, especially surrealism, Dadaism, and futurism (both Soviet and Italian), the American Whitmanic tradition, and the figuration of ethnicity, especially among the Beats (e.g., Allen Ginsberg, Gregory Corso, Jack Kerouac, and Bob Kaufman). Of course, the participation of African American poets and intellectuals, particularly Kaufman, Amiri Baraka, Ted Joans, Russell Atkins, and A. B. Spellman, within (or on the fringes of) these "schools" is an important aspect of this part of my project. However, equally crucial is delineating the influence of established African American writers and intellectuals, notably Langston Hughes, on the New American Poetry.

The second chapter takes up the early development of Black Arts ideology and the impact of this ideology on artistic practice. In its four sections, the chapter deals with the theorization of the relation of Black Arts to popular culture (and by extension, a popular audience) and the impact of this theorization on texts and performance (and textual performance); Black Arts conceptions of history; gender and Black Arts practice and ideology; and the interplay between textuality, visuality, orality, and performance in Black Arts works. As is noted in this chapter, while these issues might have a particular association with a certain region in their early forms (e.g., the conception of a popular avant-garde that issued from circles of black artists and intellectuals in New York and Phila-

delphia), they cannot be tied ultimately to a particular city or area. As a result, I consider them in a separate chapter rather than trying to subsume them in the following chapters that take up the movement in specific regions.

Chapter 3 looks closely at the embryonic Black Arts movement in New York City and elsewhere in the Northeast and at the early institutions and formations that nurtured it in the late 1950s and early 1960s. I argue that the importance of New York and other East Coast centers, particularly Washington, Boston, and Philadelphia, for the Black Arts movement lies largely in the manner in which the region served as an incubator for Black Power and Black Arts ideologies, poetics, and activists. The strong traditions of African American political and artistic radicalism in the region and the peculiarly close geographical relationship of centers of black population, notably New York and Philadelphia, inspired and informed what Aldon Nielsen has characterized as the black artistic diaspora that settled there, particularly in the Lower East Side of New York. These institutions and formations include the Market Place Gallery readings organized by Raymond Patterson in the late 1950s, the Umbra Poets Workshop (including Calvin Hernton, David Henderson, Ishmael Reed, Lorenzo Thomas, Askia Muhammad Touré [Rolland Snellings], and Tom Dent), and the magazines *Umbra*, *Liberator*, *Black America*, and *Freedomways*.

Also examined here are the relationships between proto–Black Arts poets and the "New American" poets and their institutions on the Lower East Side, including the "older generation" of New American poets (such as Allen Ginsberg, Frank O'Hara, Charles Olson, Diane di Prima, Ed Dorn, and Amiri Baraka) and the "second generation" (such as Ted Berrigan, Ed Sanders, Bernadette Mayer, and Lorenzo Thomas) as well as "Nuyorican" writers (such as Victor Hernandez Cruz, Miguel Algarín, and Miguel Piñero). One point that should be obvious with the mention of Baraka and Thomas is that the proto–Black Arts writers and New American poets were often one and the same. The formal and thematic choices of the proto–Black Arts poets and Nuyorican artists are examined through these new institutional contexts and the context of the changing civil rights movement (e.g., the growth of cultural nationalism in organizations such as SNCC) and the emergence of the New Left, particularly the SDS and the PL.

The fourth chapter considers the growth of crucial Black Arts and Chicano movement institutions in the Midwest, particularly the intense interplay between black political and cultural radicals in Chicago and Detroit. This chapter pays special attention to the interactions, whether antagonistic or sympa-

thetic, between older black artists (such as Robert Hayden, Margaret Burroughs, Gwendolyn Brooks, Melvin Tolson, Margaret Walker, and Langston Hughes) and the generally young activists of the emergent Black Arts movement. It also traces the links between still vital Left traditions and the Black Power and Black Arts movements. A particular focus of this chapter is the relatively successful midwestern emphasis on creating black cultural institutions, such as OBAC, the AACM, the DuSable Museum, the Concept East Theatre, the eta Creative Arts Foundation, Broadside Press, Third World Press, and *Negro Digest/Black World*, that significantly, with some modifications, maintained the Black Arts legacy far beyond the collapse of the movement nationally. As part of this impulse toward institution building, the movement in the Midwest was successful in producing a mass audience for poetry (and avant-garde music, visual art, dance, theater, and criticism) that had never been seen before in the United States.

The fifth chapter discusses how the Black Arts movement on the West Coast emerged (and eventually distinguished itself) from strong Left, nationalist, and bohemian traditions in California. It shows how the Bay Area and Los Angeles made large contributions to the development (and the idea) of the Black Arts movement as a broad, transregional phenomenon. It describes the process by which the San Francisco Bay Area provided some of the most important early national institutions of the movement, particularly the Black Arts and Black Power journals *Soulbook*, *Black Dialogue*, and JBP. It also examines how black artists in California, primarily in Los Angeles, early on popularized the idea of a new militant black literature, theater, and art across the United States as writers, theater workers, and visual artists associated with the Watts arts scene gained a national prominence as epitomizing the militant black artist, in much the same manner that Watts itself became the iconic epicenter of a new African American political mood represented as compounded equally of anger and pride following the Watts uprising of 1965. This iconic status that followed from the uprising also generated considerable private and public money for radical black cultural initiatives in Watts, with the same opportunities and pitfalls that became typical of foundation and public financing of the Black Arts movement across the country. Finally, this chapter discusses the Black Arts movement and its impact on the Chicano movement, Asian American literary nationalism, and the embryonic multicultural movement.

Chapter 6 focuses on the Black Arts movement in the South — where the majority of African Americans still lived in the 1960s and 1970s. The southern Black

Arts movement, especially the community-oriented institutions that character-ized the movement in Houston, Memphis, Jackson, Miami, and New Orleans, lacked the high media profile that its counterparts in the Northeast, Midwest, and California achieved. Nonetheless, this chapter not only traces the outlines of the movement in the South but also shows that the reports of the activities in the South, particularly in *Black World* and *JBP*, did reach an audience outside the region. Such reports, along with the contributions of southern political and cul-tural activists to national political and cultural events, such as the 1970 inaugural CAP convention in Atlanta and the 1972 National Black Political Convention in Gary, Indiana, provided the Black Power and Black Arts movements a sense of truly encompassing the black nation, a sense that could never be gained other-wise, given the symbolic and demographic meanings of the South for African Americans.

A Note on Definitions

This study is filled with locutions pairing the Black Arts and Black Power move-ments. It is a relative commonplace to briefly define Black Arts as the cultural wing of the Black Power movement. However, one could just as easily say that Black Power was the political wing of the Black Arts movement. There were, of course, major black political leaders who were also major cultural figures before the 1960s — one thinks particularly of W. E. B. Du Bois, James Weldon Johnson, and Paul Robeson. And there were others remembered primarily as political fig-ures with a youthful background in the arts, such as Bayard Rustin and A. Phillip Randolph. Certainly, all of these figures posited a Left or civil rights cultural-ism as major parts of their political agendas. However, the Black Power move-ment distinguished itself by the sheer number of its leaders (and members) who identified themselves primarily as artists and/or cultural organizers or who had, like Rustin and Randolph, some early professional interest in being artists. It is also difficult to recall earlier moments when radical black political groups made arts organizations primary points of concentration, as RAM did with respect to the Umbra Poets Workshop and BARTS. Finally, while Amiri Baraka's speech at the first CAP convention in 1970 that ended in a wild performance of his poem "It's Nation Time" might not be absolutely unique as convention speeches go, I at least cannot think of anything quite like it in earlier political-cultural mo-ments. As will be seen in many places in this study, Black Power and Black Arts

circuits were often the same, not just ideologically, but practically. Black orga-
nizers/artists might set up Black Power meetings, say, of the ALSC, in different
cities while on some sort of performance tour. Conversely, one might be in town
for a big meeting or political convention and put on readings, concerts, plays,
and so on.

One obvious problem that makes both "Black Power" and "Black Arts" such
elastic terms is that there was no real center to the interlocked movements. That
is to say, there was no predominant organization or ideology with which or
against which various artists and activists defined themselves. While the BPP at
times approached such a hegemony in terms of the public image of Black Power
(especially in the mass media), in a grassroots organizational sense and in an
ideological sense, no group approached the dominance that the CPUSA exercised
over black radical art and politics in the 1930s and 1940s—even if that hege-
mony took the form of a direct opposition, as in the various cases of the then
Trotskyist C. L. R. James, the Socialists A. Phillip Randolph and Frank Cross-
waith, or the nationalist James Lawson. However, while noting the relative de-
centralization, and occasionally the disunity, of the Black Power and Black Arts
movements, the common thread between nearly all the groups was a belief that
African Americans were a people, a nation, entitled to (needing, really) self-
determination of its own destiny. While notions of what that self-determination
might consist (and of what forms it might take) varied, these groups shared the
sense that without such power, African Americans as a people and as individu-
als would remain oppressed and exploited second-class (or non-) citizens in
the United States. While the right to self-determination had often been a mark
of both black nationalism and much of the Left (since at least the late 1920s),
making the actual seizing and exercise of self-determination the central feature
of political and cultural activity differentiated Black Power from any major Afri-
can American political movement since the heyday of Garveyism. And unlike
the Garveyites, a major aspect of most tendencies of the Black Power and Black
Arts movements was an emphasis on the need to develop, or expand upon, a
distinctly African American or African culture that stood in opposition to white
culture or cultures. Again, some precedents for this emphasis can be found in the
cultural work of the Left and of relatively small nationalist groups of the 1930s,
1940s, and 1950s. And the political-cultural formation known as the New Negro
Renaissance or the Harlem Renaissance certainly used the arts as an instrument
to attempt to dismantle racism and Jim Crow. But never before, I think, was such

artistic activity made an absolute political priority and linked to the equally emphatic drive for the development and exercise of black self-determination within a large black political-cultural movement in the United States.

Some preliminary definition and nuancing of such a contested term as "nationalism" is required because it subsumes ideologies, institutions, political practices, and aesthetic stances that are often distinguished from each other. Maulana Karenga's division of black nationalism into religious nationalists (e.g., the NOI), political nationalists (e.g., the BPP), economic nationalists (e.g., the black cooperative movement), and cultural nationalists (e.g., Us) points out something of the complexity of nationalism in the 1960s and 1970s. Various other taxonomies of nationalism primarily rely on the binary of revolutionary nationalists and cultural nationalists (sometimes with a third category of territorial nationalists) that marked the terminology of the Black Power and Black Arts era. I both use and question this opposition of revolutionary nationalist/cultural nationalist. Like "cultural nationalist," "revolutionary nationalist" is an elastic term that includes a range of often conflicting ideological positions. As Karenga points out, virtually every variety of African American nationalism proclaimed the need for some sort of political revolution.[13] I take a major defining characteristic of revolutionary nationalism to be an open engagement with Marxism (and generally Leninism), particularly with respect to political economy, Leninist notions of imperialism, and often Communist formulations of the "national question." Of course, black revolutionary nationalists often had a rocky, if not actively hostile, relationship to surviving "Old Left" organizations—though as we shall see, the connections between the Old Left and young black political and cultural radicals of the 1960s and 1970s were in many cases much more live than has often been allowed. It should also be pointed out that though he found Marxism rooted in a deeply problematic Eurocentrism, varieties of Marxism nonetheless marked even the cultural nationalism of Maulana Karenga, particularly in his conceptions of ideology, culture, and hegemony—if only in identifying problems for which he sought a more usable African framework for understanding and solving. Finally, one of the ironies attending the period is that very often nationalist groups took up positions originally articulated or popularized by the Left but that had been repudiated by their Left originators. Probably the most prominent of these positions is that of the black nation or republic in the South adapted by such nationalist groups as the RNA from the old "Black Belt

thesis" of the CPUSA, a position that the Communists formally abandoned in the 1950s.

For my purposes, I define "cultural nationalism" in the context of the 1960s United States relatively broadly as an insider ideological stance (or a grouping of related stances) that casts a specific "minority" group as a nation with a particular, if often disputed, national culture. Generally speaking, the cultural nationalist stance involves a concept of liberation and self-determination, whether in a separate republic, some sort of federated state, or some smaller community unit (say, Harlem, East Los Angeles, or the Central Ward of Newark). It also often entails some notion of the development or recovery of a true "national" culture that is linked to an already existing folk or popular culture. In the case of African Americans, cultural nationalism also usually posited that the bedrock of black national culture was an African essence that needed to be rejoined, revitalized, or reconstructed, both in the diaspora and in an Africa deformed by colonialism. Of course, this is also an extremely simplistic definition. For one thing, cultural nationalist ideas and organizations deeply touched a wide range of black political and cultural activists from more or less "regular" Democrats to the separatists of the RNA. Even such a reformist Democratic politician as Newark mayor Kenneth Gibson would announce the following at the first CAP convention:

> You have to understand that nobody is going to take care of you — of you, and people like you. We have to understand that nobody is going to deal with our problems but us. We have to understand that nobody is going to deal with the realities. And the realities and the basis that we are talking about — those realities — are the basis of nationalism. And so, nationalism is simply the expression of our recognition of the fact that in the final analysis it is Black people who must solve the problems of Black people.[14]

And there were other Black Power and Black Arts leaders, such as Kwame Turé, whose ideology in many respects comprehended both revolutionary nationalism and cultural nationalism. In short, the ideological divisions between cultural and revolutionary nationalists were often a matter of emphasis, tactical maneuvers in wars of position among nationalist organizations and activists, or attempts by African American nationalist theorists to find a workable, analytical structure by which to delineate and evaluate the Black Power and Black Arts movements. As with their predecessors in the Second, Third, and Fourth

Internationals who debated, split, and expelled each another over revisionism, ultraleftism, Trotskyism, Stalinism, and so on, such usages (and the polemics that surrounded them) are worth recalling in order to make distinctions among different groups and tendencies, but with caution. I will make some further observations about intergroup and intragroup variations of cultural nationalism and revolutionary nationalism, and some further caveats about the use of the terms themselves, in the course of this study.

Also, the rubrics of "Left" or "the Left" are quite elastic. Generally speaking, I use "the Left" to cover a spectrum of Marxist (for the most part) individuals, institutions, and organizations. "Communist Left" denotes the CPUSA and its circle of influence. While such a locution may seem a bit vague, it is an attempt to find an appellation that could cover people whom I know to have been CPUSA members, others whom I believe (but am not absolutely sure) were party members, and still others whom I suspect never joined but strongly supported many of the initiatives of the CPUSA, especially in its work among African Americans. Of course, the uncertainty of organizational affiliation applies to individuals in other Left circles, especially the Left nationalists of such quasi-underground organizations as RAM in the 1960s. However, the peculiar intensity of anti-Communism in the United States and the continuing impact of the Cold War make the CPUSA and its members and supporters a special case.

It is also worth noting that the CPUSA, never a monolithic organization, despite its rhetoric of "democratic centralism" in which centralism was often emphasized over democracy, was in some ways more diffuse in terms of how it (and its members) worked on the ground during the period covered by this study than it was before or since. In the 1950s and 1960s, the CPUSA was highly factionalized by debates on how to respond to McCarthyism and the Cold War, on what were the implications of Khrushchev's revelations about Stalin for party policy and organization (not to mention morality), on what was the meaning of independence and revolution in former colonial nations for the world Communist movement, on how to respond to the upsurge of the civil rights movement *and* a new black nationalism, and so on. Many left the CPUSA during the course of the debates, reducing the party to a fraction of its former membership. For those who might have joined the CPUSA during the 1960s, many were daunted both by the pressures of anti-Communism, including the legacy of Stalinism, and by a sense that many of the top Communist leaders were out of step with the changes in the post–Bandung Conference, post-Stalin world. There was also a

widespread feeling that the CPUSA had in many respects retreated from its positions most consonant with the new nationalism. For example, the notion of African Americans as a nation was largely abandoned by the CPUSA during the 1950s — in no small part due to the rise of a mass civil rights movement addressing issues of black citizenship as well as demographic changes that made the idea of a "Black Belt republic" in the South even more problematic than it had been when it was first promoted in the late 1920s and early 1930s. Undoubtedly, there was much discomfort with, and often open opposition to, various sorts of African American nationalism on the part of many in the top leadership of the CPUSA, limiting its public impact on the Black Arts and Black Power movements in important ways. The pronouncements of party general secretary Gus Hall and the Central Committee of the CPUSA had little direct influence on the new nationalist and new radical black cultural and political organizations in the 1960s.

However, many rank-and-file Communists and local leaders had a far more favorable or tolerant attitude about working with, encouraging, and joining in incipient Black Power and Black Arts organizations and activities. Even older national officers and functionaries, especially such black leaders as James Jackson, William Patterson, Claude Lightfoot, and Henry Winston, might denounce "bourgeois nationalism" one day and then work closely with nationalists on some particular campaign — or allow rank-and-file members to work within Black Power or Black Arts organizations without serious interference — the next. In short, the influence of the Communist Left is sometimes hard to define precisely because the actual work of the CPUSA on the ground locally (and even nationally) was often in contradiction to its stated positions.

"Trotskyist" indicates a number of groups (and their supporters) descended from Leon Trotsky's Fourth International, particularly the SWP and the WP and their offshoots. Here, also, a certain amount of imprecision is inevitable since many of the individuals and organizations to emerge from this Left tradition with the greatest impact on the Black Arts and Black Power movements, including James Boggs, Grace Lee Boggs, C. L. R. James, and the Correspondence and Facing Reality groups, split with the SWP (and Trotsky) over such issues as the nature of the Soviet Union and the need for a vanguard revolutionary party. Thus, calling them "Trotskyist" is problematic. Similarly, "Maoist" is applied with ambiguity to individuals and organizations that in many cases split from the CPUSA in the late 1950s and early 1960s, seeing the CPUSA as reformist, revisionist, bureaucratic, Eurocentric, and hopelessly tied to a stodgy, overcentral-

ized (if not sinisterly dictatorial), neocapitalist Soviet Union. Instead, they held up China under Mao as an icon of a new, truly revolutionary, antirevisionist, post–Bandung Conference Marxism. The most important of these groups for purposes of this study is the PL—though other Maoist or Third World Marxist formations, such as the LRBW, would be far more significant for the Black Arts and Black Power movements in the long run. Some scholars question whether the PL was genuinely "Maoist."[15] Even during the time covered by this study, many of those who might seem to be in this general category, such as the radical black journalist Richard Gibson, who was a leader of Fair Play for Cuba (and who took Amiri Baraka to Cuba on a trip that was a milestone in Baraka's political development), preferred to consider themselves "antirevisionists" rather than Maoists.[16] So, again, such categories as "Maoist" or "antirevisionist" are reductive or a bit vague, if useful.

In sum, such shorthands are convenient but do not begin to do justice to the complexities of the Left. The edges of the circles referenced above are often very blurry, even if at times they seem incredibly rigid. This should not be surprising, since nearly all these groups shared a single political family tree—a tree that branched during intense ideological splits and crises. As a result, there was inevitable ideological and even practical overlap at the same time that there was often vicious rivalry between these groups. Of course, much the same can be said about the various African American nationalist organizations of the era. And while the leaders of various groups might seem to have considered each other just about the worst people on earth, on a grassroots level, many people would participate in a wide range of radical Left and nationalist groups and activities at the same time. Although it might seem logically inconsistent to, say, simultaneously be a member of a CPUSA youth organization study group, attend SWP forums, go to Cuba through a PL tour, and spend a lot of time at the local NOI mosque, such things were common. Again, even leading leftists were far more ideologically tolerant or eclectic in terms of their personal and political associations than one might expect—especially during the formative days of the Black Arts and Black Power movements.

As a result, I often use such phrases as "CPUSA-influenced" or "associated with the SWP" to indicate that an institution or event was in whole or in part led, initiated, organized, and so on by individuals closely tied to those Left groups, usually with some degree of organizational support, but that the institution or event was not "controlled" by those Left groups. "Communist," as an adjective

or noun, refers to the CPUSA (as opposed to the uncapitalized "communist," which would comprehend the SWP, the WP, and the PL, all of which saw themselves as "communist" in the Leninist sense). Likewise, "Socialist" refers to the Socialist Party and "socialist" to the general idea of socialism as a political and economic system, an idea to which nearly all the Left groups mentioned in this study subscribed. I prefer to avoid the term "front" (except in the case of "Popular Front") because of its obvious Cold War connotations. While I try to indicate the degree to which a particular institution or individual was connected to the Left, precision is not always possible—both because the ideological orientation of institutions (and even of individuals) was often not unified and because the persistence of Cold War attitudes (and individual change of opinion) even today makes some people reluctant to reveal their precise political affiliation back in the 1950s and 1960s. Again, even when that affiliation seems obvious, actual behavior is sometimes quite surprising—at least to the outsider. For example, many, if not all, of the founders of the journal *Freedomways* were members of or sympathetic to the CPUSA—or at least what remained of the overlapping black political and cultural circles of the Popular Front. There was considerable support for the journal in the CPUSA leadership—after all, James Jackson, among the most prominent African Americans in the party and editor of the Communist newspaper *The Worker* in the early 1960s, was married to the managing editor of *Freedomways*, Esther Cooper Jackson. Nonetheless, the editors of the journal tended to be more open to black nationalism than many of the top leaders of the CPUSA—and had a hostile relationship to the historian Herbert Aptheker, who wielded enormous influence in the top echelons of the party with respect to what would now be thought of as African American studies. In short, as Lenin quoted from Goethe's *Faust* in the 1917 *Letters on Tactics*, "'Theory, my friend, is grey, but green is the eternal tree of life.'"[17]

My use of generational categories merits some comment also. Generally speaking, I use the terms "older writers" and "older artists" to designate those artists and intellectuals who were born in the early twentieth century and came of age during what I think of as the extended Popular Front era, from the mid-1930s to about 1948. "Younger writers," "younger artists," and so on refer to those born in the 1930s and 1940s, coming to artistic and intellectual maturity during the Cold War. Of course, even within those broad groupings, there are considerable differences between age cohorts. Someone who was a seven-year-old when the United States entered World War II, as was Amiri Baraka, will have

a somewhat different outlook than someone born during the war, as was Haki Madhubuti (Don L. Lee). Also, it is worth recalling that artists' career cohorts do not always coincide with their generational peers, in important ways. For example, Dudley Randall's generational peers were really the Popular Front cohort that included Esther Cooper Jackson, Margaret Burroughs, Margaret Walker, and his close friend Robert Hayden. But though, as Randall himself said, in many ways he remained much influenced by the political and cultural world of the Great Depression, his literary career did not really take off until the 1960s. So, like other sorts of political and cultural categories, generational divisions have some use as analytical categories, but only to a point. To help readers sort out these age groups, I have included a selected list of black artists and activists mentioned in this study with their dates of birth in Appendix 1. I have also included a time line (Appendix 2) to help readers navigate the complicated chronology of the Black Arts and Black Power movements.

1

Foreground and Underground:
The Left, Nationalism, and the Origins
of the Black Arts Matrix

Literary expressions of nationalism by African American writers have a long foreground, going back to at least the portions of Martin Delaney's novel *Blake* that were published in serialized form in the late 1850s. While these published chapters of Delaney's novel did not circulate widely in the nineteenth century, certainly by the early twentieth century, black nationalist thought deeply marked the production of African American art, creating antecedents for the Black Arts movement that caught the attention of scholars from widely varying ideological positions. Tony Martin, for instance, has called our attention to the Garveyite literary circle around the magazine *Negro World*. Ernest Allen Jr. (Ernie Mkalimoto) and William Maxwell have investigated the impact of both Garveyism and the Left nationalism of the African Blood Brotherhood on the New Negro Renaissance. George Hutchinson, Barbara Foley, and Anthony Dawahare in their different ways have argued powerfully that the New Negro Renaissance was a form of cultural nationalism.[1]

However, a still relatively underconsidered period that is crucial for our understanding of the artistic nationalisms of the 1960s and 1970s is the left-wing arts subculture in the two decades following the New Negro Renaissance. The importance of this subculture (or overlapping subcultures) is not simply due to the enormous number of African American writers, playwrights, directors, actors, visual artists, composers, musicians, and dancers of the 1930s and 1940s

who participated in the activities and organizations of the Left, especially the Communist Left. It also results from the circulation of a couple of Left paradigms, that of an alternative, folk-based avant-garde and that of a popular avant-garde, which were, in different forms, crucial to the development of black artistic nationalism during the 1960s and 1970s.

The first paradigm promoted by the Communist Left, particularly from the late 1920s on, was the notion of an oppositional culture that was both avant-garde, or vanguard, if you will, and rooted in a working-class or (in the case of African Americans) a proletarian-peasant national tradition that would exist outside of mass culture.[2] In this view, a sort of homegrown version of the Frankfurt school, mass culture was a form of capitalist mind control that got workers (and African Americans, as an oppressed "nation" or "national minority" depending on whether they lived in the southern "Black Belt" or urban ghettos), literally to buy into the capitalist system against their own best interests. Where most Left artists and intellectuals who subscribed to this position differed from the Frankfurt school was that they did not generally see salvation in a "high" art experimentalist avant-garde as did, say, Theodor Adorno. Instead they tended to look for or imagine residual folk or worker cultures that lay outside mass consumer culture — though they were often influenced by the formal artistic radicalism of the early twentieth century as well. In short, they had what might be called a utopian alternative culture vision of the working class and the folk. While this view might be derided as an unrealistic, reductive, and/or sentimental primitivism, it did promote the growth of a considerable network of left-wing alternative cultural institutions — theater groups, dance groups, film and photography groups, sports leagues, bookstores, reading circles, and writers' groups and affiliated journals, forums, and so on, as well as a groundswell of efforts by radical folklorists and musicologists (both professional and "amateur"), such as Lawrence Gellert, Alan Lomax, Frank Marshall Davis, Langston Hughes, Sterling Brown, John Hammond, Meridel Le Sueur, Charles Seeger, Pete Seeger, Don West, and B. A. Botkin.

This alternative approach came to have a particular application for African Americans. The sixth congress of the Comintern in 1928 defined the "Negro Question" as a "national question" and declared it to be at the heart of the work carried on by Communists in the United States. For the next thirty years, with varying degrees of intensity, instead of opposing integrationism to nationalism or nationalism to internationalism, the CPUSA argued that African Americans

in the rural South constituted an oppressed nation with the right to political and economic control. This theoretical right to self-determination included the option to form a separate political state in the so-called Black Belt region of the rural South, a group of more or less contiguous counties in which African Americans were the majority of the population. The Communists also held that African Americans in the ghettos of the urban North and West were members of a "national minority" that needed to be integrated into "mainstream" American society on the basis of full equality. An important corollary of the "Black Belt thesis," as the Communist position became known, was that African Americans had a common history and a distinct national culture rooted among Southern black farmers, sharecroppers, farm laborers, and semi-industrial laborers in the countryside ("from blackbottom cornrows and lumber camps," as Sterling Brown said).[3]

One can argue, and many have, the efficacy of the Black Belt thesis. And the leadership of the CPUSA often paid only lip service, if that, to the formulation—as was the case late in the tenure of Earl Browder as general secretary of the party. Nonetheless, it had tremendous influence as a model of cultural production that privileged this rural, southern, African American culture as the authentic culture of the black nation. This model is not the same as the dominant vision of Negro culture of the New Negro Renaissance, derived largely from nineteenth- and early twentieth-century European nationalism, in which "folk" culture would provide material for nationalist "high" artists to transform into a "high" national culture. Rather, in this Left paradigm, "folk" expressive culture is *the* national culture, at least on a formal level. The slogan of the Communist-initiated League of Struggle for Negro Rights (of which Langston Hughes was the president) sums up this stance well: "Promote Negro Culture in Its Original Form with Proletarian Content." What was necessary, then, was not the transmuting of the folk culture into high art but rather the infusing of the old forms with a new consciousness of class and national self-interest. Not surprisingly, critics of the Communist Left strongly praised the work of the poet, scholar, and critic Sterling A. Brown, whose 1932 collection of poetry, *Southern Road*, often disparaged the popular culture of the emerging black neighborhoods of the urban North and instead located authentic African American culture in the historical experience and the blues, work songs, spirituals, and other folk expressions of the rural South.[4]

The other major paradigm of popular culture by Left artists and intellectu-

als during the 1930s and 1940s was that associated with the Popular Front. The policy of the Popular Front arose after the Nazis came to power in Germany in 1933 and other nativist, racist, and/or anti-Semitic fascist or semi-fascist movements took over (or threatened to take over) governments throughout Europe. Nazi rule in Germany saw the rapid destruction of what had been the largest Communist Party in the world outside the Soviet Union. As a result, the Comintern came to the conclusion that the threat of fascism was the paramount danger to social progress and required an alliance of all democratic forces, also known as "the people" (as opposed to "the working class" or "the proletariat"), and an emphasis on the particular democratic traditions and symbologies of individual countries. This notion of "the people" included, in the United States, various liberal or social democratic groups (such as the NAACP and the SP) and individuals (such as John L. Lewis, W. E. B. Du Bois, and A. Phillip Randolph) that the Communists had often derided previously as "misleaders" or even "social fascists." Though the official period of the Popular Front as an international Comintern strategy runs from about 1935 to the Hitler-Stalin pact at the end of 1939, the Popular Front's approach to political organization, sociocultural symbology, and aesthetics characterized the domestic work of the Communist Left in the United States far beyond 1939. For example, the names of the left-wing Abraham Lincoln School in Chicago, the Jefferson School of Social Science in downtown Manhattan, and the George Washington Carver School in Harlem continued to stake symbolic claims to American democratic icons Popular Front–style in the 1940s and 1950s, whatever the ideological zigs and zags of the international Communist movement. This CPUSA vision of the democratic traditions of the United States was resolutely multiracial in the post–World War II era. It is worth noting that even though this period featured episodes of intense criticism of "nationalism" within the CPUSA, resulting in the resignations or expulsions of a substantial number of black party members, the party's version of multiracialism did allow for the celebration of distinct African American experiences and traditions. This can be seen in the promotion of Carter G. Woodson's Negro History Week (now African American History Month) as part of the public school curriculum, which became a major campaign of the CPUSA nationally and locally in the late 1940s and 1950s to a much greater degree than had been the case during the late 1930s.

The Popular Front was an extremely complex and far-reaching social formation, especially in the area of expressive culture.[5] For the purposes of this study,

its most important aspect is the approach to mass culture it generally promoted: instead of being a form of thought control, popular culture was seen as a sort of field or terrain in which "progressive" artists could battle what Franklin Delano Roosevelt called the "economic royalists" in his "A Rendezvous with Destiny" speech at the 1936 Democratic National Convention. So even "high" artists who wrote, composed, painted, directed, acted, danced, and so on infused their work with the themes, the cadences, the imagery, and the media of mass culture. The artists who took this approach for the most part did not see themselves as simply using popular culture but often celebrated what they saw as its progressive aspects as expressions of the American democratic spirit. Perhaps the most notable example of this approach is found in the work of Langston Hughes during the 1930s and 1940s (and beyond). For instance, Hughes began publishing his "Simple" stories, focusing on the life of the "average" Harlemite, Jesse B. Semple, in early 1943 as a part of his "Here to Yonder" column in the *Chicago Defender* that was eventually syndicated throughout the black press, including (by the 1960s), the NOI's *Muhammad Speaks.* Not only do these stories celebrate African American popular culture (as well as such white popular artists as Bing Crosby) and incorporate blues, jazz, and pop music, vaudeville comedy routines, various "folk" practices (such as the dozens), and a huge range of literary, musical, folkloric, sociological, political, and historical allusions into the formal structure of the stories themselves, but the stories were in fact popular culture productions in that they were written for the mass-circulation African American press.

This raises one of the most notable, and most noted, features of Popular Front aesthetics: a cultural mixing—of the "high" and the "low," of the "popular" and the "literary," of Whitman *and* Eliot (formally, if not ideologically), of folk culture *and* mass culture, of literary *and* nonliterary documents, of different genres, of different media. Examples of this generic mixing include Langston Hughes's popular 1938 poetry play, *Don't You Want to Be Free*, in which Hughes's poems were interspersed among blues and gospel songs; Woody Guthrie's "Tom Joad," a seven-minute adaptation of Steinbeck's *Grapes of Wrath* set to the tune of "Black Jack Davey" and released on record by RCA Victor in 1940; Muriel Rukeyser's poetic sequence "Book of the Dead," which was filled with fragments of "nonliterary" documents, such as government records, court testimony, diary entries, and stock exchange listings; and Richard Wright's blues song "King Joe," a minor jukebox hit in 1941 set to music by Count Basie and recorded by the Count Basie Orchestra, with Paul Robeson singing.

Another important feature of much Popular Front art is an interest in race and ethnicity and the relation of racial identity and ethnic identity to American identity. This aspect of the Popular Front has been often misunderstood in that Popular Front constructs of "the people" have sometimes been posed as sentimental or corny negations of particularized ethnic or racial affiliation. Examples of that sentimentality unquestionably exist. However, as Michael Denning puts it, the Popular Front was more often characterized by "an anti-racist ethnic pluralism imagining the United States as a 'nation of nations.'"[6] When one considers the poetry of Sterling Brown (whose popularity on the Left survived the onset of the Popular Front), Don West, Aaron Kramer, Frank Marshall Davis, Langston Hughes, Waring Cuney, and Margaret Walker; narratives such as Pietro di Donato's *Christ in Concrete*, Jerre Mangione's *Mount Allegro*, Daniel Fuchs's *Low Company*, Carlos Bulosan's *America Is in the Heart*, and Richard Wright's *Native Son*; the famous "Spirituals to Swing" concerts of 1939; and paintings by Jacob Lawrence, Ben Shahn, Aaron Douglas, Charles Alston, Elizabeth Catlett, Hale Woodruff, Charles White, and Jack Levine—to name but a few of the many examples—it is clear that race and ethnicity remained overriding concerns during the Popular Front, albeit concerns that were as much about transformation and, to employ a somewhat overused phrase, hybridity, as they were about tradition.

Finally, many of the artistic, literary, or quasi-literary works of the Popular Front are marked by an interest in place and its relation to American identity, an interest that is often closely connected to the above-mentioned concern with race and ethnicity. While the place represented, re-created, and dissected is most commonly a specific urban neighborhood—New York's Harlem, Brooklyn's Williamsburg, Chicago's South Side, Detroit's Paradise Valley, Boston's West End, and so on—such representations are frequently rural, as in Meridel Le Sueur's portrait of the Upper Midwest in *North Star Country* and Don West's poems of the southern mountains. Examples of this focus on place are legion: Woody Guthrie's *Dust Bowl Ballads*; singer and guitarist Josh White and poet Waring Cuney's recorded collaboration, *Southern Exposure*; the already noted work of such writers as Mangione, Hughes, Brown, Le Sueur, di Donato, Walker, West, Fuchs, and Wright; and perhaps most famously, the products of the WPA, notably the FWP's American Guide Series, and the photographs taken under the auspices of the Farm Security Administration.

Generally speaking, the utopian proletarian or folk-based approaches char-

acterized the early 1930s, or what aficionados of Comintern periodization refer to as the "Third Period," while the Popular Front's engagement with mass culture dominated the second half of the 1930s and the first half of the 1940s. However, one needs to be careful about drawing too sharp a line between the proletarian-folkloric period and the Popular Front. In practice, both approaches coexisted, especially from the middle 1930s on. The take on popular culture during the Popular Front, even by Left artists, was far from a monolithic optimism, as the biting (and often bitter) works of Nathanael West, Frank Marshall Davis, and Gwendolyn Brooks attest. In fact, a critique of mass culture and some awareness of the costs of using its resources was an important part of the work of even those artists who seemed most sanguine about such usage. This critique can be seen in Langston Hughes's well-known 1940 poem "Note on Commercial Theatre" (which begins "You've taken my blues and gone"), an indictment of "mainstream" popular theater appropriations of African American culture offered by an author who wrote prolifically for the commercial theater.[7]

At the same time, while there was an increased Left engagement with the forms and institutions of popular culture during the late 1930s and 1940s as compared with the 1920s and early 1930s, the notion of an alternative, "progressive," or "people's" culture that might draw on mass culture but that was at least partially outside mass culture remained influential. Perhaps the most famous example of this continuing influence is the Left "folk" music movement of the 1940s that saw the promotion of the careers of such African American musicians as Huddie Ledbetter (Leadbelly), Josh White, Brownie McGhee, and Sonny Terry and that led to the People's Song movement, the Almanac Singers, the Weavers, *Sing-Out* magazine, hootenannies, and, eventually, the folk music boom of the 1950s and early 1960s (and, perhaps ironically, hit records on the *Billboard* Top Forty). Another example can be seen in the "traditionalist" revival of trumpeter Bunk Johnson and early New Orleans–style jazz that was in no small part instigated by the 1939 study *Jazzmen*, by leftists Frederic Ramsey and Charles Edward Smith (a one-time staffer at the *Daily Worker*).

The cultural Popular Front was largely swept away during the Cold War by a liberal-conservative anti-Communist consensus in much the same way that it was in other areas of American life. The intellectual spearhead of the attack on the Popular Front in the area of literature and the institutions that support literary production was a peculiar alliance of a group consisting of, for the most part, conservative, white, male, Christian, southern academics, who dominated

what came to be called the New Criticism, and a group made up largely of Trotskyist and formerly Trotskyist Jewish New Yorkers associated with such journals as *Partisan Review* and *Commentary*, who formed the core of what became known as the New York Intellectuals. This, of course, is oversimplified, as will be my account of the New Critical–New York Intellectual alliance and its aesthetics. There were significant differences within the groups associated with the New York Intellectuals and the New Critics. Some of the New York Intellectuals, such as Irving Kristol, moved quickly toward the extreme Right; others, such as Irving Howe and Phillip Rahv, remained on the Left, albeit a Left that was antagonistic to the old Communist Left and often, as in the case of Howe, to the emerging New Left. However, since the histories of the New Criticism and the New York Intellectuals are generally far better known than that of the Popular Front, I am going to make only a few general comments on the culture wars of the 1940s and 1950s and the role of the New Critics and New York Intellectuals.[8]

The near destruction of the intellectual and artistic aspects of the Popular Front took place on many levels. While one can overestimate the impact of direct government repression, this repression — especially in collaboration with such cooperative institutions as universities, publishing houses, and film studios — was a crucial part of the breaking up of the Popular Front.[9] Ideological differences obviously remained within the various branches and agencies of local, state, and federal government, but officials of virtually every "mainstream" political persuasion joined in the attack on the CPUSA and its supporters, from right-wingers who built their careers on hunting Reds (e.g., Joseph McCarthy and Richard Nixon) to "pragmatic" politicians (e.g., the Republican senator Everett Dirksen) to liberals who in many cases owed a considerable portion of their early success to support by the Communist Left, especially within the labor movement (e.g., Hubert Humphrey).[10] Those politicians who resisted this anti-Communist push, such as the East Harlem congressman Vito Marcantonio, were driven from office — often by a joint effort of leading Democrats and Republicans (who in the case of Marcantonio were joined by the anti-Communist Liberal Party).

The details of this repression are too numerous to recount here, but suffice it to say that the end result was that the artists and intellectuals associated with the Popular Front, with some exceptions that will be noted later, either recanted, as did Langston Hughes, actor Canada Lee, writer Budd Schulberg, and singer Josh White, or fell silent (at least in the larger public arena), as did poets Sterling

Brown and Frank Marshall Davis, or found themselves virtually unemployable and/or unpublishable pariahs, as did Paul Robeson, W. E. B. Du Bois, fiction writer Meridel Le Sueur, and poet Edwin Rolfe. Even those who recanted often remained, like Canada Lee, fully or partially blacklisted. Similarly, the domestic Cold War destroyed many of the institutions that promoted the Popular Front, such as the International Workers Order (the left-wing fraternal organization that supported many cultural activities, including the publication of Langston Hughes's collection of poetry, *A New Song*, and the staging of Hughes's poetry play, *Don't You Want to Be Free*). Others, such as the journal *New Masses* (which merged with the monthly *Mainstream* in 1949 to form *Masses & Mainstream*), continued to exist only in a much circumscribed form. Both the New Critics and the New York Intellectuals played an important ideological role in shutting down the Popular Front, ranging from fairly general attacks on Left aesthetics and cultural practices (blaming the Popular Front as a major factor in the rise of "middlebrow" culture, for example) to vitriolic attacks on individual Popular Front writers and intellectuals who remained more or less unrepentant, as in the case of the vicious assaults on Muriel Rukeyser by Delmore Schwartz, William Phillips, and Randall Jarrell.[11]

The destruction of the Popular Front was not due entirely to external assaults: various sorts of infighting, sectarian policies, and disillusionment with the Communist Party and Communism played major roles in the isolation and decline of the Communist Left in the United States. However, the mass disillusionment following Khrushchev's 1956 speech at the twentieth congress of the Communist Party of the Soviet Union detailing Stalin's crimes and the invasion of Hungary, which devastated the Communist Party and diminished its membership from somewhere around thirty thousand to a few thousand, took place several years after the effective isolation of the Communist Left, particularly in the arts.

In addition to the virtual elimination of the Popular Front as an organized force in American culture, the alliance between the New York Intellectuals and the New Critics promoted a conservative modernist or neomodernist aesthetic that came to dominate criticism and pedagogy in the United States. What this aesthetic consisted of for the most part was a stripped-down "high" modernism that elided, evaded, or rejected mass culture and the more "extreme" and politically radical strains of modernism, such as Dadaism, surrealism, German expressionism, and Russian futurism—not to mention such homegrown modernism as objectivism, the protomodernist populism of Whitman, the work of

William Carlos Williams, and even much of the early Eliot. We are still familiar enough with the general characteristics of the New Criticism, with its famous detachment from social questions and social context, its focus on close reading and literature as object (the "well wrought urn" and so on), that it is not necessary to go into a long account of the admittedly diverse critics grouped under this rubric. What is important here is that the dominant aesthetic of poetry in the late 1940s and the early 1950s, as seen in the work of Allen Tate (who emerged from the right-wing Fugitives) and in that of Robert Lowell, John Berryman, and Delmore Schwartz (aligned with the New York Intellectuals and influenced by the old anti-Stalinist Left) was, despite the poets' very different social outlooks, a neomodernism that was formally conservative and aspiring toward a sort of universality, tending to avoid or decry the concerns with contemporary popular culture, ethnicity, race, and locale that animated the Popular Front. Even when these concerns did appear, as in Berryman's "Boston Common" (1942), they lacked the immediacy of Popular Front art, generally maintaining an air of historical and formal distance. (Lowell, Berryman, and Schwartz would later alter their literary approaches under the impact of the New American Poetry and their own dissatisfaction with the limits of neomodernism.) An interesting and important variation of this neomodernism is that of African American writers, such as Gwendolyn Brooks, Melvin Tolson, and Robert Hayden, who in many respects subscribed to the New Critical and New York Intellectual formal strictures while rejecting New Critical notions of detachment and universality, remaining deeply engaged with race, popular culture, and locale — be it Bronzeville, Harlem, or Paradise Valley. At the same time, the black poets most publicly associated with the Popular Front — Langston Hughes, Frank Marshall Davis, Sterling Brown, and Margaret Walker — became relatively quiet poetically, publishing little verse during the high-water mark of the McCarthy era in the mid-1950s. It should also be noted that Brooks, Tolson, and Hayden, too, had been active in the Popular Front arts subculture — with Tolson, at least, considering himself an unreconstructed Marxist until his death. And, of course, even though Hughes did not publish much poetry during the 1950s after the 1951 *Montage of a Dream Deferred*, and though he excluded his clearly "Red" poetry from his 1959 *Selected Poems*, he continued to publish his Simple stories, which did sometimes directly engage McCarthyism and the Cold War, in the black press and in collections through the 1950s. Nonetheless, it is true that there was a muting

of what had been a pronounced Left tone in black poetry with the onset of the high Cold War in the late 1940s and early 1950s.

At the same time, the Cold War contributed to the growth of new black political and artistic radicalism in some possibly contradictory ways. One result of the Cold War was the maintenance of a large peacetime military and the reestablishment of peacetime military conscription in 1948—the first such draft was enacted in 1940 as a response to the threat of fascism and was allowed to lapse in 1947. Also, as a number of scholars have pointed out, the international competition between the United States and the Soviet Union for the hearts and minds of the former colonial (or semicolonial) peoples of Asia, Africa, and Latin America made American racism, especially Jim Crow in the South, an enormous ideological liability for the United States and a tremendous propaganda opportunity for the Soviet Union and its allies.[12] The staffing needs of the huge Cold War military, the draft, and the domestic and international pressures on the federal government to make gestures against Jim Crow resulting in, among other things, Truman's executive order desegregating the armed forces in 1948, ensured that an enormous proportion of military-age men in the United States served in the military during the Cold War, including many black men who would become leaders of the Black Power and Black Arts movements. Nearly all of these future Black Arts activists, such as Askia Touré, Amiri Baraka, and Haki Madhubuti, found their military service a profoundly alienating experience that encouraged them to try to find some sort of alternative "home" in the study of radical politics and art. Madhubuti, for example, recalls a moment in Army boot camp where a white sergeant noticed that he was reading Paul Robeson's autobiographical *Here I Stand*. The sergeant viciously dressed down Madhubuti for reading the work of a notorious black Communist. This abuse let Madhubuti know immediately that the Army was going to be a hostile, racist place, strengthening his desire to study black history and culture, including such "subversive" figures as Robeson and W. E. B. Du Bois.

At the same time that the military alienated (or further alienated) these men from the United States government, it also brought together African Americans from across the country and with widely differing political, cultural, and social experiences and values. Particularly during the Vietnam era, black soldiers and sailors who were knowledgeable about, say, the BPP, Maulana Karenga's Us organization, or the work of Amiri Baraka shared their knowledge and experi-

ence with others from cities or towns in which the Black Power and Black Arts movements were much less developed. When their terms of duty ended, many of these newly inspired veterans returned home to start or join in local Black Arts and Black Power organizations. In short, the Cold War military unintentionally played a key role in moving incipient African American artists and intellectuals away from "mainstream" culture and politics in the United States and toward a wide-ranging, if often inchoate, political and artistic radicalism that gained definition as they returned to civilian life.[13]

The Popular Front and the Rise of the New American Poetry

In a somewhat more oblique impact of the Cold War on culture in the United States, the repressed Left returned transmogrified in the rise of what came to be called the "New American Poetry." In its rebellion against the high neomodernism of the New York Intellectuals and the New Critics, the New American Poetry revived many Popular Front formal and thematic concerns — though in a much different context. It is a commonplace that the circles of the 1950s writers, known under such somewhat overlapping rubrics as the "Beats," the "New York school," the "California Renaissance" the "Black Mountain school," and the "raw," constituted a resistance to McCarthyism and the social conformity of the Cold War.[14] On a more formal level, it is also usual to point out that the diverse aesthetics of the "raw" New American poets were linked by their common opposition to the "cooked" academic poetry promoted by the New Critics and the New York Intellectuals, whose critical strictures were united by an anti-Communist, anti-middlebrow, anti-lowbrow, high-modernist model. However, it is notably less common to consider the formal links between the work of radical poets in the 1930s and 1940s and that of the "raw" poets of the 1950s.

In many respects, it is natural that in their rebellion against the New Critical–New York Intellectual establishment the writers who became grouped under the rubric "New American Poetry" would consciously or unconsciously look back to the Popular Front. For one thing, many of the actors, organizers, inspirers, and audience of the New American Poetry had a history in the old Communist Left. A number of the initial patron figures of the New American Poetry, notably Kenneth Rexroth, Lawrence Lipton, and William Carlos Williams, had been active participants in the literary Left of the 1930s and 1940s. Some of them,

such as Rexroth, would distance themselves from the CPUSA later. Even in these cases, despite their antagonism to the CPUSA and the institutions of the Popular Front, some attachment to Popular Front literary styles and icons often remained. This attachment can be seen in Rexroth's 1955 "Thou Shalt Not Kill," which elegizes Dylan Thomas in a sort of apoplectic litany that resembled and possibly influenced Allen Ginsberg's "Howl," denouncing the various murderers of poets, especially Thomas — the culprit being primarily capitalism, with some help from bureaucratic Communism. What is interesting is how it draws on the Whitmanic, Sandburgian, New Testament, and hard-boiled style that Popular Front artists, such as Frank Marshall Davis and Langston Hughes, had earlier used in the 1930s and 1940s, and how it pays homage to leading Popular Front and (even pre–Popular Front Communist) writers, such as Sol Funaroff and Claude McKay, even as it attacks the CPUSA.[15] Other, older white poets and cultural entrepreneurs with much more live connections to the Communist Left, such as Walter Lowenfels and Art Berger, promoted the more political side of the New American Poetry, particularly as it intersected with the emerging New Black Poetry in the 1960s.[16]

Some of the most prominent members of the literary counterculture themselves, such as Stuart Perkoff and Bob Kaufman, had been CPUSA members; others, such as Frank O'Hara, had sympathized with the Popular Front. And, of course, Allen Ginsberg was a product of the Popular Front. Not only was his mother an active Communist until her mental collapse (and his father a Socialist), but Ginsberg's college education was partially financed by a scholarship from the New Jersey CIO, no doubt facilitated by his family's political contacts. Ginsberg as a young man had ambitions to be either a radical labor reporter or a radical labor lawyer.[17]

The presence of the Old Left can be discerned, too, in various descriptions of the audience at landmark events heralding the existence of the new artistic counterculture and in those journals willing to take this counterculture seriously, as opposed to the sensationalistic and/or condescending approach of both the popular press and many intellectual magazines, such as *Partisan Review* and *Commentary*. A number of accounts of the famous 1955 Six Gallery reading, which saw the first public presentation of Ginsberg's "Howl" as well as early performances by Phillip Whalen, Gary Snyder, Michael McClure, and Phillip Lamantia, note the presence of "Stalinists" in the audience.[18] Those few surviving journals with clear ties to the Communist Left, such as *Masses & Mainstream*

and the West Coast journals *California Quarterly* and *Coastlines*, had an ambivalent relationship to the Beats and other New American groupings. Nonetheless, Ginsberg sent review copies of *Howl and Other Poems* to *Coastlines* and *Masses & Mainstream* as well to more "mainstream" literary journals, such as *Kenyon Review*.[19] *Coastlines* published some of the earliest favorable responses to "Howl" and sponsored a reading that may have been Ginsberg's first time to perform in Los Angeles. *Masses & Mainstream* (which streamlined its name to *Mainstream* in the 1960s) was more antagonistic to what it posed as the depoliticized stance of much of the New American Poetry, something it shared with such anti-Communist (then) liberals as Diana Trilling and Norman Podhoretz. Still, as noted in Chapter 3, *Mainstream* did promote the careers of younger black writers, particularly the Umbra poets, who were closely connected with the second generation of the New York school poets and the downtown counterculture poetry journals and readings. *Mainstream*'s successor, *American Dialog*, linked itself even more closely to these interlocking communities.[20]

These connections can be overstated. After all, the New American poets, particularly those of the New York school, were still more likely to publish in *Partisan Review* than *Mainstream* or *Coastlines*—though again, some of the most vehement attacks on the Beats in the 1950s took place in *Commentary* and *Partisan Review*. Also, as Michael Denning argues, one need not be organizationally connected to the Left, or even consider oneself a leftist, to be influenced by Popular Front aesthetics—as Denning claims with respect to Kerouac.[21] But these ties are worth considering when tracing the origins of the postmodern rebellion of the New American Poetry to at least draw our attention to a possible link in the poetics of the Popular Front.

When the various theories about breath, phrasing, and lineation are demystified, when labels such as the "cooked" and the "raw" are cleared away, when one looks beyond the mystique of abstract expressionism as the reigning spirit of the era, what is it that generally distinguishes that amorphous body of writing known as the New American Poetry from the also fairly vague grouping of "academic" poets associated with the New Criticism and the New York Intellectuals? First, there is the willingness of the New American poets, particularly the Beats and the New York school, to positively acknowledge the heritage of Whitman (and to a lesser extent Blake). Second, one finds the attachment of many New American poets to the use of an urgent and deeply personal voice, tone, emotion, imagery, and "nerve" (to quote Frank O'Hara) in the work of the

left of the spectrum of European modernists (e.g., Vladimir Mayakovsky, Paul Eluard, Tristan Tzara, and Louis Aragon), many of whom had been an active part of the Popular Front in Europe. Third, there is a proclivity of the New American poets to utilize popular culture—movies, radio, television, recorded music, theater, pulp fiction, and so on—both as a source of anti-highbrow emblems and as a formal resource for poetic diction, phrasing, visual arrangement, movement, and so on. Famous examples of this utilization are legion—Frank O'Hara's poems to James Dean and Lana Turner; the jazz and poetry readings stereotypically associated with the Beats that were pioneered by Popular Front stalwarts Langston Hughes, Kenneth Rexroth, and Kenneth Patchen; and Amiri Baraka's invocation of the Green Lantern, the Shadow, and other mass culture icons.[22] Fourth, one sees the importance of place in the work of the New American poets, especially, but not exclusively, in the work of the Black Mountain poets and the Beats. Fifth, there exists a widely shared concern with establishing an authentic American diction that was both popular and literary, both self-parodic and self-celebratory, and often saturated with the vocabulary, the usages, and the accents of mass culture. Finally, one discovers an investigation of the meaning of race and ethnicity within the context of the modern United States. This is particularly true of such Beat poets as Ginsberg, Kerouac, Kaufman, and Corso. One of the noteworthy aspects of these investigations is that while the white Beats in particular often subscribed to Romantic-inflected primitivist notions of race and ethnicity with respect to African Americans, Latina/os, Native Americans, and Asian Americans that we might well consider essentialist or racist, when considering their own place in the matrix of racial and ethnic identity (as in Kerouac's sense of himself as a French Canadian from Lowell whether in New York, in San Francisco, or in Lowell), their approach was frequently far more nuanced and provisional. What largely emerges is not the conservative literary neomodernism championed by the New Critics and New York Intellectuals, nor even a literary variant of the depoliticized but more formally radical neomodernist aesthetics of abstract expressionism (however many hours the New York school poets spent in the Cedar Tavern), but an aesthetics much closer in spirit to that of the Popular Front.

One of the legacies of the New Critical–New York Intellectual anti-Communist consensus is a cultural amnesia, or what Cary Nelson has called a "literary forgetfulness."[23] This amnesia is not restricted to the "disappearing" of various poets or groups of poets but also applies to the ability to think or rethink

the legacies (and contexts) of poets, such as William Carlos Williams, Langston Hughes, Gwendolyn Brooks, Kenneth Fearing, Muriel Rukeyser, Margaret Walker, Robert Hayden, and so on, whose work is at least in part remembered or has been, to use Nelson's term, "recovered." Keeping this in mind, we can begin to see that the rise of the peculiar mixture of high and low, literary and popular, localism and internationalism, race and ethnicity and Americanism that marked many of the poets whose work became grouped within the New American Poetry can be productively read against the similar concerns of the Popular Front. The fact that by the 1960s these concerns led black artists, who had been a part of, or strongly influenced by, the post–World War II literary counterculture in directions, cultural nationalism for example, that were ultimately often at odds with Popular Front ideology (though not always with its aesthetics) should not obscure what we can learn from using such a lens, admitting (in the spirit of Ginsberg's declaration in "America": "America I used to be a communist when I was a kid I'm not sorry")[24] ancestry, affiliation, and distinction without apology.

African Americans, Chicana/os, Puerto Ricans, Asian Americans, and the New American Poetry

While scholars frequently touch upon the actual participation of individual African Americans, Puerto Ricans, Chicana/os, and Asian Americans in the New American Poetry and its institutions, this participation is generally only mentioned in passing or seen as exceptional.[25] These individuals seem less exceptional, and more significant in the aggregate, when they are added up. While Lorenzo Thomas's observation that the Beats "were probably the first group of so-called white people who—past the age of puberty—actually knew some black people as individuals, equals, and sometimes even lovers" humorously overstates the situation, it highlights how the public presence of African Americans was a constitutive element of the Cold War literary counterculture, much like such interracialism had earlier been considered a defining hallmark of Communism in the United States.[26]

The active participation of Amiri Baraka in this counterculture, as poet, fiction writer, playwright, critic, publisher, editor, and cultural organizer is well known—though the ways in which Baraka made the idea of a New American Poetry possible through the journals he edited, his Totem-Corinth imprint, his

critical writing, and even his circle of friendships has received far less attention.[27] The significance of Bob Kaufman, particularly in the West Coast Beat movement, is also widely acknowledged—even if no extended study of Kaufman has yet been published. The African American poet and music critic A. B. Spellman was a central figure in Baraka's downtown New American circle. His 1964 collection of poetry, *The Beautiful Days*, featured a preface by Frank O'Hara. Later, like Baraka, Spellman moved more definitively into the Black Arts camp. Though he was not as visible in the national movement as, say, Sonia Sanchez, Nikki Giovanni, or Haki Madhubuti—in part because of his relocation to then relatively low-profile Atlanta—nonetheless, Spellman played a significant role in the establishment of Atlanta-based Black Arts and Black Power institutions, such as the IBW and the Center for Black Art. As will be discussed in the next chapter, his work, especially his 1966 *Four Lives in the Bebop Business* (a study of musicians Cecil Taylor, Herbie Nichols, Jackie McLean, and Ornette Coleman later reprinted under the title *Black Music, Four Lives*), was, like Baraka's music writing, important in developing the Black Arts conception of a popular, revolutionary, African American cultural avant-garde rooted in a continuum of African American vernacular music.[28] Steve Jonas, like Kaufman, personified the committed new-style avant-gardist in both his work and life as an archbohemian in Boston as well as in California through his contact with Jack Spicer and the circle of West Coast poets and artists that surrounded Spicer.[29]

Much like Jonas and Kaufman, Ted Joans embodied the truly committed bohemian—and like Baraka and Spellman was an important transitional figure between the New American Poetry and the Black Arts movement. Many memoirs of 1950s and early 1960s bohemians recall Joans primarily as a self-conscious parody of the archetypal "beatnik," most clearly expressed in Joans's "Rent-A-Beatnik" service that provided suitably bohemian entertainment for parties and other social occasions. However, in many respects Joans's poetry issued from a black avant-garde tradition: an edgy, jazz-influenced surrealism that descends as much from Hughes as from André Breton or Paul Eluard and is closely akin to the work of Bob Kaufman and Russell Atkins. Joans draws attention to this connection with Hughes in such tributes as "Happy 78 Hughes Blues" and "Passed on Blues: Homage to a Poet," positing, like Atkins, a stream of modernist literature flowing from Hughes. Unlike Kaufman and Atkins, however, Joans associated himself directly with the Black Arts movement as a sort of overseas correspondent in France and Mali. Other black artists, including Ed Bullins,

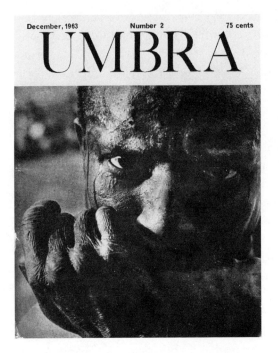

December, 1963 Number 2 75 cents

UMBRA

The cover of an early issue of *Umbra*, conveying a radical black identity without identifying with a particular ideological stance.

Quincy Troupe, Woodie King Jr., and Ron Milner, were part of Beat or bohemian circles in San Francisco, Venice Beach, and Detroit before making names for themselves as leading Black Arts poets and theater workers.

The relation of the protonationalist Umbra Workshop to the Lower East Side poetry community as a whole suggests in miniature how important black artists were to the new literary counterculture downtown (and vice versa) as well as ways in which black artists stood apart from that counterculture. The Umbra poets figure in many accounts of the 1960s literary bohemia of Lower Manhattan. For example, a fight growing out of a physical assault on Tom Dent by the apparently racist owner of Café Metro, frequently cited as causing the demise of the reading series at the Metro when white and black poets lent their support to Dent and the Umbra writers, was a legendary moment of the new Lower East Side bohemia.[30] Several Umbra members, including Ishmael Reed, Lorenzo Thomas, David Henderson, and Calvin Hernton, were regulars in the institutions of what might be thought of as the second generation of the New York school and the New York Beat scene in the early 1960s. These institutions include

the journals *Kulchur*, *C*, *Locus Solus*, *Fuck You: A Magazine of the Arts*, *Floating Bear*, *Evergreen Review*, and *The World*, C Press, Angel Hair Books, the Saint Marks Poetry Project, and the poetry readings at Les Deux Mégots coffeehouse and Café Metro. The Lower East Side reading series organized at such venues as Les Deux Mégots, Café Metro, and the St. Marks-in-the-Bowery Episcopal Church by poets Howard Ant, Carol Bergé, Allan Katzman, Paul Blackburn, and others provided African American artists places to hear the work of the various countercultural "schools," to present their own poetry, and to meet like-minded black contemporaries. Henderson and Hernton apparently encountered each other for the first time at a reading at Les Deux Mégots, again reminding us how often black writers sought an African American community within the larger bohemian subculture. Lorenzo Thomas recalls also how the Umbra poets would go to the Metro as a group and "hijack" the readings with powerful, high-energy performances.[31] Thomas's characterization of these performances as collective "hijackings" again suggests how Umbra marked the Lower East Side counter-cultural milieu while remaining somewhat separate.

In addition to those of the Umbra writers, the institutions of the first and second generations of the New York school encouraged the early careers of young black poets who were not members of the workshop. Eli Wilentz's Corinth Press published Clarence Major's *Symptoms and Madness* (1971), Tom Weatherly's *Maumau American Cantos* (1970), and Jay Wright's *The Homecoming Singer* (1971); Diane di Prima's Poets Press issued Audre Lorde's *The First Cities* (1968) and A. B. Spellman's *The Beautiful Days* (1965) as well as Umbra member David Henderson's *Felix of the Silent Forest* (1967); and Aram Saroyan's Telegraph Books printed Tom Weatherly's *Thumbprint* (1971).

Much more scholarly work needs to done in uncovering Chicana/o, Puerto Rican, and Asian American participation in the new bohemian arts subcultures of the 1950s and early 1960s. Still, there is considerable evidence that the experiences of Latina/o and Asian American writers in the Beats, New York school, and so on were not entirely dissimilar to those of the black bohemians, causing us perhaps to rethink the character of the postwar literary avant-garde. The important Chicano prison, or *pinto*, poet Raúl Salinas talks of his identification with the Beat movement—in fact, despite his identification with the Chicano movement, he still thinks of himself as a Beat in many respects.[32] Apparently, Salinas and other inmates organized a consciously Beat reading and writing group in Soledad Prison during the late 1950s:

And then poetry was something we did at night. . . . I mean, we were part of the literary beat movement who were in jail. *Howl* was on the streets and in the courts of San Francisco, and we were cheering inside. We were reading John Cheever, we were reading Kerouac by that time. We were reading Ginsberg, Corso, Patchen, McClure, Ferlinghetti, the Jazz Cellar Sessions—we had the albums.[33]

Many of the younger Chicana/o poets cite the Beats, particularly Ginsberg, as an important influence.[34] In this regard, the fact that many Chicana/o writers also name Whitman as an important predecessor may also be a result of the Beat influence, given the importance of the Beats and the New York school in reclaiming Whitman, especially the Whitmanic voice, as an available poetic resource during the 1950s—though for those Chicana/o writers who were influenced by Latin American poetry, such as Salinas and Tino Villanueva, this could have also come from such Latin American writers as José Martí and Pablo Neruda. Chicano movement activist Rodolfo "Corky" Gonzales's 1967 long poem "Yo Soy Joaquin" (quickly translated into English as "I Am Joaquin"), a sort of bible of the Chicano movement, features a catalogue of iconic Mexican and Chicana/o history, culture, and life experience descended from Whitman through Sandburg and Langston Hughes. One can also cite the engagement of a number of Chicana/o and Puerto Rican writers with the work of another New American avatar, William Carlos Williams, arguably the first Nuyorican (or Nujerican) poet, as an example of the influence of the New American Poetry. For instance, Villanueva's poem "Homage to William Carlos Williams" comes as much from Kenneth Koch's "Variations on a Theme by William Carlos Williams" as from the original Williams poem, "This Is Just to Say," that Koch honored and parodied (or, in high Kochian fashion, honored through parody).

Asian Americans are missing from most histories of the Beats and the California Renaissance, except as objects of fantasy. Other than Shig Murao at City Lights Books, the only Asian American to figure prominently in these stories is the actor Victor Wong, who appeared thinly disguised as Arthur Ma in Jack Kerouac's 1962 novel *Big Sur*. Probably the most interesting account of Asian American engagement with the Beats, more on the level of stance and poetics than a direct link, is Maxine Hong Kingston's 1989 novel *Tripmaster Monkey: His Fakebook*. In Kingston's novel, the Chinese American protagonist Wittman Ah Sing (who may be based in part on the playwright, fiction writer, essayist, and

editor Frank Chin), has a love-hate relationship with the Beats, admiring their rebellious stance but hating their romanticizing of Asians and Asian Americans.[35] Whether or not Chin is actually the model for Sing, the fact that he would make such a claim suggests the important, if ambivalent, impact that the Beats and the California Renaissance had on such West Coast Asian American writers as Chin and Lawson Inada.

Quite a few of the Nuyorican writers, such as Miguel Algarín, Miguel Piñero, Pedro Pietri, and Victor Hernandez Cruz, like the Umbra writers, participated in the institutions and periodicals of the second generation of New York school and Beat writers (notably *The World* magazine, the St. Marks Poetry Project, and the Jack Kerouac School of Disembodied Poetics at the Naropa Institute in Colorado).[36] In fact, if one were going to look for the direct descendants of the New York school and the East Coast Beats today, one would look at the scene around the Nuyorican Poets Cafe on the Lower East Side as much as the more frequently named Language Poets. Given the dual identity of the Lower East Side as the center of bohemia in New York from the 1960s (if not before) to the 1990s and as the Nuyorican literary heartland (rivaled only by East Harlem), such a conjunction is not surprising.

In short, despite the work of Aldon Nielsen, Lorenzo Thomas, Maria Damon, and others, the notion that the New American literary subculture was essentially white, with only a few black exceptions or adjuncts — and with no Latina/o or Asian American participants except Shig Murao at the cash register at the City Lights bookstore (and on the stand at the "Howl" obscenity trial) — is still common. When the *San Francisco Chronicle* revisited the North Beach bohemian subculture of the 1950s and 1960s in a cluster of articles celebrating the fiftieth anniversary of City Lights, virtually all the figures discussed were white, with the exception of Murao — though an accompanying picture of the courtroom audience at the "Howl" obscenity trial in 1957 reveals a number of black faces.[37] The bleaching of the literary counterculture has not only been promoted by the usual racist erasure but also by the narratives of cultural fall and resurrection (or exile and return) set up by various nationalists in which their conversion stories do not work unless the New American Poetry is "white." As many scholars have suggested with respect to Amiri Baraka, the poetics of the various black nationalist artists were in part inspired by the New American Poetry in which, as Nielsen and Thomas have pointed out, African American writers (including a number of the leading Black Arts activists) formed a crucial com-

ponent that in many respects defined the new bohemia. It is interracialism as a defining characteristic of downtown bohemia that Baraka engages negatively in his play *Dutchman*. Without this fundamental bohemian interracialism, it is not possible for bohemia to fail black artists in Baraka's play—echoing the failure of Communist interracialism in Harold Cruse's *The Crisis of the Negro Intellectual*. This is an important point not only in terms of understanding Black Arts poetics generally but also in the evaluation of the work of Baraka, insofar as it revises our notion of Baraka as peculiarly (as opposed to prominently) associated with "white" bohemian poetics and social values.[38]

In turn, the participation of black writers and artists in the new bohemia that they significantly shaped with their work and their physical presence also left a lasting imprint when many of these artists moved in a more nationalist direction. The nationalist or nationalist-influenced African American, Chicana/o, Nuyorican, and Asian American writers in the later 1960s and early 1970s did not follow the Garveyite poets publishing in *Negro World* in the 1920s (or nearly all the writers whose poems appeared in the Poetry Corner of *Muhammad Speaks* in the early 1960s, for that matter) and adopt a Victorian "high" Anglophile manner. Rather, the later nationalists adopted stances concerned with place, vernacular language, and the problems of racial, ethnic, and national identity, combining "high" and "popular" culture in "open" forms that are descended from the New American Poetry and the Popular Front.

Old Left, New Left, Red Left, Blue Left

The connection between Popular Front poetics and literary nationalism, particularly that of the Black Arts movement, is not entirely secondhand through the New American Poetry and postwar bohemian subcultures but also proceeds more directly from the Old Left. As noted earlier, what remained of the cultural world of the Communist Left in the United States had been generally isolated during the McCarthy era. But even then, this isolation was considerably less complete among African American intellectuals and artists than among the American writers and intellectuals generally. For example, it is impossible to think of white intellectuals or artists of the stature of W. E. B. Du Bois or Paul Robeson who were willing to be publicly and unambiguously identified with the Communist Left at that time. Possibly owing to the lesser severity of the McCarthyite blacklist in the New York stage, a number of prominent younger

African American playwrights, stage actors, and directors, notably Lorraine Hansberry and Alice Childress, retained fairly open ties with the Old Left during this era and were still able to work in their fields—though Childress would later play down her roots in the Communist Left. And as we will see again and again in place after place, when the domestic Cold War receded somewhat during the early 1960s, many more black artists and intellectuals came out of the ideological closet.

The most visible African American Left cultural institution during the early 1950s was no doubt Paul Robeson's newspaper *Freedom*. It featured work by such artists and intellectuals as Hansberry, Childress, Du Bois, Louis Burnham, John Henrik Clarke, John O. Killens, Lloyd Brown, Julian Mayfield, Frank Marshall Davis, and, of course, Robeson. Clarke, Killens, and Mayfield later mentored Black Art and Black Power activists, especially in Harlem. A host of Left-influenced cultural and political organizations, such as the Committee for the Negro in the Arts, the American Negro Theatre, the CRC, the NNLC, and the Frederick Douglass Education Center (which included Brown and Hansberry on its faculty) maintained a prominent presence in the community—though there was a clear falling off by 1954 when *Freedom* ceased publication.[39]

As will be discussed at more length in the next chapter, probably the most notable and enduring institution established in the 1960s by African Americans who had been active in the Popular Front, including a number who were still members of the CPUSA, was *Freedomways* magazine. *Freedomways*, in many ways a descendant of *Freedom* (and, indeed, the Popular Front's SNYC) publishing political and cultural commentary as well as poetry, fiction, and drama, was founded in 1961 and lasted until 1986, maintaining a strong Old Left connection throughout its existence. An interesting ideological evolution with respect to *Freedomways* that illustrates the political complexities of the Black Power era (and of the position *Freedomways* occupied) is that of James Baldwin. As a very young man, Baldwin was briefly on the periphery of the Communist Left in New York, participating in writing classes sponsored by the League of American Writers. He had a longer and closer relationship to Trotskyist and Socialist intellectuals, publishing in such journals as *Commentary*, *New Leader*, and *Partisan Review*. Baldwin became quite publicly a part of the anti-Communist *Partisan Review* "family"—a family to that point notable for its virtually all-white character. Baldwin's 1949 "Everybody's Protest Novel," a somewhat indirect attack on Richard Wright and the Communist Left via Harriet Beecher Stowe, was, I

believe, the first piece by an African American author published in *Partisan Review* after the journal was revived in 1937 as a journal of the anti-Stalinist Left—unless one counts the 1948 essay "A Portrait of the Hipster," written by Anatole Broyard, a Greenwich Village writer best known for his tenure as book critic for the *New York Times*, who "passed" for white most of his adult life. But under the impact of the civil rights movement, Black Power, and the diminishment of the Cold War, Baldwin later became a "contributing editor" of *Freedomways*, despite the close connection of much of the journal's staff to the CPUSA. Baldwin remained on the *Freedomways* masthead until the near-simultaneous demise of the journal and Baldwin himself. Nevertheless, Baldwin maintained that he was still an "anti-Stalinist" and that he found the CPUSA to be "a party whose record, intellectually and internationally, is shameful."[40]

In fact, one story that is only now receiving much scholarly attention, and which this study seeks to further uncover, is the significance in the broader Black Power movement of veterans of the 1930s and 1940s Left (and their children) who in many cases retained an ideological identification, if not organizational ties, with their old politics—though, as with Baldwin, often with complicated reservations about the CPUSA and the Soviet Union. These veterans would include well-known political activists, such as Coleman Young, George Crockett, and John Conyers in Detroit, Charles Hayes in Chicago, and Ron Dellums in Oakland, as well as others whose reputations remained far more local. As will be discussed at more length in Chapter 4, one of the interesting connections between Old Left activists and the cultural nationalism of the 1960s occurs with the establishment of the newspaper *Muhammad Speaks* as a regular publication in Chicago early in that decade. When Elijah Muhammad looked for people in the Chicago African American community with the journalistic expertise (and distance from potential NOI power struggles) to put out the paper, the people he found were in many cases veterans of the Old Left.[41] While neither the Left nor the NOI advertised this relationship, it helps account for the peculiarly hybrid character of *Muhammad Speaks*, quite possibly the largest circulation transregional black newspaper by the middle 1960s, which combined columns by Elijah Muhammad espousing an essentially conservative, black capitalist ideology with a radical, anti-imperialist editorial stance. Yet another Popular Front veteran still active on the Left, Christine Johnson, directed the NOI's school, the University of Islam.

Even among the younger activists and artists, as we will see, there is con-

siderable evidence of the influence of the cultural memory of the Old Left, especially on the West Coast, where the apex of the Communist Left in the African American community occurred in the immediate post–World War II era. The impact of the CRC on Huey Newton and the BPP is discussed at more length in Chapter 5. Not surprisingly, despite differences between the CPUSA and the BPP (which was publicly identified with Maoism), black Communist leader William Patterson played a major role in organizing the "Free Huey" campaign after Newton's arrest for murder in 1967. One could also cite the impact of the family of CPUSA leader Eugene Dennis on the early political development of Kwame Turé who, through his friendship with Dennis's son, attended a number of left-wing summer camps and Communist youth events.[42] Another SNCC leader from New York, Bob Moses, was also drawn into the now almost lost world of Communist summer camps through friends and family members. Though he later remembered those camps as a little too talk-oriented, he nonetheless credited them as a significant influence on his political development.[43] And virtually every younger (and older) black activist and politically engaged artist in Chicago knew the black Communist leader Ishmael Flory. As will be demonstrated throughout this study, Old Left–new black interaction underlay many of the most important proto–Black Arts institutions, including the journals *Liberator*, *Negro Digest*, *Dasein*, and, I suspect, *Free Lance*, the DuSable Museum, Umbra, the Watts Writers Workshop, and Broadside Press.[44]

While the early era of the Black Arts and Black Power movements is filled with gestures of independence from the Old Left by young (and not so young) militants, it also contains many dramatic and defining moments in which products of the Old Left milieu declare for the new movements, often while maintaining many of their previous ideological and organizational ties. One of the most powerful of these moments is Ossie Davis's famous eulogy for Malcolm X, a conversion narrative in which "black manhood" is reclaimed from "Negro" emasculation, with its power largely deriving from Davis's willingness to put himself in the narrative as a part of the Negro "we," as opposed to Malcolm X's redeemed (and redeeming) black masculinity. It is worth noting that the trajectory of this eulogy closely resembles that of Davis's 1964 *Freedomways* essay, "Purlie Told Me!" There Davis himself undergoes a similar conversion while writing the play *Purlie Victorious* (1961). In other words, Davis, who had a considerable history of Left activism (and who had already cast himself in a conversion drama about a transformation from supine accommodationism to militant pride), at least

implicitly distanced himself from the CPUSA, the leadership of which had been publicly critical of Malcolm X. One can also read Gwendolyn Brooks's story of her "conversion" to the Black Arts movement at the 1967 Black Writers Conference at Fisk University as a like gesture of ideological independence—albeit one that obviously has a more complicated relationship to notions of black masculinity. (Brooks's more occluded relationship to the Old Left is more difficult to tease out than that of Davis, whose past and present ties to the Left were unusually open, and her "conversion" in some senses occasioned a rejection of Popular Front poetics that Ossie Davis never undertook.)[45]

Another powerful and lasting intersection between the Old Left and the new cultural militants was the mentoring relationship that many older black writers and intellectuals with close ties to the remnants of the institutions and organizations of the Communist Left had with emerging black writers immediately before or during the early days of the Black Arts movement. One example of this sort of relationship is the encouragement John O. Killens gave to Nikki Giovanni's early career in his writers' workshop at Fisk University in the early 1960s.[46] Another would be that of Margaret and Charles Burroughs to the young Haki Madhubuti. While Madhubuti was famously antagonistic toward the Left and Marxism-Leninism in the ideological debates that split CAP and the Black Power movement generally, he continued to fondly acknowledge the importance of the Burroughses to his development as an artist, publisher, and activist—and continued to note their association with the Left.[47]

Finally, as will be outlined in more detail in the chapters dealing with specific regions, a significant number of writers and intellectuals who had central or peripheral roles in the Black Arts movement had belonged to the CPUSA or groups that the CPUSA influenced. The connection of Harold Cruse and Richard Moore to the CPUSA is well known. Though he may have done so primarily to shock, as a young man Amiri Baraka claimed to FBI interrogators in the 1950s that he was a fairly regular subscriber to the CPUSA's newspaper, *Daily Worker*, and a member of the Communist-identified American Youth for Democracy and the CRC while a student at Rutgers University and Howard University.[48] Larry Neal and Muhammad Ahmad (Maxwell Stanford) belonged to a Marxist study group in Philadelphia and were close to a number of black Communists or former Communists, particularly Bill Crawford, the manager of the local CPUSA bookstore. Neal's colleague in the Muntu group, James Stewart, was part of the Left circle of artists revolving around the older black visual artist John Wilson in

Boston. Audre Lorde and Lance Jeffers had been members of CPUSA-led youth groups.

With respect to similar connections to the Old Left among Chicana/o, Asian American, and Puerto Rican literary nationalists, the record is less clear in part because even less scholarly investigation has been done than for continuing African American links to the Old Left. Also, since the struggles of Chicana/os, Puerto Ricans, and Asian Americans were less central to the core identity of the Communist Party nationally (and internationally), there was less impetus to make a special effort in those communities (except on a local level, especially in the West), fewer avenues from those communities into the national institutions of the Left, and less of a paper trail for scholars to follow.[49] Nonetheless, it is clear that there was a strong Left presence during the 1930s and 1940s among Filipino Americans and Japanese Americans, particularly among western and southwestern agricultural workers, packing-shed workers, and cannery workers in such Left-led CIO unions as the Cannery and Agricultural Workers Industrial Union, Local 6 of the ILWU, and the United Cannery, Agricultural, Packing, and Allied Workers of America. Though the Left influence on the Chinese American community appears to be less, thousands of Chinese American sailors joined the CIO's NMU (as opposed to the AFL's racist Seafarers International Union) largely on the basis of the militant antidiscrimination stand of its openly Communist-influenced leadership. Also, in New York, Communist Chinese American union organizers had a fair amount of success in organizing Chinese American hand-laundry workers.[50] Some of these organizers on both coasts were also active in left-wing Chinese American literary circles, including Happy Gim Fu Lim, secretary of the Left-led Chinese Workers Mutual Aid Association in San Francisco, and Ben Fee, president of the association and the first Chinese American organizer for the International Ladies Garment Workers Union in New York. Unlike the Asian American radicals of the 1960s and 1970s, they wrote almost entirely in Chinese.[51]

Like Japanese Americans and Filipino Americans, Chicana/os also formed a considerable part of the membership and leadership of Left-led unions in the far West and the Southwest, especially in California and South Texas, during the 1930s and 1940s. (A scene in José Villareal's 1959 novel *Pocho*, a work that is often seen as the first modern Chicana/o novel, invokes this period, representing a meeting of the Cannery and Agricultural Workers Industrial Union and the unabashedly pro-Communist sympathies of the leaders of the union.)[52] Simi-

larly, Chicana/os played a central role in the Left-led Mine, Mill, and Smelter Workers Union in the Southwest. This role can be seen in the counter–Cold War classic film *Salt of the Earth*, made largely by leftists blacklisted from the film industry—though even this film genuflected toward the Cold War in downplaying how many of the Chicana/o union leaders in Mine, Mill were in, or extremely sympathetic to, the CPUSA. The Left was important, too, in initiating various Chicana/o civil rights organizations, such as El Congreso de Pueblos que Hablan Español (a Chicana/o equivalent of the Popular Front's NNC) and the Asociación Nacional México Americana (something like the CRC) and its newspaper *Progreso*. As Luis Valdez notes in the 1978 play *Zoot Suit* (and somewhat more obliquely in the 1981 film version), the Communist Left was at the heart of the ultimately successful defense of the young Chicanos convicted in the Sleepy Lagoon murder trial in 1942. (Interestingly, Valdez portrays the leftists involved with the defense as Anglo, ignoring the crucial role of the Asociación Nacional México Americana, particularly the Chicana labor activists Josefina Fierro and Luisa Moreno, who was deported during the McCarthy era.) Bert Corona was an important leader in both the Popular Front Chicano organizations of the 1930s and 1940s and the Chicano struggles of the 1960s and 1970s.[53] Chicano movement hero Cesar Chavez, whose father was a veteran of 1930s Left farm labor unionism, was himself molded by the Old Left in the form of the Saul Alinsky–inspired Community Service Organization. Alinsky had a problematic relationship with the CPUSA, but in many respects his neighborhood organizing methods were derived from the Popular Front and the CIO Left.

As with African American nationalism, some of the clearest connections between the Old Left and the newer Asian American and Latina/o nationalisms are in the area of literature. For example, Communist Jesus Colon's *A Puerto Rican in the New York* (1961), the first book-length literary treatment of Puerto Rican life in New York written by a Puerto Rican in English, was an important ancestor of the Nuyorican writers of the late 1960s and 1970s. Many of the sketches in Colon's book first appeared in the Communist press during the 1950s and early 1960s in his "As I See It from Here" column, a column much like Langston Hughes's "From Here to Yonder" in the *Chicago Defender* in style and format.[54] Likewise, the Filipino American writer, left-wing activist, and onetime farm labor organizer Carlos Bulosan was seen by the Asian American editors who put together the anthology *Aiiieeeee!* as a crucial progenitor of an "authentic" Asian American literature. (The editors of *Aiiieeeee!* chose a selection from

Bulosan's 1946 autobiography, *America Is in the Heart*, to open the anthology.)[55] Among Japanese American writers, Toshio Mori published stories in West Coast Popular Front journals, especially the *Clipper*, and Hisaye Yamamoto was a part of the Catholic Worker organization in the 1950s.

An important link between the cultural radicalism of the 1930s and 1940s and the Chicano movement of the 1960s and 1970s is the folklorist, poet, novelist, and short-story writer Américo Paredes. Many activists posed Paredes's fiction, poetry, and scholarship as a key progenitor and theorizer of a Chicana/o literary tradition rooted in plebeian Chicana/o culture — much as some black artists and critics cast the poetry and scholarship of Sterling Brown. Paredes's ideological participation in 1930s and 1940s (and 1950s and 1960s) radicalism is clear from his work, though his organizational connections, if any, are less clear — as might be expected from a journalist and academic who lived in the politically risky climate of Brownsville, Texas, during the 1930s and 1940s and whose politics might well have derived as much from the Mexican traditions of anarcho-syndicalism and agrarian nationalism as from the Popular Front. (A figure modeled after Paredes in Hart Stilwell's 1945 South Texas proletarian novel *Border City* sympathizes with Communist efforts to organize farm laborers in South Texas.) A similar linkage can be found in the career of former Popular Front labor activist and journalist Ernesto Galarza. Galarza's activities in the 1960s and 1970s include a number of now classic studies of migrant farmworkers and the autobiographical *Barrio Boy* (1971), a key text in the development of modern Chicano narrative — though some in the Chicano movement considered Galarza to be an accommodationist.

"The Left," of course, compasses far more than the Communist Left. The CPUSA was still the largest Marxist group in the United States during the late 1950s and early 1960s. It retained surprisingly strong roots (within the context of the McCarthy era) in African American, Latina/o, and Asian American communities, preserving at least a modicum of its former influence among artists and intellectuals, especially in the African American community — even if these Left artists were in many cases forced to the margins of "mainstream" culture. Nonetheless, the Trotskyist SWP, the Maoist PL, and other Left formations, though smaller, were often extremely significant in a particular place or a particular moment, as was the case with the SWP (and such descendants of the SWP and the WP as the Correspondence group of C. L. R. James, Grace Boggs, and James Boggs and James's Facing Reality organization) in Detroit during the 1950s and 1960s.

It is also true that the CPUSA, or at least a number of its top leaders, moved away from the sort of ideological reconciliation of Marxism and nationalism that attended its Black Belt thesis (officially abandoned by the Communists in the 1950s) toward what might be thought of as a more purely integrationist, anti-nationalist mode. A number of the top leaders of the party in the 1960s (notably, but not exclusively, General Secretary Gus Hall) were extraordinarily hostile to nationalism and even Left nationalist formations. Many leading and rank-and-file Communists retained a wariness of non-Communist radicals that was sometimes heightened to near paranoia by the Cold War. For example, Muhammad Ahmad tells of a CPUSA forum in Philadelphia during the early 1960s in which he asked Gus Hall a pointed, but not intentionally provocative, question about the CPUSA position on racism. Hall responded with hostility and suspicion, as if Ahmad were some sort of undercover police or FBI agent. Bill Crawford, a friend of Ahmad's and the manager of the local CPUSA bookstore, defused the situation, later explaining to Ahmad that the party was emerging from McCarthyism and was a little gun-shy.[56] In fact, it was often more than a little gun-shy. Of course, it is worth recalling that operatives of the FBI, the CIA (despite federal prohibitions), local Red Squads, and other security agencies were in fact still extremely active. As we now know with the release of information about the FBI's COINTELPRO operation, to cite one example, in some respects covert disruption by various government agencies increased as changes in the political and legal climate limited somewhat the direct federal repression of radical organizations. In any event, such wariness in combination with an overcentralized, top-down leadership that was in many cases hostile to the new nationalism, even in its Left variants, limited the direct organizational influence of the CPUSA, especially in the long term.

At the same time, the surviving networks associated with the CPUSA, SWP, and other Left groups within the black community provided spaces where emerging activists, intellectuals, and artists could develop ideologically, meet like-minded people, find outlets for their work, and make connections outside their community, much as with the spaces provided by the NOI, surviving Garveyite groups, and other nationalist organizations. As we will see, many of the emerging Black Power and Black Arts participants utilized the various networks of the Left and organized nationalism simultaneously. And while many CPUSA and SWP leaders remained suspicious, at best, of the new nationalist radicalism, some important leaders, particularly such African American Communists

as Ishmael Flory, William Patterson, and Roscoe Proctor, were far more open to working with and encouraging these young activists. Such openness was even more pronounced among black cultural activists who emerged from (and maintained ties to) the Left, such as actors Ossie Davis and Ruby Dee, writer Julian Mayfield, and playwrights William Branch and Lorraine Hansberry. As Rebecca Welch points out, one suggestive moment of this openness to Malcolm X and the new nationalism on the part of the black Left intelligentsia (and of Malcolm X's increased interest in the Left) was the funeral of Lorraine Hansberry in 1965. Malcolm X attended the funeral at which Paul Robeson gave a eulogy. While Malcolm X and Robeson did not meet at the funeral, afterwards Malcolm X, an admirer of Robeson, approached Ossie Davis about arranging such a meeting—an event that never took place due to Malcolm's assassination shortly thereafter.[57] Also, while the CPUSA had in many respects retreated from its notion of the Black Belt nation and African Americans as a nationality during the 1950s, the centrality of the struggle for African American freedom, often posed in such nationalist terms as "Negro Liberation" and "Black Liberation," retained such power within the party, particularly among its rank-and-file members, that those leaders and members inclined to work with nationalist-influenced black radicals were able to do so—and did so. Similarly, while such SWP leaders as James Cannon seem not to have had much sympathy for the new black nationalism, it was possible within the organization for others, notably George Breitman, to seek an engagement with various nationalist or protonationalist leaders, notably Malcolm X and Robert Williams.

Harold Cruse's reputation as a commentator on African American culture and politics has dwindled in importance—though there has been something of a revival of interest in Cruse's writings.[58] Even with this new attention to Cruse's work, only his assessments of Marxism, the CPUSA, and the Old Left are still cited with any frequency—generally when scholars want a quick gloss on black-Red relationships. Cruse's attack on the Popular Front (the era of Jewish domination of the CPUSA, in his estimation) is particularly devastating. His model of black nationalism, which posited a disjuncture between what is essentially the Popular Front and "true" intellectual self-determination and self-reliance, remains powerful despite the work of such historians as Robin Kelley, Michael Honey, and Martha Biondi to rethink the connection between 1930s and 1940s African American radicalism and that of the 1960s and 1970s.

Cruse remains valuable in his insistence on a Left thread running through

African American intellectual and artistic life from the 1930s to the 1960s. Unlike many of his contemporaries weighing in on the cultural impact of the CPUSA, Cruse did not declare the Hitler-Stalin pact the death of the Communist Left in American letters. Of course, that would have been an unlikely move on his part, since the days of his own greatest involvement with the CPUSA were in the postwar era.

Cruse's influential opposition of Third Period ethnic and racial autonomy and Popular Front co-optation and assimilationism is misleading, however. One might say that, with respect to art and literature, Third Period countercultural visions of (the black) nation and folk remained present all through the Popular Front, often existing at the same time within one work. For example, despite the notion that the Popular Front downplayed Third Period concepts of the African American nation, as late into the World War II period as July 1942, Samuel Sillen, a major critic for the Communist journal *New Masses*, in an otherwise favorable review judged Sterling Brown, Arthur P. Davis, and Ulysses Lee's 1942 anthology *The Negro Caravan* to be insufficiently concerned with the "national question."[59] Though he is not necessarily entirely reliable when discussing his own trajectory through the Communist movement, Harry Haywood claims in his autobiography, *Black Bolshevik*, that the issue of African American self-determination (and the Black Belt thesis) was a part of an internal debate within the Communist Left well into the McCarthy era.[60] And while it is useful to distinguish between the cultural implications of Third Period ideology and those of the Popular Front, it is also important to note their congruence. Both were much concerned with the interrelationship of race, ethnicity, nation, region, and (sometimes) gender. Both privileged a version of vernacular culture as the standard of artistic excellence (approaches that differed from earlier notions of creating a "high" culture using "folk" or popular elements). Other commonalities include a concern with place, an internationalist, anticolonialist perspective, some notion of being part of a vanguard, and some concept of authenticity by which vernacular culture can be reclaimed from the distortions of mass culture. This authenticity may derive from alternative folkloric promotion of work songs, hollers, "primitive" blues, and so on as genuine African American culture. Or it might derive from the discovery (or introduction) of the interests, the voice, and even the true, undistorted body of the people in popular culture, as in Hughes's "Note on Commercial Theatre" where the African American folk or popular subject imagines a popular culture product that will "look like me." This conversation between a

folkloric, utopian approach and a popular culture approach much resembles a discussion that marked the cultural nationalisms of the 1960s and 1970s.

What I am positing is not a model of influence in which there is a series of orders from interrelated and essentially white directorships (whether the Comintern, the CPUSA, or the Beats) to African American, Chicana/o, Puerto Rican, and Asian American artists and intellectuals. Neither am I trying to be an inverse Joseph McCarthy, waving a list of known Reds and suggesting that the Black Arts movement and other forms of literary nationalism were Communist plots. Rather, I am making some unremarkable (if not often remarked on) arguments. The first is that African American artists and intellectuals were at the center of the cultural conversations and the shaping of the poetics of the Popular Front in the United States—even if one believes that the decisive organizational discussions that produced the ideological positions of the Third Period, the Popular Front, and so on took place in Moscow. What I am also proposing is that the New American poets drew significantly on this African American–inflected legacy of Popular Front poetics in their rebellion against the strictures of New Critical–New York Intellectual neomodernism. However, I would also add that, despite a general sense of being in conflict with McCarthyism, virtually none of these poets (even those, such as Ginsberg, Kaufman, and Perkoff, who had once had some direct ties to the CPUSA and the Popular Front) retained any significant organizational connection to the remaining institutions of the Communist Left much into the 1950s; they were, in fact, generally hostile or indifferent to the Soviet Union and to the remnants of the Communist movement in the United States. Ironically, the younger black writers associated with the "second generation" of the literary counterculture in the early 1960s was far more likely to still have actual links to the Communist or Trotskyist Left than was the older generation of Beats, New York poets, and so on.

Nonetheless, one need not be an enthusiast of Joseph Stalin, Earl Browder, Mike Gold, or Lillian Hellman to recognize that the rise of the peculiar mixture of high and low, literary and popular, localism and internationalism, race and ethnicity and Americanism that marked many of the poets whose work became grouped within the New American Poetry can be productively read against the similar concerns of the Popular Front. My further unremarkable argument is that the New American Poetry was, like the first wave of modernism, considerably less "white" than has often been advertised and a decisive influence on later nationalist literary movements, with much of this influence stemming from

the transmission of the sorts of concerns I have tied to the Popular Front. The Popular Front's influence was facilitated by the fact that many older (and some younger) African American, Chicana/o, and, to a lesser extent, Puerto Rican and Asian American political activists, artists, and intellectuals were veterans of the Popular Front and its descendants, who in many cases retained sympathies with the politics and cultural style of the Popular Front, though their direct affiliation with the Communist Left or other Left groups in any serious organizational way often, though not always, ended in the 1940s and 1950s.

Queen Mother Audley Moore's comment that nationalists during the 1930s and 1940s were more concerned with street-corner agitation than grassroots organization, comparing unfavorably with the nuts-and-bolts community work of the Communist Left in African American neighborhoods, overstates the situation.[61] Certainly, nationalist institutions, such as the National Memorial African Bookstore in New York and the various mosques of the NOI, made a powerful local impression on the politics and culture of black communities, especially in the larger urban centers.

Still, Moore's analysis does point out that the Left was far more committed to and successful in creating national and local black political, educational, and cultural institutions, from the League of Struggle for Negro Rights in the late 1920s to the Ebony Museum, *Freedomways*, and the AAHA in the 1950s and early 1960s, than was organized nationalism after the decline of the Garvey movement in the 1920s — at least until the middle 1960s. In fact, one can think of the beginning of the Black Arts and Black Power movements in the 1960s being enabled by a commitment to institution building by more strictly nationalist groups and individuals inspired by and complementing similar Left projects. In this way, we can see the rise of the Black Arts movement as not simply a break with earlier ideologies, earlier poetics, and previous institutions. Of course, breaks did occur, and the dramatic staging of gestures of rupture and disaffiliation with earlier modes of radical politics was an important feature of the early Black Arts and Black Power movements. But the existence of such ruptures should not blind us to the continuities (and communities) of radical politics and poetics that would provide a matrix for the emergence of Black Arts institutions and ideology in a variety of locations across the United States.

2

Artists Imagine the Nation, the Nation Imagines Art:

The Black Arts Movement and Popular Culture, History,

Gender, Performance, and Textuality

As will be seen in the following chapters, the poetics and basic ideological stances of the Black Arts movement were far from unified. In many respects, from the very beginning of the movement to its decline in the mid-1970s, Black Arts poetics could be more accurately described as a series of debates linked to ideological and institutional conflict and conversation rather than a consistent practice. Broad framings of differences between cultural nationalists and revolutionary nationalists do not adequately characterize these debates either. After all, even when Amiri Baraka's art and politics were most clearly indebted to Maulana Karenga, the two fundamentally disagreed over the meaning of African American popular culture and its relation to revolutionary black art. Similarly, though both RAM and the BPP might be considered revolutionary nationalist organizations, their approach to culture sharply diverged in theory and in practice, to use a formulation of the times. Even within RAM and the BPP, despite the highly centralized images both organizations projected in their literature and press, there was considerable local variation, with intragroup differences often manifesting themselves over cultural issues. These cultural arguments were sometimes over extremely large issues, such as whether to make a distinction between African American national culture and (Pan-) African culture, and at other times over relatively narrow questions, such as the manner in which black revolutionaries were portrayed in Ed Bullins's play *We Righteous Bombers*.

At the same time, despite these differences, many leading Black Arts activists combined elements of widely circulating (and often apparently conflicting) models of black culture and aesthetic value, translating those theoretical amalgams into formal practice. Again, Baraka, Sonia Sanchez, Larry Neal, and others would draw on conceptions of history influenced by Maulana Karenga's version of cultural nationalism while at the same time employing their long-standing model of a continuum of African American culture, including popular culture, that was at odds with Karenga's vision of a prehistoric neo-African counterculture. While the tracing of the full range of Black Arts poetics and the cultural models that informed those poetics is obviously an extraordinarily complex and often contradictory undertaking, some overview of important notions of culture and history, the interrelationship of these notions, and their long-term impact on Black Arts formal and thematic choices is useful in considering how the Black Arts movement cohered (and did not cohere) as a national movement. Such an overview might also complicate still common notions that the movement was, as Henry Louis Gates Jr. put it, "a matter less of aesthetics than of protest," or that the movement was obsessed with aesthetics, but within the context of a search for a single, overarching, monovocal "Black Aesthetic."[1]

Pat Your Foot and Turn the Corner:
Free Jazz, Rhythm and Blues, and the
Poetics of the Popular Avant-Garde

As the term suggests, "avant-garde" connotes a bold journey into the future that, as Ezra Pound polemicized, made things new. For many avant-gardists — say, the politically very different Mayakovsky and the Russian futurists, on the one hand, and Marinetti and the Italian futurists (and the early William Carlos Williams in *Spring and All* for that matter), on the other — this newness grounded itself in some vision of modernity that required the wholesale abandonment or even destruction of existing "mainstream" culture. To the degree that various avant-gardists sought or claimed inspiration from or kinship to existing (or once extant) cultures, these cultures tended to be somewhere else and/or some other time. One thinks of Picasso and Africa, Artaud and Bali, Pound and Confucian China, Pound and medieval Provence.

However, by the late 1960s a largely new conception of an avant-garde found its way into the culture of the United States. This was a paradoxical conception

of an avant-garde that had roots in actually existing and close-to-home popu-
lar culture and that was itself in some senses genuinely popular while retaining
a countercultural, alternative stance. This is a conception that is still with us to
a large extent. One has only to consider the many "alternative" radio stations
that claim to be in the vanguard of the "rock revolution" while adhering rigidly
to the same playlists and style templates from market to market to see not only
the remarkable claim to avant-garde status by such major institutions of popu-
lar culture but also that such a claim is both palatable and plausible to millions
of listeners. To this one could add the phenomenon of "alt-country," which,
though less high-profile than "alternative rock," involves the sale of millions of
CDs, widely circulated fanzines, and so on. And in many respects, the almost
clichéd (and now somewhat passé) hip-hop obsession with "the real" — with, as
of this writing, the term "underground" marking the hip-hop artists and works
that are considered most "real" — expresses a similar concern with being popu-
lar, engaged, and yet formally challenging or new.[2]

The Black Arts movement in the Northeast during the 1960s significantly de-
veloped and promoted this model of a popular avant-garde through the efforts
of the poet, playwright, essayist, cultural critic, and political activist Amiri Ba-
raka, as well as the work of Larry Neal, Askia Touré, Sonia Sanchez, A. B. Spell-
man, James Stewart, and others.[3] These initiators of the Black Arts movement
in the East synthesized and revised a cultural inheritance derived significantly
from the Popular Front, using the "new thing" jazz or "free jazz" of the late 1950s
and the 1960s as a model for a popular avant-garde.

Obviously, theorizing a future society or culture rooted in some aspects of
existing American culture and American realities while distinguishing itself
from that culture is quite old in the United States, dating back at least to Ralph
Waldo Emerson. However, one significant import came to these shores in the
late nineteenth and early twentieth centuries via the nationalist movements of
the peoples of the internal colonies within the large empires of Europe: the
Irish, the Finns, the Poles, the Czechs, the Hungarians, and so on. The artists as-
sociated with these nationalist movements often saw the allegedly unco-opted
peasant cultures of their respective nationalities as containing the basis of a new
national culture that could stand in opposition to the high imperial culture from
which they needed to break. However, for those new national cultures to be cre-
ated, what was required was not the presentation or re-creation of the peasant
culture but a transmutation of "folk" elements into a new "high" culture. In

other words, Bartók, Janácek, and Sibelius did not by and large try to re-create or write music exactly in the spirit of Hungarian, Czech, or Finnish folk music but incorporated folk rhythms, tones, themes, melodies, and so on into their symphonies, string quartets, operas, and other compositions—as did the African American composers R. Nathaniel Dett and William Grant Still during the 1920s and beyond. Similarly, Synge did not try to literally re-create the voices of the Irish peasant or the Irish worker but instead employed a basically "standard" English literary language that gave the flavor of Irish vernacular speech through the use of the occasional vernacular word or phrase, a relatively small altering of standard syntax, fragments of distinctively Irish rhythms of speech, and so on. James Weldon Johnson did the same with African American vernacular speech in his verse sermons collected in *God's Trombones* (1927), using Synge and other Irish Renaissance writers as models.[4]

This notion of transmuting folk materials into a new national or quasi-national "high" culture particularly influenced older black writers and intellectuals, such as James Weldon Johnson and Alain Locke, who were crucial in the organizing, promoting, and theorizing of a "Negro renaissance" in the early twentieth century.[5] This paradigm of the relation of the folk to a new high culture was very much couched in terms of generational conflict or difference, of old and new, of the genteel and the raw, of the formally timid and the formally adventurous, in short the familiar rhetoric of the avant-garde.

One related, though somewhat opposed, aspect of the New Negro Renaissance was the attempt by some writers, notably Langston Hughes, Sterling Brown, Waring Cuney, and Helene Johnson, to project the folk or popular voice as *the* national voice. In this paradigm of the relationship between the folk and the black artist, the writer serves as a sort of oracle from whom the voice of the folk emerges rather than as a cultural alchemist transforming relatively base, raw folk materials into high-culture gold along the lines of Bartók, Synge, Sibelius, Dett, Still, or Johnson. Of course, this is a very broad characterization of that paradigm. On closer inspection, as many scholars have noted, these poets differed quite a bit. Brown in the early 1930s, for example, generally opposed "authentic" folk culture to "inauthentic" popular culture. Hughes traced a continuum between folk culture and popular culture, distinguishing instead between true and false popular culture usages of folk. Helene Johnson, drawing on the ambivalent and ambiguous forms of African American minstrelsy, blurred

the line between folk and popular, between inauthentic and authentic, in her most interesting poems, such as "Poem":

> Little brown boy,
> Slim, dark, big-eyed,
> Crooning love songs to your banjo
> Down at the Lafayette.[6]

As noted in Chapter 1, these writers, notably Hughes and Brown, anticipated, influenced, and were influenced by the positions of the Communist Left that rose to a new prominence in the 1930s. Brown's poetry resonated powerfully with the tendency of the Communist Left and its cultural institutions in the early 1930s to promote the idea of an alternative worker or (in the case of African Americans) a national culture based in large part on residual folk (or noncommercial proletarian) practices allegedly lying outside of popular commercial culture.[7] In other words, what we see is the idea of a political avant-garde rooted in folk practices right here, right now, and yet still countercultural or alternative.

The other general theorization of the relations among a political vanguard, high culture, folk culture, and popular culture that emerged in the later 1930s via the Communist Left is associated with the Popular Front. Hughes was the artist par excellence of the period, his work epitomizing the Popular Front's multimedia, multigenre engagement with popular culture, race, history, and geography. And as argued in Chapter 1, while the major political and cultural institutions of the Popular Front were largely swept away or isolated by the Cold War, significant aspects of Popular Front poetics and cultural models survived, sometimes oddly transmuted, in the literary counterculture of the Beats, the New York school, and other formations of the New American Poetry.

A touchstone of this counterculture was jazz, particularly bebop, and its association with African American culture. In this fascination with bebop, these writers (the white ones anyway) could be accused of the old modernist "someone else, somewhere else, some other time" romanticism. And bebop could be (and often was) considered more avant-garde than popular. However, the work of many of these writers also featured prominently, if sometimes campily, other sorts of popular culture forms and icons that were the stuff of mainstream lowbrow: Hollywood movies, radio, jukeboxes, advertisements, baseball, the Shadow, the Green Hornet, Jayne Mansfield, James Dean, Lana Turner, and so

on. Nonetheless, despite this interest in popular culture that they represented as more generally "American" and less specifically "other," the Beats, the New York school, and so on, unlike the Popular Front artists who preceded them and the Black Arts participants who followed them, represented themselves as a permanently small, embattled subculture for the most part.[8] In fact, one of the main distinctions between the early works of the different "schools" can be found in the manner in which they represented their alienation. The Beats were often by turns pessimistic, prophetic, and humorously satiric and self-satiric; the poets of the Black Mountain school, especially Charles Olson, as Frank O'Hara noted, were highly (and perhaps overly) conscious of the Pound heritage of finding the great statement; and the New York school poets, especially Frank O'Hara, Kenneth Koch, and James Schuyler, often made this alienation seem fun — at least on the surface.[9]

Once again, as with constructions of the "white Left," one has to be careful about setting up rigid dichotomies between black artists and "white" bohemia in the 1950s and 1960s. Again, Baraka was essential to the creation of the idea of a New American Poetry comprised of these fairly disparate schools — thereby preparing the way for the production and reception of Donald Allen's defining anthology of the new poetry counterculture, *The New American Poetry* (1960). Relatively early in his participation in this literary bohemia, Baraka began to theorize a continuum of African American folk culture, African American popular culture, the semi-avant-garde of bebop, and the so-called free jazz of such musicians as Ornette Coleman, John Coltrane, Cecil Taylor, and Sun Ra (Herman Blount). In his landmark 1963 cultural history of jazz and the blues, *Blues People*, Baraka wrote of the new jazz avant-gardists:

> What these musicians have done, basically, is to restore to jazz its valid separation from, and anarchic disregard of, Western popular forms. They have used the music of the forties with its jagged, exciting rhythms as an initial reference and have restored the hegemony of blues as the most important basic form in Afro-American music.[10]

It is important to note here that Baraka is claiming, much as Hughes did before him, a cultural continuum stretching from the earliest work songs and hollers through the blues, early jazz, bebop, and rhythm and blues to the certifiably "out there" sounds of Cecil Taylor and Ornette Coleman. He argues that rather than being a cultural alchemist, archivist, imperialist, or mimic, the jazz

avant-garde at its best engages in a conversation with Son House, Duke Elling-ton, Thelonious Monk, Ray Charles, Muddy Waters, and Mahalia Jackson. I say "at its best" because contained in *Blues People* is a kernel of the proscriptive as-pect of Baraka's later Black Arts work in which he polemicizes against jazz mu-sicians relying too heavily on the European art music tradition (or the "main-stream" pop tradition) at the expense of the blues and rhythm and blues.

Thus, Baraka at this time adopts and adapts the Beat notion of African Ameri-cans as a class of permanent nonconformists (or involuntary saints) — who are nonetheless quintessentially American — and locates himself inside it without the sort of primitivist mysticism that often attended Beat expressions of this idea (as seen in Jack Kerouac's portrait of Mardou Fox in *The Subterraneans*):

> Harlem for this reason is a community of nonconformists, since any black American, simply by virtue of his blackness, is weird, a nonconformist in this society. A community of nonconformists, not an artists' colony — though blind "ministers" still wander sometimes along 137th Street, whispering along the strings of their guitars — but a colony of old-line Americans, who can hold out, even if it is a great deal of the time in misery and ignorance, but still hold out, against the hypocrisy and sterility of big-time America.[11]

Later, Baraka takes his proscriptive notion of cultural continuity and amal-gamation to a much higher pitch, so to speak, in poems, plays, and essays that are still often seen, however inaccurately, as a synecdoche for the entire Black Arts movement. One could say that Baraka's vision is both synchronic and dia-chronic in that black culture is something that develops over time and yet is strangely present in its entirety in a single performance, say, by Ornette Cole-man or James Brown.[12] He articulates this notion most famously in his essay "The Changing Same" (1967), the title of which has become almost ubiquitous shorthand for the essential continuity of African American expressive culture:

> That what will come will be a *Unity Music*. The Black Music which is jazz and blues, religious and secular. Which is New Thing and Rhythm and Blues. The consciousness of social reevaluation and rise, a social spiritualism. A mysti-cal walk up the street to a new neighborhood where all the risen live.[13]

To continue the music analogy, this was a note not simply struck by Baraka but one sounded over and over by such Black Arts participants as Askia Touré, Sonia Sanchez, Jayne Cortez, Tom Dent, Larry Neal, A. B. Spellman, critic

Stephen Henderson, James Stewart, and Ishmael Reed. As noted above, Touré early on theorized African American popular music as a part of the Black Arts upsurge and the necessity for serious black revolutionary artists to engage rhythm and blues and other forms of black popular culture. Though less well known now than "The Changing Same," Touré's "Keep On Pushin': Rhythm and Blues as a Weapon" (1965) anticipated many of Baraka's points—and Baraka's prophetic voice:

> Somewhere along the line, the "Keep On Pushin'" in song, in Rhythm and Blues is merging with the Revolutionary Dynamism of COLTRANE of ERIC DOLPHY of BROTHER MALCOLM of YOUNG BLACK GUERRILLAS STRIKING DEEP INTO THE HEARTLAND OF THE WESTERN EMPIRE.[14]

As Mike Sell points out, another crucial, though almost completely unstudied point of development and transmission of this idea, both influencing and influenced by Baraka, Touré, and other New York–based activists, was the Muntu circle of Philadelphia, which included Larry Neal, the playwright Charles Fuller, and the painter, musician, and writer James Stewart.[15] Though the origins of the Muntu group and its contribution to the emergence of the Black Arts movement in the Northeast will be taken up at more length in the next chapter, Stewart's contributions to the development of Black Arts ideology are worth some comment here. While Neal's importance as a Black Arts theorist and critic has been widely acknowledged, Stewart has received much less attention. Nonetheless, Stewart's intellectual, artistic, and political interests matched Neal's well. The U.S. Air Force stationed Stewart in New England during the late 1940s. There he moved in Left and African American arts circles in Boston, forming a close friendship with black painter and printmaker John Wilson. Wilson's studio was a meeting place for Left artists and activists, both black and white. Wilson's experiences and associations with other African American Left artists ranged far beyond Boston, though. During the 1940s Wilson, like a number of younger black artists and intellectuals, such as Lorraine Hansberry and fellow Bostonian Calvin Hicks, found work in summer camps affiliated with the CPUSA. He spent much of the McCarthy era working with African American Left artist Elizabeth Catlett at the famous Taller de Gráfico Popular in Mexico City as well as with some of the leading older artists of the mural movement—he originally went to Mexico on a fellowship to study with José Orozco, but Orozco died before he

arrived. Wilson critiqued Stewart's paintings while opening up his intellectual horizons in wide-ranging discussions about politics, culture, and art, especially the Mexican muralists and the African American Left artists influenced by the Mexican public art movement.[16]

Stewart returned to Philadelphia with a wide familiarity with Left artists, journals, and political and cultural theory. An early friend of Philadelphia native John Coltrane, Stewart participated in the bop and postbop jazz scene of Philadelphia. At the same time, he stayed closely tied to popular music as a reed player in the house band at the Uptown Theater, where he backed many of the leading R & B and soul singers of the late 1950s and early 1960s.

Stewart's different cultural and political interests, including an increasing engagement with African thought and culture, mark his critical writings. Stewart's essay "The Development of the Revolutionary Black Artist" (first published in *Black Dialogue* in 1966) opens the seminal 1968 *Black Fire* anthology edited by Baraka (then LeRoi Jones) and Neal. Though Stewart's vision of the continuity of African American culture is more folkloric and more broadly diasporic and less engaged with popular music than either Neal's or Baraka's, nonetheless, he also posits the notion of a black avant-garde rooted in contemporary popular African American artistic/spiritual practices:

> We need our own conventions, a convention of procedural elements, a kind of stylization, a sort of insistency which leads inevitably to a certain kind of methodology—a methodology affirmed by the spirit.
> That spirit is black.
> That spirit is non-white.
> That spirit is patois.
> That spirit is Samba.
> Voodoo.
> The black Baptist church in the South.[17]

Stewart's vision includes not only various syncretic religious practices of the African American diaspora but also a commercial Afro-Brazilian dance and music form (with a long folk ancestry) popularized in the United States and Europe in the early twentieth century—and successfully marketed in the United States in different guises throughout the century. While Stewart here could be seen as a proto–cultural nationalist, his notion of a creolized black poetics dif-

fers considerably from the neo-African vision of Maulana Karenga. One might say that Stewart was an early nationalist progenitor of the concept of the "Black Atlantic."

Some of the most important articulators of these ideas of cultural continuity and interchange between Africa and the diaspora, and between the popular and the vanguard, were the free jazz musicians themselves. One can see this in Ornette Coleman's persistent emphasis on his early training as an R & B musician in Texas and in Cecil Taylor's claim, in A. B. Spellman's seminal *Black Music* (1966), that, despite the tendency of white critics to associate him with such white European and American avant-gardists as Karlheinz Stockhausen and John Cage, he plays "an extension of period music — Ellington and Monk."[18] The actual performance of Sun Ra and his Arkestra presented perhaps the most striking statement of this notion of continuum, in which neo-African chants and instrumentation merged with Fletcher Henderson, doo-wop, bebop, electronic music, and "free" improvisation, often culminating in "When the Saints Go Marching In."[19] The critical and belletristic writings of such Black Arts activists as Baraka, Touré, Sanchez, Neal, and Spellman elaborated and made more ideologically consistent the framing of free jazz by the musicians, who in many cases had ambivalent relationships to the Black Arts movement. In other words, comments by these musicians were given public voice and contextualized most often in such works as Spellman's *Black Music* and Baraka's *Black Music* (1967), as well as in then uncollected essays by Touré, Neal, Baraka, Spellman, and others in such periodicals as *JBP*, *Liberator*, *Kulchur*, and *The Cricket* (a Black Arts music journal edited by Baraka, Neal, and Spellman and oriented mostly toward the new jazz that nonetheless featured such R & B artists as Stevie Wonder and Otis Redding on its cover). Thus, when considering the often vexed question of the relationship of jazz musicians to the Black Arts movement, the impact of Baraka, Neal, Spellman, Stewart, Sanchez, Ron Welburn, and other artist-critics on how the musicians themselves (and their audiences) understood and articulated the bond between their art and black culture and history generally might help us provide a more nuanced notion of Black Arts influence.[20]

Black Arts writing, particularly poetry, and the theorization of a usable cultural past based on black music often had a dialectical relationship. Sonia Sanchez, for instance, did not consciously utilize black music in the creation of her early poetry, despite the longtime importance of jazz and other forms of black music in her life — her father had been a well-known jazz drummer and club

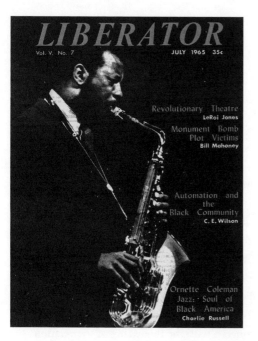

Saxophonist Ornette Coleman on the cover of *Liberator* when it was most closely associated with the Black Arts movement.

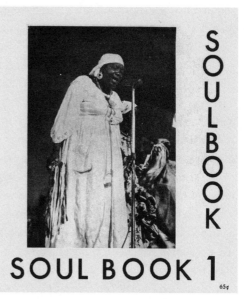

The cover of the first issue of *Soulbook*, the earliest of the Bay Area black revolutionary journals of the 1960s. Four of the first five issues showed black musicians. (Reproduced by permission of Ernest Allen Jr.)

owner in Alabama before her family's move to Harlem. However, as she began to perform her poetry to live audiences and as she increasingly listened to the new music of such free jazz artists as John Coltrane and Pharaoh Sanders in the 1960s, she heard a sort of music in her work. Subsequently, she more consciously drew on jazz both thematically and formally in her lineation, rhythms, phrasing, use of tone, and so on, striving to amplify that music "in between the lines" even when jazz and other sorts of African American music were not directly invoked.[21] In other words, a reading of the formal structure and sensibility of black music gave her a tool for assessing her early work, which in turn led her to a more elaborate conception of the meaning and utility of jazz for the black poet, drawing especially on the "new thing" avant-garde but also on such older artists as Billie Holiday.

Never before could one find such a large, relatively cohesive, and heavily theorized American avant-garde that so emphatically linked its radical formal and ideological practices to popular culture with the notion that this counterculture would be all — at least so far as the African American community was concerned. In fact, despite the fairly common attribution of anti-intellectualism to Black Arts, an almost obsessive concern with the theorizing of the relationship of the African American artist and his or her formal practices to the black community (or nation) was one of the distinguishing features of the movement. As with variations of folkloric alternative models, this is not to say that this paradigm of a popular avant-garde did not empower a variety of formal and thematic results on the part of Black Arts poets. As Amiri Baraka and Lorenzo Thomas have noted, in some poets, notably Askia Touré (who was an R & B singer as a young man), the formal rhythms, emotions, gestures, and other elements of performative style were significantly rooted in gospel and the R & B vocal-group style that later became known as doo-wop as well as in new thing jazz. In other cases, particularly those of Larry Neal and Yusef Rahman (Ronald Stone), a sort of bop sensibility predominated in which jagged rhythms and anaphoric fragments of sentences and phrases resembled the riffs of bop improvisation.[22]

Baraka himself drew on both strains in his work. To get a sense of the impact of Touré, Rahman, and Neal on Baraka's performative style, it is instructive to listen to Baraka's reading of "BLACK DADA NIHILISMUS" on the LP *New York Art Quartet* recorded in November 1964 and compare it to his reading of "Black Art" on *Sonny's Time Now*, recorded almost exactly one year later. Obviously, both readings are engaged with new thing jazz, featuring some of the lead-

ing free jazz players of the era, including drummer Sonny Murray, reed player Albert Ayler, trumpeter Don Cherry, percussionist Milford Graves, trombonist Roswell Rudd, bassist Lewis Worrell, and saxophonist John Tchicai—and both mark Baraka's political transition to a militant nationalism. In the earlier reading, Baraka declaims the poem in the almost sing-song cadences of what was then a typical downtown poetry performance style. Given Baraka's subsequent performance practices, his voice is surprisingly uninflected. However, the later reading is clearly more directly influenced by gospel and R & B song and is more self-consciously in a black vernacular register, often using a sort of street apostrophe (e.g., "Put it on him, poem"). At the same time, Baraka interpolates into the verbal text of "Black Art" vocalized noises (sirens and machine guns) and shrieks that echo Ayler's imitation of voices and noises (and the bitter humor of Ayler's musical quotes of pieces like Gershwin's "An American in Paris"). Baraka's later style, which also shows the influence of the scatting, onomatopoetic sounds, and interpolated jazz and R & B phrases of the Chicago poet Amus Mor, in turn became a foundation for the performance styles of a wide range of Black Arts poets.[23] Baraka himself brought the R & B and soul music elements to the fore of his later Black Arts performances, while continuing to draw on avant-garde jazz, as heard in a 1972 live recording of "It's Nation Time" on Motown's Black Forum label in which leading free jazz musicians, including Gary Bartz and Lonnie Liston Smith, back Baraka's double-time performance filled with James Brownesque nonverbal vocalizations.

However, again, these shared or synthesized strategies operate quite differently in the work of different poets. For example, Touré draws on vernacular black music to create a sweeping epic tone in much of his poetry (and prose for that matter) whereas Baraka and Sanchez, like Langston Hughes before them, invoke and utilize much the same resources while remaining in a basically lyric mode, even in such long poems or poetic series as Baraka's *Wise, Why's, Y's* (1995) —recalling the lyric sequences of Langston Hughes in *Montage of a Dream Deferred* and *Ask Your Mama*. That is to say, Touré often draws on an older mythic sense of the epic (even in his shorter poetry), sometimes including a sort of invocation to the gods or ancestral spirits and speaking in prophetic or vatic tones in long lines. Baraka, like Hughes, draws on what might be thought of as the modern American epic tradition of the lyric montage that looks back to Hart Crane's *The Bridge*, though like Hughes, favoring jagged, fragmented, and often repeated verbal and vocalized riffs.

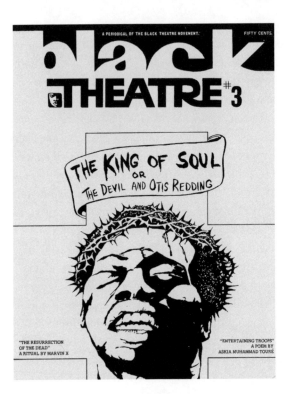

Cover of *Black Theatre* with an illustration by Maxine Raysor of R & B singer Otis Redding as a Christ martyred by the white recording industry. The illustration refers to a play by Ben Caldwell that both attacks the mass culture industries and extols rhythm and blues as a source of black communal feeling. (Reproduced by permission of Ed Bullins.)

The model of the popular avant-garde was a source of uneasiness and debate as well as inspiration. The relationship of many Black Arts works to popular culture and a resulting blurring of genres, as well as conflict and confusion about appropriate techniques of evaluation for such hybrid materials, occasioned a great deal of discomfort or anxiety both inside and outside the Black Arts movement—much as has been the case with the reception of some of the works of the New American Poetry counterculture. In other words, few, if any, critics look at an old MGM or Warner Brothers animation in the same way that they do a Chekhov play. So what do you do with a Baraka play in which the influence of a Tom and Jerry cartoon might be greater than Chekhov—or Gorky?

How does one determine the tone and authorial stance of a play by Ed Bullins that might seem to have a naturalist setting in a ghetto apartment, a bar, a street corner, a jail cell, and so on but that draws on nonrealist popular traditions of satire and parody and on the inescapable funhouse mirrors of a mass culture that from its very beginning rested substantially on representations of African American culture and the ventriloquism of the black speaking subject? While some early viewers (and potential producers) of Bullins's work may have been made uneasy by his proclivity to build plays around pimps, prostitutes, drunks, and other sorts of "lumpen" elements, one senses that the real issue was not so much who was portrayed but the difficulty of figuring out what was the position of the play (and the authorial consciousness) vis-à-vis the represented characters.[24] An obvious source of such unresolved ambivalence and indeterminacy was the European and American absurdist avant-garde theater of the 1950s and 1960s that influenced so many of the early Black Arts playwrights and directors (Jean Genet's *The Blacks* was a seminal performance text for new black theater companies from Los Angeles to New York). However, another important ancestor of Bullins's drama was the African American comic musical theater of the late nineteenth and early twentieth centuries that significantly derived from African American minstrelsy (performed by African American artists) and, ultimately, blackface minstrelsy (performed by "blacked-up" white artists). This was an extraordinarily popular (with black audiences) and extraordinarily ambivalent theater in which layered and uneasy, if often hilarious, satire and parody shifted their aim back and forth between artist, audience, representations of the black subject, representations of the white subject, representations of black and white subjects together, and the genres of African American and blackface minstrelsy themselves.

The most extreme example of the sort of anxiety caused by Bullins's work can be seen in the intense debate around the 1969 New Lafayette Theatre production of his play *We Righteous Bombers*. Bullins in fact draws attention to the play's connection to the above-mentioned African American comic tradition by assigning the authorship of the play to Kingsley G. Bass Jr. (allegedly "a 24-year-old Blackman murdered by Detroit police during the uprising"). Bass's name is derived from Kingfish, one of the chief characters of *Amos 'n Andy*, which could be said to have a double life as sonic black-face minstrelsy (in the radio version voiced by white actors) and visual African American minstrelsy (in the television series featuring a black cast).

In *We Righteous Bombers*, Bullins adapted (or plagiarized) without credit a translation of Albert Camus's *Les Justes*. Bullins transposed Camus's treatment of early twentieth-century Russian terrorists to a police-state future in which a group of often cartoonish black revolutionaries discuss the nature and need for revolutionary violence; meanwhile, one of their number, a poet named Murray Jackson, is imprisoned, tried, and (perhaps) executed on television for killing a black comprador official who oversees for the white power structure what amounts to a giant concentration camp for African Americans. The discussion of violence and what it means to be a black revolutionary is complicated by the ways in which the representations of black revolutionaries (or "terrorists") by the mass media shape this discussion. In fact, to a large extent the mass media becomes the terrain of the revolution in the eyes of these militants. "'One dawn not so long from now I will join you on TV,'" announces one of the most cartoonish of the revolutionaries, Bonnie Mae Brown, at the end of the play.[25] One of the ironies of this statement is that is unclear in the play whether Murray Jackson has actually been executed, becoming a heroic martyr, or has taken over the position of executioner, becoming then a traitor suitable for assassination. Other ironies abound; one of the most hilarious is when one of the group of militants, Kenneth Burk, announces that he has "'always been afraid'" and that he will do his "'thing in propaganda, on revolutionary committees . . . and shit like that'" rather than throw bombs, satirically invoking the theorist Kenneth Burke and his notion of "rhetorical action."[26]

The production of *We Righteous Bombers* at the New Lafayette occasioned a famous symposium at the theater featuring Ernest Allen Jr., Amiri Baraka, Robert Macbeth, Marvin X, Larry Neal, and Askia Touré, where it was revealed that Bullins, not the fictional Bass, wrote the play and that *Les Justes* was the uncredited source of the play. An intense argument followed over the ethics of authorship, intellectual property, the representation of black revolutionaries and the black liberation struggle, and the participation of women (or lack thereof). What was relatively little discussed was how the play not only foregrounds popular culture thematically (with Murray Jackson, Bonnie Brown, and the other revolutionaries as television spectators and actors in a mass media hall of mirrors that blurs performance and reality) but also draws on the formal resources of mass culture from minstrelsy to the popular theater to NBC—as well as on a dizzying array of high-culture drama, philosophy, and political and literary theory. This is not to suggest that various participants in the symposium

missed the point or that their arguments do not say some important things about the play and its impact; only that, as the work of such black Popular Front–era artists as Frank Marshall Davis and Gwendolyn Brooks raised at an earlier moment and as postmodern critics of "containment culture" would argue later, Bullins's engagement with popular culture was self-reflexively shown as coming at a considerable, if unavoidable, cost and was filled with contradictions and ambivalences.[27]

One enormous impact of this notion of a popular avant-garde is the obvious influence it exercised on conceptions of race, ethnicity, nationality, gender, and sexuality in the United States and on what might be thought of as movement poetics — whether this influence comes through inspiration by the Black Arts movement or as a reaction against it (or both, as in second-wave feminism). In poetry, it shaped how writers approached diction, tropes, lineation, voice, tone, rhythm, nonverbal vocalizations, and so on both on the page and on the stage. Dancers, theater workers, visual artists, and prose writers similarly drew on this model in the formal choices they made. Of course, black (and white, Asian American, and Latina/o) writers had long done this sort of thing, but the unprecedented degree to which Black Arts artists and critics theoretically detailed this model allowed interchange among artists within and between genres and disciplines on a new level. Even musicians whose work to a large extent provided the base examples that the theorists held up as embodying the relationship between the black artist and the community (and between black art and the community) often came to understand their work within this theoretical frame. And such framing helped create a relatively large audience for black avant-garde art, giving that audience new benchmarks by which this art could be understood, evaluated, and appreciated. The continuing power of such largely negative terms as "essentialism" and "identity politics" (and "race," for that matter) and of more positive (if often vague) notions of "resistance," James Scott's "hidden transcript," and even "hybridity" in academic discourse attest to the impact of this nationalist notion of a black popular avant-garde.

Having noted this direct and easily traceable (if one is willing to look) aspect of Black Arts influence, another perhaps less obvious effect is the manner in which the movement fundamentally transformed the way art is received and understood in the United States. Again, this influence derived from the model of a popular avant-garde inspired by the relation between iconic free jazz artists and popular artists of rhythm and blues and earlier jazz as theorized by black

artists and intellectuals. Free jazz artists had an iconic status for many rock and R & B artists as well as for Black Arts participants. Kalamu ya Salaam raises the example of James Brown's call to "blow me some Trane, brother" on the hit single "Super Bad, Part II." Perhaps Brown liked Coltrane. Perhaps he was paying tribute to a band member, Robert "Chopper" McCollough, who, like many R & B instrumentalists, had another musical life as a jazz player — and whose solos on "Super Bad" were certainly more akin to the sound of Coltrane than of King Curtis (himself a sometime jazz musician) or Junior Walker.[28] However, it also had the effect of publicly (and one might say, authoritatively) linking Brown's music with an icon of the African American avant-garde, suggesting a basic connection or kinship.[29]

The liner notes of the first Byrds album, *Mr. Tambourine Man*, mention that one band member, Chris Hillman, liked to play Coltrane riffs on the mandolin and that the drummer, Mike Clark, worshipped Coltrane's percussionist, Elvin Jones. This worship may or may not have been true, but why raise it at all on the cover of a popular LP (the title track of which hit number one on the pop music charts), except to, like Brown, publicly associate the group with Coltrane's embodiment of a new sort of avant-garde? Likewise, the opening of the 1965 Byrds single "Eight Miles High" paid direct homage to Coltrane's "India." A similar sort of genuflection can be found in the name of Rob Tyner, the lead singer of the MC5, a radical Detroit rock band that covered Sun Ra's "Starship" on its first album. Tyner (Robert Derminer) took his adopted last name from McCoy Tyner, the pianist of the classic Coltrane groups.[30] Many other leading popular musicians during the 1960s and early 1970s claimed musical and spiritual kinship to Coltrane, Coleman, Albert Ayler, Sun Ra, and other leading free jazz artists in album liner notes and interviews.

In part, as Frank Kofsky argued in the early 1970s, these rock and R & B musicians were drawn to free jazz by the new chordal, rhythmic, and tonal approaches of such musicians as Coleman and Coltrane. This attraction dramatically changed the character of rock performance so that the ability to solo in a relatively free improvisational style became a marker of artistic sophistication.[31] And in turn, jazz musicians, such as Miles Davis and, especially, alumni of Davis's bands, including Wayne Shorter, Herbie Hancock, Tony Williams, and John McLaughlin, would draw on the drive and popular appeal of rock and rhythm and blues as well as the jazz avant-garde to create early fusion jazz. This sort of fusion was often much more self-consciously radical in form and

politics than later fusion, as in the work of Hancock's Mwandishi group in the early 1970s that displayed a noticeable affinity with Maulana Karenga's Kawaida movement. Whatever his limitations as a critic, Kofsky makes a further, well-taken point about black jazz avant-gardists, particularly Coltrane, serving for rock musicians and fans as an embodiment of the uncompromising artist (and the uncompromisingly modern artist) whose integrity is not explicitly political but is a sort of objective correlative for the integrity of radical nationalist leaders, specifically Malcolm X.[32]

These twinned ideas of the free jazz artist as hero and of an avant-garde art that is both cutting edge thematically and formally and yet rooted in popular culture found their most powerful and developed articulation within the Black Arts movement. Of course, worship of the jazz modernist as countercultural hero reaches back to, at least, the bohemian hipster worship of Charlie Parker and bebop in the late 1940s and the 1950s. But this heroism took on a new valence in the era of free jazz, rock, and the Black Arts movement. Kimberly Benston has skillfully examined the Black Arts subgenre of the Coltrane poem as a major node of African American modernity (or postmodernity). However, Benston's emphasis on Coltrane as the heroic figuration of a revolutionary blackness perhaps underestimates the nearly ubiquitous northeastern Black Arts insistence on the traditional roots (tonally, rhythmically, emotionally, and ideologically) of the new jazz.[33] This insistence was even more clearly enunciated, developed, and illustrated in the essays of Baraka, Spellman, Neal, Stewart, Touré, and others in *Liberator*, *The Cricket*, and other journals of the movement. As we have seen, the idea of the popular artist as countercultural (even revolutionary) hero and the model of a popular avant-garde promoted by the Black Arts movement circulated far beyond the boundaries of the ghetto (and old-style bohemias, black, white, or interracial).

As a result, the position of many segments of the U.S. population now vis-à-vis popular culture and what is valuable, authentic, real, oppositional, cutting edge, or underground (and what is not) is vastly different than before the Black Arts movement. This is not to say that the promotion of such a model through popular culture is the "real" contribution of the Black Arts movement. Rather, my point here is that the work of Baraka, Neal, Touré, Sanchez, Stewart, Cortez, and other Black Arts activists, rather than being short-lived in influence and ultimately peripheral to the main cultural arenas of the United States, as some still charge, fundamentally changed the conception of art and culture in the

United States, both inside and outside the African American community — often in ways that have received little or no commentary inside or outside academia.

Death as History: The Black Arts Movement in the Northeast and Black Arts Counterhistory

One might expect that the rise of the Black Power movement, the Chicano movement, and other movements of nationalist political self-assertion would bring a new interest in history on the part of African American, Chicana/o, Puerto Rican, and Asian American artists. After all, many nationalist political leaders from Malcolm X to Kwame Turé to Rodolfo "Corky" Gonzales spoke of the lessons of history and the importance of recovering a past erased or distorted by repression and a racist historiography and educational system. And in the academic discipline of history, such a surge of nationalist-influenced and nationalist-inspired work did take place — one thinks, for example, of Harold Cruse's *The Crisis of the Negro Intellectual* (1967), John Blassingame's *The Slave Community* (1972), and Sterling Stuckey's *The Ideological Origins of Black Nationalism* (1972).

However, generally speaking, such an interest with respect to the arts did not occur for the most part — not directly anyway. In fact, Robert Hayden, the most powerful African American writer of historical poetry of that era — and perhaps any era — was seen, along with Ralph Ellison, as the epitome of the anti–Black Arts black poet by a number of nationalist artists and intellectuals, most prominently by Haki Madhubuti in his 1968 essay "On *Kaleidoscope* and Robert Hayden" in *Negro Digest*. Of course, this had much to do with Hayden's claims at the 1966 Fisk Black Writers Conference and elsewhere that he was not a "Negro" or "black" poet but simply a poet — and his critical comments on the new literary nationalism in the introduction of Hayden's *Kaleidoscope* anthology. Many leading Black Power and Black Arts writers and intellectuals, including Hoyt Fuller, Dudley Randall, and Stephen Henderson, clearly valued Hayden's poetry, if not his stance at the Fisk conference — in fact a number of them had personal ties to Hayden, perhaps Fuller and Randall most of all. Certainly, the leading Black Arts activists of the Northeast lacked Madhubuti's animus toward Hayden for the most part.

Nonetheless, few Black Arts writers appear directly influenced by Hayden's historical poems.[34] Neither did they inherit the same interest in history that

marked work of other black artists who emerged from the same Popular Front milieu as Hayden, such as the poet and novelist Margaret Walker, the novelist John O. Killens, and the visual artists Hale Woodruff, Elizabeth Catlett, Charles Alston, and Charles White—even if these older artists inspired them in other important ways. The notable exception among the younger black writers was the Baltimore poet Sam Cornish. Cornish moved from the interiority and oblique angularity of his published poems in the early and mid-1960s to the far more direct style that has continued to characterize his work, deeply engaging African American history from slavery through civil rights and beyond, often in lyric cycles. Sometimes these cycles take up well-known figures or a series of well-known figures, as in the sequence "The Moses of Her People—Harriet Tubman." In other cases Cornish's collections center on family members or unnamed black "everypeople" drawn with sharp historical specificity despite their typicality—such as the black Communists during the Depression that are the speakers in a number of the poems in the 1993 *Folks like Me*. However, though Cornish was deeply affected by the example of Black Arts institutions, especially Broadside Press and Third World Press, which inspired his own efforts at small press publishing, and though he was published in such journals as *JBP* and *Liberator* and was included in key anthologies, such as Clarence Major's *The New Black Poetry*, he felt somewhat at odds with the separatist impulse in Black Arts ideologies and institutional practices as well as what he perceived as cliquishness in the Black Arts institutions of Boston, where he moved in the early 1970s.[35]

More typically, the poetry and drama of the Black Arts movement and various sorts of literary nationalism are often marked and linked by a sort of Edenic story of implicit paradise, fall, and potential salvation. As in the first version of the Eden tale, the fall is rendered as a fall into history that needs to be transcended. The visual arts, especially the mural movement, worked somewhat differently. Even there, however, one tends to find the representation of mythic or iconic historical figures but not much rendering of historical events. Thus, redemption and salvation lie in the escape from history into a mythical counterhistory or antihistory. Drawing on the model of a popular avant-garde discussed in the preceding section, the Black Arts activists of the Northeast were particularly influential in this regard, encoding a counterhistory (or finding an encoded counterhistory) within African American popular culture, especially black music. As Larry Neal commented on what he called the ritualized base of Baraka's play *Slave Ship*:

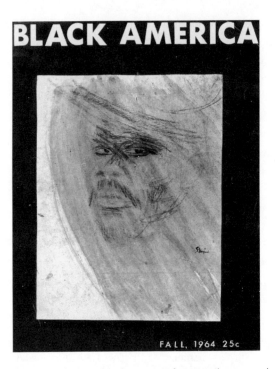

BLACK AMERICA

FALL, 1964 25c

The cover of RAM's *Black America,* featuring the watercolor "Garvey's Ghost" by RAM leader Muhammad Ahmad, a visual artist who became known primarily as a political activist. (Reproduced by permission of Muhammad Ahmad.)

One of the prime motivations behind the work is to suck the audience into a unique and very precise universe. The episodes of this "pageant" do not appear as strict interpretations of history. Rather, what we are digging is ritualized history. That is, history that allows emotional and religious participation on the part of the audience.[36]

Strangely, here historical events, or at least a ritualized version of a historical experience, are used to get beyond history, at least as Neal understands the framing, presentation, and interpretation of European and Euro-American history. This idea of black art as a sort of religious or quasi-religious ritual that erased the boundary between performers and audience, taking them to a common space outside European culture and European notions of history, exerted

enormous influence on many of the leading Black Arts theaters, especially the New Lafayette and the NBT.[37]

In African American poetry and drama, it is generally enslavement and the middle passage to the Americas that occasion this fall into history. Thus, one means of escaping history involves the reconstitution of an ahistorical or transhistorical symbolic African space. To say this might seem to be something of a commonplace, not only about much of the African American nationalism in the 1960s and 1970s but also about black nationalism as it existed in the United States throughout the twentieth century. But this space is more complicated than it might seem at first appearance. For one thing, generally, the space is to be constituted or reconstituted in the United States, not Africa. There are few visions of a permanent physical return in Black Arts poetry and drama except for an imaginative return to a prehistorical past. In this, the influence of the NOI and later the RNA, with their revival and revision of the old CPUSA notion of a Black Belt republic in the rural South, seems crucial.

In addition to that of the NOI, other countercultural visions of ahistorical or transhistorical black societies presented in miniature by different groups, communes, and collectives powerfully affected the development of the ideology and style of the Black Arts movement, especially in the Northeast. One such group that Baraka and many in and around BARTS found attractive was Harlem's neo-African Yoruba Temple, led by Baba Oserjeman (a former Communist). Sun Ra and his Arkestra also attracted many Black Arts activists in New York not simply through his eclectic and often challenging music and the virtuosic skill of many of his band members but also through their embodying how a truly alternative black culture might look and sound. Nonetheless, Maulana Karenga's Kawaida vision of a neo-African counterculture, with its seven principles (*Nguzo Saba*) of unity (*umoja*), self-determination (*kujichagulia*), collectivity (*ujima*), cooperative economics (*ujamaa*), purpose (*nia*), creativity (*kuumba*), and faith (*imani*), provided the most sophisticated (and most usable) ideological scaffolding for the early visions of a mythic history advanced by Baraka, Neal, Touré, and others — even though these ideas of Baraka, the Muntu group, the Umbra poets, and others in the Northeast initially developed before or contemporaneously with Karenga's Kawaida philosophy (and possibly influenced Karenga to some extent). Perhaps the notion of a counterculture does not entirely capture Karenga's project, since it suggests a certain priority of European (and Euro-American) culture to which other visions merely react. Karenga emphatically insists that

his modern synthesis of what might be thought of as recovered (in the sense of the reconstruction of what has been lost on the continent as well as in the diaspora) and contemporary African culture, philosophy, political theory, and so on attempted to decenter European epistemologies, which he saw as essentially self-congratulatory narratives or myths. In this, Malcolm X was perhaps the most important immediate inspiration in his emphasis on what Karenga calls an African "cultural recovery and retrieval," whether on the continent or in the diaspora.[38] Given the highly intellectual and theoretical underpinnings of the cultural nationalism of Karenga and Us (and Larry Neal and the Muntu group of Philadelphia, for that matter), it is not surprising that one of the chief appeals of Malcolm X was not simply his militant, uncompromising stance but also his intellectual sharpness and his artistry with language.[39]

Perhaps influenced by the examples of these neo-African countercultural subcommunities, the Black Arts movement frequently transformed the Black Belt nation on the land into a vision of a liberated city-state or federation of such states, rooted in the landscape of the urban ghetto, as in Baraka's "new neighborhood where all the risen live." This vision, particularly as the Black Power movement attempted to make it a reality, was no doubt much indebted to James Boggs, who in the mid-1960s began to widely circulate the idea of black political control of the cities where African Americans formed the majority or near majority of the population as a step toward the establishment of a revolutionary society.[40] Boggs's notion was at least initially far more concerned with the practical issues of seizing the economic and political apparatuses of the city-state than the culturally oriented vision of Baraka and others. Similarly, Boggs's frequent collaborator in Detroit, Rev. Albert Cleage Jr., also envisioned a neighborhood- or city-based vision of Black self-determination — though he was much more interested in culture and the symbols of a black identity than was Boggs — as the renaming of Cleage's Central Congregational Church to the Shrine of the Black Madonna (with an accompanying painting of the Black Madonna by artist/bank robber Glanton Dowdell) attests. Interestingly, much as Cleage did in Detroit, Baraka and activists of the CFUN and Newark CAP in many respects eventually combined their older, Kawaida-influenced countercultural approach with Boggs's economic and political vision in a largely successful campaign to elect a black mayor, Kenneth Gibson, and new black city councilpeople in Newark in 1970.

Yet if this black cultural space was *in* and in some senses *of* America, it was

also in part African. However, there was little reference to the historical Africa since the advent of slavery in the Americas.[41] Those relatively few allusions to contemporary African history, for example, the invocation of the names Patrice Lumumba and Kwame Nkrumah, tended to represent African history as a fall also, much as it was for African Americans, with Lumumba's murder serving as an emblem of Africa's continued suffering. Instead, in terms of positive identification, there was a persistent use of the figure of the African warrior to embody an essential African identity to which African Americans should aspire, representing a reconstruction of an integral wholeness shattered by slavery, racism, and colonialism:

> Where are the warriors, the young men?
> Who guards the women's quarters — the burnt-haired
> women's quarters —
> and hears their broken sobbing in the night?[42]

Despite (or perhaps because of) the images of African warriors in the mass culture of the United States, the warrior appeared relatively infrequently in African American literature of the pre–Black Arts era, and then generally as an emblem of a certain sort of nostalgia or displaced sexuality rather than as a model for African Americans in the present. However, the reclamation of the warrior image in African liberation movements of the 1950s and 1960s led to a similar usage by radical black writers. Such a reclamation can be found in the scene in Lorraine Hansberry's *Raisin in the Sun* in which a drunken, yet strangely noble, Walter Lee Younger invokes the name of Jomo Kenyatta and assumes for a minute the persona of a warrior-leader, breaking through what had been a farcical moment without any apparent irony on Hansberry's part. So the figure of the warrior, too, is a trope of a cultural-political fall into a history in which the warrior is not generally present, only invoked or called — though in some cases a certain historicizing of the figure within the context of world liberation struggles is suggested, as in Baraka's "A POEM SOME PEOPLE WILL HAVE TO UNDERSTAND" when the poem's speaker asks, "Will the machinegunners please step forward?"[43]

This Black Arts warrior is both implicitly and explicitly male — though some black women writers in the post–Black Arts era, notably Audre Lorde, pointedly introduced figures of the woman warrior and the Amazon (with its lesbian subtext) into their work — both invoking and critiquing the Black Arts movement.

Of course, there is a female figure associated with Africa in Black Arts poetry, resembling the long-standing trope of Mother Africa, linking black women and Africa with nature and procreation:

> Black women, timeless, are sun breaths
> are crying mothers
> are snatched rhythms
> are blues rivers and food uncooked,
> lonely villages beside quiet streams[44]

Here, as in many Black Arts poems, say, Baraka's "Beautiful Black Women," African American women are touchstones of essential blackness who renew the identity of black men who will in turn change the world.

Both the male and female figures associated with Africa are essentially ahistorical, again located in a construction of Africa that exists in a sort of prehistory. In fact, Africa serves as a sort of alternative to history, a return to a cultural wholeness before the fall. For example, in Jay Wright's "Death as History," history is posited as a fall or death, proclaiming, "it is that African myth / we use to challenge death."[45] Here, history is a sort of death, and "African myth" an antidote to death as history, allowing the reader to see a certain wholeness beyond history (and death). While Wright is not usually thought of as a Black Arts writer and has, like Clarence Major and some others, sought to distance himself from the movement, his poetry was circulated widely in the central Black Arts journals and anthologies.

A more dynamic attempt to escape history while giving some sense of the movement and development associated with constructs of history can be found in the frequent substitution of cultural expression for history by Black Arts poets and dramatists. Following in many respects the lead of Langston Hughes, a continuum of African American expressive culture, particularly music, also becomes an alternative history. This differs somewhat from the notion contained in, among other places, the famous prologue of Ralph Ellison's *Invisible Man*, which suggests that the history of African Americans (and the United States) is encoded in or contained within African American music. Rather, it is the notion that African American vernacular music is itself a sort of history that is truer than the account of events we normally associate with history. This is particularly the case in the poetry and plays of Amiri Baraka that are often located in a landscape of popular culture, where the conflict between Ruby Dee and Eliza-

beth Taylor, between the Rolling Stones and John Coltrane, is as prominent as what might be normally considered political conflict. Perhaps the clearest expression of this is not in Baraka's poetry but in the play *Dutchman*, where the character Clay advances the view that jazz is a displacement of black rage that, if one is able to hear it, is a truer account of black experience in the United States than any formal history or than actual events themselves:

> Old bald-headed four-eyed ofays popping their fingers . . . and don't know yet what they're doing. They say, "I love Bessie Smith." And don't even understand that Bessie Smith is saying, "Kiss my ass, kiss my black unruly ass." Before love, suffering, desire, anything you can explain, she's saying, and very plainly, "Kiss my black ass." And if you don't know that, it's you that's doing the kissing.[46]

Sonia Sanchez advances a similar notion in "A Coltrane Poem":

> but I saw yo/murder/
> the massacre
> of all blk/musicians. planned
> in advance.
> yrs befo u blew away our passsst
> and showed us our futureeeeee.[47]

Other examples of this "hidden transcript" can be found in Larry Neal's "Don't Say Goodbye to the Porkpie Hat," A. B. Spellman's "Did John's Music Kill Him," and Askia Touré's "Extension" (with its invocation of John Coltrane, Sun Ra, Pharoah Sanders, and Milford Graves). Of course, as is often the case with Black Arts theory in the Northeast, this concept has a long foreground, having been previously advanced by Langston Hughes, as seen, for example, in the "Simple" story "Bop." There, Jesse Semple explains that the apparent obscurity of bebop and its accompanying vocalizations contains a history of police brutality in black communities — the syllable "bop," for example, having an onomatopoetic relationship to the sound of a police club on a black skull. For that matter, one could go back to Frederick Douglass's discussion of slave music in his first autobiography, where he asserts that coded within the sound and structure of this music is the sorrow and horror of slavery.

This notion of antihistory, or history as a sort of fall, dovetailed nicely with Maulana Karenga's emphasis on mythology and the need to essentially create

new, ahistorical or prehistorical African traditions that were mythically or spiritually true but not exactly rooted in historical practice, as he did most famously and successfully with the introduction of the holiday Kwanza. Of course, Karenga also invoked history, but in many ways his concept of history was closely linked to mythology as something that needed to be created from transhistorical African values and African culture. Again, one reason why Karenga and his Kawaida philosophy had such an enormous ideological impact on Baraka and others (largely through Baraka) is that he provided a more fully elaborated theoretical underpinning for the conception of history already advanced by Baraka, Neal, Touré, Stewart, Charles Fuller, and others in the Northeast.[48] Interestingly, the influence of Karenga through Baraka helped lead to one of the most significant divides in Black Arts conceptions of culture, with Baraka and many activists in the Northeast (and elsewhere) retaining their notion of a popular avant-garde while Haki Madhubuti and a number of black artists and intellectuals, especially in the Midwest, posited a vision of an alternative avant-garde black culture that, like Karenga's, significantly rejected black popular culture.

Holding Up the Sky, Holding Up the Guy: Gender and Black Arts

Given the importance of gender to many Black Arts understandings of the relation between black history and culture, it might be appropriate here to address the issues of misogyny and homophobia within the Black Arts movement more directly than I do elsewhere in this study. After all, a commonplace about the Black Arts movement is that it was characterized, almost defined, by an extremely misogynist and homophobic masculinism. In fact, one might say that certain branches of Black Arts (and post–Black Arts) thought are locked in a sort of death embrace with some schools of feminist criticism, with the result that the Black Arts movement is often projected as hopelessly masculinist and homophobic in the worst ways, and feminism is equally often portrayed as an alien interloper in the African American community. The reading, archival research, and interviews that I have done in the course of this study suggest a somewhat different, more complicated, and conflicted reality about the Black Arts movement and gender — which is not to say that misogyny and masculinism were not significant presences in the movement, both individually and institutionally. Some crucial Black Arts activists, such as Askia Touré, deny bitterly

that the movement was particularly homophobic and misogynist. Sure, Touré and others say, they were influenced by homophobia and male supremacy and were often not nearly as sensitive to the particular interests of black women as they should have been, but that was true of almost every segment of American society. Even Maulana Karenga, whose Kawaida philosophy, with its notion that black women should be "complementary" to, rather than equal with, men was unquestionably masculinist, later renounced this masculinism, saying that he was influenced by a sexism that was rampant in all sectors of the United States.

However, these Black Arts veterans also note that many of the most active and influential national and regional figures of the movement were women, such as Nikki Giovanni, Sonia Sanchez, Abena Joan Brown, Jayne Cortez, Elma Lewis, Val Gray Ward, Carolyn Rodgers, Sarah Webster Fabio, Johari Amini (Jewel Lattimore), Margaret Danner, Barbara Ann Teer, Nayo Watkins, and Gwendolyn Brooks, to name a few, and they often did contest expressions of misogyny and male supremacy within the movement from the inside.[49] Six of the fourteen writers on whom Haki Madhubuti focuses in his 1971 *Dynamite Voices* are women. It is hard to think of another critical work of that time considering a large artistic movement in which the work of women formed such a large proportion of the subject matter—though some of these women, notably Nikki Giovanni, found Madhubuti's comments condescending. Perhaps a tendency to focus on the largely male-dominated scene of the Umbra Poets Workshop, *Liberator*, and BARTS in New York has occluded the central roles played in the development of early Black Arts institutions outside New York by such women as Jayne Cortez in Los Angeles; Sarah Webster Fabio and Sonia Sanchez in the Bay Area; Margaret Burroughs, Val Gray Ward, Gwendolyn Brooks, Carolyn Rodgers, and Johari Amini in Chicago; Margaret Danner, Naomi Long Madgett, Gloria House, and (a little later) Melba Joyce Boyd in Detroit; Elma Lewis in Boston; and so on. But even in New York, one could cite many black women, such as Lorraine Hansberry, Esther Cooper Jackson, Jayne Cortez, Rosa Guy, Sarah Wright, Abby Lincoln, Sonia Sanchez, and Barbara Ann Teer, who made large contributions to the development of a Black Arts infrastructure. One would have to go back to the early New Negro Renaissance to find a major black cultural movement in which women played such leading roles prior to the 1970s.

Some Black Arts veterans also point out in conversation (if not always in print) that quite a few artists and activists, most notably *Black World* editor Hoyt Fuller, were widely known within the movement to be gay, lesbian, or bisexual

and still played crucial roles in the Black Arts movement, enjoying a wide respect that complicates notions of the movement as fundamentally homophobic. While one could find open or only slightly coded antigay attacks on the more publicly "out" James Baldwin, in general there was also tremendous respect for Baldwin among most Black Arts activists—especially Baraka, who became an extremely close friend of Baldwin despite Baraka's famous (and not undeserved) reputation for homophobic writing during the Black Arts era. The problem is, says Touré (and others), that people took work from a certain period of Baraka's career that was marked by an extremely homophobic and misogynist masculinism, say, as seen in the poem "Black Art," and mistakenly generalized it to encompass all of the movement.[50]

These people have a point. To say that the Black Arts movement as a whole was particularly male supremacist and particularly homophobic, as opposed to, say, the abstract expressionist painters, the early high modernists, or the bohemian arts community of the Lower East Side in the 1950s and 1960s, is in fact problematic. The homophobic and sometimes violent, drunken machismo of Jackson Pollock was part of the cowboy aura that helped make him the embodiment of abstract expressionism in the mass media. Hettie Jones attests to the casual yet profound pre–Black Arts masculinism of the Lower East Side bohemia in the 1950s and early 1960s in her recollection of artists' softball games in which only the men could play, while the women had to stay on the sidelines and cheer on their husbands, boyfriends, or male friends.[51] Seen in this context, the relegation of women to a supporting role in Umbra shows the group to be in the mainstream of downtown bohemia in terms of gender roles rather than following some black nationalist imperative. In fact, the Black Arts and Black Power movements were among the few intellectual spaces in the United States in the 1960s where it was comparatively easy to raise the issue of male supremacy as opposed to, say, the institutions of mainstream academia. (The proportion of women in the leadership of the Black Arts movement measures up well against that of tenured women faculty in the overwhelming majority of college and university English departments in the 1960s and early 1970s.)

As Amiri Baraka, Haki Madhubuti, and others have pointed out, many of the women in the movement did struggle frequently and openly with male supremacy—for which Baraka, Touré, Madhubuti, Kalamu ya Salaam, and others are retrospectively grateful.[52] Barbara Sizemore's "Sexism and the Black Male," which strongly attacked the sexism of Baraka and the Kawaida movement, ap-

peared in a 1973 issue of *Black Scholar*, a Black Power journal that included virtually every ideological tendency within the movement on its editorial board, from the Old Left to the new Marxism-Leninism to cultural nationalism. Like Toni Cade Bambara's 1970 anthology *The Black Woman*, the essay of Sizemore, an influential educator in Chicago who had already made a great impact on Madhubuti and other midwestern Black Power and Black Arts activists, argued against sexism and masculinism from within Black Power, not from the outside.

It is worth remembering that the positions of Sizemore, Bambara, and the other women in the Black Arts and Black Power movements who fought against sexism were not marginal within those movements but were so powerful that they largely carried the day in the end. Even the leading Kawaidaists eventually repudiated the notion that women were "complementary," not equal. While one might attribute Baraka's alteration in this regard to his adoption of Marxism, an ideology that has traditionally opposed "male supremacy" in theory if not always in practice, Karenga, Salaam, and Madhubuti remained cultural nationalists despite their new opposition to male supremacy. And there were male Black Arts activists who actively struggled for the inclusion of black women and black women's subjectivity in the leadership. For example, the most intense uproar at the famous (or infamous) symposium on Ed Bullins's play *We Righteous Bombers* sponsored by the New Lafayette Theatre was provoked by pointed questions from Askia Touré and Ernest Allen Jr. about the lack of women on the forum's panel and their call for women's participation from the floor.[53] This is not to say that sexism and masculinism disappeared from the Black Arts and Black Power movements; far from it, as argued below. Rather, it is to claim that caricatured versions of those movements as fundamentally and unusually sexist distort them and the legacy of black women (and some men) in those movements as well as their contributions to the rise of second-wave feminism.

Nonetheless, it is also fair to say that, significantly influenced by the masculinist ideologies of the NOI and Maulana Karenga in the 1960s and early 1970s, a fairly normative heterosexual vision of the liberated African American community was a powerful current in Black Arts ideology. One of the pillars of this vision was the reconstructing and revolutionizing of the black family in which men were men and women were women, in surprisingly conservative ways. The notion of reconstruction was often predicated on the cultural fall of a prehistoric Africa, as discussed above, figured as a loss of masculinity—a familiar trope of African American nationalism reaching back into the nineteenth century. In

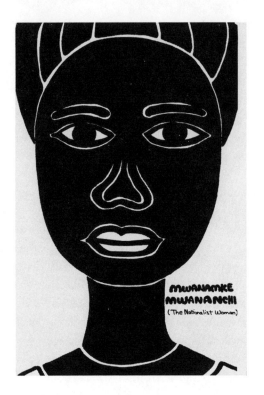

MWANAMKE MWANANCHI
(The Nationalist Woman)

The cover of a 1971 pamphlet issued by a women's group affiliated with CFUN and CAP.

this scheme, the figure of the gay male as a sign of cultural decay and the use of the epithet "faggot" as a free-floating slur also became common in the work of quite a few Black Arts activists. There were, of course, women who pushed the envelope, representing black women's subjectivities that were at least in part separate and even opposed to that of black men, as did Nikki Giovanni in such poems as "Woman Poem" and "For Theresa" (in which the speaker appears to ironically weigh what she calls "the pleasure of loneliness" against the pain of a same-sex love).[54] However, even Giovanni generally operated within a frame of normative heterosexuality, as in her better-known "Beautiful Black Men."

Perhaps the high point of this vision within Black Power was the first CAP convention, where Amina Baraka (Sylvia Robinson), a woman who did not generally hesitate to argue against gross sexism within the movement) approvingly quoted Karenga in the coordinator's statement to the Social Organization workshop: "As Maulana points out, 'What makes a woman appealing is femininity and she can't be feminine without being submissive.'" She goes on to add, "De-

fining submissiveness in the role of the Black woman we are talking about sub-mitting to your natural roles, that is understand that it will take work and study in areas that deal specifically in things that women are responsible for. Such as Maulana teaches inspiration, education and social development of the nation."[55] In other words, even in this unreconstructed Kawaidaist view, the responsibility of black women to transmit both traditional and revolutionary culture, while presupposing a submission to black men in other areas of political and social leadership, allowed women a tremendous latitude within the Black Arts move-ment.

In short, a paternalistic, often homophobic, masculinism was a powerful strain within the Black Arts and Black Power movements as it was in many of the ideologies and social lives of post–World War II bohemias and countercul-tures. However, it was not the only strain, even when and where the Kawaida movement and the also masculinist NOI were most influential. Again, the Black Arts and Black Power movements were among the very few organizational and ideological spaces of that era in the United States, outside the organized Left and the reemerging feminist movement, where one could effectively raise the issue of male supremacy and gender oppression — and sometimes Black Power and Black Arts groups would form committees or other institutional structures to address these concerns. This was to a large degree a result of the various Left currents that significantly fostered and continued to circulate through the Black Arts movement, especially the increasingly influential Third World Marxism-Leninism, with its famous Maoist slogan "Women hold up half the sky." Once again, the effectiveness of those efforts against sexism can be seen in the fact that the women (and men) who contested sexism, male supremacy, and to a lesser extent homophobia within the Black Arts and Black Power movements won the day for the most part with even the Kawaidaists, including Karenga himself, not simply revising their ideological stances but often offering formal apologies.

Text and Performance in the Early Black Arts Movement

Another commonplace about the Black Arts movement is that it elevated the oral over the written, and public collective performance over more individual modes of cultural production and reception.[56] There is considerable truth to these claims. Poetry, drama, dance, and music (or some combination of these

genres) lent themselves to performance in public spaces much more easily than the novel. It was relatively easy to stage a short play, a poetry reading, or a musical performance on a street corner, in a community center, at a rally or a convention, or in a public housing project courtyard and get an immediate response from a wide range of people. As Kimberly Benston notes, there was an interplay between Black Arts performance and collective audiences within the larger social context of mass African American struggle, as the "long hot summers" of urban uprising became a recurrent phenomenon. This interplay lent a peculiar intensity and immediacy to the movement's paradoxically twinned formal and ideological vanguardism and community building—much like the way economic depression and militant labor struggles helped to make Clifford Odets's *Waiting for Lefty* and Marc Blitzstein's *The Cradle Will Rock* electrifying theater in the mid-1930s.[57] To a large extent, these performances as well as the collective creation and viewing of murals were the calling cards of the Black Arts movement to the broader black community. In fact, the production of murals and other forms of public art took on a performative aspect. This was famously true of Chicago's *Wall of Respect*, where musicians performed and poets recited as the mural was painted by members of the OBAC Visual Arts Workshop. The completion of the *Wall of Respect* was particularly gripping theater, taking place before a mass audience that included armed (and hostile) policemen watching from surrounding rooftops.[58] Even a more formal presentation in a theater or community arts center housed in a black neighborhood was a public event that left a considerable impression on the street—if only on a marquee or on a pasted-up flyer advertising the production of a new play by Ed Bullins or Ron Milner or a concert by Pharoah Sanders or Milford Graves.

There was also a sense that African cultures (and the culture of the black folk in the United States) were essentially oral and musical and that Western cultures were literate—and that while the novel exemplified the Western approach to literature, oral-based poetry, music, and ritualized drama typified the African and the non-Western:

> The dead forms taught most writers in the white man's schools will have to be destroyed, or, at best, radically altered. We can learn more about what poetry is by listening to the cadences in Malcolm's speeches than from most of Western poetics. Listen to James Brown scream. Ask yourself, then: Have you ever heard a Negro poet sing like that? Of course not, because we have

been tied to the texts, like most white poets. The text could be destroyed and no one would be hurt in the least by it.[59]

As Mike Sell observes, this distinction between these dead white forms and living African, black, Third World art predicates itself on the notion of a Western fetishization of the object, or the product over process, and of a bourgeois, individualistic split between artist, artwork, individual consumer, and community over an organic web connecting artist, art, the audience member, and society as a whole.[60] Conversely, Haki Madhubuti argued,

> Black art, like African art is *perishable*. This too is why it is functional. For example, a black poem is written not to be read and put aside, but to actually become a part of the giver and receiver. It must perform some function: move the emotions, become a part of the dance, or simply make one act. Whereas the work itself is perishable, the *style* and *spirit* of the creation is maintained and is used and reused to produce new works.[61]

Here Madhubuti imagines a tradition of writing patterned on a sense of an oral tradition. He echoes a widely shared notion of the era about an African American heritage of nonliterate, artistic, improvisational transmission within the context of traditional forms and sensibilities, as seen in pianist-composer Cecil Taylor's practice of teaching his band compositions by ear rather than from a written score for a period in the 1960s.[62]

Of course, these sorts of arguments were not unique to the Black Arts movement but sound remarkably similar to oppositions of process versus product, open forms versus closed forms, the "cooked" versus the "raw," the "New American poets" versus the "Academic poets" that critics and artists associated with the Beats, the New York school, the Black Mountain school, and the California Renaissance (and their descendants) posited in the 1950s and 1960s. As Daniel Kane notes, the Lower East Side poetry counterculture of the early 1960s, led by such white poets as Paul Blackburn, Ed Sanders, and Ted Berrigan as well as African American writers like Baraka and the members of the Umbra Poets Workshop, generally put a high premium on orality and performance.[63] Such process/product oppositions also resemble the distinction between the Living Theater's politically and formally radical improvisatory method that sought to draw the audience directly into the production and more traditional, textually based drama during the 1960s and 1970s.[64]

However, such oppositions of product and process, Africa and Europe, orality and literacy, and so on, however useful or symbolically powerful, can cause one to underestimate the importance of the printed text and textuality in the Black Arts movement. To the degree that the movement opposed performance and orality to textuality, it was, as Mike Sell notes, in many respects "a textually supported anti-textual movement."[65] Even this antitextuality can be overstated. Leading Black Arts critics, such as Neal, Madhubuti, Addison Gayle Jr., and Hoyt Fuller, more frequently attacked what they saw as a white academic obsession with the word (and literature) as product and the fetishization of a fraudulent universal, rather than the text as such.

Also, the positing of the oral as a distinctly African and African American tradition can be overemphasized, too. As Tom Dent noted with respect to the Umbra poets and the black writers of the Lower East Side, one reason why poetry readings and performance became such a central part of their practice was because the well-developed countercultural coffeehouse and poetry reading scene associated with the New American Poetry there inspired and facilitated the oral presentation of their work — if they had wanted to do that in Harlem, they would have had to create the infrastructure themselves (as did Raymond Patterson for the relatively short-lived Market Place Gallery series before Umbra, and as the Uptown Writers Group and BARTS would do after Umbra).[66]

On a very basic level, the Black Arts largely cohered as a movement in its early days through the printed media. Early Black Arts and Black Power apostles, such as Donald Freeman, Larry Neal, Ernest Allen Jr., Muhammad Ahmad, Sonia Sanchez, and Askia Touré, did much traveling, helping to create networks of cultural and political activists. Tours of traveling performance troupes, particularly the FST and Nkombo groups in the South, inspired sympathetic artists (or aspiring artists) to emulate them and to stay in touch. Even a few early television shows, notably the NBC documentaries on the Watts Writers Workshop, presented images of a new black art and a new sort of black artist to a national audience. However, it was the journals, including *Liberator*, *The Crusader*, *Freedomways*, *Negro Digest* (later *Black World*), *Black Dialogue*, *Soulbook*, *Black America*, and *JBP* that built a national community in which ideology and aesthetics were debated and a wide range of approaches to African American artistic style and subject displayed.

In fact, one of the archetypal Black Power and Black Arts stories through which participants understood that a new political and cultural era had begun

describes the founding of journals and newspapers (e.g., *Mr. Muhammad Speaks* by Malcolm X, *The Crusader* by Robert Williams, and *Black America* by Ahmad and the RAM group in Philadelphia at the urging of Ethel Azalea Johnson), perhaps showing the lingering influence of old Leninist notions about the necessity of a nationwide organ for a truly national revolutionary movement. As they made their rounds locally and from city to city, such cultural and political organizers as Freeman, Touré, Neal, and Ahmad circulated journals, essays, broadsheets, position papers, and other printed forms as well as the spoken word. When Touré surveyed what he called "the crisis of Black culture," he argued thus:

> Also, we Black writers *must* produce more literary journals. It's a shame that our main journals — *Soulbook, Black Dialogue, Journal of Black Poetry* — are all located on the West Coast. There should be some kind of regular literary publication representing each area — East Coast, Mid-west, South, and West Coast — as well as publications geared for national and international circulation.[67]

Touré's comments here have been taken by some scholars as exhibiting an East Coast bias.[68] Another way to understand them is as an argument for a revolutionary black cultural press that takes into account the diverse regional character of the movement as well as its national and international needs. Underlying Touré's critique is his sense that the development of an interlocking network of regional and national journals was crucial for the success and survival of the Black Arts movement.

When the explosion of African American cultural centers, theaters, bookstores, galleries, and so on occurred as the Black Arts began to see itself as a movement, the new black publishers, such as Broadside Press, Third World Press, Journal of Black Poetry Press, and Jihad Productions, and the new journals were deluged with letters requesting printed (and sound-recorded) materials, since it was these texts that largely tied communities outside the large Black Arts centers to the movement.[69] Likewise, the reports, letters, news briefs, and announcements from scores (if not hundreds) of cities in every region of the United States inundating the young Black Arts and Black Power journals issued from a similar sense of print as the glue holding together a movement with relatively little consistent access to (and even less control of) other forms of national media. Even the seminal multimedia mural, the *Wall of Respect*, which included both painting and photography, prominently featured a short text,

Baraka's poem "SOS," as a sort of centerpiece. As he later recalled, at least one of the mural's creators, William Walker, was fascinated by the aesthetic and political impact of combining visual images with text—a fascination he brought to other high-profile murals he helped create in Chicago and Detroit.[70] It is this sense of an urgent need for black people to produce and circulate printed texts by African American authors to the broader black community across the United States (and beyond) that made the establishment of journals, newspapers, and presses such a high priority of Black Power and Black Arts institution building and made those textual or text-producing institutions among the most successful and most long-lived of initiatives by those movements. It also motivated the intense discussion about whether black authors should only publish with black presses that came to a head with the heated debate attending the publication of Clarence Major's anthology *The New Black Poetry* with a "white" (albeit radical) publisher, the CPUSA's International Publishers.

One reason for the importance of poetry as a Black Arts genre is not merely because it is more easily and dramatically performed than prose, particularly the novel, but also that the relative brevity of the lyric poem lends itself to the space and economic constraints of journal and small press publishing far better than the novel. Despite a deeply ingrained feeling in the United States that poetry is a relatively rarefied genre as compared with fiction, these small press publications often sold many more copies than novels by authors associated with the movement who were published by "mainstream" presses.[71]

What can be generally said about Black Arts poets is that their work opposed what could be called (in the terminology of the time) "academic" textuality promoted by the New Criticism, with its notion of the poem as aesthetic object, or as Cleanth Brooks put it, a "well wrought urn."[72] However, while the metaphor of the urn perhaps accurately catches the sense of literature or art as a sort of product or object for its own sake, it is misleading in that it implies the importance of the visual or material existence of literature. "Academic" poetry in the 1950s and early 1960s may have existed primarily for the page, but it did not on the whole draw attention to itself much in a material way. Generally speaking, one aspect of the different schools of the New American Poetry in the 1950s and 1960s is their insistence on the materiality of the poem as a primary aesthetic value. As noted in Chapter 1, William Carlos Williams was a patron saint of these schools; and his poetic stricture "No ideas but in things" (which was echoed by Baraka's shocking opening claim in "Black Art" that "Poems are bull-

shit unless they are / teeth or trees or lemons piled / on a step") was a sort of maxim.[73] While Williams is justly famous for his use of American dictions and rhythms derived from varieties of everyday speech, it was his visual placement of vernacular American English on the page, including his use of the triple line break (under the influence of Russian futurism, cubism, and other avant-garde schools of visual art that he absorbed as part of Alfred Steiglitz's artistic circle in the early twentieth century), that made his work so arresting. One might add that Langston Hughes performed much the same operation in such early poems as "The Owl and the Saxophone, 2 A.M."

One of the divides between the Beats, including Allen Ginsberg, Jack Kerouac, and Gregory Corso, and the New York school, including Frank O'Hara, Kenneth Koch, Barbara Guest, John Ashbery, and James Schuyler, can be found in their approach to this materiality and the inheritance of Williams and Hughes. The Beats (depending on whom you consider a Beat) by and large paid less attention to visual dimensions of their work, focusing more on the materiality of the sound of a range of American voices and music—with some exceptions, such as Corso's "Bomb," which took the shape of a mushroom cloud. It is not surprising that these poets felt far more at home in poetry readings than, as John Ashbery admits, was generally the case with their New York school counterparts.[74]

The New York school, particularly O'Hara, also drew on the sonic legacy of this approach to diction pioneered by Williams and Hughes (though, like the Beats, they generally only acknowledged Williams) but paid more attention to the visual dimension of this inheritance. As with Williams and Hughes, the New York writers, say, O'Hara in his poem "In Memory of My Feelings," frequently fragmented their texts into a sort of verbal and visual collage that called attention to the solidity of words and phrases, often with considerable humor. Of course, the New York poets were famously engaged with the New York visual arts scene, often working as art critics, museum curators, and so on. They also publicly admired various schools of writing, especially the French surrealists and the Russian futurists, in which writers (e.g., Paul Eluard, Robert Desnos, Max Jacob, Pierre Reverdy, and Vladimir Mayakovsky) were similarly bound up with the visual arts. Also, like Hughes (and like Ginsberg and Kerouac), the New York poets, especially O'Hara, drew thematic and structural inspiration from a wide range of musical genres, composers, and performers from Rachmaninoff, to Satie and the other early twentieth-century French avant-gardists of Les Six, to John Cage, to Billie Holiday, rendering musical form through visual as well as

sonic arrangement. In this, the attachment of the New York poets to these French modernists and to Cage is particularly crucial, since the visual (and literary) elements of the scores of Satie and Cage were important components of their art.

As noted in the previous chapter, African American artists played major roles in the inspiration, development (and even the concept) of the New American Poetry. Interestingly, a number of black writers, notably Baraka and Kaufman, were enormously influential and yet had liminal positions with respect to these schools. While critics still frequently refer to a "Beat" era of Baraka's career, in fact he was never a "Beat," a "New York poet," or a "Black Mountain writer" but had close relations with the founding members of all those schools, especially O'Hara and Ginsberg. Kaufman epitomized the Beat sensibility in the Bay Area, but as will be discussed at more length in Chapter 4, his work drew on a wide range of styles in ways that would be hard to fit into any of the schools comfortably. Certainly, both Baraka and Kaufman created poems with a powerful visual impact, as in Kaufman's "Abomunist Manifesto" and the typography of much of Baraka's proto–Black Arts poetry in *The Dead Lecturer*—such as the period beginning "BLACK DADA NIHILISMUS" (". Against what light") that is inaudible in Baraka's reading of the poem on the recording *New York Art Quartet* and the unclosed left bracket of the Crow Jane poems.

In addition to such black writers directly involved in New American Poetry circles as Baraka, Kaufman, Ted Joans, A. B. Spellman, and Steve Jonas, important groups of textually or visually oriented African American literary avant-gardists existed outside, or in complicated relation to, those circles. Aldon Nielsen (one of the most perceptive scholars on both text and performance in the work of twentieth-century black avant-garde writers) has done much to reveal the importance of Russell Atkins and the Cleveland journal *Free Lance* and of the Washington, D.C., Dasein group to the black avant-garde literary tradition. As Nielsen notes, one thing that distinguished these more strictly African American "schools" from their white (and many of their black) counterparts in the better-known centers and groupings of the counterculture was their willingness to unabashedly acknowledge their debt to older black writers, particularly Langston Hughes and Sterling Brown. Hughes encouraged and promoted Atkins and *Free Lance*, and Atkins (much like Ted Joans in New York) in turn posited Hughes as the progenitor of an important stream of modernist syntactical juxtapositions, tone, lineation, and typography.[75] Sterling Brown mentored the Dasein poets, linking them to political activists of NAG, with whom he had

similar relationships, as well as earlier generations of black writers. While the Dasein poets remained somewhat aloof from the grassroots activities of NAG, SNCC, and the civil rights movement, their work was nonetheless informed by civil rights, decolonization, black nationalism, and the other currents sweeping through the African American community and especially the Howard campus in the late 1950s and early 1960s. For example, as Nielsen observes, Dasein poet Percy Johnston whimsically reconfigures "Beat alienation" in a radical African American modality in "Variations on a Theme by Johnston."[76] This sense of black alienation riffs on Allen Ginsberg's similarly whimsical gay "red diaper baby" litany, "America," so that the humorous but pointed juxtaposition of Johnston's lines "I don't salute old glory! / I wept for Patrice Lumumba, / I respect Jomo Kenyatta" echoes and revises Ginsberg's "Mother Bloor made me cry I once saw Israel Amter plain. Everybody must have been a spy."[77] Johnston pays a certain textual tribute to Ginsberg here but also makes a political point in replacing the CPUSA leaders Bloor and Amter with revolutionary nationalist icons Lumumba and Kenyatta, belying any sense of Johnston's (and the Dasein group's) Afro-bohemianism as apolitical or ideologically naive. The historical sweep and ideological complexity of this point about African American literature in the early 1960s was further emphasized by the name of the anthology of Dasein group poetry in which Johnston's poem appeared, *Burning Spear: An Anthology of Afro-Saxon Poetry*, "Burning Spear" referring to the nickname of Kenyatta and "Afro-Saxon" to a term often used within the African diaspora of the former British empire to indicate a black person who has adopted British (or white) culture, manners, and values.[78]

Thus, if the Black Arts movement inherited from various avant-garde sources a predilection to stress process over product and a sense of the materiality of the voice, especially the black voice, it also received an emphasis on the importance of the visual text as a means for conveying this materiality. This visual impact was heightened by the frequent juxtaposition of nonverbal images (photographs, line drawings, block prints, lithographs, and so on) with written texts (poems, plays, essays, sketches, stories, manifestos, and so on) in such Black Arts and Black Power journals as *Black Dialogue, Soulbook, Liberator,* JBP, RAM's *Black America,* and *Negro Digest/Black World,* as well as in many chapbooks, pamphlets, and broadsides produced by Black Arts presses. (Black Arts texts issued by "mainstream" commercial publishers — and even bohemian or radical presses, such as Corinth and International — were far more likely to adhere

The Resurrection Of The DEAD!

a ritual
By Marvin X

ILLUSTRATIONS BY MAXINE RAYSOR

1st Movement

Dead bodies in the hells of North America. Slowly, with great pain, great suffering, they come to life. There is drum music (Milford Graves style). Slowly, slowly, they come to life, men and women — though they are not yet men and women. They are things, tools, negroes, grunting like beasts. They make animal sounds, primal noises as they help each other up from the pits of hell.

2nd Movement

The bodies are standing now, wandering blindly in the darkness of day. The men find each other, the women find each other, but not without pain and suffering. Great joy — they sing and dance, still uttering animal sounds, primal noises.

26

The first page of Marvin X's ritual drama *The Resurrection of the Dead* as it appeared in *Black Theatre*, illustrating a conjunction of Black Arts text and performance. (*Black Theatre*, no. 3 [1969]; reproduced by permission of Marvin X.)

to conventional [by mid-twentieth-century standards] arrangements of black print and white space.) Again, this conjunction of the verbal text and the visual is also seen in the incorporation of the texts (and the representation of textual objects, including the titles of key novels and poems) in visual art, again, most famously, the *Wall of Respect*.

Rather than being a mere adjunct, the written/visual Black Arts text frequently existed in symbiotic relation to performance. That is to say, very often the written text draws on performative modes, including everyday speech, and is posed in dynamic relationship to those modes, but it does not function simply as a score for performance. Or if a poem on the page can be said to be a score, it is a score that exists as more than a shadow of performance. As Lorenzo Thomas notes, the radical lineation and visual phrasing of Sonia Sanchez's "A Coltrane Poem," which proceed on both vertical and horizontal axes, let the reader know how the poem might be read aloud.[79] At the same time, the experience of reading the poem on the page differs from hearing it aloud. Interestingly, in some ways Sanchez's poem on the page can be seen as a more powerful re-creation and explication of the music of Coltrane than the oral performance. It is true that the nonverbal sounds of Sanchez's poetry (like those of Baraka's) sometimes do not translate well onto the page. However, the sense of the near simultaneity of Coltrane's chordal runs and the actual simultaneity of the playing of his quartet on "My Favorite Things" (not to mention Coltrane's penchant for multiphonics, or producing more than one note at a time) is more easily represented by the visual arrangement of the text than by a single reader. In any event, Sanchez's "A Coltrane Poem" exists as more than a bare score for performance. In fact, Sanchez did not attempt to perform the poem until years after its initial publication, when it was requested by an insistent audience member at a reading at Brown University in the early 1970s.[80]

In short, as Aldon Nielsen suggests, "African American traditions of orality and textuality were not opposed to one another and did not exist in any simple or simplistic opposition to modernity and postmodernity."[81] Rather, African American artists and cultural theorists proposed a new relationship between text and performance that in some important respects formally resembled other sorts of avant-garde poetry and theater, but within a different ideological frame heavily shaped by Black Arts notions of history and the relation of popular culture to high culture.

3

New York Altar City: New York,
the Northeast, and the Development of
Black Arts Cadres and Ideologies

New York altar city / black tears / secret disciples
BOB KAUFMAN, "Walking Parker Home"

The Northeast, particularly New York City, is frequently cited as the birthplace of the Black Arts movement. This is due in no small part to the national reputations of Amiri Baraka, Larry Neal, and the relatively short-lived BARTS in Harlem and to Baraka's coinage of the term that came to designate the movement. It also has to do with the long-held notion of Harlem as the center of African American intellectual, artistic, and political life, a notion that retained a strong hold on many leading Black Power and Black Arts activists, even as the geographical extent of those movements radically destabilized any notion of a single "capital"—or even of two or three primary sites. And of course, a great many important poets, dramatists, fiction writers, visual artists, musicians, dancers, and critics associated with the Black Arts movement lived in New York City for some significant period during the 1960s and 1970s. Among them were Baraka, Neal, Sonia Sanchez, Addison Gayle Jr., Jayne Cortez, Keorapetse Kgositsile, Yusef Rahman, Nikki Giovanni, David Henderson, Calvin Hernton, Eleo Pomare, Ishmael Reed, Lorenzo Thomas, Ron Milner, David Rambeau, Askia Touré, Harold Cruse, Ed Bullins, Woodie King Jr., Barbara Ann Teer, Ernest Allen Jr., Tom Dent, Marvin X, Henry Dumas, Edward Spriggs, and the Last Poets.

However, as Kalamu ya Salaam and others have pointed out, relatively few secure, long-lived Black Arts institutions of national significance were established in New York City. BARTS itself lasted less than a year, dissolving in a maelstrom of internal personality conflicts, threats, and violence as well as external pressures. The major Black Arts journals, publishers, and organizations were based primarily in the Midwest and on the West Coast.[1] During the height of the Black Power and Black Arts era, Newark was as important a center as New York in many respects—again, owing largely to the work of Amiri Baraka and the influence of Baraka's CFUN on CAP.[2] Even in the case of Newark, CFUN, and CAP, the influence on the Black Arts movement nationally came through essentially political rather than cultural institutions. In other words, though the Newark-based institutions Spirit House, the music journal *The Cricket*, and Jihad Productions had an impact on the Black Arts movement, this national impact was nowhere near as great as that of such Midwest and West Coast institutions as JBP, *Soulbook*, *Black Dialogue*, Broadside Press, *Negro Digest* (later *Black World*), OBAC, the AACM, AFRI-COBRA, and Third World Press. As noted below, the New York–based journal *Black Theatre* did make a considerable impression, but it lasted only for seven issues between 1968 and 1971.

One might characterize New York Black Arts activity, especially the radical African American cultural activity that took place in Harlem, as a sort of dynamic instability that simultaneously thwarted and generated Black Arts institutions. As Amiri Baraka noted about Newark, the Spirit House center that he founded after his return to Newark in 1967 and the Cellar, a Black Arts and jazz club run by musician Art Williams, was (with the Newark Museum) practically the sum total of the arts scene in Newark at the time.[3] While such a relatively solitary status was daunting in some respects, it also allowed Baraka and Spirit House to make an impact on the city that would have been impossible in New York. No doubt New York's status as the heart of various culture industries in the United States, notably publishing, music (especially jazz), theater, and the visual arts, undermined the creation and survival of Black Arts institutions in many respects, even as the city's high profile and highly developed mainstream and countercultural arts infrastructure drew African American artists from across the United States (and black artists from across Africa and the diaspora), creating a countervailing pull toward the formation of such institutions. As had long been the case, the concentration and ideological variety in New York of large, commercial, countercultural publishers (including what

might be thought of as big small presses, somewhere between the mainstream and the avant-garde, such as Grove and New Directions) and left-wing publishers (such as the CPUSA's International Publishers and the SWP's Merit Press, later Pathfinder Press) inhibited the development of independent black presses there in ways that were not true in cities like Detroit, Chicago, or New Orleans, where mainstream literary publishing was virtually nonexistent and small-press publishing comparatively scant. Similarly, the sheer number of major institutions devoted to modern art, including the Guggenheim Museum, the Museum of Modern Art, and the Whitney Museum, in addition to the downtown, Fifty-seventh Street, and Madison Avenue gallery centers to a certain extent undercut the realization of stable African American museums and galleries by sucking up various sorts of intellectual and material resources. At the same time, the frequent neglect of black art by these highly developed networks of mainstream and countercultural visual arts institutions (in which the mainstream and the counterculture overlapped to a larger degree than was true of the music, publishing, and theater industries) in a city with so many African American visual artists spurred the desire of black artists, intellectuals, and community activists to create their own centers of visual arts, especially in Harlem, with its lingering image as the capital of the black world. However, it was well into the Black Arts period (and an increased availability of various sorts of public and private patronage for black institutions generated by urban uprisings and social unrest, particularly after Martin Luther King Jr.'s assassination) before centers with any real stability and visibility were created in New York, most notably the Studio Museum in Harlem (which opened its permanent facilities in the fall of 1968).[4]

New York City also remained the center of the jazz industry, with an enormous proportion of the declining number of club venues, concert halls, recording companies, and so on open to jazz artists in the United States during the late 1950s and early 1960s. Consequently, the percentage of professional jazz musicians who actually lived in or near New York was also extremely high. Nonetheless, as always, only a small number of major jazz institutions there were run by African Americans, and no significant organization of black jazz musicians arose with the staying power and the visibility within black communities of the AACM in Chicago or UGMA in Los Angeles — or BAG in St. Louis, for that matter.[5]

Unquestionably, as the hub of the theater industry in the United States, New York was in many respects the premiere showcase for black drama during the 1960s and 1970s, attracting at different times from across the United States such

leading playwrights and directors as Woodie King Jr., Ed Bullins, David Rambeau, Ron Milner, Jayne Cortez, Gilbert Moses, Robert Macbeth, and Barbara Ann Teer. Harlem's New Lafayette Theatre, founded in 1967 and led by Macbeth, probably had the highest profile of any Black Arts theater in the United States during its six-year life span. In many respects, the New Lafayette and its playwrights enjoyed an extraordinarily reciprocal relationship. The hiring of Bullins to be writer-in-residence and the New Lafayette's productions of Bullins's plays transformed Bullins from an essentially regional playwright in the Bay Area to perhaps the most important national Black Arts dramatist, with the possible exceptions of Baraka and Milner. Bullins's influence as a playwright and as the editor of the New Lafayette–supported journal *Black Theatre* and of widely distributed anthologies of contemporary African American drama was tremendous.[6] In turn, the mounting of Bullins's plays made the New Lafayette a showcase of the new black theater. Of course, the location of the theater in Harlem within the context of the Black Power moment also gave it a certain advantage in the search for foundation money, since these foundations still found a special cachet in a Harlem address—though, ironically, an arson attack on the New Lafayette forced the theater's early productions of Bullins's plays to move downtown. Such foundation funding made the New Lafayette's ambitious institutional plans plausible. Perhaps because of its visibility, the New Lafayette became a lightning rod for many of the intense debates over aesthetics, subject matter, the nature of institutional support, and what might be considered territorial disputes over ideological and institutional turf between groups that characterized the Black Arts movement in New York. The two best-known expressions of such debates and disputes, expressions that had considerable impact outside New York, came over a fight following a symposium on Harold Cruse's *The Crisis of the Negro Intellectual* that may have led to the burning of the New Lafayette's building and a production of Bullins's *We Righteous Bombers* that occasioned another notoriously contentious symposium. These struggles compounded persistent funding problems growing out of the high overhead of maintaining fifteen actors, the building, and a relatively large staff, problems that grew much worse with the sharp decline of foundation support in the early 1970s. Exhaustion and an unwillingness to convert the New Lafayette into a smaller, less costly operation led to the disbanding of the company in 1972.[7]

The NBT, the longest surviving New York company with roots in the Black Arts movement, started in 1968 after Barbara Ann Teer broke with Robert Hooks

and Douglas Turner Ward over the course of the NEC, including the symbology of using "Negro" in the NEC's name, its location downtown instead of uptown, and its somewhat adversarial relationship to the Black Arts movement and the new nationalism. The NBT, a pioneer of black ritual theater, became an integral part of the Harlem Black Arts loft scene of the late 1960s and early 1970s centered at Fifth Avenue and 125th Street that also included the Black Mind, the Last Poets' East Wind, the Studio Museum in Harlem, and, for a time, the New Lafayette Theatre. Like many Black Arts institutions, the NBT was a school and workshop as well as a performing group, drawing both on Teer's experience in avant-garde theater (including a troubled stint in BARTS where she had a violent confrontation with the unstable Patterson brothers, Charles and William) and more naturalist productions. In many respects, though, the NBT institutionally and ideologically resembled Sun Ra's Arkestra more closely than a traditional theater — or even most Black Arts theaters — in that the communal NBT addressed every aspect of the black theater worker's life rather than simply his or her skills as an actor, stagehand, director, and so on. Also, as in Sun Ra's group, the aesthetics of the theater were governed by a broad mythic vision of the spectrum of African and African American culture. Teer directed theater members/students to attend black churches in Harlem, particularly Holiness or Pentecostal churches, as well as neighborhood taverns, to get a broad sense of African American expressive traditions. She also seriously studied various West African traditional cultures, especially that of the Yoruba, and then incorporated these studies into her pedagogy at the NBT. So again, as in Sun Ra's music, the NBT's training and productions exhibited a fascinating combination of what I have called the popular avant-garde approach with a neo-African alternative culture stance, emphasizing the importance of establishing black spiritual and social myths that would enable the true self-determination of black people. In other words, like Sun Ra's band or Us in Los Angeles, for that matter, the NBT sought to embody a new, yet strangely traditional, black world as well as represent it on the stage.

The long-term impact of Teer and the NBT on the Black Arts movement is a little hard to judge. For one thing, the theater presented no public performances during its first two years of existence, concentrating instead on the training of actors (or "liberators," in NBT terminology) and technical staff as well as on the development of a viable nonmimetic, non-European dramaturgy that would appeal to a broad black audience. As with many other Black Arts groups, money remained a persistent problem in the early days of the NBT but was even more

acute for Teer's theater in progress than for, say, the NEC or the New Lafayette Theatre, both of which did attract significant, if ultimately insufficient, foundation support. Paradoxically, the apogee of NBT performances was arguably the period from the mid-1970s to the mid-1980s — a time when many other Black Arts institutions were in sharp decline (if not long gone), especially in New York. Perhaps the relatively long-term survival of the NBT is not so paradoxical in that Teer's organizational and aesthetic strategies may have caused the theater many difficulties in the short-term but allowed it to better weather the decline of foundation and public support for radical black cultural institutions than initially higher profile institutions like the New Lafayette. In any case, many Black Arts veterans cite the importance of the NBT as a training ground of young black actors in New York (and simply for the NBT's ability to remain in Harlem and outlast virtually all its counterparts). And while the NBT did not mount public productions as such, it hosted lectures, forums, readings, concerts, and so on by many of the leading black artists and intellectuals in New York. Ernest Allen Jr., who taught classes in African American history and politics at the nearby Black Mind loft, recalls hearing the great jazz avant-garde reed player Albert Ayler and poet Felipe Luciano perform on a program at the NBT loft.[8]

The only other Black Arts theater in New York with a longevity comparable to the NBT's is Woodie King Jr.'s New Federal Theatre, based on the Lower East Side since its first season in a church basement in 1970. The New Federal indirectly grew out of the multiethnic, publicly funded, antipoverty program MFY, which provided classes in the arts for black, Latina/o, and Asian American youth. King directed the arts program of the MFY on the Lower East Side from 1965 to 1970. Though King and the MFY had close relationships with Black Arts theaters uptown in Harlem and across the river in Brooklyn, the MFY not only served a multiethnic and multiracial population but also brought in a diverse group of artists, including the white poet Diane Wakowski, jazz musicians Jackie McLean and Kenny Dorham, the playwright (and HWG veteran) Lonnie Elder III, and Amiri Baraka, to teach their classes. It would be hard to imagine Wakowski or even Elder teaching a BARTS workshop — though Baraka was one of the earliest publishers of Wakowski in his Totem-Corinth series.

King's success with the MFY played a considerable part in the decision by the Henry Street Settlement House to hire MFY director Bertram Beck to essentially replicate the agency's success. Beck then turned to King to run the program to train minority theater workers that became the New Federal Theatre.[9] So, as at

virtually all the other Black Arts theaters, the development of new playwrights, the production of new plays by minority writers (including the New York debut of Ntozake Shange's *for colored girls who have considered suicide when the rainbow is enuf*), and the training of actors, directors, and technicians of color were (and are) major functions of the New Federal. It was also a major venue for the plays of such Black Arts stalwarts as Baraka, Charles Fuller, and King's old colleague from Detroit, Ron Milner. However, like the NEC, the New Federal was far more professionally oriented than many other Black Arts institutions, say the NBT, BARTS, BAW, or even the New Lafayette—owing in part to King's productive associations with such mainstream theaters as the American Place Theatre and Joseph Papp's Public Theatre. Also, unlike the ritual theater that dominated the most prominent Harlem Black Arts theaters, such as the New Lafayette and the NBT, the aesthetic of the New Federal was far more eclectic stylistically—though generally veering away from neo-African spiritual or quasi-spiritual ritual and toward narrative storytelling. And, again, it also differed from its counterparts uptown in that it regularly presented works with white, Latina/o, and Asian American authors and directors aimed at a multicultural audience—even if a large proportion of its offerings in the 1970s were authored and directed by African Americans.

Yet this multiculturalism was radical in a way that echoed other Black Arts institutions in a number of respects. King saw the New Federal as a sort of combination of the Concept East Theatre in Detroit, in which African Americans exercised executive power, and the ethnic theaters of the WPA's FTP, including its "Negro units," that brought drama to working people in their own languages and accents. Thus, he imagined the New Federal as a sort of umbrella for a black theater, an Asian American theater, a Latina/o theater, and a Jewish theater. While King was certainly willing to bring white technicians to work on black productions (or black technicians to work on Asian American productions, for that matter), he argued that black plays should be directed by African American directors, Jewish plays by Jewish directors, and so on. One might think of this as a multicultural nationalist approach to the theater.[10]

Two other durable theaters led by African Americans, the NEC (founded 1967) and Ellen Stewart's La Mama (founded 1961), also based on the Lower East Side or in Greenwich Village, survived and even thrived past the 1970s. Both had ambivalent relationships to the Black Arts movement. In many ways, the NEC was a product of the early Black Arts impulse—one of its originators, Robert Hooks,

played Clay in the initial production of Amiri Baraka's *Dutchman*. However, its founders, especially Douglas Turner Ward, had close ties to the older milieu of the Communist Left — Ward had been chair of the Harlem chapter of a Communist youth group, the Labor Youth League, in the 1950s. Even the company's name, using "Negro" in 1967, polemically emphasized a connection to earlier moments and institutions of black political and cultural radicalism, such as the American Negro Theatre. This polemic was often taken negatively by some Black Arts activists who saw the NEC as the epitome of old-style opportunistic accommodationism and integrationism slightly repackaged for the Black Power and Black Arts era. Barbara Ann Teer was one of the most important theater workers to take this attitude toward the NEC. She worked closely with Hooks in the Group Theatre Workshop (a workshop for young black actors named after the famous left-wing New York troupe of the 1930s) in the early 1960s. She acted in the 1965 production of Douglas Turner Ward's *Day of Absence* that grew out of the Group Theatre Workshop and ran off-Broadway for more than a year. This run provided Hooks and Ward the leverage to gain the support from the Ford Foundation that launched the NEC — though, like the other black theaters of the era, it continued to suffer from financial instability. However, Teer split with Hooks and Ward to start the NBT. She rejected the NEC's location downtown at the St. Marks Playhouse rather than in Harlem and what she saw as the ideological thrust of the NEC's name, finding in them an encapsulation of a general careerism literally and figuratively steering the theater away from the black community in a revolutionary moment.[11] La Mama was a pillar of the downtown "experimental" theater in the 1960s and 1970s. It was far more likely to stage work by such European or Euro-American avant-gardists as Jerzy Grotowski, John Vaccaro, or Charles Ludlam than by Ron Milner or Sonia Sanchez — though it did mount several productions of plays by Ed Bullins in the early 1970s. In short, despite the concentration of trained black theater workers and a relatively large African American audience for black drama, stable, long-lived theaters did not, for the most part, take root in New York's black neighborhoods, even Harlem — Barbara Ann Teer's NBT being the notable exception and a relatively late bloomer in terms of actual productions.

Rather than in the creation of enduring institutions in black communities, the importance of New York and other East Coast centers, particularly Washington, D.C., Boston (a notable locus of African American visual arts, especially outdoor murals, in the 1960s and 1970s), and Philadelphia, for the Black Arts

movement lies largely in the ways black intellectuals, artists, and often short-lived institutions in the region prepared the ground for the movement. The Northeast, with its long history of African American nationalist, Left, and avant-garde intellectual, political, and artistic movements, was an incubator for Black Power and Black Arts ideologies, poetics, and activists. As Lorenzo Thomas argues, there was a kind of African American artistic underground during the 1950s and early 1960s in which "scholars of Marxism, left-over Garveyites, and Pan-Africanists" provided "alternative" role models to younger black artists and intellectuals.[12] Larry Neal also claimed in the late 1970s that the important influence of the Communist Left on the creation and circulation of African American literature lingered, though "transmuted or synthesized," in the 1960s.[13] Nowhere in the United States was there a greater concentration of older Marxists and nationalists than in New York City.

The East Coast cities, particularly New York, also had a long tradition as diasporic destinations, drawing black immigrants with a wide range of cultural and ideological backgrounds from the Caribbean and, to a lesser extent, Africa. This tradition of black cosmopolitanism was strengthened as the newly independent nations of Africa, the Caribbean, and Asia opened diplomatic missions in New York and Washington, D.C. Furthermore, the proximity of cities in the northeast corridor, particularly between New York and Philadelphia, stimulated political and cultural ferment among young black activists, artists, and intellectuals — much as was the case between Chicago and Detroit. And if the power and sheer number of the mainstream, Left, and bohemian cultural institutions of New York made it more difficult to establish black institutions in some respects, they, too, drew African American artists who went on to form various networks and communities that would be crucial to the development of Black Arts ideologies, poetics, and activists.

Harlem as Exceptional and Representative Cultural Landscape

New York, of course, was the focal point for the political and cultural movement later known as the Harlem (or New Negro) Renaissance. This movement is still most commonly associated with a wave of literature, music, visual art, dance, and theater by African American artists following World War I. However, much of the impetus for this renaissance came from the emergence and growth of a

new black political activism and new political institutions in the period immediately before, during, and after the war. Harlem became the headquarters of a host of political organizations covering a wide political spectrum, including the NAACP, the Urban League, Marcus Garvey's UNIA, the 21st A.D. (Assembly District) Socialist Club, and the black socialist (and pro-Bolshevik and nationalist) African Blood Brotherhood.[14]

There were other important loci of New Negro political and literary activity — again, particularly Washington, Philadelphia, Boston, and, to a lesser extent, Cleveland and Baltimore. However, the literary and political circles there were generally held by many contemporary observers and participants to be more conservative and more provincial than those in Harlem.[15] Thus, Harlem came not only to be seen as a "race capital" but also as the center of cutting-edge African American art and politics.

This notion of Harlem as the focal point of black political and cultural progressivism continued in the 1930s Depression era. To a certain extent, especially as far as literature is concerned, the sense of Harlem as a "race capital" was an ideological inheritance from the New Negro Renaissance rather than simply a reflection of actual cultural production. In many respects, Chicago was the most vital center of black artistic production during the 1930s and 1940s, especially in literature, music, dance, and the visual arts. Washington, D.C., was arguably as important a locus of African American intellectual activity as New York, with dynamic groups of radical and progressive intellectuals at Howard University, including E. Franklin Frazier, Ralph Bunche, Eugene Clay Holmes, Doxey Wilkerson, and Sterling Brown. Brown, in his capacity as national editor of Negro affairs for the FWP, not to mention as a poet and a critic, was quite possibly the most significant black literary figure in the United States during the second half of the 1930s.

However, Harlem retained a claim to political vanguard status. Political progressives, such as Adam Clayton Powell Jr., and political radicals, such as the well-known African American Communist city councilman Benjamin Davis and the Italian American congressman from East Harlem, Vito Marcantonio, prominently figured in the Harlem landscape. Among black cultural workers in New York, especially writers, visual artists, and theater workers, a huge proportion had some tie to the Popular Front during the late 1930s and early 1940s.[16] As noted in Chapter 1, even during the late 1940s and early 1950s, Harlem was the actual and symbolic center of a vibrant, though increasingly embattled, African

American Left subculture in which such cultural or largely cultural institutions as Paul Robeson's newspaper *Freedom*, the Committee for the Negro in the Arts, and the American Negro Theatre were nearly as prominent as the more strictly "political" organizations, such as the CRC and the NNLC.[17]

Various large and influential activist nationalist groups generally descended from the Garvey movement, though claiming fewer well-known artists, intellectuals, and politicians than the Left during the 1930s and 1940s, also maintained a very visible public presence and grassroots popularity in Harlem. Nationalism had a long and prominent history in the neighborhood, reaching back not only to Garvey and the UNIA (and its journal *Negro World*) but also to the Left nationalist African Blood Brotherhood (and its organ, *The Crusader*) during the Harlem Renaissance. In the 1930s and 1940s, neo-Garveyites and other sorts of nationalists spoke on street corners and led demonstrations, rallies, parades, and picket lines, addressing such issues as the Italian invasion of Ethiopia, police brutality, and Jim Crow hiring practices by public and private employers in Harlem.[18] In fact, one could characterize the 1930s and 1940s New York forerunners of the later activist civil rights movement (as opposed to the generally more legalistic strategy of the national NAACP) as alternately competition and cooperation between the Left and various stripes of nationalists. And even when the nationalists and the Communists competed, they often conducted parallel campaigns, say, for jobs or against police brutality, so that their work sometimes had a certain practical synergy even if they were opposed on an ideological level.

Though the New Negro Renaissance notion of Harlem as an artistic and political "capital" remained (in a more distinctly Left register perhaps than in the 1920s), in some ways the community's claim to distinction in the 1930s came, ironically, through a new sense of its hypertypical status. In other words, Harlem became a sort of "everyghetto" rather than the unique "city of refuge" or the neo-Emersonian figuration of African American potential invoked both straightforwardly and ironically during the New Negro Renaissance. In this later, overlapping vision of exceptionalism and hypertypicality, Harlem embodied the conditions of oppression and poverty seen as attending urban black life throughout the United States. Harlem was still distinctive in that the qualities of ghetto life were perceived as more intense there than in other black communities, due to Harlem's sheer size and population density. In addition, the earlier symbolic promise of the Harlem Renaissance accented this intensity of ghetto oppression, with earlier visions of the "city of refuge" standing as sour reminders of

a dream deferred. One could track this transition from refuge to "everyghetto" in the changing figurations of Harlem as "home" from Claude McKay's 1928 novel *Home to Harlem* to Amiri Baraka's 1966 collection of essays *Home*. This later home was, Baraka would write during his transition toward nationalism, "a place one escapes from" (or "Their heavy Egypt," as he said in the poem "Return of the Native") and was one to which an estranged black artist or intellectual could "return," even if, like Baraka as he wholeheartedly embarked on the Black Arts project, he or she had never lived there before.[19]

Harlem still remained a central topography for African American artists and intellectuals during the 1950s and early 1960s. In part, as noted above, this was because Harlem was where Langston Hughes still lived—with the landscape of the neighborhood a prominent feature of his work. Again, the writings of Hughes, along with those of the émigré Harlem-native James Baldwin, Ralph Ellison's *Invisible Man*, and the detective novels of Chester Himes (though Himes was more of cult figure at the time), still promoted Harlem not only as a literary landscape but also as a symbolic merging of the earlier "Negro capital of the world" of the Harlem Renaissance with the prototypical everyghetto "home" of the 1930s and 1940s. The symbolic importance of the neighborhood would have continued to exist without Hughes, Baldwin, Ellison, Himes, and other writers and artists, but still the work of these writers was crucial in vividly maintaining Harlem as race capital and down-home uptown.

There were more material reasons why Harlem continued to maintain its symbolic status as a fulcrum of black politics and culture. By the late 1950s, the portion of the neighborhood that centered on the intersection of Lenox Avenue and 135th Street had been a predominantly black community for more than fifty years. Harlem had a long tradition of black (and often radical) political representation rivaled only by the South Side of Chicago. It is true that the cultural institutions of the neighborhood had declined—much as had happened in the old urban black entertainment districts from Los Angeles's Central Avenue to Detroit's Hastings Street to Washington's U Street. There were virtually no clubs left for innovative jazz musicians—those spaces were in downtown clubs, coffeehouses, and lofts, generally in Greenwich Village or on the Lower East Side. However, a number of important institutions remained, such as the legendary 135th Street branch of the New York Public Library and its affiliated Schomburg Collection of Negro Literature, History, and Prints; the Apollo Theater (still New York's most prominent venue for African American popular music,

comedy, and dance catering to predominantly black audiences); and the Left-influenced HWG.

Because of a persisting image as the symbolic "capital of the Negro world" as well as its decaying but not negligible arts infrastructure, more new cultural initiatives were undertaken in Harlem in the early 1960s than in other black neighborhoods in New York, including the adjoining neighborhoods of Bedford-Stuyvesant, Brownsville, Crown Heights, Fort Greene, and East New York in central Brooklyn (where the rapidly growing African American population came to outnumber that of Harlem), the black communities of south and southeast Queens (where much of Harlem's black professional class had moved), and the recently established black and Puerto Rican neighborhoods of the South and East Bronx. Even those initiatives undertaken primarily outside the neighborhood often attached themselves to Harlem in one way or another.

Freedomways, for example, had such an attachment to Harlem, even though its office was downtown and many of its editors and staff lived in Brooklyn. It devoted a special issue to the neighborhood edited by John Henrik Clarke, an older Left nationalist (and Harlem resident) who later served as a sort of mentor to many of the young New York Black Arts activists. This issue, which heavily emphasized literature and art, was among the most popular of the journal's early years. Esther Cooper Jackson credits it with "making" *Freedomways* in terms of public attention, demonstrating the importance of Harlem to the journal's readers as well as to its editors.[20] The neighborhood's continuing international symbolic significance, especially for the Left, allowed the issue to form the basis of a 1964 book, *Harlem, U.S.A.: The Story of a City within a City*, published in English by a press in the German Democratic Republic, Seven Seas Publications. This edition achieved such popular success that it was picked up by commercial publishers in the United States, going through several editions. Similarly, when Raymond Patterson and others initiated a reading series by young black poets in 1959, including Calvin Hernton, David Henderson, Lloyd Addison, Gloria Oden, Allen Polite, and Sarah Wright, they did so at the Market Place Gallery, an art gallery on 125th Street—even though, as Tom Dent pointed out, they had to start from scratch rather than piggyback onto an existing reading scene, as the Umbra group would do shortly on the Lower East Side.[21]

To a certain extent, Harlem's continued identification with various sorts of radical politics resulted from a circular movement of symbolic and practical political acts. In other words, Harlem's reputation as the seat of the black political

and artistic cutting edge and, paradoxically, its hypertypicality made a trip to Harlem a visit to black America, past, present, and future. This vanguard hypertypicality rendered the neighborhood a magnet for short-term and long-term radical Left and nationalist political activity that, in turn, maintained its reputation. The move by Fidel Castro and his delegation uptown to the Hotel Theresa during his 1960 visit to the United Nations demonstrated Harlem's continued international cultural and political meaning. "Mainstream" community leaders, most prominently Adam Clayton Powell Jr., maintained an ambivalent stance toward Castro's ten-day sojourn in Harlem. Nonetheless, the community as a whole received the visit far more favorably. This reception and Castro's Harlem meetings with Malcolm X, the militant Monroe, North Carolina, NAACP leader Robert Williams (who is discussed at more length in Chapter 6), and other black activists and community leaders energized nationalists and leftists (and Left nationalists), facilitated the circulation of radical ideas in the community, and reinforced the image of Harlem as a center for such ideas.[22]

Progressive or radical black organizations, such as the Monroe Defense Committee (supporting Robert Williams) and OGFF, often located their headquarters in Harlem—whether or not the leaders of those groups actually lived in the neighborhood. Similarly, when radical or activist black groups sought to do grassroots work in the black community, the community they often chose was Harlem. Of course, the specific political and cultural attractions of the neighborhood were not simply imaginary or symbolic. For example, the NSM, headquartered in nearby Morningside Heights, saw as its mission applying the goals and tactics of SNCC and the southern black student movement to the issues and conditions of the North. Though the NSM had projects in a number of cities, including Philadelphia, Boston, Washington, Baltimore, and Detroit, Harlem was a particular focus.

In part, the NSM project in Harlem was so vital because of the richness of the living nationalist and Left traditions of the neighborhood. William Strickland, who came from the NSM's Boston Project to become director in 1963, describes the inspiration and influence of Jesse Gray, a former Communist and NMU activist who led the National Tenants Organization. Gray was also instrumental in the founding of ACT (the group's name, not an acronym), a national group that conducted significant actions around the issues of housing and education involving tens of thousands that drew in many older African American leftists as well as younger militants with little direct experience in the organized

Left. While Gray had left or been expelled from the CPUSA in the 1950s, his ideology and practical political skills remained very much marked by his time in the party. Much like the black Communist leader Ishmael Flory did with the young black activists in Chicago, Gray not only introduced the young cadre of the NSM to longtime grassroots organizers in Harlem but also mentored them in the nuts and bolts of effective community work.

At the same time, Strickland also mentions the influence of Malcolm X, a reminder that an enormous portion of Harlem's continued cachet was due to Malcolm X's presence there. Strickland had previously met Malcolm X when he spoke at Harvard in the early 1960s. (Strickland, then a Harvard student, had grown up in Malcolm X's old neighborhood in Roxbury and had some family connections to the former Malcolm Little.) The radicalism of both Jesse Gray and Malcolm X facilitated the move of the NSM in New York toward a practical Black Power stance, anticipating SNCC's decision to use only African American organizers in black communities by a couple of years. At the same time, the younger militants helped bring the Left and nationalist traditions that the men represented into a new and productive relationship. For example, it was largely through Strickland and the NSM that Gray and Malcolm X met each other.[23] In short, the center of new, black artistic activity may have been downtown on the Lower East Side, but when black artists and intellectuals engaged in radical cultural and political African American–identified activities, organizations, and institutions, their symbolic (and often practical) locus was often still Harlem, both because of Harlem's continued cultural meaning and because the long history of Left and nationalist political and artistic activity allowed for the meeting of different generations of black radicals more easily than was true downtown.

Black Art and Literature, Nationalism, and the Left in New York during the Cold War Era

By the late 1950s, the political and intellectual landscape of Harlem (and the black communities of the Northeast generally) had changed greatly—though notions of both Harlem's exceptionalism as the "capital of the Negro world" and representativeness as the "everyghetto" still lingered. World War II and the immediate postwar era saw the growth of a number of Left-initiated African American organizations and institutions, such as the CRC, the NNLC, Paul Robeson's *Freedom* newspaper, the literary journal *Harlem Quarterly*, and the Left-

influenced Harlem-based newspaper *People's Voice*. African Americans also held prominent positions in late Popular Front cultural and intellectual groups, such as the National Council of the Arts, Sciences, and the Professions in which Paul Robeson served as the vice chair and Langston Hughes and W. E. B. Du Bois were prominent members — Shirley Graham Du Bois and actor Canada Lee were leaders of the council's important New York affiliate.[24] However, by the mid-1950s these institutions and organizations collapsed, for the most part, under the weight of Cold War pressures and often outright persecution.[25] Important African American political and cultural activists formerly associated with the Communist Left, such as Max Yergan (a YMCA leader and a founder of the Left-influenced Council on African Affairs), Adam Clayton Powell Jr., Canada Lee, Langston Hughes, and musician Joshua White, distanced themselves from the Communists and their allies. Some, such as Yergan, White, and Lee, became actively anti-Communist — though that did not always save their careers. Others, notably Hughes, maintained ties to the Left but were very cautious about any public demonstration of those ties.

Those political and/or cultural leaders who maintained open affiliation with the Communist Left, such as Benjamin Davis, Ewart Guinier, James Jackson, Esther Cooper Jackson, Paul Robeson, and W. E. B. Du Bois, found themselves hounded by federal and local governments, blacklisted (so to speak) in their professions, and isolated from mainstream political and cultural institutions — and in some cases, like Davis, imprisoned. The NAACP refused to support W. E. B. Du Bois (and actually cooperated with governmental efforts against him) — though Du Bois had been one of the chief architects of the organization. James Jackson, a CPUSA official and former leader of the SNYC, went underground for five years with a Smith Act charge hanging over his head. His wife, Esther Cooper Jackson, another former SNYC leader and later the managing editor of *Freedomways*, describes this period as one of constant surveillance and intimidation by the FBI — surveillance that extended beyond herself and her children to include virtually the entire extended family of the Jacksons.[26]

Beyond these external pressures, the Harlem Left (and the Communist Left generally) was torn by internal problems — often exacerbated by the pressures of overt governmental repression and covert government surveillance and destabilization. Mirroring CPUSA campaigns against "white chauvinism" and "Negro nationalism" within the party during the late 1940s and early 1950s led to disciplinary proceedings against both rank-and-file and leading members, often for

a small and sometimes ambiguous remark or act. These campaigns caused considerable turmoil and the loss of important activists, black and white. Factional battles stimulated by Khrushchev's "secret speech" about Stalin at the Twentieth Congress of the Communist Party of the Soviet Union and the Soviet invasion of Hungary further decimated the CPUSA's membership and largely paralyzed its leadership. The middle and late 1950s saw the expulsion or resignation of such prominent African American Communists as Abner Berry, Harry Haywood, Howard "Stretch" Johnson, and Doxey Wilkerson. Beyond those who were imprisoned, exiled, expelled, driven away through the threat of public sector and private sector persecution, or alienated by 1950s factional strife and the revelations about Stalin, many in Harlem (and elsewhere) fell out of regular contact with the CPUSA as its infrastructure disintegrated under the combination of government repression, factionalism, international ideological crisis, and the prevalence of an "underground" mentality in much of the remaining leadership.[27]

Nationalist grassroots political activism also diminished by the late 1950s, possibly because of a combination of relative optimism engendered by the promises of early desegregation efforts and a general Cold War atmosphere of antiradicalism. Lorenzo Thomas argues that there was a sort of African American McCarthyite attitude in which nationalists were marginalized as "crazy."[28] Another factor may have been, ironically, the increasing influence of the NOI. On one hand, as noted above, the NOI, its new Harlem leader, Malcolm X, and, a little later, its newspaper *Muhammad Speaks* (founded in 1961) were powerful and often radical voices for black self-determination in the Harlem community (and beyond) on a scale not seen since the Garvey movement in the 1920s. As noted in Chapter 4, the direction of the staff of *Muhammad Speaks* by such Left veterans as Richard Durham and Joe Walker buttressed this radicalism. Malcolm X took a keen interest in local politics, speaking at demonstrations led by CORE and other civil rights groups.[29] He also inspired and sometimes personally encouraged many young black activists.[30] On the other hand, the NOI in New York relatively rarely conducted the sorts of grassroots political activities, like the "Don't Buy Where You Can't Work" campaigns, as had earlier nationalists in Harlem — though Malcolm X clearly had interests in that direction that were only partially restrained by the leader of the NOI, Elijah Muhammad.[31]

There were, however, still old-school, nationalist street-corner speakers in Harlem, most famously Eddie "Pork Chop" Davis, lively if diminished street

protests by James Lawson's neo-Garveyite (and extremely anti-Communist) United African Nationalist Movement, "Buy Black" consumer boycotts led by Carlos Cooks's African Nationalist Pioneer Movement, and such visible nationalist presences as the NOI and the National Memorial African Bookstore at 125th Street and Seventh Avenue (which would continue to be an important nationalist and Black Arts–era landmark until its condemnation as part of the Harlem State Office Building site in 1970).[32] And like the veterans of the Old Left, there were still thousands of Harlemites who had been engaged in organized nationalist political activity, whether or not they were still members of an existing nationalist grouping.

Thus, at the height of the McCarthy period, both the Left and the activist nationalist movements were at a relatively low ebb in New York and the other urban centers of the Northeast. Nonetheless, numerous African American artists and intellectuals (and other black New Yorkers) who had been associated with the Left and/or organized nationalist movements remained. Some, such as W. E. B. Du Bois, Shirley Graham Du Bois, Paul Robeson, Ossie Davis, Ruby Dee, Esther Cooper Jackson, John O. Killens, John Henrik Clarke, Lloyd Brown, Ernest Kaiser, Alice Childress, Richard Moore, and Lorraine Hansberry, were more or less unchanged ideologically (or at least retained a sympathy for their old politics) — though often their precise organizational affiliations, if any, were murky.

Even black artists and intellectuals who publicly distanced themselves from their past leftist politics often maintained contact with those who remained on the Left to one degree or another. For example, the correspondence of Langston Hughes reveals that he kept in close touch with a wide range of Left writers and intellectuals, such as Childress, Hansberry, Killens, Clarke, Theodore Ward, and Margaret Burroughs, and with leading Communists, such as Louise Thompson Patterson, William Patterson, and Ishmael Flory, at the height of the Cold War. While one might argue that Hughes's enduring friendship with Louise Thompson Patterson (and her husband William) was simply a continuation of a relationship that predated her membership in the CPUSA, even a quick look at the letters between Hughes and the Pattersons in the Louise Thompson Patterson Papers at Emory University reveals that their association remained strongly political in nature — with William Patterson serving as a sort of political conscience for Hughes.[33] Other black intellectuals participated in less public, sometimes semi-underground, activities of the Communist Left. For example, during the

McCarthy era W. E. B. and Shirley Graham Du Bois hosted an annual Christmas party at their apartment in Brooklyn for children whose parents were jailed under the Smith Act and other anti-Communist laws — or were, like James Jackson, in hiding.[34]

Many of these same writers and intellectuals formed the core of the Left-influenced HWG. Though it was formed in Harlem in 1950 as the Harlem Writers Club, the HWG frequently met in the Brooklyn home of John O. Killens, its name again serving as a reminder of the continuing cultural charge of Harlem as a symbolic landscape rather than as a simple marker of the group's physical location. Though the HWG has received comparatively little scholarly attention as a locus of black literary production in the 1960s, even a partial list of important novels, plays, and autobiographical narratives that passed through the HWG's workshop in the 1960s is striking: Maya Angelou's *I Know Why the Caged Bird Sings*, Lonnie Elder III's *Ceremonies in Dark Old Men*, Rosa Guy's *Bird at My Window*, Louise Merriwether's *Daddy Was a Numbers Runner*, Douglas Turner Ward's *Day of Absence*, and Sarah Wright's *This Child's Gonna Live*. While some later commentators, notably Harold Cruse, posited an unbridgeable gulf between the HWG and the young nationalist writers of the incipient Black Arts movement, in practice there was considerable interaction. The HWG and the Cultural Association for Women of African Heritage, founded by such HWG members as Angelou, Guy, Wright, and singer Abby Lincoln, largely instigated the organization of the 1961 demonstration against Patrice Lumumba's assassination that took place outside and inside the United Nations headquarters in New York, again bringing together nationalists and the Left. The HWG, particularly the fluent French-speaking Guy, had formed a sort of extended family for the Congolese UN delegation, which had felt isolated in New York because French was the only European language most of the delegation spoke proficiently. As a result of this intense personal connection, Lumumba's murder with the complicity of the United States struck HWG members particularly hard. Their response was to contact a wide range of Left and nationalist groups within the black community of New York, bringing together at the United Nations a coalition of a sort that had not been seen for years, if ever. Among the demonstrators were such important future Black Arts activists as Amiri Baraka, Askia Touré, Aishah Rahman, and Calvin Hicks.

HWG members Sarah Wright and Calvin Hicks originated the Left nationalist group OGFF as an effort to continue the coalition engendered by the UN dem-

onstration. Largely through the organizational efforts of Hicks, Amiri Baraka's Organization of Young Men (a similar, if more ideologically inchoate, group formed in 1960) merged with OGFF.[35] The enlarged OGFF then included many of the leading downtown black artists and activists, including Baraka, Tom Dent, Archie Shepp, Harold Cruse, and A. B. Spellman. While Hicks did not promote a single ideology, he both prodded and inspired black artists on the Lower East Side to become politically active and to see art and politics as inextricably linked. OGFF's membership for the most part lived in the Lower East Side but was active in Harlem, particularly in the Monroe Defense Committee. OGFF also brought the downtown black bohemians together with other African American artists' groups in the city, particularly those with roots in the older Harlem (or Harlem-identified) Left. Tom Dent recalled that he met many members of the HWG, including Rosa Guy, Sarah Wright, and Jean Carey Bond, through OGFF.[36] Ultimately, OGFF split over many of the same issues that fragmented Umbra and other proto–Black Arts and Black Power institutions, such as what role, if any, white liberals and radicals could play, what the relation between art and activism should be (including whether there was a need to develop a relatively unified ideological stance), and whether it was necessary for black artists to live and work in "mainstream" African American communities, embodied by Harlem, rather than in the bohemian enclaves of the Lower East Side and Greenwich Village.[37]

This Old Left–new black intersection was also displayed in the important HWG-sponsored forum on the black writer and social responsibility at the New School for Social Research in April 1965. This forum featured incipient Black Arts writers, such as Amiri Baraka and Calvin Hernton, as well as older (and not so old) artists and intellectuals more normally associated with the HWG, *Freedomways*, and the Old Left, including Alice Childress, Sarah Wright, James Baldwin, John O. Killens, Sterling Brown, Paule Marshall, and John Henrik Clarke.[38] In retrospect, perhaps the most interesting moment of the forum was a panel on "The Negro Woman in American Literature." In this panel, later published in *Freedomways*, Wright, Marshall, and Childress took up the issues of what would later be called the triple oppression (gender, race, and class) of black women and how it was represented (or not represented) in literature, in a manner that remarkably anticipated black feminist critiques of nationalist masculinism. Wright challenged the rhetoric of "manhood" in an especially sharp manner: "I am convinced that most American men, and unhappily, far, far too

many of our Afro-American men, are walking around begging for a popular recognition of what is fictitiously called 'manhood,' a begging which takes the form of attacks on women launched from many different directions."[39] Wright did differ from some later critics of the Black Arts and Black Power movements in that she did not attribute a peculiar sexism to black men in general, or to black nationalists in particular, but instead argued that this sexism derives from American culture generally. Nonetheless, the panel (and the HWG forum generally) reminds us that the issues of gender oppression were subjects of discussion and debate from the very beginning of the Black Arts and Black Power movements, especially within Left-influenced formations and institutions.

There was also some nationalist and Left participation in basically anti-Communist Cold War institutions, particularly AMSAC. The CIA secretly funded AMSAC to channel African American anticolonialism and Pan-Africanism away from the Communist Left (and radical nationalists), which had dominated such pro-independence organizations as the Council on African Affairs. Leftists and nationalists, particularly in New York, used AMSAC as a vehicle for a more radical politics with some success. As Rebecca Welch points out, the HWG and AMSAC in New York converged to a significant degree.[40] For example, the Conference Planning Committee of the AMSAC-sponsored Conference of Negro Writers in 1959 was virtually a who's who of the most unrepentant Left (and nationalist) black writers: John O. Killens (the committee chair), William Branch, John Henrik Clarke, Julian Mayfield, Loften Mitchell, and Sarah Wright. The conference itself was sort of an old-home week for the Harlem Left in which Langston Hughes and Arna Bontemps mixed with members of the *Freedom* circle, such as the former managing editor, Louis Burnham (by then an editor at the *National Guardian*, a Left newspaper that had its roots in the 1948 Progressive Party presidential campaign of Henry Wallace), Lorraine Hansberry, and Alice Childress, and HWG stalwarts, such as Killens, Clarke, Mayfield, and Wright. The refusal of the conference organizers to genuflect before McCarthyism can be seen in the page of photographs under the heading "The Many Postures of the American Negro Writer" that begins the published conference proceedings. In the right-hand corner of the page is a picture of Burnham and Lloyd Brown, author of the openly pro-Communist, McCarthy-era novel *Iron City* (1951) and an editor of *Masses & Mainstream*—in short, two black artists and intellectuals who still prominently and publicly associated themselves with the Communist Left.

Many of the papers presented at the conference, such as those of Hughes, Kill-

ens, and Wright, dealt with the practical problems confronting black writers as they sought to develop their skills and their careers — though, obviously, these considerations all took stock of the larger political context of the Cold War, Jim Crow, and civil rights to one degree or another. However, other papers, particularly Mayfield's, launched radical critiques of the American "mainstream," questioning integration as a cultural strategy without rejecting African American demands for full citizenship:

> In this I believe the writers were being wiser than most of our church, civic, and political leaders, who are pushing with singular concentration toward one objective: integration. This is to be applauded and actively encouraged so long as integration is interpreted to mean the attainment of full citizenship rights in such areas as voting, housing, education, employment, and the like. But if, as the writers have reason to suspect, integration means completely identifying the Negro with the American image — the great-power face that the world knows and the Negro knows better — then the writer must not be judged too harshly for balking at the prospect.[41]

Here Mayfield (who would go on to be a major supporter of the exiled Robert Williams and a leader of the large black radical expatriate community in Nkrumah's Ghana, which included W. E. B. and Shirley Graham Du Bois, William Branch, Jean Carey Bond, Maya Angelou, and Tom Feelings) remarkably anticipates the position of many revolutionary nationalists a few years later in his insistence on black democratic rights while rejecting what he sees as the imperialist stance of the United States (and implicitly the capitalist system associated with the "mainstream") and in his emphasis on the importance of culture and the black artist to revolutionary struggle.[42]

Some black intellectuals who had left or been expelled from the CPUSA, like Richard Moore (expelled in the 1940s for "nationalism"), remained on friendly terms with the Communists and their remaining cultural and political institutions. Much like Lewis Michaux's National Memorial African Bookstore, Moore's Frederick Douglass Bookstore was an essential stop for any radical black artist or intellectual living or visiting in Harlem — Michaux's store was frequently described as inspiring chaos and Moore's rigorous organization. Moore frequently contributed to *Freedomways* between 1962 and 1965 at the same time that his involvement with the more nationalist (though also Left-influenced) *Liberator* was greatest. Still other former members of the Communist movement, like

Harold Cruse in New York and Queen Mother Audley Moore and Abner Berry in Philadelphia, were more or less hostile to the Old Left but still heavily influenced by Marxism and the organizational practices they learned in the CPUSA. For many of them, such as Cruse, this hostility was not entirely public (and the final break not entirely made) until the early 1960s.[43]

As noted above, the Cold War destroyed or isolated many of the cultural institutions of the Old Left. But those that remained, such as the national centers of the CPUSA and the SWP, the CPUSA publishing house International Publishers and its SWP counterpart, Merit Press (later Pathfinder Press), the CPUSA and SWP bookstores, the CPUSA-influenced cultural journals *Masses & Mainstream* (later *Mainstream*) and *American Dialog*, the CPUSA newspaper *The Worker*, the SWP newspaper *The Militant*, and, of course, the HWG, were more concentrated in New York than anywhere else. And nowhere else, even Chicago or Detroit, was there such a density of past and present Communists, Trotskyists, and Socialists, black and white. As Gerald Horne has shown, CPUSA leader Benjamin Davis remained a familiar presence in Harlem. Davis, a street speaker who regularly held forth across the street from the National Memorial African Bookstore, could still draw audiences of hundreds and sometimes thousands in Harlem after his release from prison in 1955 until his death in 1964.[44]

McCarthyism remained a powerful force in the late 1950s and early 1960s, shaping (or deforming) the newly energized civil rights, peace, student, and anticolonialist movements in many ways. Sometimes this impact was wholly negative, resulting in the exclusion of known radicals and organizations deemed too Red from other organizations, coalitions, events, and so on. McCarthyism also caused many leftists to hide their precise political beliefs and affiliations—at least from the broader public, if not always from the leadership and rank-and-file members of the movements in which they were active. This concealment was often due to individual fears about careers, family safety, and so on as well as questions of how to maximize personal political effectiveness and avoid isolation in a time of widespread and deeply felt public anti-Communism. And larger legal or quasi-legal considerations often came into play. For a group to be legally classified as a Communist front or a subversive organization (or to be declared Communist infiltrated) gave the local, state, and federal governments tremendous leverage to use against it if they so chose (as seen in the forced dissolution of the International Worker's Order in 1954 and the seizure of the property of the Highlander School by the State of Tennessee in 1961). So

officers and staff members of organizations from the ILWU to the MFY rarely, if ever, would admit to formal Left affiliations if they had them, to avoid such legal problems. One aspect of this evasion is that Communists severed formal ties with the CPUSA, sometimes on their own initiative and sometimes on orders from the CPUSA leadership, to allow them to evade provisions of such federal legislation as the Smith Act, the Taft-Hartley Act, and the McCarran Act (and their state and local counterparts) restricting the participation of Communists in unions, government-funded programs, civil rights organizations, and so on. While these people at least initially still considered themselves Communists, the breaking of formal ties with the CPUSA (and, at times, similar behavior by members of other Left parties, though these groups were rarely as legally restricted as the CPUSA) led to a further blurring of what had previously been relatively clear lines of organization and influence. Sometimes, however, Cold War pressures had the opposite result, leading young activists to publicly break with liberal anti-Communist restrictions. Some of these public ruptures included the refusal of the SDS to ban Communist observers from their inaugural Port Huron convention in 1962, despite intense pressure from their then parent organization, the social democratic (and highly anti-Communist) League for Industrial Democracy; and the decision by SNCC to use the services of the National Lawyers Guild (the members of which included Communists), ignoring similar anti-Communist coercion by liberal supporters.

The increasing power of the civil rights movement, the inspirational examples of the decolonization movements, the willingness of some, mostly younger activists to challenge Cold War ideological restrictions, and some significant abatement in legal anti-Communist persecution convinced African American veterans of the Popular Front that new political and cultural initiatives were possible. As noted above, some of these initiatives included the use of basically Cold War institutions, notably AMSAC, to advance progressive cultural activity and new efforts by remaining black Left institutions from the last gasp of the black Popular Front of the late 1940s and early 1950s, like the HWG, to reach out to younger black artists, especially in the increasingly politicized black bohemia of the Lower East Side. Of even greater significance than these initiatives by and in established groups was the creation of relatively stable intellectual and artistic institutions by alliances of leftists, former leftists, nationalists, and Left nationalists. Among the artists and intellectuals who organized these new institutions were nationalist intellectuals and radicalized civil rights workers who had be-

come impatient with the limits of Cold War liberalism, seeing it as patronizing, too willing to accommodate itself to a racist power structure, and out of step with the new spirit of radical decolonization as embodied in such leaders as Ghana's Kwame Nkrumah and, particularly, the Congo's Patrice Lumumba. Others were leftists who attempted to push the civil rights movement in various directions (e.g., away from anti-Communism; toward more clearly anti-imperialist, anti-colonialist, internationalist stances; and toward black self-determination, North and South) without rejecting or sharply criticizing it. In many respects, the figure that best embodied the distinctions between these two camps was Martin Luther King Jr. The new nationalist camp was often severely critical of King, his philosophy of nonviolence, and what it saw as an overwillingness to accommodate himself to northern liberalism and to restrain the more radical elements of the movement; the Left was far more favorable towards King, seeing him as more of an ideological work in progress. Of course, the distinctions at that time between the Left and the nationalists were not so clear, with many (particularly, but not exclusively, in the older generation) occupying a middle position. However, these ideological poles are worth noting, since they foreshadow later tensions and cleavages that would become clear in the Black Arts and Black Power movements.

One of the first of these new institutions was the journal *Freedomways*, which initially appeared in 1961. It was initially conceived and developed by Edward and Augusta Strong, Louis Burnham, Shirley Graham Du Bois and W. E. B. Du Bois, Esther Cooper Jackson, and other black Left intellectuals and activists largely as a continuation of the Left, anti-imperialist, anti–Jim Crow, and culturally oriented project of Paul Robeson's *Freedom* within the new context of the revived civil rights movement and the successes (and failures) of the African, Asian, and Latin American independence movements. Its founders also saw the mission of the new journal as not unlike that of *The Crisis* in the 1920s, which had also been a crucial vehicle for progressive black political commentary and cultural expression. Burnham, who had been a leader of the SNYC with the Jacksons and the Strongs as well as the former managing editor of *Freedom*, was particularly instrumental in the planning of *Freedomways*. He felt that the diminishment of McCarthyite repression and the growth of the civil rights movement provided an opening for a new, Left African American cultural journal that would provide an outlet for emerging black artists as well as for somewhat more established cultural activists, such as Alice Childress, John O. Killens, Lorraine

Hansberry, W. E. B. and Shirley Graham Du Bois, Margaret Burroughs, Elizabeth Catlett, Charles White, and others who had been a part of the *Freedom* circle and other cultural institutions of the Left from the 1930s to the 1950s. The idea was to provide a venue for politically engaged literature, art, and social commentary, giving both older and younger artists a vehicle for linking their work to the liberation struggles at home and abroad. Burnham died in early 1960 before the journal could get off the ground. However, W. E. B. and Shirley Graham Du Bois strongly supported continuing on with the journal. Jackson, who became the managing editor of the new journal, spent a year talking to people, fundraising, and putting together an editorial board before the first issue appeared in 1961. For the first few years, Shirley Graham Du Bois served as the editor—though her day-to-day work on the journal was limited by her expatriation to Ghana. *Freedomways* lasted for twenty-five years, providing an internationalist perspective, a strong emphasis on the arts, and a deep sense of the history of black radicalism as it both reported and theorized black liberation movements at home and abroad.[45]

While often critical of African American nationalism, *Freedomways*, which was conceived, organized, and run entirely by African Americans (though it also published work by non–African Americans), was often more sympathetic to nationalism and certainly the notion of African American self-determination (under the rubric of "black liberation") than has sometimes been allowed.[46] Esther Cooper Jackson and the board of the journal were generally much more open to the whole ideological spectrum of the Black Power movement than was the top leadership of the CPUSA, including her husband, James Jackson, and adamantly insisted that African Americans run the journal. For example, they consciously decided not to invite Herbert Aptheker, the most prominent white Communist scholar of African American history, to join the editorial staff in any capacity, precisely to maintain both the reality and appearance of black control, causing some antagonism between Aptheker and the journal's staff.[47] In fact, especially as the 1960s wore on, the dominant ideology of the poets, fiction writers, and other artists associated with the magazine was, as John O. Killens (who, along with leading *Freedomways* editor John Henrik Clarke, helped Malcolm X draft the "Statement of Basic Aims and Objectives of the Organization of Afro-American Unity") approvingly characterized the ideology of the late Lorraine Hansberry in its pages, "Black nationalist with a socialist perspective."[48] Much like Dudley Randall, John O. Killens, Sterling Brown, Margaret

Walker, and Langston Hughes did in their writings, anthologies, classes, lectures, and so on during the 1960s, *Freedomways* undertook to remind younger readers of earlier moments of radical black art, publishing older writers (and often older work of these writers), such as Brown and Walker as well as Claude McKay and Naomi Long Madgett, and reproducing the work of such visual artists as Charles White and Jacob Lawrence. At the same time, again like Randall, Killens, Brown, Walker, and Hughes, it undertook to alert older readers to the new currents in black art and politics, printing the work of such younger artists as Mari Evans, Tom Feelings, Nikki Giovanni, David Henderson, Calvin Hernton, Audre Lorde, Haki Madhubuti, Askia Touré, and Alice Walker. Through its wide range of contacts among older and younger activists, the journal was able to bring together an incredibly wide range of black artists, intellectuals, political organizers, and politicians in its pages and at its events — especially once the civil rights movement and the rise of Black Power had blunted Cold War divisions and taboos within the African American community a bit. One instance of this range can be seen in the 1968 centennial celebration of W. E. B. Du Bois's birth under the auspices of *Freedomways*. The celebration's sponsor list ranged from the CPUSA's national chairman, Henry Winston, to the NAACP's Roy Wilkins, to Amiri Baraka, to Cleveland's mayor, Carl Stokes. The inclusion of Wilkins is particularly noteworthy, since it occasioned something of a rift between Esther Cooper Jackson and Shirley Graham Du Bois, who still felt anger toward Wilkins over his role in the McCarthyite persecution of her husband a decade earlier. Jackson, however, despite her own bitter experiences with anti-Communism, felt it was essential to have present a leader of the organization to which W. E. B. Du Bois devoted so much of his life. It is hard to think of another institution besides *Freedomways* that could have put together such a celebration even in the late 1960s — though in some respects one could consider it a forerunner of the political breadth of the first CAP convention in Atlanta and the National Black Political Convention in Gary during the early 1970s.[49]

Despite Harold Cruse's assessment of the journal as being dominated by an old and discredited CPUSA integrationism, young writers who were prominently identified with the new nationalism and what became known as the New Black Poetry, such as Madhubuti and Touré, published in *Freedomways* well into the 1970s.[50] In fact, Esther Cooper Jackson and a number of the staff members of the journal, especially Jean Carey Bond and John Henrik Clarke, felt very close to the young black artists active in the Lower East Side literary scene of the

early 1960s. A number of the Umbra members, particularly Tom Dent (who had known Jackson from childhood and was close friends with Jean Carey Bond), Calvin Hernton, and David Henderson, regularly attended *Freedomways* events. Likewise, Jackson and others in the *Freedomways* circle supported Umbra and frequented Umbra readings, fund-raising events, and so on.[51] Similarly, artists closely linked to the journal mentored some of the best-known younger black writers—as in the relationships between Madhubuti and Margaret Burroughs and between John O. Killens and Nikki Giovanni. And as Kalamu ya Salaam notes, the *Freedomways* book column of Ernest Kaiser, a research librarian at the Schomburg Library in Harlem and veteran of the postwar institutions of the Harlem cultural Left, such as *Harlem Quarterly*, was considered by many of the younger activists to be a must-read annotated compendium of new African American writing in the 1960s (and 1970s and 1980s).[52] Though the journal's role in promoting black visual art has received less comment than its literary and critical contributions, there, too, it juxtaposed the work of leading older and younger artists, including Elizabeth Catlett, Charles White, Romare Bearden, Ollie Harrington, Jacob Lawrence, Tom Feelings, and Hugh Harrell, who donated their work to the journal. Here, as in literature and criticism, the journal reminded readers of the distinguished heritage of progressive black political art while showcasing the work of young artists, who in many cases received their first introduction to a broader black public through *Freedomways*.

The journal *Liberator* also combined the new (and old) nationalism with the Old Left in shifting and sometimes unstable fashion. *Liberator* was launched in 1961 by the small Liberation Committee for Africa headquartered in midtown Manhattan. Though initially a newsletter dedicated almost solely to African liberation struggles, by 1962 the journal began to metamorphose into a larger and more elaborately produced vehicle for radical African American thought, focusing on black struggle in the United States as well as Africa. The early politics of the journal and its publisher, Daniel Watts, who associated himself with the HWG and the early OGFF, are hard to define precisely. A number of commentators, most prominently Harold Cruse, accuse Watts and *Liberator* of lacking any real intellectual or ideological center.[53] At times, Watts took pains to distinguish himself and *Liberator* from the CPUSA.[54] However, as Cruse and others have also pointed out, it is equally clear that Watts had long associated with Communists and other sorts of leftists in the HWG and other Left-influenced organizations, an association that was reflected in the early *Liberator* masthead and table of con-

tents. In fact, there were a number of early overlaps between *Liberator* and *Freedomways*, including the presence of John Henrik Clarke in important editorial positions in both journals—Clarke left the editorial board of *Liberator* in 1962. In many respects, Watts's political evasiveness about the journal's relationship to the Communist Left and, later, to such underground or semi-underground revolutionary nationalist groups as RAM, was a typical strategy of McCarthy-era radicals still involved in the organized Left who sought to work effectively in a very circumscribed political climate. The early writers and the advisory board were largely a mixture of past and present Communists (or Communist supporters) and radical nationalists, including such Left-identified figures as Captain Hugh Mulzac (a pioneer in the struggle to break Jim Crow barriers in the merchant marine and a close associate of Louis Burnham, who helped record Mulzac's autobiography, *A Star to Steer By*), *Baltimore Afro-American* publisher (and former *Freedom* business manager) George Murphy, and actor and playwright Ossie Davis. Some of the radical nationalists, such as Richard Moore, had been Communists and publicly retained cordial relations with the Communist Left, whatever private reservations about the CPUSA they might have had. Others, notably Harold Cruse, were former Communists who had become antagonistic to the Communist Left—though, as mentioned before, Cruse's open criticism was somewhat muted in the very early days of *Liberator*. The journal gradually moved away from the Old Left and vice versa. However, the final break did not occur until 1966, when Ossie Davis and James Baldwin left the advisory board over the issue of anti-Semitism. Even then, Davis's comments about his departure from the advisory board suggest that it was not a clean break.[55]

It was in no small part frustration with liberalism along with a sense of enthusiasm about the decolonization movements of Africa, Asia, and Latin America (and anger about U.S. support of the colonial powers during a time when liberal Democrats dominated the federal government) that pushed the journal to a more militant nationalism (or more accurately, a range of nationalisms). This nationalism generally alienated or forced out the more traditionally Left board members and writers. Though the leftists also supported the new anticolonialist, anti-imperialist movements, the younger militants frequently associated what they often called the "white Left" with either an ineffectual isolation or a tailing after the more social democratic side of American liberalism in the Democratic Party and in the labor movement—or sometimes both. It was, after all, a liberal Democratic administration that was complicit in (or per-

haps instigated) the murder of Patrice Lumumba in 1961. As noted above, the death of Lumumba was a galvanizing event for the new radical nationalists, inspiring the previously noted demonstration at the United Nations where Adlai Stevenson's speech to the General Assembly was disrupted by angry shouts and thrown shoes. This demonstration marked a personal crossroads and was seen as a larger cultural turning point by a number of the young militants who would be pivotal in the Black Arts movement. In some accounts, not only were white sympathizers banned from the main body of the demonstration but so, too, were Benjamin Davis and Paul Robeson Jr. (son of the famous singer, actor, and political leader), suggesting a new (or renewed) nationalist conflict with the Communist Left and the older mode of radicalism embodied by the CPUSA along the lines of Harold Cruse's *The Crisis of the Negro Intellectual*.[56] However, since the Left-influenced HWG played such a large part in the organization of the demonstration, it is unclear whether Davis and Robeson would have been excluded simply for their association with the CPUSA—though it is also true that some of the nationalists at the rally, such as James Lawson and his supporters, were bitterly anti-Communist.[57]

The specific debate about anti-Semitism in *Liberator* and whether the article in question was actually anti-Semitic (and the still charged question of whether being anti-Zionist and anti-Jewish is fundamentally the same thing) raises the issue of the existence and function of unquestionable expressions of anti-Semitism in the larger Black Arts and Black Power movements. The issue is a complicated one—which is not to excuse the ugliness of the imagery, the rhetoric, and the sentiments sometimes expressed. As many commentators have noted over the years, negative Black Arts and Black Power representations of Jews have some roots in actual contact between African Americans and Jews, particularly in northeastern cities where Jews (as merchants, landlords, teachers, social workers, and so on) stood in for a larger power structure. Beyond everyday encounters of African Americans and Jews were a number of dramatic (and traumatic) events, most famously the 1968 teacher's strike in New York over the issue of community control in the Ocean Hill–Brownsville section of Brooklyn, that took on an enormous symbolic importance as examples of Jewish frustration of black aspirations and self-determination (and of anti-Semitic black betrayal of liberal ideals).

Of course, much of the genesis of the anti-Semitism found in Black Arts literature can also be traced to general, though less publicly discussed, sentiments

about Jews held in American society as a whole. The notion that Jews wield great power over domestic (and often the world) economy and culture, particularly in the mass culture industries, is widely held in the United States to this day. This is not only true of the relatively small number of hardcore anti-Semites but also of many who are not particularly disturbed by this understood Jewish power. Such assumptions lurk behind the commonly accepted, if often factually dubious, notions of the liberal bias of the press and the arts community. After all, during the 1960s and 1970s, a president of the United States, Richard Nixon, uttered many unquestionably anti-Semitic pronouncements (e.g., that Jews run the art world, making it something to be avoided) to a large number of political and religious leaders who either approved or registered no protest. Finally, a long-standing New York–centered focus on assessments of the Black Arts movement has tended to project the interaction between African Americans and Jews in New York, where contacts were frequent, as a model that would encompass cities in which personal black-Jewish interaction was far less common and where landlords or foremen were far more likely to be, say, Irish American or Polish American (as the circulation of the midwestern term "honkie," derived from the old, widely used, anti–Eastern European immigrant slur "hunkie," attests).

However, expressions of anti-Semitism and negative invocations of the figure of the Jew can be found in more Black Arts texts than those of Amiri Baraka and his immediate circle—though such expressions are not as ubiquitous as some commentators have claimed.[58] This anti-Semitism in the Black Arts and Black Power movements can be seen as another gesture of disaffiliation with older Left and bohemian political and cultural radicalism, marking continuity as well as rupture. The particular vitriol of Baraka's anti-Semitism during this period is often attributed largely to an inner psychodrama in which he tries to break off from his close emotional ties to individual Jews in downtown bohemia, most intensely his first wife, Hettie Jones. This attribution is plausible, though it ignores Baraka's frequent use of a range of ethnic stereotypes to personify the white power structure (e.g., the Jewish merchants, Irish policemen, and Italian gangsters of the poem "Black Art") and not simply Jews. In fact, such Black Power and Black Arts visions of whiteness drawing on negative (and long-standing) ethnic stereotypes were commonplace if somewhat variable, depending on the demographics of a particular city—though, as with Baraka, it was true that Jews, Italians, and Irish had a certain stable transregional status that was in part due

to their iconic positions in the broad popular culture of the United States during the 1960s as owners, mobsters, and cops.

But beyond pathology, usage of the stereotypes of American culture generally, and actual interaction between the broader African American community and Jews (and other "white ethnics"), anti-Semitism obviously demonstrated a dramatic and intentionally ugly break with the Old Leftism and the old bohemianism. This sort of anti-Semitism as rupture is clearly seen and theorized in Harold Cruse's *The Crisis of the Negro Intellectual*. The need for such a gesture particularly, though not solely, in the Northeast, where Jews made up a huge proportion of the membership of Left organizations, points up not only the general importance of the Old Left and the old bohemia in the genesis of the Black Arts movement but also the importance of individual Jews with a Left background (e.g., Allen Ginsberg, Art Berger, Budd Schulberg, and Walter Lowenfels) — many of whom retained contact with Black Arts activists and institutions after these gestures were made.[59] It is also worth noting that a number of Jewish intellectuals and writers (and some political leaders, like the American Federation of Teachers' Albert Shanker), particularly some increasingly conservative former radicals associated with such journals as *Partisan Review* and *Commentary*, similarly used the issue to mark a symbolic disaffiliation, emphasizing a break both with a radical past and the contemporary Left that was designed to legitimize their own path to the Right as well as to persuade others.

In any event, there is no doubt that there was an increasing distance between many of the most important young (and not so young) militants and the ideology and remaining institutions of the Old Left by the mid-1960s. The evolution of *Liberator* is a good barometer of this change — as well as how the imprint of older radicalisms lingered on in the work of the Black Arts movement. Some mark *Liberator*'s importance for the movement as beginning when Larry Neal and Amiri Baraka joined the journal's editorial board in 1965, at least in part through the urging of Askia Touré — Neal would become the arts editor in 1966.[60] Certainly, Baraka, Neal, and Touré gave the journal much more direct access to a national network of young black artists and organizers forged by their participation in RAM, Umbra, the Muntu group, SNCC, OGFF, BARTS, and so on. However, *Liberator* began publishing the work of such younger black poets as Ishmael Reed, Baraka, and Touré well before Neal and Baraka were added to the board.

In addition to poetry, *Liberator* published essays that were crucial in defining the ideological field of the Black Arts movement. These included early essays by

Cruse (especially "Rebellion or Revolution," serialized in four parts in the fall of 1963), Muhammad Ahmad, and Touré that broke with Old Left ideology and institutions, though often (especially in the case of Cruse's work) much shaped by Marxist thought. These writers generally agreed with Leninist conceptions of capitalism and imperialism (the terms seen as basically synonymous) and used economic class as a valid analytical category more openly than had often been the case with nationalist writers previously. Nonetheless, they rejected what they saw as the paternalism and arrogance of the "white" Left as well as the notion that white workers would be willing to give up the benefits of racism (and imperialism) to join in the struggle of African Americans and other peoples of color around the world.

Beyond their close ties to many young, black, politicized artists and culturally oriented activists, Neal, Baraka, and Touré brought to *Liberator* an emphasis on an antimaterialist, anti-Western, though somewhat inchoate, spiritualism. Neal, like many of those around *Liberator* (and, indeed, like many black critics of the CPUSA and its various offshoots since at least the 1930s) rejected the Old Left because of his perception that the organizations of the Left were essentially run by white people for their own purposes, leaving African Americans without agency. But in addition to this notion of black self-interest and black self-determination (a term that was, after all, popularized by the Communist Left), Neal rejected the "Western" rationalism as embodied in Marxism. In his view, Marxism ignored the spiritual component, however accurate Marxism's critique of economic exploitation might be. The sources for this spirituality ranged widely, with Malcolm X, Elijah Muhammad, and the NOI being the chief models, but also drawing on such countercultural groups and figures as Sun Ra, the Yoruba Temple, and, indeed, Neal's own Muntu group in Philadelphia. While the spiritualistic impulse that Neal, Touré, Baraka, James Stewart, and others helped popularize in their *Liberator* essays was not always clearly defined, a commitment to a generally non-Christian, sometimes Islamic (or Islamic-influenced), sometimes neo-African or syncretic African spirituality became a hallmark of the Black Arts movement.[61]

Black Bohemia

New York differed from many of the other early centers of the Black Arts and Black Power movements in that academia played only a minor role in the birth

of the movements there. A number of those active in the early New York Black Arts scene eventually held tenured or long-term positions in academia — though generally outside New York City. However, no school in New York had the same impact that San Francisco State University, Merritt College, the University of California–Berkeley, the University of California–Los Angeles, Los Angeles City College, Wayne State University, Fisk University, or the historically black schools of Atlanta's University Center did in their respective regions. Instead, as such scholars as Eugene Redmond, Valerie Wilmer, Aldon Nielsen, Michael Oren, Tom Dent, and Lorenzo Thomas have noted, New York was a sort of anti-academic bohemian delta where many streams of black avant-garde poetry, fiction, drama, criticism, music, dance, photography, and visual art flowed in the 1950s and 1960s.[62] Poets and dramatists from the South (Bobb Hamilton, Julia Fields, Tom Dent, Calvin Hernton, A. B. Spellman), the Midwest (Askia Touré, Nikki Giovanni, Ted Joans, Woodie King Jr., James Thompson), the West (Jay Wright, Edward Spriggs, Ed Bullins, Jayne Cortez, and the regionally ambiguous Bob Kaufman), and elsewhere in the East (Amiri Baraka, Larry Neal, Ishmael Reed) joined such more or less native New Yorkers as David Henderson, Sonia Sanchez, Aishah Rahman, Raymond Patterson, Tom Postell, and Lorenzo Thomas.

As with similar lists of the Harlem Renaissance, such a roll of poets and playwrights fails to delineate the full dimensions of the black avant-garde in New York during this period because it leaves out such musicians as Ornette Coleman, John Coltrane, Archie Shepp, Marion Brown, Sam Rivers, Cecil Taylor, Sun Ra and his Arkestra, and such visual artists as Tom Feelings, Bob Thompson, and Joe Overstreet — most of whom were also transplants. It also misses the degree to which different artistic fields cross-fertilized and intersected with each other. This intersection can be seen not only in, say, the well-known impact of new thing or free jazz on the new black (and white) writing but also in wide-ranging interests and projects of the artists themselves. Artists known primarily as musicians, such as Shepp, Taylor, Brown, and Sun Ra, were serious writers or dramatists. Some who became associated with the new literature were also visual artists, such as Touré, Spriggs, and Joans. Some of the writers, including Wright, Joans, and Stanley Crouch, had a previous history as relatively high-level musicians. Even those who saw themselves primarily as political organizers often had backgrounds in the arts, as was true of Muhammad Ahmad, who went to college to study painting (and whose work later illustrated the cover and pages

of RAM's organ, *Black America*), and Calvin Hicks, who became a close friend of Lorraine Hansberry while working at the Communist summer camp, Camp Unity, and was invited by her to join the original cast of *Raisin in the Sun* (an invitation he declined).[63]

The focal point of this cross-genre activity was not uptown in Harlem but downtown, increasingly in the new bohemian center of the Lower East Side. In part, the Lower East Side emerged as the locus of the literary and artistic avant-garde in New York because artists were driven out of the older bohemian neighborhood of Greenwich Village by rising rents. Certainly, low rents and the concentration of avant-garde artists and institutions in the neighborhood drew black artists there to live and to participate in artistic activities and institutions of the neighborhood (and the adjoining Greenwich Village and Union Square areas), from readings at the Café Metro, to hearing new thing jazz at the Five Spot bar in Cooper Square, to hanging out at Stanley's Bar on Avenue B.[64]

However, the increasingly multiracial character of the community, long a haven for immigrants, also appealed to the black bohemians. Many Asian Americans, Puerto Ricans, and, to a lesser extent, African Americans migrated to the Lower East Side in the 1950s and 1960s, especially east of Tompkins Square Park and south of Houston Street. The symbolic (and often literal) move of black artistic activity from the Lower East Side to Harlem at the beginning of the Black Arts era (actually signaling the beginning of that era in New York for many observers and participants) involved the coding of Harlem (aka "uptown") as "black" and the Lower East Side (aka "downtown") as essentially "white." Still, part of the initial appeal of the Lower East Side was that in fact it was far less "white" than Greenwich Village (despite the Village's history as a center of the black community in New York during the nineteenth and very early twentieth centuries).[65] Racial and ethnic relations in the Lower East Side were hardly idyllic — Baraka recalls being assaulted by white thugs on St. Marks Place; Lorenzo Thomas remembers hostile neighborhood bars; and both black and white artists describe a fight resulting from a physical attack on Tom Dent by the white owner of the Café Metro as a defining moment of the Lower East Side literary counterculture.[66] Nonetheless, things were somewhat more relaxed than in Greenwich Village, where black bohemians faced the constant threat of violence, particularly in the predominantly Italian American south Village.

Although the point has been made before in various ways, it is still worth recalling that many of the various streams of black bohemians in New York

took part simultaneously in three distinct, though often intersecting, spheres: an interracial (though sometimes coded as essentially "white"), culturally radical bohemia; an interracial Left political milieu; and a "black" and generally Left nationalist subculture. A number of scholars, most astutely Aldon Nielsen and Lorenzo Thomas, discuss the participation of African American writers in the artistic avant-garde on the Lower East Side during the late 1950s and early 1960s.[67] For the most part, African American writers did not directly share much in the early formation of the various schools of the groups gathered under the rubric of the "New American Poetry"—at least east of the Mississippi. The Beats (on the East Coast), the New York school, and the Black Mountain school were basically all-white in their earliest incarnations. In part, this was due to the de jure or de facto segregation of education in the United States in the 1940s and 1950s, since the nucleus of each group was formed at educational institutions (Harvard University, Columbia University, and Black Mountain College). As argued in Chapter 1, Langston Hughes and other black writers did have a major, though generally unacknowledged, influence on the New American Poetry through their impact on Popular Front poetics. And black music served as both icon and formal resource for many of the New American poets. Nonetheless, the relative whiteness of the early incarnations of these circles can be seen in Donald Allen's landmark anthology, *The New American Poetry* (1960), that included only one black poet, Amiri Baraka. Such a framing of the various schools as "white" shaped future assessments of the poetic counterculture (and the trajectory of Baraka's career) to no small extent, even after the exponential growth of a black bohemia on the Lower East Side in the late 1950s and early 1960s. This framing had the effect of making the Lower East Side poetry scene appear far whiter (and Baraka's participation in it much more anomalous) than was actually the case in the early 1960s. Again, as Aldon Nielsen and Lorenzo Thomas, among others, have called to our attention, even for the period when Allen assembled his anthology, his choices are strange at the very least, since he leaves out the central West Coast figure, Bob Kaufman, as well as a number of somewhat lesser-known experimental black poets.

That Baraka was the one black poet who would have to be included in the Allen anthology is in many ways inescapable. This is not simply because of Baraka's increasing reputation within the literary counterculture (by those standards, Kaufman and perhaps Ted Joans and Steve Jonas would have been included) but also because Baraka in many respects made the notion of a "New

American Poetry" possible. Though Baraka was younger than the presiding figures of the different schools, it was his desire to bring the different groups together, both on the page and in his personal relationships, that promulgated the notion of a larger poetic community. Baraka's work as an editor of *Floating Bear*, *Yugen*, and the Totem-Corinth series of books did much to make the work of the Beats, the New York school, and the Black Mountain school known beyond their respective circles. Baraka also served as a pivot of the avant-garde literary communities through his personal friendships with members of the Black Mountain group (especially such younger members as Joel Oppenheimer, Ed Dorn, and Fielding Dawson), the New York poets (primarily Frank O'Hara), and the Beats (particularly Allen Ginsberg, with whom Baraka maintained a lifelong friendship).[68]

Some of the original, white Beat, Black Mountain, and New York poets, especially O'Hara and Ginsberg, formed close ties with younger African American artists. However, it was within the institutions and circles of what came to be known as the "second generation" of the New York school that most of the black poets downtown found a space. In part, this connection may have been due to the fact that many of the younger black writers, including Calvin Hernton, Tom Dent, David Henderson, Lorenzo Thomas, Ishmael Reed, and Askia Touré, moved to (or began frequenting the bohemian milieu of) the Lower East Side at about the same time as did the mainstays of the second-generation New York scene, such as Ed Sanders, Ted Berrigan, Tom Clark, Bernadette Mayer, Ron Padgett, Anne Waldman, and Lewis Warsh. It may be that since these younger white writers were approximately the same generation as that of many in the black student movement, coming of age during the civil rights era, they were more comfortable working with black artists than their elders. In any event, the journals started by the second generation, such as Sanders's *Fuck You: A Magazine of the Arts* and Berrigan's *C*, published a larger number of the younger black poets, especially Henderson, Hernton, Thomas, Spellman, and Baraka, than was generally true of the journals associated with the older generation.

To these second-generation journals could be added what might be thought of as transitional magazines, such as *Yugen*, *Floating Bear*, and *Kulchur*, in which first-generation writers, especially Frank O'Hara, mixed with younger black and white writers, such as Baraka, Spellman, Diane di Prima, and Hettie Jones. To a large extent, it is misleading to speak of the second-generation writers and the African American artists on the Lower East Side as if they were distinct entities,

since the participation of Henderson, Dent, Hernton, and other Umbra poets as well as black writers unaffiliated with Umbra, such as Baraka and Spellman, imparted much of the excitement and special character of the reading series at Les Deux Mégots, then Café Metro, and finally the St. Marks-in-the-Bowery Episcopal Church that anchored the New American literary counterculture on the Lower East Side. Some African Americans, especially Lorenzo Thomas and Tom Weatherly, remained closely connected to the Poetry Project at St. Marks throughout the Black Arts era and beyond.

Black artists often encountered each other for the first time at the various bohemian institutions, events, and gathering places of the Lower East Side and Greenwich Village. For example, Sonia Sanchez first met Amiri Baraka at the Five Spot in the early 1960s. At the time, Sanchez lived uptown in Harlem (where she grew up) and worked as a schoolteacher. She was also a member of CORE and a self-described "Malcolmite," and though she was a member of a writers' workshop in Greenwich Village and had published poetry in small journals, she was not a part of the black Lower East Side arts scene. Apparently Baraka had read her poetry in a small magazine and recognized her when she walked into the bar. He called out to her and asked if she wanted to submit some poems for a section of *Revolution* (a radical, Paris-based, English-language journal devoted primarily to struggles against colonialism and neocolonialism in Africa, Asia, and Latin America) that he was guest editing. She said yes but did not follow up, since she thought he was not serious. She ran into Baraka a few weeks later at the Five Spot, and he asked her why she had not sent the poems. Sanchez rushed out, drove uptown, typed some of her poems, and sent them to Baraka. Baraka's response was a letter, the entirety of which went something like, "Dear Sonia Sanchez, Yeah!"[69]

Her poems "slogan," "july," and "why" appeared in the January 1964 issue alongside work by Baraka, A. B. Spellman, and the Umbra workshop's Lorenzo Thomas and Joe Johnson. This marked the beginning of an enormously important artistic and intellectual relationship, particularly, as will be discussed in Chapter 5, for the Black Arts movement and the emergence of black studies on the West Coast. It also says something about the persistence of a sort of African American consciousness downtown and how this consciousness created a network even among artists like Baraka and Sanchez who knew each other and each other's work (or at least knew of each other and each other's work, even if they had never met) and often, like Sanchez, had published, played, acted, or

shown only in relatively obscure venues, if at all. This word-of-mouth (or text) network often led, as it did for Baraka and Sanchez, to direct working relationships or associations as the Black Arts movement emerged.[70]

The East Is Red: Black Bohemia and Political Radicalism in the 1960s

One aspect of the new bohemia on the Lower East Side at the beginning of the 1960s that has not been discussed much by scholars is the existence of a politically radical, interracial bohemia. No doubt this lack of discussion derives in part from the fact that this bohemia grew up while McCarthyism was very much alive, if weakening somewhat. Red squads, blacklisting, HUAC, the Justice Department's Subversive Activities Control Board, the McCarran Act, and the Smith Act were still a part of American political life. In March 1962, for example, Benjamin Davis and Gus Hall were charged with Smith Act and McCarran Act violations for the CPUSA's refusal to register as the agent of a foreign government and for its unwillingness to give the names of its membership (which would in turn make those members liable to legal prosecution). The Communist youth group Advance (an organization much involved with the Left bohemia of the Lower East Side, especially Umbra) also was the target of harassing public investigations and hearings by the Subversive Activities Control Board in the spring of 1963. The MFY suffered similar treatment a couple of years later, following the leaking of an FBI memo alleging that MFY employees and board members, including Calvin Hicks, Marc Schleifer, and Archie Shepp, were members of subversive organizations, basically the CPUSA and the SWP, or had engaged in subversive activities. These leaks resulted in hostile city and state investigations led by state senator John Marchi of Staten Island. Not surprisingly, Left organizations and individuals continued to remain cagey about their precise ideological colorations and institutional affiliations.[71]

The Cold War environment not only inhibited the open functioning of the Left (with a resulting scarcity of historical documents and other sorts of physical evidence) but also shaped later memoirs and interviews. For example, Amiri Baraka has long cited the importance to his political development of his trip to Cuba in 1960 with a group of black activists, intellectuals, and artists, including Sarah Wright, Harold Cruse, Robert Williams, and Julian Mayfield, most of whom had some past or present connection to the Communist Left — and

in some cases, also the Trotskyist and emerging Maoist/antirevisionist Lefts.[72] This journey not only politicized Baraka in a general sense but also led directly to his practical participation in the Fair Play for Cuba Committee, OGFF, and the Monroe Defense Committee. One is generally able to intuit the broad ideological colorations of these groups and their organizers in his autobiography, but immediate links to the organized Left (basically the CPUSA, the PL, and the SWP) are sketched a bit vaguely—as is often the case in such memoirs of the era. Again, as Baraka himself admits, this is at least partially due to the fact that Cold War anti-Communism made it difficult for Communists, and to a certain extent members of the SWP and the PL, to be entirely open about their affiliations. The result was that newly politicized artists like Baraka, lacking the sensitivity to ideological nuance possessed by those like Calvin Hicks who had basically grown up in the Left, were often initially unclear about the precise political affiliations of older members of the groups the newly engaged (or reengaged) young cultural radicals joined.[73]

Nonetheless, the Lower East Side and the adjoining Union Square area contained an unusual concentration of openly Old Left national organizational headquarters, bookstores, newspapers, journals, and Left-influenced ethnic institutions, such as the Ukrainian Labor Hall, Club Polonia, the Yiddish-language newspaper *Morning Freiheit*, and a left-wing artistic subculture with roots in downtown bohemia going back to the early twentieth century. These institutions often had an ambivalent relationship to the interlocking Beat, New York, and Black Mountain countercultures of the 1950s. However, by the 1960s there was a new engagement with the avant-garde, especially the black avant-garde, on the part of some Communist cultural activists and the surviving and new institutions of the Communist Left. *American Dialog*, founded in 1964, succeeded *Mainstream* as a primary literary vehicle of what remained of the cultural circles associated with the CPUSA. The journal sought to recapture some of the earlier glory of *New Masses*, choosing as its chief editor a prominent former *New Masses* editor, Joe North, while negotiating the new artistic and political currents of the 1960s more astutely than had *Mainstream*.

As one might expect, black artists and intellectuals associated with *Freedomways*, the HWG, and what remained of the old Harlem Left gave their support to the founding of the new magazine. John O. Killens and Paule Marshall lent their names to the organizing committee of an inaugural fund-raising dinner for *American Dialog* honoring the seventieth birthday of the Communist screen-

writer John Howard Lawson. At the actual dinner in November 1963, Paul Robeson made his first public appearance in years. However, the journal also worked hard to reach younger black artists and intellectuals downtown who were outside or on the periphery of the cultural orbit of the Old Left. It is no doubt *American Dialog* that Amiri Baraka has in mind when he mentions in his autobiography that the CPUSA asked him to be the editor of a new cultural journal in the early 1960s. In fact, Baraka goes on to say that "Later, they started a 'black magazine' called *Dialog* and made the photographer the editor."[74] While *American Dialog* was never really a "black magazine," it was from its beginning far more consistently engaged with the new black cultural radicals, especially writers, visual artists, and free jazz musicians, than had been *Mainstream*. This was in no small part due to the efforts of Alvin Simon, who had been a member of the Organization of Young Men and OGFF as well as Umbra. Simon was a cofounder and "editorial assistant" of the journal and an occasional contributor to *The Worker*—and almost certainly the photographer that Baraka mentions. John O'Neal, leader of the FST, was also listed on the masthead as a "sponsor" of *American Dialog* throughout its eight-year existence. The magazine published such younger writers as Baraka, Julian Bond, Jayne Cortez, Mari Evans, Calvin Hernton, David Henderson, Julius Lester, Clarence Major, Lennox Raphael, Eugene Redmond, Ishmael Reed, and A. B. Spellman.

The remaining Old Left institutions of the CPUSA, the SWP, the Catholic Worker, and so on and such new configurations of Old Left institutions as *American Dialog* and Advance coexisted, conflicted, and sometimes intersected with newer Left formations, especially the PL and the Fair Play for Cuba Committee, which included several prominent downtown bohemians, most actively Baraka and early *Kulchur* editor Marc Schleifer (who gave up the editorship of *Kulchur* to travel to Cuba). As the number of U.S. troops in Vietnam increased, more and more of the writers and artists of the Lower East Side took part in the antiwar movement. The St. Marks Poetry Project, led by antiwar activist poets Joel Oppenheimer (St. Marks's first director) and Joel Sloman (the project's first assistant director, who also would later go to Cuba to support the revolution), became a center of artistic opposition to the war in 1966 and 1967.[75]

The role of this Lower East Side–Greenwich Village Left bohemia, especially that portion closest to the CPUSA and other Old Left groups, in the growth of new black poetry, music, theater, and visual arts lurks in the back of many accounts of the activities of the Umbra Poets Workshop and other proto–Black

Arts groups downtown. As Tom Dent recalled, "The Lower East Side had a long-standing tradition of leftist socialism and Communist Party activism which we absorbed and were a part of, also."[76] Both black and white cultural activists associated with the Communist Left, including Alvin Simon and poets Walter Lowenfels, Art Berger, and Henry Percikow (whose workshop Lorenzo Thomas and David Henderson belonged to and which provided, somewhat under duress, much of the early financing for Umbra) did much to underwrite the maintenance of the workshop and to advance the careers of its members.[77]

Umbra declared itself to have no particular ideology, not surprising for a group that included a range of political beliefs from neo-Garveyite Pan-Africanism to Marxism to a liberal-Left progressivism. However, as Amiri Baraka (who had relatively little direct contact with Umbra) notes, almost all the Umbra members "agreed that art was a social and political thing."[78] Again, the circles around *Freedomways* and the HWG felt close to many of the core members of Umbra, especially Tom Dent — and Umbra members generally supported the activities of the *Freedomways* group. Alvin Simon, with a typically Cold War evasiveness, retrospectively located Umbra and much of the Lower East Side black artistic community in a matrix of bohemianism, new radicalism, and implied Old Left politics:

> Among the ideologists who had a major influence, during the "pre-Umbra" period, on the outlook and actions of some key black artists living on the Lower East Side were the Marxists and Marxist-Leninists. During that period, many left-oriented periodicals and literary journals emerged on the Lower East Side and were among the first to publish works of the neighborhood's struggling young artists, both black and white. One was the bi-weekly newspaper, *The Worker*, to which I regularly contributed news-stories, photographs, articles, and reviews. Another was the literary and political periodical, *New Horizons for Youth*, of which I was an editorial staff member and which published in 1962 an important piece on the arts by the musician and composer Archie Shepp.[79]

Another Umbra member, Brenda Wolcott, characterized the group as "people of a political orientation — some clear leftists, Marxists, some flirting with the left. [There was] also a strong feeling of nationalism."[80]

When Umbra held its first major benefits to raise money for its journal, they took place in the Advance "clubhouse" on Clinton Street in the Lower East Side.[81]

These benefits generally featured a band led by jazz saxophonist, composer, and writer Archie Shepp, who figured prominently in radical black cultural activity and would remain on the Marxist end of the Black Arts political spectrum for some time. Shepp more openly identified himself with Marxism than did any of the other prominent downtown black artists and intellectuals (with the possible exception of Calvin Hicks), actively participating in a Left subculture that included Advance and Marxist study groups in the early 1960s. As noted above, this activity was high-profile enough to have Shepp cited by the FBI and other investigating committees as one of the dangerous subversives associated with the MFY. Perhaps the high point of Shepp's engagement with the Communist Left, at least in terms of public performance, was when he led a band (and encouraged other musicians to go) to the 1961 World Youth Festival sponsored by the World Federation of Democratic Youth (a legacy of what might be thought of as the second-wave, anti-Nazi, international Popular Front that also included the World Federation of Trade Unions) in Helsinki. As with Calvin Hicks and Harold Cruse, Shepp's relatively developed Marxism and experience with Left activists and institutions dating back to his days as a student at Goddard College aided him in articulating a theoretically sophisticated and coherent analysis of domestic and international politics, giving him a certain status among other politically engaged black artists on the Lower East Side, whose ideological stance was more inchoate, if generally radical.[82]

The first major introduction of the work of the Umbra poets outside their own sporadically published magazine took place in the pages of *Mainstream*, a CPUSA cultural journal. This publication was due largely to Art Berger's links to what remained of the literary Left. Berger, a white Communist, did not circulate his own poetry in Umbra but played a facilitating role, drawing on his skills as a printer as well as his contacts with a variety of Left institutions to promote the group. In addition to the special Umbra section in *Mainstream*, Berger used his contacts to get Umbra's magazine typeset at Prompt Press, a CPUSA-run print shop.[83] The CPUSA's biweekly newspaper *The Worker* reprinted excerpts of three poems by Askia Touré, Art Berger, and George Coleman from the December 1963 issue of *Umbra* in early 1964, further raising the profile of the group beyond the Lower East Side. Again, there is no doubt that Art Berger had some role in this reprinting. It is also quite likely that the closeness of a number of Umbra's members to *Freedomways*, whose managing editor, Esther Cooper Jackson, was

married to *The Worker*'s editor, James Jackson, facilitated the appearance of the poems in a journal that did not publish a lot of serious poetry at that time.

Berger's politics were far from singular in Umbra; neither was he the only member to use his contacts on the Left to build and support the infrastructure of the workshop. Another Umbra member, Nora Hicks, was married to OGFF leader Calvin Hicks and, like her husband, had basically grown up in the CPUSA youth movement — though, again like her husband and many "red diaper babies" during the Cold War, she was ambivalent about the CPUSA as an institution while maintaining many personal ties to individual Communists. Nora Hicks primarily contributed to Umbra in a supporting role to the more famous black male artists — many recollections of Umbra note that it was a strongly male-dominated group in which women did not take themselves seriously as artists (and were not encouraged to take themselves seriously). Also, like Art Berger, as one of the relatively few white members of the group, her behavior was guided by understood limits in a group designed to foster, promote, and publish young black avant-garde writers. Nonetheless, again like Berger, she is cited by many Umbra participants as the sort of organizer who made sure that the practical activities of the group took place smoothly.[84] Brenda Wolcott was also a member of the openly Marxist tendency within Umbra.[85] Despite his later announced antagonism toward the CPUSA and Marxism, Ishmael Reed worked closely with Joe Walker (subsequently part of the left-wing staff of *Muhammad Speaks*) on the radical black Buffalo newspaper *Empire Star* before his move to New York City and later grew close to Walter Lowenfels. The relation of other members of Umbra to Left groups, individuals, and ideologies is less clear — and some, such as Askia Touré, were already fairly straightforward nationalists. Still, they had to be willing to at least participate in and be promoted by leftists and Left institutions.

Old Left and new black countercultural interchanges spurred by a new political climate opened spaces in the visual arts downtown too. Much like the genesis of *Freedomways*, the civil rights upsurge and a new sense of political and cultural possibility brought together black painters and sculptors, including such older artists as Charles Alston, Romare Bearden, Hale Woodruff, Norman Lewis, and James Yeargans and such younger artists as Felrath Hines, Richard Mayhew, William Pritchard, Emma Amos, Richard Gammon, and Alvin Holingsworth, in the Greenwich Village–based Spiral group. Spiral grew out of a meeting to

discuss the possibility of organizing a bus of black artists to go to the 1963 March on Washington. Many of the older artists, particularly Alston, promoted a vision of the role of art shaped by their experiences with the Communist Left in the 1930s and 1940s. They conceived of Spiral as an attempt to re-create the sort of community-building spaces in which black artists discussed politics, aesthetics, and technical or professional problems during the Depression — like Alston's old studio at 306 West 143rd Street in Harlem, where virtually every black visual artist and writer in New York would gather during the 1930s.[86] Despite the opposition of some Spiral members, especially Alston, to the new nationalisms, Spiral's wide-ranging and contentious discussions about the connection of art to practical politics, the relation of the black artist to the artistic "mainstream," and the appropriateness of more representative modes of art as opposed to abstraction prefigured similar discussions within Black Arts visual arts organizations like the OBAC Visual Arts Workshop and AFRI-COBRA in Chicago and the Weusi group and the more abstraction-oriented Smokehouse group in New York.[87] Beyond this sort of organized effort, black visual artists with roots in the Popular Front guided and supported younger artists in more informal ways, from general words of encouragement to sympathetic but trenchant criticism of new work. Askia Touré, who began as a painter before turning to poetry, recalls that Jacob Lawrence was particularly accessible and generous to young black artists like himself and Tom Feelings — much like Hughes with their literary counterparts.[88]

One can overemphasize the CPUSA as a Left influence on the Black Power and Black Arts movements in New York. The CPUSA was unquestionably the preeminent group on the Left from at least the early 1930s through the mid-1950s, especially in the African American community. By the early 1960s, Cold War Communist losses and isolation and the appearance of new organizations (or the reenergizing of older groups) considerably weakened the CPUSA's status as the organization with which or against which other Left parties aligned or defined themselves — though it was still the largest Marxist organization in New York, with some significant political capital among black activists. New York generally, and the Lower East Side (and the Village and Union Square) particularly, was also the epicenter for Trotskyist, Socialist, anarchist, Catholic Worker, and emerging Maoist groups as well as circles of more loosely connected independent radicals. The Trotskyist SWP alienated many young black militants on the Lower East Side and in Harlem for what was perceived as a proclivity for heavy-handed sectarian attempts to control organizations like the Monroe De-

fense Committee and Fair Play for Cuba—a proclivity that was also ascribed to the CPUSA and other, older "white" Left groups. Nevertheless, the educational institutions of the SWP furthered the growth of community and communication among new radical black artists, intellectuals, and activists. Though only a few of the activists who formed BARTS and other early Black Arts groups in New York, such as Cornelius Suares and Clarence Franklin, actually joined the SWP, the early recognition of the importance of Malcolm X by leaders of the SWP, particularly George Breitman, led to the circulation of the more radical (in a Left sense) thoughts of Malcolm X through the books and pamphlets of the SWP's Merit Press (later Pathfinder Press). Similarly, the SWP forums that featured Malcolm X brought young black militants from the Lower East Side, Harlem, and elsewhere in the city in contact with each other.[89]

After 1962, Maoism, particularly through the newly formed Progressive Labor Movement (later the Progressive Labor Party), began to have a significant impact, both among black artists and intellectuals uptown and downtown —particularly through the efforts of Harlem PL organizer Bill Epton. As with the SWP, relatively few Black Arts activists became directly affiliated with the PL, even much later when many like Baraka embraced some form of Maoist, "Third World Marxism" (which was posed as distinct from the "white Left" or "European Marxism")—no doubt largely due to the PL's sharp opposition to nationalism. And fewer future Black Arts and Black Power leaders from New York seem to have gone to Cuba on PL-sponsored tours than from the Midwest and the West Coast. (Fair Play for Cuba trips that seem to have recruited largely through the circuits of the CPUSA and the SWP were more directly important to the evolution of the Black Arts movement in New York—though even here, "antirevisionists" with some sympathy for the early PL, notably journalist Richard Gibson, were important leaders.) Nonetheless, Epton and the PL were fixtures of the black political and cultural scenes in Harlem and on the Lower East Side and contributed to the circulation of radical ideas and other variants of Marxism than those promoted by the CPUSA and the SWP. And while the PL was not a Third World Marxist organization ideologically, its extolling of China as the center of world socialism and a Chinese man as Marxism's greatest living theorist, rather than a European nation and a European (or white North American) leader, played a significant part in the development of a black or Third World Left.[90]

The point here is not to claim that the black avant-garde artists of the early

1960s were directly linked to the Communist (and Trotskyist and Maoist) Left in the manner of a great number of their predecessors in the 1930s and 1940s (though some of them were). Rather, it is to point out that there was an inter-racial, semi-underground, Left bohemia with some institutional strength on the Lower East Side, Greenwich Village, and, to a lesser extent, Harlem, with which many downtown (and uptown) black writers and artists interacted to an extent that went far beyond the vast majority (though again, not all) of their white counterparts in the second-generation New York school.

This interaction with (or outright participation) in the Left as well as in nationalist organizations similarly oriented toward education, study, and intel-lectual discussion helped produce a greater degree of political (and artistic) sophistication and engagement among black writers than nearly all the younger (and older) white writers associated with the Lower East Side. No doubt some of this sophistication and engagement (not to mention considerable organiza-tional skills) issued from experience in the civil rights movement. For example, Tom Dent, who was the publicity director for the NAACP's Legal Defense Fund when Umbra began, had a long personal (and family) history in the civil rights movement before, during, and after his tenure in Umbra. For that matter, the formation of such political groups as the Organization of Young Men (and its journal In/Formation) and OGFF by young black intellectuals and artists living primarily on the Lower East Side was seen by their founders as largely an exten-sion of the black student movement and the civil rights movement up North. However, the tone, shape, and vision of these organizations, which were gener-ally skeptical of Martin Luther King Jr. and the notion of nonviolent resistance as an absolute principle and which venerated the militancy of Robert Williams and Malcolm X, were marked by the long traditions of nationalism and Left activism in New York and the Northeast generally. The familiarity of many of the proto–Black Arts activists with a wide range of radical texts and radical theory, and their proclivity for starting study groups and political organizations with a strong bent toward ideological self-education, was an updating of a hallmark Old Left activity, even if the theory studied sometimes significantly diverged from what would be encountered in the institutions of the SWP, the PL, and the CPUSA.

The Old Left also provided spaces in which the new black radicals connected with each other, even if those radicals were never truly a part of any Old Left grouping but simply took advantage of the various sorts of possibilities for edu-

cation, inspiration, and entertainment that, say, seeing Malcolm X at a Path-finder Forum provided. As mentioned above, when Malcolm X spoke at these forums organized by the SWP downtown in Greenwich Village, it was an occasion for black intellectuals and activists living uptown in Harlem to meet some of the black bohemians living on the Lower East Side. Again, though only a few of these artists, activists, and intellectuals in New York had much direct involvement with the SWP and the organizations it led, these forums helped shape the nucleus of what would emerge as BARTS in 1965. Similarly, though the UN demonstration against Lumumba's murder was (and is) taken as an expression of a new militant nationalism, its initiation (and much of the organizing) occurred through the cultural circuits of the black Left, particularly the HWG, leading to the intersection of downtown black bohemia with uptown nationalism and Left activism, with considerable impact in Harlem and the Lower East Side.[91]

The Darkest Part of the Shadow: Black Institutions, Black Feeling from Downtown to Uptown

At the same time that many of the younger black poets were engaged in the interracial milieus of the New American Poetry and the Left, they also participated in more distinctly black political and cultural institutions. Probably the best-known and best-documented of such institutions in New York is the Umbra Poets Workshop. Founded in 1962, Umbra included such prominent Black Arts–era writers as Askia Touré (then Rolland Snellings), Ishmael Reed, Calvin Hernton, David Henderson, Tom Dent, and Lorenzo Thomas. Several other black artists known primarily for work in genres and media other than writing, such as the musician Archie Shepp and the photographer Alvin Simon, had a sort of associate status in the group. Though begun to build community among the black artists and writers in the new Lower East Side bohemia, Umbra had a bifurcated identity in several ways. For one thing, it had a number of white members, largely female partners of black male writers but also including Art Berger, who, as mentioned above, functioned more as a facilitator than as an artist in his own right — though his poetry was sometimes published alongside work by black Umbra members. And despite the fact that its members lived almost exclusively on the Lower East Side, Umbra had significant emotional, ideological, and practical ties to Harlem, where a number of the members had lived and at least one, Henderson, had grown up. One of the important predecessors to

the organization was the reading series at the Market Place Gallery in Harlem organized by Raymond Patterson during the late 1950s, at which a number of the future Umbra poets met and/or read. It was also through the Market Place readings that these poets established ties with an older generation of Harlem-identified black writers, most importantly Langston Hughes, who maintained an intense interest in the work and careers of younger black writers. Hughes strongly encouraged the Umbra group, maintaining close ties with several of its members, especially Tom Dent.[92] These ties with Hughes, John Henrik Clarke, and other older black artists and intellectuals linked to Harlem helped stimulate the desire of Umbra members to work "uptown" culturally and politically in such groups as OGFF, the Monroe Defense Committee, the Uptown Writers Group, and RAM, even though the active membership of these groups, like that of Umbra, lived largely (or sometimes entirely) downtown.[93]

As noted earlier, the Umbra group is a case in point about the complexities and contradictions of distinguishing the political from the aesthetic even in the proto–Black Arts phase. Umbra existed largely as a sort of workshop/discussion group in which members and guests read their work and received often sharp criticisms as well as encouragement and support. This criticism and encouragement revolved frequently (perhaps most frequently) around questions of craft rather than content. Another primary purpose of the group was to promote the publication of its members, since many of the older Lower East Side journals edited by white bohemians were not initially all that receptive to younger black writers other than Baraka and, to a lesser extent, Spellman.[94] In fact, one of the great accomplishments of Umbra was its powerful group presentation of these younger black writers at poetry readings and other public events, making them a prominent feature of the Lower East Side arts scene. This prominence allowed them to forcefully claim a space in the second-generation New York school journals—and set the stage for the later success of many of these artists inside and outside the Black Arts movement.

However, Umbra was more than a venue through which artists developed their craft and promoted their careers—however important those functions were to the group. While the foreword of the first issue of the group's journal *Umbra* makes a point of emphasizing the aesthetic over the political, radical politics, whether Marxism, nationalism, or some combination of the two, was central to the lives of many of the members. For example, Art Berger, though his sense of what constituted progressive literature and aesthetics might differ from

some other Communists, saw the building of politically and artistically "advanced" African American cultural institutions and art as a revolutionary imperative—as Communist activists had for decades. In short, there was a specific radical motivation behind Berger's work in Umbra rather than with some other bohemian grouping on the Lower East Side. The political engagement of the workshop can also be seen in the attendance of civil rights movement activists, such as Andrew Young and Julian Bond (also a fairly widely published poet at the time), at Umbra meetings when they were in New York as well as in Umbra's decision to attend the 1963 March on Washington as a group (and according to Art Berger, armed with guns in case of some kind of attack on the demonstration).[95] On the other hand, many of the members were interested primarily in questions of poetic craft and finding an audience, questions that they saw as at least partially distinct from, if not inimical to, an overarching political ideology.[96]

In the end, ideological conflict and the relation of ideology to group action split the group in 1964—though the journal *Umbra* would appear intermittently after the split and the effective demise of the workshop. The event that brought the divisions in the organization to a head was a debate over whether to print a poem by former Communist and Spanish Civil War veteran Ray Durem attacking John F. Kennedy in *Umbra*. Though the poem had been written and accepted by the editorial board before Kennedy's death, some felt that it was inappropriate in light of the subsequent assassination. Others believed that a refusal to print the poem represented a kowtowing to the sort of Cold War liberalism, epitomized by Kennedy, that had hamstrung the civil rights movement. Fundamentally, the division seems to have been between those members who thought Umbra should adopt nationalism as part of its basic stance and others who were opposed to tying the organization so closely to a particular ideological position—for a variety of aesthetic and political reasons, including a fundamental Marxist opposition to separatist nationalism.[97] While it is (and has been) easy in retrospect to judge the so-called hard-liners negatively as those who brought Umbra to an effective end, their notion of being called by the times to take a strong, unified position may have fit the moment better than the varied positions of their adversaries. In fact, the hard-line faction was arguably more productive artistically and intellectually during the Black Arts era than their opponents.[98] Again, the sort of rupture between different moments and modes of black radicalism seen here was one repeated many times, in many places, carrying a symbolic importance and emotional charge that goes far beyond the often

apparently small issue or event (the publication of a single poem or the control of a small amount of money) that appears to have precipitated the break.

Articles in *Liberator* by Cruse, Touré, Neal, and Baraka from 1963 to 1965 enacted more theoretical gestures of rupture with liberal-Left ideologies and institutions echoing the Umbra split, the debates in OGFF (and the Watts Writers Group on the West Coast), and Baraka's highly public departure from the downtown bohemia to Harlem. Crucial in defining the ideological field of the Black Power and Black Arts movements in the Northeast were such essays as Cruse's "Revolution or Rebellion"; Touré's "The New African American Writer," "Toward Repudiating Western Values," "Afro-American Youth and the Bandung World," and "Keep On Pushin': Rhythm and Blues as a Weapon"; and Neal's "The Black Writer's Role" series. Such work marked out a post-Communist, radical nationalism that moved toward cultural nationalism while maintaining a systemic critique of capitalism and colonialism in a way that was far more friendly toward popular culture, especially popular music, than was generally true of the cultural nationalists of the West Coast and the Midwest. Touré's "Keep On Pushin'" as well as later essays, such as "The Crisis in Black Culture" in *JBP*, stood in sharp contrast to Maulana Karenga's famous indictment of the blues and blues-based popular music as accommodationist and counterrevolutionary in "Black Cultural Nationalism," which first appeared in *Negro Digest* in 1968 and was later reprinted in Addison Gayle Jr.'s influential 1971 anthology, *The Black Aesthetic*. Like Baraka, Touré not only argued that militant black artist-activists should pay attention to developments in rhythm and blues but that some R & B musicians, especially Curtis Mayfield, were in fact part of the Black Arts movement.[99] In many respects, these Black Arts critics, especially after the ghetto uprisings that began in 1964 and mushroomed after the Watts uprising in 1965, took a leaf from such antivanguardist radicals as C. L. R. James and James Boggs in suggesting that the masses were often (if not always) in advance of organized revolutionary groups.

The rise of BARTS marked a new moment of black artistic development in New York (and the apparent reinstallation of Harlem as the undisputed center of black politics and art); the collapse of the group signaled the decline of New York, especially Harlem, as the symbolic cultural center of African Americans. While BARTS was not the parent from which all Black Arts institutions were born, as some have claimed, it was tremendously inspirational as the first major black nationalist art institution of the 1960s with a national reputation, syn-

thesizing earlier Left, nationalist, and avant-garde strains with black counter-culturalisms of the Yoruba Temple, Sun Ra and his Arkestra, and various NOI-influenced nationalisms.[100] Though BARTS contained many different ideological tendencies, it might be characterized as a predominantly revolutionary nation-alist group with a hybrid cultural nationalist–avant-garde style. This style can been seen in one of the inaugural public events of BARTS in Harlem, a parade down 125th Street led by Sun Ra and his band, recalling Left and Garveyite marches through the community from the 1920s through the 1940s but with an avant-garde cast. Though inspired in part by Popular Front notions of cultural education and art for the people (in theaters and on the streets) and an almost Dadaist approach to confronting the political and cultural establishment, BARTS emulated both the Yoruba Temple and the NOI (and certain aspects of down-town bohemia) in not simply imagining a liberated black future but attempting to embody it institutionally.

The move of the center of vanguard black literary, theatrical, and, to a lesser extent, musical activity uptown from the Lower East Side seemed to mark the complete reestablishment of Harlem as the cultural capital of black America. However, when BARTS collapsed under the weight of personal and ideological conflicts that reached their apex (or nadir, perhaps) with the shooting of Larry Neal in early 1966 and threats of violence against Askia Touré and Sonia Sanchez, as well as the external withdrawal of funding by government antipoverty pro-gram agencies, Harlem never regained its place as *the* center of the Black Arts movement, particularly in the area of poetry.[101] In part, this was due to the exodus of leading black intellectuals and artists elsewhere, particularly to the South and to the West Coast. This exodus left its stamp on the Black Arts move-ment in those regions.

Obviously, new Harlem Black Arts and Black Power organizations appeared and often thrived after the collapse of BARTS. New York remained a major area of African American artistic production, particularly drama. There was what might be thought of as a second wave of Harlem-based Black Arts activity in the late 1960s, resulting in the founding of such institutions as the New Lafayette The-atre (with Ed Bullins as playwright-in-residence), the NBT, Liberation Books, and the Studio Museum in Harlem. Several of these, particularly such theater institutions as the New Lafayette and the journal *Black Theatre*, had a national impact. The Harlem poetry scene in the late 1960s and early 1970s featured such artists as the Last Poets, Touré, Neal, Nikki Giovanni (though she actually lived

in the nearby Upper West Side), and (for a time) Marvin X.[102] There was a dynamic loft scene that included the NBT, the Studio Museum, the Open Mind, and the Last Poets' East Wind. Some post-BARTS Harlem institutions founded in 1967–68, such as the NBT, Liberation Books, and the Studio Museum, survived far beyond the end of Black Arts era. The appearance of the anthology *Black Fire* (1968), edited by Baraka (then LeRoi Jones) and Neal, announced a national movement that owed much of its conception, terminology, and inspiration to BARTS. Clarence Major's *The New Black Poetry* (1969), issued by the CPUSA's International Publishers, was another key anthology conceived in a New York Black Arts–Communist Left matrix—key both in terms of presenting a wide range of black poetry of the moment and serving as a rallying point for those, such as Touré and Edward Spriggs (both BARTS-connected artists), who called for black poets to publish with African American presses rather than white publishers, even radical publishers such as International.[103]

Nonetheless, the importance of Harlem as both real and symbolic center receded. Outside the New Lafayette, the new institutions of the second wave of the Harlem Black Arts and Black Power movements did not have the national prominence that BARTS or even Umbra had. Liberation Books, for example, did not have quite the same meaning that the National Memorial African Bookstore had in the early 1960s. Even in the Northeast, Harlem was at least partially eclipsed by Newark, to which Baraka returned in 1965, and by central Brooklyn. The Black Arts linchpin of central Brooklyn was The East, an educational and arts center founded in the summer of 1969 by Jitu Weusi (Les Campbell) and other activists of the African American Students Association. The East (and its offshoot, The Far East, in St. Albans, Queens) featured performances by many of the leading young jazz avant-gardists of the time, such as Rashid Ali, Milford Graves, Gary Bartz, and Andrew Cyrille, as well as drama, dance (including soul music dances on Sunday), poetry, film festivals, night classes (including workshops in the visual arts, drama, Yoruba culture, music, and drumming), and political meetings of such groups as the RNA and Nat's Women, a local nationalist women's group. While the NBT and the other spaces of the Harlem loft scene fulfilled some of these functions, there was no single space in Harlem that could rival The East. Central Brooklyn (and The East) was also the home of *Black News*, an offset biweekly nationalist newspaper with sophisticated graphics and block print covers. With a circulation of about ten thousand, *Black News* featured much poetry by local writers, especially high school and junior high school stu-

dents, and nationally known writers, such as Haki Madhubuti and Mari Evans. As with The East, no nationalist Harlem-based newspaper or journal came close to matching *Black News* in the late 1960s and early 1970s. Indeed, central Brooklyn in that period was a hotbed of Black Arts and Black Power theatrical performances, concerts, poetry readings, night classes, lectures, independent schools, demonstrations, rallies, political meetings, and so on.[104]

In short, the symbolic importance of Harlem had been vital in imparting a certain sort of national status to the Black Arts movement, inspiring, influencing, and giving a sense of national connection to a number of proto–Black Arts groupings, individuals, and institutions across the country. However, with the passing of BARTS, a new moment was reached in which the notion of a genuinely nationwide, grassroots movement became dominant. In this moment, the romance of Harlem as race capital was less important or even inimical to some degree. Certainly, that romance continued (and continues) to linger in somewhat more muted form, as seen in Cruse's *The Crisis of the Negro Intellectual* and Neal's continued insistence on the centrality of Harlem in black culture and politics — and, indeed, in the founding of the New Lafayette Theatre and the Studio Museum uptown. But it seems fair to say that there was a symbolic decentering of the Black Arts movement that to a large degree matched its practical, geographical dispersion.[105]

The Diaspora Corridor: Boston and the Black Arts Megalopolis

One side of New York as a sort of delta of African American artistic and political radicalism during the 1950s and 1960s was not only the sheer number of black artists and intellectuals from across the United States, the Caribbean, Latin America, Europe, and Africa who settled there for long periods of time but also the dynamic relationship between New York and other urban clusters of African Americans in the Northeast. Of course, black (and white) artists and intellectuals living in cities all over the United States frequently visited New York. Many out-of-towners also held important positions in New York–based cultural institutions. The Chicago-based Margaret Burroughs, for example, served as the art editor of *Freedomways* from 1961 until 1964. Ultimately though, the distance between New York and Chicago was too great to make that arrangement practical.[106]

The relatively short tenure of Burroughs as the *Freedomways* art editor (she remained as a contributing editor through the journal's existence) demonstrates how New York had a different relationship with other northeastern cities than with those outside the East Coast megalopolis. Boston early on provided an East Coast example of the successful building of neighborhood-based African American arts institutions with national (if not fully realized) aspirations enabled in part by its relatively close proximity to New York. Its black community in the 1950s and early 1960s was small compared with that of other East Coast urban centers. Despite an important tradition of African American cultural and intellectual activity dating back before the founding of the republic, African American arts activity in Boston was relatively low-key in the 1950s — though it included the presence of some important black visual artists, notably the painter Allan Crite, and a still thriving music scene in the South End. The medium in which the Boston Black Arts movement would grow was a mixture of older nationalism (principally Garveyism), what was left of the late nineteenth- and early twentieth-century settlement house movement, remnants of the Popular Front, New Deal liberalism, and the emerging civil rights movement (which in Boston included long struggles for open housing, school desegregation, and black representation on the school committee).[107]

Contributing to the low-key nature of black artistic production and radical African American politics was the particular intensity of the domestic Cold War in Massachusetts. Some sense of this intensity can be gleaned from the Crimes against Government section of the General Laws of Massachusetts, which banned "subversive" organizations. Belonging to, contributing financially to, or renting property to such organizations was declared a crime punishable by up to three years in state prison. These laws also prohibited a member or supporter of a subversive organization from holding a public position, including a teaching position in public or private schools, colleges, and universities. Concealing or destroying records, membership lists, and lists of financial contributors to subversive organizations, too, was outlawed. The single organization clearly defined as "subversive" was (and is, since the laws remain on the books) the CPUSA.

What would become the center of black community-based arts activities in Boston, the ELSFA, opened in a six-room apartment in Roxbury in 1950. No doubt due to the intensity of the Cold War in Boston and the byzantine nature of the local Democratic machine, the politics of the school and its founder, Elma Lewis, are hard to sort out. Lewis grew up in a Garveyite family in Boston. Her

father, an immigrant from Barbados, considered himself a Pan-Africanist his entire adult life (as did Elma Lewis).[108] Lewis had considerable training in dance and theater, and early on she aspired to be a professional actor. As an eighteen-year-old, she met Paul Robeson while he was playing Othello at the Colonial Theater downtown and became a lifelong admirer of him.[109] However, she despaired of breaking the color barrier for serious black actors and spent many years working as a speech therapist and a social worker at the Harriet Tubman House in the South End during the 1930s and at the Robert Gould Shaw House in Roxbury during the 1940s before opening the ELSFA.

From the beginning, the ELSFA pursued mixed and not always easily reconcilable goals as it served its various constituencies in the African American community and negotiated with a paternalistic and often extremely racist political structure in which the relatively small black population lacked the actual or potential clout that its counterparts had in Chicago, Cleveland, Detroit, or New York. The school primarily worked with young people, providing workshops in a wide range of genres and media, including theater, dance, music, and the visual arts. While many parents who sent their children to the school subscribed to middle-class notions of art as a social grace, Lewis saw the program as a way of promoting black character and building self-respect. There also was an emphasis on professional preparation for those students who were felt to be particularly talented. For example, later school brochures emphasized how many former students had gone on to careers in the New York theater.[110] The annual performances of the dance, theater, and music departments sometimes included works written or composed by African Americans but more often than not featured such "classics" as *Swan Lake* and *The Nutcracker*.

The school grew through the 1950s and early 1960s, supported by money raised privately and almost entirely in the African American community of Boston. ELSFA's annual performances became important community events, as seen in the wide range of businesses, individuals, and organizations, from funeral homes to politicians to trade unions, that took out ads in the programs for these performances. However, the availability of public and foundation support increased geometrically after the Watts uprising of 1965 and, more locally, after the 1967 uprising in Grove Hall and Roxbury. Then the school was able to attract significant public funding as well as important private contributions from outside the community, allowing it to considerably expand its programs. It also has to be said that this funding was not simply due to the new political atmosphere but

also to Lewis's adeptness in negotiating Boston's complicated and often fiercely competitive politics, cultivating the local Democratic establishment, the black Republican U.S. senator Edward Brooke, and younger black community activists, despite Lewis's personal demeanor that some found harsh or forbidding.

Much like Gwendolyn Brooks at the 1967 Fisk Black Writers Conference, Lewis was transformed by a 1968 meeting on African American art in Chicago. Though the younger artists associated with OBAC, such as poet Haki Madhubuti, painter Jeff Donaldson, and theater worker Val Gray Ward, had not been initially invited, they showed up anyway, demanding to be heard. Lewis met with these younger artists and came away a believer in the idea of a radical black cultural movement—a belief to which she was predisposed by her long-held Pan-Africanist sympathies.

Out of this urge toward national movement and institution building, Lewis and the ELSFA became the anchor for a flurry of important cultural initiatives, including the Playhouse in the Park program, which staged music, dance, theater, and poetry before thousands, and the plan for the NCAAA with its associated museum. Again, the accessibility of New York and its artists and arts infrastructure by car, train, or bus made Lewis's ambitious undertakings feasible in spite of Boston's comparatively small African American community. This geographical closeness allowed for relatively easy (and cheap) visits by New York-based artists and for tour stops of various sorts of shows, with New York as a primary destination, in ways that were not possible in larger cities (with bigger black communities), such as Houston and St. Louis. (Of course, the greater distance between New York and places like Houston and St. Louis encouraged the growth of self-sufficient local and regional Black Arts groups and institutions to a degree unmatched in New England.) Some of these institutions were (and are) plagued by undercapitalization and other practical problems (including arson) that slowed or prevented their full realization. The museum, for example, did not occupy a permanent space until 1979, and though it remains in existence, has suffered from severe physical plant problems; the school closed in 1990.

However, for years the ELSFA and its affiliated institutions housed or supported much radical black cultural activity, making Boston an essential stop on the Northeast's Black Arts cultural circuit. With the hiring of a young Left nationalist director, Barry Gaither, in 1969, the Museum of the NCAAA put on six to eight shows a year in the temporary quarters it shared with the ELSFA, including a 1970 exhibit on the AFRI-COBRA group. However, despite Lewis's

long-standing nationalist and, to some extent, Left sympathies that attracted her to the Black Arts movement, the ELSFA, and the NCAAA were never exactly part of the Black Arts or Black Power movements in the same way as BARTS, AFRI-COBRA, or OBAC. Rather, the institutions that Lewis initiated resembled Margaret and Charles Burroughs's DuSable Museum in Chicago, supporting and nurturing Black Power and Black Arts efforts, as it did when it offered its resources to the arts initiatives proposed and endorsed at the first CAP convention in 1970. At the same time, it diverged from more strictly nationalist organizations in some important respects. While the 1968 plan for the NCAAA proclaimed the need for the development of black pride, self-worth, unity, and self-reliance, it also stated that one of its main tasks was outreach to and education of white people.[111] Even the programming of the institutions associated with Lewis and the ELSFA was often wildly eclectic. The theater group affiliated with the ELSFA and the NCAAA in the 1970s mounted plays ranging from Sonia Sanchez's *Sister Son/Ji* to Langston Hughes's *Black Nativity* (which remains a Christmas tradition in Boston) to *Brigadoon*. The spectrum of the Playhouse in the Park programs included Duke Ellington, Nigerian drummer Babatunde Olatunji, the folk singer Odetta, theatrical productions directed by Val Gray Ward, and the Boston Pops Orchestra.[112] A sense of the mixed character of these institutions reflecting both the political realities of Boston and Lewis's complex ideological background can also be seen in the board of directors of the NCAAA, which included Edward Brooke, Old Left veterans Charles White and John O. Killens, and the younger Black Arts luminaries Jeff Donaldson and Woodie King Jr.

It could be argued that these institutions never quite lived up to the national ambitions that Lewis articulated after her new engagement with the Black Arts movement in 1968. The NCAAA mounted many valuable shows but receded in importance compared with similar institutions in larger centers of African American population, such as New York, Atlanta, and Chicago. Even in Boston, the associated institutions and programs declined in importance, some closing and others barely holding on. Nonetheless, in addition to the local impact of the ELSFA and the NCAAA and its museum, Elma Lewis's early commitment to institution building within the black community provided a model for similar efforts elsewhere as well as a link between earlier moments of black cultural and political activity stretching back to the Garvey movement in the early twentieth century.

A Philadelphia Story: The Muntu Group and RAM

Philadelphia, only a couple of hours by train or car from Manhattan, had a unusually close association with New York that substantially molded the Black Arts and Black Power movements in New York and, ultimately, across the United States. While no Black Arts institutions of national status on the scale of Broadside Press, the FST, *Liberator*, *Negro Digest/Black World*, or JBP emerged in the city, radical political and artistic subcultures of black Philadelphia decisively shaped some of the key national figures of the Black Power and Black Arts movements. Philadelphia also served as a key transmission point between the emerging organizations and institutions of the movements in New York, in the Midwest, particularly Detroit and Cleveland, and in the South.

The black community of Philadelphia in the early 1960s was large, with an old, established professional class and a long tradition of black cultural and educational institutions — Pennsylvania was one of the few northeastern states with historically black schools of higher education, Lincoln University and the Cheney State College (both founded before the Civil War). In some respects, as the archetypal bastion of middle-class black life, tastes, and cultural institutions and with all the positive and negative connotations that being a capital (if not *the* capital) of the "black bourgeoisie" entailed, Philadelphia held much the same position with respect to African American culture that Boston (the famously blue-stocking "Athens" of the United States that early twentieth-century bohemians loved to hate) held for the United States generally. Only Washington was a serious contender in this regard. Thus, when Langston Hughes looked for an embodiment of black bourgeois values in his famous 1926 essay "The Negro Artist and the Racial Mountain," he located it in the figure of the "Philadelphia clubwoman."[113]

The city also had a strangely contradictory character in that it had been both a hotbed of middle-Atlantic abolitionism and the site of much racial violence and extreme discrimination against African Americans in the nineteenth century. In the twentieth century, Philadelphia retained a large degree of de jure and de facto segregation in housing, employment, education, and so on. Yet the relatively large size of the black community (more than 11 percent of the population by 1930), the ability to vote, and a tradition of political activism gave the community a certain degree of political leverage — though often within the con-

text of the patronage system of the Republican Party machine that dominated the city until the New Deal.

Philadelphia was a center of the New Negro Renaissance surpassed only by New York and Washington (and on a par with Boston). Lesley Pinckney Hill, the principal (and later president) of nearby Cheney, published one of the first collections of poetry, *Wings of Oppression* (1921), imbued with the postwar spirit of black protest. Two of the figures most responsible for the promotion of the artistic side of the New Negro Renaissance, Alain Locke and Jessie Fauset, were products of the black middle class of Philadelphia. Locke and Fauset epitomized the long line of migrant artists and intellectuals, stretching though John Coltrane, Jimmy Garrison, McCoy Tyner, Archie Shepp, and Larry Neal, who left Philadelphia to find greater fame elsewhere, generally New York or Washington. Nonetheless, like many of the above-named artists who achieved fame in the 1960s, Locke and Fauset retained a special connection to the city (where Fauset would return at the end of her life).

Fauset's brother, the educator Arthur Huff Fauset, edited *Black Opals*, a literary journal devoted primarily to young black writers from Philadelphia that also published more established writers, such as Locke, Lewis Alexander, Langston Hughes, and Gwendolyn Bennett (who edited the Christmas 1927 issue). Drawing on much the same opposition of old and new as Hughes's "The Negro Artist," Locke's essay in *Black Opals*, "Hail Philadelphia," poked fun at the middle-class mores of the city's black cultural leaders while calling upon the younger generation of writers to strike out in the direction of the new modernisms. However, Locke's more sympathetic vision of his hometown posed Philadelphia as both a bastion of a conservative, hidebound black middle class and a potentially fertile ground for the growth of a new culturalist (also middle-class) avant-garde. Thus, Philadelphia takes on a meaning different from Locke's casting of Harlem as a visionary race capital, becoming instead a place where the old directly contests with the new for the future of the race in the United States.[114]

Despite this identification with the black bourgeoisie, "middle class" here should be used advisedly. Philadelphia projected an established, genteel eastern image with a notable colonial and early federal past when it was arguably the dominant city in (and briefly the political capital of) the English North American colonies and the early republic. However, beneath this veneer was a major mass-production factory town that had more in common in many re-

spects with the automobile, electrical, rubber, and steel producing centers of the Midwest than New York, Boston, or Washington. Philadelphia and the nearby cities of Chester and Camden contained enormous electrical, automotive, and food-processing plants, gigantic shipyards, and a thriving port (long a center of radical black trade unionism) — though many mass-production plants essentially excluded black workers until World War II. Not surprisingly, a large and comparatively stable working-class population undergirded the better-known black middle class. It was in this working-class section of the black community that the UNIA and other nationalist movements struck their most responsive chord from the 1920s onward. Philadelphia was the home of one of the seven largest divisions of the UNIA in the United States — which still had a membership of six thousand in 1923, even after the fallout of Marcus Garvey's mail fraud trial.[115] Remnants of the UNIA and other nationalists were in the forefront of 1930s "Don't Buy Where You Can't Work" picket lines, much as they were in New York.[116] Of course, nationalism and black-run cultural, political, and spiritual institutions were nothing new in Philadelphia, as the founding of the African Methodist Episcopal Church there by Rev. Richard Allen in 1790 attests. It should also be noted that the distinction between the working class and the middle class there, as elsewhere, was often quite blurry, with the latter category often including railroad workers (such as Larry Neal's father, an ardent race man), postal workers, teachers, and others who would be considered working class in most Marxist analyses.[117]

This blurring deepened during the Popular Front when a significant section of the African American intelligentsia in Philadelphia moved to the Left, supporting the efforts of the CIO, the FWP, the FTP (which established a Negro unit in Philadelphia), and such black Popular Front organizations as the NNC. Even before the Popular Front, Philadelphia contained one of the largest concentrations of black members of the CPUSA. The local chapter of the John Reed Clubs issued the lively journal *Left Review*, frequently printing the poems of Frank Ankenbrand, a writer who had achieved some local prominence during the New Negro Renaissance (and who would publish poetry in *Freedomways* during the 1960s).

As was true in much of the Northeast, the Popular Front heralded a new level of Left influence in the African American communities of Philadelphia. The NNC, headed by Arthur Huff Fauset and Saul Waldbaum, challenged the NAACP as the preeminent civil rights organization of the city in the late 1930s.[118]

Philadelphia hosted the second national conference of the NNC in 1937, demonstrating the vitality of the local affiliate — though some of the divisions between the Communist Left and other liberal and Left forces that would eventually spit the NNC began to surface at this meeting. The core of the NNC in Philadelphia could be described as being largely working class in orientation, leading demonstrations around employment, wages, and labor rights, but with significant participation by a Left intelligentsia.

The left wing of the CIO also established a strong base there led by the United Electrical, Radio, and Machine Workers Union, the United Cannery, Agricultural, Packing, and Allied Workers of America, and the Transport Workers Union — organizing plants of such corporate giants as Philco, Westinghouse, RCA, and Campbell's Soup. In addition, the Left had significant strength in a number of AFL affiliates, notably the Philadelphia Federation of Teachers (of which Arthur Huff Fauset was a vice president). Even in industries where African Americans remained a relatively small proportion of the workforce in the 1930s and 1940s, such as the electrical industry (where Philco was notoriously racist in its hiring practices), these Left-influenced unions still provided support for civil rights initiatives, especially by such Popular Front organizations as the NNC and later the CRC and the NNLC.

Though splits in the NNC following the Hitler-Stalin pact diminished the effectiveness of the organization, and though the deepening of the Cold War that culminated in the expulsion of most of the Left-led unions from the CIO in 1949 weakened the Left's base in the trade union movement, the Communist Left maintained considerable influence within Philadelphia's black communities in the years immediately following World War II. Edward Strong, a former leader of the SNYC and the NNC and one of the early architects of *Freedomways*, led the local section of the CPUSA in the late 1940s and early 1950s. The Philadelphia chapter of the CRC was among the most active, influential, and long-lived — again, Arthur Huff Fauset was a prominent sponsor. The CRC led demonstrations against discrimination in public accommodations, education, and hiring as well as campaigns against police brutality and the unjust prosecution of African Americans, such as Leroy Grice, Bayard Jenkins, and Fletcher Mills.[119]

In 1945, a Left slate headed by Joe Rainey (later an important radio personality) and Goldie Watson (who was purged from her job as a public school teacher for her connections to the CPUSA) defeated the old centrist leadership of the Philadelphia chapter of the NAACP despite the opposition of the national

headquarters. The new Left administration advocated a more activist and less legalistic and legislative strategy for challenging segregation and racial discrimination than had been employed by the chapter in the past. It also sought to engage poorer, working-class African Americans who felt excluded by the professionals who had previously dominated the leadership. However, constant battles over the control of the branch between the Left and the centrists (aided by the national office of the NAACP, sometimes covertly, sometimes openly) within the context of the deepening Cold War hobbled efforts to fulfill this Left vision of a broader, more activist NAACP attuned to the needs of working-class African Americans. The anti-Communist liberal bloc regained power in 1951. For the next decade, the NAACP maintained a relatively low profile in Philadelphia politics.[120]

Like its counterparts in New York and other former hubs of African American Left activity, black Philadelphia appeared politically quiet for the most part during the height of the Cold War, particularly after the defeat of the Left in the NAACP in 1951 and the final demise of the CRC in 1956. Philadelphia saw both what might be thought of as common-variety McCarthyism (HUAC hearings, firings of teachers and others, decertification campaigns against Left-led unions, obvious surveillance of radicals by the FBI and other intelligence agencies, and so on) and some more extreme expressions of anti-Communism (e.g., the burning of the CRC office and physical attacks on known leftists in the former Left stronghold of the Strawberry Mansions section of North Philadelphia).[121] At the same time, the anti-Communist consensus in Philadelphia was weaker than in other areas in some respects. A combination of civil libertarians, the local bar association, the Quaker community, and the Left combined to successfully defend local Smith Act defendants, marking the gradual erosion of the legal and ideological underpinnings of McCarthyism.[122]

As in New York, Detroit, Chicago, Oakland, and elsewhere, veterans of the Left and of various nationalist organizations in Philadelphia remained at the edge of mainstream political discourse in the black community, organizing around grassroots issues, maintaining study groups, bookstores, forums, and other educational institutions, and offering critiques of Cold War liberalism (and traditional racism) that were available to young militants, artists, and intellectuals from the ghettos of West and North Philadelphia. Undoubtedly, the most influential nationalist group in Philadelphia during the 1950s was the NOI. Malcolm X spent a brief period in the city during 1954, founding (or shoring up a

moribund) Mosque Number Twelve. Malcolm X soon moved on to Harlem but remained a frequent visitor to Philadelphia. Elijah Muhammad's son, Wallace Muhammad, soon followed Malcolm X as the leader of the NOI in Philadelphia. As elsewhere, the NOI rarely joined directly in activist politics in Philadelphia, but its emphasis on black pride and black self-reliance, its rejection of liberal integrationism, and, by the 1960s, the Left internationalism of its paper, *Muhammad Speaks*, greatly influenced the emerging generation of black radicals in the city.

One of the young radicals that the NOI touched was Larry Neal, who, as mentioned above, played key roles in defining the field of the Black Arts movement and in moving the black bohemians downtown toward Harlem and cultural nationalist formations. Neal, a graduate student in folklore at the University of Pennsylvania in the early 1960s, had grown up in North Philadelphia, the son of a railroad worker and a domestic worker. He went to Catholic parochial schools, where he met the playwright Charles Fuller. In the early 1960s, Neal also became involved in both the Left and the NOI, attending Mosque Number Twelve and participating in an independent black Marxist group, Organization Alert, led by Bill Davis, who was equally at home in CPUSA and nationalist circles. Organization Alert saw its task as "providing leadership" to the black community but in many respects functioned as a study group. While Organization Alert was not directly affiliated with the CPUSA, quite a few of its members were (or became) CPUSA members or supporters, including Bill Crawford (the manager of the CPUSA bookstore in Philadelphia) and Jarvis Tyner (the brother of jazz pianist McCoy Tyner and a future national leader of CPUSA youth groups and, eventually, the party itself).[123] Neal also mentions that he worked in a "communist bookstore" while a graduate student. This bookstore was almost certainly the CPUSA bookstore that Bill Crawford managed.[124] At the same time, Neal met with other black artists and intellectuals centered in the Powelton Village neighborhood near Drexel University in West Philadelphia (where the Philadelphia police would attack the headquarters of the organization MOVE decades later).

Neal himself describes traveling to New York with Davis, meeting former CPUSA activist and tenant leader Jesse Gray and labor organizer Jim Houghton, and visiting Lewis Michaux's National Memorial African Bookstore, the nationalist landmark on 125th Street and Seventh Avenue, and the CPUSA's Jefferson Bookstore on Twelfth Street just off Union Square.[125] Neal's comments on the symbolic and practical significance of the square in front of Michaux's book-

store, where "one could feel emanating all of the necessary, but conflicting strands of nationalism," points up how important the accessibility of New York, particularly Harlem, was to his development:

> It was Freedom Square, Garvey Square, Little Africa, Mecca, the University of Timbuctoo, the voice of Nat Turner, Du Bois, Benjamin Davis, Duke Ellington, Eloise Moore, Queen Mother Moore, Charlie Parker, Shango, Black John the revelator, Buy Black, Carlos Cook[,] Porkchop Davis (somebody oughta do a book on him), Malcolm X, Mr. Michaux, James Lawson, Richard Wright, Kwame Nkrumah, and Ellison's Ras.[126]

Here Neal reveals the "necessary but conflicting" ideological strands that characterized his work (and the artistic and political work of many of the Philadelphia activists), where the nationalist Eddie "Porkchop" Davis intersects with the Communist Benjamin Davis.

Neal, however, did not develop this vision entirely from experiences in New York. As mentioned above, he encountered nationalism and the Left in Philadelphia, moving among artists and intellectuals who read such journals as *Muhammad Speaks, Freedomways, Masses & Mainstream, Presence Africaine, Studies on the Left*, and *Negro Digest* and such authors as Antonio Gramsci, Frantz Fanon, Amiri Baraka, Harold Cruse, and Janheinz Jahn. Jahn's *Muntu: The New African Culture* inspired the creation of the Muntu group, which grew from the Powelton Village circle and included Neal, Charles Fuller, Maybelle Moore, and James Stewart, influencing crucial elements of their approach to art (and politics). Jahn argued that underlying African art across many cultures, languages, and so on was a unity based on notions of spiritual force and rhythm. The conceptual framework not only gave the Muntu group a truly Pan-African way of thinking about culture on the continent but also a means for analyzing African American culture for the deep structures binding it to Africa. It was this notion that molded the attempts of the Muntu group to formally experiment with incorporating some sense of this underlying spiritualized African rhythm in their work. It also helped them theorize a revolutionary alternative to the "Western" revolutionary tradition, providing an African spiritual and aesthetic dimension that they felt had been missing in Marxism. This aesthetic/spiritual dimension combined with what Neal called the proposition of Malcolm X and the NOI that African Americans needed to organize around a "separate and distinct" identity

and with Harold Cruse's 1962 critique of institutionalized "Western Marxism" in "Revolutionary Nationalism and the Afro-American," which called for a new "revolutionary nationalism."[127] At the same time, Neal, Stewart, and the Muntu group continued to use class as an important concept for defining their sense of what they were trying to do with their art and what audience they were trying to address. Stewart, for example, argued that it was a black working-class audience in Philadelphia that nurtured John Coltrane and the other important jazz modernists that emerged from that city in the post–bebop era, contrary to the usual truisms about the avant-garde and popular audiences. This sense of the black jazz avant-garde's plebeian grounding in Philadelphia no doubt underlay the contributions that Neal and Stewart in particular made to the model of a popular avant-garde, which are discussed at more length in Chapter 2.[128]

One of the people that Neal met in Organization Alert who would have great impact on his career — and the shape of the Black Arts movement — was a young Philadelphian, Muhammad Ahmad. Ahmad's political and cultural education came from many ideological sources. His father, an NAACP activist, espoused what might be thought of as a black entrepreneurial nationalism and was deeply suspicious of the impact of integration on black-owned businesses. Political discussions and NAACP meetings in his father's house were important features of Ahmad's childhood. At the same time, his mother, a working-class woman who divorced his father when Ahmad was young, remained dubious of the father's middle-class aspirations. Ahmad also absorbed the ideas of the NOI and Malcolm X through a cousin who was a member of Mosque Number Twelve. Another cousin who frequently minded him when he was a child introduced him to jazz, taking him to see Charlie Parker at age nine. Jazz and art became the passions of Ahmad, who envisioned a career as a painter for himself.[129]

Ahmad left Philadelphia to study art education at the historically black Central State University in Wilberforce, Ohio, in 1960. As with other historically black colleges in the early 1960s, Central State's student body included a significant number of African students, many of whom were radicals and sometimes Marxists. Also among the student body were young militants who had been expelled or forced out of southern black schools for their activities in the civil rights movement. And as at other northern historically black schools, there were liberal-Left professors on the faculty (including Marxists) who had trouble getting jobs elsewhere.[130] In short, Central State was the sort of place where a

student could be directly exposed to other students deeply familiar with the sit-in movement of 1960, Malcolm X and the NOI, and Robert Williams's call for armed self-defense outside the classroom, while being introduced to radical ideas about philosophy, art, political science, and economics in his or her courses. In the case of Ahmad, his education also took place off campus when he became active in the local chapter of CORE.[131]

Events off campus, both North and South, influenced Ahmad and other militants with whom he would later join. In Ahmad's hometown, the Philadelphia Youth Committee (including Stan Daniels, later a RAM leader) initiated a series of pickets at Woolworths, Grants, and Kresges in support (and in emulation) of the southern student movement in 1960. Ultimately, these demonstrations provoked a broad (if short-lived) alliance of civil rights organizations, bringing thousands to the picket lines.[132] These picket lines were followed by the Selective Patronage campaign aimed at the hiring and promotion practices of major corporations in Philadelphia. This campaign, spearheaded by Rev. Leon Sullivan and other leading black ministers who formed the 400 Ministers group, revived the "Don't Buy Where You Can't Work" efforts of the 1930s. During 1961–64, Selective Patronage (which avoided the word "boycott" due to Pennsylvania antiboycott laws) successfully took on such corporate giants as Tastykake, Pepsi-Cola, Gulf Oil, Sunoco, Breyers Ice Cream, and A & P in what was probably the most effective drive of its type in the history of the United States. One of the things that made the movement distinctive is that it did not make moral appeals to white consumers and organizations for support but relied completely on the solidarity of the broad black community and was led entirely by African Americans.[133]

It was within this context of southern *and* northern struggle that a number of black student activists went to a 1961 conference of the National Student Association in Madison, Wisconsin. Ahmad attended the conference as a representative of Central State. At the conference, the SDS organized a progressive caucus, including Donald Freeman (not to be confused with the Bay Area's Don Freeman), a black student at Case Western and a charismatic speaker and writer with a background in the SP and the SP roots of the SDS. Ahmad met Freeman during the course of a failed effort to get SNCC admitted to the NSA. At an informal get-together of SNCC members and their supporters (including Ahmad), news came of Robert Williams's flight from the United States. This provoked a discussion of the significance of Williams's work and the need to do something

to allow him to return to the United States. Though no formal group was constituted, there was general agreement to stay in touch.[134]

Back at Central State, a group of students (including Ahmad), some of whom had participated in the southern movement and others who had been members of various nationalist groups, organized Challenge, a radical but ideologically diverse group. Challenge dedicated itself to campus issues, particularly the typically paternalistic attitudes of the administration, and to advancing a sense of black political consciousness and solidarity (not unlike the early AAA in California, the protorevolutionary nationalist group UHURU in Detroit, and the Organization of Young Men in New York).

Challenge kept up its correspondence with Donald Freeman, who now advocated the creation of a nationwide revolutionary nationalist organization that combined the focus on identity and culture of the NOI, the militancy of Robert Williams, the direct-action tactics of SNCC (but oriented toward the urban North), and a working-class orientation and cadre structure (and political analysis) that owed much to Marxism and Leninism. Like Neal, Freeman strongly promoted Cruse's "Revolutionary Nationalism and the Afro-American." Freeman, by then a public school teacher in Cleveland, spent his vacations traveling across the Northeast, the South, and the Midwest, attending events sponsored by Left and nationalist groups, looking for young African Americans interested in nationalism and socialism. In this way, he began to assemble a network of like-minded young black activists, such as introducing Ahmad to Askia Touré and Calvin Hicks.[135]

Challenge moved organizationally toward the model Freeman advocated, changing its name to the Revolutionary Action Movement in 1962 — though to avoid antagonizing the Central State administration, the group initially used Reform Action Group publicly. Challenge took control of the Central State student government, rallying a wide spectrum of students against the behavior of the administration (which had called the Ohio State Patrol on campus over a panty raid). After this campus success, some of the RAM activists decided to go back to their hometowns to organize local chapters as cadre groups along the lines that emerged from the discussions between Freeman and the Central State group.[136]

Ahmad returned to Philadelphia in the summer of 1962. He soon organized a meeting of his high school friends that was addressed by Freeman. Freeman envisioned the group that grew from the meeting as a sort of pilot project of RAM — though it was some time before RAM gained any real coherence in Phila-

delphia. While Cleveland continued to be an important locus of RAM activity, Philadelphia increasingly became the organizational center from which most of the group's publications issued, including its major organ, *Black America.*

By the early 1960s, Philadelphia had not only become a center of northern civil rights struggle but, not surprisingly, also a northern waypost of the southern movement. In the early period after Ahmad's return to Philadelphia and the loose establishment of a RAM core group, this civil rights dynamism allowed him to work with activists and organizations over a wide ideological spectrum, including SNCC (which established an office in the city), the remnants of the UNIA, Organization Alert, and the NOI. He also drummed with members of the local Yoruba Temple on the weekends. It was through this ideologically diverse network of civil rights, Left, and nationalist groups and individuals that Ahmad met a series of elders and contemporaries who would be crucial for his political development. Early on, Ahmad was encouraged by SNCC's Ella Baker, who had read a position paper that he circulated on the civil rights movement. Ahmad also met Ethel Azalea Johnson, an important co-worker of Robert Williams in Monroe, North Carolina, who lived in Philadelphia for a time during this period. Like Baker, Johnson was impressed with the position papers written by Ahmad. She took him under her wing, giving him pointers on the hows and whys of grassroots organizing, including the old Leninist dictum of a revolutionary movement's need for a regularly issued organ. Before she left Philadelphia, Johnson also introduced Ahmad to another important mentor, Queen Mother Audley Moore, a former Garveyite and former Communist who left the party in the early 1950s, seeking to combine Marxism, CPUSA organizational principles, and a neo-Garveyite nationalism.[137]

It was in Organization Alert that Ahmad met Neal, whose broad interests in Marxism, nationalism, and culture dovetailed nicely with those of Ahmad and the emerging RAM group.[138] Ultimately, Ahmad was expelled from Organization Alert. His expulsion stemmed largely from an argument with Bill Davis (and Larry Neal) in which Ahmad claimed that SNCC was the key black political group of the period, while other Organization Alert members, especially Bill Davis, believed it would never be a revolutionary force. However, Ahmad retained his connection to Neal, who joined RAM at its national meeting in Detroit in 1964.[139] It appears that Ahmad had at least peripheral contact with other Left groups during this period. According to an FBI report, he spoke on the black liberation movement at an SWP forum in Philadelphia on at least one occasion.[140]

Following the discussions with Freeman, Johnson, Moore, and the members of Organization Alert and a dialogue between Malcolm X and RAM leaders Ahmad and Wanda Marshall, Ahmad and the RAM core decided to move the group toward a more open, activist identity that would emphasize mass action as well as study. The RAM leadership in Philadelphia, which now also included Stan Daniels, enthusiastically joined the Selective Patronage campaign, seeing it as a grassroots example of the sort of black working-class mass action that they wanted to promote.[141] RAM also allied itself with Cecil Moore, who had won the leadership of the Philadelphia chapter of the NAACP in 1963 on a platform that synthesized nationalist calls for black pride, black self-determination, and black self-defense with an approach to organizing that concentrated on the black working class and emphasized the direct action tactics of the student movement and the Selective Patronage campaign. While Cecil Moore seemed to most clearly invoke a nationalist rejection of the liberalism that had dominated the chapter since 1951, he also gestured toward earlier moments of Philadelphia radicalism—Goldie Watson made the fund-raising appeal at the kickoff membership rally at the Corner Stone Baptist Church that was the first major event of the Moore administration. RAM joined in the Freedom Rallies of the NAACP that drew thousands of participants. It also significantly influenced NAACP-supported protests of racist hiring and promotion in the construction trades in 1963—protests in which Ahmad and Daniels were beaten and arrested by the police for "inciting a riot."[142]

RAM's ideology at this point is hard to define precisely—in part because the ideology of Ahmad and the core of RAM was in process. In truth, RAM was never as unified organizationally or ideologically as its projected image as an underground cadre organization would suggest. There was much variation about how the group worked in different cities. Perhaps the best way to describe RAM nationally is as a network of, for the most part, young activists. The network was essentially revolutionary nationalist in orientation with a strong bent toward self-study involving "traditional" Marxist theory (often through the urging of Queen Mother Moore, who insisted that they master Marxism-Leninism without allowing it to master them), "classic" black nationalism, anticolonialist works by such intellectual-activists as Frantz Fanon, Aimé Césaire, Julius Nyerere, Kwame Nkrumah, and Jomo Kenyatta and such African American radicals and/or nationalists as Malcolm X, James Boggs, and Robert Williams.[143] Its members tried to move black politics and culture in a revolutionary

nationalist direction through broad agitation using RAM publications, such as *Black America* and various leaflets, broadsides, and pamphlets, and non-RAM publications, notably Williams's *The Crusader* and *Soulbook* (which might be thought of as a semi-organ of RAM). On the model of the CPUSA and other basically Leninist organizations (though, again, in practice without the centralism that marked most Leninist groups), the RAM cadre also worked through membership in various "mass" organizations, such as SNCC, BARTS, and so on. One important method through which RAM's network expanded was the tours of Freeman, and later Ahmad, who would visit different cities and organizations looking for young African Americans interested in nationalism, militant political action, and/or socialism. Ahmad's relationship with activists in New York was particularly important, as he would take the train up from Philadelphia, visiting such young political and cultural leaders as Baraka and Calvin Hicks, distributing literature and promoting communication between black radicals of various types.[144]

Despite RAM's emphasis on preparing for guerrilla warfare and relatively little mention of culture in its programmatic documents, one aspect of RAM in Philadelphia that is noteworthy is its orientation toward the arts — even in a time of great interest in culture and education by Left and Left nationalist groups.[145] Other revolutionary nationalist organizations, such as the various Black Panther parties (inspired by James Forman's call for independent black political organizations after the model of SNCC's Lowndes County Black Panther Party in Alabama) and the LRBW, paid much attention to the question of culture and the Black Arts movement as a crucial component of Black Power. The BPP's Bobby Seale (who had been in RAM on the West Coast) acted in the plays of Ed Bullins and Marvin X before he was a leader of the Panthers; Eldridge Cleaver was introduced to Seale and Huey Newton largely through mutual contacts in the BAW, primarily Bullins and Marvin X. Even after the BPP's split with Bullins and Marvin X, and indeed its alienation from much of the Black Arts movement, it still retained enough interest in culture (and the Black Arts counterculture) to bring Sun Ra to Oakland as a sort of artist-in-residence, if only for a brief and troubled time in the 1970s. An early New York Black Panther Party independent of the BPP featured Larry Neal and other former BARTS activists among its leadership.[146] CAP, too, put a high priority on the arts and culture, with its sessions on culture at its first convention chaired by former RAM member Neal. But no early Black Power organizations besides RAM, as far as I am aware, actually di-

rected leading members to work with emerging cultural institutions like Umbra or BARTS as their primary political task in the same way that they might assign someone to work in a trade union, civil rights group, or community political association. Cultural workers and cultural groups (with an interest in politics) were key stops on the circuit of Ahmad's visits, especially in New York, as well as political activists and organizations (interested in culture). As noted by Baraka, there was a convergence in RAM—and eventually in the Black Arts movement generally—between essentially political types with an interest in culture, such as Ahmad (who, in fact, had an arts background), and essentially cultural types with an interest in politics, such as Neal (and Baraka, who never joined RAM but was greatly influenced by RAM members Ahmad, Neal, and Askia Touré). According to Ahmad, RAM at this time saw no difference between culture and politics.[147] In fact, Ahmad claims that Baraka visited him after the assassination of Malcolm X while Ahmad was living in Brooklyn. Baraka asked Ahmad what he should do, and Ahmad suggested that he start the cultural wing of the new radical movement, in part inspiring the creation of BARTS. Though only Neal was officially assigned to work in BARTS, Ahmad and Touré remained crucial supporters, joining in many BARTS activities.[148]

Touré and Neal also prepared the ground in Harlem for BARTS through their activities in the Uptown Writers Group, a fairly loosely structured organization that also included such poets as Keorapetse Kgositsile (then a leader of the cultural section of the African National Congress in exile) and Yusef Rahman (Ronald Stone). The Uptown Writers Group organized a series of poetry readings in Harlem lofts drawing a diverse black audience, ranging from bohemians to sorority members, largely through Neal's wide contacts.[149] RAM was also a crucial influence on the seminal West Coast journal *Soulbook*.[150] As noted earlier in this chapter, the essays of RAM members, particularly Neal, Touré, and Ahmad, in *Liberator* in the mid-1960s (after Neal's move to New York in 1964) significantly defined the ideological field of the Black Arts movement. It was through the offices of Neal in *Liberator* and *Black Fire* that the Muntu group intersected with Ahmad and his RAM comrades, promoting the notion of a popular avant-garde continuum, as is discussed in Chapter 2. In short, the radical direction that the Black Arts movement took in New York City was in no small part due to a long foreground of radical black political and artistic activity in Philadelphia and to the special relationship that size and proximity established between New York and Philadelphia.

Black Arts, the Nuyorican Poets, and Multiculturalism

Writers of Puerto Rican descent joined the Black Arts movement in New York almost from its beginning. Victor Hernandez Cruz, like many of his black contemporaries on the Lower East Side, mingled with members of the second-generation New York school while at the same time joining in African American nationalist institutions and events. Both Cruz and his friend Felipe Luciano hung around the edges of the Umbra group and downtown black bohemia.[151] Cruz's poetry appeared in several Black Arts journals as well as in the anthologies *Black Fire* and *The New Black Poetry*. Luciano went on to greater fame uptown as part of an early configuration of the Last Poets before becoming a leader of the Young Lords (a revolutionary nationalist Puerto Rican organization modeled largely on the BPP) in Newark. In Newark, Luciano and Amiri Baraka were instrumental in forming the alliance between African American and Puerto Rican activists that allowed the Black Power movement in Newark to take over city hall — at least for a while. Even though the revolutionary nationalist Young Lords were theoretically hostile to Baraka's cultural nationalist CFUN, the relationship that Baraka and Luciano forged in the Black Arts movement in New York helped CFUN and the Young Lords in Newark transcend this potential conflict.[152] Baraka also became close to a number of the other key Nuyorican writers, especially Miguel Algarín and Miguel Piñero. Algarín's Nuyorican Poets Cafe on the Lower East Side first produced Baraka's 1978 play *What Was the Relationship of the Lone Ranger to the Means of Production?*[153]

The work of the Nuyorican writers as framed by Algarín and Piñero in their seminal anthology *The Nuyorican Poets* (1975) was strongly inflected by northeastern Black Arts conceptions of the relation between language, music, popular culture, and a national identity that is distinct from that of the "mainstream" United States and of what might be thought of as originary cultures outside the United States. As with the Black Arts writers, the Nuyorican identity and its poetic expression is conceived as turning on a creolized language and music:

> There is at the edge of every empire a linguistic explosion that results from the many multilingual tribes that collect around wealth and power. The Nuyorican is a slave class that trades hours for dollars at the lowest rung of the earning scale. The poems in this anthology document the conditions of survival: many roaches, many busts, many drug poems, many hate poems—

many, many poems of complaints. But the complaints are delivered in a new rhythm. It is a *bomba* rhythm with many changing pitches delivered with a bold stress. The pitches vary but the stress is always *bomba* and the vocabulary is English and Spanish mixed into a new language. The power of Nuyorican talk is that it is street rooted.[154]

Here one finds a Nuyorican version of the continuum of culture proposed by Baraka, Neal, Sanchez, and Touré in which a link is made between the traditional Afro–Puerto Rican *bomba* rhythm and the culture shaped by the streets of the Bronx, East Harlem, and the Lower East Side—one that also resembles Black Arts theorist Stephen Henderson's notion of "saturation."[155]

However, in some respects the Nuyorican poetry published during the late 1960s and early 1970s differed considerably from much that was produced by African American and Chicana/o nationalist poets. Attempts to link contemporary identity to a prehistoric culture, whether African, Aztec, or Mayan, are far less pronounced in Nuyorican poetry. In fact, on occasion some key Nuyorican poets, such as Miguel Algarín, criticized notions of neoindigenism and advanced a hybrid concept of national identity located in, but not of, the United States:

> your survival
> is Nuyorican not Taino
> not black, not white
> just Nuyorican[156]

There is a connection to the perceived interculturalism of the island, a model of culture containing Native American, European, and, especially, African elements in easier association than was the case with the Black Arts movement and the Chicano movement, which posed the opposition of African and European cultures or indigenous Native American and European cultures. Of course, such nonconformist hybridity resembles that which Baraka proposed for African Americans in his transitional pre–Black Arts work, particularly *Blues People*.

Nonetheless, much Nuyorican poetry (and its theorization) draws heavily on the northeast Black Arts focus on the urban neighborhood as homeland, present and future:

> A small nationalist clique is any city gang that is geographically located in a particular neighborhood or city block and protects its laws. The purpose for wearing colors, designing a flag, or having an anthem is to develop an iden-

tity. A city clique needs to have a geographical identity as inviolable as that of any nation formally recognized by the UN.[157]

The barrio, particularly East Harlem ("El Barrio"), the South Bronx, and the Lower East Side (or "Losaida," as it was known to many Puerto Ricans), is the ur-landscape of Nuyorican identity—though Nuyorican poetry lacks the un-ironic utopianism common in Black Arts poetry and such theoretical statements and manifestos as Baraka's "The Changing Same" for the most part. And as in much Chicano movement (and some northeastern Black Arts) poetry, this literature focuses on the street figure, the gang member, the junkie, and so on as the embodiment of a Nuyorican counterhistory. This figure is very often that of the poet himself or, more rarely, herself. This merging of poet and street also occurs in Chicana/o poetry, particularly that by such *pinto*, or prison, poets as Raúl Salinas and José Montoya. However, this location of the poet-speaker as a street figure–participant rather than as an observer (albeit an insider-observer) is even more pronounced in the work of such Nuyorican poets and playwrights as Algarín, Piñero, Cruz, and Pedro Pietri than in that of the Chicano movement and Black Arts poets. Again, this poet-speaker frequently recounts personal histories that give a sense of the dynamism of social history without much direct reference to a historical narrative beyond autobiography.

As with the proto–Black Arts movement writers in New York during the early 1960s, the locus of Nuyorican writing was the Lower East Side. East Harlem (and to a lesser extent, the South Bronx) held a special symbolic meaning as the ur-Nuyorican "home," much like central Harlem for black writers—as its designation as "the" barrio would suggest. However, since nonbohemian Puerto Ricans clustered in the Lower East Side in a way that African Americans never did, it was not necessary for the Nuyorican writers to move uptown physically and ideologically in order to be home. Instead, much Nuyorican literary activity continued to be rooted downtown as well as uptown in Harlem and the Bronx without the sorts of intense contradictions that black artists who remained downtown often felt.

It seems quite likely that the location in the polyglot Lower East Side, a multiethnic neighborhood wracked with ethnically inflected political struggles all through the 1970s, encouraged the self-consciously hybrid, anti-neoindigenous nationalism that marked many of the Nuyorican writers.[158] It could be argued that the cultural location of Puerto Rican migrants in similar neighborhoods

throughout the Northeast encouraged such a hybridized quasi-national iden-
tity—the interlingual speech popularly known as "Spanglish" was not, after all,
unique to the Lower East Side. However, much the same could be said about
Chicana/os, and yet various sorts of neoindigenous essentialism (a concept that
would not have been understood to be the academic insult it eventually be-
came) were far more common in Chicana/o literature than among the Nuyori-
can writers. In part, this is no doubt due to the fact that the figure of the Native
American and Native American cultures play a greater role in the Mexican na-
tional myth than in the Puerto Rican—except, ironically, in the Taino-derived
"Boricua" (or "Boriqua") favored by Puerto Rican nationalists of various types
as a name that figured an essential commonality between Puerto Ricans on the
island and in the diaspora. Even where Puerto Rico's *indio* heritage was extolled,
it was often in conjunction with other cultural influences, generally African.[159]
(And, no doubt, the fact that large Native American communities survived in
Mexico after the indigenous population of Puerto Rico was long gone con-
tributed to the differing degrees of neoindigenism in the Chicano movement
and Nuyorican art.) The archetypal Chicano movement's literary landscape of
poetry, drama, and fiction is almost exclusively the Chicana/o barrio or rural
hamlet of Southern California, Texas, and the Southwest, encouraging visions of
Aztlan and cultural purity—even if it somewhat ironically involves casting the
pachuco or the *vato loco* (a street term for a gang member that loosely translates
as "crazy guy") as an Aztec warrior reborn. It is true, as discussed in Chapter 5,
that the stance of many Chicana/o poets active in San Francisco's Mission Dis-
trict, another traditionally immigrant neighborhood much like the Lower East
Side, during the late 1960s and the 1970s resembled the Nuyorican poets. In
fact, one Nuyorican poet, Victor Hernandez Cruz, figured prominently in the
Mission District scene. And some Chicana/o writers, especially those like Raúl
Salinas who grew up in mixed Chicana/o–African American neighborhoods,
foregrounded in their work an interface between Chicana/o and African Ameri-
can cultures in much the same way that many Nuyorican poets did with Puerto
Rican and black popular culture. However, despite the importance of the work
by Chicana/o artists in the Mission District to the rise of multiculturalism, the
early canon of the Chicano movement and Chicano studies focused far more on
the landscapes of Los Angeles, rural California, Texas, and New Mexico than of
the Bay Area.

Thus, it makes sense that the Nuyorican writers, such as Algarín and Piñero,

would be crucial in the formation of the multicultural performance poetry movement of the 1980s and 1990s. Their engagement with a pan–cultural nationalism, their continued location on the Lower East Side, and their connections with the New York Black Arts movement (uptown and downtown), the West Coast multiculturalists who were active in or influenced by the Black Arts movement in the Bay Area, the multiracial bohemian communities of the Lower East Side (from Beats to post-Punks), and the hip-hop scene (itself much marked by the Black Arts movement) that emerged from the heavily Puerto Rican South Bronx all contributed to the creation of what might be thought of as the "rainbow" end of multiculturalism.

Conclusion

As noted before, the most vital contribution of the Black Arts movement in the Northeast was not primarily institutional. This is not to dismiss the importance (and in a few cases, the longevity) of The East in Brooklyn; the New Lafayette Theatre, the NBT, the Studio Museum, the journal *Black Theatre*, and Liberation Books in Harlem; Spirit House and Jihad Productions in Newark; ELSFA, the NCAAA, and the Museum of the NCAAA in Boston; the Lee Cultural Center, the Black Museum, the Freedom Theatre, and the Afro-American Thespians in Philadelphia; and a host of similar institutions in Baltimore, Hartford, Buffalo, Pittsburgh, and other small, medium, and large cities in the region. It is also important to note that even though there were relatively few major Black Arts institutions in the Northeast that endured for very long, various individuals served (and continue to serve) as linchpins for series of activities and institutions that have more continuity than might at first seem to be the case. For example, Amina and Amiri Baraka have been at the center of black cultural activity in Newark for decades, providing a living link between Spirit House in the 1960s and their Kimako's Workshop in the twenty-first century.

However, it seems fair to say that the Northeast, especially New York, was most important as an incubator of a Black Arts cadre and crucial Black Arts ideological stances. Again, this is not to claim, as has been occasionally asserted, that the movement started in New York and spread elsewhere. As is argued throughout this book, there were too many initiatives going on across the country to trace the birth of the movement to any one site. Nonetheless, if there

was, as Aldon Nielsen and others have claimed, a migration of innovative black writers to New York in the late 1950s and early 1960s, there was also a later emigration that greatly influenced the shape of the movement in other areas. The temporary or permanent relocation (or return home in some cases) of writers active in the radical black artistic and political movements in New York during the early and mid-1960s, including Amiri Baraka, Sonia Sanchez, Askia Touré, David Henderson, Tom Dent, A. B. Spellman, Lorenzo Thomas, and Ishmael Reed, to the West Coast, the South, and elsewhere in the Northeast had a huge impact on the way the Black Arts movement developed in those regions. The circulation of writers and ideas from New York helped give the local movements elsewhere a sense of a coherent national movement while at the same time providing activists remaining in the Northeast a clearer picture of what was taking place in other regions. In turn, this direct encounter with local Black Power and Black Arts organizations in the South and in the West by East Coast artists and intellectuals facilitated the exchange of ideas and practices that had a major impact on the Black Arts movement in the Northeast. For example, as noted in Chapter 5, Amiri Baraka was not much engaged with the cultural nationalist ideology of Maulana Karenga until his sojourn at San Francisco State and the BCP, when he got to see Karenga's Us organization on the ground level.[160]

Beyond the part the proto–Black Arts and early Black Arts institutions played in shaping this cadre of artist-activists, BARTS served as an inspirational model (and cautionary tale) of what a radical nationalist institution might be. Due to the high profile of New York City and the symbolic meaning of the Harlem community, BARTS helped catalyze the radicalization and growth of Black Arts institutions across the nation. BARTS had the impact that it did (and attracted the attention and resources that it did) because of the mythic power of Harlem and in turn reinforced that power. BARTS ultimately collapsed under external pressure and from its own extreme internal conflicts and contradictions. In any event, it probably would have been unable to maintain its position as the Black Arts movement gained a sense of national coherence, weakening notions of center and periphery, cultural capital and provinces—though the power of the myth of Harlem as cultural capital only diminished, not completely vanished. Again, it is too much to claim that BARTS was the parent of the movement, but it did much to influence Black Arts self-consciousness and ideological/aesthetic stances. And as mentioned above, the influence of the early Black Arts move-

ment on young writers of Puerto Rican descent, both through example and through the direct participation of some of those writers in early Black Arts activities and institutions, did much to promote the emergence of the Nuyorican writers and, ultimately, the multicultural literary movement on both the East Coast and the West Coast.

4

Institutions for the People: Chicago, Detroit, and the Black Arts Movement in the Midwest

Though the Northeast has often been the regional focus of accounts of the Black Arts movement, due largely to the national reputation of Amiri Baraka, the Midwest and the San Francisco Bay Area birthed the most important and most enduring Black Arts institutions. The Midwest, home of Broadside Press, Free Lance Press, Lotus Press, and Third World Press (now the oldest continuously functioning African American–run literary publisher), was the heart of African American independent publishing. A host of nationally influential newspapers, journals, artists' groups and workshops, theaters, book clubs, anthologies, and schools also emerged in the Midwest. Some of these included *Negro Digest* (later *Black World*), *Black Books Bulletin*, OBAC, AFRI-COBRA, the Kuumba Workshop, Concept East Theatre, Affro-Arts Theater, the eta Creative Arts Foundation, the AACM, the Institute for Positive Education, BAG, and Katherine Dunham's Performing Arts Training Center. In fact, we owe much of the physical record of Black Arts literature today to midwestern institutions, since Broadside Press, Third World Press, and Lotus Press alone produced an inordinately high proportion of the titles issued by black publishers in the 1960s and 1970s, sometimes with sales in the tens of thousands—a remarkable feat for small press poetry publications. And as Haki Madhubuti notes, if one wants to get a sense of the development and range of the Black Power and Black Arts movements, the first thing to do is to look at the run of *Negro Digest/Black World*.[1]

Detroit and Chicago stand out as hubs of the movement not only regionally

but also nationally. Other midwestern cities contributed to the early growth of the Black Power and Black Arts movements, especially Cleveland and St. Louis–East St. Louis but also Columbus, Cincinnati, Indianapolis, and Kansas City. However, the numerous direct exchanges and interconnections between African American cultural and political activists in Chicago and Detroit made the Black Arts movement in those cities exceptionally vital. Of course, many of these activist-artists had close links to individuals and institutions in other midwestern cities, particularly St. Louis–East St. Louis and Cleveland, and in Black Arts centers outside the region. And the power and vitality of the Black Arts movement in Chicago and Detroit were no doubt due in part to the concentration and size of the black community in those cities. Nonetheless, there were cities with large African American populations that had much less impact on African American cultural production nationally.

The story that this chapter provisionally sketches, then, is the relation of the nascent Black Arts movement in Chicago and Detroit to earlier moments of African American political and artistic radicalism and the special contribution of those two cities to the growth of the movement nationally. The focus here is on literary production, but as will become obvious, literature was only a part of a wide-ranging black artistic scene in Chicago and Detroit. Perhaps the most distinctive feature of the Black Arts movement in Chicago is that it is difficult, if not impossible, to pick out a dominant artistic genre. The visual arts there were at least as important in the nationalist cultural movements of the city as poetry, drama, and music, particularly after the painting of the *Wall of Respect* in 1967 by the artists of the OBAC Visual Arts Workshop (out of which came the core of the AFRI-COBRA group). Also, as noted in Chapter 2, the pronounced tendency of the Black Arts movement toward multimedia, multigenre productions make clear generic distinctions problematic — as seen, for example, in the incorporation of a text, Amiri Baraka's poem "SOS," as a prominent feature of the *Wall of Respect*. In short, even more than in other regions, it is not possible to discuss a single Black Arts genre without doing considerable violence to the historical record.

As we have seen elsewhere, nuts-and-bolts political activism (not simply some sort of symbolic politics) cleared a space for, energized, and created a support network for black artistic production in Chicago and Detroit and vice versa. One political feature that the two cities shared in the 1950s and early 1960s was a long history of African American nationalist organizations with significant grassroots support. Perhaps the most important Chicago-Detroit exchange in this regard concerned the NOI, founded in Detroit during the early 1930s by W. D. Fard and Elijah Muhammad. After the disappearance of Fard in 1934, Muhammad moved the headquarters of the NOI to Chicago. Muhammad did not generally encourage grassroots political involvement by NOI members and espoused a fairly conservative ideology of black capitalism—though his opposition to militant activism has often been overstated insofar as he did not absolutely prevent local NOI leaders from supporting local political initiatives.[2] Still, as Sterling Plumpp recalls, the sheer size of the black community in Chicago and the hypersegregation that characterized the city encouraged a tradition of black self-reliance and institution building.[3] The NOI's continuation of this tradition in a nationalist modality greatly attracted local Black Power and Black Arts activists. Also, despite his conservatism, Muhammad staffed the NOI newspaper *Muhammad Speaks* largely with Left-leaning veterans of the African American press and the Popular Front in Chicago, such as editors Dan Burley, John Woodford, and Richard Durham, whom he defended from anti-Communism within the NOI. Durham in particular set a Left editorial direction in the early 1960s that lasted until the 1970s.[4]

Thus, Muhammad's relatively conservative columns notwithstanding, the general editorial direction of the paper was militantly antiracist and anti-imperialist (and often anticapitalist) as well as nationalist, anticipating the anticapitalist and anti-imperialist sentiments of both nationalists and Marxists within the Black Power movement—however much nationalists and Marxists would come to disagree about ultimate strategies and goals. As Penny Von Eschen points out, the sophisticated Left internationalist coverage of Africa and the post-Bandung world by *Muhammad Speaks* was often far superior to that of more mainstream African American newspapers, such as the *Chicago Defender* and the *Pittsburgh Courier*. Though the impact of the poetry page of the newspaper, which favored

conventional nineteenth-century styles, on black writers and intellectuals was small, the influence of the radical editorial stance of the paper, the largest circulation African American newspaper at its height, was considerable.[5] In addition to the Left presence at *Muhammad Speaks*, Christine Johnson, another veteran of the Communist Left who, like Richard Durham, had been a victim of McCarthyite purges, led the NOI education program at the University of Islam. Johnson frequently participated in public events sponsored by Left-led Chicago groups, especially the AAHA (of which she was the president in the early 1960s).

Seen against the general editorial thrust of *Muhammad Speaks* and the work of Christine Johnson within the NOI educational structure, Malcolm X's radical and uncompromising nationalism and anti-imperialism and his willingness to speak at forums of GOAL (the nationalist civil rights organization led by Rev. Albert Cleage Jr. and brothers Gaidi and Imari Obadele [Milton and Richard Henry]), the proto–Black Power Freedom Now Party, and the SWP and at other events organized by activist Left and/or nationalist groups seem less anomalous among the national voices of the NOI during the 1950s and early 1960s than one might expect. Of course, Malcolm X himself, aptly termed the spiritual father of the Black Power movement by Kalamu ya Salaam, is the other major Chicago-Detroit crossing associated with the NOI.[6] Returning to his native Michigan after being released from prison in 1952, Malcolm X was brought into the NOI organizationally by his brother Wilfred X, the leader of Detroit's Mosque Number One. Malcolm X soon became the leading recruiter for the NOI in Detroit. In 1953, Elijah Muhammad brought Malcolm X to Chicago for further training, launching Malcolm X on his national career.[7]

Malcolm X retained both emotional ties to Detroit as the birthplace of the NOI and site of his conversion and practical ties through his brother Wilfred. It was on the initiative of Wilfred X that Malcolm X came to speak at the 1963 Grass Roots Conference organized by Rev. Albert Cleage Jr., GOAL, and the Freedom Now Party.[8] Malcolm X's famous address to the conference, "Message to the Grassroots," proclaimed, "A revolutionary is a black nationalist. He wants a nation . . . If you're afraid of black nationalism, you're afraid of revolution. And if you love revolution, you love black nationalism."[9] This fiery speech rhetorically brought together familiar tropes of the nationalists and of the black Left before a large and enthusiastic crowd, galvanizing the African American community and greatly increasing interest in the Freedom Now Party and organized nationalism in Detroit.[10] Later, in Detroit as elsewhere, the murder of Malcolm X by killers

linked to the NOI limited the direct appeal of Elijah Muhammad and the NOI to Black Arts activists, opening the way for the influence of Maulana Karenga and the sort of disciplined nationalism that had formerly been the trademark of the NOI, particularly in Chicago.

Another thing that both cities had in common was that they had been major centers of African American Left activity associated with the CPUSA during the Popular Front era. In Chicago, this activity was concentrated in the trade union movement, particularly the United Packinghouse Workers Union of the CIO, as well as in a host of cultural and educational institutions, such as the South Side Writers Group, the South Side Community Art Center, the Abraham Lincoln School, *Negro Story* magazine, the FWP, the FTP, the FAP, *New Challenge* magazine (the brief and more consciously Communist incarnation of *Challenge* edited by Richard Wright and Marian Minus), and the *Chicago Defender.*[11]

In Detroit even more than in Chicago, the locus of the African American Left, and the Communist Left generally, was the labor movement, especially the CIO's UAW. The Communist Left was influential in those UAW locals with large numbers of black workers, notably Local 600 at the Ford Rouge plant in nearby Dearborn and, to a lesser extent, Local 3 at Chrysler's Dodge Main Plant in Hamtramck, a small, largely Polish American city surrounded by Detroit. Local 600 remained an active center of Left influence well into the Cold War era. Even after the Communist Left became a comparatively minor organized force within the local, powerful challenges to Carl Stellato's presidency of the union at the Rouge Plant in the 1960s often invoked the memory of the Left leadership of the 1940s when black workers held many top union posts there. These challenges sometimes won the majority of UAW members still working at the Rouge Plant, 40 percent of whom were black, though Stellato was able to hold on, largely through the support of white retirees. Dodge Main, where African Americans came to comprise the majority of production workers in the 1960s, eventually became the first major flash point of a Black Power labor activism that would spread throughout organized labor through DRUM and the Revolutionary Union Movement more generally. And though DRUM was generally hostile to the CPUSA, older African American workers with ties to the Communist Left, most prominently Lee Cain, played important roles in the wildcat walkouts and the struggles for black leadership in Local 3 that DRUM sparked — struggles that again were significantly frustrated through racist appeals to white retirees in union elections.

Prolabor black ministers, especially Horace White of the Plymouth Congregational Church and Charles Hill of the Hartford Avenue Baptist Church, worked closely with Communists in the CIO's organization of the Rouge Plant — a brave stand, since most African American ministers supported the largest employer of African Americans in Detroit in that struggle. White and Hill were also outspoken supporters of the NNC in Michigan. Hill became so closed identified with the CPUSA that he was called as an unfriendly witness in a 1952 HUAC session. Hill and the Hartford Avenue Baptist Church continued to host leading African American Communist speakers, such as Benjamin Davis and Henry Winston, into the 1960s. Hill's political ambitions suffered from his Left politics. He was expelled from the Detroit branch of the NAACP during the McCarthy era and was unsuccessful in his runs for the city council — unlike his protégé Coleman Young, who lived long enough to escape from the shadow of McCarthyism. Nonetheless, Hill retained great respect within Detroit's black community. White and Hill inspired a younger generation of engaged black ministers in Detroit, particularly Rev. Albert Cleage Jr., whose Central Congregational Church (later the Shrine of the Black Madonna) became a focal point of black nationalist politics and culture in Detroit — even if Cleage's nationalism eventually took him far from the older clerics' combination of the Popular Front and Social Gospel (a prolabor, sometimes prosocialist, Protestant movement powerful in the early twentieth century).[12]

This labor-based Left milieu of the late Popular Front produced some of the most significant players in the drive for black empowerment in Detroit during the 1960s. The most prominent of these activists were no doubt Coleman Young and George Crockett. Young had been a Left activist in the CIO during the 1940s before being driven from his job with the Wayne County CIO by Walter Reuther, and he was an outspoken supporter of the NNLC in the 1950s. Young's Left activities, including running for state legislature as a Progressive Party candidate in 1948, earned him a summons to appear before the HUAC in 1952. As a left-wing lawyer, Crockett had been the first black lawyer to work for the U.S. Department of Labor and served as a UAW staff attorney before being purged by the Reuther administration. He defended Michigan CPUSA leader Carl Winter after the latter's indictment for violating the Smith Act, ultimately resulting in a four-month contempt of court sentence for Crockett. He also represented Young and Rev. Charles Hill in their HUAC appearances. Young's and Crockett's refusals to retreat before the pressures of McCarthyism and the Cold War per-

secution of the Communist Left in the United States damaged their careers in the short term but also advanced their reputations as militants within the black community and provided much of the base for their later electoral successes in the 1960s and 1970s, beginning with Young's campaigns for the Michigan House of Representatives in the early 1960s (unsuccessfully in 1962 and successfully in 1964) and Crockett's election to a recorder's court judgeship in 1966.

There were fewer African American Left cultural institutions in Detroit than in Chicago during the Popular Front, though black Detroit writers, of whom Robert Hayden became the best known, had been involved in the John Reed Clubs and UAW organizing drives during the 1930s. Nonetheless, the major black newspaper, the Sengstacke Enterprises' *Michigan Chronicle*, like the Sengstacke flagship, the *Chicago Defender*, much marked by the Communist Left, actively participated in Detroit's cultural life. For example, *Chronicle* publisher Louis Martin, a strong Popular Front supporter, and a group of Left UAW activists (including the black Communist Christopher Alston) arranged and subsidized the publication of the first collection of poems, *Heart-Shape in the Dust* (1940), by Robert Hayden (a *Chronicle* reporter).[13]

In addition to the CPUSA, groups in what might be thought of as the Trotskyist tradition stamped their mark on African American political and cultural activism in Detroit to an extent unmatched by their counterparts in any other city, even New York—though some of these groups moved quite far ideologically and organizationally from their roots in the older Trotskyist SWP and the offshoot WP led by Max Schactman (and even from the thought of Trotsky himself).[14] Though Trotskyism, generally through the SWP, was sometimes locally influential elsewhere, the impact of the Trotskyist tradition on the African American community and on the politically engaged artists of the 1960s and 1970s in Detroit was unusual for its intensity and duration. The various organizations in the tradition were small, with national memberships often measured in the hundreds (or less) and with few African Americans, but they became focal points for militant trade unionism and radical cultural and intellectual activity outside and often opposed to the policies of the CPUSA at certain critical junctures. Also, despite the relatively small number of African Americans who joined Trotskyist (or post-Trotskyist) organizations, a remarkable group of black, white, and Asian American intellectuals grew out of the "Johnson-Forest tendency" of the WP in Detroit during the 1940s and 1950s. This group did significantly influence black political and cultural radicalism across the United

States in the 1960s—though it ultimately left Trotskyism behind and itself suffered numerous splits.

In the 1940s, Detroit became the center of the Johnson-Forest tendency, which had split from the SWP in 1940 (and later joined the WP) over the SWP's call for the defense of the Soviet Union despite the German-Soviet nonaggression pact and the Soviet invasion of Finland. This split deepened at the first WP convention in 1941 where the embryonic Johnson-Forest group more directly attacked the older SWP notion (and, indeed, Trotsky's formulation) of the Soviet Union as a "degenerated workers' state" that was still at base socialist. Instead, the group advanced the concept of the Soviet Union as an example of a new "state capitalism." The Johnson-Forest group was led by the Trinidad-born intellectual C. L. R. James (aka "Johnson") and the Russian-born intellectual Raya Dunayevskaya (aka "Forest") and included Jessie Glaberman, Martin Glaberman, James Boggs, and Grace Lee Boggs. C. L. R. James had become simultaneously involved with Trotskyism and Pan-Africanism in Britain during the middle 1930s. With a deep interest in political philosophy, he helped shape what might be thought of as orthodox Trotskyist thought on the national question in the United States through his writing and eventually through discussions with Trotsky himself in Mexico in 1939. James came to the United States later in 1939 on a more or less official mission from Trotsky to direct work among African Americans through the SWP, then the official affiliate of the Trotskyist Fourth International in the United States. Multilingual and with considerable training in political economic theory, Dunayevskaya also had direct ties to Trotsky, having served as his secretary and translator. Not surprisingly, much of the focus of the early Johnson-Forest group concerned the development of Marxist economic theory and materialist philosophy.[15]

The Johnson-Forest group further coalesced when the WP sent six party activists, including Martin Glaberman, to Detroit during a WP campaign to "proletarianize" itself in 1942, joining the single member already there. Glaberman, who had done graduate work in economics at Columbia University, left a government job in Washington, D.C., becoming the organizer of the WP Detroit branch in 1944. He was instrumental in making the WP a viable organization in Detroit and in making Detroit a Johnson-Forest stronghold. Glaberman became a pillar of Detroit radicalism for the next sixty years, working as an autoworker for two decades before returning to academia in the 1960s and teaching at Wayne State University until his retirement in the late 1980s. In many re-

spects, it was Glaberman's stabilizing presence that made Detroit such a vital center of Trotskyism (and post-Trotskyism) in part by attracting and mentoring younger radicals in his study groups and also by providing continuity through many organizational splits and mergers—much like Ishmael Flory did in Chicago Communist circles.[16]

James Boggs, a black Alabama-born autoworker at the Jefferson Avenue Chrysler Plant joined the emerging Correspondence group that grew out of the Johnson-Forest group in the early 1950s. He eventually served as a sort of father figure for many of the young Marxists who became the initial core of UHURU, the staff of *Inner City Voice*, DRUM, and the LRBW, as well as for Left nationalist political and artistic activists, such as RAM leaders Muhammad Ahmad and Askia Touré. His *American Revolution* (1963) advanced the concept that African Americans, rather than the labor movement or the working class generally, comprised the true revolutionary force in U.S. society, making a domestic argument that dovetailed nicely with Harold Cruse's influential statement on Third World revolutionaries as the true vanguard in "Revolutionary Nationalism and the Afro-American." *American Revolution* was widely read by young black revolutionaries in Detroit and elsewhere.[17] Given the role that white workers, especially white retirees, played in frustrating efforts to increase black representation in union leadership at Dodge Main, the Rouge, and other Detroit automobile plants, efforts that were tied to the fight against speedup and to a decline in the effectiveness of the UAW's shop steward and grievance systems that had a disproportionate impact on black assembly line and foundry workers, Boggs's (and Cruse's) arguments resonated strongly with the leaders of UHURU, the LRBW, RAM, DRUM, and the other Revolutionary Union Movement groups.

Grace Lee Boggs, a Chinese American Johnson-Forest activist with a background in philosophy and a deep interest in African American liberation, first met James Boggs while attending a Correspondence "third layer" school in New York City in the fall of 1952. The idea behind the classes was to reverse the usual practice of Left cadre schools so as to have rank-and-file workers (the "third layer") like James Boggs teach trade union leaders (the "second layer") and organizational functionaries and intellectuals (the "first layer") like Grace Lee Boggs. She went to Detroit in 1953 to work on the new journal *Correspondence* headquartered there as part of a 1952 Johnson-Forest decision to move its organizational center to Detroit. After a short and, according to her, somewhat eccentric courtship, James Boggs and Grace Lee married.[18] As the editor of *Cor-*

respondence, she also worked closely with both revolutionary nationalists and the cultural nationalists, such as the UHURU group (and the various organizations that grew out of UHURU), the Obadele brothers (then the Henry brothers), and Rev. Albert Cleage Jr., in Detroit. Many of the early revolutionary nationalists, especially those connected with RAM, frequently stayed at the Boggses' home, often while drafting important documents and position papers with the Boggses' assistance.[19]

Though they became caught up in their share of ideological disputes, the Boggses generally took an ecumenical approach to Left (and nationalist) tendencies other than the Correspondence and Facing Reality formations, reinforcing the sort of ideological cross-fertilization that typified radical Detroit. James Boggs, unlike C. L. R. James, had little compunction about working with members of the CPUSA in neighborhood and UAW politics. In fact, Boggs had considerable admiration for the domestic activities of the CPUSA in Detroit.[20] Similarly, Grace Lee Boggs claims that she never really felt herself to be a Trotskyist in an ideological sense; rather the WP was simply a vehicle for her to pursue her true interest in African American liberation and economic democracy at a time when she felt the Communists downplayed these issues. In another moment, she says, she might well have joined the CPUSA.[21] The Boggses publicly broke with James in 1962 over the issue of the working class and its relation to social change. As noted above, the Boggses, influencing and anticipating later nationalist and Third World Marxist positions, argued that no group was an inherently revolutionary class and that in the present moment (1962) African Americans constituted the revolutionary class and white workers an essentially reactionary group.[22]

While the Johnson-Forest group did not attract huge numbers of industrial workers in the 1940s, through its distribution of the WP's journal *Labor Action* it became a focal point of Left dissatisfaction with CPUSA support of the wartime no-strike pledge and what was seen as Communist backpedaling on issues of black liberation, especially among Detroit autoworkers.[23] The Johnson-Forest group left the WP, rejoining the SWP in the late 1940s when reunification negotiations between the two parties stalled. The Johnson-Forest group withdrew from the SWP again in 1952, finally severing its ties with the Trotskyist movement and again rejecting Trotsky's characterization of the post-Lenin Soviet Union as fundamentally still a socialist state as well as his theory of permanent revo-

lution and the need for a vanguard political party, positing instead a notion of grassroots leadership.

The new Correspondence group that emerged suffered a number of crises in fairly rapid succession. C. L. R. James was arrested for "passport violations" in 1952 and forced to leave the United States in 1953. Dunayevskaya broke with James in 1955, in part over her emphasis on the need for a well-organized cadre group—though like James she rejected the notion of a vanguard party in the Bolshevik manner.[24] However, it seems that this break was more due to James's inability to fully share leadership and acknowledge her parity with him as a theorist—a characteristic of James that would play a part in provoking later splits. Dunayevskaya and her supporters, including Si Owens (author of the classic memoir *Indignant Heart: A Worker's Journal* under the name Charles Denby) formed the News and Letters group, which published its own newspaper, *News and Letters*, edited by Owens, and supported a study group attended by many 1960s activists in Detroit. Finally, as mentioned above, the Boggses broke with James and his supporters (basically Glaberman and a handful of others, mostly in Detroit and New York) over the revolutionary potential of white workers in 1962—though perhaps the break had as much to do with what was perceived as James's attempt to micromanage the group from abroad without paying sufficient attention to those on the ground as it did over major ideological questions. The Boggses, supported by much of the membership of the group, retained control of the journal *Correspondence*. James and Glaberman regrouped James's remaining supporters as Facing Reality, which took its name from the title of a 1958 book by James, Grace C. Lee (Grace Lee Boggs), and Pierre Chaulieu (Cornelius Castoriadis) that was basically a manifesto of what they saw as the guiding principles of the Correspondence group at the time.[25]

The publications and study groups of the circle that emerged from Johnson-Forest, particularly in the later, post-Dunayevskaya, Correspondence and Facing Reality organizations, exerted considerable influence on black political and cultural radicalism in Detroit. The authors of *Facing Reality* argued that all Marxist groups since the Bolshevik Revolution had essentially failed due to a fetishization of the "vanguard party" and that the primary role of the Marxist organization was to provide "the people precise information about where they are, what they are doing, [and] what they have done in the past" so they can set their own course.[26] James here provided a model later adapted by the Boggses

into a more race-oriented and less class-defined mode that powerfully inflected the work of such early Black Power groups as RAM and UHURU, which also saw their mission as largely informational and agitational, anchored by newspapers and journals.

Not surprisingly, the center of this circle's activities for many years was the production and circulation of the journal *Correspondence*, which went through a number of incarnations. In its early days under the editorship of UAW activist Johnny Zupan (Glaberman was the managing editor), the journal distinguished itself through its interests in African American liberation and in popular culture, particularly film, music, and television. This sort of interest was not unknown in other Left publications—the CPUSA's *Daily Worker* (and later *The Worker*) also regularly covered the emerging medium of television. However, the proportion of space devoted to popular culture in the early *Correspondence* and the level of often positive engagement was unusual. (Its television critic was a rabid fan of *Dragnet*, for example.) Zupan left the group and the journal with Dunayevskaya in 1955. Despite James's later association with popular culture studies, *Correspondence* then allotted much less space to the consideration of contemporary cultural production of any type and became almost entirely devoted to larger theoretical and philosophical questions (and the work of James) until Grace Lee Boggs became the editor in 1957. Though James wrote on the relation of art and politics in *Correspondence*, these pieces remained for the most part in a general philosophic mode rather than directly engaging local black art—an unsurprising state of affairs given his distance from Detroit.

When Zupan departed, Martin Glaberman remained as managing editor until the split with the Boggses in 1962, maintaining, as he did in many ways throughout his political career, some organizational and editorial continuity and stability. *Correspondence* in the 1950s serves as a reminder that though James was deported in 1953, he remained a real ideological presence in Detroit through the newspaper and, later, the Facing Reality group, which was much influenced by James's notion of taking leadership from the grassroots rather than the grassroots being directed by a vanguard party—a notion that continued to influence the Boggses even after their break with James.

During Grace Lee Boggs's editorship, *Correspondence* became again more oriented toward grassroots community and labor politics as well as toward literature and art. This interest in literature and art, particularly African American literature and art, accelerated after the break between the Boggses and James.

That break also caused Glaberman's departure from the journal and moved *Correspondence* toward a Left nationalist stance under the direction of the Boggses, who, like the founders of *Freedomways*, *Black Dialogue*, *Liberator*, and OGFF, felt a renewed sense of possibility, of something new in African American politics and in culture during the early 1960s and, as a result, a need for new outlets for black political and cultural expression—especially art and literature informed by the new political moment.[27] The January 1963 issue featured a "Special Emancipation Supplement on Black Art" that included poetry by Margaret Danner, a "Who's Who of Black Art," and an essay, "Jazz Must Benefit Blacks," by drummer Max Roach (among the most radical and politically engaged jazz musicians of the era, with a long history of participation in Left institutions and events—though more often those of the CPUSA than the Trotskyist or post-Trotskyist tradition). During the early 1960s, *Correspondence* published more than half a dozen poems by Dudley Randall, including Randall's best-known poem, "Ballad of Birmingham," as well as poems by Danner, Langston Hughes, James Randall Jr., James Thompson, Oliver LaGrone, Sonia Sanchez, and Amiri Baraka. The poems by Baraka, Sanchez, and Hughes were reprinted from other radical African American journals, such as *Liberator*. However, the work by Detroit-based poets Dudley Randall, James Randall Jr., Thompson, LaGrone, and Danner often represented the first or most prominent early publications of these poets—Danner being the exception. Thus, despite the relatively small circulation of the journal (around 1,800, according to its October 1963 circulation statement), it presented Detroit poets to an audience outside Detroit and promoted a sense of community among Detroit artists and activists within a basically Left nationalist framework. And while the circulation of the journal was small for a political journal seeking to reach a mass audience, it was considerable for a radical cultural journal. Certainly, some of the poems *Correspondence* printed, in particular "The Ballad of Birmingham," quickly gained a considerable national notoriety—and wide republication.

As previously noted, despite the various conflicts and splits and an extreme antagonism toward the Communist Left by some Trotskyist or post-Trotskyist leaders (especially James), a number of leading Detroit radicals from the Trotskyist tradition besides the Boggses displayed an unusual willingness toward coalition and discussion with other Left groups and independent radicals. Both GOAL and the Freedom Now Party drew a broad spectrum of nationalists, leftists, and Left nationalists into their ranks. The Debs Hall Socialist Forums of the

SWP in Detroit run by Frank Lovell, Sarah Lovell, and George Breitman featured a wide ideological range of speakers (though generally not activists associated with the CPUSA). These forums were notable because they did not emphasize recruitment but discussion among a core group of attendees ranging from twenty to one hundred people. While the forums did not often focus on culture as such, the frequent discussions of the civil rights movement, Malcolm X, the armed self-defense tactics of Robert Williams, and the new nationalism were crucial in developing the ideological field from which emerged black cultural and political militants, such as General Baker, Chuck Johnson, John Williams, and Kenneth Cockrel, who played leading roles in the protorevolutionary nationalist group UHURU, the newspaper *Inner City Voice*, and the LRBW.[28] In turn, the new nationalism that was frequently the subject of the forums deeply touched many older Left activists. Breitman became a champion of this nationalism, especially the thought and work of Malcolm X, within the SWP, leading in part to the publication of many of Malcolm X's speeches by the SWP's Merit (later Pathfinder) Press and the appearance of Malcolm X (and Rev. Albert Cleage Jr.) at a number of SWP forums. The activist-intellectuals of UHURU and other young radicals attended similar forums, lectures, and study groups held by the CPUSA and Dunayevskaya's News and Letters group.

Quite a few young Detroit radicals, both black and white, joined a private Marxist study group led by Martin Glaberman. This study group and lectures by James Boggs and others associated with the Correspondence and Facing Reality groups did much to impart basic Marxist political thought (and James's and Boggs's antivanguardist revisions of classic Marxist-Leninist theory) to emerging revolutionary leaders. The informal beer-and-coffee–fueled socializing that took place afterward also stimulated networking among these young militants, some of whom, like Dan Georgakas, were also artists or writers. Jessie Glaberman took a particular interest in nurturing and developing young radicals, patiently encouraging them to find their own approach to political (and cultural) work. And as Rachel Peterson notes, *Speak Out* (the newsletter of Facing Reality that Martin Glaberman edited after the split with the Boggses), like *Correspondence*, served as a model for an independent workers' press that was adapted by the black radicals of UHURU, DRUM, and the LRBW, even if the actual content of the newsletter was less consonant with the new black nationalism and less a vehicle of black cultural expression than was *Correspondence*.[29]

As noted in the following chapter, a number of the UHURU leaders, includ-

ing General Baker, Chuck Johnson, Charles Simmons, and Luke Tripp, were also much influenced by a visit to Cuba sponsored by the Maoist PL in 1963. While the PL never exerted much direct organizational influence among black radicals in Detroit, this trip brought the UHURU militants together with RAM leader Muhammad Ahmad, Robert Williams, and Ernest Allen Jr. (who would play significant roles in the Black Power and Black Arts movements in the West, Midwest, and Northeast), laying the basis for transregional connections among early Black Power and Black Arts activists and organizations.[30]

In Chicago, the Left-influenced African American institutions of the 1940s largely disappeared during the Cold War.[31] Most of those that survived, such as the South Side Community Art Center and the *Chicago Defender*, purged from active roles (and often even membership) known leftists who had founded or shaped the character of those institutions in the early 1940s—though some institutions readmitted these radicals, often to leadership positions, after the emergence of the Black Arts and Black Power movements (as the South Side Community Art Center did with the writer and visual artist Margaret Burroughs). Many artists and intellectuals who had emerged from and/or had been nurtured by the Popular Front, such as the poets Margaret Danner and Gwendolyn Brooks, distanced themselves from the Communist Left both publicly and privately—though they often maintained close, if sometimes tempestuous, personal relationships with active leftists, such as Charles and Margaret Burroughs. Others stayed on the Left but became (and long remained) vague about the precise details of their political sympathies and affiliations.

However, despite the decline, disappearance, or reorientation of African American cultural institutions shaped by the Popular Front, a more informal network among black artists and intellectuals who emerged from the cultural milieu of the Communist Left in the 1930s and 1940s remained. Once the Cold War receded a bit, this network would be crucial to the establishment of new Left-led African American institutions, especially discussion groups, educational associations, workshops, and arts organizations, prefiguring, influencing, and often becoming those of the Black Arts movement. In an odd way, Cold War repression promoted the grassroots African American cultural infrastructure of Chicago—and elsewhere. Arts and educational institutions had long been a major feature of the public face of the CPUSA and other Left groups. However, such efforts took on even greater importance as ways to present Left ideas in the community and to involve a relatively broad range of intellectu-

als, artists, and activists without the degree of political liability that directly supporting the CPUSA would entail. For example, many black artists and virtually every African American political activist in Chicago knew Ishmael Flory, a popular African American Communist and former trade union leader who was one of the leaders of the Afro-American Heritage Association (later the African-American Heritage Association), a Left, South Side–based educational group formed in the late 1950s. The AAHA sponsored forums and cultural events and published the Equality Series of pamphlets, including W. E. B. Du Bois's *Socialism Today* (1960) and *Africa in Battle against Colonialism, Racialism, and Imperialism* (1960), under the AfrAm Books imprint.

Flory personally influenced many of the more radical civil rights workers in Chicago with his emphasis on black pride and the building of black institutions—for instance, he long insisted on the use of "Afro-American" rather than "Negro."[32] As one of those young activists, John Bracey Jr., recalls, Flory's influence was practical as well as ideological, showing young militants how to put together a leaflet, organize a meeting, publicize a rally, and so on—mundane but essential skills for both political and cultural organizations.[33] Flory also maintained close contact with many older black artists—even some who had supposedly abandoned their ties with the Left. In 1959, for example, he invited Langston Hughes to appear as part of an AAHA program for Negro History Week in 1960. Hughes accepted and ultimately participated in two programs, one on the South Side and one in the newer African American neighborhood on the West Side. Flory also asked Hughes to participate in a similar program in 1961, but Hughes declined the invitation due to a scheduling conflict. In the same letter, Hughes asked Flory if he had seen a poem on the Little Rock desegregation struggle by his old friend, the Cuban radical Nicolás Guillén, signaling to Flory a reaffirmation of his old Left politics and connecting that politics to the new political moment nationally and internationally.[34]

In addition to forums, lectures, and publications, the AAHA pressed for the official recognition of Negro History Week, convincing, for example, Illinois governor Otto Kerner to issue a proclamation honoring the week in 1962. The association also weighed in on issues that were not strictly educational, protesting cases of police brutality on the South Side. Beyond practical instruction in the nuts and bolts of organizing and the formal activities of the AAHA, Flory was also the center of a more informal social circle in which older activists, many past or present members of the CPUSA, and younger militants sat around drinking

Flory's bourbon and discussing history, politics, and culture, linking different eras of black political thought and activity in a very relaxed setting.[35] In short, Flory, like his close associates Margaret Burroughs and Christine Johnson, not only introduced budding black activist-artists to older traditions of black radicalism in Chicago but also helped older artists reconnect to their Left political pasts and connect for the first time to new modes of African American militancy.

In addition to those like Flory who still belonged to the CPUSA, there were also many older activists who had left the CPUSA or had been expelled for "nationalism" but were, like Richard Moore in New York, still basically Marxist in orientation and often part of Communist Left circles in Chicago. Again, it needs to be recalled that after the orgy of expulsions for "white chauvinism" and "nationalism" in the 1940s and 1950s (and the general decimation of party membership in the 1950s), the CPUSA essentially invited many of those who were expelled to return—though it never really apologized publicly for the expulsions. Some, like Cyril Briggs, did rejoin; others, like Richard Moore, did not for various reasons but remained publicly friendly to the Communists; and still others, like Harold Cruse or Queen Mother Audley Moore, became more or less hostile to the party but were still much marked by their tenure in the CPUSA. Otis Hyde, the leader of the Washington Park Forum, an African American discussion group strongly influenced by the CPUSA, was one such former Communist in Chicago who remained close to the Communist Left. Hyde and other black Leftists in Chicago particularly gravitated toward the organization ACT. Though relatively short-lived, the proto–Black Power ACT was a national organization with considerable strength in Chicago, New York, Detroit, and Washington, D.C. Its leadership included older Left activists who helped shape the movements of the 1960s and 1970s, such as the former Communist and current Harlem tenants leader Jesse Gray and James Boggs, as well as many younger radicals and civil rights workers. ACT played a key, if relatively unpublicized, role in putting together broadly supported demonstrations around the issue of quality education for black children and "Freedom Day" school boycotts involving hundreds of thousands of black students in Chicago in 1963 and 1964. The CCCO, a broad umbrella group of civil rights groups, neighborhood associations, labor unions, and so on, organized boycotts against the blatant segregation of Chicago schools resulting in extreme crowding and inferior facilities of black schools and against the inability or unwillingness of school superintendent Benjamin Willis to address the concerns of African American parents.

ACT chair Lawrence Landry (also a local leader of Friends of SNCC) headed the CCCO boycott committee.[36]

In 1962, Sterling Stuckey (whose mother, Elma Stuckey, was a well-known poet in the black community and sometime contributor to *Freedomways*), Don Sykes, Thomas Higginbotham, and others launched another liberal-Left black educational and cultural group centered on the South Side, initially named the Frank London Brown Society, in honor of the writer, educator, and community and labor activist. Later renamed the Amistad Society, this group was less explicitly Left in character than the AAHA, although some of the founders had family connections to the CPUSA and had grown up in the milieu of the Popular Front. Even its name drew on the Left emphasis on the revolutionary slave-revolt tradition promoted by the CPUSA and its circles. Certainly, the Amistad Society was not averse to sponsoring events featuring leftists speaking on political subjects. For example, the society sponsored a 1963 meeting on "The Black Writer in an Era of Struggle" with a panel that included unrepentant leftists (and nationalists) John O. Killens and John Henrik Clarke as well as *Ebony* editor Lerone Bennett and Hoyt Fuller. Similarly, the program for another 1963 event in memory of the recently deceased Frank London Brown emphasized Brown's support of the Cuban Revolution—a telling political declaration in the post–Bay of Pigs, post–Cuban Missile Crisis era.[37]

Founded in 1961 by Charles and Margaret Burroughs, the Ebony Museum (later the DuSable Museum of Afro-American History) exerted the most direct influence on the growth of the Black Arts movement in Chicago among the new black cultural and educational institutions started by Old Left veterans. Margaret Burroughs in particular had a long history in black Left cultural institutions, from the South Side Community Art Center, to the Committee for the Negro in the Arts, to the AAHA, to *Freedomways*.[38] Probably more than any other individual in Chicago, she had worked to keep alive the spirit of the South Side "cultural front" (to use Michael Denning's term for the Popular Front arts milieu) through the 1950s in neighborhood forums, writers and artists workshops, and so on. The DuSable Museum served as a model of what a black-initiated and black-run, socially engaged cultural institution aimed at the broad African American community might be in the 1960s.[39] The DuSable's emphasis on education, the preservation of African American art and culture, an internationalist linking of African culture with black culture in the diaspora, and the nurturing of new black artists within an ethos of black pride and self-determina-

tion (though not separatism on the whole) prefigured and inspired the Black Arts movement in Chicago. The museum also frequently provided space for the activities of such early Black Arts groups as OBAC.[40]

The model of the DuSable certainly impressed Haki Madhubuti (then Don L. Lee), who became the most influential of the younger Black Arts activists in Chicago. Madhubuti worked as an unpaid assistant curator at the museum from 1962 to 1966. He still emphasizes the impact that Charles and Margaret Burroughs and the DuSable Museum had on his artistic and intellectual evolution. He discovered the museum after reading about it in a magazine while he was in the Army. Charles Burroughs, who had grown up in the Soviet Union, introduced him to the library at the museum and set him on a systematic course of reading social history, literature, political theory, art history, and philosophy, including Russian literature and classic Marxist works. This study of African, diasporic, and European cultures augmented Madhubuti's earlier, intense, but more haphazard reading of black literature, politics, and history begun while growing up in Detroit and Chicago and continued in no small measure as a mental survival mechanism in the military.[41] Again, it was not only the Burroughses' radical politics and commitment to African American liberation or even their erudition that engaged Madhubuti and other Chicago Black Arts activists but also their dedication to building black institutions. The Burroughses' example (and encouragement) led Madhubuti to publish his own works and (with Carolyn Rodgers and Johari Amini) to begin Third World Press in 1967. Margaret Burroughs directly urged Madhubuti to self-publish his first book, *Think Black*, in 1966. Madhubuti sold out the entire first printing of six hundred copies in a week through the museum, meetings, and demonstrations, giving him a sense that an African American audience for serious, politically engaged literature by black authors not only existed but was hungry for such work — and that it was possible to reach such an audience outside mainstream avenues of book and magazine distribution. Burroughs also introduced Madhubuti to Dudley Randall, with whom she was working on the Broadside Press's *For Malcolm* anthology. Eventually, Madhubuti asked Randall whether he would be interested in publishing his second book, *Black Pride*. After seeing Madhubuti's work, Randall said yes, beginning a long relationship between the two poet-publishers. When Madhubuti came to Detroit, he saw that Broadside Press's operation was run out of Randall's house (and largely financed by Randall's librarian salary). Madhubuti concluded that this was something he could do — and did, with the

founding of Third World Press, initially a mimeograph operation run from Madhubuti's apartment.[42]

Madhubuti's relationship to the Burroughses also illustrates how a basically political activity (the building of African American cultural institutions as the means of self-liberation and the encouragement of socially engaged young black artists and black art) translated into personal links that in turn allowed ideological and aesthetic conversations between different generations of black radicals. These sometimes featured sharp disagreements, but the different parties acknowledged each other with some degree of attentiveness and mutual respect. For example, Margaret Burroughs used the occasion of a 1969 tribute to her old friend Gwendolyn Brooks to attack what she saw as formal deficiencies (an overuse of obscenities and cheap visual tricks, a lack of attention to craft, and a willful ignorance of literary predecessors) and ideological flaws (a rage-filled black separatism and political amnesia concerning earlier black activism) in the work of younger African American poets — the sort of gesture of critical support from a veteran of the 1930s and 1940s (and 1950s) black Left that should now be familiar to readers of this study.[43] While Madhubuti (notably concerned with issues of craft in his own critical writings) might have sympathized with some of Burroughs's arguments about form, one would expect a rejection of Burroughs's attacks on black separatism and her call for artistic universalism from a poet as identified with cultural nationalism as he. And perhaps he did reject this portion of her critique. Nonetheless, Madhubuti still included Burroughs's essay in the volume arising from the tribute that Madhubuti coedited with Patricia Brown and Francis Ward, *To Gwen with Love* (1971). This is not to say that Margaret Burroughs had the same close relationship to Black Arts circles as Brooks, who wholehearted embraced the movement. Some Black Arts participants recall that Burroughs's politics caused some of the younger artists in Chicago to distance themselves a bit from her, especially as more strictly nationalist black power institutions and organizations became better established.[44] Nonetheless, the existence of this close, if uneven, relationship between Madhubuti and the Burroughses demonstrates the continuation of a very personal Old Left–new black dialogue — even on the part of artists as famously opposed to Marxism as Madhubuti, who became a leading spokesperson for cultural nationalism in the ideological battles within such major Black Power organizations as CAP and the ALSC during the 1970s.

Though published in New York, the appearance of the journal *Freedomways* in 1961 can also be seen as part of this dialogue. Artists and intellectuals from the old South Side Left cultural circles constituted a sizable part of the staff, contributors, and readers of the journal—which also published many of the younger black midwestern writers. For example, Margaret Burroughs served as the art director of the journal in its early days. Even when the distance between Chicago and New York proved too great for Burroughs to continue to fill this position, she remained a contributing editor throughout *Freedomways*' existence. It is quite likely that it was Burroughs's continuing affiliation with the journal that kept its pages open to midwestern cultural nationalist writers, including Madhubuti.

In addition to the new artistic and educational organizations initiated by individuals connected to the old South Side Left, lingering institutions of the Popular Front and New Deal Left-liberal alliances found new life during the 1960s as artistic and political centers. The United Packinghouse Workers Union in Chicago remained much influenced by the Left, even after the union's merger with the Amalgamated Meat Cutters and Butcher Workmen of North America in 1968. The Packinghouse Workers' union hall on the South Side, the United Packinghouse Center, was the frequent site of militant black political and cultural events, embodying the intersection of black nationalists and leftists in Chicago as the Black Power and Black Arts movements took shape; and it literally became a sort of artwork when William Walker painted his famous mural *The Worker* on the outside of the hall in 1974. One early moment when this intersection was made plain at the United Packinghouse Center was a memorial meeting for W. E. B. Du Bois under the auspices of the AAHA held shortly after Du Bois's death in 1963. The committee for the memorial, which was part of the association's annual celebration of the Emancipation Proclamation, included Ishmael Flory, Margaret Burroughs, the NOI's (and the AAHA's) Christine Johnson, and the Nigerian Pan-Africanist scholar Chimere Ikoku.[45] Roosevelt University, a liberal school founded in 1945 with a history of social activism and a deep engagement with Chicago's black community, too, featured a close cooperation between a wide range of liberal, Left, and nationalist groups as the Black Power and Black Arts movements took shape. Its Negro History Club was yet another ideologically diverse but politically radical organization that mixed culture, education, and politics, drawing together artists and activists from different generations. For example, it brought Gwendolyn Brooks to campus in

1963 to read poetry as a fund-raiser for SNCC, reminding us that Brooks's famous "conversion" to the Black Arts movement at the 1967 Fisk Black Writers Conference had a long political foreground.[46]

In short, the Communist Left in Chicago had always been concerned with education and culture in such Popular Front–era institutions as the Abraham Lincoln School, the South Side Writers Group, *Negro Story* magazine, the South Side Community Art Center, and the various arts programs of the WPA. However, the pressures of the Cold War caused the black Left in Chicago to focus on art and education even more intensely as a means of maintaining a presence in the African American community within the constraints of McCarthyism. This focus gave the city's black artists and intellectuals avenues for development of their skills, venues to present their work, and spaces in which communities and networks could be forged. This work by leftists such as Margaret and Charles Burroughs and Ishmael Flory also directly inspired younger and far more nationalist (and sometimes, as in Madhubuti's case, eventually quite anti-Marxist) black artists and intellectuals in the founding of OBAC, Third World Press, the Kuumba Workshop, and other Chicago-based Black Arts institutions.

Bohemia and the Black Press in the Emergence of the Detroit Group and OBAC

Before the rise of the Black Arts and Black Power movements, Chicago and Detroit were not centers of small press and "mainstream" book publishing on the scale of New York, Boston, or the San Francisco Bay Area. The bohemian communities of both cities, especially Detroit, were relatively small. However, Wayne State University and the nearby Cass Corridor community in Detroit anchored an interracial bohemia that played something of the catalyzing role that similar communities did in New York, the Bay Area, and Los Angeles. While the Beat community of Detroit was decentralized and not particularly politically activist initially, it was a milieu where black and white writers interacted. For example, two out of the four editors of *Serendipity*, a Wayne State student journal started in 1958 and one of the earliest self-consciously Beat institutions in Detroit, were black. The Wayne State student center became a meeting place for black political radicals associated with UHURU and, later, the LRBW, such as Kenneth Cockrel, white Left bohemians, such as Dan Georgakas, and white and black cultural radicals, such as John Sinclair and the Beat-influenced poets of

the Artists Workshop (who were relatively apolitical but respected the stance of black militants like Cockrel and John Watson). The Burns Bar and the Decanter Bar served a similar function off campus — much as Stanley's did in New York.

To a large extent, these radicals and bohemians continued what Angela Dillard has shown to be an important and long-standing element of Detroit Left subcultures that cemented communal ties in integrated bars (the so-called black and tans), clubs, and other informal meeting places. This practice took on increased importance as many of the formal institutions of the Left were crushed by the Cold War.[47] Such intersections facilitated an engagement with the arts on the part of political activists while helping to politically radicalize bohemians, especially Sinclair and the Artists Workshop; Sinclair hung a banner reading "Burn, Baby, Burn" with a picture of a black panther from his apartment that the police riddled with bullets during the Detroit uprising in 1967.[48] While relatively few black poets (though somewhat more local black musicians) directly belonged to the Artist Workshop or published in its journal *Cricket*, Sinclair and his circle supported black political and cultural efforts locally, further strengthening the sense of the city as a locus of cross-racial, avant-garde fertilization and sometimes interracial cultural cooperation that acknowledged the leadership of black artists and activists.

Also, given the working-class character of the city with its long history of radical labor activism and of black nationalism, many of the more politically minded younger bohemians participated in the previously mentioned Left forums and study groups sponsored by the WP, the SWP, the CPUSA, the News and Letters group, and so on.[49] As was the case in New York, Philadelphia, Boston, Los Angeles, and San Francisco, one aspect of bohemia (or what might be thought of as interlocking bohemias) in Detroit was that the line between black artists and intellectuals who were a part of the interracial Beat and avant-garde scene and those deeply influenced by black nationalism, particularly the NOI, was not as clear as one might imagine in retrospect. For example, the writer Herb Boyd, who would later be a leader of the LRBW and a founder of the black studies program at Wayne State, recalls being a member of the NOI and part of the bohemian circle of black and white artists and intellectuals who hung around the Minor Key jazz club, a stronghold for the emerging jazz avant-garde of the late 1950s and early 1960s and a center of black and white bohemia in Detroit.[50]

Another small but important interracial, Left bohemian outpost during the 1960s was the Unstabled Coffeehouse located off Woodward Avenue between

downtown and the campus of Wayne State. Founded by Edith Cantor, a white member of the World Socialist Party (a Marxist group with its roots in pre-Bolshevik Socialism), the Unstabled featured music and readings during the week and jazz and theater on the weekend. Cantor sought African American participation in the dramas staged at the coffeehouse from the beginning. The theater was unusual for the time in that it mounted racially integrated productions in which African Americans ran things rather than simply appearing in the cast and in the audience. The Unstabled put on work by internationally famous avant-garde playwrights, including the pre–Black Arts work of Amiri Baraka, as well as that of local playwrights, such as Ron Milner's *Life Agony* (an early version of the better-known *Who's Got His Own*).[51]

Of course, as was the case elsewhere, this Left bohemian milieu not only provided a space for the intersection of cultural and political avant-gardes and opportunities for black artists to develop their craft but also embodied an integrationism from which black artists could make a symbolic gesture of disassociation, much as Baraka and other downtown black bohemians did in New York and Ed Bullins and other African Americans in the Venice Beach and Bay Area countercultural communities did on the West Coast. This disassociation was in many cases not simply ideological but also represented a sense of the practical limits that a white-dominated avant-garde (as well as what might be thought of as regional "mainstream theater") imposed on black artists. The Concept East Theatre was started in 1960 by young black (and a few white) theater workers in Detroit, including Woodie King Jr. and David Rambeau, out of just such dissatisfaction and disaffiliation with the small theater movement of Detroit. Ron Milner, initially a fiction writer, became increasingly drawn into the theater through his friendship with King—especially after King's production of *Life Agony* at the Unstabled in 1959 showed him some of the possibilities for storytelling inherent in that medium. (Even in the rehearsals, Milner saw the black actors performing the play and the black employees of the coffeehouse make an immediate and visceral connection with the material that he had not previously experienced with readers of his work.)[52] In the view of King, Rambeau, and the other founders of Concept East, the company grew out of the failure of both the local mainstream *and* bohemian theaters (with the partial exception of the Unstabled) to provide black artists the opportunity to perform the full range of directorial, production, and creative roles. King recalls that the nature of segregation (and the taboo of miscegenation and its explicit or implicit representation) was such that it was

almost impossible for a black actor to appear on stage in a lead role in a typical integrated production at that time. Instead, African American actors were restricted almost entirely to what King terms "buddy roles" and dramatic monologues. Concept East changed that dynamic in Detroit. It was not that the theater was initially overtly political or nationalist as such—though Ron Milner at least had an early agenda of putting Hastings Street and black working-class Detroit on the stage, and there was a general engagement with the civil rights movement, North and South, an engagement that would play a part in King's move to New York City. The authorship of the plays, ranging from Baraka's *The Toilet* to James Weldon Johnson's *God's Trombones* to several plays by Malcolm Boyd, a white Episcopalian chaplain at Wayne State, was not strictly African American. And as mentioned before, white theater workers and backers were among the founders of Concept East. What distinguished Concept East was that African Americans made nearly all the executive decisions and that the company did new plays, setting it apart not only from the established "white" or integrated theater groups of the city but also from the few black groups, which focused almost entirely on restaging well-known plays by white authors with black casts. Also, though there were some early white supporters, the initial money that launched Concept East was collected largely from the black community. The core of this financing came from the members of the company, but Concept East reached out to the wider community with some success—eventually even Barry Gordy at Motown Records provided some financial support for the theater. Much as with the early Broadside Press, this sense of self-determination and black institutional control demonstrated that it was possible for black actors, directors, and playwrights in their twenties to create their own spaces and provided training in the practical nuts and bolts of running a black company that King, Milner, and Rambeau brought to theaters in New York and elsewhere, where such hands-on executive experience was harder to come by for young, black theater workers in the early 1960s.[53]

Concept East's production of a pair of plays by Malcolm Boyd, *A Study in Color* and *Boy*, to raise money for the civil rights movement was so successful that the Episcopal Church sponsored a tour of the double bill to dozens of cities. King traveled to New York with the plays. As discussed in Chapter 3, he stayed in New York, becoming a part of the downtown theater scene—though as in Detroit a sense of the limitations of downtown bohemia for black theater workers pushed him toward building black theater institutions (or multi-

racial institutions with African Americans in the lead) and becoming perhaps the best-known Black Arts–era director. Thus, in addition to addressing specific, practical questions of professional training and advancement, the emergence of Concept East, which nurtured some of the most important national Black Arts–era dramatists and directors, embodied the new nationalist spirit of self-determination and institution building that was so powerful in the Midwest, visibly breaking with older sorts of radicalisms while less obviously maintaining links to the Left-bohemian matrix out of which Concept East largely issued.[54]

One relatively stable black-run cultural institution that existed alongside (and often intersected with) the more mutable circles of bohemia in Detroit and Chicago was the black press. The two cities were major centers of African American journalism featuring major black newspapers, the *Chicago Defender* and its Sengstacke Enterprises subsidiary, the *Michigan Chronicle* (and a number of smaller African American newspapers), as well as the magazines of the Johnson Publishing Company, including the new mass-market magazines *Jet* and *Ebony* and the revived *Negro Digest*. As Bill Mullen has shown, the African American press in Chicago, particularly the *Defender*, had been a hotbed of Popular Front activism during the 1940s.[55] Similar claims could be made for the *Michigan Chronicle* in Detroit.

Journalists trained in the black press of Chicago and Detroit, whether still sympathetic to the Old Left (like Richard Durham), alienated from their former Left politics, or apparently never directly affiliated with the Communist Left (like Hoyt Fuller), brought their considerable skills, connections, and political sophistication to the creation of Black Arts institutions in the Midwest.[56] In part, it was this concentration of African American journals and newspapers with a tradition of Left political engagement that made Detroit and Chicago such fertile ground for attempts to fuse radical and nationalist politics with commercial journalism in the 1960s. The most influential and successful of these attempts was no doubt Hoyt Fuller's move to make *Negro Digest* a vehicle of the Black Power and Black Arts movements, but the Detroit journals *On the Town* and *Now!* (published by Imari Obadele and closely linked to the Freedom Now Party) also reflected much the same spirit.[57]

Even those older artists and intellectuals who separated themselves from the Communist Left organizationally retained many of the personal ties that they had developed before the Cold War and the crisis in the Communist movement occasioned by the invasion of Hungary and Khrushchev's "secret speech" in

1956 — whether to individuals who remained clearly on the Left, such as Ishmael Flory and Margaret and Charles Burroughs, or to others who had also either drifted, fled, or been expelled from their former political affiliations, or often to both. These ties formed networks that not only helped maintain a modicum of community among the older writers but also provided cultural circuits through which younger writers could find mentors and promoters inside and beyond their communities. The role of Langston Hughes as a critical supporter of the Black Arts movement and African American writing generally in the 1960s has been noted in several places in this study. Though his influence touched many cities, especially New York, Hughes, who was born and raised in the Midwest, kept alive his many friendships and associations there, including a considerable number from the Popular Front era. These associations enabled (and were in turn strengthened, renewed, and augmented by) Hughes's efforts as the editor of *New Negro Poets, U.S.A.* (1964) and the revised version of *The Poetry of the American Negro* (1970). As he did throughout his career, Hughes unselfishly promoted the work of younger writers (and lesser-known older writers) from the Midwest. Hughes was particularly helpful in advancing the careers of Margaret Danner and several of the so-called Detroit group of black writers, especially Ron Milner and Woodie King Jr.[58] Hughes's readings in Detroit in 1963 and 1964 were landmark events for the Detroit group and the African American literary scene there. An appearance with Danner, recorded and later released by Motown Records as *Poets of the Revolution*, greatly boosted Danner's reputation in Detroit.[59]

Like her sometime friends (and rivals) Gwendolyn Brooks and Margaret Burroughs, Danner emerged from the Left subculture of the South Side in the 1930s and 1940s, joining Brooks and Burroughs in Inez Stark Cunningham's poetry workshop at the South Side Community Art Center.[60] Danner early established a reputation outside the South Side, winning a number of awards and in 1956 being appointed an assistant editor on the journal *Poetry*, perhaps the most influential poetry journal of that era. However, Danner's career as a poet seemed to her stalled in Chicago during the late 1950s — perhaps in part due to her proclivity for intense emotional and intellectual crushes on individuals and near-paranoid fears of plots against her career.[61]

Though Danner's letters to Hoyt Fuller in the 1950s and 1960s suggest indifference and even a certain degree of hostility toward the Communist Left by that time, she stayed in touch with a number of African American Left artists and

intellectuals, especially Margaret Burroughs. For example, in 1946 Danner initiated Art Associates, a group promoting African American literary and artistic production in Chicago and one of the few South Side cultural institutions (not directly linked to the Communist Left) to include such a well-known political radical as Burroughs in their activities during the late 1940s and early 1950s.[62]

Personality conflicts generated largely by Danner's mercurial temperament appear to have kept Art Associates from having the impact that she wished for it.[63] However, one crucial event for the development of the Black Arts movement occurred when Fuller, a journalist and writer from Detroit who had left an editorial position on the *Michigan Chronicle* in 1951 to work for the new *Ebony* magazine in Chicago, joined Art Associates in the mid-1950s. Though Fuller ceased active participation in the group after a short stint as cochair, he established a long-standing relationship with Danner.

Feeling emotionally and professionally frustrated in Chicago, Danner moved to Detroit in 1959 to work with a group of writers at Wayne State University (where she was named a poet-in-residence in 1962). Fuller served as Danner's guide to black intellectual and artistic life in Detroit.[64] As she had in Chicago, Danner sought to build a community of writers outside the academy as well as in it — with more success. In 1962, Danner convinced the pastor of the Solomon Baptist Church, T. S. Boone, to allow the use of an empty parish house for the meeting of a new community arts group. Boone House provided space for individual artists to work as well as for public readings. It served as a focal point for intersecting groups of black poets and artists, including Danner, James Thompson (who was later active in the Umbra group in New York), Naomi Long Madgett, Oliver LaGrone, Edward Simpkins, Ron Milner, Woodie King Jr., and Dudley Randall — some of whom had been introduced to Danner through Fuller. Several of these writers, including Madgett, LaGrone, Simpkins, and Randall, already had a certain reputation and had previously formed a loose group in the early 1960s.[65] Largely through Danner's connections to black writers across the United States, Boone House became a frequent stop for out-of-town writers when they visited Detroit. At least one important frequenter of Boone House, Madgett, later downplayed its significance (and that of Danner), arguing that Danner was in Detroit only a relatively short time and that the group at Boone House was small and decentralized, without much more of an audience in Detroit than the poets themselves.[66] However, Boone House was crucial in further solidifying a sense of community among these poets and — largely through

Fuller and various visiting poetic dignitaries—presenting that community to the world beyond Detroit. In short, the idea of the Detroit group as a dynamic locus of grassroots African American literary production outside the better-known centers of black art and culture (especially New York) was in the long run probably more important to the development of the Black Arts movement than the actual work the group produced—at least in terms of their own poetry.

This embryonic Detroit group also gained significant cohesion and prominence through the research for and publication of the 1962 anthology *Beyond the Blues*, the first serious anthology of contemporary African American poetry in more than a decade. This anthology was assembled by Rosey E. Pool, a Dutch-born leftist living in the United Kingdom.[67] Pool was introduced to Danner first through Fuller—though Pool, whose base for a time during her first visit to the United States in 1959–60 was Wayne State University, met various Detroit poets through many sources.[68] Pool's anthology appeared only in Britain and was never issued in the United States. Nonetheless, it gained considerable attention within black intellectual circles. Its inclusion of Danner, Madgett, Randall, LaGrone, and Thompson introduced a number of Detroit poets to each other and did much to give Detroit, and the world beyond, a sense that there was a "Detroit group" of black poets doing interesting work. Pool's anthology broke the ground for Arna Bontemps's *American Negro Poetry* (1963) and Langston Hughes's *New Negro Poets, U.S.A.* (1964), both of which contained significant selections of the work of Detroit poets.[69] This sense of Detroit as a dynamic literary center was also enhanced locally by Pool's lectures at Wayne State and by a Michigan Public Television series on black poetry, *Black and Unknown Bards*, produced by Gordon Heath. The series (which took its title from a James Weldon Johnson poem about the folk creators of the spirituals) featured works selected by Pool and read by Heath, Earl Hyman, and Cleo Laine. Pool also organized black poetry festivals at Alabama A & M in 1964 and 1966 that gave a special prominence to the work of the Detroit group.

A crucial event for the Black Arts movement nationally, as well as in the Midwest, was the return of Hoyt Fuller to Chicago in 1961, after a sojourn in Spain and New York, to edit *Negro Digest*. Fuller, by this time widely traveled in Africa and Europe, identified himself as a "Nkrumahist" (which is to say, a Left Pan-Africanist).[70] Initially launched in 1942 by the Johnson Publishing Company as an African American version of *Reader's Digest*, *Negro Digest* had ceased publication in 1951. Even in this early incarnation, *Negro Digest* deviated somewhat from

the *Reader's Digest* model in its content, publishing serious literature by African American authors. When publisher John H. Johnson revived the journal in 1961, Fuller built upon this precedent. While at first adhering fairly closely to the general format of *Reader's Digest*, Fuller early on envisioned *Negro Digest* as a vehicle for high-level African American political commentary and cultural expression aimed at a broad black audience. Certainly, the journal was far more open to Left activists and intellectuals, such as Margaret Burroughs, than was *Reader's Digest*.

Increasingly, particularly after 1965, Fuller saw *Negro Digest* (renamed *Black World* in 1970) as an intellectual journal promoting the intertwined Black Power and Black Arts movements. With a circulation in at least the several tens of thousands at its height, *Negro Digest/Black World* had perhaps the largest readership of any serious cultural journal in the United States.[71] It is probably fair to say that without *Negro Digest/Black World*, the articulation of the Black Arts movement as a national phenomenon would have been far different and more limited. The magazine not only provided a vehicle for major Black Arts artists and intellectuals but also, as Kalamu ya Salaam points out with respect to the South, allowed the dissemination of information about activities and institutions that found few outlets for national publicity elsewhere.[72] Under Fuller, *Negro Digest/Black World* also functioned as a bridge between the Black Arts and Black Power movements and the larger-circulation Johnson Publishing journals, particularly *Ebony*, which dramatically covered the *Wall of Respect* and other major Black Arts creations and institutions and published important essays on the movement by Larry Neal, A. B. Spellman, and other leading radical black cultural figures.

The burgeoning grassroots black poetry and theater scene of Detroit provided Fuller with a dynamic example of a potential national African American literary movement in the early days of the revived *Negro Digest*. No doubt in part through his longtime relationships with Margaret Danner, Dudley Randall, and the black intellectual scene in Detroit, Fuller was instrumental in publishing and publicizing members of the Detroit group and the Concept East Theatre. Fuller's "Perspectives" column in *Negro Digest*, which was devoted to literature for the most part, frequently promoted the work of the Detroit poets. The most important result of Fuller's engagement with the Detroit group was the advancement of the poetry of Dudley Randall. It was at a party for Fuller that Randall apparently first met Danner, leading Danner to invite Randall to an early Boone House function. At the same time, it seems that it was Randall's activity in the

circle of Boone House writers that gave Fuller, who had known Randall since their days at Wayne State University, a deepened interest in Randall's work. Six poems by Randall appeared in *Negro Digest* between 1962 and 1964.[73] These publications, along with the inclusion of three poems in *Beyond the Blues*, provided a major lift to Randall's literary career. Randall, like Danner, had ties to the cultural world of the Popular Front. Randall's brother Arthur had been the Detroit representative of *New Challenge* and later moved to Baltimore to work on the *Afro-American*, perhaps the most consistently Left-influenced major African American newspaper during the Cold War era. Dudley Randall also became close to Robert Hayden while Hayden was active in Left political and cultural institutions in Detroit, such as the John Reed Clubs.[74] Though Randall wrote actively and published sporadically in the 1950s, it was the emergence of Boone House, the Detroit group, and their link to *Negro Digest* that connected him to new black literary circles of the Midwest and pushed forward his career as a writer and, ultimately, as a publisher.

Randall's first efforts as a publisher were his early broadsides under the imprint of Broadside Press, beginning in 1965. This initial group of broadsides, "Poems of Negro Revolt," included two poems by Randall ("Ballad of Birmingham" and "Dressed All in Pink"), initially printed to safeguard copyright, and poems by Robert Hayden ("Gabriel" from Hayden's "Red" period), Melvin Tolson ("The Sea Turtle and the Shark" from *Harlem Gallery*), Margaret Walker ("Ballad of the Free"), and Gwendolyn Brooks ("We Real Cool"). The first wave of Broadside writers were all veterans of the cultural and political milieu of the Popular Front in the Midwest.[75]

The event that would transform Broadside Press into a major Black Arts book publisher was another Chicago-Detroit crossing facilitated by this Old Left–new black circuit. At the 1966 Black Writers Conference at Fisk University, Randall ran into Margaret Burroughs and Margaret Walker, another artist and intellectual who had emerged from the cultural world of the South Side Popular Front during the 1930s and 1940s, as Walker was rehearsing her reading of a poem dedicated to Malcolm X.[76] An impromptu conversation about the number of exciting new works about Malcolm X and how they would make a wonderful collection ultimately led to the initiation of Broadside Press's first book project, the anthology *For Malcolm* (1969), edited by Burroughs and Randall—though various production delays kept it from being the first book that Broadside Press actually issued.[77] Randall's conception of Broadside's books as cheap, popularly

accessible volumes was also shaped by midwestern Old Left links between Detroit and Chicago insofar as his inspiration was the popular Soviet editions of poetry produced and priced to be accessible to a mass audience that Randall encountered on a tour to the Soviet Union led by Burroughs.[78] As noted earlier, the production of *For Malcolm* also facilitated the introduction of Randall to Haki Madhubuti (who contributed to the collection at the urging of Burroughs), leading to the publication of some of the best-selling volumes of poetry in the history of the United States, Madhubuti's *Black Pride* and *Don't Cry, Scream* (which quickly sold several tens of thousands of copies after an article on Madhubuti's appointment to a writer-in-residence position at Cornell University appeared in *Ebony* at nearly the same time as the book came off the presses), as well as to the establishment of Third World Press.[79]

Fuller was also a prime initiator of the most important Chicago Black Arts writers' and visual artists' organization, OBAC, in 1967, again building on the models of older, politically engaged, African American educational and cultural institutions in Chicago, such as the South Side Writers Group, the AAHA, and the DuSable Museum, as well as the newer AACM. In its inception through the efforts of Fuller, poet Conrad Kent Rivers, and sociologist Abdul Alkalimat (Gerald McWhorter), OBAC aimed to facilitate and inspire the creation of art that engaged the new black political movements and raised black consciousness.[80] The workshops of the writers and the visual artists quickly became the most visible manifestations of the organization. Fuller and the younger writers of OBAC, especially Haki Madhubuti, organized the Writers' Workshop not long after the inception of OBAC. This workshop operated much like Umbra in New York and the Watts Writers Workshop in Los Angeles, critiquing the new work of individual members as well as discussing more general issues of craft and its relation to politics. The workshop, however, was far more ideologically unified by nationalism (and less directly influenced by Marxism and the remnants of Popular Front aesthetics) than Umbra or the Watts Writers Workshop had ever been, perhaps contributing to the longer life of the Chicago group, which survived into the 1990s. Like their counterparts on the West and East Coasts and in the South, OBAC poets reached out to the broader community, performing their work in bars, bus stops, coffee shops, housing projects, colleges, and the DuSable Museum, to name a few of their wide-ranging venues. Also like Umbra, OBAC sporadically issued a journal, *Nommo*, which gave Chicago writers a local outlet besides *Negro Digest/Black World* (which was more national in scope than

Nommo). In addition to providing members a chance to present their work and have it critiqued, like Umbra and Boone House, OBAC became an essential stop for black writers visiting Chicago. These out-of-town guests provided a link to the broader movement, serving as vehicles through which general Black Arts poetics were discussed, articulated, and disseminated in Chicago—and beyond, as the guests carried home their experiences in Chicago.[81]

As with their peers in such groups as BLKARTSOUTH and Sudan Arts South/West, quite a few of the poets in the OBAC circle were relatively uninterested in publishing—or at least in literary careers as such. For example, the work of Amus Mor remained (and remains) almost completely unpublished. Mor, who was extremely concerned with poetic craft, was considered by many to be the most electrifying performer of poetry in Chicago—no small thing given the number of accomplished poets on the scene there. Perhaps more than any other poet of the early Black Arts era, Mor successfully drew on jazz from the bebop era through free jazz, incorporating jazz phrasing, repetition of verbal riffs, rhythmical shifts, and scatting sounds into his poetry—not to mention vocalized imitations of actual jazz riffs and R & B singing. Certainly, Mor, particularly in his readings of his signature works, "The Coming of John" and "We Are the Hip Men," deeply influenced the performing styles of some of the leading writers of the movement, especially Amiri Baraka and Larry Neal, and through them touched virtually every Black Arts–era poet.[82]

Some activists contrasted the grassroots, nonprofessional orientation of the OBAC Writers' Workshop to the workshop Gwendolyn Brooks ran in her home, which included many of the same artists. The Brooks workshop, they said, focused more specifically on poetic craft and career, detracting somewhat from the community orientation in favor of more individualistic technical and professional artistic concerns—focuses that were presumably influenced by Brooks's own approach to art as an established writer who had succeeded in the market of bourgeois art. However, such a sense of Brooks seems somewhat at odds with much of her career even before the advent of the Black Arts movement. Despite her relative literary fame, Brooks had lived in the South Side since infancy and had chronicled its landscape and residents in her poetry since the 1940s, often reading that poetry at community events. As Haki Madhubuti notes, he and others in the workshop first met Brooks in the spring of 1967, shortly after the Fisk Black Writers Conference, at a creative writing class she ran for members of the Blackstone Rangers in the First Presbyterian Church on the South Side.

It is hard to believe that Brooks would have conducted the workshop with gang members without some sense of deep political commitment to the community and a belief that the process of writing poetry would be useful for these young men who were unlikely to pursue literary careers in the traditional sense.[83] The implication that Brooks simply dictated her sense of vocation and aesthetics to the young poets is also questionable. Brooks herself suggested that young poets in her workshop in many respects led her to their concerns, both aesthetic and political, rather than the other way around. And as Dudley Randall and Melba Boyd make clear, Brooks's course was not without its contentious moments, despite the clear respect that she commanded among the younger writers.[84]

Still, there is a sense among some early OBAC veterans that a divide over how much to emphasize individual literary career and artistic product and how much community and process, a divide somewhat institutionalized in the two workshops, was a more significant source of difference than clichéd divisions between cultural nationalists and revolutionary nationalists — though some of these criticisms may be shaped by later ideological battles between cultural nationalists and Marxists within the Black Arts movement. However, others, notably Madhubuti, consider such a dichotomy to be false. Why wouldn't one want to interact with two of the premier black artist-intellectuals in the country, Hoyt Fuller at OBAC and Gwendolyn Brooks in her workshop? Certainly, though less publicized than her "conversion" at the 1967 Fisk Black Writers Conference, the workshop was a crucial link in the transformation that changed her from an older writer like, say, John O. Killens, who supported the Black Arts movement to one who was an intimate part of the grassroots movement in Chicago, both mentoring and in some senses being mentored by the younger black writers, painters, dancers, actors, musicians, and so on. This transformation in turn profoundly marked the Black Arts movement in the Midwest, further strengthening the impulse to build black arts and educational institutions. As Madhubuti recalls, Brooks's decision to leave her prestigious mainstream publisher in New York, Harper, for a small African American press in Detroit, Broadside, was a rejection of old-style careerism in favor of black self-determination and the support of black institutions that inspired many of the Chicago artists.[85] In fact, one thing that distinguishes the Black Arts movement in the Midwest from the movement in other regions is that, following the example of Brooks, its leading writers (with the exception of Carolyn Rodgers) published (and continue to publish) almost all their work with African American publishers, especially

Broadside, Third World, and Lotus Press, long after the heyday of the Black Arts movement, even though many of them certainly had other options.

OBAC also served as the vehicle for important cultural exchange between Chicago and Detroit in the visual arts. Much like the OBAC Writers' Workshop, its Visual Arts Workshop grew out of the disciplinary needs of visual artists when the original OBAC grew too large to efficiently address its diverse membership without these working subgroups. First meeting in June 1967, the Visual Arts Workshop decided that it wanted to create some sort of public artwork that would showcase its nationalist aesthetics and ideals to the broader black community of the South Side.

One older member, William Walker, had a direct connection to the late Popular Front muralism of the 1930s and 1940s. The painter and art historian Samella Lewis introduced Walker to this sort of public art (and the work of the Mexican muralists that informed it) while they were both in Columbus, Ohio, in the late 1940s. Lewis in turn had earlier studied with Elizabeth Catlett at Dillard University and the Hampton Institute. In the OBAC meeting, Walker mentioned that he was going to paint a piece on a wall at Forty-third Street and Langley Avenue on the South Side with the idea of reviving the older tradition of politically engaged public art. He added that there was room for other artists' works.

Rather than do individual works, the workshop decided to create a collective piece, a "wall of heroes," that would belong to the community and would have no signatures. The work would also be a "guerrilla" effort in the sense that it had the support of the neighborhood, including that of the Blackstone Rangers, but not the approval of the absentee landlord who owned the wall. Its production was entirely funded through money collected by the artists themselves in the community without any larger financial or political sponsorship.

Workshop member Sylvia Abernathy designed the piece, aided by research done by the OBAC Writers' Workshop. Executed by more than a dozen artists, the resulting *Wall of Respect* was probably the first and certainly the most influential Black Arts and Black Power mural of the 1960s and 1970s. It became a favored venue for South Side cultural and political events and inspired literally thousands of socially engaged community murals in a wide range of neighborhoods across the United States. Unfortunately, the success of the mural led to dissension within the group over how to deal with mainstream media and institutions. This conflict was heightened by William Walker's self-appointment as the caretaker of the *Wall of Respect*, leading to the whitewashing of a section

of the mural painted by Norman Parish and its replacement by the work of an artist not previously connected to OBAC without consultation with the broader group. While the repainting of Parish's portion of the mural may have been warranted due to some technical problems with the section's production (and subsequent wear), its sudden replacement split the group badly. After the split, Walker not only led in the painting of many subsequent murals in Chicago as part of the multiracial Chicago Mural Group but also traveled to Detroit in the late 1960s where he painted a number of important murals with Eugene Eda (whose "Statesmen" panel replaced that of Parish in the *Wall of Respect*) funded by an ecumenical group of churches. The best-known of these murals was (and remains) the 1968 *Wall of Dignity*, which had something of the same political and cultural impact in Detroit that the *Wall of Respect* had in Chicago.[86]

In part because of the conflict over the control of the *Wall of Respect* and its maintenance, the Visual Arts Workshop disintegrated, with Jeff Donaldson, Wadsworth Jarrell, and Barbara Jones forming the core of a new group, COBRA, which eventually became AFRI-COBRA. Despite this break, COBRA and AFRI-COBRA's relations with other Black Arts groups and institutions in Chicago demonstrate the intense multigenre and interdisciplinary character of the Black Arts in Chicago. Though formally separated from OBAC, COBRA and AFRI-COBRA maintained close contact with leading OBAC members, inviting Hoyt Fuller, Abdul Alkalimat, Gwendolyn Brooks, and others to their meetings.[87] And at the groups' events, shows, public paintings, and so forth, they involved artists from other media and genres along the lines of the production of the *Wall of Respect*, as discussed in Chapter 2.

Similarly, the AACM, formed in 1965 by two leading local jazz avant-gardists, pianist Muhal Richard Abrams and trumpeter Phil Cohran, was closely linked to OBAC. This was not surprising because, as Haki Madhubuti notes, not only were many of the young black artists deeply into jazz (Madhubuti had early ambitions of being a jazz trumpeter) but many of the writers were performing their work at clubs where the new jazz was played.[88] In fact, the AACM both inspired the creation of OBAC and precluded the formation of a musicians' workshop on the same lines as those for the writers and the visual artists, since the founders of OBAC thought the AACM made such a move redundant. While the AACM is most famous outside Chicago for the performances of such members as Anthony Braxton and the Art Ensemble of Chicago, it, too, saw itself as a community-oriented organization, providing free musical training for South Side children.[89]

Cohran was a veteran of Sun Ra's Arkestra (originally based in Chicago) who, like Sun Ra, had a background in a wide range of African American music, having worked in swing, blues, rhythm and blues, and bebop with such musicians as Kansas City–based pianist Jay McShann and singer, actor, and dramatist Oscar Brown Jr. (with whom he set to music poems by Paul Laurence Dunbar). Cohran eventually left the AACM, considering its focus on jazz at the expense of other forms of black music too limiting. His Sun Raesque Artistic Heritage Ensemble became a mainstay of Black Arts and Black Power events in Chicago, mixing avant-garde jazz, swing, rhythm and blues, and neo-African music with dance, theater, and visual arts. In 1967, Cohran also began the Affro-Arts Theater, a major venue for black music, theater, visual arts, and poetry on the South Side anchored by the Artistic Heritage Ensemble, drawing participants from OBAC, the AACM, and other black cultural organizations until its demise in 1970. Its ultimate closing was due to the familiar combination of financial problems, internal fighting (often based on personal rather than political differences), and external attacks by local authorities that largely destroyed the Black House in San Francisco, BARTS in New York, and the House of Respect in Los Angeles—though some Affro-Arts alumni would go on to fame as the core of the R & B group Earth, Wind, and Fire.[90] Like The East in central Brooklyn, the Affro-Arts was a political as well as cultural center. It hosted many meetings, rallies, lectures, and speeches, including a rally drawing thousands in support of a school boycott organized in the fall of 1968 demanding the hiring of more black teachers and the inclusion of courses in African American history and culture in the basic curriculum of Chicago public schools. Cohran himself prominently supported this boycott in which tens of thousands of black students left their classes.[91] Again, such meeting and mixing of genres and media (and politics) characterized the Black Arts movement in many cities. However, in Chicago there was truly a sense of interdisciplinary equality in which no genre or medium absolutely dominated.

Cleveland and St. Louis in the Chicago-Detroit Black Arts Nexus

Of course, other midwestern cities hooked up to the Chicago-Detroit political and cultural circuit. Cleveland, too, claimed a long heritage of cultural and political radicalism. It was the home of Charles Chesnutt, a sort of grand old

man of African American letters by the second decade of the twentieth century. Garvey and the UNIA also made a powerful impression on municipal politics during that period—perhaps to a greater extent than in any other city in the United States. A number of UNIA leaders rose to prominence in community and citywide institutions and were appointed to significant municipal offices during the 1920s—though there is some question among scholars about whether or not their advancement represented a sort of co-optation.[92]

The SP achieved considerable electoral success in the early twentieth century. Cleveland Socialist leader C. E. Ruthenberg and the Ohio local of the SP, particularly the foreign language groups of Cleveland, were among the strongest forces in the left wing of the SP that split from the Socialists in 1919 to form the core of what would become the CPUSA. Cleveland became a relative stronghold of black membership in the CPUSA in the North during the early 1930s. In 1931, African Americans made up 16 percent of the party in Cleveland—a far higher proportion than in New York at that time (3 percent).[93] As in Detroit and Chicago, the Communist Left had a significant base in the CIO unions, particularly the UAW locals at General Motor's Fisher Body facility and at the White Motor Company, the United Electrical, Radio, and Machine Workers Union, and smaller unions, such as the United Public Workers. Radicals of various stripes in the Cleveland automobile factories, notably Wyndham Mortimer (a Communist who worked at White Motor Company and went on to become a leading figure of the early UAW, most famously as the top UAW negotiator during the Flint Sit-Down Strike), were instrumental in initiating the various conferences and meetings that led to the formation of the UAW.[94] Cleveland was also a particularly dynamic locus of the Left-led NNLC, which held its second national convention there in 1952, culminating in a march of thousands down Euclid Avenue to protest the discriminatory policies of American Airlines.[95] While the Left leadership in Cleveland unions was largely crushed during the McCarthy era, a lingering local legacy of the Popular Front in the incipient Black Power movement could be seen in the 1965 and 1967 mayoral campaigns of Carl Stokes, who had been a supporter of Henry Wallace and the Progressive Party during his college days at Case Western and whose early political education was in part molded by NNLC leader Bert Washington of the United Public Workers and by Paul Robeson (who met Stokes through Washington).[96] Though the Trotskyist tradition did not achieve the prominence in Cleveland that it did in Detroit, the SWP made itself felt in the 1960s in the peace movement, the labor movement (especially

the Amalgamated Meat Cutters and Butcher Workmen of North America), and the Cleveland affiliates of Fair Play for Cuba and CORE, where the presence of SWP activists occasioned a fierce factional struggle in 1964 that paralyzed an already troubled chapter, ending with a change of leadership after a bitter election contest and the departure of the SWP members and their supporters.[97]

As in many cities, black cultural production in Cleveland was closely bound up with this history of Left and nationalist activity. Like Philadelphia and Boston, Cleveland was a vital if secondary hub of the New Negro Renaissance. Karamu House, originally the Neighborhood Association Settlement House established in 1915 by progressive white sociologists Rowena and Russell Jelliffe, blossomed as an arts center much like Chicago's South Side Community Art Center — though considerably before the Chicago institution. The adoption of the Swahili "Karamu" (meaning something like "community center") after a fire destroyed the center's theater in 1940 made public its greater engagement with the African American community. This engagement was motivated in part by the demographic changes in the surrounding Third Precinct of Cleveland, which had changed from a mixed black, Jewish, Italian, and Middle Eastern area to an almost entirely African American neighborhood — though a large proportion of the students in the various Karamu arts programs were (and long continued to be) white people from outside the neighborhood drawn by the high quality of the center's classes. However, even before the neighborhood's transformation, the center's pioneering interracial theater group, the Gilpin Players of Cleveland (named for the early twentieth-century black actor and original star of Eugene O'Neill's *Emperor Jones*, Charles Gilpin) led by Rowena Jelliffe, was instrumental in the artistic development of black actors, directors, and playwrights, including a young Langston Hughes (who retained a lifelong connection to Karamu). In the early 1930s, the Gilpin Players moved to the Left, allying itself with the Communist-led workers' theater movement and presenting material aimed at a working-class audience.

The various arts programs associated with the WPA did much to bring black Cleveland artists, especially visual artists, into the cultural world of the Popular Front. The Gilpin Players later sponsored the local "Negro unit" of the FTP. The national office of the FTP eventually closed the Cleveland Negro unit, recalled FTP head Hallie Flanagan, because of the lack of interest in the black community — though the tour of *Macbeth* by the New York Negro unit that Orson Welles directed, known as the "Voodoo *Macbeth*," traveled to Cleveland (and

Indianapolis, Chicago, and Detroit).[98] While the FTP apparently made relatively little impression on black Cleveland, the FAP hired several African American artists, including painters and printmakers Charles Salleé Jr., Hughie Lee-Smith, Elmer W. Brown, Curtis Tann, and Zell Ingram, most with ties to Karamu House — often as actors or set designers in the Gilpin Players. Like their counterparts in Chicago, Atlanta, New York, Philadelphia, and Hampton, Virginia, these artists drew much of their inspiration from the Mexican muralists, establishing a local tradition of socially engaged, black public art depicting street scenes, cabarets, industrial landscapes, and African American history (including the history of black labor) on which later Black Arts activists were able to build. Tann, in fact, took this aesthetic to Los Angeles during the Black Arts era when he became director of the Simon Rodia Art Center at the Watts Towers in 1967.[99] While the FWP seems to have had less impact on local black writing over the long term than the FAP had on the visual arts, it did advance the career of Chester Himes who, among other things, wrote an unpublished history of Cleveland for the FWP before his departure for California. Though Himes lived in Europe during most of the Black Power and Black Arts era, he became a sort of hero to many Black Arts writers.[100] Himes's ideological trajectory from a close association with the Communist Left in Ohio (and such figures of Cleveland's literary Left as the Jelliffes at Karamu House and Dan Levin, editor of a local Left journal, *Crossroad*) and California to a quasi-nationalist radicalism that acknowledged its Left origins in various ways while rejecting the Old Left can be traced in his work from such novels as *If He Hollers Let Him Go* (1946) and *The Lonely Crusade* (1947) to his 1960s Gravedigger Jones and Coffin Ed Johnson hard-boiled detective fiction series set in Harlem, a literary journey that began in Popular Front Cleveland.

Cleveland was also the home of *Free Lance*, one of the few literary journals in which African Americans set editorial policy during the 1950s and early 1960s. It was not, strictly speaking, a black institution, growing as it did out of an interracial writers' workshop begun in the 1940s and printing the work of many white writers throughout its existence. In fact, in many respects it became more akin to such interracial bohemian and avant-garde journals as *Kulchur*, *Yugen*, and *Floating Bear* than to *Nommo* or JBP after a fierce editorial battle between the avant-gardists and members of the original workshop who looked back to an essentially British Victorian poetics, a battle in which the avant-gardists triumphed. As Aldon Nielsen argues (and as noted in Chapter 2), the importance of *Free Lance* to black literature was not due simply to its near singularity in

terms of the number of African Americans on the editorial board at that time but also to its equally rare willingness to publish more consciously experimental African American writing in the 1950s and 1960s, especially by the poet and composer Russell Atkins. Atkins's poetry ran in three basic modes: a visual, concretist vein; an avant-gardist sound poetry; and a satiric, "editorial" manner that was relatively conservative formally, but often politically or socially radical in subject (as in the relatively regularly end-rhymed 1963 "Editorial Poem on an Incident of Effects Far-Reaching," which protested the prosecution of Robert Williams's co-worker in the Monroe, North Carolina, NAACP, Mae Mallory, a Left nationalist cause célèbre). Though *Free Lance* was never a Black Arts journal as such, Atkins's theoretical writings in it posited the existence of a black avant-garde tradition descending from the work of Langston Hughes (who did much to promote the journal, contributing an introductory note to the journal's inaugural issue, and to advance the career of Atkins) — not unlike Cecil Taylor's claim of an ancestry for his work in the compositions of Thelonious Monk and Duke Ellington rather than European and Euro-American modernist (and postmodernist) art music. These theoretical writings were often extremely difficult, filled with abstruse mathematical formulas. But like the work of visual artist Noah Purifoy in Los Angeles and Percy Johnston in Washington, D.C., they promoted the notion of a politically engaged, theoretically informed, black avant-garde. Though rarely identified as a Black Arts poet, by the early 1960s Atkins referred to himself as a "Nationalistic Phenomenalist," advocating the development of black or "non-dominant group" epistemologies: "A non-dominant group might have to assume the DEFINING OF KNOWLEDGE (what can or cannot or should or need be 'known,' and how much treated as such). It may have to create what it knows and know what it creates: and create what it learns and learn what it has created."[101] Atkins also wrote an introduction to the 1971 collection *Above Maya*, by the leading Black Arts poet in Cleveland, Norman Jordan. Given that *Free Lance* printed the work of a number of poets associated with the Black Arts movement in the Midwest, such as Mari Evans, Haki Madhubuti, Dudley Randall, and Conrad Kent Rivers (and Langston Hughes), one could expect these poets to be familiar with the journal and with Atkins's work. Certainly Madhubuti, who planned to write about Atkins in a projected but never published second volume of *Dynamite Voices*, knew Atkins's poetry well. It seems quite probable that his theoretical writings influenced the deep interest of Madhubuti, Carolyn Rodgers, and others in Chicago in developing

Black Arts epistemologies and aesthetics.[102] One might also see the formal impact of Atkins's poetry on Madhubuti's own use of concretism and sound poetry in his early published work—though obviously, the widely read Madhubuti had plenty of sources, black and white, from the Dadaists, Russian futurists, and e. e. cummings to Dingane Joe Goncalves, Sonia Sanchez, Edward Spriggs, and Norman Pritchard.

Both the school desegregation efforts led by the United Freedom Movement, a broad coalition of civil rights organizations, during the early 1960s and the mayoral campaigns of Carl Stokes in 1965 and 1967 gave a concrete focus to the growing Black Power organizations in the city, ultimately transforming arts institutions in the black community, particularly Karamu House. As noted in Chapter 3, Donald Freeman, a public school teacher with early connections to the SDS, tirelessly proselytized for a Left nationalist ideology and the need to build grassroots activist black organizations both locally and across the Midwest, especially Detroit, and the Northeast. His activities, including his correspondence, lectures, publications, and peripatetic tours, not only led to the emergence of RAM and the Cleveland-based Afro-American Institute, a primarily agitational and educational institution aligned with RAM and sympathetic to the AAA that brought together African American activists from the Left nationalist end of the labor movement, the civil rights movement, and the black arts community. His efforts also made Cleveland an important clearinghouse of ideas between the Black Power and Black Arts centers of the Midwest and those of the West Coast and the Northeast. Along with his wife, Norma Jean Freeman, he coedited the journal *Vibration* ("dedicated to the Resurrection of the Mentally and Spiritually Dead"), perhaps the most culturally (and spiritually) oriented of all the journals associated with RAM (or former RAM members), even more than *Soulbook*, but without quite the national circulation of *Soulbook* or *Black America*.

Like the South Side Community Art Center in Chicago, Karamu House gained a new energy and a new context from the Black Power and Black Arts movements—though much of the student body continued to be white.[103] It made available new, cutting-edge black drama, visual arts, music, and literature to local audiences. For example, the painter Nelson Stevens, later a member of AFRI-COBRA in Chicago, recalls seeing Amiri Baraka's play *Dutchman* at Karamu the same year that it debuted in New York. Karamu was also the

base of the most prominent of the Cleveland-based Black Arts writers, the poet-dramatist Norman Jordan. A sort of writer-in-residence, Jordan was also the guiding force behind Vibrations Press and worked closely with the Freemans on *Vibration*. His spare, visually oriented, short-lined poems formally resembled the work of the objectivist poets, such as Louis Zukofsky and George Oppen, the shorter lyrics of Williams Carlos Williams, and the plain but rhythmic poetry of Robert Creeley, but with a direct, cultural nationalist, aphoristic content that many then found politically inspiring and visually engaging — though the poems have not worn particularly well.

Jordan also provided an explanation of why Cleveland, despite its history of black political and cultural radicalism and the existence of such institutions as Karamu House, *Free Lance*, and *Vibration*, never rose to the same level in the Black Arts movement as Detroit or Chicago. According to Jordan, much of the early Black Arts scene in Cleveland was characterized by disunity, co-optation, and an inability to build stable, independent Black Arts institutions. Perhaps as a result of a failure to establish an infrastructure of ongoing institutions that would support cultural production and venues in which to present their art, with the partial exception of Karamu House, Cleveland suffered from an out-migration of many of its most dynamic artists, particularly to Chicago, without enough of an in-migration to replace them.[104]

If Cleveland was an ideological and cultural waypost between the Midwest and the East Coast, St. Louis and East St. Louis to some extent served as a meeting point between the Black Arts movement in the South and in the Midwest, especially Chicago — much as they always have in African American culture.[105] Among St. Louis's Black Arts institutions was BAG, a relatively short-lived but significant organization of black writers, artists, musicians, and theater workers, including at times as members or on its periphery reed players Julius Hemphill, Oliver Lake, and Hamiet Bluiett (who would later join with David Murray in New York to form the World Saxophone Quartet), trombonist Joseph Bowie, writers Quincy Troupe, Robert Malinke Elliott, and Ntozake Shange, actor Vincent Terrell, and painter Oliver Jackson. (Trumpeter Lester Bowie, Joseph Bowie's brother, moved to Chicago before the founding of BAG in the late 1960s and was a prominent member of the AACM and the Art Ensemble of Chicago who retained close ties to the black avant-garde scene in St. Louis, facilitating artistic interchange between the AACM and BAG.) BAG distinguished

itself from many similar groups in the diversity of genres and media of its artists and the depth of engagement of its members in a variety of art forms. Generally speaking, there was often much interchange between various types of artists elsewhere, but relatively rarely did such large numbers of musicians, actors, writers, dancers, visual artists, and so on interact so closely and intensely in the same cultural groups. And if they did, as in the case of the OBAC Visual Arts Workshop, the artists often maintained a sort of disciplinary autonomy even though they had close relations with other artists and activists and frequently participated in multigenre and multimedia events.[106]

Across the Mississippi, the predominantly black East St. Louis was home to Katherine Dunham's Performing Arts Center, founded in 1969 by the choreographer and pioneering folklorist of the African diaspora (especially Haiti). Dunham had been a major figure of the cultural Left in Chicago and New York during the 1930s and 1940s and joined the faculty of Southern Illinois University in 1967. Eugene Redmond, a tireless political and cultural organizer as well as poet, teacher, and editor, initiated many Black Arts projects in his native East St. Louis, including the Black River Writers Press. However, as in Cleveland, the black cultural scene in St. Louis and East St. Louis was weakened by the loss of key activists. For example, many BAG members went on to gain national attention as musicians, actors, playwrights, poets, and painters, but virtually all did so in Chicago, New York, or California.

In the end, St. Louis and Cleveland, despite their early practical and theoretical contributions to the Black Power and Black Arts movements, did not share the same dynamic relation with Detroit or Chicago that those cities had with each other. Of course, both Detroit and Chicago also saw a considerable emigration of leading artists to other cities, particularly New York City. As noted elsewhere, black theater in New York particularly enriched itself with the work of such transplanted Detroiters as Woodie King Jr. and Ron Milner — though both, especially Milner, kept close ties to Detroit. However, despite these migrations, Detroit and Chicago remained hubs of radical black cultural and political activity in ways that Cleveland and St. Louis (and Cincinnati and Indianapolis) did not, largely through the density and longevity of black institutions that stayed unusually stable despite the movement of individual cultural and political workers.[107]

Nationalism, Cultural Nationalism, and the
Black Arts Movement in Chicago and Detroit

Dudley Randall and Margaret Burroughs's 1969 anthology *For Malcolm* in some ways embodies the character of the early Chicago and Detroit Black Arts institutions. It is a tributary volume to the presiding spirit of the new radical African American nationalism. At the same time, the writers contributing to the anthology were, for the most part, a mixture of older African American poets, such as Margaret Walker, Robert Hayden, Gwendolyn Brooks, and Margaret Danner (many of whom, like Burroughs herself, came of age in the Popular Front in the Midwest), and younger black poets, such as Amiri Baraka, Sonia Sanchez, Haki Madhubuti, and Larry Neal, who, though often with some past Left connections, were closely linked to the emerging nationalist movements. Though Chicago and Detroit poets are heavily represented, it is a truly national anthology with a range of poets from the East and West Coasts and, to a lesser extent, the South. Far more than LeRoi Jones (Amiri Baraka) and Larry Neal's *Black Fire* (1968), an anthology that some scholars have taken to be a précis of the early Black Arts movement, *For Malcolm* attempts to bridge the generations and eras of political activism while maintaining a militant, nationalist stance.

At the same time, like other cultural initiatives emerging out of the black Left of Chicago, the anthology differs from mature midwestern Black Arts institutions it helped birth. One way in which *For Malcolm* was anomalous in terms of how the movement developed in the Midwest was the presence of several white radical poets among the contributors. This practice had some precedent in the inclusion of white "tributary" writers in earlier African American anthologies, such as Langston Hughes and Arna Bontemps's *The Poetry of the American Negro* (1949). Also, Black Arts participants on the West Coast, notably Quincy Troupe and Ishmael Reed, put together prominent anthologies and journal issues that included white, Asian American, Puerto Rican, and Chicana/o writers. However, this protomulticultural practice happened extremely rarely, if ever, in Chicago and Detroit Black Arts journals and anthologies after *For Malcolm*.

To a certain extent, the catholic approach to age, ideology, and (to a lesser extent) race in *For Malcolm* may have been influenced by the age and ideology of the editors themselves. The younger cultural activists in the Midwest, by and

large, tended to be more militantly nationalist and separatist than their elders. This may have led to one of the distinctions between the literary scene of Detroit, where older artists and intellectuals guided a number of the key Black Arts institutions, especially Broadside Press and Lotus Press, and that of Chicago, where younger artists (and older artists who came to largely share the views of the younger artists) increasingly took the lead. As time passed, though a close connection between Black Arts institutions in the two cities remained, Chicago came to be generally dominated by a cultural nationalist aesthetic to a greater extent than was true of the black literary institutions of Detroit. There was also little of the early multicultural literary interaction that took place in the San Francisco Bay Area and even the Northeast in either city.

This distinction between Chicago and Detroit can be overstated. Though *Negro Digest/Black World* increasingly became a national vehicle for the Black Power and Black Arts movements and cultural nationalism, Hoyt Fuller (perhaps because he himself was older than many of the Chicago militants) kept the pages of the journal open to writers, such as Robert Hayden, who were heavily criticized by some cultural nationalists, most prominently Haki Madhubuti. As mentioned earlier, the DuSable Museum was extremely supportive of the Black Arts movement, but it was a critical support that was never dominated by cultural nationalism. And even someone like Madhubuti, who became a harsh critic of Marxism, honored individual leftists, particularly such older activists as Charles and Margaret Burroughs, whose politics shaped in the Popular Front (and under the pressures of the Cold War) may have rejected separatism but also led them to work to build an awareness of African American history, culture, and art in the community rather than to attempt to remake Black Power and Black Arts groups in a Marxist-Leninist mode.[108]

Conversely, as noted near the beginning of this chapter, militant nationalism had a long history in Detroit. Revolutionary and cultural nationalist institutions, such as GOAL, Vaughn's Bookstore, UHURU, the LRBW, the RNA, Rev. Albert Cleage Jr.'s Central Congregational Church (later the Shrine of the Black Madonna), and the NOI, played important parts in stimulating and maintaining the Black Arts movement in Detroit. If anything, a very large segment of the Black Power movement there, perhaps catalyzed by the uprising of 1967, was less inclined to work with white people than was the movement in Chicago — and sometimes was more harshly critical of older modes of black political and cultural radicalism. Nationalist organizations, such as the RNA, and basically sepa-

ratist leaders, such as Cleage and the RNA's Imari and Gaidi Obadele, exerted a tremendous influence in Detroit—though their visions of the liberated black community often varied considerably. Even the revolutionary nationalist LRBW and the Revolutionary Union Movement groups from which the LRBW largely emerged (e.g., DRUM, the Eldon Avenue Revolutionary Union Movement, and the Ford Revolutionary Union Movement) were often ambivalent about cooperating with supportive white workers (and the Old Left), much less trying to win over those who were indifferent or even hostile—though the LRBW often cooperated with white radicals on a more informal level.[109] The BPP nationally was often willing to work with white radicals but was dominated by LRBW members in Detroit.[110]

Hardcore nationalist institutions underpinned the black cultural life of Detroit to a significant extent too. The bookstore of Edward Vaughn (later a state senator) and the Forum '65, Forum '66, and Forum '67 discussion groups that met there were hotbeds of radical African American nationalist literary and political activism during the middle 1960s—so much so that Detroit police publicly attacked the bookstore in 1967. Vaughn's Bookstore was relatively small, but it was a place for a wide range of activists to gather, both in public meetings, such as those of the Forum groups, and more informally. It was also virtually the only place in Detroit where one could buy books by black authors. Increasingly, radicalized people who were not members of any organization came, as Grace Boggs describes it, to satisfy "a hunger for blackness."[111]

As elsewhere, perhaps even more intensely than elsewhere, these cultural institutions intersected with Detroit's vibrant Black Power movement that emerged out of a Left-nationalist matrix. The staff of the radical community paper *Inner City Voice*, led by John Watson and other members of UHURU (who later formed the nucleus of the leadership of the LRBW) had in many cases regularly attended CPUSA and SWP forums, studied Marxism with Martin Glaberman, and gone to Cuba on PL-sponsored trips. Not surprisingly, given this background, the paper engaged a wide spectrum of Left and nationalist groups in Detroit. Like *Correspondence*, as Bill Mullen points out, it was also an important venue that further wedded different currents of black political radicalism with Detroit's emerging Black Arts community. Much as it did with its political coverage and commentary, the paper placed local Detroit political organizers and artists, such as James Boggs and poet Gloria House (a former SNCC activist and one of the early teachers in Wayne State's black studies program), alongside

such better-known writers from outside the region as Amiri Baraka and Askia Touré. And like *Black News* in Brooklyn, *Inner City Voice*'s circulation of ten thousand during its relatively brief existence in 1967–68 brought these artists to a grassroots African American audience that *Correspondence* (and the journals and newspapers of the Old Left) did not directly reach very often, if at all.[112]

A crucial contribution of these interlocking political and cultural institutions to the development of a national movement, especially the idea of a national Black Arts movement, was the Black Arts conventions that took place in 1966 and 1967 at the Central Congregational Church. Sponsored by Vaughn's Bookstore, the Inner City Organizing Committee, and the Forum discussion groups, these conventions were notable because they provided a counterpoint to the better-known writers conferences organized by John O. Killens at Fisk University during the same years. Older black writers dominated the first Fisk conference, in which the work of the younger militant artists was an obsessive point of discussion, but younger writers themselves were not present except for the novelist William Melvin Kelley. Conversely, the Detroit conventions were oriented almost completely toward the new nationalism. Some older artists and activists, such as Killens, Grace Lee Boggs, and Dudley Randall, participated in the convention—and these were among the artists and activists most associated with the new black politics and art. Still, younger political leaders, such as Muhammad Ahmad of RAM, and younger artists, such as poets Larry Neal, Bobb Hamilton, Haki Madhubuti, David Llorens, and Keorapetse Kgositsile, largely filled the Detroit program. A powerful symbolic gesture uniting the new black poetry with the new black politics occurred at the ceremonial high point of the 1967 Detroit convention when Randall publicly presented Malcolm X's widow, Bettye Shabazz, with a copy of the forthcoming Broadside Press anthology *For Malcolm*.[113] Of course, as previously noted, the actual impetus for the creation of the anthology occurred at the first Fisk conference through a meeting of cultural activists rooted in the Popular Front era. But it was at the Detroit convention, not at Fisk, where public celebration of Malcolm X, his politics, and his relation to the emerging Black Arts movement was made a centerpiece of the program.

Nonetheless, despite these powerful nationalist currents, the institutions of the literary Black Arts movement in Detroit, notably Broadside Press and Lotus Press (founded by Naomi Long Madgett in 1972), were at least initially far less guided by the cultural nationalism, and less hostile to earlier political and cultural moments, than were many of their counterparts in Chicago, particularly

OBAC and Third World Press. In fact, Madgett claims she founded Lotus Press as a result of frustration with both "white publishers" and rigid, even opportunistic, nationalist independent black presses.[114] Again, no doubt, this was in part due to the fact that Danner, Madgett, and Randall were older, with personal ties to established writers, such as Hughes and Walker, who maintained an attitude of critical support toward the Black Arts movement, as well as to those, like Robert Hayden, who were seen as more purely antagonistic.[115] This personal connection went beyond Randall's long friendship with Hayden but was also shaped by Hayden's continuing interest in and support of grassroots African American literary initiatives in his hometown. For example, Hayden's 1967 anthology *Kaleidoscope* (held up, with some justification, by Madhubuti as the anti–Black Arts anthology) featured poems by Danner, Madgett, and Randall.

As noted earlier, Broadside Press (and the institution-building example of Charles and Margaret Burroughs at the DuSable Museum) obviously inspired the founding of Third World Press by Madhubuti (then Don L. Lee), Johari Amini (Jewel Lattimore), and Carolyn Rodgers in 1967. In its early years, though, Third World Press published a group of writers with a narrower range of age, ideology, and poetics than did Broadside Press. In the 1960s, both presses focused on poetry, publishing many of the same younger black writers. However, Broadside also printed work by the older generation, such as Hayden, Brooks, Walker, Danner, and Melvin Tolson — a number of whom differed considerably from the dominant ideology at Third World Press that became, like Madhubuti himself, increasingly influenced by the cultural nationalism of Maulana Karenga.[116]

However, as the 1960s passed into the 1970s, the two presses became closer in terms of mission and publishing lists — at least so far as poetry and its criticism were concerned. Broadside never covered as great a range of topics as did Third World, but it did issue its important Broadside Critics Series that included work by Madhubuti, Houston Baker Jr., Bernard Bell, and Addison Gayle Jr., a series that greatly advanced the notion of African American literary studies as a serious field of scholarly inquiry. Dudley Randall increasingly adopted a nationalist tone in his comments about the goals of Broadside Press, sounding much like the mission statements of Third World: "Broadside is, in embryo, one of the institutions that black people are creating by trial and error and out of necessity in our reaching for self-determination and independence."[117] Though it became less strictly a poetry press in the 1970s, issuing titles in history, psychology, soci-

ology, and religion as well, Third World began to issue the poetry and prose of such older writers as Brooks, Walker, John Henrik Clarke, and Robert F. Williams — some of whom, like Walker, had significant ideological differences with cultural nationalism.[118]

Aesthetics/Poetics and Institutional Development

The Detroit group of poets coalesced before the Chicago Black Arts movement really took off. Chicago had been the most dynamic locus of African American writing as well as a vital center of black music, theater, and visual arts from the mid-1930s until the late 1940s — far more so than Detroit, despite the accomplishments of Robert Hayden and the still thriving music scene of Detroit's Hastings Street. However, by the end of the 1950s, the community of black Chicago writers and artists supported, encouraged, and energized by the Popular Front had greatly diminished. In many cases, the artists had left Chicago; for example, poet and novelist Margaret Walker to Mississippi; poet Frank Marshall Davis to Hawaii; poet Margaret Danner to Detroit; poet, novelist, and playwright Arna Bontemps to Tennessee; dancer Katherine Dunham to New York; visual artist Charles White to Los Angeles (after a series of teaching jobs across the country); playwright Theodore Ward to New York; and Richard Wright to New York and then Paris. A few of the important participants in the South Side cultural scene of the 1930s and 1940s had died, their passing having a larger meaning than simply personal loss. One, Edward Bland, a precocious young writer and critic of seemingly unlimited promise, embodied a widening black intellectual horizon before he died in World War II (as memorialized in the long title poem of Gwendolyn Brooks's 1949 *Annie Allen* dedicated to Bland). Another, Fenton Johnson, who died in 1958, had served as an elder statesman of African American letters with a career stretching back to the early twentieth century, when he was hailed as the forerunner of a new modernist African American poetry.[119] Of the older generation of poets, only Gwendolyn Brooks remained in Chicago and published consistently through the 1950s and early 1960s.

It is true that, as elsewhere, many from the Popular Front cultural world remained active in Chicago, if on a less prominent level, providing much of the ground on which the Black Arts movement in Chicago would grow. For example, Margaret Burroughs may have been exiled from the South Side Community Art Center, but as we have seen, she was still a familiar figure in grassroots cultural

initiatives on the South Side. And many of those who left the city stayed in touch with their former colleagues and comrades on the South Side—some, like Margaret Danner, back and forth to and from Chicago, and others, like Theodore Ward, returning to the city in the 1960s to take part in the Black Arts upsurge. And there were certainly black poets of the Popular Front generation, like Elma Stuckey, who were known on the South Side and on the West Side even if they published little or not at all—Stuckey's critically acclaimed first book, *The Big Gate*, did not appear until 1975.

Nevertheless, members of the Detroit group generally outnumbered their Chicago counterparts in the major anthologies of African American poetry during the early 1960s. The Pool anthology *Beyond the Blues* included five Detroit poets (Danner, Madgett, Randall, Oliver LaGrone, and James Thompson) and two Chicago poets (Brooks and Conrad Kent Rivers); and Hughes's *New Negro Poets, U.S.A.* had four Detroit writers (Danner, LaGrone, Madgett, and Randall) and two from Chicago (Rivers and Lerone Bennett—and Bennett became far better known as a popular historian than as a poet). Only Bontemps's *American Negro Poetry* gave Chicago poets (Brooks and Rivers) parity in numbers with those of Detroit (Danner and Randall.) The Detroit writers also received a major boost from a special "Detroit Writers" issue of the Association for the Study of Negro Life and History's *Negro History*, featuring the poetry of Danner, Madgett, LaGrone, Thompson, Randall, and Edward Simpkins as well as an essay by Hoyt Fuller, in October 1962.

The early work of the Detroit group was formally and thematically diverse. In general, the group shared a sense of the value of "high" art that is at least implicitly opposed to previous Popular Front blurring of distinctions between high, middle, and low. Danner's poetry had much in common with the neo-modernist work of her Chicago contemporary and former colleague Brooks in the 1940s and 1950s. Danner's diction has a slightly abstract or oblique playfulness in even her most politically engaged, pre–Black Arts lyrics: "instead, I vision other tan and deeper much than tan / early Baroque-like men who (seeing themselves still / strutlessly groping . . .)." Danner's phrase "greyed intensity" later in the poem evokes (and invokes) the "greyed in and grey" of Brooks's "kitchenette building" (which in turn suggests the T. S. Eliot of "Gerontion") in *A Street in Bronzeville* (1945).[120]

Like Brooks's early works, Danner's poems typically evade traditional English notions of lineation, meter, and capitalization—though, like Brooks (and,

indeed, Russell Atkins), Danner sometimes uses end rhyme (as in "I'll Walk the Tightrope"). The oblique playfulness of Danner's diction (e.g., "strutlessly groping") is anchored instead by a tremendous concentration of sonic bonding that often avoids end rhyme—alliteration, slant rhymes, internal rhymes, and especially assonance. In short, Danner's early work (and her later work in many ways, for that matter) is formally very much in the vein of the neomodernism that dominated American poetry in the 1950s.

Of course, the subjects and landscapes of Danner's poetry, as with that of Hayden, Tolson, and Brooks, were often far different than that of, say, the early Robert Lowell or John Berryman. The poetry for which Danner became most famous during the Black Arts movement, her portraits of African art, landscapes, and flora and fauna, asserted an African American cultural and spiritual link to Africa.[121] While sometimes Danner's work seems to resemble the Harlem Renaissance primitivism of, say, Claude McKay's "Harlem Dancer," in which African American "civilized" degradation is compared unfavorably to African naturalness, ultimately there is often the suggestion that what is superior is not African savagery or unrepressed, inherent nobility but African civilization, as seen in "Sadie's Playhouse," in which the demimonde is reminded of African nature and civilization by a mural of an African American artist on a tavern wall:

He then charmed nine
green palm trees and two Egyptian
perfume urns,
so that those who might some night call
flotsam, pimps, jadies,
after tippling their cheap, heady
drinks, could discern
the palms waving, cool, green
shady,
over the (dancing now) African ladies[122]

Though "Sadie's Playhouse" is set in a site of popular consumer culture, it is worth noting that a notion of "high" art, which is clearly privileged over popular culture, remains.

Dudley Randall's early work by comparison often seems to be set consciously against the "high" neomodernism of the 1950s as well as against the vernacular-based poetry of Langston Hughes, Sterling Brown, Waring Cuney, and Margaret

Walker. Even in his early poetry most inflected by neomodernism, for example, the Haydenesque "Legacy" (first published in a 1954 issue of *Free Lance*), Randall draws on traditional schemes of poetic meter to a degree rarely seen in his African American neomodernist contemporaries.[123] Other free verse poems, such as "Memorial Wreath," are even more characterized by an archaic, self-consciously poetic diction and a predominantly, if not entirely regular, traditional metrical pattern (in the case of "Memorial Wreath," iambic pentameter):

Fit gravefellows you are for Douglass, Brown,
Turner and Truth and Tubman . . . whose rapt eyes
Fashioned a new world in this wilderness.[124]

Often, Randall worked with older European poetic forms, such as the ballad and the ballade. Of course, the ballad had long served as the vehicle of African American vernacular poetry by such authors as Hughes and Brown (e.g., Brown's "Frankie and Johnny"), reflecting its dual identity as an established high literary form and as a vehicle of African American popular or folk culture — drawing on a tradition of English-language vernacular poetry reflecting an anti-metropolitan, regional, class, or ethnic identity reaching back at least to Robert Burns. However, Randall's "The Ballad of Birmingham" (perhaps his most famous poem after "W. E. B. and Booker T.") is for the most part couched in a modified, English border ballad–like diction ("She has combed and brushed her night-dark hair, / And bathed rose petal sweet") — with the partial exception of the interpolated speech of the unnamed mother of one of the four girls blown up in the infamous bombing of Birmingham's Sixteenth Street Baptist Church in 1963. The mother speaks in a slightly folk-inflected voice, marked by the use of the word "baby" as an affectionate appellation (which is, of course, not necessarily "African American" but can be seen as so within the "standard" and even archaically poetic English of the rest of the poem). Interestingly, the martyred daughter also speaks but uses only the "standard" English of the narratorial voice of the poem. Thus, the poem can be seen as continuing the old African American generational trope of the Negro mother organically connected to a folk past, as distinguished from her urban children whose relation to that culture is problematic. At the same time, this figure here maintains a clear distinction between "high" and "low." In fact, Randall heightens this distinction in a later version of the poem included in his 1971 anthology, *The Black Poets*, where a line in the mother's voice is changed from the original "aren't good for a

little child" to "ain't good for a little child." (Randall also gives the later version a somewhat prosier look by capitalizing the first word in a line only when it begins a sentence rather than following the older poetic practice of capitalizing the first word of every line, as he did in earlier printings of the poem.) These later revisions heighten the already present contrast between the "standard" voices of the ballad's speaker and of the daughter and the folk voice of the mother, showing the poem to be in a critical dialogue with the work of earlier and contemporary black poets in their approach to poetic diction while clearly invoking a black literary tradition through the use of the Negro mother trope. Perhaps the impact of the movement, then, did not so much fundamentally change Randall's stance in the poem as lead him to make his intentions clearer.

An even more obvious example of Randall's conscious distinction between his work (and poetics) and vernacular works by earlier authors can be seen in the ballade "The Southern Road." It is hard to read the poem without thinking of Sterling Brown's blues and work song–based "Southern Road." Yet the ballade form and the archaic English diction of Randall's poem, even when it vividly describes a lynching ("Where bonfires blaze and quivering bodies char. / Whose is the hair that crisped, fiercely glowed") formally argues for a distinction between "high" and "low" that is blurred in Brown's vernacular poetry (especially seen in conjunction with the "high" poetry in Brown's collections *Southern Road* [1932] and *No Hidin' Place* [unpublished until the 1970s]) while thematically making a connection between African American experience North and South that Brown's poetry often denies. In this, Randall's contestation of Brown's division of North and South resembles that of Hayden's early poem "We Have Not Forgotten" (which seems directly addressed to Brown's "Sporting Beasley").[125] Again, it is worth noting that through these inescapable invocations of earlier (and contemporary) African American literature, Randall does not place this stance outside a tradition of African American poetry in some category of "Poetry" or "Art" transcending race but locates it squarely within a dialogue between the works of black writers over questions of form and theme and larger questions of how one might conceive and understand African American history and culture.

Inspired by the Black Arts movement, especially its Chicago manifestations, Randall's own poetry later moved far more toward the conversational than had been the case in his earlier work, depending on assonance instead of traditional meter and end rhyme to bond words:

The Revolution
did not begin in 1966
when Stokely raised his fist
and shouted, Black Power.[126]

Often his use of the vernacular had a certain ironic flavor as he used it to criticize what he saw as errors, excesses, and sometimes a lack of historical memory in the Black Power and Black Arts movements, as in the poem "Abu," which describes "a stone revolutionary," which is to say, a show revolutionary (and possible agent) mirroring equally shallow poetic technique and subject, as seen in purposely slack William Carlos Williamsian line breaks and a not very interesting example of eye dialect ("inten / shun"), made interesting only through Randall's sarcasm:

Decided to blow up City Hall.
Put full-page ad
in *New York Times*
announcing his inten /
 shun.[127]

Again, it needs to be recalled that Randall here is not condemning nationalism or Black Arts attempts to develop a distinct black poetics as such. After all, he was the most important publisher of Black Arts poetry—just as Broadside early on printed vernacular work that differed greatly from his own. And both "Abu" and "Seeds of Revolution" appeared in a collection published by Third World Press, a press even more oriented toward cultural nationalism and the younger black poets than Broadside. In this way, Randall's collections often resemble Langston Hughes's *The Panther and the Lash*, both in the attitude of supportive criticism toward the Black Power and Black Arts movements and in the inclusion of poetry written over several decades linking past and present black art and black struggle in a very personal manner.

None of the other leading members of the early Detroit group wrote regularly in a vernacular or overtly popular culture–influenced vein—or if they did, those works were rarely published. Naomi Long Madgett's works oscillated between self-consciously premodernist poems of racial uplift and somewhat "modern" free verse lyrics. Her free verse efforts often recalled the subject and the anxious (and frequently bitter) tone of Edna St. Vincent Millay's early twentieth-century

poems of sexual conflict and desire, such as Millay's 1931 sonnet sequence *Fatal Interview*. The conservative and studiedly poetic diction and syntax of Oliver LaGrone's work were closer to Randall's early unrhymed verse. Again, in general, nearly all the Detroit group sought to maintain, or revive, a notion of high art that was distinct from the blurring of "high" and "low" so typical of the Popular Front era (and the literary countercultures of the 1950s and 1960s) while attempting to maintain a Popular Front–influenced social engagement with the community that is generally absent from neomodernist writing by white poets during the 1950s and early 1960s.

The various approaches to high art by the Detroit group only rarely drew on the formal resources of black popular culture and African American vernacular speech—despite the closeness of Langston Hughes to many in the group, especially Danner. Of course, it is worth pointing out here that, despite the commonplace that Black Arts poetry was rooted in the vernacular tradition, a large proportion of African American nationalist poetry of the 1960s and 1970s did not employ a distinctly "black" diction, and that many poets, say Lance Jeffers in "The Song," struck an oddly, if often powerfully, archaic and somewhat purple anthemlike or epic Anglo-American note—as indeed had been typical of much nationalist poetry in the United States from Garvey's *Negro World* to the poetry page of *Muhammad Speaks*.

The Detroit Group and the Creation of the Midwestern Black Arts Infrastructure

At the same time, the Detroit group remained quite influenced by a characteristic Popular Front cultural objective of providing "Art" to "the people." Popular Front cultural politics were complicated in that there were continuing debates or tensions about what art should bring to the people (and what the people should get out of it), how art should speak to the people, and what art should get back from the people. Many Popular Front artists, such as Hughes in his revolutionary poetry and music play *Don't You Want to Be Free* (1938) or Frank Marshall Davis in his poem "Snapshots of the Cotton South," blurred or even erased the line between "high" and "popular" art. While Hughes's play was indubitably serious in its survey of African American history and its final call for revolution, it utilized the formal resources of African American popular culture (blues, gospel, jazz, black vaudeville comedy, dance, and so on) in an attempt to reach a

popular African American audience (with some success). Davis's poem invoked and drew on pulp fiction and the visual and verbal forms of tabloid journalism. However, at other times, the Popular Front reinforced the idea of high art (or "Art" with a capital "A") as something the people need and deserve—though what constitutes Art was considerably debated. In short, Shakespeare, Ibsen, or Odets should not be the preserve of the cultural elite in a few cosmopolitan cities but should be made available to a mass audience, especially in communities that had historically been deprived of "serious" theaters, museums, concert halls, bookstores, and so on.

There had been precedents for this approach within the African American community, as seen in Du Bois's arguments about African American education with Booker T. Washington, suggesting somewhat contradictorily the establishment of black political and cultural leadership through popular accessibility to an elite education, and in various New Negro Renaissance attempts (or at least conceptions) of starting "serious" African American–run theater companies, symphonies, and so on in black neighborhoods. Nonetheless, such attempts tended to project a cultural equivalent of the "talented tenth" as their natural constituency rather than some notion of a mass black audience.

Popular Front–influenced cultural institutions, whether the local Negro units of the FTP or the South Side Community Art Center, differed from these earlier initiatives in that they were aimed at a wide audience in an egalitarian spirit that held that "Art" and training in the production and appreciation of "serious" art was something the masses, say, working-class residents of Chicago's South Side or Detroit's Lower East Side, needed and would accept if given access and encouragement. It was in this spirit that Danner understood her work in the creation of Boone House.[128] It was also in this spirit that Randall imagined the initial series of poetry broadsides: "At that time my intention was to publish famous familiar poems in an attractive format so that people could buy their favorite poems in a form worth treasuring."[129]

This can make Randall's project seem more pedantic and elitist than was actually the case. He had a more formally catholic sense of the African American classics than his own work might indicate. Though he often employed a conservative Anglo-American formalism in his own early work, the first broadsides he published displayed a wide aesthetic range, including vernacular-inflected works. In at least one case, Hayden's early poem "Gabriel," Randall had to win over an author reluctant to see the work in print again.

As in his poetry, one agenda that Randall pursued with Broadside was point-ing out to younger militants the long foreground of black struggle and militant black literature. All the initial six broadsides printed by the press were written by older black writers (Randall, Hayden, Walker, and Tolson) whose literary careers dated back to the 1930s and 1940s. These writers, along with other older writers (Hughes, Jean Toomer, and Madgett) dominated the first three years of Broadside's existence. Thirteen out of the first eighteen broadsides were written by authors born before 1924, twelve of whom were born before 1918. It was not until 1968 that younger writers would form the majority of Randall's publishing list — after some prodding by Black Arts critics. Significantly, two of the poems in the initial group were politically radical efforts by a pair of poets, Hayden and Tolson, who had received much criticism from some nationalist-influenced critics for being in essence too ideologically and/or formally white.[130] In other words, Randall saw his task as recalling the relevance of classic African Ameri-can poetry to the new moment as much as providing a vehicle for the new black poetry. This recollection featured not only the promotion of poets relatively unknown to younger black readers but also a revaluation of the work of more familiar writers like Hayden and Tolson.

What the Detroit group and its proto–Black Arts and early Black Arts in-stitutions contributed was a dedication to the African American community, a sense of the range and history of African American political struggle and artistic expression, and a commitment to institution building. As Margaret and Charles Burroughs at the DuSable Museum in Chicago, Margaret Danner at Boone House, Dudley Randall at Broadside Press, and Woodie King Jr. and David Rambeau at Concept East Theatre showed, one did not have to have a lot of capital or outside support to set up these institutions. Will, energy, and a belief that it could be done were more crucial qualities than outside funding.

The actual literary works of the Detroit group receded in importance as the Black Arts movement developed. Despite their early start, none of the Detroit poets, with the possible exception of Randall, would be accounted prominent writers of the movement. Of course, some of the movement's most important theater workers emerged from Detroit, notably Woodie King Jr., Ron Milner, and David Rambeau — though all three left Detroit for long periods during the Black Arts era (and King never really returned). However, the Detroit writers were vitally important in initiating and maintaining institutions that inspired and operated synergistically with Chicago writers and literary institutions —

which did produce such major writers as Haki Madhubuti, Johari Amini, Sterling Plumpp, and Carolyn Rodgers, as well as providing a new context for some of Gwendolyn Brooks's most powerful work — and their importance was recognized as such by Black Arts participants both in the Midwest and nationally. As noted above, Hoyt Fuller did much to promote the Detroit group in the pages of *Negro Digest/Black World*. But again, if Fuller in a sense gave much to the Detroit group, he got much back. When he established *Negro Digest* as a serious intellectual journal promoting a new, dynamic, community-oriented, and artistically serious black cultural movement, the Detroit group provided him with a vital example of what that movement might be. Thus, the Detroit group was crucial in the evolution of *Negro Digest* into the major national Black Arts and Black Power institution it became.

Structures and Strictures of Feeling: Chicago Black Arts Institutions and Aesthetics

As noted above, the literary institutions of the Black Arts movement in Chicago developed later than those in Detroit for the most part and were in many respects inspired by Broadside Press and the various offshoots of the Detroit group, Concept East Theatre, and other Detroit cultural formations. Still, the legacy of earlier activism on the South Side, both in terms of informal networks and of such formal institutions as the DuSable Museum, *Negro Digest*, and the African American press, laid much of the foundation for the growth of the Black Arts movement in Chicago *and* in Detroit. Again, the dual identification of such key figures as Danner, Fuller, and Madhubuti with both cities and the African American cultural scenes there cannot be overemphasized. And important non-literary Black Arts institutions in Chicago, such as the AACM, coincided with or even antedated much of Detroit's early Black Arts literary activity, serving as models for cultural institution building in both places. Once again, even though the black public mural movement and jazz artists and organizations, including the pioneering New Music Society, were prominent features of the Black Arts scene in Detroit, literature and theater dominated that scene in a way that was never the case in Chicago, which was the most important center of African American visual art and a locus of radical black musical production rivaled only by New York during the Black Arts era.[131]

Though inspired to a large degree by the Detroit institutions, perhaps by

virtue of emerging when the Black Power and Black Arts movements were much more fully developed, and perhaps due to a longer and stronger local tradition of separate black cultural, economic, and political organization, the Chicago institutions, such as Third World Press, *Black Books Bulletin*, and OBAC, were generally far more overtly nationalist in orientation, with a greater focus on younger black artists. Among the poets, the only prominent older artist to directly identify herself with the Black Arts movement in Chicago in its first years was Gwendolyn Brooks. As alluded to previously, Brooks had a famous Black Arts conversion experience during the second Fisk Black Writers Conference in 1967. To use the term "conversion experience" is not to poke fun at Brooks's transformation—after all, it is basically the terminology and frame of reference that she herself used.[132] Rather it is to suggest that her relationship to the Black Arts movement was unlike that of most of her contemporaries—though, other than her avoidance of the sonnet in the later work, the formal differences between Brooks's early poetry and such Black Arts efforts as *In the Mecca* (1968) were overestimated by some Black Arts participants, including Brooks herself. Unlike most older writers sympathetic to the Black Arts movement, such as Owen Dodson, Margaret Walker, James Baldwin, Dudley Randall, Margaret Danner, Langston Hughes, and Sterling Brown, Brooks generally devalued her pre–Black Arts work and the milieu in which it was produced. When Brooks edited *A Broadside Treasury* (1972), an anthology of poetry published by Broadside Press, she included little work by poets of her generation—for example, none of the early broadsides that founded the press. Even her pointed dropping of the sonnet as an iconic, high European and Euro-American form symbolically marked a divide between her careers before and after the Fisk conference, whether or not the actual formal or even thematic distinctions between the two periods are all that sharp.

At the same time, it is worth noting that even though Brooks seemed to adopt the Black Arts movement more wholeheartedly than many of her age cohort, she joined her own earlier work begun in the 1950s about the Mecca Building (an infamous South Side slum apartment block destroyed in 1952, over the protests of the tenants, to make way for an expansion of the Illinois Institute of Technology campus) with new poems that directly engaged the current political and cultural moment, such as "The Wall" (dedicated to the *Wall of Respect*), in the 1968 collection *In the Mecca*. In this work, her project seems closer to that of Hughes's *Ask Your Mama* and *The Panther and the Lash* and Randall's

Cities Burning in the assertion of a fundamental historical continuity between the Black Arts movement and earlier moments of black cultural and political radicalism through the juxtaposition of works written over three or four decades within the frame of the Black Power and Black Arts moment than one might expect. It should also be pointed out that Haki Madhubuti frequently paid homage to older black Chicago artists in his tributary poems and in the dedications and acknowledgments of his collections.

As with the Detroit group, there was considerable formal diversity among the Chicago Black Arts poets. However, in general the Black Arts activists shared a basically cultural nationalist commitment to developing a black literary diction (or dictions), black tropes, black imagery, black thematic concerns, black lineation, black typography, black standards of evaluation, and black audiences; in short, a "Black Aesthetic":

- The encouragement of the highest quality of literary expression reflecting the Black Experience
- The establishment and definition of the standards by which that creative writing which reflects the Black Experience is to be judged and evaluated[133]

> The third world is a liberating concept for people of color, non-European — for Black people. That world has an ethos — a black aesthetic if u will — and it is the intent of Third World Press to capture that ethos, that black energy.[134]

My above list of formal qualities preceded by the modifier "black" (to which many more could be added) is not meant as an indirect dig at what a "black" typography, so to speak, might mean. (Though it is worth asking how Black Arts experiments with typography, say, the conventions of uppercase and lowercase, are different from the Beat poetry that, as Sonia Sanchez notes, influenced many Black Arts writers.)[135] Rather it is to indicate the difficulty of defining what the black nation's culture was or should be — as the participants in the Black Arts movement were well aware. Yet despite this difficulty, or perhaps because of it, most of these participants felt it was a pressing task — even before the considerable later influence of Maulana Karenga and his Kawaida philosophy made itself felt in Chicago. Thus, there was the sense among Chicago Black Arts activists, as well as their counterparts in Oakland, San Francisco, Los Angeles, Philadelphia, New York, and so on, that they ultimately had to be more knowledgeable than their white contemporaries:

The encouragement of the growth and development of Black Critics who are fully qualified to judge and to evaluate Black literature on its own terms while, at the same time, cognizant of "traditional" values and standards of Western literature and fully competent to articulate the essential differences between the two literatures.[136]

This militantly separatist tone (at least vis-à-vis black and white) was not unusual among Black Arts activists—indeed it was less violent in tone than much of the work and many of the statements associated with Amiri Baraka and the cultural circles of BARTS in Harlem and of Spirit House and Jihad Productions in Newark.

As elsewhere, this basic stance led to an increasing interest in the Kawaida thought of Maulana Karenga, which impressed many artists with its systematic emphasis on the centrality of culture. However, as Madhubuti notes, the impact of this interest differed somewhat from, say, that of Baraka and CFUN in Newark in that the major Black Arts cultural and educational institutions of Chicago, such as OBAC, the AACM, Third World Press, the Institute for Positive Education, the Kuumba Theatre, the Affro-Arts Theater, and so on, were well established before Karenga's work was much known there. Perhaps as a result of this tradition of building radical black grassroots cultural organizations, educational groups, museums, and so on reaching back to the Popular Front, the Black Arts scene eschewed the quasi-military style of Us, even in the institutions most marked by the Kawaida movement, such as the Institute for Positive Education. In other words, unlike other areas where the failure of black cultural groups, such as BARTS, BAW, and the Black House, made some sort of paramilitary model attractive as a means of calming the chaos that often attended these groups, the success of local Chicago institutions showed that a military-type structure and discipline was not necessary to guarantee stability and continuity.[137] Certainly, despite the presence of such powerful figures as Madhubuti, Hoyt Fuller, Gwendolyn Brooks, Val Gray Ward, Phil Cohran, and Muhal Richard Abrams, the movement remained far less hierarchical in organization than was the case with Us in Los Angeles or Spirit House and CFUN in Newark when they were most influenced by Maulana Karenga.

What marked the intensity of cultural nationalism in Chicago was the commitment of artists and intellectuals to building and maintaining black institutions that reached a comparatively large audience (by the standards of radical

avant-garde art). These institutions, by and large, were seen as founding an alternative black avant-garde culture, cultural values, and aesthetics that would replace both bourgeois high culture (whether "mainstream" or "bohemian") and popular culture. As Jennifer Jordan points out, Madhubuti was generally more hostile to African American popular culture in the 1960s and 1970s than were Amiri Baraka, David Henderson, Sonia Sanchez, Jayne Cortez, and many East Coast Black Arts poets.[138] This can be seen most clearly perhaps in his elegiac exaltation of John Coltrane, "Don't Cry, Scream," in which he projects the saxophonist as a black avant-garde destroyer of white *and* black popular culture:

> i cried for billy holiday.
> the blues. We ain't blue
> the blues exhibited illusions of manhood.
> destroyed by you.[139]

Madhubuti then goes on to announce, "we ain't blue, we are black." This projection of an ideological and aesthetic space that displaces or even destroys existing culture and cultural values, echoing African American millenarian Christianity and equally millenarian Left strains (as expressed, say, by how "the earth shall turn on new foundations" after the "final conflict" in "The Internationale"), animated much of the Chicago project of institution building and, one might add, institution maintenance. Even Phil Cohran, who left the AACM over what he perceived as the group's jazz elitism, projected through his musical groups and the Affro-Arts a radical, Afrocentric, countercultural vision, albeit one that, like that of his former bandleader Sun Ra, encompassed a wide range of popular and art music.

At the same time, this alternative stance has a certain popular or mass dimension. Part of the appeal that made (and continues to make) Madhubuti perhaps the best-selling African American poet of all time (and certainly one of the best-selling American poets ever), with at least hundreds of thousands of volumes of his poetry circulating among an overwhelmingly African American audience, can be seen in the above passage from "Don't Cry, Scream," in which Madhubuti does not simply proscribe and prescribe but uses himself as a sort of exhibit A of a black consciousness in transit toward full liberation. There is something here that resembles Baraka's portraits of a black mind in pain as it tries to work through its location in American culture in *The Dead Lecturer*, but with a much clearer direction of where the process will end up. While Madhu-

buti does preach to and about others, in a tradition reaching back to Frederick Douglass's first autobiography, he uses a version of his life to embody the possibilities for African American self-knowledge, self-recovery, and self-reliance as well as for delusion and self-hatred, as when he draws a portrait of black men pursuing white women living out racist weekend fantasies and then places himself in the middle of the picture:

> i ran. she did too, with his pennies, pop bottles
> & his mind. tune in next week same time same station
> for anti-self in one lesson.[140]

In other words, part of the power of Madhubuti's poetry for many readers was (and is) not simply in the clear and skillful (and often quite funny) indictments of racial oppression and racism-induced shortcomings common in the black community, or even simply his obvious love for black people, but, after the manner of church testimony and spiritual autobiography, also his willingness to identify himself with the speaker of the poem and to locate that speaker in the middle of his critique.

While there were many similar attempts to establish such institutions across the nation, outside of those that found a niche in some larger, "mainstream" institutions (e.g., African American studies departments in colleges and universities), few important Black Arts institutions in other cities survived as long as OBAC, the AACM, the eta Creative Arts Foundation, and Third World Press. Certainly there are no other cities where so much of the Black Arts infrastructure still exists. Even older institutions in Chicago, such as the South Side Community Art Center, were reenergized and refocused by the Black Arts movement there.

Conclusion

The great casualty of the midwestern Black Arts movement (and the national movement) was *Black World*, shut down by Johnson Publishing Company in 1976, ostensibly over the issue of an allegedly anti-Semitic article about Zionism. However, many Black Arts activists attributed the journal's failure to the fact that *Black World* was never truly a Black Power and Black Arts institution, since its finances were controlled by mainstream black business executives rather than by members of those movements. While the inability of the Black Arts and Black

Power movements to leverage the Johnson Publishing Company into continuing the journal seemed to say something dismaying about ideological disunity in the broader black community, what was even more ominous was the ultimate failure of attempts to replace *Black World* with a national journal not beholden to commercial interests, black or white. Still, if this loss was later seen as a marker of the death of the Black Arts movement in Chicago and Detroit (and nationally), nowhere else did so many significant Black Arts institutions remain vital beyond the mid-1970s.

The nationalist artists and intellectuals of Chicago and Detroit set themselves the tremendously difficult task of building a stable cultural infrastructure for the black nation. They succeeded in many respects, despite the decline of the Black Arts and Black Power movements. They were able to create, by American standards, a mass audience for a politically and formally radical African American art, including an unusually, if not uniquely, large audience for poetry by writers for the most part operating outside mainstream channels of publication and distribution.[141] This audience in large part resulted from the synergistic relationship between Third World Press in Chicago and Broadside Press in Detroit—though both went through periods of ups and downs (and of the two, only Third World remains a viable publisher as of this writing).[142] Not only did the two presses see themselves as allied, mutually supportive institutions but also shared many of the same authors. Broadside published the first books of Haki Madhubuti, and Third World published Dudley Randall. The circulation of books published by Broadside and Third World was (and is) phenomenal for small presses. Madhubuti, for example, quickly sold tens of thousands of copies of his first Broadside books—many times the numbers sold by poets considered (and considering themselves) more central to American letters as it is usually portrayed by the academy.[143] Third World Press and Broadside Press were unquestionably the most important black literary presses of the last century—perhaps the most important American small presses publishing poetry ever.

The Chicago poets, for the most part, committed themselves not only to representing the "black experience" but to developing distinctly African American forms for such representations. This was not restricted to the development of the black poetic voice but also to theorizing how a "Black Aesthetic" might determine the writing, reception, analysis, and evaluation of black poetry. This aesthetic differed from that of many of their East Coast (and later West Coast) contemporaries, such as Amiri Baraka, Larry Neal, Sonia Sanchez, Ishmael Reed,

and Askia Touré, in the general rejection of commercial popular culture, preferring instead a model that linked political and cultural avant-gardism with constructs of African American and African folk culture allegedly lying outside mass culture. One might say that the Chicago Black Arts activists held a sense of themselves as an avant-garde or cultural vanguard in the traditional sense of a movement outside and opposed to existing popular culture, albeit in an African American modality. For example, though Chicago poet and critic Useni Eugene Perkins in a 1969 essay on African American writing says that "the blues are an artistic expression that can only be heard in the voices of Bessie Smith, Huddie Leadbeally [sic], Billie Holiday, Ray Charles, and Aretha Franklin," when he names musicians from whom black writers "will learn their craft," he mentions only Charlie Parker, Lester Young, and John Coltrane.[144] In other words, among the musicians he characterizes as "the vanguard of the Black cultural revolution," he not only fails to mention such living Chicago blues and R & B artists as Muddy Waters, Howlin' Wolf, Junior Wells, Buddy Guy, Major Lance, and Jerry Butler but does not even note the politically engaged Curtis Mayfield, whom East Coast Black Arts activists had long held up as a popular Black Arts artist.[145] Of course, the important Chicago poet Sterling Plumpp, whose work frequently appeared with that of Perkins in Chicago journals, especially the *Black Liberator*, did invoke and draw on blues—though this became a more pronounced feature of his work in the 1970s than it had been in pieces published in the late 1960s.[146] And as mentioned before, Phil Cohran's vision of black culture, especially music, did encompass popular music—and if he was not a widely known theorist, he was a ubiquitous performer at Black Arts and Black Power events, influencing artists from the Art Ensemble of Chicago to Earth, Wind, and Fire. It is also worth noting that the *Wall of Respect* did feature a "Rhythm and Blues" panel as well as a "Jazz" panel. But even in this case, the artists portrayed in the jazz section (overwhelmingly dominated by bebop and free jazz musicians) were shown much more prominently and individually than those in the R & B section (which featured more Detroit-based artists, such as Stevie Wonder, Smokey Robinson and the Miracles, the Marvelettes, and Aretha Franklin, than Chicago musicians, like Muddy Waters).

As seen in the short discussion of Russell Atkins and *Free Lance* above, the Chicago activists were not unique in their discussions of what a "Black Aesthetic" might be, but they were unusually concrete in their early attempts at definition—and certainly more concerned with making this theory accessible to a

broad black audience than Atkins was. Though cultural nationalists are some-
times seen as hostile to literary theory, the Chicago Black Arts movement was
crucial in raising the level of theoretical discourse in African American letters —
if arguably at times in a prescriptive or reductive manner.[147] Carolyn Rodgers's
1969 "Black Poetry — Where It's At" was one of the first extended attempts to
theorize systematically a Black Arts poetics, anticipating Stephen Henderson's
better-known *Understanding the New Black Poetry* (1972). Madhubuti's *Dyna-
mite Voices* (1971) was (and remains as of this writing) the only book-length criti-
cal survey of Black Arts poets (as opposed to Henderson's attempt to theorize
a field of black poetry against which, or within which, Black Arts–era poetry
could be read).

The movement in Chicago also complicates later critical notions of the rela-
tionship between masculinism, male supremacy, cultural nationalism, and black
artistic production. Since the Black Arts scene in Chicago was arguably more
dominated by cultural nationalism than any other major black cultural cen-
ter (and given the attribution of an intense, walk-three-paces-behind-the-man
masculinism as virtually a defining characteristic of 1960s and 1970s cultural
nationalism by many critics of the Black Arts and Black Power movements),
one might expect that it would be particularly unfriendly to black women art-
ists. However, the reverse seems to be true. Such women as poets Johari Amini,
Carolyn Rodgers, and Gwendolyn Brooks, dramatists Abena Joan Brown and
Val Gray Ward, and visual artists Barbara Jones, Carolyn Lawrence, Sylvia Aber-
nathy, and Myrna Weaver were enormously important both in terms of the work
they produced and of the leadership they provided in setting up the major Black
Arts institutions of Chicago, such as OBAC, AFRI-COBRA, the eta Creative Arts
Foundation, and the Kuumba Workshop. The genre of music (and the institu-
tion of the AACM) was the only one that was absolutely male-dominated (and
probably the least influenced by cultural nationalism). Of course, women were
crucial to the movement in other cities, but the Chicago Black Arts movement
distinguished itself by the sheer number and prominence of its women artists
and activists. And, likewise, some of the male artists most closely associated
with cultural nationalism and the Kawaida movement, especially Haki Madhu-
buti, powerfully supported the ideas of women's equality, of black women de-
fining themselves, and of black men (particularly black revolutionaries) strug-
gling against their sexism (as seen in poems like Madhubuti's "The Third World
Bond" and "The Revolutionary Screw").

Thus, if the Chicago-Detroit Black Arts axis did not, despite the "Third World" rhetoric of the Third World Press's Statement of Purpose, build the sort of multicultural interactions that were seen on the West Coast or the East Coast, it did produce long-lasting black institutions that significantly, with some modifications, maintained the Black Arts legacy far beyond the collapse of the movement nationally. To a large degree, it was successful in creating a mass audience for poetry (and avant-garde music, visual art, dance, theater, and criticism) that had never been seen before in the United States. With the possible exception of New York City, the Black Arts activists of Chicago and Detroit produced the most accomplished and most influential body of poetry, music, theater, criticism, and visual arts of any region of the Black Arts movement. Unlike the Black Arts circles of New York (and the West Coast, for that matter), the Chicago and Detroit Black Arts writers, visual artists, dancers, and theater workers were virtually all homegrown, rooted in the communities of the industrial Midwest. And if one includes its presses, newspapers, and journals, the influence of the Midwest was unmatched by any other region, including New York.

5

Bandung World: The West Coast, the Black
Arts Movement, and the Development of
Revolutionary Nationalism, Cultural Nationalism,
Third Worldism, and Multiculturalism

To paraphrase W. E. B. Du Bois in *The Souls of Black Folk*, one might say that
the various regional expressions of the Black Arts movement brought their own
special gifts to it. The Left nationalist and bohemian antiacademic milieu of
the Northeast provided a space for the development of a Black Arts cadre. This
milieu also left a lasting imprint on Black Arts ideology, particularly in the
notion of what I have called a popular avant-garde. The institution-building
impulse in the Midwest, establishing black journals, presses, theaters, work-
shops, and organizations of writers, visual artists, and musicians that reached
tens of thousands (and in some cases, hundreds of thousands) of people across
the United States, provided much of the material base of the movement as well
as models for similar activities in other regions. And as we will see in the next
chapter, the Black Arts movement in the South was ultimately the most suc-
cessful in reaching a broad grassroots regional constituency while ideologically
imparting a sense of the movement as a genuine expression of the entire black
nation throughout the United States (and beyond) because of the South's sym-
bolic and demographic importance for African Americans.

Nonetheless, it was the West Coast that saw perhaps the most influential re-
gional expressions of the Black Arts and Black Power movements. In some ways,

its contributions resembled a combination of northeastern cadre and ideological development with midwestern institution building. A complicated and often contradictory network of cultural activists and institutions incubated African American cultural nationalism, revolutionary nationalism, and the multicultural movement. The West Coast was the birthplace of three of the most important Black Arts literary and cultural journals, *Soulbook*, *Black Dialogue*, and *JBP*, as well as the BPP, the multicultural, Third World organizations of San Francisco's Mission District, and Maulana Karenga's cultural nationalist Us organization.[1] Young black writers (and political activists) of Los Angeles gained the attention of a national audience as the voices of a new militant African American mood. In no small part, these writers achieved this status through the connections of Watts Writers Workshop founder and patron Budd Schulberg, the emergence of Los Angeles as the preeminent center of the television industry, and the emblematic status that the Watts uprising of 1965 had for the entire United States (and beyond). And as Kalamu ya Salaam has noted, Karenga's attention to culture, the detailed elaboration of his Kawaida philosophy (which focused heavily on culture and cultural values), the impressive discipline of his Us organization, and the symbolic status of Watts within black politics and culture gave the already existing work of many Black Arts activists and organizations a sophisticated theoretical underpinning while providing a model that inspired future work and its interpretation.[2] This dynamic Watts arts scene produced two of the earliest Black Arts literary anthologies, Schulberg's *From the Ashes* (1967) and Quincy Troupe's *Watts Poets* (1968).

The West Coast was also the locale for some of the most heated (and sometimes violent) internal conflicts of the movement's early days with reverberations not just on the West Coast but across the country. These conflicts led to vivid incidents that epitomized for many the struggles between cultural nationalists and revolutionary nationalists. California also saw intense infighting between various strains of cultural nationalism and between different sorts of revolutionary nationalism. No doubt the most infamous of these incidents was the 1969 gun battle between BPP and Us activists on the University of California–Los Angeles (UCLA) campus that resulted in the deaths of two leading Panthers and the wounding of an Us member. Another was the expulsion of Marvin X, Ed Bullins, and other artists from San Francisco's Black House political and cultural center by Eldridge Cleaver and the Bay Area BPP leadership in 1966 on charges of cultural nationalism. One more can be found in the alleged and widely noted

BPP threats to Amiri Baraka, Askia Touré, Sonia Sanchez, and other members of the BCP at San Francisco State after the Black House rift. Both the Bay Area and Los Angeles also featured intense and near-violent arguments between revolutionary nationalists about whether the BPP would have exclusive rights to the Black Panther name.[3]

Yet these revolutionary nationalists and cultural nationalists emerged from largely the same political and cultural matrix, especially in the Bay Area, and had often been closely associated in their early activism. In fact, this common ancestry helps us probe the limitations of "revolutionary nationalist" and "cultural nationalist" as analytical categories. At the same time, the fact that Us declared itself and its Kawaida philosophy to be "cultural nationalist" (and even appropriated the phrase, redefined it, and made it a commonplace of the movement) while the BPP national leadership used it as an elastic phrase of ideological abuse—much as the CPUSA used "Trotskyite"—to attack not only Us but even the New York chapter of the BPP suggests that these categories cannot be simply dismissed.

As suggested above, the origins of the Black Power and Black Arts movements here had much in common with those in other regions. As in the South, colleges and universities and the black student movement were vital sites for the creation of early Black Power and Black Arts institutions. As in New York, a multiracial, multiethnic bohemian delta drew African American artists and intellectuals from across the United States. And as in other regions, conflicting but often intertwined traditions of nationalist and left-wing African American activism as well as a substantial number of Left and Left-influenced institutions supported African American artistic production.

Beneath these similarities there were considerable differences that gave the Black Arts movement in the West a distinct character. For one thing, the West Coast had not been a hotbed of radical African American cultural activism in the 1930s to the same degree as Detroit, Chicago, Cleveland, Philadelphia, New York, Washington, Boston, Birmingham, Richmond, Virginia, and New Orleans in their various ways. Black writers were a part of the literary Left in California during the 1930s. Langston Hughes sojourned among Ella Winter, Lincoln Steffens, and the Left bohemians of Carmel. Short story writer and Spanish Civil War veteran Eluard Luchell McDaniel worked on the FWP in San Francisco. Hughes's close friends Matt and Evelyn Crawford were active within the Communist Left in the Bay Area—though more as political than cultural activists,

despite their close friendship with Hughes that began when Matt Crawford and his longtime family friend and future CPUSA activist Louise Thompson Patterson traveled with Hughes to the Soviet Union in 1932 as part of the famous, if failed, Soviet effort to make a movie about African American life. Arna Bontemps wrote part of the most prominent (and best) Left fictional treatment of an antebellum U.S. slave revolt, the novel *Black Thunder*, in his parents' house in Watts during the early 1930s—though his period of greatest involvement with the Communist Left came later in the decade through his work on the FWP in Chicago and his association with the South Side Writers Group and Jack Conroy, editor of the left-wing literary journal *Anvil*. Still, the sort of African American, or largely African American, Left arts and educational institutions, groups, and activities that were so important elsewhere in the country seem to have been largely absent on the West Coast in the 1930s. Those black intellectuals and artists from the West who did leave a mark on black letters during the 1920s and 1930s, such as Bontemps, Patterson, and novelist and New Negro Renaissance luminary Wallace Thurman, grew up in small western African American communities (even Watts was a mixed, semirural neighborhood then) but made their initial reputations in the East.

In part this relative institutional absence derives from the relatively small size and dispersed character of black communities of the West Coast before the second wave of the great migration that sent huge numbers of African Americans from the South and the Southwest in the 1940s to work in the war production industries in the North and the West. For example, according to the United States Census Bureau, the black population of San Francisco increased from 4,846 in 1940 to 43,502 in 1950. The African American population of Alameda County (which includes Oakland) grew from 12,335 to 69,442 during the same period. (The black community in Los Angeles County also expanded dramatically but started from a much higher base, going from 75,209 to 217,881.)

One result of this late migration and the powerful presence of such Left-led trade unions as the ILWU and the Marine Cooks and Stewards Union in the industries where African Americans found jobs was that the high point of the Communist Left in the major African American communities of the West Coast occurred in the immediate post–World War II era rather than during the Popular Front of the 1930s.[4] Certainly, the Cold War severely damaged the Left on the West Coast, contributing, for example, to the failure of a major Left-influenced African American newspaper, the *California Eagle*, whose longtime publisher,

Charlotta Bass, was closely identified with the CPUSA. Nonetheless, the Communist Left functioned there more openly and was less isolated than perhaps anywhere else in the United States. Even in the case of the *California Eagle*, its decline and final demise took decades as, somewhat ironically, another veteran of the 1930s and 1940s Communist Left, Loren Miller, tried to reposition the paper more toward the political center. In the Bay Area, San Francisco's first major black paper, the *Sun-Reporter*, and its publisher, Carlton Goodlet, also displayed a noticeable Left influence.[5]

In part, this relatively high-profile Left presence was due to the somewhat maverick actions of the local CPUSA organization in California that sometimes resisted the policies of the national leadership. One important moment of such resistance was the reluctance of Communist leaders on the West Coast to share in the assessment of many in the CPUSA national office that the United States was moving toward fascism in the early McCarthy era. These West Coast leaders made a greater effort to maintain the CPUSA as a public rather than underground organization than occurred in most other regions. Consequently the Communist Left remained more visible in California (and to a certain extent, Oregon and Washington) than was generally the case in other regions — though, like elsewhere, repression, general Cold War anti-Communism, factionalism, the Soviet invasion of Hungary (and, later, Czechoslovakia), and the fallout from Khrushchev's 1956 speech about Stalin's atrocities still took a severe toll on local party leadership and rank-and-file membership.[6] As a result, the public campaigns and organizations of the Left were a part of the cultural memory of young black militants in ways that were unusual elsewhere. For example, BPP leader Huey Newton told writer and former CPUSA activist Jessica Mitford that the local campaigns of the Oakland–East Bay chapter of the Communist-led CRC, with a membership of five hundred in the late 1940s (as opposed to about fifty in the local NAACP), had a big impact on him as a child growing up in Oakland.[7]

Once pointed in this direction, it is not hard to imagine how these local CRC campaigns, which focused largely on the abuses of the Oakland African American community by the police and other arms of the criminal justice system, served as important antecedents for the early activities of the BPP in the Bay Area. This cultural memory might also help explain Eldridge Cleaver's close association with Roscoe Proctor, a black Bay Area CPUSA leader with deep roots in Warehouse Local 6 of the ILWU in Oakland, and the declaration of an alliance between the BPP and the CPUSA for a period of time. It no doubt contrib-

uted to the cooperation between another leading African American Communist, William Patterson, and various revolutionary and cultural nationalists in the initial formation of a committee to defend Huey Newton when the Oakland Police charged him with murder in 1967.[8]

The power of this cultural memory was strengthened through an important aspect of the relatively maverick behavior of many California Communist activists, including leading white functionaries: an open sympathy with the aims and institutional expressions of the emerging Black Power and Black Arts movements. Of course, as we have seen, Communists across the country, particularly black party leaders, were far more engaged with the movements on a local level than the pronouncements of the national office of the CPUSA would seem to indicate. Nonetheless, the 1968 formation of a Los Angeles club (the basic unit of CPUSA organization), the Che-Lumumba Club, made up entirely of African American and Latina/o members, was unique and much criticized by some national CPUSA leaders.[9]

Left sympathies also traveled to the West Coast from other parts of the United States. Like other Californians, many African Americans in the state were migrants from elsewhere. As a result, a number of regionally transplanted black artists and intellectuals, particularly (though not exclusively) those from the Northeast, had a previous, significant contact with the Left, either through personal involvement in Left organizations or through a close family member (or both).[10]

The impact of the Left on the Black Arts and Black Power movements in California was not entirely a product of distant memory or a previous life in another state, especially in the Bay Area. The Communist Left retained considerable institutional strength in the Bay Area through the 1950s and 1960s—though, of course, the McCarthy era had an enormous effect there as elsewhere in the United States. Unlike its eastern counterpart, the *Daily Worker*, the West Coast CPUSA newspaper *People's World* published continuously throughout the period and had a local influence unmatched by the Communist press elsewhere—especially in the labor movement. One huge factor in the persistence of the Communist Left as a political and cultural force on the West Coast (and the ability of *People's World* to circulate in the labor movement), particularly in the Bay Area, was the inability of the federal, state, and local governments, employers, and rival AFL and CIO unions (and later, AFL-CIO unions) to dislodge the ILWU from the docks and many of the warehouses of the West Coast (and a host of indus-

tries in Hawaii) or to destroy the openly Left national leadership of the union, whose president, Harry Bridges (born in Australia), was a frequent target of federal deportation proceedings.[11] Though the Cold War enabled anti-Communists to dominate a number of locals outside the Bay Area, especially in Washington and Oregon, and weakened the CPUSA as an organized force in the more Left locals, and though automation eventually much reduced union membership, the ILWU preserved a powerful left-wing presence in the Bay Area, particularly among African Americans who comprised approximately a third of its membership in the longshore and warehouse divisions in the 1950s—and nearly half of the important Bay Area Local 10, the largest longshore local in the union, by the mid-1960s. The docks and warehouses of the Port of Oakland, just west of the traditional center of the East Bay African American community in West Oakland, remained a particular stronghold of an older tradition of the CIO Left that merged, somewhat uneasily, with Black Power initiatives in the community and the trade union movement—not unlike the case of the United Packinghouse Workers Union on Chicago's South Side.[12] As BPP leader David Hilliard recalls, the port was one of the relatively few places in the United States where the CPUSA operated openly in the late 1950s and early 1960s.[13] In San Francisco, Local 10 was a major part of a coalition to elect African Americans to the board of supervisors during the early 1960s.[14]

As was the case in Chicago, the Communist Left in the Bay Area devoted much attention to educational institutions aimed at the black community, particularly the Negro Historical and Cultural Society (a local affiliate of Carter G. Woodson's Association for the Study of Negro Life and History). The Historical and Cultural Society initiated or sponsored many festivals, readings, lectures, publications, concerts, dramatic performances, and so on within the African American community as well as beyond the boundaries of the ghetto, contesting racist versions of black culture and history in academia, the public schools, and popular culture. The society served as an interchange where older black artists, such as Langston Hughes, Arna Bontemps, and composer William Grant Still, mixed with such younger artists as Marc Primus (the son of the dancer Pearl Primus, a familiar figure of Café Society and other venues of the Popular Front cultural circuit in New York) and the proto–Black Arts Afro-American Folkloric Theater he helped found and with the painter and writer Edward Spriggs. Spriggs served for a time as the program director of the Negro Historical and Cultural Society and later played a prominent part in the establishment of such

crucial Bay Area and New York Black Arts institutions as the journal *Black Dialogue* and the Studio Museum in Harlem before establishing himself as a cultural leader in Atlanta.[15]

The Bay Area and Los Angeles were also epicenters of the Beat and California Renaissance artistic countercultures. The participation of such African American artists as Bob Kaufman, Ed Bullins, Art Sheridan, and Quincy Troupe was a key feature of the West Coast bohemian subcultures of North Beach, Haight-Ashbury, the Fillmore District (also the heart of the African American community in San Francisco during the 1950s and 1960s), Berkeley, and Venice Beach. As in New York and other cities with visible bohemian communities, this interracial character significantly defined the public image of these subcultures — again, much like interracialism had been earlier considered a telltale sign of Communist activities in many quarters.

As in New York, the Left can also be discerned in these bohemian communities, if in a somewhat less obvious and more ambivalent manner than the African American presence. Many of the Beat and California Renaissance artists, including poets Bob Kaufman, Allen Ginsberg, Robert Duncan, Gary Snyder, Jack Spicer, and Stuart Perkoff, had radical political backgrounds in (or family connections to) the Communist movement and/or various anarchist, syndicalist, and pacifist groups. The older poet-critic Kenneth Rexroth and (for lack of a better term) Beat impresario Lawrence Lipton mentored and promoted (and bored, bullied, and hectored) many of the younger bohemians. Both men had participated actively in such cultural institutions of the Communist Left as the John Reed Clubs and the League of American Writers during the 1930s and were quite likely CPUSA members for a time — though Rexroth in particular later attempted to downplay his close relationship with the Communists. As noted in Chapter 1, the Left and Left activists found their way into the stories of various seminal institutions and events of the postwar West Coast bohemia, from the Six Gallery reading where Allen Ginsberg first performed "Howl" to the early Family Dog rock dances and concerts at the ILWU hall in San Francisco. The Bay Area (and founding) chapter of the W. E. B. Du Bois Clubs, a Communist youth group, was, like Advance and (later, other chapters of the Du Bois Clubs) in New York, a familiar institution in the post-Beat bohemian scene of the 1960s and an important part of the increasingly radical student movement and student-based civil rights movement at the University of California–Berkeley and San Francisco State College in the early 1960s.[16] In Southern California, John Haag,

the Los Angeles chairman of the Du Bois Clubs, an activist in CORE and other civil rights organizations, and the owner of the Venice West Café (one of the most notorious Beat public meeting places), found himself a major target of an "anti-beatnik" campaign (including a restriction on public bongo playing) conducted by Mayor Yorty and various local officials, the police department, and local business and real estate groups in 1964.[17]

As in black communities elsewhere in the United States, there was also considerable history of black nationalist agitation dating back to at least the Garvey movement (which had been quite active in Los Angeles), though, again as in much of the country, nationalism generally lacked the cultural and educational institutions that the Left continued to maintain (even if damaged by McCarthyism). In the late 1950s and early 1960s (before the organization of the AAA), Californian nationalist groups tended to be small and relatively informal, such as the Afro-American Vanguard study group that Maulana Karenga helped organize while a student at Los Angeles City College.[18]

The NOI, Elijah Muhammad, and Malcolm X did have an impact on West Coast African American neighborhoods. The increasingly high profile of Malcolm X made his writings and speeches required reading for nationalist study groups in Southern California and the Bay Area — and generated interest in nationalism beyond these study circles. As a result, though there were few large, organized nationalist groups on the West Coast in the late 1950s and early 1960s, nationalist ideas (and the idea of nationalism as a viable stance that reasonable people could take) found their way into more "mainstream" civil rights organizations, such as CORE and the NAACP Youth Council (and campus branches of the NAACP) as well as black student groups and the institutions of the Left. This increased circulation of nationalist ideas piqued an interest that in turn led to the invitation of Malcolm X, Robert Williams, and other nationalist or quasi-nationalist advocates of black pride, cultural recovery, and self-defense to forums, symposia, debates, and so on, further sparking African American interest in nationalism and building nationalist institutions.

It was within this background of interconnected political and cultural radicalism that both the West Coast revolutionary nationalists and cultural nationalists emerged. As in much of the South, black students spearheaded the formation of the Black Arts and Black Power movements on the West Coast. However, where the student movement in the South had been based in historically black colleges and universities, that of the West Coast grew largely out

of public, community-oriented colleges, particularly Merritt College (Oakland City College), San Francisco State College (changing to San Francisco State University in 1974 after a short period as California State University–San Francisco), the University of California–Berkeley — and to a lesser extent Los Angeles City College and the University of California–Los Angeles.

Both the cultural nationalists and the revolutionary nationalists, including the core of the original BPP leadership, the staffs of *Soulbook* and *Black Dialogue*, and such key cultural nationalists as Marvin X and Maulana Karenga, worked closely together in study groups, black student organizations, civil rights groups, black theaters, and other cultural and political organizations. It was only in the 1966–68 period that clear distinctions were made between the various groups and intense, often personal conflicts arose, perhaps intensified by the fact that many of the contestants had previously worked so closely together. One factor that helped Black Arts institutions, participants, and audiences mature while crystallizing differences between various strains of the movement was the arrival of important Black Arts activists from the East Coast, notably Amiri Baraka, Sonia Sanchez, and Askia Touré, to teach in (or develop) the new black studies programs at West Coast colleges and universities, especially San Francisco State. Of course, as in the case of Baraka in his relationship with Maulana Karenga, the Us organization, and Karenga's Kawaida philosophy, the exposure of East Coast transplants to West Coast–based individuals, institutions, and ideologies significantly affected the practices and politics of the transplants and, ultimately, the national Black Arts movement.

Bay Area: East Bay

The early Black Power and Black Arts activities in the East San Francisco Bay communities of Oakland, Berkeley, and Richmond were distinct from those in San Francisco. There was considerable cross-fertilization and interaction between activists on both sides of the bay, especially among older artists and intellectuals connected with the Black Arts movement. However, in part because mass transit was less developed before the advent of the Bay Area Rapid Transit, in the late 1950s and early 1960s it was much harder to travel between San Francisco and the East Bay, especially for young people without an automobile.

The campuses of Merritt College and the University of California–Berkeley nurtured the early Black Power and Black Arts movements in the East Bay that

did ultimately reach across the bay to San Francisco. What were initially the ad hoc efforts of a handful of students grew to have an enormous impact on the movements and their public image across the United States. These early efforts figured prominently in the genesis of the journals *Soulbook* and *Black Dialogue* (and ultimately *JBP*) as well as in the formation of RAM, the BPP, and Us.

At the beginning of the 1960s, there were relatively few black students at UC-Berkeley—a couple hundred African Americans and a smaller but significant number of Africans. The high quality and the low tuition of the university (even for out-of-state students) attracted ambitious students from outside California—including black students from across the United States (and beyond). As was the case at historically black schools, many of the Africans were radical supporters of decolonization, embracing the socialist orientation of many of the new African states and of such African independence leaders as Ghana's Kwame Nkrumah, Guinea's Sekou Turé, Congo's Patrice Lumumba, Tanzania's Julius Nyerere, and Kenya's Jomo Kenyatta.

This period featured not only the physical expansion of UC-Berkeley but also the growth of student activism there on a scale not seen there since the advent of the McCarthy era. Indeed much of this renewed activity involved protests against local and national manifestations of the Cold War: HUAC hearings in the Bay Area, UC-Berkeley administration attempts to severely limit the activities of campus political groups (especially those on the Left), and the Bay of Pigs invasion. While it appears that only a small number of black students participated in these protests, at least initially, a growing progressive (and even radical) student movement figured prominently in the intellectual climate of the university in the early 1960s—especially outside the classroom.

The revival of a grassroots, direct-action-oriented civil rights movement in the late 1950s and early 1960s also spurred campus activism. As elsewhere across the United States, the southern student movement that seemed to erupt spontaneously after the Greensboro sit-ins by North Carolina A & T students in 1960 electrified black students at UC-Berkeley. By 1961, the campus NAACP, led by J. Herman Blake, a student from New York, had become a dynamic center of black student life. It sponsored forums, lectures, and debates that reflected the new campus activism as well as the different trends of the civil rights movement and of the post-Bandung decolonization movements of Latin America, Asia, and Africa. It also backed local black candidates for office and picketed the campus job-recruitment efforts of companies that refused to hire African Americans.

And it organized dialogues with African students in which issues of colonialism, decolonization, and postcolonial development were debated and discussed.[19]

Nearby Merritt College was distinguished by its close connection to the African American communities of the East Bay, especially in Oakland. Located in a predominantly black neighborhood in northwest Oakland, Merritt drew a significant proportion of its student body from local working-class African American families. Since Merritt functioned as a sort of feeder school for UC-Berkeley, quite a few of these students would go on to the university after completing their two years at Merritt, producing a close link between black political, educational, and cultural efforts on both campuses. Merritt also came to serve as a cultural center for the broader black community in Oakland, again providing a vital point of connection between the nationally prominent university campus in Berkeley and East Bay African American neighborhoods.

A number of watershed events leading to the establishment of key Black Arts and Black Power organizations and institutions occurred at UC-Berkeley in 1961, largely through the office of the campus NAACP. Robert Williams came to the Bay Area in early 1961 under the auspices of the Fair Play for Cuba Committee. The campus NAACP invited Williams to speak about his work in Monroe, North Carolina, his call for armed self-defense, and the Cuban Revolution. This invitation contrasted considerably with the actions of the national NAACP leadership, which had suspended Williams from the organization in 1959 (and had given information on Williams to the FBI).[20] Williams's charisma, the vivid militancy of his calls for armed self-defense against the Klan, and the personal ties with black students at UC-Berkeley established by his visit fueled the development of the first proto–Black Power groups on campus after Williams later fled the United States.

The campus NAACP also sponsored a debate on separatism versus integrationism that year, reflecting the increasing circulation of the ideas of Malcolm X and the NOI within the black community. A UC-Berkeley law student, Khalid Monsour (then Donald Warden), initiated the debate by placing a challenge in the campus newspaper that the NAACP's J. Herman Blake accepted, guaranteeing maximum public attention. Blake made the case for integrationism before an audience of a couple of hundred. Monsour presented the argument for separatism in the exhortatory style of a black Holiness preacher. In a sharp exchange, Monsour's basic point resonated strongly with the largely northern and urban audience: if legal Jim Crow in the South were dismantled by the civil

rights movement, what would the South look like? His answer was that it would look like the North, like Oakland. That is to say, such a dismantling would leave de facto discrimination and huge inequities in housing, health care, access to the legal system, education, income, job opportunities, and so on basically untouched.

The interest that this debate generated led to the invitation of Malcolm X to campus by the UC-Berkeley NAACP. The university's administration blocked Malcolm X's appearance on campus, claiming that such a speech would violate the principle of the separation of church and state (though Billy Graham had recently visited the campus and led a public prayer meeting). This resulted in considerable faculty and student protest — and much publicity for Malcolm X's visit. The UC-Berkeley NAACP and other groups arranged for Malcolm X to speak off campus at the Berkeley YMCA, where, as had happened with Williams, even basically nonviolent integrationists like Blake were deeply moved by his magnetism, his eloquence, and the power of his message. While relatively few students immediately joined the NOI, Malcolm X's points about separatism, identity, and the need for self-help and self-determination left a profound impression.[21]

Within the context of this ferment at the university, a group of African American graduate and law students organized a study group in the spring of 1961 to take up issues of history, politics, and culture. The ideological spectrum of the group's regular members, thirty to fifty at its height, was quite broad. Monsour's politics, for example, came in large part from the relatively conservative nationalist tendency of self-help and self-development promoted by Booker T. Washington, Marcus Garvey, and Elijah Muhammad. On occasion, however, Monsour's sympathy with Third World independence, decolonization, and the nonaligned movements led him to take part in events with a Left character, as when he spoke before nearly one thousand students at a rally protesting the Bay of Pigs invasion in the spring of 1961.[22] Ann Cook, author of a piece in Toni Cade Bambara's seminal Black Arts feminist anthology *The Black Woman* moved on a trajectory that would lead her toward a sort of cultural nationalism that resembled that of Maulana Karenga without the subordination of women. Mary Lewis's ideological stance significantly reflected a family background in the Detroit Left and trade union activism. Donald Hopkins, a future defense lawyer for Huey Newton, fell somewhere in the middle of this ideological spectrum between what might be though of as the forerunners of revolutionary nationalism and cultural nationalism.

As happened to similar groups elsewhere, Robert Williams's escape to Cuba to avoid bogus charges of kidnapping in the late summer and early fall of 1961 shocked the members of the study group into political action. They assembled an ad hoc committee to bring Williams's case to the larger black community. The group organized demonstrations and street meetings in black shopping centers in Oakland and San Francisco's Fillmore District, bringing a soapbox style to the Bay Area that resembled the nationalist and/or Left street-corner rallies in front of the National Memorial African Bookstore in Harlem and in Washington Park on Chicago's South Side. They also reached out to the Merritt College campus and across the bay to San Francisco State College. While Monsour's preacherly style left some of the study group's members cold, since it was an oratorical mode that dominated rather than facilitated discussion in meetings, it served him well as a street speaker.[23]

Monsour, who had graduated in June and started a law practice, brought the group into crisis with a proposal that the ad hoc committee be transformed into some sort of permanent organization. The nub of the crisis was a disagreement over what direction this proposed group would take. Monsour wanted to concentrate on issues of black self-sufficiency and black enterprise and to downplay civil rights work. Others were interested in a more socialist direction, emphasizing the creation of cooperatives of various types. While the majority of the group apparently rejected Monsour's vision, they did not have enough cohesion or desire to successfully put together a more formal organization, and so the ad hoc group collapsed. However, a number of Monsour's opponents went on to work in other Black Power and Black Arts efforts in the Bay Area. Group members Mary Lewis and Aubrey Labrie, for example, taught some of the first courses in black studies at San Francisco State.[24]

Monsour invited those who supported him to join him in a new group. He was able to use his law practice as well as contacts made in previous street activities to build a new base that was much more rooted in the black community beyond the campus, particularly in the black neighborhoods of the East Bay. He initiated the AAA in March 1962. The AAA contained a range of ideological tendencies within a generally nationalist framework. It was theoretically decentralized in the sense that it had no permanent officers, but in practice its organizing principle was Monsour's personality. At its height, it had two hundred to three hundred active members, making it the largest African American activist political group in the East Bay since the demise of the CRC during the

McCarthy era—and no doubt the largest politically involved black nationalist organization in California since the heyday of Garvey and the UNIA.

The AAA retained the style of the Harlem street rally that was so congenial to Monsour's oratorical manner. The poet and playwright Marvin X, who participated in AAA events at Merritt College, recalls his impression of the group as that of a collection of nationalist street preachers.[25] The primary activity of the group consisted of what another young member, Ernest Allen Jr., termed "exhortation rallies," in which AAA speakers challenged the "integrationist paradigm" of the leadership of the national NAACP and the African American establishment of Oakland. The topics of these speeches frequently concerned the independence movements of Africa and such militant and charismatic African leaders as Nkrumah, Lumumba, and Kenyatta as well as domestic nationalist thought, particularly that of Malcolm X.[26] Ostensibly a political rather than a cultural organization, the AAA nonetheless put a heavy emphasis on the importance of culture and cultural values to the development of a distinct black political identity and self-consciousness. Beyond the number of important activists who entered nationalist politics through the organization, a later split in the AAA also led to the creation of institutions that would be crucial to the establishment of the Black Arts movement as a national phenomenon.

Though the direct-action efforts of the civil rights movement in the South inspired many of the younger black activists of the Bay Area, these activists were not for the most part engaged by the general strategy of nonviolence in the face of massive racist violence against civil rights demonstrators. They were also alienated by what they perceived as attempts to exclude young people from leadership positions in Bay Area NAACP chapters off campus. These young people also resented what they saw as attempts to rein in the local NAACP Youth Council from becoming too involved in confrontational protests that NAACP officials felt would undermine their traditional methods of lobbying and legal action. As a result, the uncompromising nationalist rhetoric and the colorful staging of AAA rallies as well as the self-assured preacherly eloquence of AAA speakers excited the imaginations of black students at Merritt College and elsewhere.

Given Merritt's connection to both the Oakland African American community and to black students at Berkeley, it is natural that it early on became a major site of AAA activities. The AAA's rallies, debates, and lectures at Merritt drew students (and friends) who would go on to play major roles in the Black Power and Black Arts movements, including Bobby Seale, Huey P. Newton, Ernest Allen Jr.,

and Marvin X. The radicalization of black Merritt students also created the conditions for the growth of some of the earliest black studies classes, particularly with the hiring of poet-critic Sarah Webster Fabio to the Merritt faculty in 1965, mirroring the growth of similar classes across the bay at San Francisco State.

At the same time, some of these newer AAA members, influenced by Left currents also circulating in the Bay Area, developed many of the same reservations as the participants in the original study group about the limitations of Monsour's messianic approach and his essentially conservative ideology. These reservations led them to split from the AAA—though the organization would continue for some years.[27] Perhaps the most important consequence of this AAA split for the emergence of the Black Arts movement was the establishment of yet another relatively small and somewhat informal study circle in the spring of 1963 by Mamadou Lumumba (Ken Freeman) consisting largely of former members of the AAA, including Carol Freeman, Don Freeman (not the Cleveland Donald Freeman), Isaac Moore, Bobby Seale, and Ernest Allen Jr. Resembling similar groups in Detroit, Philadelphia, Chicago, Cleveland, New York, and elsewhere, this study circle was Left nationalist in orientation with a strong internationalist, Pan-African bent. The group read and discussed a wide range of classic and contemporary nationalist and Left (especially Marxist-Leninist) texts with a focus on culture as well as politics. From this group emerged the initial core staffs of both *Soulbook* and *Black Dialogue*.[28]

One important way in which younger revolutionary nationalists of the Bay Area came into contact and cooperation with their counterparts elsewhere in the United States occurred through a series of tours to Cuba organized by the PL. Three young AAA members, Wayne Combash, John Williams, and John Thorne went to Cuba on the first tour in 1963. As mentioned in Chapter 4, Ernest Allen Jr. joined the second tour, bringing him together with leading members of RAM and the Detroit-based UHURU group (and eventually the LRBW) as well as with Robert Williams. Allen joined RAM and retained close contact with a network of Left nationalist activists in the Midwest, the East Coast, and, eventually, the South who found that they had convergent political, cultural, and intellectual interests. Though RAM itself, like the BPP, was far more decentralized in its practical activity than the image of the Leninist-style underground cadre organization found in much of its literature might suggest, and though there would be moments of conflict between members of RAM, the BPP, and the LRBW, this

network was a crucial step in the establishment of a sense (if perhaps not the actuality) of a relatively coherent national movement.[29]

In 1964, two Black Arts and Black Power journals with national audiences, *Soulbook* and *Black Dialogue*, grew out of the study group led by Mamadou Lumumba and the new political network engendered by the Cuba tours. *Soulbook* was the source of a division within the study group. Initially planned as a collective effort with a broad, though generally nationalist, ideological focus, *Soulbook* was taken in a more strictly Left nationalist direction by Lumumba along with Ernest Allen Jr. and Carol Freeman, drawing on contacts with RAM, UHURU, and various emerging Left nationalist organizations. *Soulbook*'s editors loosely attached it to RAM, featuring work by RAM leaders and reprinting RAM documents. However, *Soulbook* never became an official RAM journal, and it highlighted culture and the arts to a far greater degree than RAM's organ, *Black America*—though, as noted in Chapter 3, RAM was deeply bound up with East Coast Black Arts institutions, particularly BARTS. Through the connections that Lumumba, Allen, and others had formed with activists in the East and the Midwest, *Soulbook* became a national vehicle for the expression of Left nationalism, maintaining a more ideologically consistent and coherent voice than any other culturally oriented black nationalist publication. It also drew in local East Bay artists, most notably Marvin X, providing one of the earliest outlets for their work beyond the confines of Oakland and Merritt College.[30] And it also had a paradoxically productive negative impact in that disgruntled members of the original planning group who argued for a more ideologically eclectic editorial direction joined activists from the black student movement and the black bohemia across the bay in beginning *Black Dialogue* and, ultimately, JBP.

San Francisco: Black Bohemia West and the Legacy of Bob Kaufman

San Francisco was clearly the capital of West Coast bohemia. While Venice Beach contained a major outpost of the Beats, black bohemians, such as Bob Kaufman and Ed Bullins often migrated from Los Angeles to San Francisco in the 1950s and early 1960s in search of a larger avant-garde arts community. In the Bay Area, as elsewhere, this counterculture provided black artists, especially poets and playwrights, greater opportunities to develop their crafts and interact with

other artists and intellectuals than was generally the case in so-called mainstream cultural institutions and artistic circles.

These interlocking countercultural circles left a considerable imprint on the formal and thematic practices of black artists on the West Coast. The interest of the Beats and other schools of the literary avant-garde in voice (especially some notion of an American voice), the idea of natural breath as determining the length of a poetic line rather than some variation of traditional metrics, popular culture, and non-Western literary and dramatic forms informed emerging Black Arts attempts to represent and re-create a distinctly black voice on the page and in performance. Black, white, Chicana/o, and Asian American artists within the avant-garde theater movement shared similar interests in popular theatrical forms, particularly satire and farce, as well as nonnaturalist and often non-European dramatic forms that emphasized gesture, ritual, and spectacle over plot and character development.

Such avant-garde troupes as the San Francisco Mime Troupe, El Teatro Campesino (founded in 1965 by Mime Troupe alumnus Luis Valdez to support the organizing efforts of the United Farmworkers Union), the Afro-American Folkloric Troupe, and New York's Living Theater were often more directly political than the Beats—though there were considerable areas of intersection between the Beats and other post–World War II countercultural literary circles. As a result, the new drama by Bay Area black playwrights and directors was often "socially aware" but broke with the naturalist tradition often associated with politically radical drama in the 1940s and 1950s, say, Theodore Ward's *Our Lan'* and Lorraine Hansberry's *Raisin in the Sun*, in much the same way that Baraka's *Dutchman* and *The Slave* did on the East Coast. Baraka's early drama itself had an enormous impact on Ed Bullins, Marvin X, Jimmy Garrett, and other young black playwrights. However, that Baraka drew on many of the same sources and dramatic paradigms of the avant-garde theater as these young artists greatly strengthened this impact. As Marvin X notes, though Baraka and the establishment of BARTS significantly shaped how he, Bullins, and other black playwrights and directors in the Bay Area understood and framed their work, the theater workers who went on to form BAW were doing essentially avant-garde improvisational, multimedia, and multigenre Black Arts plays in the middle 1960s before they had any real sense of being part of a national movement.[31]

Some of these young black cultural activists, like Bullins, basically left the multiracial counterculture behind—much as Baraka and many of the Umbra

poets did in New York and as Woodie King, Ron Milner, and David Rambeau did in Detroit. Others kept one foot in the old bohemia. San Francisco State College student leader and *Black Dialogue* editor Arthur Sheridan retained a lingering attachment to North Beach bohemia, alienating him from some of the more deeply nationalist black artists and intellectuals. This increasing distance is further suggested by Sheridan's withdrawal (or removal) from the journal's editorial collective by the time *Black Dialogue* moved its base from the Bay Area to New York City in 1969.[32] Of course, even the younger artists who never joined in the North Beach or Venice Beach Beat scenes but moved more directly into the new institutions and groups of the Black Arts and Black Power movements often felt the influence of the Beats and other strains of the bohemian literary counterculture secondhand in their approaches to voice, lineation, syntax, rhythm, staging, use of music, and so on. And it is worth noting that even those artists who moved on from the older avant-garde drew on many of their earlier associations as sources of political and material support that helped maintain Black Arts institutions in the face of perpetual financial crises and recurring governmental hostility. For example, Bullins knew rock music promoter Bill Graham from Graham's days as manager of the San Francisco Mime Troupe and used that acquaintance to arrange benefits for BAW and the BPP (when he was the BPP minister of culture) at Graham's Fillmore West Theater in San Francisco and Fillmore East Theater in New York.[33]

In both his work and his person, the poet Bob Kaufman in many respects embodied the Old Left–bohemian connection that lay beneath the beginnings of the Black Arts movement in San Francisco (and beyond). Unlike other African American contemporaries who prominently participated in the New American Poetry groupings of the 1950s, such as Ted Joans and Amiri Baraka, Kaufman seems not to have been much engaged with the Black Arts movement of the 1960s and 1970s—though he did publish in early issues of *Black Dialogue* and did have relationships with a number of artists who would be leaders in the new black poetry, drama, music, visual arts, and so on. However, Kaufman's work as a linchpin of the San Francisco Beat community was in many respects a crucial forerunner of the Black Arts model of a popular avant-garde art rooted in African American popular culture discussed in Chapter 2. It also anticipated the radical, antiracist, anticolonialist, and internationalist (and often surrealist) sensibility that would be characteristic of a large proportion of African American nationalist verbal and visual art in the 1960s and 1970s.

As noted earlier, the model of a popular avant-garde is heavily associated with Baraka and his close comrades on the East Coast, especially Larry Neal and Askia Touré—with considerable justice, since they theorized it extensively in their prose and poetry. Nonetheless, Kaufman actually conceived his version of a popular avant-garde simultaneously with or even earlier than that of Baraka, Touré, Neal, or Ted Joans. As Lorenzo Thomas points out, this version was clearer and more fully realized than those found in the early poetry of Baraka and the others.[34] In no small part, this was due to the fact that the notion of the popular avant-garde poetry derived significantly from the Popular Front subculture from which Kaufman emerged and with which he continued to identify after its decline during the Cold War.[35]

At an early age (probably eighteen), Kaufman, like his older brother George, joined the merchant marine. During the 1940s, Kaufman became an activist in the NMU, a union of merchant sailors famous at the time for its radical leadership and its racial egalitarianism—its national secretary was Ferdinand Smith, a black Communist whose political sympathies were a matter of public record. In the late 1940s or early 1950s, Kaufman may have been one of approximately two thousand sailors expelled by the union or "screened" from the merchant marine by the federal government for their Communist associations.[36] Kaufman is said to have engaged in a number of radical labor and political activities in New York and the South before ending up on the West Coast, where he became an active and very visible part of the Beat and San Francisco Renaissance literary circles.[37]

In San Francisco, Kaufman was a crucial influence on the emerging New American Poetry circles in the city as a writer, as an organizer (he was one of the catalysts for the seminal West Coast journal *Beatitude*), and as a public figure of uncompromising resistance to aesthetic and political authority. Kaufman spent most of the 1950s and 1960s in San Francisco, with a sojourn in New York City. His period in New York is frequently characterized as one of mental decline brought on by drugs, especially speed, and his arrest and brutal treatment by various authorities, including numerous forced courses of shock therapy. However, there is evidence that even in New York Kaufman continued to serve as a cultural catalyst, particularly among African American artists.[38] Returning to San Francisco, he took a vow of silence, allegedly after John F. Kennedy's death, which he intended to make last until the Vietnam War was ended. He died in 1986, after years of poverty, drug abuse, and mental problems.

Kaufman publicly claimed that his mother was a Martinican vodun initiate

and his father a German Jewish refugee from Nazism. In reality, he was a product of an old, black New Orleans family that would not have been understood as Jewish in his hometown (or according to the Jewish tradition of matrilineal descent — though there is a possibility that Kaufman's paternal grandfather had some Jewish ancestry).[39] Kaufman's identification with Judaism had much more to do with a secular American radicalism than any simple religious or ethnic identification. His work shows little or no interest in Jewish religious practices, including the Jewish mystical traditions drawn upon by some of his literary contemporaries. Neither is it much concerned with the sort of Left Zionism that dominated the new state of Israel in the 1950s — a time, too, when the Communist Left had a basically favorable attitude toward Israel that was only slowly moving toward its later equation of Zionism and colonialism (and racism). His poetry is far more engaged, at least imaginatively, with the working-class Jews of the Lower East Side and the more secular side of their generally Left-influenced subculture, as seen in his depiction of the suicidal rabbi who would rather be an actor in the Yiddish theater in "Sullen Bakeries of Total Recall." While generally indifferent to Zionism, Kaufman's verse shows sympathy for North African anticolonialist struggles, including that of the Egyptians in the 1956 Suez War. The Holocaust is a persistent theme in his work, but it is worth noting that the Nazi death camps also figure prominently in the poetry of a number of Popular Front–influenced African American poets who made no claims to a Jewish identity, including Robert Hayden and Melvin Tolson. There are also some complex invocations of Exodus, as in "Benediction": "Pale brown Moses went down to Egypt land / To let somebody's people go. / Keep him out of Florida, no UN there."[40] The complication here is that Kaufman's anticolonialist, antiracist stance compares unfavorably the willingness of the United Nations (under pressure from the United States) to bring an end to the Suez Crisis in 1956 to its failure to act on American barbarisms at home (especially the Ku Klux Klan murder of Florida NAACP leader Harry Moore in 1951) and abroad. In addition, both the straightforward and ironic use of Exodus to figure contemporary realities has a long and well-known tradition in African American literature and folk culture generally. Thus, this apparent "Jewish" reference is also "African American," as is obviously seen here in Kaufman's satiric reworking of the spiritual "Go Down, Moses." For that matter, because "Go Down, Moses" was so prominently identified with Paul Robeson in the 1940s, Kaufman's reference to it may signal a multivalent and somewhat contradictory conjunction of Jewish, Afri-

can American, and Popular Front radical identities that mirrors the complicated position of the Communist Left in the United States as it tried to reconcile its earlier positive treatment of Israel (and often quite negative representations of the Palestinians in its press during the 1948 war) with the increasing importance of Egypt and Arab nationalists in the nonaligned movement that flowered with the Bandung Conference in 1955.

As Ellen Schrecker notes, this linking of imperialism and racism, commonly made by even such representatives of resolutely moderate (and often anti-Communist) civil rights leaders as Walter White of the NAACP before the Cold War, had become increasingly a radical (and politically marginal) public position in the United States during the McCarthy era.[41] Outside the United States, this linking would remain a prominent feature of the work of Third World writers, such as Nicolás Guillén, Nikim Hikmet, Leopold Senghor, Pablo Neruda, and Aimé Césaire, during the Cold War. Indeed, Kaufman's false claim that his mother was Martinican paid homage to the surrealist poetics and radical anticolonialist politics of Césaire. Kaufman's particular internationalism can be seen as related to the longtime Communist emphasis on the interconnection between local and global struggles, say, the linking of domestic McCarthyism, Leadbelly in Sugarland Prison, Egyptians battling neocolonialism, Cuban poverty, South African repression of native peoples, and the independence movement in the Congo that a reader finds in "I, Too, Know What I Am Not" (which seems to be an ironic and less optimistic Cold War revision of Langston Hughes's "I, Too" that pointedly raises and then evades the notorious McCarthyite question of what one is or has ever been).

At first glance, Kaufman seems to be an unlikely progenitor of the black popular avant-garde stance. Mass culture fares poorly in Kaufman's work. There is none of the nostalgia for, say, the Green Lantern or the Shadow that one finds in Baraka's early work. Film and television particularly are seen as a sort of mind control (e.g., in "Benediction": "Every day your people get more and more / Cars, televisions, death dreams").[42] Charlie Chaplin is a heroic figure, but as a sign of the rampages of and resistance to McCarthyism rather than as an artist. Instead, resistance to the Cold War conformity is located in various subcultures—bohemian, African American, immigrant, gay, and so on—that are seen as being excluded or voluntarily withdrawing from mass culture. In this sense, Kaufman's stance does resemble Baraka's early 1960s notion of African Americans as involuntary "non-conformists" who can hold out "against the hypocrisy

and sterility of big-time America."[43] However, like Baraka, Kaufman posits an alternative culture that is also rooted in popular culture, particularly the African American–identified musical genres of the blues, rhythm and blues, and jazz.

Maria Damon, Lorenzo Thomas, and others have pointed out that bebop was a particular formal and thematic resource for Kaufman.[44] As Damon calls to our attention, the complicated, shifting, and often double-time rhythms, the break with older jazz harmonies and tonalities, the often humorous playfulness, and the fragmented anger of bebop informed the structure of Kaufman's work (as it did Langston Hughes's 1951 *Montage of a Dream Deferred*).[45] Like Hughes's poetic sequence and Allen Ginsberg's "Howl," the lineation and phrasing of Kaufman's work as well as the relation between images or clusters of images, particularly in his longer poems, are significantly influenced by the bebop (and proto-bebop Kansas City jazz) practice of organizing improvisation around a series of musical phrases or riffs.[46] Of course, this sort of formal hybrid of different "high" and "popular" artistic genres and media has a long history in the literary culture of the United States — one thinks of the engagement of the work of Vachel Lindsay, Carl Sandburg, Fenton Johnson, Ezra Pound, Langston Hughes, Paul Laurence Dunbar, and James Weldon Johnson (to cite a few examples) with various sorts of popular or folk music in the late nineteenth and earlier twentieth centuries. Nonetheless, as noted above, intermixture of "high" and "low" genres and media in a deep and systematic manner was a particular mark of Popular Front expressive culture — and would continue to distinguish the poetic practice of the New American Poetry, especially of the Beats and the New York school poets.

Bebop also provided a model of popular African American avant-gardism that was unquestionably "modern" and "revolutionary" and yet was seen as rooted in a continuum of African American experience. For example, Kaufman draws a lineage of jazz in "Walking Parker Home" that extends from ancient Egypt ("Smothered rage covering pyramids of notes spontaneously exploding") through the blues and dance music of the southwestern territory bands from which leading bebop or proto-bebop musicians, such as Charlie Parker, Lester Young, Coleman Hawkins, and Charlie Christian, emerged (with Parker, Young, and Hawkins as well as the most famous center of southwestern jazz, Kansas City, all named in the poem) to the bebop avant-gardism of postwar New York ("New York altar city / black tears / secret disciples") that Kaufman ties to the ghetto and its sharp pains and pleasures.[47] Kaufman's sense of African Ameri-

can culture does not oppose popular culture either to a "residual" culture on the margins of mass culture (à la Raymond Williams) or to an avant-garde "high" culture (à la the Frankfurt school). Rather he sees a continuum of folk, popular, and "high" African American culture in which the new avant-gardism is distinguished from more sterile versions of formal radicalism by its grounding in African American popular culture. In short, Kaufman proposes bebop (and the postbop jazz) as a model of black artistic production that anticipates similar formulations that Black Arts theorists and critics, such as A. B. Spellman and Amiri Baraka, would promote using bebop and the "new thing" jazz of such musicians as Ornette Coleman, Cecil Taylor, John Coltrane, and Sun Ra. (Indeed, Kaufman's take on bebop as encompassing a black cultural continuum from the pyramids to modern Harlem and Fifty-second Street jazz in "Walking Parker Home" looks remarkably like the vision of black music presented by Sun Ra and his Arkestra in their performances.)

The reader also frequently encounters in such poems as "Walking Parker Home" and "Blues Note" ("Ray Charles is a dangerous man") the proposition that if you really have the ears to hear, what the music is expressing is pain, rage, and (often) displaced violent rebellion. Of course, this notion of a secret transcript of African American music goes back in African American letters at least to Frederick Douglass's first autobiographical narrative, where he speaks of the "deep meaning of those rude and apparently incoherent songs" with which the slaves powerfully, if obliquely, expressed the horror of their bondage.[48] Much the same sense can be found in Hughes's *Montage of a Dream Deferred*, particularly in the persistent, if fragmentary, references to a hidden meaning, hints of the significance and ramifications of a dream too long deferred, that lie within African American music—especially postwar bop and rhythm and blues. However, the rage and symbolic violence that Kaufman depicts resemble (and anticipate) even more the particular take on this old trope put forward by such Black Arts writers as, say, Baraka in the proto–Black Arts play *Dutchman* and Sonia Sanchez in the poem "on seeing pharaoh sanders blowing," in which fantasies of the righteous murder of clueless white auditors are displaced into the music—and then clarified by the playwright or poet explicating the music (speaking for the music and the musician). In this, Kaufman's work can be seen as a bridge between the writing of Hughes in the early Cold War and a significant section of the Black Arts movement.

In some respects, Kaufman's work here is an extension of an old debate on the

Left. There is still the sense among some scholars that the allegedly middlebrow aesthetics and institutions of the Popular Front were antagonistic to bebop.[49] However, the situation was considerably more complex. Some artists and intellectuals associated with the Popular Front, such as Frank Marshall Davis, Charles Edward Smith, and Frederic Ramsey, valued earlier forms of jazz and the blues, especially "primitive" New Orleans jazz, at the expense of bebop. In this sense, Ralph Ellison, with his famous distaste for Charlie Parker and bebop, remained close to this wing of Popular Front cultural criticism even after his break with the Communist Left, substituting an attachment to southwestern territory bands for the New Orleans musicians dear to Smith and Ramsey.

However, bebop also had its proponents within the late Popular Front, forming a sort of left-wing "hipster" sub-subculture.[50] Like Hughes, Kaufman can be seen as emerging from this hipster section of the Popular Front, arguing for bebop as an expression of modern, urban, African American anger and militancy in the politically difficult moment of the Cold War. Contra Ellison and others who saw bebop as a rupture between the black artist and the African American community, Kaufman (and Hughes) posited bop as an organic part of the entire continuum of African American culture—again anticipating Baraka's contention that bebop was not a break with black tradition but a return.

Kaufman also promotes bebop (and postbop jazz) as a crucial analogue to (as well as resource for) his poetic project because of bebop's self-conscious stylistic internationalism. One aspect of this internationalism is the relation of bebop (in its later development) to the European art music tradition. Charlie Parker and other leading bebop musicians drew freely on this tradition, particularly on such modern composers as Igor Stravinsky and Edgar Varese, with a new sense of the equality of jazz (or at least the subset of bebop and postbop jazz) with European art music.[51] Jazz had always had such borrowings. However, in bebop the prominent appropriation and assimilation of modernist European art music promoted a new sense of the status of the black artistic tradition as equal or superior to European art music. This publicly reversed the old idea of taking African American vernacular music and re-presenting it within the frame of "classical" or conservative European art music—a concept going back at least to the rearrangement of the spirituals in a "light classic" style by the Fisk Jubilee Singers in the nineteenth century. Instead, bebop publicly reframed contemporary European musical ideas within an African American vernacular context. Thus, Kaufman's influences from (and references to) European and

Euro-American modernism can be seen not so much as an evasion or lessening of African American identity as part of a modern African American discourse.

Bebop and some variants of postbop jazz in the late 1940s and the 1950s also served Kaufman as models for incorporating diasporic African influences. Such incorporations can be seen in the influence of Latin music in the late bebop period, most notably in the hiring of Afro-Cuban conga player Chano Pozo by Dizzy Gillespie in 1947, but also in the Latin-influenced recordings by a number of leading bebop players, including Bud Powell and Max Roach. Another example would be the Caribbean-influenced recordings by a young Sonny Rollins in the 1950s, such as his version of the Trinidadian song "St. Thomas" on the 1956 *Saxophone Colossus* album — a rendition that made the song a virtual jazz standard. Jazz, then, offered Kaufman a way to talk about his spiritual and artistic connection to a larger diasporic sensibility, particularly a radical, diasporic, anticolonialist sensibility, anticipating a similar connection drawn by Black Arts poets.

This diasporic consciousness is linked in turn to an anti-Fascist, modernist sensibility. "Like Father, like Sun," for instance, invokes the names of Spanish poet Federico García Lorca, Spanish painter Joan Miró, Nigerian drummer Babatunde Olatunji (who played on seminal bebop percussionist Max Roach's 1960 anticolonialist, anti–Jim Crow *We Insist! Freedom Now Suite*), Hart Crane, and Louis Armstrong as well as the historical events of the Spanish Civil War, the European seizure of the Americas, and European enslavement of Africans. At the same time, there is a sort of Popular Front–derived vision in the poem commemorating and praising an America of "the losers in earth's conflicts," merging the long-standing African American trope of "the black Christ" with the related Left vision of the crucified worker that is found, to cite a couple of examples, in the paintings of Ralph Fassanella (which include a number of canvases representing the painter's iceman father crucified on a pair of ice tongs) and Harriet Arnow's 1954 novel of displaced Appalachian migrants in industrial Detroit, *The Dollmaker*.[52] In fact, this merger of the black Christ figure with that of the crucified worker itself was a common move by black Left authors in the 1930s, 1940s, and even the 1950s, as seen in Langston Hughes's poem "Scottsboro" and in the final dream resurrection and transfiguration of Lonnie James, a black prisoner falsely accused of murder, in Lloyd Brown's *Iron City* (1954).

Perhaps the most important formal inheritance from the literary Left of the Popular Front era can found in the voice and diction of Kaufman's poetry. This

voice is by turns (or sometimes simultaneously) lyric, vatic, parodic, outraged, matter of fact, hard-boiled, hip, inflected by mass culture, apocalyptic, earnest, and campy:

> The bony oboe doorway beyond the burning nose translates
> me into Hebrew. I know that Faust was actually anti-
> symbolic and would never have married Kate Smith.[53]

The tone and diction of this passage in which Kaufman suggests that it is the Holocaust and not blood that made him Jewish might seem strangely goofy and campy for such a weighty subject: the Holocaust, Faust, and Kate Smith in a single strophe? Yet such mixtures of "high" and "low" diction, of the lyric and the mass, of the parodic and the earnest, in which the focus of parody seems to shift rapidly is characteristic of much poetry by writers associated with the Communist Left in the 1930s and 1940s, such as that of Langston Hughes, Frank Marshall Davis, Waring Cuney, Kenneth Fearing, and the early Thomas McGrath.

Beyond the persistent adoption of an emphatically radical stance (even if the specific sort of radicalism is not always clear), this formal playfulness of tone, diction, and syntax may be Kaufman's most lasting influence from the Popular Front as it manifested itself in the United States. It is also this serious (and often anxious) but nonetheless witty and sly playfulness that distinguishes Kaufman from his surrealist or surrealist-influenced models, particularly Lorca and Césaire, in which such a play of diction and tone, of high and low, of literary and popular is absent or is present in a heavy-handed way.[54] Of course, in this regard Kaufman's poetry shares much with the work of other "New American" writers, but this peculiar mixture of high and low, literary and popular, localism and internationalism, race and ethnicity and Americanism that marked many of the poets whose work became grouped within the New American Poetry can be seen as an inheritance from the Popular Front that in turn would, as Lorenzo Thomas suggests, go on to mark Black Arts poetry.[55]

Thus, Kaufman resembles other important African American artists and intellectuals with ideological roots in the Communist movement (however anti-Communist they eventually became), whether as leaders, like Richard Moore, or relatively minor participants, like Harold Cruse, who would bridge the Old Left and the Black Power and Black Arts movements. Kaufman's model of a continuum of African American culture, from Africa to Fifty-second Street jazz clubs, conceptually encompassing folk, popular, and avant-garde culture, was

significantly marked by the late Popular Front, which anticipated and influenced the development of similar models of African American literary expression during the Black Arts movement. Kaufman is a vital figure, then, because, as Lorenzo Thomas suggests, his work prefigures the New Black Poetry (and indeed one of the main Black Arts trends in general) but also because he provides a crucial link to a past African American radical cultural production that has been often overlooked or effaced.[56]

The Black Student Movement in San Francisco and Black Arts Journals

The nucleus of the group that began *Black Dialogue* in 1964 took part in the initial planning of *Soulbook* but became alienated by what they saw as Mamadou Lumumba's attempt to dominate *Soulbook* and push it in a relatively narrow revolutionary nationalist direction—essentially into an organ of RAM, in their view. *Black Dialogue* was open to a wider range of nationalist thought than *Soulbook* and had an even stronger cultural bent. Like the *Soulbook* circle, the *Black Dialogue* group had significant roots in the AAA; however, its locus was not the East Bay but San Francisco State College.

Like Merritt College across the bay, San Francisco State attracted a significant group of young (and not so young) black students. However, unlike Merritt, whose student body came largely from nearby East Bay communities, San Francisco State attracted black undergraduates from across the West Coast, particularly from California's public junior colleges. Drawn in part by San Francisco's bohemian arts communities, these students, such as the poet and playwright Marvin X from the Fresno area (where his father edited a local African American newspaper, the *Fresno Voice*), Ed Bullins from Philadelphia by way of Los Angeles City College, and Edward Spriggs from San Francisco, were in many cases already developing artists with connections to grassroots theater and arts institutions beyond the campus. Ed Bullins's earliest productions in the mid-1960s took place in bohemian cafes and such "alternative" theater spaces as the avant-garde Firehouse Theater.[57] Other noncampus institutions, like the Left-influenced Negro Historical and Cultural Society, sponsored lectures, forums, and other functions attended by San Francisco State students, promoting the notion of a distinct African American history and culture and providing meeting places for black artists and intellectuals inside and outside academia.[58]

By the early 1960s, a wave of liberal-Left student activism brought the campus to a new political prominence. San Francisco State students joined in demonstrations at local hearings of the HUAC. Student groups provided much of the leadership and rank and file for direct-action civil rights efforts in San Francisco. The Direct Action Group, initially led by Art Sheridan, and the Du Bois Club worked closely with CORE in forming the United Freedom Movement, an umbrella coalition of civil rights groups in the city. The United Freedom Movement mobilized large numbers of students and community activists in successful demonstrations against racist hiring practices by hotels, car dealerships, and supermarkets.[59]

The primary African American group on campus in the early 1960s was the NSA. It has been described in some accounts as a primarily social organization. However, as we have seen, NSA members were at the forefront of the student and civil rights upsurges in such groups as the AAA, United Freedom Movement, the Negro Historical and Cultural Society, and the Afro-American Folkloric Theater, including in its ranks (or on its periphery) such activist intellectuals and artists as Sheridan, Bullins, Marvin X, Spriggs, Marc Primus, Welton Smith, and Gerald Labrie (Abdul Karim — the brother of Aubrey Labrie). Members of the NSA would go on to play central roles in the building of the Black Power, Black Arts, and black studies movements in the Bay Area (and in the cases of Bullins and Spriggs, beyond). It was out of the NSA and their contacts in Bay Area bohemia, together with disgruntled members of the group that launched *Soulbook*, that the primary conceptualizers and organizers of *Black Dialogue* came.[60]

Even more than *Soulbook*, *Negro Digest*, or *Liberator*, *Black Dialogue* can be seen to emblematize the early Black Arts and Black Power era. As noted above, it had a long foreground in radical bohemian, Left, and nationalist political and artistic subcultures of the Bay Area. At the same time, its creators had a certain sense of impatience with "leaders" of all stripes and with older organizations. They saw in the journal a much-needed forum for young black artists, activists, and intellectuals that allowed them to build new communities among themselves and to articulate their ideas in society. Since no such national institution existed, these activists simply created one. While *Black Dialogue* was generally Pan-Africanist, anticolonialist, and pro-civil rights, it maintained an intentionally ideologically diverse editorial policy. In short, the editors took the notion of dialogue seriously. They also saw the journal as a cultural magazine, but one with a political rather than commercial basis, distinguishing it from

Negro Digest/Black World—which faced the contradiction of being an increasingly nationalist black cultural and political journal with a commercial underpinning.[61]

Like the young people of the 1960 sit-ins and of the early days of SNCC, the activists who produced *Black Dialogue*—and *Soulbook*—were not responding to the directives of leaders at home or abroad, though they certainly had heroes and inspirations, but were early practitioners of a sort of "just do it" philosophy that characterized the movement in many areas. None of the early founders of these journals were established or even "up-and-coming" in any broad public sense. Thus, later comments concerning the lack of first-rate contributions by better-known black writers associated with militant nationalism in some respects miss the point of the enterprise of these journals (especially *Black Dialogue*) organized around notions of finding voice, essaying articulation, and creating dialogue on a national level. In some ways, these journals resembled such second-generation New York school and Black Mountain school little magazines as *Kulchur, C,* and *The World* (where, indeed, one could find a number of young writers associated with the Black Arts movement, such as Baraka, A. B. Spellman, David Henderson, Lorenzo Thomas, and Calvin Hernton) because they emphasized process rather than final product—though in many respects *Soulbook* and *Black Dialogue* (and later, *JBP*) were more open and less motivated by a publish-your-friends orientation than their second-generation New American Poetry counterparts. This notion of becoming, of progressive transformation, was a crucial aspect of the Black Arts movement. Both *Black Dialogue* and *Soulbook* were early, though ideologically divergent, vehicles that promoted this ideal on a national level.

One of the most important results of the creation of *Black Dialogue* in terms of the Black Arts movement was that it led to the creation of the third important Bay Area journal, the *Journal of Black Poetry,* in 1966. The editor of *JBP,* Dingane Joe Goncalves, raised in Boston, was a leader of CORE in the Bay Area. In fact, it was in the San Francisco CORE office that the visual artist and poet Edward Spriggs and Goncalves first met. The relationship between Goncalves and Spriggs no doubt strengthened, if not actually forged, Goncalves's ties to the various black political and cultural circles centered on San Francisco State. Goncalves and Spriggs (who soon relocated to New York) joined the staff of *Black Dialogue* on which Spriggs served as the East Coast correspondent and Goncalves as the poetry editor. When *Black Dialogue* received far more worthwhile

poetry than it could possibly print, Goncalves saw the need for a new journal devoted to black poetry. The result was *JBP* — on which Spriggs worked, too, as a regional corresponding editor from Harlem. In many ways the project of *JBP* was much like that of *Black Dialogue*: to allow young black writers with or without wider reputations to speak to each other, to try out their voices. Again, much like the new avant-garde outside the Black Arts movement as well as within it, *JBP* emphasized process over finished product.[62]

However, *JBP* became far more than a journal of poetry. It published criticism, reviews, and news about black cultural and political movements sent in from all over the United States (and beyond). Regular corresponding editors, such as Spriggs and Clarence Major in New York, provided some of this news. But reader-correspondents sent in much more, reporting on theaters, workshops, readings, presses, and so on from Savannah to Seattle. Also, despite his political and cultural commitments, Goncalves was in many respects a very reclusive person, staying out of the conflicts that became endemic in the Bay Area after the split between the BPP and many of the Black Arts activists in the Bay Area in 1967, allowing *JBP* to weather political storms that destroyed, hamstrung, or forced the relocation of many key Bay Area Black Arts activists and institutions.[63] In short, *JBP* was incredibly important in facilitating grassroots communication and a sense of community among black artists across the country. If one truly wishes to gain a sense of the scope of the Black Arts movement and how the movement worked on the ground in the second half of the 1960s and the early 1970s, especially outside New York, Chicago, and the Bay Area, the news section of *JBP* is indispensable.

San Francisco State, Black Studies, and Black Arts

One aspect of the increasing radicalization of the student body at San Francisco State was the partial transformation of the college itself. Or if the institution itself was not fundamentally transformed, the relatively large radical constituency in the student body within the larger context of the political and cultural matrix of the Bay Area, which included increasingly militant and vocal African American nationalist or nationalist-influenced organizations, made it possible to create new spaces within San Francisco State that promoted the Black Power and Black Arts movements.

The creation of the San Francisco State Experimental College in 1966 pro-

vided an early institutional home for a nascent black studies program that would be an important channel for promoting the Black Arts movement in the Bay Area as well as a source of income for young black artists and intellectuals. It was in the Experimental College that perhaps the first black studies courses anywhere were taught by students Jimmy Garrett, Mary Lewis, and Aubrey Labrie—though Sarah Webster Fabio across the bay at Merritt College also taught similar courses at roughly the same time. During this period, the NSA became increasing radicalized, changing its name to the Black Students Union (BSU) in the spring of 1966 under the leadership of Marrianne Waddy, Chuck Sizemore, and Garrett—though not without considerable debate. As argued above, despite the familiar Black Arts and Black Power conversion story about how the accommodationist and socially oriented NSA becomes the militantly political BSU, the NSA and its members had in fact been integral parts of radical African American civil rights, educational, and cultural activity in San Francisco. However, it does seem fair to say that the name change indicated a much more formal adherence to nationalist politics, and a more public declaration of affiliation to broader nationalist movements, than had ever been the case with the NSA. Waddy, daughter of Los Angeles artist Ruth Waddy (herself a key figure in organizing and encouraging black visual artists in Southern California during the 1960s), in particular powerfully argued for the BSU name and for the radical nationalist politics the name implied, in no small part carrying the day with the force of her personality. Conflict between Waddy and Garrett, an aspiring playwright who apparently believed that women should play a supporting rather than leading role within the Black Power movement, divided the organization and led to Waddy's withdrawal from the BSU, which she felt was being hamstrung by infighting. (Though in fairness to Garrett, it should be noted that he directly took a hand in bringing Sonia Sanchez to teach black literature at San Francisco State and help build the black studies program there.)[64]

The BSU put an increasing priority on politicized cultural work. It organized a Black Arts and Culture Series in the fall of 1966. This series led to clashes with white staff within the Experimental College over control of funding. Eventually the series withdrew from the Experimental College and was run entirely under the aegis of the BSU.[65] This mirrored a pattern at Wayne State University in Detroit and other educational institutions where black studies programs took shape in various "alternative" spaces within the larger institutions and subsequently left those alternative spaces largely due to struggles over how the emerg-

ing programs would be funded and administered. There was also a symbolic aspect of this rupture that replicated the other sorts of dramatic public acts of disaffiliation with the Old Left (and old bohemia) across the country, from the Douglass House in Los Angeles to Concept East in Detroit to BARTS in New York.

The BSU saw culture as a key component of its conception of black studies, leading to the recruitment of some of the most important Black Arts figures to anchor the emerging program. The BSU approached Sonia Sanchez about teaching African American literature based on her experience as a teacher, a poet, and a participant in BARTS. Though she hesitated at first, Sanchez became increasingly drawn to the idea of working in the Bay Area after growing tired of the chaos and threats of violence (both from inside and outside the organization) that attended the final days of BARTS. A chance meeting with Jimmy Garrett and BSU members in Mexico in which they urged Sanchez to come to San Francisco State heightened that interest. Garrett and others from the BSU met with Sanchez and Amiri Baraka in Newark in 1966, again attempting to recruit them to the emerging program.

The BSU's prodding and her frustration with the Black Arts scene in New York soon led Sanchez west. She initially taught a noncredit course in black literature at San Francisco State. That course and subsequent credit courses attracted an enormous enrollment. Buoyed by this success, Sanchez encouraged Baraka to join her at San Francisco State.[66]

The BSU brought Baraka to campus in the spring of 1967 to found the BCP. Funded largely by the student government under BSU sponsorship, the BCP attempted to bridge the gap between campus and community by putting on plays, poetry readings, and other events in Bay Area African American neighborhoods and on other college campuses with close ties to those neighborhoods, particularly Laney and Merritt colleges in Oakland, the epicenter of the newly formed BPP.[67] Sanchez along with Jimmy Garrett helped convince Askia Touré to serve as a visiting faculty member in 1967. Garrett, a SNCC activist in San Francisco, had been greatly impressed by the Black Power statement that Touré coauthored as a member of SNCC's Atlanta Project. Sanchez knew Touré from BARTS and her own civil rights activism in CORE in New York City.

The move of Baraka, Sanchez, and Touré to the West Coast helped solidify the push for black studies at San Francisco State and energized the Black Arts scene in the Bay Area. The aim of these East Coast transplants was to replicate

and institutionalize the successful activities of BARTS on the West Coast without the destructive psychodrama that had dogged BARTS. They staged weekly readings of poetry and drama and served food, drawing on their extensive national connections as well as their local contacts. During his tenure at the BCP, Baraka directly encouraged and inspired two of the most important playwrights and poets of the Bay Area scene, Ed Bullins and Marvin X—and they in turn provided considerable material and much of the creative energy for BCP productions. At the same time, the BSU initiated and won the drive for black studies and ethnic studies programs after a long struggle that culminated in the student strike of 1968–69 and the formation of the Third World Liberation Front—though the shape of the black studies program continued to be debated.[68] Due in part to the conflicts within the Black Power and Black Arts movements that consumed the Black House and other African American arts institutions in the Bay Area, by the time the program was fully established, Sanchez, Baraka, and Touré had returned east, and black studies at San Francisco State became more academic and less oriented toward artistic production.

However, before the weakening of the Bay Area Black Arts scene by political infighting, the arts activities anchored by the BSU and the BCP had a tremendous impact on the development of the national movement—even the conflict itself produced some far-reaching, if unexpected, results. A sense of the growth of the audience for radical black art and of the success of the BCP and its activities can be gauged from two poetry readings. Early in the stay of Sanchez and Baraka at San Francisco State, they organized a reading in San Francisco's primarily African American Hunter's Point neighborhood. About twenty-five people attended the reading that featured Baraka, Sanchez, and Bullins. Nearly half of the audience left when they found that the readers were not singers. A year later, a similar reading that included Sanchez, Baraka, Bullins, Sarah Webster Fabio, and Marvin X drew more than one thousand people—primarily African American but also Asian American, Latina/o, and white.[69]

The engagement of Bullins and Marvin X with Baraka, Sanchez, and the BCP had some far-reaching consequences. Even before their collaboration with Baraka in the BCP and the Black House, Bullins and Marvin X had been much inspired by Baraka and BARTS. Bullins had been born and raised in Philadelphia. He moved to Los Angeles in the late 1950s after a tour of duty in the Navy. Like many other young African American writers and political activists in Los Angeles during that period, he became interested in literature and politics at

Los Angeles City College (LACC), which played something of the same role for developing black artists and intellectuals that Merritt College and San Francisco State did in the Bay Area. While at LACC, he briefly roomed with Maulana Karenga (then Ronald Everett), who was extremely active in campus politics as well as in off-campus civil rights and peace activities. Also, like many of the younger members of the Watts Writers Workshop (and like Baraka and the Umbra writers on the East Coast), Bullins frequented the Beat scene in Venice Beach. His novice efforts at writing, primarily short stories and poems, issued from this bohemian milieu.[70]

Bullins left for the Bay Area in 1964, seeking a wider community of political and cultural radicals. His apprenticeship as a playwright came largely through the avant-garde small theaters of San Francisco. His first plays produced at the bohemian Firehouse Theater in 1965, *How Do You Do*, *Clara's Old Man*, and *Dialect Determinism*, drew on contemporary avant-garde theater, particularly Baraka's early drama, as well as older nonrealist traditions of parody, farce, and satire, gaining him some notoriety as a new black playwright. The Firehouse productions of Bullins's early plays attracted the attention of Art Sheridan, who had connections in Bay Area bohemian circles and in the radical black political and cultural circles of *Black Dialogue* and San Francisco State. Sheridan in turn mentioned Bullins's work to Marvin X, who had put on his own plays, such as *Flowers for the Trashman* and *Come Next Summer* (in which future BPP founder Bobby Seale had a part), in bars and on the Merritt and San Francisco State campuses. Intrigued, Marvin X sought out Bullins and found their interests in black nationalist politics, the avant-garde theater (especially the plays of Amiri Baraka), and putting together a black theater in the Bay Area along the lines of BARTS were copacetic.[71] Bullins and Marvin X, along with Duncan Barber, Ethna Wyatt, Hillery Broadous, and Carl Bossiere (who later worked with Baraka at Spirit House in Newark), set up BAW in 1966. On Marvin X's suggestion, they took over the American Theatre in the Fillmore District. The American was an old movie theater used by an Islamic preacher named Shabazz who could no longer afford the rent. Like BARTS, BAW staged multimedia, multigenre street theater as well as more conventional productions in the theater. Much like Baraka was doing at the same time with Sun Ra and other musicians on the East Coast (and as the Living Theater had done with Archie Shepp and other jazz musicians in its production of Jack Gelber's *The Connection*, for that matter), BAW fully integrated jazz musicians and an improvisational jazz ethos into their

performances, which they altered nightly depending on where the acting, the music, and the audience's response took them.[72] However, BAW was more open to white participation in the audience and was generally friendlier to bohemian and radical cultural institutions outside the black community than was the case with BARTS—as seen in the BAW fund-raisers at the Fillmore West and the Fillmore East rock music venues.[73]

The formation of the Black House in San Francisco marked a high point in the Bay Area Black Arts movement, and its dissolution gave a preview of the sort of ideological (and personal) divisions that would later split the movement and wreak havoc on West Coast Black Arts institutions. Members of the *Black Dialogue* staff, including Marvin X, met Eldridge Cleaver for the first time when they made a presentation to a black cultural club at Soledad Prison—a club that also included future Los Angeles BPP leader Alprentice "Bunchy" Carter. Marvin X and Ed Bullins kept in contact with Cleaver while BAW was beginning to implode from the same sorts of aesthetic and ideological conflicts and personality clashes that crippled BARTS. After Cleaver was released from prison in 1966, Bullins and Marvin X convinced him to use some advance money from *Soul on Ice* to set up the Black House in an old Victorian house on the edge of the Fillmore District. Like the House of Respect in Los Angeles, the Black House was a combination group house, school, and cultural center with programs (performances, classes, formal and informal discussion groups) modeled in many respects on those of BARTS. This connection was strengthened by Baraka's frequent participation in Black House events while he headed the BCP. In fact, the Black House became a sort of headquarters for Baraka during his sojourn in the Bay Area. As was true at BARTS, OBAC, and the House of Respect, much of the wide-ranging discussion between political and cultural activists took place in informal sessions. The participants included Bullins, Marvin X, Cleaver, Baraka, Sonia Sanchez, visual artist (and future BPP minister of culture) Emory Douglas, Sarah Webster Fabio, and members of the Art Ensemble of Chicago.

Unfortunately, Black House survived less than a year, again destroyed by much the same sort of infighting and personality conflicts that plagued BARTS and BAW—though in this case the repercussions of these conflicts would go far beyond the Black House and even San Francisco. It was via Marvin X and Bullins that Cleaver was introduced to Bobby Seale, Huey Newton, and the other leaders of the BPP. Marvin X and Bullins knew much of the Oakland leadership of the BPP through political and cultural organizations dating back to the AAA

and the Merritt College and San Francisco State student movements. As noted earlier, Seale had also been an actor in some of the earliest productions of plays by Bullins and Marvin X. Cleaver saw in the BPP an instrument much more amenable to advancing his Marxist-Leninist vision of armed revolution (and his position as revolutionary leader) than the Black House, which was dominated by nationalist artists who were largely either uninterested in or hostile to the sort of vanguardist Marxism-Leninism Cleaver espoused. Cleaver soon became a powerful force within the BPP, and differences developed between the "artists," particularly Bullins and Marvin X, and the "politicals" of the BPP that were in part personal but also presaged the later splits, with Cleaver accusing the Black House artists of being "cultural nationalists" who were more interested in making symbolic gestures than in doing the hard work of seizing real power, and the artists feeling that Cleaver was far too deferential toward the "white Left." Cleaver and the BPP evicted Marvin X, Bullins, and most of the other artists from the Black House in 1967, essentially eliminating it as an important Black Arts site. Not long after, both Bullins and Marvin X left the Bay Area — Bullins to New York and Marvin X to Toronto, New York, and a host of other places before returning to the Bay Area.[74]

This eviction did not immediately destroy all connections of leading Bay Area Black Arts activists to the BPP. Many of the artists formerly associated with the Black House would soon participate in a benefit for the BPP — and Bullins briefly served as the Black Panther's minister of culture in 1967–68. The campaign to free Huey Newton from prison was widely supported by black artists and activists of almost every political tendency. However, the BPP in the Bay Area would never again be the locus of artistic activity that it was for a short period before the Black House split — though it would retain a broad symbolic impact as the embodiment of a new black militancy, both in the black community and in popular culture in the United States as a whole. The fallout of the BPP's conflict with the artists created an atmosphere of hostility and conflict that stifled local cultural efforts in the Bay Area and led many, such as Bullins, Marvin X, and the writers from the East Coast who helped build black studies and the BCP at San Francisco State, Baraka, Sanchez, and Touré, to leave the region, generally for New York. It also created an atmosphere of hostility between many artists and the BPP that lasted for years — as can be heard in asides about BPP leaders made by Baraka and Touré during the poetry reading at the Apollo Theater recorded on the *Black Spirits* album released by Motown's Black

Forum label in 1972.[75] At the same time, Marvin X's and Bullins's interaction with Baraka, Sanchez, Touré, and the BCP at the Black House and San Francisco State gave them new connections and visibility outside the Bay Area that promoted their careers, particularly that of Bullins, who would go on to be writer-in-residence of the New Lafayette Theatre in Harlem and editor of the journal *Black Theatre* associated with the New Lafayette.

The conflict with the BPP and the resulting exodus also had the somewhat ironic consequence of promoting West Coast ideological and institutional influences nationwide, especially increasing the circulation of the thought and organizational practices of Maulana Karenga and Us. The student upsurge at San Francisco State, the growth of the BCP, and the conflict growing out of the split that destroyed the Black House (and the BCP, for all practical purposes) indirectly resulted in a much wider dissemination of the ideas of Karenga and his rise as a national influence on the Black Arts movement, largely through the agency of Amiri Baraka. Baraka encountered Karenga's Us organization firsthand while he was at San Francisco State. Prior to Baraka's sojourn on the West Coast, Karenga visited him at Spirit House, probably in late 1966 while attending a planning meeting for the 1967 Black Power Conference that took place in Newark. Baraka was impressed by Karenga's energy and self-assurance. In some ways, Karenga's neo-Africanist vision resembled the countercultural stance of the Yoruba Temple that Baraka and others in BARTS had found so attractive, but it was far more theoretically sophisticated and elaborated. However, Karenga also antagonized Baraka with what the latter perceived as arrogance and a wrong-headed condemnation of African American popular culture, particularly the blues and its musical descendants, as a sort of accommodationist defeatism.[76]

Despite these mixed feelings about Karenga, Baraka and his BCP group performed at the Us headquarters in Los Angeles while they were in town for a CORE meeting. Though he (and other East Coast activists) for the most part continued to reject Karenga's antagonism to black popular culture, Baraka was extraordinarily impressed by the discipline of Us and Karenga's ability to verbalize and project through Us a fleshed-out vision of an alternative, African-centered culture. Baraka contrasted the discipline of Us and the breadth and coherence of Karenga's projection to the personal and ideological chaos attending BARTS, BAW, the Black House, and Spirit House. According to Karenga, Baraka was also interested in developing organizational skills and structures that would allow

him to defend his new institutions against the sorts of external pressures, both psychological and physical, that helped lead to his departure (and the departure of other artists) from the Bay Area — and his departure from BARTS, for that matter. In short, Karenga's ideas as embodied in Us seemed like a workable basis for building stable black countercultural institutions that could withstand much external pressure while avoiding internal strife. Baraka returned to Newark as a sort of disciple of Karenga's Kawaida philosophy and system of organization — though, as noted in Chapter 2, a disciple who attempted to fuse a notion of a popular avant-garde with Karenga's neo-African countercultural vision.[77]

The Bay Area and the Rise of Multiculturalism

As Kalamu ya Salaam has pointed out, the multicultural movement is in part a legacy of the Black Arts movement in the Bay Area. Black Arts and Black Power groups generally featured a wide circulation of ideas and personnel within and between different regions. However, the sheer volume of the interchange of artists and activists set apart the relationship between New York and the Bay Area, long the two principal poles of post–World War II bohemia. This circuit was also distinguished by the fact that the flow of artists was nearly equal in both directions. While such artists and activists as Edward Spriggs, Ed Bullins, Jay Wright, Welton Smith, Ernest Allen Jr., and Marvin X (for a time) found their way to New York, others such as Ntozake Shange, Amiri Baraka, Askia Touré, David Henderson, Ishmael Reed, Victor Hernandez Cruz, and Sonia Sanchez made their way west to the Bay Area for stays of longer or shorter duration. Of course, much the same could be said for their white counterparts. Quite a few of the white members of the 1960s St. Marks-in-the-Bowery poetry circle on the Lower East Side, including Aram Saroyan, Lewis Warsh, Tom Clark, and Jim Carroll, formed a quasi-rural expatriate community in Bolinas, a bohemian enclave in Marin County. However, unlike these white poets, African American artists and intellectuals settled in the urban areas of San Francisco and the East Bay, particularly Berkeley and Oakland, and not only joined the local Black Arts and Black Power scenes but also encountered vital circles of Chicana/o and Asian American cultural and political activity.

Important interactions between nationalist African American, Latina/o, and Asian American artists took place elsewhere. As noted in Chapter 3, there was a close relationship between the Black Arts movement and many Puerto Rican

writers in the Northeast (and to a lesser extent, the Midwest) during the late 1960s. However, the close interchange and interconnection that took place in the Bay Area between African American, Asian American, and Chicana/o (as well as Nuyorican and white) artists was unmatched elsewhere in the United States—even New York. As Salaam notes, even the generally cultural nationalist JBP published Third World writers from outside Africa and the African diaspora, particularly revolutionary-patriotic writers from Vietnam and China, practicing a sort of post–Bandung Third Worldism.[78] This apparently paradoxical intersection of black cultural nationalism and Pan–Third Worldism is not so strange. Such identifications of common interest among "the colored peoples of the world" characterized African American nationalism in the twentieth century from at least the Garvey movement through the Afro-Asiatic theology of Elijah Muhammad and the NOI and beyond. As will be noted below, various sorts of African American cultural nationalism energized and inspired Chicana/o and Asian American artists, shaping their politics and poetics.

One of clearest examples of artistic Third World multiculturalism growing out of the Black Arts movement took place in San Francisco's Mission District in the early 1970s. The area at that time was a multiethnic neighborhood in which Latina/os, primarily Chicana/os and Central American immigrants, had replaced Irish Americans as the predominant ethnic groups. The neighborhood also had a considerable history as a center of radical political arts activity. The San Francisco Mime Troupe, perhaps the best-known post–World War II radical theater in the United States (with the possible exception of the Living Theater), had been based in the Mission District since the early 1960s. The district was also the main locus of Chicano movement activities in San Francisco. So it is not surprising that a vital poetry and performance community arose in the Mission District that included such artists as African Americans Ntozake Shange and David Henderson, Asian American Jessica Hagedorn, Chicano Juan Felipe Herrera, and Nuyorican Victor Hernandez Cruz. Neither is it surprising that various configurations of the Mission District poetry scene generally self-consciously identified as "Third World" or "of color."[79] The demographics and political landscape of the neighborhood made this poetry scene a unique hybrid of the Black Arts movement and the Chicano movement. Unlike the Chicano movement in Southern California, which tended to form more strictly Chicana/o institutions (which then often worked with black organizations in united-front fashion), the artists and activists of the Mission-based journal *Tin-Tan* and the Pocho-Che

group included non-Chicana/o artists within their circles almost from the beginning, leading to the formation of the Third World Communications Collective comprised of black, white, Asian American, and Latina/o artists.[80]

Such interrelated Bay Area institutions as the journal *Yardbird*, Yardbird Press, and the Before Columbus Foundation (and its various publications) presaged the development of multiculturalism as an academic field. The linchpin that held these institutions together was the novelist, poet, and essayist Ishmael Reed, a former member of the Umbra Poets Workshop in New York best known for his postmodernist novels that mixed Westerns, hard-boiled detective novels (especially Chester Himes's Coffin Ed Johnson and Gravedigger Jones series), the bitter parodic modernism of Nathanael West, the cynical satire of George Schuyler (and H. L. Mencken), Zora Neale Hurston's folkloric studies, and a "neo-hoodoo" ideology of Black Arts political and aesthetic multiplicity. The orientation of these institutions was quasi-scholarly in the sense that they were deeply concerned with questions of canon formation and definitions of American culture and identity. Such questions of canon, culture, and identity were notable features of the Black Arts and black studies movements practically everywhere. However, Reed's various projects were far more focused on America and far less interested in what a unified black nation and a unitary black national culture might be like than was often the case elsewhere and with other black artists and intellectuals.

In many respects, the *Yardbird* and Before Columbus circles more closely resembled what might be thought of as later mainstream multiculturalism than the Mission District Third Worldists in that those circles included larger numbers of non-Hispanic white artists and intellectuals. However, the *Yardbird*–Before Columbus take on American literature radically reconceived canon formation, challenging what might be thought of as external (outside the United States) and internal (within the United States) boundaries rather than simply adding a few writers "of color" and/or a few women to "mainstream" syllabi. Influenced by Black Arts concerns with recovering and/or constructing a liberated black culture, *Yardbird* emphasized alternative, ethnic literary traditions as relatively coherent wholes rather than simply publishing individual authors "of color." In this manner, Reed claimed in an interview published in *Black World*, *Yardbird* cleared the way for Asian American literature as a cultural category, anticipating, inspiring, and even making available writing for the seminal 1974 *Aiiieeeee! An Anthology of Asian American Writers*. Both the Third World ap-

proach epitomized by the poetry scene of the Mission District and the *Yardbird*-style multicultural approach were products — really aspects — of the West Coast Black Arts movement rather than separate developments.[81]

West Coast Black Arts and the Asian American Movement

The Asian American movement, like the Chicano movement, was significantly based on the West Coast. The West Coast not only contained the largest concentrations of Chinese, Filipino, and Japanese Americans (who made up more than 80 percent of the total Asian American population in the late 1960s) but also featured a long tradition of legal and extralegal anti-Asian discrimination that paralleled the treatment of African Americans and Chicana/os in many respects. As noted in Chapter 1, different Asian American communities also shared with Chicana/os and African Americans a considerable Left political and cultural history, particularly in the western United States. Though, as was true in other sectors of society in the United States, the Cold War considerably disrupted this Asian American Left, this earlier activism provided inspiration and a sense of political ancestry to many in the Asian American movement. At the same time, the Asian American movement differed from the Chicano movement and Black Power in that it grew far less out of earlier civil rights activities and organizations and issued far more directly from post–civil rights movement nationalism.[82]

One consequence of the direct impact of the new African American nationalism on the emergence of the Asian American movement is that Asian American activists followed the lead of the Black Power and Black Arts movements in making culture and cultural production a central aspect of their political work. The Black Power and Black Arts movements inspired Asian Americans to pursue what Larry Neal saw as the injunction of Malcolm X and the NOI to organize around a "separate and distinct" identity. Sometimes Black Power quite practically helped enable Asian American cultural projects. *Aion*, one of the first Asian American movement cultural journals, was a direct product of the 1968 student strike at San Francisco State initially motivated by the demands of BSU and black studies advocates and taken up by the various groups that came to form the Third World Alliance on campus.

One of the obvious complications in building the Asian American movement was the question of how one might establish a unified identity out of essentially

three ethnic groups with some history of mutual antagonism and somewhat different historical and legal relationships to the American state, despite a degree of negative commonality based on the de facto and de jure racist category of Asian or "Oriental." Even such a common racist categorization as "Oriental" often intensified the division and conflict between Asian American communities, perhaps most notoriously symbolized by those Chinese Americans who wore buttons or some other token that indicated they were not Japanese during World War II. One response to the problem of building a Pan-Asian identity was a notion of Third World affinities that would include Chicana/os, Puerto Ricans, African Americans, and Asian Americans (and "people of color" around the world). This approach manifested itself in the Black Arts–influenced radical multiculturalism of the Bay Area (in which, as noted above, Asian Americans played a major part). Such a response was not entirely in contradiction to more cultural nationalist visions in that specific groups organized around a particular racial or national identity frequently allied themselves with each other out of a sense of Third World solidarity and common interests — as was the case during the 1968 student strike at San Francisco State.

Another response came ideologically out of the cultural nationalist side of the Black Arts and Black Power movements — though, as noted above, often promoted practically by the multiculturalist–Third Worldist end of the Black Arts spectrum, especially Ishmael Reed's *Yardbird*. Frank Chin and the circle of artists who put together *Aiiieeeee!* posited a concept of Asian American identity that distinguished this identity from white "American" culture, a dualistic "minority" culture, and the cultures of the ancestral "homelands" in Asia:

> We have been encouraged to believe that we have no cultural integrity as Chinese- or Japanese-Americans, that we are either Asian (Chinese or Japanese) or American (white), or are measurably both. This myth of being either/or and the equally goofy concept of the dual personality haunted our lobes while our rejection by both Asia and white America proved we were neither one nor the other. Nor were we half and half or more one than the other.[83]

In the view of the *Aiiieeeee!* group, a recent immigrant could not really be Asian American — a position that was still somewhat tenable, since recent immigrants constituted a relatively small proportion of the Asian American population of the United States in the late 1960s and early 1970s due to restrictive

immigration laws that had only changed in 1965. In this view, Asian American identity and culture was rather a creolized product of the true homelands of Asian Americans, the "Chinatowns," "Little Tokyos," and "Manillatowns" of the West, not Guangdong province (from which the ancestors of the vast majority of Chinese Americans in the 1960s had come), Japan, or the Philippines:

> Chinese- and Japanese-Americans have been separated by geography, culture, and history from China and Japan for seven and four generations respectively. They have evolved cultures and sensibilities distinctly not Chinese or Japanese and distinctly not white American. Even the Asian languages as they exist today in America have been adjusted and developed to express a sensitivity created by a new experience.[84]

The true language of the Asian American, then, was not Japanese, Tagalog, or Chinese but the creoles produced in the Asian American ghettos. The poetics of Chin and his circle here resemble those of the Nuyorican poets, whose sense of "authentic" diction was similarly distinct from an overseas ancestral language. And since for historical reasons such large territorial "homelands" on the North American continent as the "Black Belt nation" or "Aztlan" were not ideologically available to Asian Americans, Asian American cultural nationalist visions of "home" were closer to the liberated neighborhoods or city-states envisioned by Amiri Baraka and the Nuyorican poets. In short, the Black Arts movement not only inspired, and to a significant extent promoted, the art and artists of the Asian American movement in a general sense but also ideologically marked the cultural wing of the Asian American movement in some very specific ways, particularly in aesthetic or ideological-aesthetic notions of what constituted a truly Asian American diction, literary landscape, relation to popular U.S. culture, and so on.

From the Ashes: The Black Arts Movement in Southern California

The Los Angeles area was an early training ground for many of the most significant first-wave free jazz musicians, including alto saxophonist Ornette Coleman, reed player Eric Dolphy, trumpeter Don Cherry, and drummer Billy Higgins, as well as some of the most powerful second-wave jazz avant-gardists of the 1960s and 1970s, including tenor saxophonist David Murray, alto saxophonist Arthur

Blythe, and cornet player Butch Morris. While these artists would gain national reputations after moving to the East Coast, they developed their skills and aesthetics in Los Angeles jazz clubs, homes of like-minded musicians, proto-Black Arts organizations like UGMA—later UGMAA—and the Pan Afrikan Peoples Arkestra. Similarly, such writers and cultural activists as Jayne Cortez, Quincy Troupe, Ed Bullins, and Stanley Crouch served artistic and political apprenticeships in Southern California before going on to wider reputations elsewhere. Los Angeles also came to embody a new militant African American spirit politically *and* culturally after the Watts rebellion of 1965, in much the same way that armed black resistance to racist mobs in the riots of 1919 was taken by A. Phillip Randolph and other black radicals to represent a truly "new Negro" in the post–World War I, post–Bolshevik Revolution era.

However, despite all of this and despite being the mass culture capital of the United States in the second half of the twentieth century, Los Angeles never developed the stable cultural institutions, particularly journals, newspapers, and presses, that could give the region a lasting national visibility in the Black Arts movement. Those Black Arts activists who went on to have a national reputation generally followed in the footsteps of Dolphy, Coleman, Cherry, and Charles Mingus by moving east to relative fame, if not fortune. Those who remained in the Los Angeles region, such as musician and leader of the Pan Afrikan Peoples Arkestra Horace Tapscott, visual artists Noah Purifoy and John Outterbridge, and poets Eric Priestly and Ojenke (Alvin Saxon) enjoyed a much lower national profile.

Many accounts of the African American communities centered on Watts and South Central Los Angeles in the 1950s and early 1960s describe them as culturally and politically chaotic.[85] In some respects, these accounts overstate the disorganization of black Los Angeles. As previously noted, there was still an active jazz and R & B scene in Los Angeles, including some musicians who became Black Arts icons of the new thing jazz. The poet Jayne Cortez recalls seeing a wide range of swing, bebop, free jazz, R & B, and blues artists, from Lightning Hopkins and Howlin' Wolf to Ornette Coleman and John Coltrane, from the late 1940s to the early 1960s.[86] Local musicians stood in the forefront of the national struggle against racism in the mass culture industries during this period. Black "modern" jazz artists, notably Buddy Collette and Bill Douglas, led the battle to end Jim Crow in the American Federation of Musicians (AFM), resulting in the amalgamation of the black Local 767 with the white and Latina/o Local 47.

The successful amalgamation of these segregated locals spurred similar moves in the AFM across the country.[87] There was also a considerable, if largely informal, black bohemia that had revolved around the jazz scene since the 1940s.

Watts was also the site of the most prominent avant-garde artistic landmark in Los Angeles, the Watts Towers, a series of structures including towers (one almost one hundred feet high), a "ship," a "patio," and spires. Simon Rodia, an Italian immigrant, spent over thirty years constructing this huge assemblage of steel rods and hoops and such found materials as ceramic tiles, pottery, seashells, mirrors, and glass from broken bottles, on a residential lot next to his house. Completed in 1954, the Watts Towers survived attempts by the city government to condemn it as unsafe, becoming a tourist landmark and an increasingly important site for local arts initiatives as the black community in Watts continued to grow.

If black success in electoral politics was relatively small until the election of Mervyn Dymally to the State Assembly in 1962 and the appointment or election of three black members to the city council in 1963 due to various sorts of gerrymandering and exclusionary policies within the local Democratic Party, there were a number of issue-oriented, grassroots organizations, often led by black women.[88] And if more radical political organizations and institutions did not exactly thrive in Southern California during the McCarthy era, various sorts of ideologies and institutions outside the "mainstream" remained a public presence and a part of the cultural memory in the black community. Though no single organization or leader stood out, nonetheless, Los Angeles had a long history of black nationalism dating back to the Garvey movement of the early twentieth century. By the late 1950s and early 1960s, other than the NOI, most organized nationalist activity before the founding of the Southern California chapter of the AAA took place in relatively small and informal discussion groups, such as the one Maulana Karenga founded at Los Angeles City College. And though the Left, particularly the CPUSA, had been damaged and isolated by repression and internal conflict, it also retained some influence in the black community. As elsewhere, the CPUSA and Communist-led groups and institutions afforded a space in which black radicals of various sorts networked and developed organizational skills. For example, one of the early founders of the Us organization, James Doss-Tayari, had been a member of the local Du Bois Club in the early 1960s. There is also some evidence that local Communists evinced an interest in the black avant-garde. Ornette Coleman, for example, recalls that

a group of Communists helped him get jobs playing music at a time when virtually no club or band would employ him — though Coleman ultimately broke with these Communists over what he saw as their patronizing and ultimately false attitudes toward him. Horace Tapscott also mentioned that the Pan Afrikan Peoples Arkestra often played at CPUSA and other left-wing events. While this says something about the attitudes of the musicians, it also says something about a willingness of the Left to associate itself with a black avant-garde band — albeit one that, as will be discussed below, saw itself as a community organization.[89]

However, it is true that in many respects the political and cultural infrastructure of black Los Angeles was in decline by the late 1950s despite the considerable growth of the African American population. The black entertainment district of Central Avenue rapidly decayed in the face of official harassment, the integration of (or less overt segregation in) public facilities, and the dispersal of jazz clubs outside the African American community. As happened elsewhere, the Cold War took a major toll on African American political and cultural organizations. Los Angeles had been one of the most dynamic centers of the CRC in the late 1940s and early 1950s. At its height, the CRC had eleven chapters in the Los Angeles area — and was also active in San Diego. Like the CRC in the Bay Area, it did much work in the areas of police brutality and unequal legal treatment of African Americans and Chicana/os. It also focused on the issue of deportation because of its engagement with the Chicana/o community and important Latina/o Popular Front–era organizations, such as El Congreso de Pueblos que Hablan Español and the Asociación Nacional México Americana — anticipating similar cooperation between the Black Power and Chicano movements. Still, the Los Angeles CRC eventually collapsed under the same Cold War pressures that caused the national organization to dissolve in 1956.[90] Similarly, the *California Eagle*, once the major African American newspaper in Southern California, had a long history of Left sympathies under the leadership of publisher Charlotta Bass. The newspaper suffered from overt and covert anti-Communist attacks that contributed to its decline even after Bass's retirement in 1951 and Loren Miller's efforts to bring the paper toward a more mainstream liberalism, leading to the paper's closure in 1965.[91] And as Josh Sides notes, even the Los Angeles NAACP was largely consumed with questions of whether and how closely one should work with actual or suspected Communists and the degree to which Communists and their sympathizers had infiltrated (or might infiltrate) local branches.[92]

Non-Communist (and even anti-Communist) civil rights organizations also

sharply declined during the height of the Cold War. As was the case elsewhere on the West Coast (and across most of the country), the NAACP dramatically lost membership during the late 1940s. Its Los Angeles branch shrank from 14,012 members to 2,570 between 1946 and 1950, despite the fervent devotion to anti-Communism on the part of the national office. (The three Bay Area branches—Alameda, Richmond, and San Francisco—dropped from a combined membership of 6,528 to 1,161 during the same period.) Though membership drives in the early 1950s increased membership and staved off the collapse of the organization on the West Coast, the NAACP failed to regain the mass membership of the immediate postwar era.[93] Throughout the early 1960s, the Los Angeles branch appears to have remained disorganized, with a fluctuating membership and considerable internal turmoil over its identity and its role within the civil rights movement in Southern California—a turmoil that concerned regional and national NAACP leadership as well as local members.[94] The national office noted with alarm that the membership of the Los Angeles branch declined from 6,860 in 1961 to 4,278 in 1962—and that the branch made no contribution to the national NAACP Freedom Fund in 1962.[95] There was a flurry of civil rights activity during the spring and summer of 1963 in which the NAACP played an important role. This activity followed a visit by Martin Luther King Jr. in May, drawing thirty-five thousand to Wrigley Field, a minor league baseball stadium in South Central Los Angeles. Such local NAACP leaders as the president, Christopher Taylor, and the education committee chair, Marnesba Tackett, were instrumental in the formation of the United Civil Rights Committee, an umbrella group that led a series of rallies, protests, and marches primarily addressing fair housing and school desegregation. However, these efforts provided few short-term results and, while impressive for Los Angeles in the early 1960s, did not for the most part match the scale of similar efforts in midwestern and eastern cities in the period leading up to the March on Washington. In short, as its own assessments suggest, the NAACP failed to establish itself as a consistent leader of activist civil rights work in Los Angeles before the Watts uprising of 1965.[96]

The early 1960s saw a new level of cohesion of radical African American cultural and political activity. Like the NAACP, the more activist (and more open to Left influence) CORE suffered from a decline in membership and severe disorganization of its West Coast chapters during most of the 1950s.[97] Prior to the 1960s, CORE's membership in Los Angeles consisted largely of white pacifists.

However, in the early 1960s, a group of black and white CORE activists succeeded in engaging significant numbers of young African Americans in the Avalon and Watts neighborhoods of South Central Los Angeles, where the black community was concentrated. This CORE cadre led a series of sit-ins and demonstrations in 1962–63 around education, housing, and unemployment. Ironically, the success of the CORE drive to reach the broader black community also led to dissension within the organization between the relatively small group of "actives" and the larger CORE membership. Militant direct-action tactics established CORE as a dynamic civil rights organization at a time of national upsurge of support for the movement in the South. While CORE's higher profile brought in new members, apparently many were relatively passive voting members who were made uneasy by militant direct-action tactics against local targets (as opposed to targets in the South). This contention between the different segments of Los Angeles CORE also affected the relationship of the actives to the national organization, especially when a number of actives picketed an appearance by CORE national director James Farmer in the relatively suburban and predominantly white San Fernando Valley. The pickets felt that the attention of Farmer and the national office should be on Watts and the other black neighborhoods of Los Angeles instead.

The conflict among the different local segments of CORE and the national office led to the formation of a new Central Avenue CORE chapter in the Avalon–South Central area by the actives. While the chapter retained an affiliation to CORE, apparently a sense of Central Avenue's extremism exacerbated by bitterness over the San Fernando Valley picket line caused both the regional and national offices to pressure the group to remove CORE from its name. As a result, the Central Avenue CORE became the Non-Violent Action Committee (N-VAC). Among the active members of N-VAC were a number of radicals, black and white, influenced by Marxism to one degree or another. While this was not that uncommon in the more militant chapters of CORE, the black leaders of N-VAC joined older Left notions of African American self-determination with nationalist ideas of black self-help, self-reliance, and consciousness raising, anticipating the later movement of the national CORE leadership. N-VAC not only worked with local nationalists, such as Maulana Karenga and Us, but also initiated Operation Bootstrap, an African American–run job-training program in Avalon, in 1965.[98] Though the activities and organization of CORE were, like those of the NAACP, uneven, the actives of CORE did help revive the tradition

of militant, grassroots direct action in the black community, focusing on civil rights struggles in Southern California and linking these struggles to those of the new militant black student movement.

Of course, such a connection was not only made through CORE. Maulana Karenga remembers taking part in demonstrations at a Woolworth's in 1960 in solidarity with the southern sit-in movement as part of a Los Angeles City College civil rights group. This link with the black student movement among black civil rights workers in Los Angeles was further strengthened and formalized by the founding of a Friends of SNCC group by Jayne Cortez (who had been a SNCC worker in Greenville, Mississippi) and Bob Rogers (a designer who would, like Cortez, become active in Studio Watts) in 1963.[99]

A Southern California branch of the AAA headed by Karenga was established in 1963 after he met with Khalid Monsour. As in the Bay Area, the Southern California chapter functioned primarily as an educational and agitational organization, sponsoring study groups, lectures, street rallies, and speakers. Though the AAA seems not to have gained quite the same visibility in the black community or on campus in Los Angeles that it did in the Bay Area, it did lay the groundwork for Us and other nationalist organizations that would emerge in the wake of the 1965 uprising. Despite its less visible presence, the Southern California branch of the AAA remained relatively intact longer than its Bay Area counterpart, which split in the spring of 1963 when AAA leader Monsour attempted to further dominate the organization. Eventually the strife in the AAA caused Karenga to leave the organization in 1964. Still, his tenure there marked the Kawaida ideology (particularly its critique of liberal and radical integrationism) and his vision of a vanguard nationalist organization exerting what he would call a "programmatic" influence through essentially educational channels that would evolve with the founding of Us.[100]

Though the old Central Avenue black entertainment district had largely disintegrated by the end of the 1950s, there remained a diverse jazz scene with a strong, if unorganized, avant-garde presence, including a young Ornette Coleman. The Hillcrest Club and the It Club in midtown Los Angeles were notable loci of the incipient free jazz movement, hosting Coleman's band as well as important East Coast musicians, including John Coltrane.[101] As elsewhere, jazz had inspired black Los Angeles artists working in many media, and, as noted earlier, jazz clubs that favored bebop and later free jazz had previously provided a sort of communal space for the African American avant-garde in Los Angeles. And

as in other cities, black writers and intellectuals articulated and fleshed out a tradition of black culture from this music that in turn influenced the musicians themselves. Trumpet player Don Cherry recalls the importance of Jayne Cortez's wide-ranging record collection (and the sense of history and genre that organized her collection) for his musical education in the jazz tradition. He also implies that Ornette Coleman (who was then married to Cortez) owed some of his sense of this tradition to Cortez. According to Cherry, Cortez also helped the jazz avant-garde of Los Angeles cohere through her friendships with many young musicians. She introduced him to Coleman, for example. Since club dates for these budding free jazz players were few and far between in 1950s Los Angeles, such a personal network made it possible for like-minded musicians to find each other. Cortez's hands-on practicum in black music also strengthened a sense of community and a feeling of a cultural trajectory rooted in black culture among the young avant-gardists.[102]

The black avant-garde in Los Angeles gained a new institutional solidity with the formation of the Pan Afrikan Peoples Arkestra in 1961. The Arkestra's name and eclectic avant-gardism was inspired by Sun Ra and his Arkestra, albeit without Sun Ra's messianic (if sometimes tongue-in-cheek) interstellarism.[103] Containing a number of outstanding musicians with strong personalities, the Pan Afrikan Peoples Arkestra did not revolve around a single person, a single aesthetic vision, and a single idiosyncratic ideology, as did Sun Ra's group. Though the pianist Horace Tapscott played the leading role in the conception and organization of the Arkestra (and though he remained an anchor for the group throughout its history), he did not assert the sort of absolute musical, spiritual, social, and philosophic control that characterized the relationship between Sun Ra and his musicians.

Tapscott and the other early members of the Pan Afrikan Peoples Arkestra saw as the group's mission both to provide greater coherence to the embryonic network of young, radical, black artists in Los Angeles as well as to bring jazz and other forms of black expressive culture back to the heart of the African American community, countering the decline that occurred with the disintegration of the Central Avenue music scene. As the name of the group suggests, there was also an increased interest in African culture and nationalist notions of collective black pride and black identity.[104] At the same time that the group emphasized community and various notions of tradition, both African and African American, it couched itself in terms of a black avant-gardism, as seen in the name of the orga-

nization that grew from the Arkestra, the Underground Musicians Association (UGMA). In this sense, the Arkestra and UGMA anticipated similar developments in New York and Chicago, such as the Collective Black Artists and the AACM.

Tapscott and others conceived the Arkestra as the focal point for multimedia performances that would include poetry and dance as well as music, much like BAG in St. Louis. This commitment to bringing different artistic media and genres together continued and deepened with the founding of UGMA, which sponsored classes in, among other things, reading, dance, and acting. Though there was an emphasis on musical performance, the multimedia orientation of UGMA and its dedication to bringing art and education to the heart of the black community attracted a wide range of African American artists, including the poet Jayne Cortez, who had a long association with jazz artists in Los Angeles. Cortez, for example, developed a one-woman show of black literature and jazz that she first performed with a band that included Tapscott in 1963. She also performed with the Arkestra periodically between 1964 and 1966. It was during this period that she conceived of the combination of neosurrealist poetry, theater, music, and dance that would characterize her mature artistic practice—though she did not fully develop this multimedia presentation until after her move to New York City in 1967.[105]

The Arkestra and UGMA marked a new degree of institutional connection and multigenre interaction in the black bohemia of Los Angeles. They also provided vehicles for the intersection of formal artistic radicalism and radical, community-oriented, and nationalist-influenced politics. Not surprisingly, the Arkestra became a familiar feature of Los Angeles political events, especially those of nationalist and/or Left organizations, including the CPUSA.[106] In turn, Watts became a magnet for the activities of black artists and writers who in many cases were a part of the circles around the Arkestra and UGMA. For example, in 1964 James Woods, an accountant who had supported the African American arts community in Los Angeles for some years, called a meeting to discuss founding an African American arts collective. Woods wanted both to encourage the development of local artists and to address the lack of affordable studio space for black visual artists. At the meeting, Cortez, who had known Woods since 1958, suggested Watts as a logical location for a new organization that would address these issues of training and space for African American artists. Woods found a building in Watts at Grandee Avenue and 104th Street. In short order, the new Studio Watts opened workshops in acting and writing for theater, de-

sign, painting, sculpture, and dance. Cortez led the writing and acting workshop. Woods served as director/administrator. Studio Watts provided a home for avant-garde black drama and poetry performance in Watts as well as a place where black artists learned their craft and connected on a more informal basis. Studio Watts attracted wide attention outside Watts and the local arts community with a performance of Jean Genet's *The Blacks* directed by Cortez during the 1966 Watts Festival. Cortez and the drama group departed Studio Watts over aesthetic and institutional disagreements with Woods to form the Watts Repertory Theatre in 1967 — and Cortez left the city altogether that same year, though she returned at times to work with the theater. Watts Repertory continued in the same spirit of black community-based avant-garde poetry, music, and dramatic performance.[107] Thus, in many respects, the early performances and programs of UGMA, the Arkestra, and Studio Watts anticipated the sorts of multimedia, multigenre events and programs that BARTS would later stage in Harlem. These performances and programs took place, at first, largely without the government support that helped sustain BARTS — though that changed later, after the Watts uprising. Such performances became models of the archetypal Black Arts cultural event. They also anchored black avant-garde artists working in a wide range of genres and media to the broader black community in Los Angeles.

The Watts uprising of August 1965 was a watershed event for the Black Power and Black Arts movements in Los Angeles. There had been uprisings in Jacksonville, Florida, and in New York, Philadelphia, and a number of small northeastern cities during the previous year, but none with the scope, the ferocity, and the national profile of the Watts rebellion. Beyond the sheer size of the rebellion (and its repression), no doubt the still current image of California as a promised land gave the Watts uprising a symbolic charge that was lacking in earlier events in North Philadelphia, Jacksonville, Paterson and East Orange, New Jersey, and even Harlem — cities and neighborhoods where explosions caused by deferred African American dreams might seem unremarkable.

As Gerald Horne points out, one result of the uprising was an increase in influence of both revolutionary nationalism and cultural nationalism.[108] Undoubtedly the most important of the new cultural nationalist groups, both locally and, in the long run, nationally, was Maulana Karenga's Us, which like so many other Black Arts and Black Power groups began as a study group. Led by Karenga, the group first met in 1965 at the Aquarian Center in Los Angeles, an African American–owned bookstore that was a favorite gathering place for black radi-

cals of various stripes—much like Vaughn's in Detroit and the Frederick Douglass Bookstore and the National Memorial African Bookstore in Harlem. Like the AAA, Us was in many respects an advocacy and educational group, promoting Karenga's Kawaida philosophy and its famous seven principles. While Karenga supported the notion of political revolution, he emphasized the centrality of culture and the need to reconstitute and circulate within the black community an African cultural framework that encompassed politics, history, economics, ethics, religion, philosophy, and art so as to provide the scaffolding for political revolution. Language study was a particularly important focus of the Us program, especially the study of Swahili. Karenga (who had at least a reading ability in several African and European languages) saw Swahili as the basis of a modern transcontinental Pan-African culture, since it was already a regional common language in eastern and southern Africa not tied to any particular nation or ethnic group.

Though Us in Los Angeles had a well-defined hierarchy of leadership and organizational responsibilities, it did not seek to set up a national structure with chapters or branches in different cities in the way that the BPP (or the CPUSA or NAACP, for that matter) did. Rather it attempted to convince activists and organizations to adhere to the Kawaida principles and acknowledge Karenga's intellectual leadership without actually becoming a part of Us as such. Amiri Baraka and CFUN in Newark, Kalamu ya Salaam and the Ahidiana Collective in New Orleans, and Haki Madhubuti and the Institute for Positive Education can be seen as part of the Kawaida movement. However, they were organizationally independent of Us—often taking issue with particular positions of Karenga and Us (e.g., the meaning and utility of black popular culture and the role of women within the black liberation movement). Inspired by the example of the NOI and its efforts to institutionally project what true black self-determination would look like on the ground, one way Us differed from the AAA was that it attempted to a far greater degree to actually embody Kawaida principles and Karenga's neo-African vision so as to present an example of what a reconstituted African society might be like as part of its advocacy.[109] Other important nationalist groups more closely akin to Us than to the BPP were SLANT and the Sons of Watts—both of which intersected with the early incarnation of Us and the Kawaida movement in Los Angeles to a considerable extent.

The first of the major postuprising revolutionary nationalist groups in Southern California, the Black Panther Political Party, like the BPP, took its name

from SNCC's Lowndes County Black Panther Party in Alabama. Led by John Floyd, it resembled RAM in the sense that it saw itself as a sort of cadre group that worked through other "mass" organizations — as opposed to the BPP, which had a Bolshevik cadre group–mass party split personality, with dual public and "underground" structures (and much local variation among chapters in different cities). Perhaps because of their similar approaches to building "united fronts" (or what Us termed "operational unity"), the Black Panther Political Party and Us often worked closely together despite their considerable ideological differences. For example, both Us and the Black Panther Political Party were instrumental in the successful 1967 creation of the Black Congress, an umbrella group that included virtually every African American organization in Los Angeles from revolutionary and cultural nationalists, such as Us, SLANT, the BPP, and the Black Panther Political Party, to radical and moderate civil rights organizations, such as CORE and the NAACP, to cultural institutions, such as UGMA and the Watts Happening Coffee House. As part of this united front, Us donated its newspaper *Harambee* to the Black Congress, with John Floyd replacing Karenga as editor. One result of this upsurge in nationalist activity of various types, especially by Us, and the new status of Watts as the symbol of the new black politics and art, is that Watts became an essential stop for any African American political leader attempting to come to grips with the new political and cultural moment. As one of the most articulate new nationalists in Los Angeles and with a developed program and a disciplined organization, Karenga met with a wide range of black activists and politicians from across the United States. Thus, while it might at first glance seem unlikely that one of the five people chosen for the organizing committee of the first Black Power Conference in Newark at a planning meeting convened by Adam Clayton Powell Jr. would include the neo-African nationalist Karenga, who only a year or two before had been virtually unknown outside California, the new status of Watts played a huge role in securing this position. And this position not only enabled Karenga and Us to gain further national prominence but also led to Karenga's visit to Amiri Baraka's Spirit House after a planning meeting for the 1967 conference, beginning, as noted earlier, a relationship that would ultimately allow Karenga and the nascent Kawaida movement to make huge inroads among black artists.[110]

Despite a general shared policy of united front or coalition building among the major nationalist groups, a sort of turf war over which group (and which ideological position) truly constituted the vanguard soon disrupted the Black

Power and Black Arts movements in Los Angeles — a conflict that was actively encouraged by the FBI and other federal, state, and local law enforcement agencies. Perhaps the earliest manifestation of this struggle was the considerable and often violent debate over which group "owned" the Black Panther name in Los Angeles, the Black Panther Political Party or the BPP, which became a significant force in Los Angeles in 1967 after the release from prison of the former leader of the Los Angeles Slausons street gang, Alprentice "Bunchy" Carter, and the rise to minister of information by Eldridge Cleaver, Carter's comrade from the black culture club at Soledad Prison. Ultimately, the BPP was basically successful in eliminating the rival Black Panther group as an organized political force. However, when the BPP clashed with Us over who would have the predominant influence in the Black Congress, it found a much more formidable opponent — with its own paramilitary or defense wing, the Simba Wachanga. Though both groups had some reputation for physical intimidation, their conflict was at first largely verbal — the BPP particularly delighted in denouncing Karenga in its newspaper, *Black Panther*, as a "pork chop nationalist" (i.e., a nationalist who is more concerned with what he or she eats, the names of his or her children, or the clothes he or she wears than real questions of political power). The Us-BPP struggle went far past words in the January 17, 1969, shooting on the UCLA campus that left Black Panther leaders Alprentice Carter and John Huggins dead and an Us member, Larry Watani-Stiner, wounded. The actual events of the gun battle remain unclear. The BPP claimed that the shootings were essentially assassinations by Us orchestrated by the FBI, a claim supported by many scholars who rely heavily on sources closely linked to the BPP. Other accounts, including that of Panther leader Geronimo Pratt, suggest that a BPP member was the first to draw a weapon — though even in these accounts the question still remains as to who provoked the fight. Whatever the exact events (and whether the culpability for the shootings lay with the BPP, Us, the FBI, or some combination of these organizations), the news of the deaths of Carter and Huggins unquestionably stunned the black political community of Los Angeles (and the nation), effectively crippling the Black Congress, intensifying the tensions between Us and the BPP, creating chaos in the BPP (which would be further weakened by intense police repression and government prosecution of its remaining leaders), and greatly limiting the ability of Us to work effectively with other Black Power organizations in Los Angeles. Ironically, though, the ideological influence of the Kawaida movement outside Southern California would continue to grow in the

Black Arts movement and in such critical Black Power organizations as CAP and the ALSC.[111]

The national shock and alarm caused by the uprising of 1965 not only stimulated the growth of nationalist political organizations in Los Angeles but also vastly increased the availability of federal antipoverty money for cultural institutions and initiatives. For example, political and cultural activists, many connected to UGMA, opened the Watts Happening Coffee House in October 1965. Located in an old furniture store in what had been the commercial center of Watts on 103rd Street, the coffeehouse featured a wide range of programs, including food banks, poetry readings, music, and theater. Local community organizations funneled federal antipoverty program money into cultural activities through the coffeehouse.[112] Public antipoverty money and private foundation money that flowed in the aftermath of the uprising also bankrolled the establishment of important arts venues, including the Watts Towers Arts Center directed by the visual artist Noah Purifoy and the Mafundi Institute (an educational and performance space that operated much like a cultural nationalist version of Studio Watts) led by James Taylor with considerable help from Maulana Karenga and the Us organization. Appropriately enough, given the character of the Watts Towers site itself, the influences on Purifoy's work were a mixture of Dadaism, civil rights activism, and phenomenology that produced pieces in which abstraction intersected with social engagement, as in the 1966 assemblage "Watts Riot," constructed out of debris left from the uprising.[113] Studio Watts also received much public funding during this period as it increasingly became involved with the administration of housing redevelopment in Watts, actually becoming the Watts Community Housing Program in 1969.[114] Such public and private foundation support of community arts centers and workshops after the uprising set a pattern for the founding and funding of later arts initiatives in the black community, such as the Compton Communicative Arts Academy set up in 1969 by Purifoy's friend Judson Powell and John Outterbridge, another artist who, like Purifoy, was much influenced by post–abstract expressionist assemblages, pop art, and happenings.[115]

One important institution, the Watts Writers Workshop, grew directly "from the ashes" of the uprising—as the name of the best-known collection of the group's work suggests. Budd Schulberg, most famous as the screenwriter for *On the Waterfront* and the author of the novel *What Makes Sammy Run*, watched the uprising on television and decided to go down to Watts to see what had hap-

pened firsthand. Appalled by a scene that recalled to him bombed-out European cities he had seen during World War II, Schulberg was drawn to an undamaged building that housed a social service agency, the Westminster Neighborhood Association.[116] The head of the association, Bobbye Hollin, gave Schulberg a tour of the center and a local housing project where, according to Hollin, the youth unemployment rate was nearly 100 percent. When Schulberg asked what he could do, Hollin said that the young people of the neighborhood received substandard educations but were not stupid. She suggested that he try to somehow tap their creativity. Schulberg figured that since the only thing he really knew was writing, he would run a writers' workshop.[117]

Schulberg posted a flyer announcing the workshop at the Westminster Neighborhood Association. However, it was months before anyone showed any serious interest in the workshop. After attracting an initial participant, Schulberg was able to interest a small group of young men through the reading of *Manchild in the Promised Land*, Claude Brown's 1965 autobiographical narrative about poverty, street gangs, and drugs in 1950s Harlem. The idea that literature could show something resembling their lives from the point of view of someone they saw as like them in a voice not unlike theirs came as a sort of revelation to the group. Inspired by the notion of writing directly about their own experiences in their own voices, these young men drew other aspiring writers into the group so that it soon outgrew the small space at the Westminster Neighborhood Association.

The initial Watts Writers Workshop was overwhelmingly young and male. Soon, however, some older writers, including a significant number of women, joined the group. This generational mix led to a serious ideological and aesthetic divide. The younger members of the workshop saw themselves as politically more militant and formally more adventurous than the older writers. These older writers were in fact often quite radical, sometimes with a considerable background of community activism, but were also generally less engaged ideologically and practically with the new nationalist organizations of Los Angeles than the so-called Young Turks. The fact that the Young Turks were almost entirely male while the group of older writers contained far more women may well have contributed to the conflict — though this aspect of the division remains implicit rather than explicit in various memoirs and recollections of the Watts Writers.[118]

By late 1965, the group held its meetings in the Watts Happening Coffee

House, an environment that Schulberg describes as "creative, angry, and militant."[119] With a core group of twenty and nearly one hundred participants at some events, the Watts Writers Workshop attracted considerable attention from the local community. There was a mixed response from the nationalist organizations. Tommy Jacquette, a leader of SLANT who was part of the early incarnations of Us and one of the founders of the Watts Summer Festival, came to see Schulberg, saying that he was watching the group to see whether they were helping or exploiting the people of Watts. If the workshop was helping the community learn valuable skills, Jacquette explained, his people would support it. And if it was exploitative, they would literally destroy it. "I can live with that," Schulberg responded. Despite this threatening beginning, Jacquette became a sort of sponsor of the workshop, defending it (and Schulberg) both verbally and physically when Maulana Karenga denounced it—a reminder of how fractious even the cultural nationalist side of the Black Power movement often was in Los Angeles.[120]

The summer of 1966 saw the first Watts Summer Festival, an arts festival organized as a tribute to the uprising that focused heavily on militant expressions of black pride and the need for self-determination. Gerald Horne argues that the festival was a tacit alliance between cultural nationalists in such organizations as Us, SLANT, and the Sons of Watts (and their supporters on the Los Angeles Human Relations Commission) and the Los Angeles political and corporate establishment (including Coca Cola and the Los Angeles Chamber of Commerce) for the purpose of siphoning off potential support among militant young people (especially gang members) for the Marxist-influenced BPP.[121] While there may be some truth to Horne's claims, the festival brought the whole spectrum of Watts's growing arts community, including the Watts Writers Workshop, Studio Watts, the Watts Happening Coffee House, and a wide range of musicians and visual artists, to the attention of Los Angeles and beyond. The festival attracted an audience of hundreds of thousands, both black and white, during its three days—including an almost entirely African American crowd of fifty thousand to watch a black-pride parade led by Johnson administration antipoverty program chief Sargent Shriver—as well as national media coverage.[122] If the Watts uprising and the cry of "Burn, baby! Burn!" (taken from the trademark shout of DJ Magnificent Montague on KGFJ, Los Angeles's foremost R & B station) epitomized a new, angry, and uncompromising spirit across the United States, the Watts Summer Festival promoted another side of the public image of the

neighborhood as an epicenter of black politics and culture with a symbolic importance rivaling that of Harlem. The festival remained a prominent feature of Los Angeles's cultural life for the next sixteen years — though its content became steadily less engaged with any sort of radicalism, nationalist or otherwise.

The national profile of Watts as a center of this new black spirit in the arts also grew through the Watts Writers Workshop's use of Schulberg's connections as a Hollywood insider, attracting much attention from the national press, particularly the *New York Times*. Schulberg's brother, Stuart, produced and directed a television documentary on the group, *The Angry Voices of Watts*, that aired on NBC in August 1966. It featured workshop members Johnie Scott, Harry Dolan, Leumas Sirrah, James Thomas Jackson, Birdell Chew, and Sonora McKeller reading their work against a background of the still largely ruined landscape of the postuprising Watts. The documentary garnered much national publicity even before its broadcast.[123] The reviews of *The Angry Voices of Watts* were also overwhelmingly positive.[124] This led to a second NBC production directed by Stuart Schulberg, *Losers Weepers*, a teleplay about generational struggle in a black family warped by racism and poverty, written by Harry Dolan, a leader of the older writers of the workshop. *Losers Weepers*, too, received considerable accolades from the national press, launching the writing career of Dolan (who went on to conceive the popular *Julia* television series) and the acting career of Yaphet Kotto.[125] This media exposure allowed the Watts Writers to project the image of a new black literature that, though stylistically varied, shared a core of black pride, militancy, and social engagement.

The Angry Voices of Watts and the powerful image it engendered made it easier for Budd Schulberg to raise money for the workshop from a network of high-profile writers, actors, directors, and liberal politicians, including John Steinbeck, Irwin Shaw, Robert Kennedy, Elia Kazan, James Baldwin, Richard Rodgers, Hodding Carter, Ann Petry, Paddy Chayefsky, and Irving Wallace. With this money, the Watts Writers bought and renovated a house on Beach Street in Watts, naming it the Frederick Douglass House. The Douglass House served as a home, social center, performance space, and classroom for the group. The group also was able to refurbish a burned-out supermarket, turning it into a performance/workshop space for the affiliated Watts Theatre Workshop.[126]

Like Budd Schulberg, many of these outside supporters had been active in (or sympathetic to) the Communist Left during the 1930s and 1940s. And like him, most had publicly (and privately) distanced themselves from the CPUSA —

Schulberg and Kazan had even been prominent "friendly" witnesses at HUAC hearings on Communist influence in Hollywood. Nonetheless, Schulberg's successful fund-raising efforts point out the continued existence of a web of personal and professional relationships created during the Popular Front even after the original organizational context for those contacts had largely vanished. Though he was considerably more conservative than in the 1930s, Steinbeck was particularly enthusiastic and particularly helpful, facilitating a National Endowment for the Arts grant for the workshop. Even the name of the group's new center harked back to the Popular Front's veneration of Frederick Douglass.[127]

The prominence of the group and the symbolic charge of the Watts neighborhood after the uprising dramatically advanced the careers of its hitherto unknown (to the literary world) members, resulting in even greater renown for the workshop itself. The workshop's fame made it relatively easy to set up readings of five or six writers in libraries across the city. These readings would often draw several hundred people and would pay between $100 and $150, which, even split five or six ways, was not insubstantial in 1966. When the Watts Writers organized a big "uptown" benefit where several poets read, the movie community responded enthusiastically. Workshop participants were interviewed on television. The BBC asked if it could film Watts Writers poetry readings. Watts Writers members published poetry in *Los Angeles Magazine* and *Antioch Review*. The October 1966 issue of *Harpers* carried Johnie Scott's essay "My Home Is Watts." Comedian and television talk-show host Steve Allen set to music Jimmy Sherman's poem "The Workin' Machine" and circulated it among music publishers and record companies.[128] A delegation from the group, including Schulberg, Scott, Dolan, Chew, and McKeller, testified at hearings on the "crisis in American cities" held by Abraham Ribicoff's subcommittee of the Senate Committee on Government Organization on December 9, 1966, literally serving as representative voices of black America. Portions of Scott's powerful testimony at the committee session in which he read "The Coming of the Hoodlum," an autobiographical essay about growing up in Watts and the stark contradictions between the poverty of his childhood in the ghetto and the culture of Harvard (to which he had won a scholarship), was rebroadcast on the Huntley-Brinkley newscast and was covered by the *New York Times* on its news and editorial pages.[129] The group also produced arguably the first Black Arts literary anthology published in the United States, *From the Ashes: Voices of Watts* (1967) — though perhaps it might be more accurate to think of it as a text that had one

foot in Popular Front–style radicalism and one in the emerging Black Arts and Black Power movements.

At the same time, the filming of the documentary, the creation of the Douglass House, the flurry of publications and readings, and the production of *From the Ashes* brought differences within the group to a head. The split that finally occurred reprised similar symbolic divorces between liberal or radical white patronage and black self-determination and between older cultural politics and the new nationalism across the United States. However, perhaps because of Schulberg's relatively unique role as the leader of the workshop rather than a facilitator or supporter like, say, Art Berger in Umbra, genre and stylistic concerns inflected this conflict in a somewhat unusual way. And though the only arts institutions in Los Angeles in which Us was directly involved were the Taifa Dance Troupe (which adapted dances of migrant Zulu workers in South Africa as the basis of its performances) and the Mafundi Institute, the increasing circulation of Karenga's Kawaida philosophy, with its emphasis on self-determination, self-knowledge, and a rejection of liberalism and what Karenga termed the "white Left," no doubt influenced the trajectory of the break within the Watts Writers Workshop.[130]

As noted earlier, though Schulberg initially aimed his workshop at the young men he saw hanging out at the Westminster Neighborhood Association center and on the surrounding streets, a number of older writers, including Harry Dolan, Jeanne Scott, and Sonora McKeller, quickly joined. While in many respects these older writers (many of whom were not all that much older than some of the Young Turks) were quite militant, they were ideologically and aesthetically closer to the sort of hard-boiled social realism that marked much (though not all) Popular Front theater, reportage, and fiction. In short, their literary efforts shared a sort of kinship with Schulberg's own creative work. Such Young Turks as Leumas Sirrah and Johnie Scott, who were early participants in the workshop, and Quincy Troupe, Ojenke, and Eric Priestly, who joined a little later, were far more interested in poetry that, like the writing of Jayne Cortez, showed a considerable surrealist influence (which too, it should be recalled, was a powerful Left literary current in the 1930s and 1940s, particularly in Latin America and the Caribbean). Schulberg's *From the Ashes*, while containing a considerable amount of poetry, nonetheless devoted about twice as many pages to short fiction, essays, sketches, and realist drama as it did to poetry.

Many of the group's younger members (and some of the older writers) felt a considerable uneasiness about Schulberg's position as a sort of mentor/patron from Beverly Hills. The young writers generally respected Schulberg as a successful older artist who was committed to the development of black writers. However, some saw him not only as a patron but also as somewhat patronizing and rooted in an older cultural and political milieu that did not fully address their needs or sensibilities as young black artists after the Watts uprising. Looking back later, the various participants have been fairly generous about the actions of Schulberg and those of the different factions within the workshop for the most part. However, at the time, the conflict grew quite bitter. Quincy Troupe characterized the relation between Schulberg and the Watts Writers as "literary sharecropping."[131] Troupe, Ojenke, and Eric Priestly were originally scheduled to be the featured readers in the *Angry Voices of Watts* documentary but did not participate due to their differences with the Schulberg brothers over money and the selection of the pieces to be read.[132] Troupe and Priestly were also omitted from the anthology *From the Ashes*—though Budd Schulberg made a somewhat oblique apology for leaving Troupe out in a postscript to the collection. Again, the Young Turks felt that what was being excluded was not simply a number of individual artists but their whole nationalist and avant-garde aesthetic stance.

Troupe, Ojenke, Priestly, and the other militants (including the older writer Herbert Simmons, author of the novel *Corner Boy*) demanded control of the Douglass House. Budd Schulberg ceded the house to them in late 1966. Despite the sometimes harsh rhetoric surrounding the split, Schulberg continued to provide financial support for the center. His continuing support (and the Douglass House group's continuing acceptance of that support) serves as a reminder that the actual situation on the ground here, as elsewhere, was far more complex and contradictory than the relatively stark lines drawn by the symbolic gestures of ideological divorce within the movement would suggest.[133] Renamed the House of Respect, adopting the tone if not the Swahili terminology of Us, it served as a communal living space, school, performance space, and social center for a group of black artists anchored by the core of the Young Turks. Schulberg and the older writers continued to maintain a separate workshop that functioned much as had the original workshop. Despite a heavy emphasis on poetry in the House of Respect, many sorts of artists took part in the various activities there. Formal and informal discussions ranged widely among literature, music, philosophy, eco-

nomics, history, art history, and aesthetics, much as happened in similar proto–Black Arts and early Black Arts collectives in Oakland, San Francisco, Chicago, Detroit, Philadelphia, New York, St. Louis, New Orleans, and elsewhere.[134]

The most significant immediate product of the House of Respect circle was the anthology *Watts Poets* (1968), edited by Quincy Troupe. Though the writers in *Watts Poets* overlapped somewhat with *From the Ashes*, the later book, as the name suggests, devoted far more space to poetry, with no fiction or drama and only a single essay. Unlike *From the Ashes*, *Watts Poets* was not brought out by a major commercial publisher but was self-published by the House of Respect. In format, it was much more akin to works produced by such radical bohemian small presses as Amiri Baraka and Eli Wilentz's Totem-Corinth Press and Ted Berrigan's C Press as well as the new black cultural and political journals, such as *Soulbook*, *Black Dialogue*, and (especially) *JBP* (which also had a fondness for formal radicalism and militant nationalism), and emerging small African American presses, notably Broadside Press. It is worth noting that *Watts Poets* appeared in the same year as Amiri Baraka (then LeRoi Jones) and Larry Neal's seminal *Black Fire* (published by a mainstream commercial press, William Morrow) and a year before Dudley Randall and Margaret Burroughs's *For Malcolm*. It also lacked some of the ideological contradictions of *From the Ashes* (embodied in Schulberg's editorship), making it perhaps the first truly nationalist Black Arts anthology in terms of content, format, and production. *Watts Poets* signaled its affinity with the new nationalist impulse (and its rejection of liberal integrationism) in the first lines of the opening (and only) essay, Milton McFarlane's "To Join or Not to Join": "There can never be a successful adjustment of black people to the American economic system. And what the system is, in reality, has everything to do with its anathema for the black population."[135]

The predominant aesthetic sensibility of *Watts Poets* also varies significantly from Schulberg's anthology. As mentioned before, the generic focus of the two books is far different. Where realist prose comprises the largest part of the earlier collection, various sorts of surrealist-influenced poetry dominate the later volume. Of course, *Watts Poets* also contains other sorts of poetry. Blossom Powe and C. K. Moreland work in the long tradition of vernacular-inflected urban portrait, landscape, and elegy. Lance Jeffers, an older and somewhat established writer with roots in the Old Left (and relatively weak ties to the Watts Writers Workshop other than his residence in Southern California at the time), contrib-

utes poetry in the mode of Popular Front adaptations of Whitman and Sandburg, drawing particularly on the prophetic Old Testament and Whitmanesque catalogues of Margaret Walker. (Jeffers's "I Sing My People" directly invokes Walker's best-known poem, "For My People.")

The poetry of Ojenke, Quincy Troupe, and Clyde E. Mays descends from a bohemian prophetic (and often apocalyptic) surrealism akin to the work of Bob Kaufman, Allen Ginsberg, and much of Baraka in his *Dead Lecturer* and early Black Arts phase—a surrealism that also draws on a tradition of black religious millenarianism. For example, as in Baraka's "Black Art," Ojenke's "Legacy of the Word" ends with a sense of a new world a-coming or a moment of final judgment after a long series of violent images of chaos and oppression:

> Remember black people traveling through this place
> a desert of concrete, we are
> sacred and godly, these devils
> cannot look beyond the lights of our faces, for fear
> of melting or disappearing like trails of smoke
> blown from our lips.[136]

Other sorts of surrealist (or nonrealist) writing include Eric Priestly's "Can You Dig Where I'm Comin' From," a sort of vernacular testimony-travelogue through hell. Stanley Crouch's poems are more satiric and ribald, with echoes of the "Signifying Monkey" and the "Shine" toasts, often suddenly modulating at the end into a straight sweetness or sorrow. K. Curtis Lyle's "I Can Get It for You Wholesale" resembles the urban pastiche-collage of David Henderson, say, in "Jitterbugging in the Streets," where a sound, a tone, or a feeling ties together nodes of images and phrases, a sort of riffing approach to poetic organization:

> Rat tat tat's of M-16's
> against the forehead of wallace m. greene
> 152. millimeters split the cracker heart
> of lyndon baines Johnson and stomp-out
> all those diseased birds[137]

Despite the formal diversity among the works by the Young Turks, their poetic practices (and the fact that they practiced poetry) nonetheless demonstrate that the issues that ultimately split the Watts Writers Workshop were not just ideological in any simple way and not only about the familiar oppositions of integra-

tionism and separatism, or patronage and independence, but also about poetics, genre, and stylistic ancestry in ways that would seem familiar to many earlier avant-gardists.

The House of Respect, like many of the early Black Arts institutions, was short-lived. It collapsed from internal conflict, personal excesses, financial hardship, fire, the migration of key participants, and possible covert federal and local government sabotage.[138] Los Angeles faded in importance as a national center of black art — though, obviously, black drama, music, poetry, visual arts, and dance continued to be produced there. As noted at several times in this study, Karenga and Us had an enormous impact on the national Black Arts movement, largely through Amiri Baraka, significantly shaping the aesthetic and institutional life of Black Power and Black Arts circles around Haki Madhubuti in Chicago and of the Ahidiana Collective in New Orleans that grew largely out of BLKARTSOUTH as well as groups and events more directly connected to Baraka in Newark.

While Karenga's Kawaida philosophy and vision of an African-centered alternative culture strongly influenced the shape of cultural nationalist institutions, art, and political activity (and even the work of many opposed to Us), it had less direct programmatic impact on the Watts Writers, UGMA/UGMAA, and the visual artists associated with Studio Watts and the Watts Towers Arts Center — though Karenga and Us certainly reinforced a desire for black self-determination and black control of cultural institutions aimed at the African American community among a wide range of artists and intellectuals in Los Angeles. Ironically, despite Karenga's advancement of the notion of "operational unity," designed to mitigate sectarian infighting, the conflict among Us, the BPP, and other political and cultural organizations discouraged the development of a stable and coherent black cultural movement in Los Angeles. Of course, such conflicts took place elsewhere, notably the Bay Area and New York, where physical violence (e.g., the shooting of Larry Neal) was not unknown, but nowhere were these conflicts more intense than in Los Angeles.[139] Perhaps these conflicts mirrored a more long-term, local pattern of conflict and instability of black political and cultural organizations stretching back at least to the late 1940s. And certainly the efforts of the FBI and other sorts of law enforcement and intelligence agencies played a significant role in fanning conflicts. Some have also suggested that, as elsewhere, the federal, state, and local antipoverty money that helped enable the growth of cultural institutions and initiatives in Southern California also created a certain bureaucracy that ultimately undermined radical, independent

cultural activity.[140] In any event, unlike what occurred in the Bay Area, no major Black Arts journals or publishers developed in Los Angeles, despite its having the largest African American community in the West and despite its early prominence as a center of new, politically engaged African American artistic activity.

Black Arts and Chicano Movement Ideology and Poetics

As noted above, many of the artists of the Chicano movement in Northern California were much engaged with a radical, multiculturalist, Third World ideology — though it is worth noting that important cultural nationalist Chicano movement publishers, notably Tonatiuh-Quinto Sol International, were also located in the academic and intellectual centers of Northern California. In Southern California, the Chicano movement, particularly its cultural wing, embraced a far more cultural nationalist (or at least separatist) stance. This does not mean that the notion of Third World solidarity was lacking in Los Angeles but that it generally operated on the basis of a united front of racially and nationally identified organizations rather than through multicultural, multiethnic organizations, such as the Third World Alliance at San Francisco State or the Pocho-Che collective in the Mission District. Chicana/o nationalist leaders like Reies Lopez Tijerina and Rodolfo "Corky" Gonzales spoke at rallies and meetings in Los Angeles organized by the Black Congress and other Black Power groups as an expression of such united fronts. Similarly, the Brown Berets consciously styled themselves after the BPP and sought close relations with the Panthers, but on the BPP model of vanguard organizations of different races or nationalities (in the sense of the black nation) working in concert.

Ideologically, black cultural nationalism left an enormous mark on the framing and forms of Chicano movement literature, particularly poetry, though as with the Asian American movement, the transposition of black cultural nationalist paradigms led to some interesting formal and thematic adaptations. One example of this adoption and adaptation is the conception of home and homeland (and, ultimately, culture and the relation of revolutionary culture to popular culture) in Chicana/o nationalist poetry, drama, and fiction of the 1960s and 1970s. As has been previously noted, in all the major forms of literary nationalism of the 1960s and 1970s (African American, Nuyorican, Chicana/o, and Asian American), there was a strong tendency to posit a national identity that

was separate both from a simple "American" identity and from some uncompli-cated construction of an ancestral identity, whether African, Mexican, Puerto Rican, Chinese, Japanese, or Filipina/o.

However, concepts of a "Black Belt" nation in the South (whether in its origi-nal CPUSA form or in the later permutations of the NOI, the RNA, and other territorial nationalist groups), an Ur-Aztec Chicana/o homeland of Aztlan in the Southwest, and other less land-based conceptions of Nuyorican and Asian American identity, though clearly related, play themselves out much differently in terms of their cultural illustration and the cultural styles they imply. In many respects an adaptation of the NOI's (and the RNA's) territorial nationalism and Karenga's Kawaida counterculturalism, Aztlan figured an identity that was neither Mexican nor American, neither Spanish nor Anglo, but purely indige-nous. Aztlan also represented an unfallen culture that was not compromised by the mythic betrayal of the race by "La Malinche" (the name given to the legend-ary Aztec woman who served as Hernando Cortés's interpreter and mistress during his conquest of Mexico) resulting in the racial and ideological confusion of the Mexican national myth of a mestiza/o culture. Much like the Black Belt nation with respect to African Americans, the boundaries of Aztlan not only contained or were proximate to the greatest concentrations of Chicana/os but also enclosed a land to which they had a special historical claim through a his-tory of oppression, disenfranchisement, and uncompensated or undercompen-sated labor since the Treaty of Guadalupe Hidalgo in 1848. However, the con-cept of Aztlan also contained a sense of Chicana/o primacy for the descendants of the original Aztec inhabitants of the land as well as a certain spiritual con-nection that differed from the vision of most territorial nationalists. One might say that Aztlan allowed a return to an original prehistoric wholeness without leaving the borders of the United States — an imaginative option not really avail-able to African American nationalists. The resulting poetics of such an ideo-logical starting (and ending) point valued neo-Aztec or neo-Mayan countercul-tural forms, drawing on such pre-Columbian sources as the *Popul Vuh*, as seen in dramatist Luis Valdez's *actos* (short agitational skits) and, especially, *mitos* (mythic or "magic realist" pieces often dealing with essential Chicana/o iden-tity and spirituality) in the early 1970s. There was also a notable tendency to invoke and represent residual Native American spiritual, cultural, and artistic practices, personages, and institutions, such as *curanderas* (healer women), reli-gious visions, and traditional storytellers, as seen in Rudolfo Anaya's popular

novel *Bless Me, Ultima*, which won the Chicano movement's important Premio Quinto Sol award in 1971 and was published in 1972 by Tonatiuh-Quinto Sol.

At the same time, as in the Black Arts movement, other artists and intellectuals promoted a vision of an organic link between popular culture, Chicana/o tradition, and revolutionary culture. The premier figures of this linkage in Chicano movement literature are no doubt those of the pachuco and the *vato loco*, or urban gang members. Writers as widely varying as the post-Beat *pinto* poet Raúl Salinas, the elegiac poet of rural and urban Texas Chicano life Tino Villanueva, the whimsically fantastic novelist Ron Arias, the Rabelaisian satirist Oscar Zeta Acosta, and the playwright of mythic *actos* and *mitos*, Luis Valdez embodied in the pachuco and the *vato loco* a sometimes positive, sometimes negative, rebellious Chicano identity fashioned out of such popular culture elements as cars, film, rhythm and blues, *caló* street slang, and clothing fashions often adapted from popular black culture, such as the zoot suit.[141] This use of the pachuco/*vato* clearly resonated with latter-day "bad man" visions of the heroic criminal-prisoner that were common in Black Arts literature—though, because the pachuco as a type in Chicana/o literature and popular culture considerably antedated the Black Arts movement, and because Chicana/o and African American gang cultures (if not the actual gangs) have been so intertwined in Southern California since the Second World War, it is hard to figure exactly in which direction influence might have flowed first.

Black Power conversations and debates about the nature of culture and national identity powerfully inspired Chicano movement artists and intellectuals. Clearly, though, the historical and even the geographical situation of the Chicana/o community and its cultural inheritances would produce results on the cultural ground that varied considerably from the Black Arts movement. For instance, if a section of the Chicano movement adopted the Black Arts concept of rooting politically and structurally radical Chicana/o poetry in some concept of Chicana/o traditional music, substituting, as it did, corridos for the blues as the bedrock of that tradition, very different formal results ensued. After all, corridos are not the blues (or the music of James Brown)—one might say broadly that the organizational logic of a corrido is narrative, while the blues (and Brown's lyrics) tend to move through a tropological association. Another, perhaps crude, way to put it is that corridos are epic whereas the blues are generally lyric. In short, a very different formal trajectory derives from the transposition of the original Black Arts idea into a Chicana/o register, perhaps explaining why the novel and

the narrative poem hold a much larger place in Chicano movement–era litera-
ture than in Black Arts writing.

Conclusion

It could be argued that the first articulations of a national Black Arts move-
ment took place on the West Coast. *Black Dialogue* and *Soulbook* had different
ideological focuses born out of an intragroup conflict but were more purely ori-
ented toward the new nationalism and the new emerging militant black artists
than *Freedomways*, *Liberator*, or *Negro Digest*, which were still a mix of older and
newer political tendencies (and in the case of *Negro Digest*, a somewhat con-
flicted hybrid of emerging Black Power and Black Arts ideologies and a commer-
cial *Reader's Digest* format inherited from the Johnson Publishing Company).
JBP supplied not only an outlet for the most adventurous of the young black
poets, building a broad communal exchange of poetry in much the same way
that *Black Dialogue* aimed to do in a larger range of genres, but also provided
vital news from a network of staff and freelance correspondents about cultural
activities across the country that would have otherwise been inaccessible, in-
spiring activists, especially those outside the traditional centers of bohemian art
(e.g., New York, the Bay Area, and Los Angeles) and imparting a sense that the
Black Arts movement encompassed (or soon would encompass) the entire black
nation.

Similarly, the high profile of the Watts Writers Workshop made available to
black artists across the United States (and beyond) an image (and model) of a
new black cultural movement. This movement represented the conditions and
moods of urban black America in a range of voices that were urgent, but also
stylistically varied and formally and ideologically sophisticated—even if those
framing the national presentation of the Watts Writers in the mass media often
focused much more on the urgency than the variety and sophistication. The
power of this image was due in part to the workshop's connections in various
mass culture industries, the prominence of Watts as an emblem of black un-
rest after the 1965 uprising, and the public and private money made available to
African American cultural initiatives in Southern California after the uprising.
It was further strengthened by the appearance of the groundbreaking antholo-
gies *From the Ashes* and *Watts Poets*.

Despite the continuing influence of Maulana Karenga (largely outside the

Black Arts communities of Los Angeles), the early impact of black Los Angeles cultural institutions on the Black Arts movement beyond the region faded as some of the most dynamic local artists (e.g., Jayne Cortez, Quincy Troupe, David Murray, and Stanley Crouch) moved elsewhere. As mentioned earlier, this was a familiar pattern; Los Angeles had long been a place where black avantgarde writers, musicians, theater workers, visual artists, and so on had developed their art before moving on. And similar migrations took place in the Bay Area, where such artists as Pharoah Sanders, Ed Bullins, Marvin X (briefly), Edward Spriggs, and Jay Wright left the area (generally for New York). However, Northern California differed somewhat from the southern part of the state in that there continued to be a considerable influx to the Bay Area of such important African American artists from the Northeast as Ntozake Shange, David Henderson, Amiri Baraka, Askia Touré, and Sonia Sanchez—though even the Bay Area's importance as a Black Arts center diminished due to various splits within the Black Power movement. Such migrations to Los Angeles occurred much more rarely after the early days of the movement. This failure to establish long-term Black Arts institutions with a major presence outside the region might reflect a continuing problem of instability in the politics and culture of black Los Angeles. Still, such a possible conclusion should not obscure how much the idea of a radical new African American art bound up with postuprising, post–Malcolm X black politics gained an audience across the United States through the work of such groups as the Watts Writers Workshop, Studio Watts, the UGMA/UGMAA, and the Pan Afrikan Peoples Arkestra—not to mention Us.

The Black Arts movement on the West Coast was also crucial in the development of other varieties of artistic nationalism, particularly the Chicano and Asian American movements. Black nationalist political and cultural institutions in the Bay Area and Los Angeles provided models for these other movements and materially supported Asian American and Chicana/o activists and institutions. Not only were these Chicana/o and Asian American artists inspired to seek their own voice by the West Coast Black Arts movement but also they adopted and adapted many Black Arts cultural models and strategies—again, often with final products that looked and sounded quite different from their Black Arts inspirations.

Finally, the region, particularly the Bay Area, was an early incubator of the radical multicultural movement in both its academic and nonacademic forms. While New York's Nuyorican Poets Cafe and the performance poetry explosion

that it helped pioneer owes a lot to East Coast Black Arts activity as well as to the emergence of hip-hop, the aggressive Third Worldism of the Mission District scene contributed much to the shape of performance poetry and eventually the poetry slam — as seen in the large number of West Coast artists contained in Miguel Algarín and Bob Holman's 1994 anthology, *Aloud: Voices from the Nuyorican Poets Café*. While this sort of multiculturalism might seem at first glance to contradict stereotypes of the Black Arts movement, it was, as a leading Mission District participant, Ntozake Shange, said of herself, "a daughter of the Black Arts Movement."[142]

6

Behold the Land: Regionalism, the Black Nation,
and the Black Arts Movement in the South

The Black Arts movement in the South was shaped largely by the region's unique concentration of historically black colleges and universities and its identity as ground zero of the civil rights movement of the 1950s and 1960s. Of course, a symbiotic relationship existed between the educational institutions and civil rights—a relationship that greatly affected the development of the movement and changed the institutions. Though the administrations (and often the faculties) of many historically black colleges and universities were initially cautious or indifferent in their public relationship to the new civil rights activism, the students of these schools comprised much of the core leadership and rank and file of the movement in the South, especially of SNCC and the community-based efforts of CORE. Students from southern black schools led local sit-ins, picket lines, boycotts, and demonstrations, particularly in the 1960 sit-in movement that swept the South (and much of the North) before coalescing into SNCC. Sometimes these young people organized under the auspices of established groups, such as the NAACP Youth Council or SCLC, and sometimes they created their own local organizations. As Amiri Baraka, Kalamu ya Salaam, and Askia Touré have noted, the black student movement inspired young activists, artists, and intellectuals outside the South (often themselves, like Baraka, A. B. Spellman, Larry Neal, and Muhammad Ahmad, alumni of historically black schools) through their boldness, their militancy, and their refusal to wait for established leaders.[1]

A tremendous number of Black Arts activists were politicized and introduced

to a distinctly African American cultural tradition while at historically black colleges and universities as students or faculty members (or both). Additionally, a significant group of the younger black artists and intellectuals, such as Jayne Cortez, Tom Dent, David Llorens, Dingane Joe Goncalves, Sonia Sanchez, Michael Thelwell, Kalamu ya Salaam, Edward Spriggs, Askia Touré, Ebon Dooley (Leo Thomas Hale), Haki Madhubuti, and Sterling Plumpp, actively participated in SNCC, CORE, and other militant, direct-action civil rights groups leading the grassroots struggle in the South. Even those of this cohort of activist artists and intellectuals who never worked in the South, belonging instead to northern affiliates of the major groups or local civil rights organizations, generally saw themselves as both supporting the southern student movement and bringing that movement north to confront racism in their own region. Very often artists and activists who would go on to form early Black Arts and Black Power institutions, such as Studio Watts in Los Angeles, the journal *Black Dialogue* in the Bay Area, and RAM in its early Philadelphia incarnation, met in CORE or SNCC (or the Friends of SNCC). At the same time that they were energized by the southern fight against segregation and disenfranchisement, many future Black Arts activists who did go south (or were already in the South), tried to further radicalize the southern movement, introducing or reinforcing radical and/or nationalist thinking within SNCC and other civil rights organizations. Thus, while the Black Arts institutions of the South often had difficulty attracting attention beyond the region, nonetheless the South was far more crucial symbolically and practically to the development of the Black Arts and Black Power movements as national phenomena than has sometimes been acknowledged.[2]

However, the Black Arts movement in the South was not of a piece but divided broadly into two trends, reflecting in part the cultural power of the elite, historically black colleges and universities. In some cities, such as Houston, Memphis, New Orleans, and Miami, the movement was rooted largely in residential communities. In others, such as Atlanta, Washington, Baton Rouge, and Nashville, the movement was based more on the campus. This is not to deny that some black schools did figure prominently in the Black Power and Black Arts movements of New Orleans and Houston, such as Southern University–New Orleans, Dillard University (where Tom Dent's father, Albert Dent, was president and where the Dashiki Theatre Project, the longest-lived New Orleans African American theater, was conceived in 1968), and Texas Southern Univer-

sity (alma mater of Mickey Leland, who, as Lorenzo Thomas points out, was a poet long before he was a congressman).[3] And in virtually all the academic centers, Black Arts and Black Power organizations and institutions aimed to reach local African American neighborhoods. Nonetheless, the community-oriented BLKARTSOUTH in New Orleans and the groups it inspired, such as Sudan Arts South/West in Houston and the Theatre of Afro Arts in Miami, were far more important in those cities (and ultimately the region) than any institutions linked to a campus or group of campuses. They formed the backbone of the SBCA, the most successful regional Black Arts organization. Despite the aims of reaching a local grassroots constituency, groups from the major black academic centers seem to have been relatively inactive in the SBCA and community-based Black Arts circuits.

The Popular Front, Civil Rights, Culture, and the South

The story of the Left-led challenges to Jim Crow in the South during the 1930s and 1940s remains largely a hidden one that is only now beginning to be uncovered by scholars. The Left-influenced civil rights efforts of that era were more consistently oriented toward labor issues than were their counterparts in the 1950s and early 1960s. Still, like the later civil rights movement, these efforts were also aimed at gaining and expanding black suffrage and against legal and extralegal racist violence and Jim Crow in education and public accommodations. As in the later movement, many of the black (and white) leaders of the fight against Jim Crow in the 1930s and 1940s, such as Dorothy Burnham, Louis Burnham, Hosea Hudson, Sallye Davis, James Jackson, Esther Cooper Jackson, Augusta Jackson Strong, and Edward Strong, were young.

The Left-led SNYC particularly promoted politicized African American art and literature in the South. The SNYC grew out of the first meeting of the National Negro Congress in 1936 and was officially launched with a 1937 meeting of southern black youth that drew five hundred delegates from a wide range of political, civil rights, labor, community, religious, and fraternal organizations to Richmond, Virginia. Leaders of the SNYC included native southerners, such as Virginians James and Esther Cooper Jackson and Alabaman Sallye Davis (mother of Angela Davis), as well as products of the great migration, such as Edward Strong (born in the South but raised in the Midwest), and north-

ern transplants, such as the Harlemite Louis Burnham (originally the National Negro Congress's youth coordinator) and the Brooklynites Dorothy Burnham and Augusta Jackson Strong, who had come south, basically through the Young Communist League and the Left-led National Student Movement.

The SNYC organized the first southern African American visual arts show in Birmingham, Alabama, in 1939. It sponsored or helped initiate two radical black theaters, the People's Theatre in Richmond and the People's Theatre in New Orleans, that presented work by African American playwrights, such as Langston Hughes's revolutionary musical poetry-play, *Don't You Want To Be Free*. The SNYC-sponsored Puppet Caravan Theatre, which numbered the poet Waring Cuney among its members, toured the South, presenting plays on voter registration and labor rights to farmers and farm laborers, anticipating the work of the FST twenty years later. The SNYC also published poetry in its journal *Cavalcade* and featured poets like Hughes and Sterling Brown at their events. In part through the Left cultural work done by the SNYC and other Left groups, New Orleans also became the center of activity for the American Artists Congress in the South as well as one of the relatively few places in the South where significant numbers of African Americans were employed by the FWP.[4]

The historically black schools of University Center in Atlanta and the Hampton Institute in Virginia were perhaps the two most important centers of Popular Front black visual arts outside New York and Chicago. Atlanta University teacher Hale Woodruff anchored the black visual arts community in Atlanta in the 1930s and early 1940s, especially the circle of painters dubbed by local journalists as the "Outhouse School" because of their penchant for including outhouses in their unromanticized landscapes of the rural South. Besides the large number of black art educators in the South trained by Woodruff and the Atlanta University art program, Woodruff inaugurated a series of enormously influential visual art shows at the university beginning in 1942, spotlighting such leading black social realist artists as Charles White, John Wilson, and Elizabeth Catlett. White and especially Catlett played much the same roles at Dillard University and the Hampton Institute (where a progressive white refugee from Nazism, Viktor Lowenfeld, headed the art department) in the 1940s.

As was true of many black Left artists in the 1930s and 1940s, Catlett and Woodruff were deeply impressed by the Mexican public arts movement. However, their connection to the Mexican muralists and woodcut artists was unusually close, leading them to study in Mexico with Diego Rivera and other radi-

cal nationalist Mexican artists. Both the Atlanta artists, many of whom painted public murals for the WPA and for historically black schools (most famously Woodruff's *Mutiny of the Amistad* at Talladega College), and the Hampton artists, including Catlett's students Samella Lewis and John Biggers, anticipated and significantly inspired the black mural movement of the 1960s and 1970s. In fact, it is possible to draw a direct line from Catlett and the art program at Hampton (and Dillard) through Lewis to William Walker (mentored by Lewis) and Chicago's *Wall of Respect*.[5]

Even before the onset of the Cold War, the CPUSA was more or less underground in many parts of the South—and elsewhere in the United States. However, as noted above, Popular Front organizations and institutions, such as the SNYC, the SCHW, the Highlander Folk School, and the People's Defense League in New Orleans, as well as Left-led (and often African American–led) locals of such unions as the NMU, the Food, Tobacco, and Agricultural Workers, the United Furniture Workers, and the Mine, Mill, and Smelter Workers, had a significant public presence in the region. The CPUSA itself was able to maintain a public (or at least semipublic) face in parts of the South during periods of the 1930s and 1940s. For example, the CPUSA operated bookstores in Birmingham and New Orleans despite periodic legal and extralegal attacks. This network of explicitly Left and Left-led organizations often strongly influenced local chapters of such resolutely (in their national stance) non-Left or even anti-Communist organizations as the NAACP.[6]

The Henry Wallace presidential campaign of 1948 was the last public gasp of the Popular Front in the South—at least in its more open manifestations.[7] Following the Wallace campaign, an anti-Communist (and racist) frenzy made it almost impossible for known leftists to live and remain politically active in the region—at least in the areas in which they had worked formerly. Some, such as Junius Scales, were jailed; others, such as Don West and Stetson Kennedy, were physically threatened (or actually attacked) by federal, state, and/or local law officers or by vigilantes, especially the Klan; still others were socially isolated and unable to find employment.[8] Many, like West, Kennedy, James and Esther Cooper Jackson, Dorothy and Louis Burnham, W. E. "Red" Davis, Edward and Augusta Jackson Strong, and Hosea Hudson, moved elsewhere in the South or left the region altogether. Most of those leftists who remained kept a low political profile.

The Cold War destroyed the infrastructure of the Popular Front in the South

possibly more completely than anywhere else in the United States. Few Left-influenced institutions in the South survived the Cold War. Two partial exceptions were the Highlander Folk School, founded by Don West and Myles Horton in Tennessee, and SCEF, an offshoot of the SCHW. Highlander, despite racist right-wing rhetoric about "communist training schools," had actually been comparatively timid in challenging Jim Crow until the mid-1940s. Though the Cold War increasingly isolated Highlander from the trade union movement that had previously been its main constituency, the school played an important role in the civil rights upsurge of the late 1950s and 1960s — in part because it was one of the very few places in the South where SNCC and other civil rights organizations could hold large, interracial meetings and educational retreats. SCEF early on made an impact as a relatively open left wing of the civil rights movement — an impact heightened by the fact that it was based in the South and included white southerners among its leadership, most prominently Jim Dombrowski (a former leader of the Highlander Folk School) and Carl and Anne Braden. SCEF's uncompromising support of black self-empowerment (particularly suffrage) and equally uncompromising opposition to Jim Crow gained it considerable sympathy in the African American community and the respect of mainstream black leaders, such as Albert Dent. However, persistent attacks on SCEF by federal, state, and city authorities as a Communist front isolated the organization in many respects. While the persecution of SCEF by state agencies long associated with the Jim Crow system, such as the Louisiana Un-American Activities Committee, endeared the group to many in the black community, it also inhibited leaders of southern civil rights organizations and African American institutions from publicly associating with SCEF, since to be designated a Communist front or even a successful target of Communist infiltration was considered a political kiss of death.[9] In short, SCEF served as a clearinghouse of Left ideas in the civil rights movement and inspired admiration for its courage, but its effectiveness was limited by the Cold War.

The Left-led unions that had been influential in the South were either destroyed (as in the case of the Mine, Mill, and Smelter Workers and the Food, Tobacco, and Agricultural Workers) or taken over by an anti-Communist leadership (as in the case of the NMU, the Newspaper Guild, and the United Furniture Workers).[10] Cold War anti-Communism also limited the public roles that those known (or suspected) to be past or present members or supporters of the CPUSA

could play in the civil rights movement locally and nationally, such as W. E. B. Du Bois, Paul Robeson, and Jack O'Dell (a former activist in the NMU expelled for Communist sympathies in 1950 who became a confidant of Martin Luther King Jr. in the SCLC before becoming again a target of an anti-Communist campaign that forced him to resign). It also caused other civil rights leaders, such as Ella Baker (and King himself), to hide their considerable Left pasts and Left sympathies.[11] The liberal-conservative Cold War consensus forced civil rights organizations to practice a sort of self-inflicted Red-baiting or face severe consequences.[12]

Despite the devastating impact of the Cold War on the CPUSA, the SCHW, the SNYC, Left-led unionism, and even non-Communist, left-wing organizations, such as the SP, the Popular Front in the South had a number of important consequences for African American political and artistic culture in the early 1960s. First, the CPUSA and the organizations which it led or in which its members worked closely with liberal and non-Communist Left activists provided a space for working-class African Americans (including some who were not much engaged with Marxism ideologically) outside the traditional southern black intelligentsia to develop practical intellectual skills (e.g., how to run a meeting or put together a newsletter or a broadside) as well as to carry on an intellectual life with others interested in politics, philosophy, the arts, and so on. Since the public manifestation of the CPUSA was often a bookstore, this gave a certain emphasis to cultural and intellectual activities that may have been greater in the South than in other areas where bookstores and forums, though important, were only one public institution of the Communist Left. (It should be noted, however, that the public institutions of the CPUSA everywhere were strongly oriented toward education and culture.) The bandleader, poet, and Black Arts elder Sun Ra frequented the CPUSA's Ella Speed Bookstore as a young man because it was one of the few serious cultural institutions in Birmingham open to nonelite African Americans where one could get books, hear lectures, or simply carry on informal conversations about politics, art, philosophy, and so on with people of like interests. Also, though the leaders of the Left were generally driven from the communities in which they had formerly lived and worked, much of the rank and file remained. As Robin Kelley and Michael Honey point out, the repressed memory of such organizations as the CPUSA, the SNYC, the Sharecroppers Union, the Mine, Mill, and Smelter Workers Union, and other Left-

influenced formations and activities resurfaced periodically during the upsurge of the 1950s and 1960s, sometimes to the surprise of young organizers from the North who assumed they were starting from square one.[13]

And in some places, especially in the Upper South and the so-called Border States, such as Kentucky, West Virginia, Maryland, and the District of Columbia, some significant local institutional vestiges of the Popular Front remained. The poet Sam Cornish recalls that, as the Ella Speed Bookstore was for Sun Ra in Birmingham during the 1930s, the CPUSA's New Era Bookstore in Baltimore was a place in the early 1960s where he, a young black man from a poor family, could find people interested in literature, art, philosophy, politics, and African American culture who welcomed him into their conversations. In fact, New Era published one of Cornish's earliest chapbooks and circulated it widely, especially to those prominent in what remained of the old Communist cultural network — a distribution that Cornish credits with the establishment of his reputation beyond downtown Baltimore.[14]

Historically Black Schools, the Black Student Movement, and the Black Arts in Nashville and Atlanta

Many of the political and cultural institutions of Reconstruction in the South had been destroyed by the disenfranchisement of most black southerners and the establishment of Jim Crow, but one legacy of Reconstruction and what might be thought of as the Reconstruction spirit still thrived in the 1950s and early 1960s: the historically black colleges and universities. The vast majority of these were located below the Mason-Dixon Line — though some important schools, notably Lincoln University, Cheney State College, and Central State University, were up north, and others, such as Howard University and Morgan State University, were to be found in such regionally ambiguous cities as Washington, D.C., and Baltimore. Since de jure segregation still operated in the South and beyond, and de facto segregation or token integration at many colleges and universities elsewhere, a huge proportion of black college students (and black faculty) were concentrated at the African American schools in the South and the Border States.

The administrations of the historically African American schools in the South and in Washington, D.C., especially those dependent on public funding, were

generally politically cautious and even conservative during the period immediately before and during the Cold War. A notorious example of such caution, if not cowardice, in the face of the emerging red scare was the firing of W. E. B. Du Bois from the faculty of Atlanta University in 1944—recalling Du Bois's earlier dismissal by Atlanta at the beginning of the century after the publication of *The Souls of Black Folk*. On a less public level, another sign of institutional conservatism was an exodus of progressive and Left faculty from historically black schools in the Deep South during the late 1940s and the 1950s.[15] Administrators often sympathized with the sentiments and goals of the student movement that erupted in their institutions in 1960. Still, under explicit or implicit pressure from the local and state power structure, they frequently tried to rein in student protest, in some cases threatening to discipline or actually disciplining demonstrators—as when Southern University expelled seven students (including the senior class president, Marvin Robinson) arrested at a 1960 sit-in in Baton Rouge. And however sympathetic these administrators might be, they often had a far different vision of what tactics were appropriate and what goals were feasible than the young demonstrators.[16] Even Martin Luther King Jr. was unable to realize his long-held desire of being appointed to the board of trustees of his alma mater, Morehouse College, due in part to his perceived radicalism— particularly after King came out publicly against the United States' involvement in the Vietnam War.[17] As John O. Killens noted while describing his experience as a writer-in-residence at Fisk University from 1965 to 1968, not only did early Black Power and Black Arts supporters have to contend with conservative (often white) trustees and nervous (often black) administrators but also with both conservative and liberal faculty members who saw "Fisk as a finishing school to train black boys and girls how to be nice little young white ladies and gentlemen in black skins."[18] These faculty members were notably hostile to the Black Power and Black Arts movements, though often they attacked those movements passively or covertly. Killens recalls that when he organized the Black Writers Conferences at Fisk that became landmarks in defining the existence and shape of the emerging Black Arts movement and featured many leading black writers and scholars, the heads of the Fisk English, Speech, and Drama Departments did not even attend.[19]

The administrations of many historically black schools took an extremely paternalistic and condescending stance toward their students, even at such elite schools as Howard.[20] Ironically, as happened on many predominantly white

campuses, such as UC-Berkeley, this sort of heavy-handed paternalism actually strengthened or, as in the case of Central State University in Ohio, inspired activism by stoking general student dissatisfaction. This dissatisfaction in turn created broad support for relatively radical organizations, such as the earliest formation of RAM at Central State.[21]

Nonetheless, historically black schools were often willing to hire (or retain) intellectuals who had been part of the Popular Front subculture of the 1930s and 1940s, such as Killens (Fisk University), Margaret Walker (Jackson State University), Melvin Tolson (Wiley College and Langston University), and Sterling Brown, Mercer Cook, Owen Dodson, and Lance Jeffers (Howard University) — some of whom still retained connections to the Left. Not only did black colleges sometimes hire faculty with radical pasts but they also supported large-scale literary events initiated by intellectuals with some past or present affiliation with the Left. For example, as mentioned in Chapter 4, Rosey E. Pool was a left-wing Dutch journalist and anthologist living in Britain during the late 1950s and early 1960s who organized a festival of African American poetry at Alabama A & M in 1964 and again in 1966 — though the featured participants were drawn primarily from her connections in the Midwest (e.g., Margaret Burroughs, Dudley Randall, Margaret Danner, and Mari Evans), where she spent much time while assembling her anthology *Beyond the Blues*, rather than from the South. Pool also lectured on African American poetry at dozens of historically black campuses in 1959–60. These festivals as well as Pool's lectures did much to create a sense of the emergence of a new black poetry that was both formally and politically radical. And again, it needs to be noted that because the historically black schools drew on a national (and international) network of students and alumni, these sorts of events had an impact far beyond the South.

It is true that some schools, as was the case with Howard apparently, protected their faculty from various Red hunters with the understanding that they would not engage in high-profile radical politics. Still, despite this limited and limiting resistance to McCarthyism, there were not many historically white universities where a professor who had been a part of the activities of the Popular Front as publicly as Sterling Brown could have survived without repenting of his or her political past, including the naming of names of colleagues and comrades (and sometimes even a public repentance would not save the former leftist). While many of the scholars and artists teaching in historically black schools had

willingly or under institutional duress retreated somewhat from public radical political activism, many became energized by the revived civil rights movement, especially the black student movement that in 1960 exploded after four North Carolina A & T freshmen sat in at a downtown Greensboro Woolworth's lunch counter. Like their nonacademic counterparts in the Northeast, this older generation of radicals on black campuses helped open political and cultural spaces that were crucial in the development of what might be thought of as a Black Arts and Black Power cadre, especially in conjunction with the domestic and international currents of civil rights, nationalism, and national liberation that flowed together on historically black campuses in a distinctive way. In fact, quite a few of the black bohemians in New York who became Black Arts movement leaders had early on been mentored by older radicals at historically black schools — as had Amiri Baraka and A. B. Spellman by Sterling Brown at Howard.

Interestingly, with the exception of peripheral Black Arts participant Julian Bond, few of those who would spearhead the Black Arts movement joined directly in the early black student movement in the South — though many would join CORE, SNCC, and other civil rights organizations in the North and the West. However, a number of them, such as Baraka, Spellman, Tom Dent, Calvin Hernton, Larry Neal, and Sarah Webster Fabio, attended historically black universities in the decade before 1960. Many of these writers found what they considered to be the generally cautious and accommodationist atmosphere of most historically black schools alienating. However, they also often discovered a sense of African American folk and popular culture and history as subjects that could be approached in an engaged and intellectually serious manner — though often this education took place outside the formal circuits of the institution. For example, Baraka recalls that Howard was like "an employment agency at best, at worst a kind of church . . . for a small accommodationist black middle class." [22] Yet he also cites Sterling Brown's unofficial seminars on African American music, also attended by Spellman, as "opening us to the fact that the music could be studied and, by implication, that black people had a history. He was raising the music as an art, a thing for scholarship and research as well as deep enjoyment." [23] Baraka and Spellman in turn would become leading Black Arts proponents of the notion of a black cultural continuum, including folk, popular, and avantgarde elements, which would provide the underpinning of the political liberation movement. In a similar vein, Dent remembered that watching historian

Benjamin Quarles working in the library of Dillard University gave him a sense that a serious intellectual life, particularly one devoted to the study of black culture and history, was possible.[24]

There was also a long tradition of grassroots civil rights activism at some historically black schools, particularly Howard and Fisk. Howard students, for example, had been instrumental in launching the campaign against the segregation of public facilities and accommodations in Washington during the 1940s, using many of the tactics of later activists, including sitting in at lunch counters, and suffering much the same resistance from the Howard administration.[25] Given the inevitable turnover of students and the disinterest of college administrations in publicly acknowledging such past militancy, radical faculty often served as unofficial custodians of this legacy. In addition to introducing African American culture as a subject of serious study, Sterling Brown revealed to the NAG circle (and no doubt others he mentored in the Dasein group) Howard's considerable activist past as well as the sorts of roadblocks (and support) previous administrations had presented to earlier generations of radicals.[26]

Also, the historically black schools drew a large international student body, especially from Africa and the Caribbean. Quite a few of these students were radicals, sometimes Marxists or influenced by Marxism, engaged with the liberation movements in their home countries and intensely interested in the decolonization movements throughout Asia, Africa, the Caribbean, and Latin America. Through these international students, who were limited in their ability to participate directly in U.S. political movements by their legal status, native-born African Americans more closely encountered post–Bandung liberation movements and various strains of Third World radical thought than was possible on most U.S. campuses in the late 1950s and early 1960s.[27] In turn, the students from the United States who became active in campus politics often had some experience in black nationalist organizations and/or the civil rights movement. Some at Central State, Howard, and other African American schools outside the Deep South, such as NAG stalwart Ed Brown (brother of Rap Brown) at Howard, had been expelled from southern historically black colleges and universities for their civil rights activism.

Other students brought some background in various sorts of domestic Left organizations with them. Kwame Turé came to Howard from New York City having already had much exposure to Marxism and having participated in a range of Socialist- and Communist-initiated activities and institutions. Tom

Kahn, a gay, white Howard student and a leader of the Young People's Socialist League affiliated with the sp, worked closely with Turé in NAG. Kahn eventually became the head of the League for Industrial Democracy, the original parent organization of the sds. Kahn not only brought his radical politics with him but also a close friendship with the older, gay African American activist Bayard Rustin who became a key adviser to NAG and, later, SNCC—though Kahn, like Rustin, later moved to the right end of the Socialist political spectrum.

This Left nationalist, civil rights, post-Bandung encounter was nowhere more intense than at Howard University, which drew black students from all the regions of the United States, Africa, and the Anglophone Caribbean (as well as a handful of generally radical white students like Kahn). As we have seen, the relationships between African students from newly independent nations (or nations still struggling for independence) and African American students on campuses across the nation significantly informed the emergence of the Black Arts and Black Power movements. However, the sheer number of the black foreign students at Howard (over a third of the student body) made it a special case even among historically black schools. The location of Howard in Washington, D.C., also lent the African–African American interaction there a unique dynamic. When newly independent African, Asian, and Caribbean nations opened embassies in Washington, the direct connection of Howard students to the often revolutionary governments that grew out of anticolonialist struggles energized politically minded Howard students and, again, gave them firsthand access to a wide range of radical ideas in a way that would have been extremely difficult, if not impossible, to replicate at other campuses. In addition to the direct impact on political thought on campus, the international students also provided students at historically black schools a sophistication with respect to traditional and revolutionary African art and literature that was hard to come by on what might be thought of as historically white campuses. Again, this was especially true at Howard, where the personal access to governments of the new states of the former colonial world and to various sorts of official cultural programs and presentations was relatively easy. Not surprisingly, Howard became a particular locus of Left and Pan-African internationalist influence within SNCC and the black student movement.[28]

So-called mainstream campuses still hired relatively few African American faculty in the late 1950s and early 1960s. Many of the best-known black writers and artists, then, worked as teachers at black colleges and universities in the

South during that period. A very high percentage had radical pasts. Some, like Robert Hayden, had moved considerably from their earlier Left politics — though Hayden's continuing engagement with history in his work showed a link to earlier Left poetry of *Heart-Shape in the Dust* (1940). Others, such as Margaret Walker and John O. Killens, stayed much closer to their earlier Left commitments. How close is unclear — though both Walker and Killens became prominently associated with *Freedomways*, and Killens was a familiar endorser of and participant in events initiated by the Communist Left in the 1960s as well as the longtime leader of the HWG, even as he moved toward a more clearly nationalist position and expressed pessimism about winning white workers to the fight against racism.

Killens's term as a writer-in-residence at Fisk University from 1965 to 1968 led to some large contributions to the development of the Black Arts movement at a crucial moment. Important Black Arts writers, most famously Nikki Giovanni, passed through Killens's workshop. Like other older radical writers, Killens saw as one of his main tasks reminding the young militants of their artistic and political ancestors, especially those associated with the Popular Front era, such as Paul Robeson, while bringing younger writers to the attention (and respect) of their elders.[29] When Killens returned to New York, the workshop continued under Donald Lee Graham (Le Graham) until Graham's death in 1971.

Fisk, of course, was the institutional home of other well-known black writers, such as Robert Hayden and Arna Bontemps. But it was Killens who took the lead in organizing the Black Writers Conferences there in 1966, 1967, and 1968. The first two of these conferences in particular were watershed events marking the emergence of the Black Arts movement as the ascendant force in African American letters.[30] Older artists and scholars for the most part associated with the Left in the 1930s and 1940s (and beyond in some cases), such as Hayden, Bontemps, Ossie Davis, Saunders Redding, Margaret Walker, Loften Mitchell, and Melvin Tolson, dominated the first conference. However, the new militant nationalist writing made itself felt everywhere at the conference. Virtually the only younger writer to appear on the program in 1966 was William Melvin Kelley — apparently Baraka was invited but did not attend. Kelley at that point was a promising postmodern (and post-Faulknerian) writer whose published work already exhibited some of the bitter humor, the fragmented narration, and the concerns with possibilities of black consciousness and black language (and white apprehension about that consciousness and language) that would characterize his bril-

liant later novels, such as *Dem* (1967) and *Dunford's Travels Everywhere* (1970). Though not known as one of the young militants, Kelley consciously served as a sort of spokesperson for them. Other participants obsessively mentioned Baraka and other younger writers, either disapprovingly or as the wave of the future (or often both). Some older writers took up the banner of the new militants, as did Walker in her reading of a poem to Malcolm X and as did Tolson during his notorious debate with Hayden in which he asserted, "I'm a black poet, an African-American poet, a Negro poet," in response to Hayden's claim that he was "a poet who happens to be Negro." As noted in Chapter 4, it was also at this conference that a chance meeting between Walker, Dudley Randall, and Margaret Burroughs resulted in Broadside Press's first book project, *For Malcolm*.[31]

Young nationalist artists, particularly Baraka and playwright Ron Milner, took center stage at the 1967 Fisk conference in person. Older writers, including Killens, Gwendolyn Brooks, Margaret Danner, and John Henrik Clarke, actively took part in the conference. However, these literary elders were (or became) some of the most fervent supporters of the new nationalist writing among the older generation — with the possible exception of the mercurial Danner, whose enthusiasm blew hot and cold. A number of those older artists not previously identified with the new cultural and political militancy, most famously Brooks, publicly embraced the Black Power and Black Arts movements at the conference. In fact, these conversions, particularly that of Brooks, gave the conference much of its charge as an event marking a new day in African American letters. Those artists who opposed or expressed serious doubts about the emerging nationalist political and artistic movements at the earlier conference were for the most part absent or far less prominent. For example, Hayden did not join directly in the conference — though he was a featured artist during the week of cultural events at Fisk. Despite the fact that many of the older writers at the conference were among the most sympathetic to the new militant literary nationalism, the younger members of the audience frequently took them to task for literary Uncle Tomism or irrelevance. Though these attacks might have been unfair, reflecting in the view of a *Negro Digest* correspondent the ignorance of the attackers about the work of those they attacked, nonetheless they demonstrated a much-changed atmosphere from the previous year when the Black Arts movement was more like a haunting presence.[32]

The 1968 conference was even more centered on the now completely ascendant Black Arts movement. Perhaps the most significant aspect of this con-

ference was the introduction of Haki Madhubuti to a national audience out-side the Midwest. Gwendolyn Brooks had recommended that Killens invite Madhubuti—though Killens must have had some previous knowledge of Mad-hubuti through their mutual participation at the Detroit Black Arts Conven-tions. Madhubuti's successful presentation at the convention not only increased his national visibility, perhaps contributing to his appointment as a writer-in-residence at Cornell University later that year, but increased Chicago's reputa-tion as a center of the new black art and writing. Also, as Keith Gilyard notes, Madhubuti's enhanced relationship to Killens also resulted in the establishment of Howard University as the site of similar conferences of black artists and intel-lectuals while both were writers-in-residence there in the 1970s.[33]

At Howard University, Sterling Brown played much the same mentoring role as Killens did at Fisk—though with his own distinctive style and over a much longer period of time. One of his students from the early 1960s, Michael Thel-well, recalls Brown's formal classes as extremely competent but more or less standard literature courses of the day—though not entirely so, since it was not unheard of for someone like pianist Willie "the Lion" Smith to show up. How-ever, as noted earlier, Brown's unofficial seminars and discussion sessions (often with bourbon) on African American culture, history, music, literature, and poli-tics nurtured and inspired many writers before, during, and after the Black Arts movement, including Baraka, Spellman, Thelwell, and Toni Morrison. Brown mentored in this manner the largely avant-gardist literary grouping that pub-lished the journal *Dasein*, including Percy Johnston, Oswald Govan, Walter De Legall, and Leroy Stone, as well as the political activists in NAG, including Thel-well, Kwame Turé, Cleveland Sellers, Ed Brown, Rap Brown, Charlie Cobb, and Courtland Cox, who would later play key roles in the leadership of SNCC and the emergence of the Black Power movement.[34] While members of the Dasein group rarely participated directly in the political activities of NAG and SNCC (and while the NAG activists considered the bohemian Dasein circle to be a little too concerned with their images as artists), the active existence of both groups linked in part through Brown (and to a lesser extent poet, playwright, and di-rector Owen Dodson) contributed to a sense of a dynamic political and cultural environment on campus. At the same time, the fact that neither NAG nor *Dasein* were ever officially recognized by Howard highlights some of the contradictions of political and cultural life on historically black campuses in the early 1960s.[35]

These relatively modest campus venues for radical black art and politics took

on a new significance as a mass constituency for the Black Power and Black Arts movements grew in the general population of African Americans in the South as well as among black intellectuals and students. Young African Americans (and many older African Americans) in the South became frustrated with the unwillingness (and open resistance) of the white southern power structure to go beyond the desegregation of public facilities, if that far, blocking the black community from full access to the economic, educational, and political structures and institutions hitherto reserved almost solely for white southerners. As a result, militant Black Power groups emerged in southern African American neighborhoods and on the college campuses of such black schools as Southern University, North Carolina A & T, South Carolina State, and Jackson State.

The activities of these militant campus groups, especially at more working-class campuses, such as North Carolina A & T and South Carolina State, often revolved around specific neighborhood issues, such as racial discrimination in housing and education and the persistence of blatant Jim Crow practices, especially by white merchants. In many places, local white officials responded extremely negatively and often violently to these protests and community/campus organizing, leading to the deaths of students at Southern University, South Carolina State, and Jackson State at the hands of National Guardsmen or law enforcement agents and to the arrest and imprisonment of local activists. At South Carolina State, the state police killed three and wound dozens more after a series of demonstrations over a segregated bowling alley in the winter of 1968. The SNCC leader working with the students, the former NAG activist Cleveland Sellers, himself wounded in the attack, was charged with and convicted of inciting a riot. Sellers eventually served seven months in prison.

Such extreme responses by the police, the National Guard, and the local and state political establishments further radicalized students and faculty at the historically black schools.[36] This even higher level of radicalization among southern students, faculty, civil rights workers, and community members sparked the creation of major Black Power and Black Arts institutions that would have a high profile inside and outside the region. Some of these institutions and organizations include Malcolm X University (established in Durham, North Carolina, in 1969 and moved to Greensboro in 1970), the Student Organization for Black Unity, or SOBU (a national Black Power student organization founded by former SNCC workers at North Carolina A & T in 1969 and closely linked to Malcolm X University), the Youth Organization for Black Unity (YOBU) that grew out of

SOBU in 1972, and the SOBU/YOBU journal *African World*. Broad nationalist sentiment, especially on campus, led southern black students and faculty to prominently join in the creation of national Black Power organizations, not only SOBU and YOBU but also CAP and the ALSC, and in the establishment of very visible nationalist events, such as the promotion of African Liberation Day as a widely observed celebration in the United States.

As a result of this new constituency for radical nationalist ideas, institutions, and activities on campus and within the broader African American community, the historically black schools were much more disposed to give institutional support to Black Arts or Black Arts–influenced activities and institutions. In part, this was because of the increased political engagement (or a new willingness to be open about their political engagement) of the faculty to energetically seek this institutional support. After the Fisk conferences and the Alabama A & M conferences, the historically black colleges frequently hosted conferences and festivals of African American art and literature, including the annual Black Poetry Festivals at Southern University beginning in 1972 and the bicentennial Phillis Wheatley Festival at Jackson State in 1973.[37]

In addition to hosting Black Arts or Black Arts–influenced events, many historically African American schools hired Black Arts writers, artists, and scholars as permanent or visiting faculty. A very incomplete list would include poets Haki Madhubuti and Ahmos Zu-Bolton, OBAC painters Jeff Donaldson and Wadsworth Jarrell, and critic Stephen Henderson at Howard, poet Nikki Giovanni at LeMoyne-Owen College, poets Calvin Hernton and Jay Wright at Talladega, poet Keorapetse ("Willie") Kgositsile at North Carolina A & T, poets Jay Wright and Audre Lorde at Tougaloo, poet and critic A. B. Spellman and Stephen Henderson (before his departure to Howard) at Morehouse, poet and literary historian Eugene Redmond at Southern, and poet Donald Lee Graham at Fisk (taking over John O. Killens's Writers Workshop). In a number of cases, such as those of Henderson and Donaldson at Howard, these faculty members were hired to essentially remake departments in a Black Arts or Black Power mode.

Atlanta, with its neighboring University Center campuses of Spelman, Morehouse, Clark, Atlanta University, and Morris Brown, particularly attracted Black Arts and Black Power artists and intellectuals. In addition to the various activities and institutions directly affiliated with one or more of these schools, there were institutions like the Center for Black Art and the IBW, which were not joined to particular schools but were made possible by the sheer density of his-

torically black colleges and universities and the new level of acceptance of the Black Arts and Black Power movements by the students, faculty, and administrations of the schools. In short, there was a whole black cultural infrastructure growing out of a new level of engagement between the campuses and the Black Arts and Black Power movements that not only drew artists and intellectuals to work in the schools but also eventually brought others, such as Edward Spriggs, Hoyt Fuller, and Askia Touré, whose primary work was not in the academy.

The IBW was at first affiliated with the Martin Luther King Jr. Memorial Center rather than one of the black colleges or universities. Though the institute eventually developed a focus on education and the social sciences, it was imagined initially as a research-oriented hub of the emerging black studies movement in academia with a strong interest in furthering the Black Arts movement. The IBW was largely the brainchild of historian Vincent Harding, chair of the History and Sociology Department at Spelman, and Stephen Henderson, chair of the English Department at Morehouse, who in 1967 began to discuss the idea of a research center inspired by W. E. B. Du Bois's early twentieth-century vision of an institute "which would develop a hundred-year study of the Black Experience."[38] The assassination of Martin Luther King Jr. shocked Harding and Henderson out of the early planning stage. Harding approached the SCLC and the University Center schools with the idea of organizing a "Martin Luther King Jr. Confrontation Forum" that would bring African American community leaders to speak with black students about setting a black political and social agenda in the wake of King's murder. Once some sort of consensus about this agenda was worked out, it would be presented to the various presidential candidates. While the forum never materialized, it set in motion a process in which Coretta Scott King asked Harding to head a King "Documentation Center" to memorialize King and his work. This led in turn to Harding's suggestion that an "Institute for Advanced Afro-American Studies" be included as part of the memorial center. Coretta Scott King assented to this proposal. Harding and Henderson were then joined by A. B. Spellman, sociologist Abdul Alkalimat (a founder of OBAC in Chicago), and political scientist William Strickland (a former leader of the NSM), among others, in drafting the original plan of the institute, now named the Institute of the Black World. The IBW began running seminars in 1969 and issued its first publication in 1970.[39]

In its early years, the study and promotion of African American art ranked high among the IBW's priorities, reflecting the prominent role of artists and lit-

erary scholars, such as Henderson and Spellman, in creating the institute. When listing the central concerns of the field of black studies in the IBW's "Statement of Purpose and Program," the second of ten points discussed nationalist art and the development of a theoretical apparatus to facilitate its production and interpretation through wide-ranging discussion and debate:

> The encouragement of those creative artists who are searching for the meaning of a black aesthetic, who are now trying to define and build the basic ground out of which black creativity may flow in the arts. Encounter among these artists on the one hand, and scholars, activists, and students on the other, must be constant in both formal and informal settings.[40]

Again, though the IBW was associated with the King Center, it would not have been possible without the black schools of University Center and the politicized black artistic and intellectual communities they supported — a fact that is acknowledged in the statement and in Harding's own account of the IBW's history.

Even more grassroots-oriented initiatives, such as the Center for Black Art and the journal *Rhythm*, both spearheaded by Spellman after his move to Atlanta from New York, were largely based in the radicalized black university community and were aimed at an audience significantly outside the South. In fact, one sometimes perceives a certain alienation or distance from local black communities, at least initially, in those like Spellman who migrated south and found work in the black schools of Atlanta. In a report on the Atlanta scene in *The Cricket*, a Black Arts music journal based in Newark and edited by Spellman, Amiri Baraka, and Larry Neal, Spellman clearly considers the music and arts scene in Atlanta to be backward — though he also found a rootedness in the black community of Atlanta that he felt New York lacked.[41]

Perhaps the greatest example of the strengths and weaknesses of the Black Arts movement in Atlanta deriving from this reliance on an academic base might be found in the attempt of former *Black World* editor Hoyt Fuller and others to create a Black Power and Black Arts journal to replace *Black World*. As noted in Chapter 4, with a readership in the tens of thousands, *Black World* had been the most important intellectual journal of the Black Arts and Black Power movements. Its parent company, Johnson Publications, shut down *Black World* in 1976 after a heated debate over an allegedly anti-Semitic article on the Palestinian-Israeli conflict. Anti-Semitism and the freedom of the editor, Hoyt Fuller, to publish what he saw fit were not the only issues in the debate. Also in ques-

tion was whether Johnson Publishing, which issued such popular magazines as *Ebony* and *Jet*, wanted to continue publishing a radical, though widely circulating, intellectual journal that did not make money. Of course, this had been an issue between Fuller and Johnson Publishing for years. However, the decline of the Black Power movement, in part precipitated (and certainly hastened) by the internal battles between liberals, Marxists, and cultural nationalists in such key organizations as CAP and the ALSC, diminished and divided the audience of *Black World* (which was generally inclined toward the cultural nationalist side of the movement's internal struggles). As a result, the considerable attempts to save the journal were not sufficiently unified and broad to successfully pressure Johnson Publishing into maintaining it.

The idea then was to create a new journal, *First World*, completely controlled by the movement. It would carry on the work of *Black World* without depending on the financial support of an essentially unsympathetic owner. Atlanta, Fuller's birthplace, seemed like an ideal location, given its concentration of African American colleges and universities and radicalized black faculty, including Stephen Henderson and Fuller's close friend (and later, literary executor) Richard Long, and its prominence as a national center of the civil rights movement and black studies as embodied in the King Center and the IBW. However, after a promising start in 1977, *First World* failed, publishing its last issue in 1980. Fuller's premature death in 1981 foreclosed any hope that it might be revived.

In part, *First World* suffered from the divisions that caused the movement as a whole to decline nationally. After all, *First World* was hardly the only important black intellectual or cultural journal to disappear in that era. Much of the early impetus to initiate a journal to replace *Black World* took place outside Atlanta.[42] Still, *First World*'s failure was not only due to the decline of the Black Power and Black Arts movements nationally but also to a lack of personnel and an inability to build a local support structure in Atlanta much beyond University Center that replicated the sort of network rooted in the black community of Chicago that was crucial to the success of *Black World*. This was a failure that characterized the cultural movement as a whole in Atlanta. For example, despite Atlanta's reputation as a premier center of black intellectual life in the South, apparently no viable African American theater group developed outside the confines of University Center during the Black Arts era.[43]

As a result, Atlanta became an increasingly important national hub of nationalist thought and activity without, at least in the short term, a concomitant

growth of local grassroots institutions that reached much beyond University Center. It hosted the first CAP convention in 1970, a landmark in what Komozi Woodard has termed the "modern Black convention movement," second in importance only to the 1972 National Black Political Convention in Gary. It was at the Atlanta Congress that CAP was established as an ongoing umbrella group for a wide ideological range of black political and cultural groups—though radical nationalism dominated CAP until its effective demise as a result of factional battles between Marxists and cultural nationalists in the mid-1970s.[44]

However, the Black Arts movement in Atlanta seems to have been relatively unconnected to the less academically centered movements in the South. For example, Henderson's *Understanding the New Black Poetry* did not contain any work by the writers associated with BLKARTSOUTH in New Orleans, Sudan Arts South/West in Houston, or the Theatre of Afro Arts in Miami. The poets living in the South that Henderson did include, such as A. B. Spellman, Donald Lee Graham, Keorapetse Kgositsile, and Laedele X, were almost all based in the relatively elite, historically black colleges and universities of Nashville, Atlanta, and Washington—and the more academically oriented arts institutions linked to those schools. Similarly, Black Arts theater and cultural groups from Atlanta seem to have been relatively uninvolved in the SBCA.

It should be pointed out that to dwell solely on the shortcomings and failures of the academically (and nationally) oriented focus of the Black Power and Black Arts movements in Atlanta is to miss the important role that Atlanta, Nashville, Washington, and other black academic centers played. For one thing, serious divisions between town and gown were not products of the Black Power and Black Arts era but had long attended the culture of the more elite African American colleges and universities, especially in Washington and Atlanta. Such divisions and the cultural habits they caused made it much more difficult to draw community audiences—though Black Arts scholars and artists-in-residence generally made much more of an effort in this regard than many of their less politically engaged colleagues. And, of course, many of these scholar-artists, such as Jeff Donaldson, A. B. Spellman, John O. Killens, and Haki Madhubuti, did in fact have a history in largely grassroots community–based cultural activities in other places. This uncharacteristic (for them) lack of rootedness by some Black Arts faculty serves as a reminder that the typical short-term artist-in-resident position that typified many of the early Black Arts academic appointments allowed for a stimulating experience for students and faculty who

were exposed to an exciting range of art, aesthetics, and ideologies, but it made the establishment of stable university-community cultural institutions more difficult. Finally, as noted below, the national and international status of the black academic centers and the new openness of black educational institutions to radical nationalist art and politics did eventually attract to those centers, especially Atlanta, black artists who were not based primarily in academia, such as Edward Spriggs and Ebon Dooley, who did stay for the long term and reached a significant local grassroots constituency.

Conferences at such schools as Jackson State, Fisk, Alabama A & M, Tougaloo, and Southern early on gave visibility to new black writing and aired the national debates about art and identity that had largely been restricted to study groups, workshops, and little magazines. Later in the 1960s and the 1970s, similar conferences at Howard and the University Center schools of Atlanta, notably the 1968 Toward a Black University Conference at Howard, brought together leading radical black cultural and political leaders (who were often one and the same), again providing a sense of national (and even international coherence) to now intersecting spheres of black politics, education, and art.

Atlanta today is a national African American cultural and intellectual center that shows a major nationalist and activist influence in ways that would have seemed incredible before 1960. And if, as Adolph Reed suggests, radical black organizations were unable to offer alternatives to the "black regime" of Mayor Maynard Jackson in the 1970s and the 1980s that attracted broad support within the black community, artists who had been leading Black Arts activists led cultural initiatives that *did* reach a mass audience. The advocacy of poet Ebon Dooley, a veteran of Chicago's OBAC, played a major role in extending Jackson's desire to be known as the "culture mayor" to cover grassroots arts activities in black neighborhoods rather than simply giving more money to the old, established, historically white cultural institutions.[45] One of these activities was the establishment of a black art museum, Hammonds House, in the 1980s by poet and visual artist Edward Spriggs, who had been a leader in a wide range of Black Arts institutions in New York (including the founding of the Studio Museum in Harlem), in what was then a physically declining West End neighborhood rather than downtown. It also led to Atlanta's regionally and nationally known Black Arts Festival.

It is in part due to the Black Arts movement and its impact on the students, faculties, and even administrations of the historically black schools there that

Atlanta has gained a prominence in national African American intellectual and cultural discussions that is often quite at odds with the tradition of pragmatism and conciliation often associated with its African American politicians. Similarly, while Nashville and Washington lacked the same density of black educational institutions, the traditional prestige and long-standing, if uneven, traditions of political activism of Howard and Fisk allowed those cities to make major contributions to the growth of the Black Arts as a national movement with international ties. The concentration in these black schools of students from across the United States (and from Africa and the black Anglophone diaspora) and of older radical faculty as well as teachers and staff more recently politicized by the civil rights, Black Power, and Black Arts movements provided incipient Black Power and Black Arts leaders (and rank and file) with a usable political and cultural past and an incredibly sophisticated sense of present political and cultural possibilities. And through classes, lectures, festivals, conferences, performances, and so on, these schools promoted the sense of Black Power and the Black Arts as relatively coherent movements, a sense that gained further power as these students graduated and moved around the country.

The Civil Rights Movement and the Black Arts Movement

It is impossible to detail all the ways in which the reemergent civil rights movement of the late 1950s and early 1960s influenced the Black Arts movement both in the South and nationally. As Amiri Baraka notes, the black student movement catalyzed by the sit-ins and demonstrations of 1960 helped inspire black intellectuals, artists, and political activists in the North to form politicized cultural groups and culturally aware political groups, such as the Organization of Young Men, RAM, and OGFF.[46] Of course, inspiration flowed two ways. A number of early Black Arts participants, such as Kalamu ya Salaam, Jayne Cortez, Tom Dent, Dingane Joe Goncalves, David Henderson, and Askia Touré, participated in SNCC, CORE, the FST, and other civil rights organizations in the South. Some, like Salaam, became involved in local activities as young people in the South. Others, like Cortez, Henderson, and Touré, inspired by the movement in the South, especially SNCC and the black student movement, came from the North and the West to be on the front lines for varying periods of time. And some, like

Dent, were returning southerners who had left the region to seek wider political, cultural, intellectual, and educational opportunities in the North or West.

Some of the artist-activists from outside the South, like Touré, had been part of revolutionary nationalist organizations, such as RAM, and came south with the explicit goal of moving the civil rights movement, especially SNCC, in a more revolutionary and more expressly nationalist direction. Touré (then Rolland Snellings) was part of the Atlanta Project, a stronghold of organized nationalism within SNCC, and he, along with Bill Ware and Donald Stone, co-authored crucial sections of the position papers issued by the Atlanta Project in 1966. In many respects, these papers tried to provide a theoretical argument for black self-determination or, in short, Black Power — though some considerable conflict arose with Kwame Turé and the SNCC national leadership (many of whom came from Howard's NAG) over what they saw as the Atlanta Project's tendency for unilateral actions and statements in the name of SNCC without the consensus of the broader organization.[47] While the Atlanta Project did not make much headway in Atlanta — or organizationally within SNCC — its position papers reached an audience across the United States, perhaps influencing the direction of the movement toward nationalism more in the urban North and West than it did in the South. However, even in the South, despite the organizational conflict between the Atlanta Project and the SNCC leadership, it is not hard to see how the projection of African American self-determination and the necessity of seizing and consolidating black political power, as articulated by James Boggs and other RAM mentors, helped create an ideological field from which Kwame Turé's early articulation of Black Power emerged. As many commentators have observed, Turé and SNCC did not author the slogan "Black Power" and certainly did not originate the concept. Still, Turé's call for Black Power at SNCC rallies in June 1966 was nonetheless taken (and is still taken) as a milestone inaugurating a new political and cultural era across the country.

Such radical North-South exchanges of course did not begin or end with SNCC and the student movement. Robert F. Williams, a native of Monroe, North Carolina, had been involved with both the CPUSA and the Trotskyist Left (primarily the SWP) in Detroit and New York. After an unhappy stint in the Marine Corps, Williams returned to Monroe where he became the president of an inactive branch of the NAACP in the mid-1950s. Williams revived the branch, recruiting mostly among working-class African Americans, many of them veter-

ans like himself. Williams and a local black doctor, Albert Perry, led the Monroe NAACP against unequal segregation of public facilities. Demonstrations against the exclusion of African Americans from a public swimming pool in Monroe triggered violent attacks by the Ku Klux Klan. Williams and other members of the NAACP and their supporters armed themselves and drove off their attackers.

The resulting publicity and Williams's open avowal of the right of African Americans to defend themselves physically against racist violence made him a target and a hero. He was not only targeted by the Klan and various levels of government but also by the national leadership of the NAACP and those in the civil rights movement, especially those philosophically committed to nonviolence, who feared that his stance would isolate and endanger less directly confrontational civil rights efforts. Quite a few civil rights activists with varying degrees of sympathy for or hostility to Williams and with widely divergent politics, from national NAACP leader Roy Wilkins to SCEF's Carl Braden, supported the idea of self-defense in the face of racist vigilante violence but questioned Williams's wisdom in announcing this position publicly in the press.[48]

However, it was precisely Williams's willingness to articulate his stand on armed self-defense, his grassroots activist approach to political struggle, and his increasingly evident radicalism (which would eventually include the notion of revolution through armed struggle) as he became a political refugee (first to Cuba and later to China) that both anticipated and inspired the revolutionary nationalists of the Black Power movement. His uncompromising rhetoric, with its call for "Freedom Now or Death!" and the announcement that "we must be willing to kill for freedom," made him a powerful symbol of the political and cultural direction in which many young militants wanted the African American community to head.[49] Also, Williams's persecution by the federal government and his resulting flight were themselves dramatic events that precipitated the formation of the nuclei of what would become RAM, the AAA, and other proto–Black Power groups. It is not surprising that when Muhammad Ahmad and others organized RAM, they took Williams as their titular leader, though Williams himself never subscribed fully to their separatism and what he, perhaps ironically, considered their adventurism.

Williams's radio program broadcast from Cuba, *Radio Free Dixie*, and his book *Negroes with Guns* electrified black radicals with their bold advocacy of armed self-defense and militantly internationalist (if not always ideologically consistent) denunciations of North American racism and imperialism. How-

ever, it was his newspaper, *The Crusader*, printed first in North Carolina, later in Cuba, and finally in China, that became a semi-underground voice of post-Bandung revolutionary nationalism and a means for organizing black activist artists and intellectuals, particularly those in and around RAM. The greatest impact of *The Crusader* on the growth of the Black Arts movement had more to do with facilitating the creation and expansion of networks of politically radical artists and activists than with a direct ideological or aesthetic influence. The newspaper in its early days devoted little space to articles on black art and culture and published few literary works or reproductions of visual art other than political cartoons and Williams's own formally conservative poetry. However, the selling and circulation of *The Crusader* itself bound RAM members together and gave them a tool for approaching other black intellectual-activists. Similarly, the various committees formed to support Williams in his struggle with the federal government served as meeting grounds where black artists worked with political organizers. Amiri Baraka met Williams on a Left-led tour of Cuba under the auspices of the Fair Play for Cuba Committee. It was largely Baraka's interest in Williams (and his subsequent membership in the Monroe Defense Committee) as well as in the efforts of the black student movement in the South that inspired him to start the Organization of Young Men, a crucial step in Baraka's movement toward Black Power and the opening of BARTS.[50] One might say that Williams, both as an activist and as an inspirational figure, embodied the multidirectional circuit between northern and southern black activism from the 1960s through the 1970s.

A plausible beginning for the Black Arts movement in the South, and an example of the complexities and contradictions of radical black cultural interchange between North and South, can be pegged to the birth of the FST in 1963 under the auspices of CORE and SNCC. The FST's founders, John O'Neal, Doris Derby, and Gil Moses, young African Americans from the North with disparate backgrounds in student, community, and avant-garde theater, had come to work in the civil rights movement in Mississippi. O'Neal and Derby were originally field directors for SNCC and Moses a reporter for the *Mississippi Free Press*, a civil rights movement newspaper. Their initial conception of the FST was a necessarily inchoate combination of agitation, community cultural access, and avant-garde aesthetics—a sort of mix of the San Francisco Mime Troupe, Karamu House, the Living Theater, and the FTP.[51] The FST originally based itself at Tougaloo College near Jackson, Mississippi. In 1964 it moved to New Orleans

in search of greater material resources for the theater—and, to be honest, an environment more attractive to trained theater workers from outside the region than rural Mississippi (or even a small black college in Mississippi). In New Orleans it quickly took on more of the character of a professional traveling repertory theater.

From the beginning, a number of contradictions characterized the group. The members took seriously the notion of being of, by, and for the southern African American community, especially in the rural areas of Mississippi, Georgia, and Alabama (which became the primary focus of SNCC after it moved its base of operations off campus) and of Louisiana (where civil rights fieldwork was dominated by CORE). But the FST's members were for the most part young black and white theater workers from the North. It also saw itself as having multiple, not always easily reconcilable, missions. One was to present drama that directly addressed and supported the campaigns of SNCC, CORE, and other civil rights organizations in the rural South. Another was to expose poor, often rural, African American audiences to "serious" modern drama, from Samuel Beckett's absurdist classic *Waiting for Godot* to Ossie Davis's *Purlie Victorious* (a satiric farce drawing on the southern black trickster tradition), since these audiences had generally been directly or indirectly denied access to "high" culture. Thus, the early repertoire of the troupe sometimes seemed stylistically and thematically incoherent, though often exciting to its intended audience. In a similar vein, the theater also regularly presented new, avant-garde black poetry as part of its performing program, especially after 1965. For example, Tom Dent's old colleague from the Umbra Poets Workshop in New York City, David Henderson, joined the company on its 1967 tour, reading such formally challenging poems as "Keep on Pushing" (which was already part of the FST program) to interested, if sometimes puzzled, audiences for whom Henderson's verbal collage corresponded little to their notion of what was poetry—much like *Godot* had differed from their expectations about drama.[52]

The troupe also seriously committed itself to promoting a truly southern African American theater, attempting to develop a new repertoire, new actors, new playwrights, new directors, and so on through a number of workshops. Yet a persistent topic of discussion during the group's history was how to attract and retain high-quality, formally trained African American theater workers (almost necessarily from outside the region) rather than relying on local actors, playwrights, and stage managers that the workshop itself trained.[53] The move

of the theater from Tougaloo College to New Orleans highlights this contradiction, since to a large extent it represented the triumph of professionalism over activism. Not surprisingly, this move occasioned the FST's first major debate as some, including Doris Derby, felt that moving away from Mississippi and the center of civil rights field activity was a mistake. In fact, Derby did not make the trip to New Orleans but chose to stay in Mississippi, where she worked in SNCC's literacy program.[54]

As the Black Power and Black Arts movements gathered steam, especially after 1965, the FST moved toward a more nationalist stance, abandoning the work of European and Euro-American modernist and postmodernist playwrights and focusing on a more strictly African American body of work. Similarly, the personnel of the theater became largely, though not entirely, African American.[55] However, some of the other conflicts, such as whether to maintain the theater as a relatively elite professional group with actors and directors drawn primarily from the North, especially New York, or to become a genuine community theater committed to producing the work of local people and casting "nonprofessional" southerners in principal roles, remained throughout the group's existence.[56]

The focus of the FST's workshops became wider after Tom Dent joined the group following his return to his native New Orleans in 1965. As mentioned above, Dent had been a key figure (arguably *the* key figure) in the seminal Umbra Poets Workshop and a familiar presence in the new African American bohemia on the Lower East Side of New York.[57] Through the acquaintances he had made in New Orleans (where his father was president of Dillard University and his mother a concert pianist) and in New York (where he had worked for the NAACP Legal Defense and the black newspaper *New York Age*), Dent knew a wide range of prominent and less-prominent African American intellectuals, artists, educators, and political activists in New Orleans and across the United States.

One aspect of Dent's experience with what Lorenzo Thomas has called the "shadow world" of black grassroots artists, intellectuals, nationalists, and leftists in the Lower East Side and in Harlem was the deepening of an already present sense of the importance of artistic and intellectual ancestry. This sense caused him to search out the New Orleans counterparts of this shadow world when he returned to the South.[58] He became knowledgeable about, and sought relationships with, neighborhood artists and grassroots intellectuals, such as the jazz guitarist, banjo player, and composer Danny Barker, the poet, printer, and his-

torian Marcus B. Christian, and the poet Octave Lilly. Barker's musical experience reached back to the classic New Orleans jazz of Sidney Bechet and Buddy Bolden but also included stints in Benny Carter's and Cab Calloway's bands in New York during the swing era. Christian and Lilly were veterans of a vibrant Popular Front political and cultural scene in New Orleans during the 1930s and 1940s in such groups and institutions as the FWP, the People's Defense League, and the militant, Depression-era leadership of the local NAACP. Lilly had been part of the executive board of a branch of the NAACP in New Iberia, Louisiana, that forcefully contested segregation and African American disenfranchisement in the early 1940s until violence (and threats of worse violence to come) by the sheriff's department forced Lilly and other leaders of the branch out of town in 1944. Christian's poetry had long utilized New Orleans street scenes and black vernacular diction and rhetorical forms to depict local police brutality, racism, and Jim Crow as well as to render southern black responses to national and international events, such as the Italian invasion of Ethiopia in 1935 and the Supreme Court's 1954 *Brown v. Board of Education* decision. Dent's efforts to establish such relationships frequently met resistance, since the older writers were often alienated by what they perceived as the lack of cultural memory among the younger militant artists. In other cities, such older artists as Margaret Burroughs, John O. Killens, Langston Hughes, and Dudley Randall took it upon themselves to remind younger political and cultural activists of their predecessors even as they supported the Black Arts and Black Power movements. In New Orleans, older artists were often less forthcoming—though Christian did publish in *Negro Digest/Black World*. However, one of Dent's special gifts, again no doubt cultivated through his close relationships to Langston Hughes, Esther Cooper Jackson, and other older black artists and intellectuals in New York, was his winning drive to convince his peers of the importance of such living repositories of African American artistic memory and experience as Barker, Christian, and Lilly. Another complementary gift was his ability to woo these older writers from their antagonistic stance into a new appreciation of the work of the young Black Arts activists.[59]

Dent's varied connections proved extremely useful in grounding New Orleans Black Arts activists in local neighborhoods and in the long foreground of African American political and artistic radicalism in New Orleans, while encouraging communication with like-minded artists and intellectuals throughout the South. This was particularly important because, as Dent and other southern cul-

tural activists pointed out, the Deep South, especially beyond the campuses of the historically black colleges and universities, was largely outside the national Black Arts circuit that developed between the West, Midwest, and Northeast.[60] This southern network facilitated by Dent's multileveled local, regional, and national contacts also helped to support and disseminate the notion that there was a strong and diverse black artistic and intellectual tradition on which local writers could build without feeling themselves to be provincial or second-rate in comparison with what was going on in New York, Chicago, Detroit, or the Bay Area. In other words, Dent's connections and enthusiasm helped make it possible to imagine that an older jazz musician like Danny Barker, a younger avant-garde jazz musician like clarinetist Alvin Baptiste, an older writer like Octave Lilly, a younger writer like Kalamu ya Salaam or Quo Vadis Gex Breaux, and the theater workers of the FST might all be part of a dynamic New Orleans African American arts tradition when previously there had been some suspicion or hostility between many of these artists. This is not to say that ideological, aesthetic, and general differences did not remain but that a new framework for dialogue and the imagining of community was established.[61]

Dent had not had much direct experience with the theater before his return to New Orleans from New York. Nonetheless, he found the FST the most aesthetically, intellectually, and politically exciting cultural institution in New Orleans. As he wrote to Langston Hughes, with whom he had formed a close relationship during his time in New York, "For the first time, we have an organization with the potential of a *cultural revolution* for theater, art, that deals with how we should live our lives, not the mechanics of money and power."[62]

Gradually Dent's involvement in the organization grew, and he performed a variety of artistic and administrative roles in the theater, including chairman of the theater's board in one of the FST's financially and ideologically most difficult periods as it made the transition from being an integrated company to being a black theater (albeit with a small number of white members). Thanks to his work in Umbra, Dent also had a great deal of experience in the mechanics of organizing and maintaining a writers' workshop. Ultimately, he ran the writers' workshop of the FST that coexisted with a playwrights' workshop headed by Robert "Big Daddy" Costley.

When the professional touring portion of the theater suspended operations in 1967 due to the loss of funding, the workshops came to the fore of the group. By this time, the Black Arts movement had a much clearer sense of itself as a

national movement, albeit one with considerable local variations. Since many of the same people belonged to both FST workshops, a decision was made to merge the two. This enlarged workshop of the FST began to publish the journal *Nkombo* in 1968 and provided the core of what became BLKARTSOUTH.[63]

BLKARTSOUTH and the Emergence of a Southern Black Cultural Network

BLKARTSOUTH arose out of the enlarged FST workshop in 1968, growing into a performance-oriented, community-based poetry and theater collective. BLKARTSOUTH separated itself from the FST largely over the question of whether the primary focus of the group should be on building an indigenous New Orleans (and southern) theater and literary organization geared toward developing local artists, local audiences, and a local body of dramatic work, or whether the company should continue to be oriented toward New York and the various segments of the national theater industry embodied in "Broadway," "Off-Broadway," and "Off-Off-Broadway."[64] The only member of BLKARTSOUTH with any sort of national reputation at the time of the group's founding was Tom Dent—though Kalamu ya Salaam (Val Ferdinand) quickly attracted some attention outside the region as a playwright. (Salaam's 1969 *Blk Love Song #1* was included in James Hatch's landmark 1974 anthology *Black Theatre USA*.) The BLKARTSOUTH ensemble was far different from the professional touring unit of the FST in that it was made up almost entirely of local New Orleans people (or if, like Nayo Watkins, they were from somewhere else, they came to the workshop as people living in local communities rather than as recruited professionals from up north) and was dedicated to presenting the original work of its members.[65]

Shortly after the founding of BLKARTSOUTH, the group began performing outside New Orleans in a variety of venues ranging from schools and university auditoriums to public housing project courtyards across the South. In part, BLKARTSOUTH was able to organize these performances through the contacts of Dent and the FST. Another important factor was the involvement of many members of the group in practical political work through such Black Power organizations as CAP and the ALSC, which had strong bases in the South. As was the case in many areas of the Black Arts movement, the lines between the performing ensemble and the political groups to which the artists belonged often were quite blurry. For example, members of BLKARTSOUTH (and later the Kawaida-

ist Ahidiana Collective organized by Salaam and others from BLKARTSOUTH) would travel the South doing political work for, say, the ALSC while also setting up performances of poetry, music, and drama, and vice versa. In other words, the circuits for certain sorts of grassroots political organizing and for grassroots, community-oriented arts performances were often the same.[66] Like the Black Arts movement elsewhere, this led to some different artistic orientations or emphases among the workshop participants. As BLKARTSOUTH activist Nayo Watkins recalls, their efforts in the workshop and later in the traveling groups "were part of the movement, part of the struggle," rather than those of professional performers or aspiring professionals, as such. In short, some members of the group thought deeply about literary careers and publishing while no doubt valuing the political work they were doing. Others, such as Watkins, had only minimal interest in publishing but were primarily concerned with doing grassroots cultural work toward the political ends of black empowerment, black pride, and black self-determination that would leave little or no published record.[67] However, one thing that seems to have distinguished BLKARTSOUTH and the community-oriented movement that it inspired with its tours across the South was an intense focus on doing work in the region and building a southern Black Arts infrastructure, even on the part of those most concerned with artistic posterity. This sort of anticareerist, anticommercial attitude (an early version of the later movement cliché "think globally, act locally") on the part of many in the New Orleans Black Arts movement no doubt led to its tremendous local and regional impact but ultimately reduced its ability to project a profile outside the region (and made it more difficult for later scholars to evaluate).

The tours, as well as the orientation and openness of BLKARTSOUTH's journal *Nkombo* toward southern black artists outside New Orleans, inspired African American artists in other cities to set up groups in much the same spirit, particularly the Sudan Arts South/West in Houston and the Theatre of Afro Arts in Miami (whose leader, Wendell Narcisse, a New Orleans native, became the president of the SBCA and joined Dent and Salaam as editors of *Nkombo*). Other groups within this southern African American arts network included the Black Arts Workshop in Little Rock, Arkansas, the Black Belt Cultural Center and the Children of Selma Theater in Selma, Alabama, the Blues Repertory Theatre in Memphis, Tennessee, and the Last Messengers in Greenville, Mississippi.

At the same time, the New Orleans Black Arts activists extended the reach of their cultural network through participation in large cultural events with

nationwide audiences held at southern, historically black colleges and universities. For example, the critic and poet Jerry Ward met Tom Dent at the 1973 Phillis Wheatley Festival at Jackson State in part through another poet and critic, Sarah Webster Fabio, a former southerner who made her reputation in the Bay Area. Ward, a faculty member at Tougaloo College and a Mississippi native, hit it off with Dent and played a significant role in the SBCA, which was founded in that same year. Ward would also become a member of the Coordinating Council of Literary Magazines along with Toni Cade Bambara and Ishmael Reed in the late 1970s and early 1980s, broadening the awareness about southern black artists and arts institutions across the country.[68]

As noted above, Houston became a particularly dynamic locus of African American artistic production in Texas and a pillar of the SBCA. Rahsaan Connell Linson, Muntu Thomas Meloncon, Harvey King, Sidney Wilson, and Bill Milligan met in a Houston parking lot in the summer of 1968, where they discussed the need for a nationalist cultural and political group aimed at radicalizing young African Americans. Their discussion resulted in the Progressive Youth Movement, based in the old Fourth Ward black community near downtown Houston. However, the group had a difficult time figuring out a program and a structure that would allow them to successfully reach their target audience. A visit by the FST touring group in the fall of 1969 and a discussion with Kalamu ya Salaam about black culture, organizing, and institution building led them to create poetry and dance performing groups with allied workshops along the lines of the FST and BLKARTSOUTH under the auspices of Sudan Arts South/West. Much like Salaam (and perhaps largely through Salaam), the Sudan Arts collective was heavily influenced by Maulana Karenga and his seven principles (*Nguzo Saba*) to guide both its daily and long-term practices. Linson, the group's initial director, founded the Black Arts Center that became the anchor of Black Arts activity in Houston, serving as a performance space and school with classes in writing, drama, dance, music, and the visual arts and largely supported by various sorts of antipoverty program money—resembling Studio Watts in Los Angeles, the Affro-Arts Theater in Chicago, and BARTS in New York, though having more direct interaction with other non–African American cultural institutions than those organizations did.[69]

Early Black Arts writers in Houston were joined by artists who had been active in the movement in other regions, including Lorenzo Thomas (a member of New York's Umbra Poets Workshop who moved to Houston in 1973 and

quickly became a leading figure at the Black Arts Center and in the Houston poetry scene generally) and Ahmos Zu-Bolton (a native of De Ridder, Louisiana, who had edited *Hoodoo Magazine* in Louisiana, Washington, D.C., and elsewhere). Zu-Bolton was the chief organizer of the HooDoo Poetry and Culture Festivals that took place in a variety of cities in the late 1970s, including Galveston in 1979 and Austin in 1980. The Texas HooDoo festivals included a significant number of Chicana/os, epitomizing a sort of Texas Black Arts multi-cultural cross-fertilization that occurred in the South much more rarely than on the West Coast, despite Texas's pivotal role in the political and cultural activities of the Chicano movement. However, despite the cultural nationalist orientation of the Sudan Arts group and the leadership of the Black Arts Center, their activities took place within a multicultural context that featured much interaction, if not precisely integration, between African American, white, and, to a lesser extent, Chicana/o artists and institutions.[70]

Out of the Gumbo: *Nkombo* and the Southern Black Cultural Alliance

The unified FST workshop, and later BLKARTSOUTH, issued the journal *Out of the Gumbo*, later renamed *Nkombo* (the Bantu word from which "gumbo" is derived). Like the workshop, *Nkombo* was geared in the first place toward members of the workshop and then more generally to southern black writing. The editors purposely published very few pieces by writers of any status from outside the South. While this focus helped create a certain sense of community, some New Orleans artists, especially Tom Dent, who eventually coedited the journal with Kalamu ya Salaam and Wendell Narcisse, came to feel that the exclusion of writers from other parts of the country limited the ability of BLKARTSOUTH and *Nkombo* to gain attention outside the South.[71]

This raises the question of whether and to what degree the Black Arts activists of New Orleans and other parts of the South, especially Houston and Miami, saw themselves as southerners in any deep sense. Some, notably Kalamu ya Salaam, found the notion of being "southern" a somewhat troubling or false label. While the New Orleans Black Arts artists were definitely living in the South, being a "southern" writer in that moment carried the connotation of having something in common with Flannery O'Connor, Allen Tate, Robert Penn Warren, and William Faulkner, associations that many of the younger activists rejected.

In other words, the terms "southern literature," "southern renaissance," and "southern culture" were for them ideological terms advanced by neo-Fugitive, Lost Cause white critics, terms that were virtually defined by a second-class status for African Americans. There was also a feeling that such a regional identification weakened or erased the essential commonalities between people of African descent throughout the United States (and beyond the borders of the United States). Others, especially Tom Dent, had a strong sense of being southern and of the need for black artists in the South to organize themselves regionally in order to break through what they perceived as the indifference or possibly even condescension of the black cultural institutions and activists in the West, Midwest, and Northeast—even if these others, too, felt little sympathy for the work of Allen Tate, Robert Penn Warren, and John Crowe Ransom.

Such a sense of a regional common interest led to the birth of the SBCA. Dent was a prime mover behind the establishment of the SBCA, which grew out of a conference of southern black theaters and cultural groups at West Point, Mississippi, in 1972.[72] The SBCA, at least in Dent's view, extended the project of *Nkombo*. It was originally intended to be a coalition of African American artists and cultural institutions across the South that would serve not simply as a support network for maintaining and developing African American expressive culture in the South but also as a vehicle for gaining serious recognition (and support) for southern black artists beyond the region in the face of the neglect of national Black Arts institutions outside the South.[73] In fact, the first objective of the SBCA bylaws was "to produce, exhibit, and promote cultural attractions of our members; including drama, musical performances, intellectual, instructive, and educational entertainment to all parts of the country."[74]

The SBCA had limited success bringing southern black theater and literature to the attention of the movement beyond the South—though some well-known theater groups and arts centers based outside the South, such as Cleveland's Karamu House, New York's Black Theatre Alliance, and San Francisco's American Conservatory Theatre, did occasionally participate in the SBCA annual conferences.[75] No doubt this was in part because the SBCA grew and was most active as the larger Black Arts movement began to decline and institutions with a nationwide profile failed, such as *Black World* (which did publish essays by Dent and Salaam on the work of the SBCA and its members in an annual theater survey) and *Black Theatre* (which also published reports about New Orleans's African American theater activity and listed Tom Dent on its masthead

as the New Orleans correspondent). Another factor, as Dent suggested, was the almost exclusive focus of *Nkombo* and other southern Black Arts institutions on regional artists and arts groups. However, this focus also allowed the SBCA to strengthen and extend a support network of black cultural workers across the South, from Houston to Miami, holding important events in Alabama, Arkansas, Florida, Georgia, Louisiana, Mississippi, North Carolina, Tennessee, and Texas. The SBCA survived into the 1980s, much longer than most Black Arts institutions.[76] The survival of the SBCA serves as a reminder of the uneven development of the Black Arts movement that cohered somewhat later in the South than elsewhere in the United States but lasted longer in part because the bitter factional struggles between Marxists and cultural nationalists that wracked the movement elsewhere were more muted in the South, especially outside Atlanta.

As was true elsewhere in the country, some of the strengths of the movement and the peculiar opportunities of the political moment of the late 1960s and 1970s became liabilities for the long-term survival of the southern network of institutions growing out of the Black Arts movement in New Orleans. Various types of grant money and other sorts of local, state, and government support for grassroots and even radical black cultural activities and groups in the South became available in ways that had been unheard of before, even during the New Deal. However, as Jerry Ward points out about the arts scene in Mississippi in the 1970s, there were limits imposed by this funding that caused these institutions to run into political and economic walls, particularly as the political climate changed. While cultural initiatives aimed at the black community continued, many became increasingly commercially oriented and operated by a relatively apolitical (or highly political, in a narrow careerist sense) arts bureaucracy rather than grassroots activists, restricting the sorts of radical politics that had been the hallmark of BLKARTSOUTH and the groups it influenced — much like the Watts Festival in Los Angeles. Ward cites the Southern Arts Endowment as an especially powerful financial engine that pushed southern black cultural activities in this depoliticized direction during the late 1970s and the 1980s. This is not to say that many sincere artists and administrators did not try to keep true to their original political principles while accepting public money, but they were under increasing pressure to rein in their programs ideologically, especially as popular counterpressure diminished.[77]

Both Dent and Salaam agreed that whether or not being southern as such was an important factor in defining the identity of black artists in New Orleans and

elsewhere in the South, the fact that the artists were located, and chose to stay, in the South limited their exposure outside the region. As Salaam and Dent pointed out, even in venues outside the region where notice was taken of the work in the South, as in the annual theater issues of *Negro Digest/Black World*, local people had to write the reviews because no critics from New York, San Francisco, or Chicago would ever come down to see those productions for themselves.[78] Virtually the only major consideration of indigenous southern Black Arts work by someone outside the region was Abraham Chapman's 1972 anthology *New Black Voices*, which featured a section of BLKARTSOUTH poetry (including the work of Dent, Salaam, Isaac Black, Renaldo Fernandez, Nayo Watkins [then Barbara Malcolm], John O'Neal, and Raymond Washington) and a prose piece by Salaam about BLKARTSOUTH in the "Criticism" portion of the book.

Black Aesthetics versus the Black Aesthetic: Poetics and the Black Arts in New Orleans

In many respects, the Black Arts movement in New Orleans and in the cities that BLKARTSOUTH influenced, especially Miami and Houston, consciously marked out a particular ideological and aesthetic space for itself within the context of the larger movement. The group's leading members put forth theoretical statements, position papers, manifestos, editorials, and so on, adapting the popular avant-garde stance that I have primarily associated with the Black Arts movement in the Northeast. Like Amiri Baraka, Larry Neal, Askia Touré, James Stewart, and others, Tom Dent and Kalamu ya Salaam posited a usable past and present that included Louis Armstrong, Professor Longhair, Danny Barker, Otis Redding, James Brown, and John Coltrane. However, as the juxtaposition of the names of New Orleans–based or associated musicians (Armstrong, Longhair, and Barker) with other southerners (Redding and Brown) and nonsoutherners (Coltrane) in the above list suggests, BLKARTSOUTH revised the popular avant-garde model to authorize a kind of localism and regionalism to a degree that was unusual elsewhere. In other words, James Stewart might have tried to ground Coltrane's aesthetics in a sense of the black working-class music scene of Philadelphia, but he did not claim that Coltrane's music undergirded and validated black Philadelphian or Mid-Atlantic art as distinct from that in New York or Chicago — not prominently in print at any rate. However, Dent, Salaam, and the BLKARTSOUTH and *Nkombo* groups did make precisely such claims about

New Orleans music and the Black Arts movement there, while placing them in a larger national tradition, despite the already noted ambivalence on the part of some of them about being identified as "southern."

At the same time, unlike the movement elsewhere, especially in the Midwest, the BLKARTSOUTH artists put much less priority on the immediate development of a Black Aesthetic that could guide the composition and evaluation of African American writing and other forms of expressive culture. This is not to say that the BLKARTSOUTH activists were antitheory as such—a number of them would go on to form the Maulana Karenga–influenced Ahidiana Collective that was much concerned with education, study groups, neo-African theory, and so on. However, BLKARTSOUTH was generally unsympathetic to the notion of defining and rigorously applying ideological-aesthetic guidelines for black writing, a lack of sympathy that, again, was linked to a sort of localism. This reluctance, or even opposition, to such definitions is particularly seen in the post–Black Arts era statements about the formal, thematic, and ideological diversity of Black Arts participants in New Orleans:[79]

> Philosophically our workshop covered a wide range of opinions and beliefs and we tried our best to express the widest degree of tolerance. Can you imagine that within one poetry group we had practicing Catholics and practicing Black Muslims? Moreover, because we were from New Orleans, our skin hues, social/religious backgrounds, and individual expressions covered a very broad spectrum. One of our members had naturally blonde hair and blue eyes. Undoubtedly our collective's obvious broad spectrum of hues contributed to our concept of blackness which stressed consciousness and culture much more than race.[80]

This sort of ideological and even phenotypic diversity was echoed by Dent's notion of the stylistic heterogeneity of the group that he contrasted to the more proscriptive Black Arts stances of a number of Black Arts movement artists and critics elsewhere, such as Addison Gayle Jr., whom he saw as allied with an overly rigid sense of ideological and aesthetic blackness. Dent only partially connected his own attraction, and by extension the attraction of his FST writers' workshop, to a multivocal and multivalent stylistic diversity rooted in the cultural history of New Orleans. He also linked it to his experience in the Umbra group, where there was no consensus on questions of form or ideology.[81] Yet as is seen in Salaam's statement about a "concept of blackness that stressed conscious-

ness and culture much more than race" while also highlighting not merely the group's phenotypic diversity but also its aesthetic and religious variety (in other words, culture), there was an ideological-aesthetic tension between notions of localized diversity and black national unity.

This raises the difficult question of the relation of the New Orleans notions of blackness and multiculturalism to the sorts of Black Arts radical, multicultural models that emerged in the Northeast and in the Bay Area. The Northeast remained heavily influenced by the New Negro Renaissance diasporic notion of Harlem as "the race capital of the world." There is a sense about, say, the Black Arts–Nuyorican interactions in New York and elsewhere in the Northeast that they fit within a fundamental African-centered cultural (and historical) commonality between African American, African Caribbean (English-, French-, Kreyol-, and Spanish-speaking), and African cultures — particularly after the center of black cultural gravity shifted back uptown to Harlem from the Lower East Side (where multicultural Black Arts formations, such as the MFY program directed by Woodie King Jr., resembling those of the West Coast did exist). Rather than a sort of multicultural unity based on a common encounter with racism and/or imperialism, a Pan-Africanist sense of a fundamental kinship often marks the alliance between the work of Black Arts and Nuyorican artists (a number of whom were in fact Black Arts activists). In short, African Americans and Puerto Ricans were both seen as culturally "of Africa" rather than simply "of color." Yet in this view, strangely, despite diasporic alliances, these artistic groupings for the most part remain distinct even as they are in close cultural and geographical proximity to each other in the South Bronx, Harlem, Central Brooklyn, and so on. When Nuyorican artists did join in Black Arts activities, as did Felipe Luciano and Victor Hernandez Cruz, it was generally with the sense that they were in some way black, not just "of color," allies. The West Coast, especially the Black Arts and Third World arts scene of the Mission District in San Francisco, was heavily marked by the existence of large and long-standing Chicana/o, Chinese American, Japanese American, and Filipina/o American communities that had historically experienced a wide range of de jure and de facto discrimination based on some notion of race. Furthermore, these non–African American, Third World subcultures were connected, at least symbolically, to ancestral cultures that had (with the exception of Japan), like Africa, suffered from European and North American colonialism or semicolonialism. Thus, Black Arts multiculturalism in the Bay Area, which existed alongside the

cultural nationalism of such artist-activists as Marvin X and Jimmy Garrett, was informed by a notion of Third World solidarity and common cause that was not basically diasporic in orientation — or if it was diasporic, then it was a sort of comparative or relative diasporicism.

New Orleans, on the other hand, has a long-held and highly advertised tradition of cultural and physical intermixture between different nationalities and races that collided with its history of Jim Crow segregation. To a large degree, this reputation as a cultural "gumbo" resulted from the dual existence of (and often collision between) a residual French and Spanish approach to racial definition and an American approach. The "Latin" approach recognized categories beyond "black" and "white" and did not, for the most part, find the notion of a "free person of color" an oxymoron. The "American" take on racial identity basically admitted only categories of "black" and "white" (at least in theory) and considered the notion of a "free" African American (or later, an African American citizen) to be a contradiction to the logic of the slave system (and eventually Jim Crow). The notion of New Orleans's cultural intermixture also derived in part from the city's identity as a major port and entry point for both forced immigration, as in the case of the enslaved Africans, and more or less free immigration, as in the case of the Irish, Germans, Jews, and Italians (especially Sicilians) who flooded the city in the nineteenth and early twentieth centuries.

The usual New Orleans myth of multicultural French, Spanish, English, and American interchange and intermixture presented certain problems for the Black Arts movement. For one thing, as Tom Dent argues at length in the poem "Return to English Turn" (referring to the name of a bend in the Mississippi River), all these cultures were essentially those of the slave owners and/or colonialists in Africa and their descendants, so that in some important senses they could never be completely the cultures of the slaves and their descendants, leading the poem's speaker to call for

> no more english turns
> no more spanish turns
> no more french turns, portuguese
> or german turns[82]

Another problem was that the ideological persistence of elements of the old French and Spanish system of racial classification distinguishing between "black" families and old "*gens du colour*" had the effect of dividing the African

American community and preventing what Dent saw as the unity of identity and values possessed by African Americans in Mississippi, where the "American" system was not obscured by wrought iron and Creole cottage nostalgia. For Dent and the other BLKARTSOUTH artists, lingering notions of "Creole" or "*gens du colour*" served as a sort of false consciousness for African Americans in New Orleans. In general, one finds few of the Frenchisms so common in popular representations of life in New Orleans (and Louisiana) in the work of the BLKARTSOUTH writers, except in carefully defined historical contexts, such as in "Return to English Turn." Thus, as Dent and Salaam would argue, one of the challenges the Black Arts movement in New Orleans faced was how to put forward a notion of blackness and African American nationhood in the face of the New Orleans myth.

At the same time, there is in the poetry and editorial work of the BLKARTSOUTH writers, especially New Orleans natives like Dent and Salaam, a sense of the cultural complexity of African American culture. In this sense, their choosing *Out of the Gumbo* for the name of the group's journal is revealing, since it both contains the "gumbo" metaphor suggesting cultural, thematic, and formal diversity and inclusiveness while it transposes the metaphor into an overtly African register—a transposition made even clearer when the journal's name was revised to *Nkombo*. Thus, there is within the work and criticism of the BLKARTSOUTH group a sense of African Americans containing within themselves and within their community a sort of multicultural identity that is essentially black but also complex and not easily separable into different components. It is this complexity to which Salaam alludes in his previously quoted description of even the physical range of the groups members and that underlies his sense (and Dent's) of the wide range of formal options available to the black poet. As a result, as Jerry Ward points out, though the BLKARTSOUTH artists were by and large committed to the notion of a black nation, they strongly resisted what they viewed as overly rigid, narrow, or premature attempts to define that nation culturally and ideologically:[83]

> We feel that what we're doing is a relatively new thing in our environment. Our molds aren't quite set yet. Like jazz, what we're doing is constantly moving; the changing same. Right now all we're trying to do is get our work out there and be honest about the things we put out. Maybe two or three years from now we'll be able to set down some standards to judge our work by

(real standards and not personal considerations, likes and dislikes, theoriz-ing from "one-eyed" critics) . . . The whole problem centers around the fact that critics invariably want to judge Black artists at their first note. They are afraid to allow the BLKARTS to grow.[84]

While Salaam here is in part addressing white critics, or black critics hostile to the Black Arts movement, he also clearly aims at Black Arts critics who were, he and other BLKARTSOUTH activists felt, attempting to define the movement too soon. This stands in contrast to Haki Madhubuti, Carolyn Rodgers, and others in the Midwest (and elsewhere) who felt that if the movement were going to really mature, some sort of black theoretical and critical infrastructure needed to be developed as soon as possible and that in many respects the black critic had to take the lead.[85] At the same time, Salaam's adoption of Baraka's phrase "the changing same," invoking the iconic Amiri Baraka as the most prominent Black Arts figure (especially for Black Arts activists), and, indeed, the name of the group itself, clearly situates the work of BLKARTSOUTH both within the larger movement and Black Arts discussions about what might be the essential character of a national African American expressive tradition.

In practice, the poetics of the BLKARTSOUTH core demonstrated this tension of trying to balance an identification with the larger movement (and a corre-spondingly broad sense of a black nation) with a sense of the diversity of black culture, black art, and even the types of black people dictated by their under-standing of local traditions — an understanding complicated by a rejection of mainstream myths of New Orleans's history and culture. The diction of most of their work favored some version of African American vernacular speech or else language less specifically "black" but still generally colloquial and inflected at key moments by a stylized African American syntax, vocabulary, and pro-nunciation (in a tradition of black poetry reaching back to, at least, Frances Harper, Fenton Johnson, and James Weldon Johnson in the late nineteenth and early twentieth centuries). Interestingly, except for Tom Dent (who also wrote under the name "Kush"), few of the BLKARTSOUTH poets attempted to en-gage the particular landscape and history of New Orleans. Rather Salaam, Nayo Watkins, Raymond Washington, and Renaldo Fernandez tried to delineate a less geographically specific landscape of the urban ghetto that was filled with landmarks and concrete details that would seem familiar to African Americans living across the United States. For example, Salaam's "For my wife when i do

that thing," from his first collection, *The Blues Merchant* (1969), mentions such New Orleans landmarks as "the lake," "the seawall," and "concrete beaches." However, such landmarks could as easily be from Chicago, Cleveland, or Detroit as New Orleans. The title poem of the collection does use "gris-gris," a New Orleans–associated term referring to the talisman bags commonly used in syncretic African American voodoo practices. The diction of "THE BLUES MERCHANT" is also given the distinctly New Orleans inflection of a black street merchant calling out the names of his goods with political commentary:

GOOBER DUST BE BOUT THE ONLY THING
WHAT KEEP FALLOUT OFF YA ASS WHEN THEM LIL
RED CHINESE LAND
 BLUES FOR SALE
AND GUNS TOO[86]

Here, in a New Orleans adaptation of the sort of vernacular humor Langston Hughes used in many of his "Simple" stories, the speaker comically comments on a shifting international order and the inevitable doom of imperialism in the age of Third World liberation—though Salaam's position vis-à-vis the speaker and his street audience seems a little more ambivalent than Hughes's toward Jesse Semple.

However, more typically, the early work of Salaam and the rest of the core of BLKARTSOUTH (with the exception of Dent) focuses on an iconic documenting of the condition and experience of the black nation. This documentation in spirit resembles Stephen Henderson's later notion of "saturation" in *Understanding the New Black Poetry* (1973) in which the use of tone, diction, image, specific details, and so on evokes "a *depth* and *quality* of experience."[87] While this experience is represented as distinctly black, it is generally transregional (and possibly transcontinental). In some respects, such documentation not only draws on an understood body of shared experience and feeling but also attempts to stimulate a national consciousness, a vanguard consciousness that is sometimes at odds with older black cultural traditions, or uses them in a somewhat uneasy or unstable way. Despite the relatively antiprescriptive, ideological heterogeneity of BLKARTSOUTH and the obvious engagement with black popular culture by such leading New Orleans artists as Salaam and Dent, Maulana Karenga's countercultural Kawaida philosophy much influenced Salaam and others in New Orleans, Houston, and elsewhere in the South. Karenga's influence led in part to the for-

mation of the Ahidiana Collective with its emphasis on education, institution building, and culture with a neo-African focus. This sort of cultural nationalist influence can be seen in the second untitled poem of *the blues merchant*. The speaker of the poem, wearing a "blue babu," condemns the mother of a dead friend for hiding the natural hair of her daughter with a "white" wig:

> they'd put a wig on her bush
> i found her mother and called her a nigger for doing that
> Vivian had been too beautiful a Black woman
> to die laying in a box w/h a white wig on[88]

This notion of a black political and artistic avant-garde that is at the same time rooted in a prehistoric, neo-African tradition and at odds with old-fashioned, accommodationist, "Negro" ideology and aesthetics (and much modern popular black culture) resembles Nayo Watkins's "Bedtime Story" (a dialogue between mother and son in which the mother answers her son's question about why there must be revolution, "Cause the white devils tricked us / tricked us in to be slaves") and Raymond Washington's "Freedom Hair" ("untamed / not straightened / natural / protesting").[89]

Salaam explicitly states this "changing same" concept of an avant-garde that is somehow also popular *and* traditional in his polemical "Food for Thought" ("it do not necessarily be like / anything you heard before & / yet it sound familiar").[90] Salaam links the sound of a black poetry that is utterly new and yet familiar to the notion of a popular avant-garde promoted in the first place by Black Arts activists in the Northeast, especially Amiri Baraka. Significantly, Baraka is the only black writer to be directly named, his work doing in poetry what the simultaneously rooted and revolutionary music of Charlie Parker and John Coltrane did in jazz. Of course, the connection of BLKARTSOUTH to radical African American culture circles in New York was not only secondhand. As noted earlier, Tom Dent had taken part in many formal and informal discussions of poetics, politics, and culture in the early proto–Black Arts literary scene of the Lower East Side. As with Baraka, Larry Neal, and Askia Touré, music was a particular touchstone for Dent and the New Orleans Black Arts writers who name such popular artists as James Brown, Otis Redding, Ruth Brown, and Ray Charles as well as such new thing jazz artists as John Coltrane and Eric Dolphy in their poetry.

Yet if Dent, Salaam, and the New Orleans Black Arts activists—and those

they influenced in the South, particularly in Houston and Miami—directly and indirectly adopted the notion of the popular avant-garde from the movement in the Northeast (as opposed to the more alternative avant-garde model associated with midwestern artists and critics and with Maulana Karenga in Los Angeles), they revised it to authorize and validate the worth of their own work in New Orleans. Both Dent and Salaam, as well as other BLKARTSOUTH artists, saw in the continuing vitality of New Orleans rhythm and blues and jazz of such vital, veteran musicians as Danny Barker, Ellis Marsalis, and Professor Longhair, as well as such newer artists as Alvin Baptiste and the younger Marsalis generation, a validation of their own projects as writers:[91]

> We were ahead of our time because the national perception was that the music had left New Orleans. But we could go out on the weekends, every weekend, and hear brilliant music. I said to myself, "Wait a minute. There's a contradiction! If all the music is in New York, what are we listening to?" Not only that, our suspicions that there was a tremendous musical survivalist strength here was strengthened when friends visited us from New York or wherever and we took them out. They would say, "This is amazing." So when the new generation of musicians appeared, and went out and made it in New York, it was a proof of what we had already seen. There was a power in the music as it relates to community and ritual functions that doesn't exist in New York.[92]

Though the core BLKARTSOUTH activists (with the exception of Dent) may not have often anchored their work in an explicitly particularized landscape of New Orleans, or even the South generally, they shared a sense of the special power, and perhaps even the special mission, of contemporary New Orleans African American music. This sense grounded the fervent commitment of BLKARTSOUTH (and later the SBCA) to promoting the work of local southern artists to local audiences (as opposed to the FST's notion of serving as a sort of conduit bringing "metropolitan" art to local people from somewhere else, be it New York, Chicago, or San Francisco).[93] It allowed people such as Nayo Watkins, a mother of five and welfare rights activist who had written poetry privately, to "bring out hidden poems," "to fuse arts and activism," and to "allow a sort of analysis." It provided "an amazing kind of energy which let you get up every day and do something" politically and culturally. Watkins adds, this "was a pretty common experience."[94]

The Black Arts movement in the South, especially the community-oriented institutions that characterized the movement in Houston, Miami, and New Orleans, never gained the sort of national attention that its counterparts in the Bay Area, Chicago, Detroit, and New York did—again, this was not due simply to regional chauvinism but strangely (given the sense of neglect by some in the South) also because of the resolutely anticareerist, localist, grassroots orientation of many southern activists. Still, as Askia Touré observed, the SBCA grew to be the largest grassroots black cultural organization in the United States during that era, a model for how radical African American artists might reach a mass regional audience.[95] Ironically, then, much of this grassroots success grew out of a sense of regional neglect by the broader movement—though few seem to have doubted that a broader movement truly encompassing (or promising to encompass) the entire black nation existed and that they were a part of it. This sense of neglect and the still difficult political conditions for radical (or even reformist) black political and cultural movements in the South produced to a great degree a unity within the southern Black Power and Black Arts movements (especially outside the campus) that mitigated some of the ideological and aesthetic conflicts that racked those movements elsewhere. This sense of regional solidarity no doubt contributed to the relatively long life of the SBCA and other southern Black Arts initiatives and to the many regional expressions of the need for aesthetic tolerance and multiplicity while generally supporting the notion of a black nation and its need for self-determination.

However, the Black Arts movement in the South provided more to the broader movement than the feelings of neglect by some southern artists and arts organizers might suggest at first glance. The reports of the activities in the South in such journals as *Black World*, *JBP*, and *Black Theatre*, the participation of southern political and cultural activists in national (and international) political and cultural events, and the connections of Black Arts activists who had been active outside the South, such as Tom Dent, A. B. Spellman, and Lorenzo Thomas, did much to impart to Black Power and Black Arts participants beyond the South a sense that the movements were truly nationwide formations that transcended region—however much the vision of some of these participants was limited by region. Given the centrality of the South to almost every notion of African American identity and culture and the role of the civil rights movement in the birth of the Black Power and Black Arts movements, it is hard to see

how Black Arts activists anywhere else could have seen themselves as part of a genuinely national movement (again, both in terms of the black nation and of geographical coverage of the United States) without the work of BLKARTSOUTH, Sudan Arts South/West, the SBCA, the campus-based workshops, institutes, and festivals, and the whole infrastructure of Black Arts organizations, institutions, and events in the South.

conclusion

By 1970 it becomes possible to talk about a Black Arts movement that truly spanned the United States — albeit one that contained some large ideological and aesthetic contradictions and significant local variations. A number of the pioneering institutions, such as BARTS, Umbra, the Watts Writers Workshop, the FST, the Black House, the BCP, and BAW had disappeared or diminished radically, but others had taken their place as the movement, like Black Power, spread to virtually every city and many smaller towns in which there was a discernible African American community. A quick look at JBP's correspondence and the far-flung reports of *Black World*'s annual black theater issue reveals not only the geographical spread of the movement but also the network of communication and cooperation (and debate) that was the mature Black Arts movement. Not only did activists in, say, Danville, Illinois, or Little Rock, Arkansas, find out what was going on in San Francisco, Chicago, Detroit, or New York but black artists and intellectuals in cities more famous for radical African American politics and art really felt that they were part of an emerging nation as well as a mass movement.

As the movement grew and institutions developed, conflicts that were ideological, material (e.g., the distribution of public and foundation grant money), or personal became more intense in many respects — though as we have seen, those intense conflicts were potentially if not absolutely inherent to the complicated matrix of political and cultural radicalism out of which the movement grew. These conflicts not only contributed to the decline of the movement but also to how we remember and interpret the movement today.

As has been argued throughout this study, the Black Arts movement devel-

oped differently from place to place due to variations in local traditions of political and cultural radicalism, racial and ethnic makeup, the presence and character of higher education institutions, the existence and size of bohemian artistic communities, the personalities of key organizers, and so on. However, despite these variations, the gestation of the Black Arts movement in many areas shows many common features.

Generally speaking, what one sees in New York, Philadelphia, Boston, Detroit, Chicago, Los Angeles, San Francisco, Oakland, Berkeley, St. Louis, Washington, Cleveland, New Orleans, Houston, Miami, Atlanta, Nashville, and so on are ideological and institutional spaces in which young (and not so young) black artists and intellectuals came together to organize, study, and think about what a new black art (and a new black politics) might be in the world after the founding of the United Nations, the Chinese Revolution, the Bandung Conference, Dien Bien Phu, the Cuban Revolution, successful African and Asian independence movements, the inspirational lives and galvanizing murders of Patrice Lumumba and Malcolm X, the exile of Robert Williams, the Montgomery Bus Boycott, the 1960 sit-in movement, and the bombing of the Sixteenth Street Baptist Church in Birmingham — in short, what seemed to be a worldwide trend toward social liberation generating an often violent reaction. These spaces were largely found in what remained of the formal and informal networks (study groups, bookstores, forums, lectures, educational associations, magazines, and so on) of the Old Left, especially (though not exclusively) the CPUSA and the SWP, and those of what might be thought of as the old nationalism of Garveyites, Pan-Africanists, and so on, as well as the surviving neighborhood arts centers and schools, settlement house galleries and theaters, and grassroots artists' workshops that were so often the products of Left notions of art for the people and nationalist attempts to promote black pride and identity. Due to the continuing, if somewhat weakening, presence of McCarthyism and the Cold War, these Left and nationalist networks were often semiunderground or somewhat evasive about their precise ideological natures and organizational attachments, engendering similar attitudes that, though quite understandable, would mark many Black Arts and Black Power institutions — much as repression after World War I significantly shaped the early organizational development and psychology of the Communist Left in the United States.

As we have seen, though they were often opposed in theory, in practice these Old Left and old nationalist spaces often intersected with each other and with

those of the New Left, the civil rights movement, and the new nationalists, espe-
cially Malcolm X and the NOI, in surprising ways. In addition (and perhaps in
part due) to these surprising intersections of apparently conflicting Old Left
and nationalist institutions, many young African American artists and intellec-
tuals participated in both sorts of networks at the same time — say, like Larry
Neal, attending meetings of the NOI while serving as a leader of a black Marxist
study group. This sort of ideological double-dipping would become more diffi-
cult as the movement matured and ideological positions hardened — though the
boundaries between Marxism and cultural nationalism continued to be more
porous, even during the bitter sectarian battles that wracked the Black Power
and Black Arts movements in the mid-1970s, than some might allow.[1]

However, noting the existence of these spaces does not explain the fantastic
growth of the Black Arts movement in the 1960s. Obviously, the character of
the political moment between the symbolically charged death of Lumumba and
the rise of the black student movement (and the student movement generally)
in 1960, on the one hand, and the aftermath of the equally charged murder of
Malcolm X and the Watts uprising in 1965, on the other, resulted in unprece-
dented opportunities for radical black art and politics. Young militants and such
older radicals as Malcolm X, Harold Cruse, Queen Mother Moore, John Hen-
rik Clarke, and Robert Williams were able in their own ways to articulate a new
militancy that struck a responsive chord in a broader African American con-
stituency in the early 1960s. Still, it was the explosions of black anger over con-
tinuing oppression despite the victories of the civil rights movement that began
with Harlem, Philadelphia, and Jacksonville in 1964 and really shook the United
States with Watts in 1965 that completely changed the cultural landscape of the
United States, paradoxically promoting a feeling of new political and cultural
possibility as well as frustration. The idea of black political and cultural self-
determination that seemed like a distant dream in the early 1950s and a believ-
able possibility with the rise of the student movement of 1960 (and the continued
success of liberation struggles in the former colonial world) suddenly appeared
to be an achievable (and relatively imminent) reality to many.

The uprisings that became a regular feature of summer in the United States
provided a justification for dramatically increased repression of radical African
American political and cultural organizations — and along with the more de-
structive aspects of so-called urban renewal programs wreaked havoc on the
physical plant of many black neighborhoods, especially in their already troubled

commercial districts. At the same time, the uprisings provoked an avalanche of federal and local public money as well as private foundation support for nationalist black art and artistic institutions closely linked to revolutionary political movements. As Norman Jordan, Jerry Ward, and others have argued, this grant money sometimes had the effect of reining in radical cultural initiatives and draining initially militant institutions and annual events of their political content. This support often resulted in a depoliticized arts bureaucracy that undermined or straitjacketed the Black Arts movement, much like the "black regime" that Adolph Reed has posited as the result of post–Black Power urban politics, leaving the basic power arrangements of the United States in place.[2] However, various sorts of government and foundation support generated by black political activism—and the visible anger of a huge number of African Americans—made it possible for black theaters, cultural centers, workshops, presses, journals, and so on to flourish while promoting art with a politically radical content and an often avant-garde form. Beyond these more or less alternative black institutions and events, the sorts of political pressures and a wide interest in radical black art and politics engendered by the same forces that promoted public and private financial support also produced a distinct Black Arts strain in various mass culture media, especially radio, television, film, and popular recorded music—though, often, in more mediated or contradictory forms, as when Curtis Mayfield composed a musical soundtrack that many, including Mayfield, have argued intentionally undercut the visual images, plot, and dialogue of the classic blaxploitation film *Super Fly* (1972).[3] Dramatically increased public and private financing also allowed African American artists to reach a black audience receptive to their radical art on a scale never seen before—even during the Popular Front and the New Deal. Reed's chief example of the "black regime," Atlanta during the Maynard Jackson administration, demonstrates the new cultural possibilities opened up by the Black Arts movement as well as its limitations. While Reed makes a powerful argument, it overlooks how former Black Arts activists, such as Ebon Dooley and Edward Spriggs, were able to use Jackson's desire to be known as the "arts mayor" to successfully push for neighborhood and citywide arts projects aimed at the African American community instead of funding the usual suspects of the high art establishment.[4]

This study has attempted to give an overview of only the origins and early years of the Black Arts movement. However, many of the lasting influences of the movement on culture in the United States had already begun before the move-

ment reached its peak in the early 1970s, so it might be worth closing by enumerating some of them. Obviously (though not to some perhaps), the Black Arts movement produced some of the most exciting poetry, drama, dance, music, visual art, and fiction of the post–World War II United States. As noted above, it reached a nonelite, transregional, mass African American audience to an extent that was unprecedented for such a formally (not to mention politically) radical body of art, especially in the genres of poetry and drama. Many of its leading (and less famous) artists, such as Jayne Cortez, Lorenzo Thomas, Amiri Baraka, Askia Touré, Sonia Sanchez, Woodie King Jr., Nayo Watkins, Kalamu ya Salaam, Sterling Plumpp, and Ron Milner, to name a handful, are still artistically productive to a degree that few of their living contemporaries from the 1960s can match. Whatever one makes of the controversy over Amiri Baraka's "Somebody Blew Up America" when he was the New Jersey poet laureate, Baraka's poetry in the 1990s and the first years of the twenty-first century include some of his strongest (and most hilarious) works, such as "Masked Angel Costume: The Saying of Mantan Moreland" and his long poetic series *Wise, Why's, Y's* (1995). Many others besides Baraka, such as Spriggs, Dooley, Sanchez, A. B. Spellman, Haki Madhubuti, and Amina Baraka, again to name but a handful, play vital parts in the cultural infrastructure of their communities and regions.[5] Many important post–Black Arts artists, such as Toni Morrison, Toni Cade Bambara, Alice Walker, John Wideman, August Wilson, and Ntozake Shange, were molded by the movement—though sometimes in their negative reaction to it. The movement inspired and aided similar nationalist formations of Asian American, Chicana/o, Puerto Rican, Native American, and other "ethnic" artists. It also provided the seedbed for early radical multiculturalism.

The Black Arts movement also helped fundamentally change American attitudes about the relation between popular culture and "high" art, making the notion of a popular avant-garde a commonplace of rock, hip-hop, jazz, and even country and western. Political hip-hop artists from DJ Afrika Bombaata to Mos Def have seen the Black Arts movement as a crucial ancestor. In turn, Black Arts writers look at the socially engaged "political," "underground," and "alternative" rappers as their linear descendants. One result has been a wide range of collaborations, from conference panels to stage performances, between hip-hop artists (and hip-hop–influenced spoken-word poets) and Amiri Baraka, Touré, Sanchez, and other leading Black Arts activists. While the sort of hip-hop favored by surviving Black Arts elders is (as of this writing) less popular than

the hardcore/gangsta genres (which they heavily criticize), it nonetheless has a following in the millions and is familiar at least in concept to the broad hip-hop audience. This notion of a socially engaged, formally radical hybrid of poetry, music, dance, and so on performed live or on record to a genuinely popular audience also transformed the cultural field in which poetry operates. All poetry in the United States written over the last three decades was created during the era of hip-hop. Some poets have attempted to essentially write against rap, some have more directly allied themselves with the forms and sensibilities of hip-hop, and some have located themselves in between, but they all have had to take hip-hop into account. Two direct descendants of hip-hop and Black Arts performances (not to mention jazz cutting contests) are the related phenomena of performance poetry and poetry slams. Venues for performance poetry and slams can be found in virtually every city of the United States, with hundreds of thousands of poets and audience members participating.

The Black Arts movement also dramatically transformed the landscape of public funding for the arts and the terms of the discussion of public arts support. An increase in public and foundation money for cultural projects, including formally radical art, such as that of the abstract expressionists, was a hallmark of Cold War liberalism and government-supported Cold War competition with the Soviet Union. However, it was the Black Arts movement and the other nationalist arts movements it helped inspire that made public support of community-based and ideologically and formally radical art possible, such as the murals of the multiracial Chicago Mural Group, to a degree unmatched since the 1930s, if then. Of course, much as the demands for black studies programs inspired the establishment of a wide range of academic fields (e.g., ethnic studies, Asian American studies, Chicana/o studies, women's studies, Appalachian studies, gay studies), so did the efforts of the Black Arts movement lead to a vast number of publicly supported and sometimes radical arts projects outside the African American community—for example, the Public Broadcasting System (despite its current tame character) and National Public Radio, both founded in the late 1960s, owe much to the art-for-the-people efforts of the Black Arts movement—an impact that has yet to receive much scholarly attention. This support for often politicized art has also engendered heated debates about the desirability of public funding, about the ideological nature of the art funded and of the funding selection process, and about what culture truly is, what it might do, and what it should do. The bitter disputes over the National Endowment for the Arts,

National Public Radio, the Public Broadcasting System, and public support for museum exhibits are significantly rooted in debates arising from the Black Arts era. In short, rather than being a short-lived failure, the Black Arts movement was arguably the most influential cultural movement the United States has ever seen. Indeed, that has been one of my claims throughout this book. This is not to say that these influences have always been positive. However, in coming to grips with what the Black Arts movement was and from what it came, to a large degree we come to grips with where we are now and how we got here — and, perhaps, where we might go.

appendix 1

Birth Dates of Selected Black Arts
and Black Power Figures

Ahmad, Muhammad (Maxwell Stanford), 1941

Allen, Ernest, Jr. (Ernie Mkalimoto), 1942

Amini, Johari (Jewel Lattimore), 1935

Angelou, Maya, 1928

Atkins, Russell, 1926

Baldwin, James, 1924

Bambara, Toni Cade, 1939

Baraka, Amiri (LeRoi Jones), 1934

Boggs, Grace Lee, 1915

Boggs, James, 1919

Brooks, Gwendolyn, 1917

Brown, Sterling, 1901

Bullins, Ed, 1935

Burnham, Louis, 1915

Burroughs, Margaret, 1917

Childress, Alice, 1916

Clarke, John Henrik, 1915

Cohran, Phil, 1927

Cortez, Jayne, 1936

Cruse, Harold, 1916

Cruz, Victor Hernandez, 1949

Danner, Margaret, 1915

Davis, Ossie, 1922

Dent, Tom, 1932

Donaldson, Jeff, 1932

Dooley, Ebon (Leo Thomas Hale), 1942

Du Bois, Shirley Graham, 1896

Du Bois, W. E. B., 1868

Dumas, Henry, 1934

Elder, Lonnie, III, 1931

Evans, Mari, 1923

Fabio, Sarah Webster, 1928

Flory, Ishmael, 1907

Fuller, Charles, 1939

Fuller, Hoyt, 1927

Giovanni, Nikki, 1943

Goncalves, Dingane Joe, 1937

Graham, Donald Lee (Le Graham), 1944

Guy, Rosa, 1925

Hansberry, Lorraine, 1930

Hayden, Robert, 1913

Henderson, David, 1942

Hernton, Calvin, 1934

Hughes, Langston, 1902

Jackson, Esther Cooper, 1917

James, C. L. R., 1901

Jeffers, Lance, 1919

Joans, Ted, 1928

Jordan, June, 1936

Jordan, Norman, 1938

Karenga, Maulana (Ronald Everett), 1941

Kaufman, Bob, 1925

Kgositsile, Keorapetse, 1938

Killens, John O., 1916

King, Woodie, Jr., 1937

Knight, Etheridge, 1931

LaGrone, Oliver, 1915

Lewis, Elma, 1921

Lincoln, Abby, 1930

Llorens, David, 1939

Lorde, Audrey, 1934

Luciano, Felipe, 1947

Madgett, Naomi Long, 1923

Madhubuti, Haki (Don L. Lee), 1942

Major, Clarence, 1936

Marvin X (Marvin Jackmon), 1944

Mayfield, Julian, 1928

Milner, Ron, 1938

Monsour, Khalid (Donald Warden), 1936

Moore, Richard, 1885

Morrison, Toni (Chloe Wofford), 1931

Moses, Gilbert, 1942

Neal, Larry, 1937

Patterson, Raymond, 1929

Plumpp, Sterling, 1940

Randall, Dudley, 1914

Redmond, Eugene, 1937

Reed, Ishmael, 1938

Rodgers, Carolyn, 1945

Salaam, Kalamu ya (Val Ferdinand), 1947

Sanchez, Sonia, 1934

Scott, Johnie, 1946

Shange, Ntozake, 1948

Shepp, Archie, 1937

Shockley, Ann Allen, 1927

Spellman, A. B., 1935

Spriggs, Edward, 1934

Stevens, Nelson, 1938

Stewart, James, 1926

Strickland, William, 1937

Sun Ra (Herman Blount), 1914

Taylor, Cecil, 1933

Teer, Barbara Ann, 1937

Thelwell, Michael, 1939

Thomas, Lorenzo, 1944

Touré, Askia (Rolland Snellings), 1938

Troupe, Quincy, 1943

Turé, Kwame (Stokely Carmichael), 1941

Walker, Alice, 1944

Walker, Margaret, 1915

Walker, William, 1927

Ward, Douglas Turner, 1930

Ward, Theodore, 1902

Ward, Val Gray, 1932

Williams, Robert, 1925

Williams, Sherley Anne, 1944

Wright, Jay, 1935

Wright, Sarah, 1928

appendix 2

Time Line of the Early Black Arts
and Black Power Movements

1954 Supreme Court rules that segregation in schools violates the Four-
teenth Amendment in *Brown v. Board of Education*.

1955 Montgomery Bus Boycott begins. *Freedom* ends publication. Bandung
Conference in Indonesia is held.

1956 NNLC folds. Khrushchev gives "secret speech" about Stalin to Twenti-
eth Congress of the Communist Party of the Soviet Union. Civil Rights
Congress ceases.

1957 The SCLC is formed with Martin Luther King Jr. as president. Eisen-
hower orders federal troops to Little Rock. Congress passes the Civil
Rights Act of 1957 (voting rights legislation). Grace Lee Boggs becomes
editor of *Correspondence*. Ghana becomes independent. First Interna-
tional Congress of Negro Writers and Artists takes place in Senegal.
AMSAC is organized.

1959 *A Raisin in the Sun* opens on Broadway. Market Place Gallery readings
are initiated in Harlem.

1960 Sit-ins by North Carolina A & T students in Greensboro inspire a wave of similar protests throughout the South. SNCC is founded in Raleigh, North Carolina.

1961 *Muhammad Speaks* begins as a regularly issued newspaper. *Freedomways* is founded. *Liberator* first publishes. *Negro Digest* is revived. The Selective Patronage campaign begins in Philadelphia. CORE Freedom Riders go South. Congo's Patrice Lumumba is murdered. Demonstrators at the United Nations protest Lumumba's murder and disrupt a speech by Adlai Stevenson at the General Assembly session. Margaret and Charles Burroughs start the Ebony Museum in Chicago.

1962 Albany, Georgia, anti–Jim Crow movement begins; Martin Luther King Jr. is arrested. James Meredith is admitted to University of Mississippi after local resistance; riot by white mob results in two deaths and more than one hundred wounded. Umbra Poets Workshop is founded in New York City. RAM is formed at Central State University in Ohio. Margaret Danner begins Boone House in Detroit.

1963 Martin Luther King Jr. leads a campaign against discrimination in Birmingham, Alabama. March on Washington takes place. Martin Luther King Jr. delivers his "I Have a Dream" speech. Medgar Evers is murdered in Mississippi. Spiral artists group forms in New York City. Malcolm X delivers "Message to the Grassroots" speech at Grassroots Conference in Detroit. CCCO school boycotts begin in Chicago. Sixteenth Street Baptist Church in Birmingham is bombed. The FST is founded in Mississippi.

1964 The Civil Rights Act becomes law. Malcolm X splits from the NOI and founds the Organization of Afro-American Unity. Beginning in Harlem, serious racial disturbances occur in more than six major cities. The FST moves to New Orleans. Studio Watts begins in Los Angeles. Amiri Baraka's *Dutchman* is first performed in New York. John Coltrane records *A Love Supreme*.

1965 The Voting Rights Act is signed into law. The SCLC launches a voter drive in Selma, Alabama. Malcolm X is assassinated in Harlem by members of the NOI. The Watts uprising leaves 34 dead, over 1,000 injured, and more than 3,900 arrested. BARTS is formed in Harlem. Broadside Press begins in Detroit. The AACM is organized in Chicago. US (later Us) is started by Maulana Karenga and others in Los Angeles.

1966 "Black Power" is popularized as a slogan, largely through SNCC. The BPP is founded by Huey P. Newton and Bobby Seale in Oakland, California. First Fisk University Black Writers Conference takes place. First Detroit Black Arts Convention occurs. SNCC launches its Atlanta Project. The First World Festival of Negro Arts takes place in Senegal.

1967 More than forty uprisings and one hundred other disturbances occur, most prominently in Detroit and Newark. Martin Luther King Jr. publicly announces his opposition to the Vietnam War. OBAC organizes. OBAC's Visual Artists Workshop paints the *Wall of Respect* in Chicago. Third World Press is founded. Carl Stokes is elected mayor of Cleveland. *Inner City Voice* newspaper is first published in Detroit. Second Black Arts Convention occurs in Detroit. Second Fisk University Black Writers Conference takes place. The NEC is founded. The New Lafayette Theatre debuts in Harlem.

1968 Martin Luther King Jr. is assassinated in Memphis, Tennessee, sparking uprisings in more than one hundred cities across the country. Ocean Hill–Brownsville teachers strike in New York City. Amiri Baraka and Larry Neal publish *Black Fire*. Toward a Black University Conference takes place at Howard University. BLKARTSOUTH and *Nkombo* are founded in New Orleans. *Black Theatre* begins publishing. The NBT begins in New York. The Studio Museum in Harlem opens in its own building. The Museum of the NCAAA is founded in Boston. DRUM is formed at the Dodge Main Chrysler Plant in Hamtramck, Michigan; black workers subsequently organize Revolutionary Union Movements at a number of Detroit area factories and workplaces.

1969 The Supreme Court rules that racial segregation in schools must end immediately. Broadside Press publishes *For Malcolm*. Sudan Arts South/West is founded in Houston. Museum of the NCAAA opens in temporary spaces in Boston. The Student Organization for Black Unity (SOBU) is formed at North Carolina A & T. Malcolm X University opens in Durham, North Carolina. The LRBW forms in Detroit.

1970 Kenneth Gibson is elected mayor of Newark, New Jersey. Angela Davis is captured and arrested after fleeing from a shoot-out in a California courthouse. National Memorial African Bookstore is destroyed by the Harlem State Office Building project. First convention of CAP takes place in Atlanta. Malcolm X University moves to Greensboro, North Carolina.

notes

Abbreviations

BU Special Collections, Mugar Library, Boston University
HFP Hoyt Fuller Papers, Special Collections, Woodruff Library, Clark
 Atlanta University
HU Moorland-Springarn Research Center, Howard University
NU Archives and Special Collections, Northeastern University Libraries,
 Northeastern University
SC Schomburg Center for Research in Black Culture, New York Public Library
SI Oral history interviews, Archives of American Art, Smithsonian
 Institution, Washington, D.C.
UMA W. E. B. Du Bois Library, Special Collections, University of
 Massachusetts–Amherst
UPWSC Umbra Poets Workshop Oral History transcripts, Schomburg Center for
 Research in Black Culture, New York Public Library
YU Beineke Library, Yale University

Introduction

1 In this study, I generally employ the gender-inclusive locution "Chicana/o" (and "Latina/o,"
 "Filipina/o," and "mestiza/o") except in quotations or where a specific gender designation
 seems appropriate. However, I do retain the term "Chicano movement" as the historical name
 for the Chicana/o analogue to the Black Power and Black Arts movements.
2 Gates, "Black Creativity," 74.
3 *Black Panther Party Reconsidered*, a collection of essays edited by Charles E. Jones, and *Libera-
 tion, Imagination, and the Black Panther Party*, a similar collection edited by Kathleen Cleaver

and George Katsiaficas, are steps toward a fuller historical account and analysis. Nonetheless, while presenting some important scholarly assessments of the Panthers and their legacy, particularly Singh's "Black Panthers" in the Jones anthology, their main contribution is the presentation of a number of reflections and memoirs of former BPP members.

4 "Nuyorican" refers to people of Puerto Rican descent residing in the United States, primarily in the New York metropolitan area.

5 One work that makes this attempt is Flowers, *African American Nationalist Literature* (1996). Flowers's study is a valuable introduction to the subject but makes no real effort to examine the Black Arts movement in any historical or regional specificity. Another very valuable but (intentionally) limited scholarly work is Melhem, *Heroism* (1990), which consists of relatively brief introductions to six important poets of the Black Arts era (Gwendolyn Brooks, Dudley Randall, Haki Madhubuti, Sonia Sanchez, Jayne Cortez, and Amiri Baraka), each followed by an interview (conducted in 1980 and 1981 for the most part).

6 Nielsen, *Black Chant*, 58.

7 Ibid., 42.

8 Hall, *Mercy, Mercy Me*, 48.

9 Self, "'Negro Leadership,'" 99.

10 D. Smith, "Chicago Poets," 254.

11 Salaam, *Magic of Juju*, 14.

12 Wilkinson, "'In the Tradition of Revolution,'" 192–201.

13 Author's interview with Maulana Karenga.

14 Gibson, "Speech," 20.

15 For example, Ignatiev makes a distinction between "antirevisionist" groups that were pro-China and those that were authentically Maoist organizations ("Antirevisionism," 48). However, as Foley notes, in many respects the PL (along with the BPP) had the Maoist franchise in the United States until the 1970s, with the Chinese Communist Party regarding the PL and the BPP as "the Left" (that is, the antirevisionist Left). She also points out that when PL members and supporters clashed with the Revolutionary Youth Movement I and II factions at the 1969 SDS convention, they held up the Red Book and chanted "Mao, Mao, Mao Tse-Tung"; their antagonists in the two factions (a number of whom subsequently founded some of the most prominent post-PL Maoist organizations, such as the October League [later the Communist Party-Marxist-Leninist] and the Revolutionary Union [later the Revolutionary Communist Party]), countered with "Ho, Ho, Ho Chi Minh." As Foley also notes, while the outward form of this conflict might seem somewhat silly in retrospect, the issues (of which the character of nationalism is probably most pertinent for this study) were significant. In any event, it is clear that PL members themselves early on identified with Mao and his version of antirevisionism (author's correspondence with Barbara Foley).

16 For a sense of Gibson's politics during the early and mid-1960s, see his letters to Julian Mayfield (Julian Mayfield Papers, box 5, folder 6, SC). Gibson was later accused of being a CIA agent and largely discredited—though his case still remains murky.

17 Lenin, *Letters on Tactics*, 9.

Chapter One

1 See Martin, *Literary Garveyism*; E. Allen, "New Negro"; Maxwell, *New Negro, Old Left*, 13–124; Hutchinson, *Harlem Renaissance*; Foley, *Spectres of 1919*; and Dawahare, *Nationalism*.

2 For example, when Mike Gold became editor-in-chief of *New Masses* in 1928, he soon moved it away from the Greenwich Village Left bohemianism (with which Gold himself had been associated) toward a self-consciously "proletarian" vision that looked beyond the Northeast. The most notable aspect of Gold's editorship over the next few years was his invitation to working-class writers (and would-be writers) across the country, particularly in the Midwest, to tell their stories in their own voices.

3 Brown, *Collected Poems*, 62. For a discussion of the genesis and significance of the Black Belt thesis and the debate around it at the Sixth Comintern Congress, see Solomon, *Cry Was Unity*, 68–91.

4 For a more detailed discussion of the Communist ideological approach to the "Negro Question" and its impact on African American writing in the 1930s and 1940s, see Smethurst, *New Red Negro*, 16–42. See also Foley, *Radical Representations*, 170–212.

5 For a sense of the range of the forms and influence of the Popular Front in American culture, see Denning, *Cultural Front*. For examinations of the impact of the Popular Front on African American cultural institutions in Chicago, see Mullen, *Popular Fronts*.

6 Denning, *Cultural Front*, 125.

7 Hughes, *Collected Poems*, 215.

8 For valuable studies tracing the origins and evolution of the New York Intellectuals, see Wald, *New York Intellectuals*; and Cooney, *Rise of the New York Intellectuals*. Wald's study is particularly exhaustive in tracing the personalities of the New York group, including many key political figures rarely considered by scholars previously (or since). For a study that examines the ideological and institutional creation of a New Critical–New York Intellectual consensus (including the crucial role of the Rockefeller Foundation) with respect to literature, see L. Schwartz, *Creating Faulkner's Reputation*. For a similar consideration of the visual arts and Cold War aesthetics, see Guilbault, *How New York Stole the Idea*.

9 For a study of what might be thought of as the infrastructure of McCarthyism, see Schrecker, *Many Are the Crimes*. For a more wide-ranging case history of McCarthyism, see Caute, *Great Fear*. For scholarly considerations of the Cold War and its particular impact on African Americans and African American political and cultural institutions, see Dudziak, *Cold War Civil Rights*; Plummer, *Rising Wind*; and Von Eschen, *Race against Empire*.

10 Dirksen prided himself on being a pragmatic politician rather than a right-wing ideologue. As Senate minority leader, he helped shepherd the 1964 Civil Rights Act past right-wing Republican and Dixiecrat opposition. However, as a member of McCarthy's Senate Permanent Subcommittee on Investigations, he sharply (and ham-fistedly) questioned Langston Hughes about the un-American nature of Hughes's work, especially the poem "Goodbye, Christ," and about Hughes's connections to international Communism. For a sense of Dirksen's performance, see the newly released transcripts of the interrogation of Hughes in volume 1 of the

Executive Sessions of the Senate Permanent Subcommittee on Investigations of the Committee on Government Operations (McCarthy Hearings 1953–54), which, as of this writing, can be accessed on-line at <http://www.access.gpo.gov/congress/senate/senate12cp107.html> or ordered through the United States Government Printing Office.

11 In his 1947 essay "Legacy of the 1930s," Robert Warshow claimed that the "Stalinists" led a significant portion of the intelligentsia into embracing a debased middlebrow culture (which he defined as "mass culture of the educated classes") even if the Popular Front did not precisely create that debased art (*Immediate Experience*, 3–5). A colorful instance of the attack on Rukeyser can be found in Jarrell's short review of *The Green Wave* (1948). Jarrell opened his essay with the sort of half-praise followed by a vivid and nasty image in which he excelled: "Muriel Rukeyser is a forcible writer with a considerable talent for emotional rhetoric; but she works with a random melodramatic hand, and with rather unfortunate models and standards. One feels about most of her poems almost as one feels about the girl on last year's calendar" (*Poetry and the Age*, 148).

12 For an extremely useful collection of essays discussing the complexities of international politics, the Cold War, and the civil rights movement in the United States, see Plummer, *Window on Freedom*. See also Dudziak, *Cold War Civil Rights*; and Plummer, *Rising Wind*.

13 Author's interviews with Amiri Baraka, Askia Touré, and Haki Madhubuti; Amiri Baraka, *Autobiography*, 137–78. For a brief discussion of the influence of Us and the Kawaida movement on African American soldiers in Vietnam, especially on black Marines, see Scot Brown, *Fighting for US*, 86–87.

14 For examples of the association of the Beats, the California Renaissance, and the New York School with a generalized anti-McCarthyism, see Ashton, *New York School*, 228; and Silesky, *Ferlinghetti*, 59–60.

15 Rexroth, for example, worked in CPUSA-influenced literary and political organizations throughout the 1930s — though he moved toward the anarchist politics that characterized his later life as the decade wore on. There is some evidence that, despite later disclaimers, Rexroth was a CPUSA member for several years. For an account of Rexroth's relationship with the Communist Left during the 1930s, see Hamalian, *Life of Kenneth Rexroth*, 64–101.

16 Berger was one of the few white members of Umbra, in which he played a low-key but valuable role as a sort of cultural facilitator. It was through Berger that the special section on the Umbra writers appeared in *Mainstream*. Lowenfels was a poet and former "Lost Generation" expatriate in France who returned to the United States, where he eventually became the editor of the Philadelphia edition of the *Daily Worker* and eventually a prominent Smith Act defendant. Lowenfels edited a number of important radical anthologies and special issues of journals in the 1960s, including *Where Is Vietnam?* and *Poets of Today*, assiduously promoting the work of many of the new black poets, especially the Umbra group.

17 Maynard, *Venice West*, 62, 162–68; Damon, *Dark End of the Street*, 33; Gooch, *City Poet*, 128–29; Schumacher, *Dharma Lion*, 23; Smethurst, "Remembering When Indians Were Red."

18 For example, in her biography of Jack Kerouac, Charters mentions the audience as containing "left-over gypsies from the Stalinist era" (*Kerouac*, 240). One of the founders of the Six Gallery, the painter Wally Hedrick, recalled that the core of the group that started the gal-

lery was on the periphery of the Left, especially the Henry Wallace campaign, during the late 1940s (Wally Hedrick interview, June 6, 1974, SI).

19 Ginsberg, *Journals*, 309.

20 In another instance of how these communities interlocked, Stanley Faulkner, a radical lawyer with close ties to the Communist Left, defended Baraka and Diane di Prima in the *Floating Bear* obscenity trial (di Prima, *Recollections of My Life*, 269–71).

21 Denning argues that Kerouac's dreamlike novel *Dr. Sax* (1959) is a late example of the Popular Front–style "ghetto pastoral" (*Cultural Front*, 235). This claim is not as far-fetched as the critical consensus about Kerouac's essential political conservatism would seem to make it. Kerouac and his close friend Sebastian "Sammy" Sampras started a left-wing study group, the Prometheus Club, during their high school days in Lowell, Massachusetts, in the late 1930s. Idolizing such Left labor heroes as the ILWU's Harry Bridges, the Prometheus Club discussed classic Marxist theory as well as the contemporary criticism and literature in *New Masses*. While the Prometheus Club seems to have been relatively short-lived, Kerouac's connection with the Left seems to have stayed alive, especially through Sampras (a sometime soapbox speaker on the Boston Common), until his friend's death in combat during World War II (McNally, *Desolate Angel*, 25, 41, 46). In short, Kerouac was deeply familiar with Popular Front (and classic Marxist) thought and literature, whatever later public political professions he may have made.

22 O'Hara, *Collected Poems*, 498. One uninvestigated area is the relation between the intersection of sexuality, popular culture, and camp in the New American Poetry (particularly in the work of such gay New York school poets as Frank O'Hara, James Schuyler, and Kenward Elmsie) and the use of popular culture by Popular Front artists. While the official attitude of the CPUSA towards homosexuality was ambiguous at best during the 1930s and 1940s (and actively hostile during the 1950s), many of the leading Popular Front artists, especially those whose work was most engaged with popular culture (e.g., Marc Blitzstein and Langston Hughes) were gay or bisexual.

23 C. Nelson, *Repression and Recovery*, 4.

24 Ginsberg, *Howl*, 31.

25 Nielsen's *Black Chant* is one of the few studies that thinks about post–World War II African American poetry within the context of "experimental" or avant-garde American poetry — though even in Nielsen's study this contextualization takes place only on a very general level. Interestingly, one of the few places where the direct relationship between the poetics of New American poets and those of African American writers takes place is in the memoirs of those black writers themselves. For example, Amiri Baraka mentions the impact of particular works, for example, Allen Ginsberg's "Howl" and Kenneth Koch's "Fresh Air," on the development of his literary aesthetic (*Autobiography*, 150, 159).

26 Lorenzo Thomas, *Extraordinary Measures*, 197.

27 The importance of Baraka as an anchor of the New American Poetry scene, not only in New York but internationally, can be seen in the 2003 collection of Beat poet Gregory Corso's letters, *Accidental Autobiography*, where Corso frequently asks his correspondents if they have seen *Yugen*, requests that they send him copies of the journal, or says that he received the latest issue.

28 Sun Ra, an African American musician who was crucial in developing this Black Arts notion of a popular avant-garde, was also touched by the Popular Front in his youth — though he was far from the Communist Left politically by the 1960s. Sun Ra, then Herman "Sonny" Blount, had been a frequent patron of the CPUSA bookstore in Birmingham, Alabama, during the 1930s and was apparently a regular reader of *Cavalcade*, the journal of the Popular Front organization, the SNYC (Szwed, *Space Is the Place*, 33, 38). This is a reminder of the importance of the CPUSA and the organizations it influenced as catalysts of African American artistic and intellectual life during the 1930s and 1940s. Some leading younger "new thing" jazz leaders also had encounters with the Communist Left. Ornette Coleman mentions his engagement and disillusionment with Communists in Los Angeles during the early 1950s (Spellman, *Black Music*, 109–10). And in a 1994 interview, Cecil Taylor intimated a onetime sympathy with (and probable active participation in) the Communist Left during the early Cold War: "I'd rather not talk about my political adventures, beyond saying this: when I was very young, I went to the second Peekskill rally. Paul Robeson was there, [W. E. B.] Du Bois was there, and it was in an area that my father's boss lived in. And what happened to me then, and I was thirteen — and the family read the *Daily News* at that time — and we were lucky to get out of Peekskill alive. When I got back Monday and I read the *Daily News* reportage of what they said had happened, then I knew that I had to have other options because that is not what I experienced. And if they were going to say that that's what was happening then I knew that I had to choose another course" (quoted in Funkhouser, "being matter ignited").

29 For a description of Jonas and his connection to Spicer and others in Spicer's circle, albeit a description that focuses more on sexual and social interaction than intellectual and artistic community, see Ellingham and Killian, *Poet Be like God*, 70–76.

30 Kane, *All Poets Welcome*, 54–56.

31 Ibid., 80.

32 Performance by Fred Ho and Raúl Salinas, Mar. 13, 2004, San Antonio, Texas.

33 Binder, *Partial Autobiographies*, 151–52.

34 Bruce-Novoa, *Chicano Poetry*, 122, 188, 257.

35 Kingston has denied that Sing is modeled on Chin. However, Chin asserts that Kingston's character is a clear parody of him. For a brief discussion of the troubled literary relationship of Kingston and Chin, see Wei, *Asian American Movement*, 68–70.

36 For a claim that Victor Hernandez Cruz is really a "New York School" poet rather than a "Nuyorican" poet, see Mohr, *Nuyorican Experience*, 104–5.

37 These articles appeared in the *Chronicle* from June 5 to June 11, 2003.

38 This longtime evaluation of Baraka as essentially a downtown bohemian (read "would-be white slummer") in super blackface has been most recently and prominently articulated by Jerry Watts in *Amiri Baraka*. Watts, in fact, combines practically every criticism of Baraka ever made, with mixed results. He suggests that Baraka's work was at its peak during his early downtown bohemian days. Yet Watts also claims that Baraka has remained at heart a bohemian, alienated from the black community all his adult artistic and intellectual life. In short, Watts not so seamlessly combines familiar but usually opposing universalist and nationalist critiques of Baraka, without any sense that these critiques are potentially contradictory.

39 For discussions of *Freedom* and the Left circles of Harlem during the 1950s, see J. Smith, *Visions of Belonging*; 281–327; and Washington, "Alice Childress."

40 Joe Walker, "Exclusive Interview," 141. This statement to Walker in a 1972 interview originally published in *Muhammad Speaks* is even more pointed because of Walker's own connection to the CPUSA and the international Communist movement, which can be seen in his attempts to defend the record of the Soviet Union in Africa from criticisms by Baldwin. At the same time, the fact that Baldwin agreed to do such a lengthy interview and that his attacks on the CPUSA did not derail the mostly cordial interview or prevent its publication says something about the way in which ideological lines could be fluid in a practical sense, even when they publicly seemed quite rigid.

41 For example, Richard Durham, the editor-in-chief of *Muhammad Speaks* for much of the 1960s, was during the 1950s the educational director of the United Packinghouse Workers Union, one of the few CIO unions with significant Left leadership (especially in Chicago) not expelled from the labor federation in 1949. Durham had also been a reporter for the *Chicago Defender* and a writer of radio scripts for a progressive African American radio series, *Destination Freedom*, during the late 1940s and early 1950s. Ben Burns, a longtime journalist in the African American press who worked with Durham at the *Defender*, describes Durham's politics in the 1940s as "left-oriented" (*Nitty Gritty*, 19–20). For examples of Durham's scripts and a sketchy and not always reliable summary of his career, see Durham, *Richard Durham's Destination Freedom*.

42 Turé and Thelwell, *Ready for Revolution*, 86–95; Carson, *In Struggle*, 162.

43 Presentation by Bob Moses, National Endowment for the Humanities Summer Seminar for College Teachers on the Civil Rights Movement, Cambridge, Mass., July 31, 2003.

44 For a brief discussion of *Liberator* and the initial influence of Communists and former Communists on its original advisory board, see Johnson and Johnson, *Propaganda and Aesthetics*, 172–80. A number of the official faculty advisers of the journal *Dasein*, including Sterling Brown and Owen Dodson, had (and retained) connections to the literary Old Left. One of the members of the Dasein circle, Lance Jeffers, had himself been involved in the Communist Left as a young man. For an account of the journal and the Dasein circle of Washington, D.C., poets around it, see Nielsen, *Black Chant*, 59–77. Black nationalist and Socialist thought early on marked the editor of *Negro Digest*, Hoyt Fuller. As a veteran of the black press of Chicago and Detroit in which the Left was extremely influential during the 1930s and 1940s, Fuller knew many black leftists in those cities quite well and opened the pages of *Negro Digest* to black radicals, such as Margaret Burroughs and John O. Killens.

45 For Brooks's own account of this conversion, see *Report from Part I*, 83–86.

46 Like quite a few of the younger black political and cultural activists of the 1960s, Giovanni had a family connection to the Old Left through her grandmother, a political activist who took part in various conferences at the left-wing Highlander Folk School in Tennessee (Fowler, *Nikki Giovanni* 2–3).

47 West, *Restoring Hope*, 168–71.

48 Baraka FBI file, box 9, Amiri Baraka Papers, HU. Of course, there is the strong possibility that Baraka exaggerated his participation in subversive activities to the agents as a way of out-

raging them and demonstrating his opposition to this sort of inquisition. Certainly, he has never acknowledged a connection to the organized Left during his youth in any of his autobiographical writings—and it is hard to believe that Baraka would feel that he has anything to lose by such a revelation at this point.

49 As Mark Solomon has suggested, future regional histories of the Communist movement in the West and the Southwest, along the lines of Naison's *Communists in Harlem* and Kelley's *Hammer and Hoe*, may significantly complicate our sense of the CPUSA's approach to the "national question" (*Cry Was Unity*, xxv).

50 For a historical overview of Asian Americans and the Left before the rise of the New Left, see Lai, "Survey."

51 Ho, "BAMBOO," 250.

52 Villareal, *Pocho*, 48–50.

53 For a biographical account in which Corona both recalls and distances himself from his Left past, see Garcia, *Memories of Chicano History*.

54 For an assessment of Colon and his relation to Nuyorican writing by an important scholar of Puerto Rican culture in the United States, see Flores, foreword, xvi.

55 Ho, "BAMBOO," 250.

56 Author's interview with Muhammad Ahmad.

57 Welch, "Black Art and Activism," 1–4.

58 For example, see the reader published in 2002, Cruse, *Essential Harold Cruse*.

59 Sillen, review of *The Negro Caravan*.

60 For an example of Haywood's representation of this sort of debate, see his description of the battle between "Left," "Center," and "Right" factions of the CPUSA following Khrushchev's "Secret Speech" in 1956 (*Black Bolshevik*, 605–27). While Haywood's account is possibly distorted and almost certainly self-serving, it does present a picture that is more complicated than the usual simplistic oppositions of Left and Right that usually accompany studies of the period.

61 Biondi, *To Stand and Fight*, 7.

Chapter Two

1 Gates, "Black Creativity," 74.

2 My term "popular avant-garde" is clearly influenced by Sollors's notion of "Baraka's persistent demand for a populist modernism, a unity of life and art, literature and society" (*Amiri Baraka*, 8) and indeed Baraka's own allusion to "a continuing tradition of a populist modernism" (*Moderns*, xvi) on which Sollors draws—though my genealogy and application of the term differs from that of Sollors. I am similarly indebted to William Harris's formulation of Baraka's "jazz aesthetic," though again my sense of the ancestry of Baraka's poetics as traced through the New American Poetry "schools" of the 1950s and 1960s and its link to popular culture differs somewhat from Harris's—at least as expressed in *Poetry and Poetics*.

3 The stance of the Black Arts movement elsewhere, though influenced by the movement in

the Northeast, was often quite different. For example, the early movement in Chicago, especially among many writers, was much closer to a more traditional notion of an avant-garde that viewed popular culture with some suspicion, if not outright hostility. On the other hand, the notion of a popular avant-garde greatly influenced the artists of BLKARTSOUTH in New Orleans, even those most influenced by the Kawaida movement. However, according to Tom Dent, the New Orleans poets and theater workers took this model and used it (and the vital New Orleans jazz and R & B scene of the time) to assert the worth of their own efforts in the South against what they saw as northern neglect or condescension (Salaam, "Enriching the Paper Trail," 335, and "BLKARTSOUTH," 469).

4 For a study that juxtaposes the Irish Renaissance to the New Negro Renaissance, see Mishkin, *Harlem and Irish Renaissances*.

5 Locke's most famous invocation of an African American transposition of European nationalism can be found in the opening essay of *New Negro* (1925): "Without pretense to their political significance, Harlem has the same role to play for the New Negro as Dublin has for the New Ireland or Prague for the New Czechoslovakia" (7). A similar sentiment can be found in J. Johnson's preface to the first edition of *Book of American Negro Poetry* (1922), where he declares, "what the colored poet in the United States needs to do is something like Synge did for the Irish" (41)

6 H. Johnson, "Poem," 279.

7 For an early articulation of this position by Brown himself, see S. Brown, "Blues as Folk Poetry."

8 Diane di Prima recalled about the Beat bohemia of the 1950s: "As far as we knew, there was only a small handful of us—perhaps forty or fifty in the city—who knew what we knew: who raced about in Levis and work shirts, made art, smoked dope, dug the new jazz, and spoke a bastardization of black argot. We surmised that there might be another fifty living in San Francisco, and perhaps a hundred more scattered throughout the country: Chicago, New Orleans, etc., but our isolation was total and impenetrable" (*Memoirs*, 126).

9 O'Hara, *Standing Still*, 11. The New York school's stance toward popular culture also derives, no doubt, from a pronounced attachment to twentieth-century French modernism and the deep but generally ironic affection many French artists had for French and American popular culture, from the music hall and other popular elements in the work of Satie and other members of Les Six to the B-movie science fiction and film noir to which Jean-Luc Goddard so frequently paid homage in the late 1950s and 1960s.

10 Amiri Baraka, *Blues People*, 225.

11 Amiri Baraka, *Home*, 93.

12 The directly proscriptive spirit of the essay comes mostly in quick asides—for example, "the black artist is most often always hip to European art, often at his jeopardy" (ibid., 197).

13 Amiri Baraka, *LeRoi Jones*, 210.

14 Touré, "We Are on the Move," 450. Touré retitled the essay when it was reprinted in 1970 since he had always been unhappy with the title that Daniel Watts gave it in *Liberator*.

15 Sell, "Black Arts Movement," 57–59.

16 John Wilson interview, May 18, 1993, SI. For a series of articles outlining Stewart's career and his contributions to the Black Arts movement, see Spady, "Requiem," "New Stylistics," and "Muntu-Kuntu."

17 Stewart, "Development," 6.

18 Spellman, *Black Music*, 29.

19 For a brief description of a typical Sun Ra performance (and its relation to Black Arts theory), see Lorenzo Thomas, "Classical Jazz," 239.

20 For example, Archie Shepp claims that he rejected the embryonic cultural nationalist ideology animating Baraka's move to Harlem and the formation of BARTS but loved the idea of a "Black Arts" movement that theoretically elaborated the connection between an artistic/political avant-garde and black popular culture (author's conversation with Archie Shepp).

21 Author's interview with Sonia Sanchez.

22 Amiri Baraka, *Autobiography*, 236–37; author's interview with Amiri Baraka; Lorenzo Thomas, *Extraordinary Measures*, 130–31, and "Communicating by Horns," 295–97; author's interviews with A. B. Spellman and Askia Touré.

23 Amiri Baraka, *Autobiography*, 237; author's interview with Amiri Baraka.

24 In the 1978 documentary *Black Theatre*, Bullins asserts that he sent Robert Macbeth and the New Lafayette Theatre some early work that impressed Macbeth but that he considered inappropriate at the moment because of its focus on pimps, prostitutes, and other sorts of "street" characters. Nonetheless, Macbeth encouraged Bullins to send more work, which he did, leading to his tenure as playwright-in-residence at the New Lafayette.

25 Bullins, *We Righteous Bombers*, 96.

26 Ibid., 27.

27 For an incomplete transcript of the New Lafayette symposium, see "Reaction to *We Righteous Bombers*." For the best discussion of Bullins's play and its complicated relationship to text, authorship, and "editorial performance," see Sell, "Ed Bullins."

28 Salaam, *Magic of Juju*, 193–94. As Suzanne Smith notes, many members of the Motown studio band, the Funk Brothers, were also jazz players (*Dancing in the Street*, 159–61). For another look at the Funk Brothers, albeit one that almost totally depoliticizes them and the cultural moment of Detroit in the 1960s, see Paul Justman's 2002 documentary *Standing in the Shadows of Motown*.

29 It is also worth recalling that the favor was returned, since Brown's approach to rhythm, melody, and chord changes influenced the new jazz, especially after the mid-1960s. As drummer Beaver Harris said, "James Brown recorded this tune and I remember him saying, 'Give the drummer some!' That opened a lot of eyes and ears" (quoted in Wilmer, *As Serious as Your Life*, 155).

30 Author's interview with John Sinclair.

31 Kofsky, *Black Nationalism*, 185–94.

32 Ibid., 194–97.

33 Benston, *Performing Blackness*, 113–86. For an interesting meditation on Coltrane and his place in African American (and American) culture in the 1960s, see Hall, *Mercy, Mercy Me*, 113–50.

34 Author's interview with Askia Touré. For an insightful consideration of Hayden's complicated

relationship to the cultural moment of the 1960s (and the equally complicated response of Black Arts activists to Hayden's work), see Hall, *Mercy, Mercy Me*, 39–77.

35 Author's interview with Sam Cornish.

36 L. Neal, "Black Arts Movement," 285.

37 For an interview with New Lafayette founder Robert Macbeth that gives a sense of the impact of this notion of ritual on many of the leading Black Arts theaters, especially in New York, see Marvin X, "Black Ritual Theatre." The fact that Macbeth was early on ambivalent about the relation of the New Lafayette to the Black Arts movement and black artistic nationalism makes his articulation of the practically and ideologically separatist notion of ritual that he articulated in this interview even more striking as an example of how deeply the idea penetrated among black artists. However, it might also be noted that virtually everyone to whom I have spoken about this topic, whether favoring the ritual theater or, like Woodie King Jr., unenthusiastic about it, admits that black audiences overwhelmingly preferred more naturalistic and/or humorous nonritual stagings, such as the plays of Ron Milner.

38 Author's interview with Maulana Karenga.

39 Ibid.; L. Neal, *Visions*, 125.

40 Boggs's classic statement of this position is the essay "The City Is the Black Man's Land," which was written in 1965 and first appeared in the April 1966 issue of *Monthly Review*. The essay was later collected in J. Boggs, *Racism and Class Struggle* (1968).

41 It is worth noting that many of the leading Black Arts–era poets who have remained extremely productive, such as Amiri Baraka, Askia Touré, Jayne Cortez, and Sonia Sanchez, engage history, both African and American, as it is normally understood in their post–Black Arts poetry far more than they did in the late 1960s and early 1970s — at least in their published poetry. Baraka's long poem *Wise, Why's, Y's* (1995), a sort of lyric epic of African American history, mixes the counterhistory he sees contained in vernacular black music with perhaps the most powerful attempt to get into specific historical subjectivity since Robert Hayden's "Middle Passage," written in the early 1940s. Similarly, Touré's *Dawnsong* (2000) is in a more traditionally epic voice, combining the sort of mythic African counterhistory that characterized much of Touré's Black Arts work, with concrete details of African and African American oppression and freedom struggles.

42 Touré, "Earth."

43 Amiri Baraka, *LeRoi Jones*, 211.

44 L. Neal, "For Our Women," 310.

45 J. Wright, *Homecoming Singer*, 63.

46 Amiri Baraka, *LeRoi Jones*, 97. It is worth noting that though *Dutchman* is often assigned to the transitional moment between Baraka's bohemian phase and his high nationalist period, it not only exerted a tremendous influence over the most important playwrights, actors, and directors who form the core of Black Arts theaters across the country but also became a staple of BARTS street performances. As Baraka notes ironically, what had been praised by white mainstream and countercultural critics when performed downtown was held as an example of Baraka's and BARTS's extremist black racism when staged uptown (ibid., 309).

47 Sanchez, *We a BaddDDD People*, 69.

48 For the most thorough study of Maulana Karenga and his Us organization, see Scot Brown, *Fighting for US*.

49 Author's interviews with Askia Touré, Amiri Baraka, Sonia Sanchez, Nayo Watkins, and Maulana Karenga.

50 Author's interview with Askia Touré.

51 H. Jones, *How I Became Hettie Jones*, 100–101.

52 Author's interviews with Amiri Baraka, Haki Madhubuti, Sonia Sanchez, Askia Touré, and Kalamu ya Salaam.

53 Author's interview with Askia Touré. For an apparently truncated transcript of the forum, see "Reaction to *We Righteous Bombers*." For an interpretation of the symposium that differs radically from that of Touré (or mine, for what it is worth), see Benston, *Performing Blackness*, 66–68.

54 Giovanni, *Selected Poems*, 60.

55 Amina Baraka, "Coordinator's Statement," 178.

56 For an interesting argument that "the Black Arts Movement founded its politics on the valorization and exploitation of performative modes of culture," see Sell, "Black Arts Movement." See also D. Smith, "Black Arts Movement," 98–101.

57 Benston, *Performing Blackness*, 26–27.

58 For accounts of the creation of the *Wall of Respect*, see Donaldson, "Rise and Fall"; Cockcroft, Weber, and Cockcroft, *Toward a People's Art*, 1–8; and William Walker interview, June 12 and June 14, 1991, SI. For a discussion of Gwendolyn Brooks, her poem "The Wall," and the also dramatic (though less tense) dedication of the mural at which she read the poem, see Lowney, "Beyond Mecca."

59 L. Neal, *Visions*, 20–21.

60 Sell, "Black Arts Movement," 65–73.

61 Madhubuti, "Black Writing," 37–38.

62 Spellman, *Black Music*, 70–71.

63 Kane, *All Poets Welcome*, 27–56.

64 For a thoughtful consideration of the Living Theater and its place in the U.S. avant-garde of the 1960s, see Sell, "Performing Crisis," 26–64.

65 Sell, "Ed Bullins," 418.

66 Tom Dent interview with Michel Oren, Dec. 25, 1981, UPWSC. (Except where noted, all Umbra Poets Workshop oral history interviews cited were conducted by Michel Oren.)

67 Touré, "Crisis in Black Culture," 456.

68 Johnson and Johnson, *Propaganda and Aesthetics*, 180.

69 As noted in Chapter 2, it is instructive in this regard to look at the letters requesting materials from Jihad Productions in the Amiri Baraka Papers, HU. These requests came from such small and midsize cities as Atlantic City, New Jersey; Chambersburg and New Castle, Pennsylvania; Youngstown, Yellow Springs, and Dayton, Ohio; as well as the larger cities more often associated with Black Arts and Black Power.

70 William Walker interview, June 12 and June 14, 1991, SI.

71 For example, Ishmael Reed complained in an infamous 1977 interview that the hardcover edition of his most recent novel sold only eight thousand copies (Domini, "Ishmael Reed," 142).

72 C. Brooks, *Well Wrought Urn*.

73 Amiri Baraka, *LeRoi Jones*, 219. Baraka's restatement of Williams also seems remarkably close to Jack Spicer's often hilarious epistolary dialogue with the dead Federico García Lorca in *After Lorca* (1957) in which Spicer says that he wants "to make poems out of real objects. The lemon to be a lemon that the reader could cut or squeeze or taste" (Spicer, *Collected Books*, 33). However, when I asked Baraka if there was a direct allusion to Spicer's work in "Black Art," he said that he had not intended one, though perhaps there was one on a less conscious or serendipitous level (author's interview with Amiri Baraka).

74 Kane, *All Poets Welcome*, xvi–xvii.

75 Nielsen, *Black Chant*, 58–59. For a sense of how Hughes mentored Atkins and promoted his early career, see the letters between the two in the Langston Hughes Papers, box 6, YU.

76 Nielsen, *Black Chant*, 66.

77 Johnston, "Variations on a Theme," 46; Ginsberg, *Howl*, 33.

78 For example, the Kenyan writer Ngugi wa Thiong'o would later use "Afro-Saxon" as a term for literature in English written by Africans, which he negatively posed against authentic "African literature" in indigenous African languages, in the 1979 essay "Return to the Roots" in *Writers in Politics*.

79 Lorenzo Thomas, *Extraordinary Measures*, 211. For another discussion of the visual elements of Sanchez's poem, see M. Jones, "Jazz Prosodies," 71–75.

80 Author's interview with Sonia Sanchez.

81 Nielsen, *Black Chant*, 34.

Chapter Three

1 Salaam, *Magic of Juju*, 20.

2 CFUN became the Newark chapter of CAP after the first CAP convention. For a study of CFUN and CAP and its impact on the Black Power movement, see Woodard, *Nation within a Nation*.

3 Author's interview with Amiri Baraka.

4 Even in the case of the founding of the Studio Museum, the mainstream press emphasized the roles that white liberals, particularly the social worker Frank Donnelly and the socialite, philanthropist, arts patron, and political operative Carter Burden, played in the creation of the museum, downplaying the contributions of African American artists and activists. For an example of this coverage, see Glueck, "Very Own Thing in Harlem."

5 The closest equivalent to the AACM and UGMA in New York, the Collective Black Artists (CBA), lasted about five years as a viable organization during the first half of the 1970s. For an in-depth look at the CBA, see Porter, *What Is This Thing?*, 215–39.

6 For a valuable consideration of Bullins's work as an editor and the relation of this editorial function to his plays, see Sell, "Ed Bullins."

7 Comments of Robert Macbeth and Ed Bullins in the 1978 documentary *Black Theatre*; author's interview with Ed Bullins.

8 Author's interviews with Ernest Allen Jr., Askia Touré, and Woodie King Jr. For scholarly considerations of Teer and the NBT that are strong on the philosophy, poetics, performance strategies, and pedagogical practice of the NBT but not much concerned with assessing the theater's actual impact on the Black Arts movement (or even African American theater in the 1960s and 1970s) in any detailed way, see J. Harris, "National Black Theatre"; B. Lewis, "Ritual Reformations"; and Lundeana Thomas, *Barbara Ann Teer*. See also Teer's comments in the 1978 documentary *Black Theatre*.

9 Salaam, "Black Theatre," 647–52.

10 Author's interview with Woodie King Jr.

11 Teer's comments in the 1978 documentary *Black Theatre*. Amiri Baraka also saw the NEC as a sort of sop to the black community promoted by corporate America in place of genuine Black Arts theater ("Afro-American Literature," 14). For yet another jaundiced view of the situation of black theater in New York during the late Black Arts era, see King, *Black Theatre*, 66–71. It should be noted, however, that King was (characteristically) relatively generous toward the NEC as compared with, say, Baraka or Teer.

12 Lorenzo Thomas, *Extraordinary Measures*, 140.

13 Undated interview transcript, Larry Neal Papers, box 26, folder 2, p. 12, SC.

14 For examinations of New Negro Renaissance radicalism and its relation to expressive culture, see E. Allen, "New Negro"; Maxwell, *New Negro, Old Left*, 13–124; and Solomon, *Cry Was Unity*, 3–21.

15 For a description of the New Negro Renaissance in Washington, D.C., see Hutchinson, "Jean Toomer."

16 For an account of the Left and the Harlem intelligentsia during the Popular Front, see Naison, *Communists in Harlem*, 193–226.

17 For an excellent discussion of the black cultural Left in Harlem during the 1950s, see Welch, "Black Art and Activism."

18 For discussions of nationalist activities in Harlem during the 1930s, particularly those of the UNIA, the African Patriotic League led by Ira Kemp, the Pan-African Reconstruction Association, the Garvey Club, the Harlem Labor Union led by Kemp and Arthur Reid, and the Negro Industrial and Clerical Alliance led by Sufi Abdul Hamid and on the competition and cooperation between nationalist groups and the Communist Left, see Naison, *Communists in Harlem*, 115–25, 138–40, 261–63; and Greenberg, *"Or Does It Explode?,"* 114–39.

19 Amiri Baraka, *Home*, 92, and *LeRoi Jones*, 217. For an examination of the transformations of the symbolic landscape of Harlem, see De Jongh, *Vicious Modernism*, 151–52.

20 Author's interview with Esther Cooper Jackson.

21 Tom Dent interview, Dec. 25, 1981, UPWSC.

22 For an account of Castro's visit and its significance, see Plummer, "Castro in Harlem." For a personal recollection of the impact of Castro's visit by a leading HWG member, see S. Wright, "Lower East Side," 594–96.

23 Author's interview with William Strickland.

24 Shirley Graham Du Bois Papers, box 17, folder 1, Schlesinger Library, Harvard University.

25 For studies of the impact of the Cold War on African American political activism, see Horne, *Black and Red*, *Communist Front?*, and *Black Liberation*; and Dudziak, *Cold War Civil Rights*. For a recent examination of the infrastructure of McCarthyism, see Schrecker, *Many Are the Crimes*.

26 Author's interview with Esther Cooper Jackson. One particularly cruel aspect of this aggressive surveillance was the repeated questioning of James Jackson's father in which agents would ask him how the family would contact his son in the event of his death. Another example of the far-reaching nature of these methods of intimidation can be seen in an attempt to expel the Jacksons' young daughter from a nursery school that received government funds. Only the broad support of their community in Brooklyn prevented their daughter's expulsion. James Jackson resurfaced in the late 1950s—he had not seen his family for five years. His Smith Act trial featured W. E. B. Du Bois as a witness for the defense. Though Jackson was convicted and sentenced to two years in prison, he avoided jail time (except while awaiting bail) when the Supreme Court ruled against the Smith Act. During this period, Esther Cooper Jackson held a series of jobs that she left due to FBI pressure before becoming the managing editor of *Freedomways*.

27 For example, two longtime residents of Harlem and former members of cultural worker "sections" of the CPUSA told me that the CPUSA structure in Harlem seemed to vanish almost overnight in the mid-1950s—at least for many rank-and-file members. Both agreed that there were hundreds of people in Harlem at the time who still considered themselves Communists but could not find the CPUSA. Most of these former members did not reconnect with the CPUSA later, but some, especially artists and intellectuals, maintained at least a degree of willingness to participate in activities initiated or supported by a reemergent (if greatly diminished) Communist Left in the early 1960s.

28 Lorenzo Thomas, *Extraordinary Measures*, 138.

29 Author's interview with Sonia Sanchez.

30 Author's interviews with Muhammad Ahmad and Sonia Sanchez; typescript of conversation between Maya Angelou and Rosa Guy, Rosa Guy Papers, box 2, folder 13, BU.

31 For a contemporary look at nationalist activity in the late 1950s and early 1960s, see Clarke, "New Afro American Nationalism."

32 Biondi, *To Stand and Fight*, 257–62.

33 For example, in 1962 Hughes wrote Arna Bontemps that John O. Killens spent a day with him and that they "had a long session over literary matters" (Bontemps and Hughes, *Letters*, 446). One is tempted to view Hughes's statement as a sort of code for any third party reading his mail. In any event, it is one of many examples of how Hughes maintained contact with those artists and intellectuals who had not separated themselves from the Left. For a longer consideration of Hughes, the Left, and the Black Arts movement, see Smethurst, "'Don't Say Goodbye.'"

34 Author's interview with Esther Cooper Jackson.

35 Baraka initiated the Organization of Young Men after his return from Cuba in 1960. It was intended as a vehicle for downtown black artists and activists to engage and enter into the more

militant side of the domestic civil rights movement and to link civil rights in the United States with struggles against colonialism and neocolonialism around the world, while maintaining a distance from "mainstream" civil rights organizations. In practice, the group functioned largely as a discussion and propaganda group and did little practical political work. While some, such as Tom Dent, attribute the group's relative inactivity to Baraka's allegedly mercurial political behavior, others cite an internal, ideological struggle between Marxists (primarily associated with the CPUSA) and nationalists, much like that which eventually played out in OGFF and also to some extent Umbra (Oren, "'60s Saga [Part II]," 179).

36 Tom Dent interview, June 21, 1984, UPWSC.

37 S. Wright, "Lower East Side," 594; author's interview with Calvin Hicks; Tom Dent interview, Dec. 25, 1981, and Art Berger interview, no date, UPWSC.

38 Fuller, "Harlem Writers Guild."

39 Childress, Marshall, and Wright, "Negro Woman," 291–92.

40 Welch, "Black Art and Activism," 304–7. For another view of the AMSAC arguing that it largely achieved its purpose in marginalizing African American Left writers, see Washington, "Desegregating the 1950s."

41 J. Mayfield, "Into the Mainstream," 30.

42 For an account of Mayfield's role in the expatriate community in Ghana, see Gaines, "Cold War." For another take on the ideological and interpersonal complexities of that community and an argument that it had a great impact on Malcolm X's political evolution, see Horne, *Race Woman*, 173–96.

43 In the case of Cruse, it was his widely read 1962 essay "Revolutionary Nationalism and the Afro-American" in the journal *Studies on the Left* that dramatically signaled his public break with the CPUSA and what he called "western Marxism." The essay was reprinted in Cruse's 1968 collection *Rebellion or Revolution*.

44 Horne, *Black Liberation*, 293–320.

45 E. Jackson, *Freedomways Reader*, xxi–xxii; author's interview with Esther Cooper Jackson. It is worth noting that almost from the moment that *Freedom* folded, there were attempts to create a new African American Left journal that might fill the vacuum. For example, as early as 1956, Doxey Wilkerson, George Murphy, Louis Burnham, and Edward Strong, all veterans of such black Left institutions as *Freedom*, *People's Voice*, and the SNYC, discussed the possibility of such a journal with W. E. B. Du Bois (and presumably others). For an exchange between Strong and Du Bois about a prospectus for the proposed journal that Strong sent Du Bois in December 1956 after an earlier discussion, see W. E. B. Du Bois Papers, reel 72, UMA.

46 For example, Johnson and Johnson in their important study of African American literary magazines underestimate the impact of nationalism on *Freedomways* (*Propaganda and Aesthetics*, 228).

47 Author's interview with Esther Cooper Jackson.

48 Killens, "Lorraine Hansberry," 337. For an analysis of Killens's ideological stance during the early 1960s before his move to Fisk University, see Gilyard, *Liberation Memories*, 59–77.

49 Du Bois Centennial program, Julian Mayfield Papers, box 4, folder 12, SC.

50 Cruse, *Crisis*, 242–49.

51 Author's interview with Esther Cooper Jackson.

52 Salaam, *Magic of Juju*, 86.

53 Cruse, *Crisis*, 404–18; author's interview with Askia Touré.

54 Woodard, *Nation within a Nation*, 58. However, Harold Cruse associates what he sees as *Liberator*'s failure to become a truly revolutionary vehicle of black liberation with a persistent Communist influence on the editorial policies of the journal until 1966 (*Crisis*, 404–19).

55 An article by Eddie Ellis, "Semitism in the Black Ghetto," in the February 1966 issue prompted the departure of Davis and Baldwin. However, it is worth noting that in Davis's letter explaining his departure, which appeared in *Freedomways* in 1967, Davis reiterated his respect for Daniel Watts and proclaimed himself a "black nationalist," calling into question some characterizations of the event — and indeed of the character of *Freedomways*, with which Davis was long associated.

56 Woodard, *Nation with a Nation*, 58. The precise events are not entirely clear. As far as I can tell, Davis did join in various activities protesting Lumumba's murder that day but may have been excluded from part of the demonstration at the United Nations. I have not been able to come to a firm conclusion concerning Robeson, other than that he did take part in the action at the United Nations on some level. Participants in the demonstrations outside and inside the UN building to whom I have spoken could not recall seeing or hearing about the banning of Davis at the time of the demonstration — though they read or heard reports of it afterwards. In any event, they were not able to affirm or deny whether the banning occurred. A report on the demonstration in the *New York Times* suggests that Davis was prevented by nationalists from taking part in an all–African American picket line at First Avenue and Forty-third Street — the *Times* piece says that Davis eventually joined a largely white picket at First Avenue and Forty-second Street. The *Times* article also suggests that Robeson participated in the black picket line unmolested. According to the *Times*, Davis was the first speaker at an outdoor unity rally in Harlem attended by several hundred people later that day ("Riot in Gallery"). The retrospective written accounts of the demonstration by participants that I have seen, including that of Baraka in his autobiography, make no mention of the rejection of Davis and Robeson. Certainly, many of the black writers and intellectuals associated with the Left-influenced HWG who helped organize the demonstration felt a considerable attachment to Davis. On the other hand, some of the nationalists at the picket, James Lawson for instance, might well have been publicly hostile to Davis and Robeson in a way that they would not have been toward leftists whose persons or names were not icons of the Communist Left (S. Wright, "Lower East Side," 594; author's interviews with Calvin Hicks and Esther Cooper Jackson; Angelou, *Heart of a Woman*, 154–66; Welch, "Black Art and Activism," 310–14).

57 S. Wright, "Lower East Side," 594; author's interview with Calvin Hicks.

58 Morris Dickstein, for example, uses the anti-Semitism of Baraka's "Black Art" to peremptorily dismiss the Black Power and Black Arts movements in *Gates of Eden*, 173–74.

59 While precise figures are hard to find, some scholars estimate that close to half of the CPUSA's national membership was Jewish during the Popular Front era. The percentage of Jewish members was even higher in the urban centers of the Northeast. For example, Paul Lyons claims that the CPUSA in Philadelphia was at least 75 percent Jewish (and perhaps 10 percent Afri-

can American) during the Popular Front (*Philadelphia Communists*, 70–86). Other Old Left groups, such as the SP, the WP, and the SWP, also had large numbers of Jewish members.

60 Author's interview with Askia Touré.

61 For an example of Neal's position, see his response to a letter to the editor from Frank Kofsky in the Feb. 1966 *Liberator*. For an early example of a rejection of Marxism and the positing of a new African American spirituality by a leading Black Arts activist, see Askia Touré's 1964 letter to James Boggs, James and Grace Lee Boggs Papers, series 1, box 2, folder 1, Walter P. Reuther Library, Wayne State University. Again, it is worth noting that Touré fundamentally accepts Boggs's Marxist take on economic oppression but characterizes it as too limited.

62 For accounts of the African American literary scene in New York during the late 1950s and early 1960s, see Redmond, *Drumvoices*; Hernton, "Umbra"; Dent, "Umbra Days"; Amiri Baraka, *Autobiography*, 124–201, 243–94; Oren, "'60s Saga (Part I)"; Lorenzo Thomas, *Extraordinary Measures*, 118–44.

63 Author's interviews with Muhammad Ahmad and Calvin Hicks.

64 For a brief recollection of Stanley's as a social linchpin of black bohemia on the Lower East Side and as an informal venue for wide-ranging intellectual discussion and debate, see Hicks, *African-American*. According to Askia Touré, it was also a place where black, out-of-town civil rights activists gathered when they were in New York, allowing cross-fertilization between what might be thought of as African American cultural and political front lines (author's interview with Askia Touré).

65 For Dent's recollection of the Lower East Side as a multiracial environment in the 1960s, see Salaam, "Enriching the Paper Trail." It is worth noting that the writers themselves did not universally share this vision of a multiracial neighborhood. A number of them recall the Lower East Side in the early 1960s as overwhelmingly white. For an example of this sense of the neighborhood, see Hernton, "Umbra," 579–80.

66 Amiri Baraka, *Autobiography*, 171–72; Lorenzo Thomas, "Alea's Children," 574–75; Kane, *All Poets Welcome*, 54–55.

67 Nielsen, *Black Chant*, 78–169; Lorenzo Thomas, *Extraordinary Measures*, 196–202.

68 Amiri Baraka, *Autobiography*, 124–201; Nielsen, *Black Chant*, 106–8.

69 Author's interview with Sonia Sanchez.

70 Ibid.

71 "Youth Group Ruled a Communist Front"; J. Griffin, "2 in Youth Agency"; Bigart, "4 in Youth Agency."

72 Amiri Baraka, *Home*, 11–62, and *Autobiography*, 243–46.

73 Author's interview with Amiri Baraka.

74 Amiri Baraka, *Autobiography*, 270.

75 Kane, *All Poets Welcome*, 143–45.

76 Tom Dent interview, Dec. 25, 1981, UPWSC.

77 Author's interview with Lorenzo Thomas.

78 Amiri Baraka interview with Lorenzo Thomas, June 21, 1984, UPWSC.

79 Alvin Simon, letter to the editor, 48. By "Marxist-Leninists," Simon seems to mean those "associated with the CPUSA." One fascinating aspect of Simon's account is how it displays

the lasting impact of Cold War anti-Communism. Appearing in a 1985 issue of *Freedomways*, Simon's letter to the editor speaks of "Marxists" and "Marxist-Leninists," but nowhere do the words "Communist" or "Communist Party" appear, even when discussing such clearly Communist institutions as *The Worker* and *American Dialog*.

80 Brenda Wolcott interview, June 27, 1978, UPWSC.

81 Dent, "Umbra Days," 108; Tom Dent interview, Dec. 25, 1981, UPWSC.

82 Brenda Wolcott interview, June 27, 1978, UPWSC.

83 Oren, "'60s Saga (Part II)," 241, and "Umbra Poets' Workshop," 206; Art Berger interview, no date, UPWSC.

84 Tom Dent interview, Dec. 25, 1981, and Art Berger interview, no date, UPWSC.

85 Art Berger interview, no date, and Brenda Wolcott interview, June 27, 1978, UPWSC.

86 Charles Alston interview, Oct. 19, 1968, and Romare Bearden interview, June 29, 1968, SI.

87 For a short history of Spiral—albeit one that suffers from residual Cold War elision of the politics of the participants—see Bearden and Henderson, *History of African American Artists*, 400–403.

88 Author's interview with Askia Touré.

89 Author's interviews with Amiri Baraka, A. B. Spellman, and Calvin Hicks; Amiri Baraka, *Autobiography*, 249–50.

90 Author's interviews with A. B. Spellman and Amiri Baraka; Baraka, *Autobiography*, 317.

91 Amiri Baraka, "Black Arts Movement," 3–4; author's interview with Amiri Baraka.

92 In a conversation with the author, Askia Touré recalled that Hughes would send Umbra complimentary tickets for the opening of his plays—no small favor for the perpetually broke black artists of the Lower East Side.

93 Amiri Baraka, *Fiction*, 345, and *Autobiography*, 290–92.

94 Hernton, "Umbra," 581; Tom Dent interview, Dec. 25, 1981, UPWSC.

95 Tom Dent interview, Dec. 25, 1981, and Art Berger interview, no date, UPWSC.

96 For example, David Henderson and Lorenzo Thomas had been part of Henry Percikow's writing workshop. Percikow, like Berger, was also affiliated with the Communist Left and no doubt considered his group, largely consisting of garment workers, to have a certain political purpose. Nonetheless, Thomas at least was far more interested in the group as a way of developing his writing and was not particularly engaged in Percikow's politics—not that Thomas saw politics and craft as necessarily mutually exclusive (author's interview with Lorenzo Thomas).

97 Oren, "'60s Saga (Part II)," 237–39; author's interview with Lorenzo Thomas.

98 As noted elsewhere, Askia Touré, one of the leaders of the hard-liners, left a particularly large mark both as a writer and as an organizer. Of course, as Amiri Baraka recalls, two of the other militants, the brothers Charles and William Patterson, also figured significantly in the history of the BARTS but mostly as destructive (if not pathological) forces (*Autobiography*, 297–328).

99 Touré, "Crisis in Black Culture," 459.

100 While Amiri Baraka has claimed that most of the intellectuals and artists associated with the BARTS did not know a great deal about the specifics of the NOI beyond the public presence of Malcolm X, nonetheless he notes that various sorts of cultural nationalist "Muslim" stances were taken by BARTS members (*Autobiography*, 301–4; author's interview with Amiri Baraka).

101 For a brief journalistic account of Neal's shooting and the final dissolution of the BARTS, see Stern, "Arms Cache." See also the interview with Askia Touré in *Konch*, Ishmael Reed's on-line journal, at <http://www.ishmaelreedpub.com/konch.html>. BARTS not only became the target of political attacks locally but also was used as a focal point of attempts to discredit federal antipoverty efforts headed by Congressman Adam Clayton Powell Jr. of Harlem (Friendly, "Powell Says His Study").

102 For a somewhat anecdotal account of what might be thought of as the second wave of the Black Arts movement in Harlem circa 1968–70, see Marvin X, *Somethin' Proper*, 153–95.

103 Author's interviews with Edward Spriggs and Askia Touré.

104 One of the best ways to get a sense of the dynamism of black nationalist political and cultural activity in Brooklyn during the very late 1960s and the early 1970s is to scan the pages of *Black News*. For a brief account of the founding and early character of The East, see the Sept. 26, 1970, column by Big Black, "Around Our Way."

105 For an example of Neal's argument that Harlem had to be the center of the Black Arts movement, based on its unique history and symbolic meaning, see "Cultural Conference Notes #1," 10, Larry Neal Papers, box 6, folder 25, SC.

106 Author's interview with Esther Cooper Jackson.

107 For an examination of the long history of African American civil rights activity in Boston focusing on public education, see Theoharis, "'I'd Rather Go to School.'"

108 Biography, Elma Ina Lewis Papers, box 3, folder 10, NU.

109 Elma Lewis, letter to Harry Belafonte, Mar. 19, 1973, NCAAA records, box 35, folder 23, NU.

110 ELSFA records, box 12, folder 1, NU.

111 "Plan for the National Center of Afro-American Artists," p. 2, box 2, Museum of the National Center of Afro-American Artists Records, NU.

112 ELSFA records, box 13, folder 48, NU.

113 Hughes, "Negro Artist," 28–29.

114 For a brief account of *Black Opals*, see Johnson and Johnson, *Propaganda and Aesthetics*, 89–92.

115 Cronon, *Story of Marcus Garvey*, 206.

116 Vincent, *Black Power*, 165–66.

117 L. Neal, *Hoodoo Hollerin' Bebop Ghosts*, dust jacket note; Spady, *Larry Neal*, 6–7.

118 For a study of the CPUSA in Philadelphia that depends heavily on the accounts of former Communists, see Lyons, *Philadelphia Communists*. For discussions of the NNC in Philadelphia, see Banner-Haley, *To Do Good*, 153–61; and Countryman, "Civil Rights and Black Power," 54–55.

119 Horne, *Communist Front?*, 251–55.

120 Countryman, "Civil Rights and Black Power," 52–72. For an account of Watson's dismissal, along with dozens of other teachers, by the Philadelphia Board of Education following a series of hearings by the HUAC, see Caute, *Great Fear*, 419–20. Watson was unusual in her testimony before HUAC in that she was the first "unfriendly" witness to base her defense on the First Amendment since the notorious "Hollywood Ten" in the late 1940s.

121 One person whose parents were Communist activists in North Philadelphia during the Mc-

Carthy era recalled to me an incident in the neighborhood in which known leftists were dragged into the streets, stripped naked, and beaten by right-wing vigilantes. He also recalled constant and obvious FBI and Red Squad surveillance during the 1950s.

122 For a memoir of McCarthyism in Philadelphia by one of the local Smith Act defendants, see Labovitz, *Being Red*.

123 Author's interview with Muhammad Ahmad; e-mail correspondence with Jarvis Tyner, Apr. 7, 2003.

124 Spady, *Larry Neal*, 11; author's interview with Muhammad Ahmad.

125 Spady, *Larry Neal*, 10–11; L. Neal, "New Space," 16–17.

126 L. Neal, "New Space," 16–17.

127 Spady, *Larry Neal*, 12, and "Requiem," 20.

128 Spady, "Muntu-Kuntu."

129 Author's interview with Muhammad Ahmad.

130 Ibid.

131 Stanford, "Revolutionary Action Movement," 74; author's interview with Muhammad Ahmad.

132 Countryman, "Civil Rights and Black Power," 158–67.

133 Ibid., 168–91.

134 Stanford, "Revolutionary Action Movement," 75; author's interview with Muhammad Ahmad.

135 Stanford, "Revolutionary Action Movement," 76–77; author's interview with Muhammad Ahmad; Kelley, *Freedom Dreams*, 72–73.

136 Author's interview with Muhammad Ahmad.

137 Ibid.

138 Stanford, "Revolutionary Action Movement," 77–79; author's interview with Muhammad Ahmad.

139 Author's interview with Muhammad Ahmad.

140 *Black Power Movement, Part 3*, reel 1.

141 Stanford, "Revolutionary Action Movement," 79–80; author's interview with Muhammad Ahmad; Countryman, "Civil Rights and Black Power," 189–90.

142 Author's interview with Muhammad Ahmad. Both Ahmad, largely through his father's work in the NAACP, and Daniels, who also had a long history with the NAACP, were well-known to Cecil Moore—hence his willingness to trust them. For a discussion of Moore and his NAACP administration, see Countryman, "Civil Rights and Black Power," 215–373. For descriptions of RAM's relationship to Moore and the NAACP, see ibid., 253–54; and Stanford, "Revolutionary Action Movement," 83–84.

143 Author's interview with Muhammad Ahmad.

144 Ibid.; author's interview with Amiri Baraka; Amiri Baraka, *Autobiography*, 289.

145 For an example of this emphasis on preparing for armed struggle, see "The 12 Point Program of RAM (Revolutionary Action Movement) 1964" in *Black Power Movement, Part 3*, reel 1. In the second point of the program discussing the establishment of RAM, "Ideology (Freedom) Schools," the proposed curriculum of the schools is "history of the movement, current events,

political theory[,] methods of social action, methods of self-defense, principles of guerilla warfare, techniques of social dislocation, propaganda techniques and indoctrination, black history, etc." No mention is made of culture or the arts as such.

146 Author's interviews with Ernest Allen Jr.; T. Johnson, "Black Panthers Picket."

147 Author's interviews with Amiri Baraka, Muhammad Ahmad, and Askia Touré; Amiri Baraka, *Autobiography*, 289–90. One interesting example of this orientation toward culture is RAM's official endorsement of the analysis of Baraka's study of black music, *Blues People*, and its decision to circulate the book throughout its network (author's interview with Muhammad Ahmad).

148 Author's interview with Muhammad Ahmad. Of course, as Ahmad notes, though RAM assigned Neal to "mentor" Baraka, Baraka largely mentored himself during this period and significantly influenced Neal.

149 Author's interview with Askia Touré.

150 Ibid.

151 Art Berger interview, no date, UPWSC.

152 For a brief account of the creation of the alliance between CFUN and the Young Lords in Newark, see Woodard, *Nation within a Nation*, 138–43. For a scholarly examination of the Neorican/Nuyorican writers, see Wilkinson, "'In the Tradition,'" 156–220.

153 Baraka, *Eulogies*, 112–17.

154 Algarín and Piñero, *Nuyorican Poetry*, 15–16.

155 S. Henderson, *Understanding the New Black Poetry*, 62–66.

156 Algarín, "San Juan," 145.

157 Algarín and Piñero, *Nuyorican Poetry*, 14.

158 For example, during the 1970s the political landscape of the Lower East Side was marked by extremely bitter school board elections between slates supported on the one hand by the United Federation of Teachers and white voters who had few children in the public schools and on the other by largely Puerto Rican (and African American and Asian American) voters whose children made up the overwhelming majority of the students in the district (District One). For an account of the District One conflicts by the Puerto Rican district school superintendent who was at the center of the conflict, see Fuentes, "Struggle for Local Political Control."

159 For example, point 7 of the 1970 version of the Young Lords Party's "13-Point Program and Platform" reads, "We want a true education of our Afro-Indio Culture and Spanish language" (240).

160 Amiri Baraka, *Autobiography*, 355–59; author's interview with Amiri Baraka.

Chapter Four

1 Madhubuti, "Amiri Baraka and the Millennium"; author's interview with Haki Madhubuti.

2 For example, Wilfred X and the NOI were supportive of such nationalist initiatives as Rev. Albert Cleage Jr.'s Freedom Now Party. Wilfred X was also instrumental in bringing his brother, Malcolm X, to speak at the 1963 Grassroots Conference (S. Smith, *Dancing in the Street*, 82–88).

3 Author's interview with Sterling Plumpp.

4 For a memoir of Durham and his relationship to Elijah Muhammad during his tenure at *Muhammad Speaks* by the novelist and protégé of Durham at the newspaper, Leon Forrest, see *Furious Voice for Freedom*, 86–94. For another recollection of the newspaper by a Left editor-in-chief, see Woodford, "Testing America's Promise." For a discussion of the evolution of the NOI, including the Left influence at *Muhammad Speaks*, see E. Allen, "Religious Heterodoxy."

5 Von Eschen, *Race against Empire*, 174.

6 Salaam, *Magic of Juju*, 24.

7 Malcolm X, *Autobiography*, 195–215; S. Smith, *Dancing in the Street*, 83–84.

8 GOAL was an all–African American organization that combined elements of the modern civil rights movement with economic campaigns reminiscent of the nationalist (and Left) "Don't Buy Where You Can't Work" campaigns of the 1930s and 1940s. Like ACT in Chicago and New York, it focused on housing and education. Gaidi and Imari Obadele (then Milton and Richard Henry) would go on to become two of the most important territorial nationalist leaders, initiating the RNA, which revived the CPUSA's old call for a Black Belt republic in the South. Before coming to Detroit, the Henry brothers had been active in Philadelphia. There they founded the United Negro Assemblage in the early 1950s, addressing issues of jobs, police brutality, education, and political representation that would become familiar in 1960s black Detroit politics. However, it says something that the public events of the United Negro Assemblage, at least, were couched largely in Popular Front terms of social and economic democracy rather than separatism and self-determination. For a sense of the United Negro Assemblage, see the correspondence of W. E. B. Du Bois (who spoke at a United Negro Assemblage event in 1953) in W. E. B. Du Bois Papers, reel 70, frames 93–98, UMA. Freedom Now was a Left nationalist formation, which included in its leadership Cleage, the Obadele brothers, the young Left nationalists of UHURU, members of the SWP, and at least one Communist (or former Communist), Christopher Alston. It was also open to white people willing to work for black political power. Though it was a national group, its Michigan chapter probably had the strongest grassroots support. In short, it was the sort of ideologically eclectic group that characterized much Detroit radicalism in the early 1960s. This eclecticism, however, led to considerable tension within the group, particularly between nationalists and the SWP. For an excellent account of GOAL, the Freedom Now Party, UHURU, and Detroit radicalism, see Dillard, "Religion and Radicalism," and "From the Reverend," 292–317.

9 Malcolm X, *Malcolm X Speaks*, 10.

10 S. Smith, *Dancing in the Street*, 85–88.

11 For an outstanding study of the Left and African American cultural activity in Chicago during the 1940s, see Mullen, *Popular Fronts*.

12 For an account of Cleage's ideological development and his impact on nationalism in Detroit, see Dillard, "Religion and Radicalism," and "From the Reverend," 274–333. It should also be remembered that even though Cleage came to view Old Left groups with a certain amount of suspicion, or to at least keep them at arms length, he was often willing to work with members of such groups in larger umbrella organizations, such as GOAL and the Freedom Now Party, and to speak at the Debs Hall Forum of the SWP and the Global Forum of the CPUSA.

13 M. Boyd, *Wrestling with the Muse*, 49–50; conversation with Melba Joyce Boyd, Apr. 8, 2004.

14 For an attempt to untangle the relationship of Trotskyism to the radical intellectuals who emerged from the Johnson-Forest group focusing on one of the leaders of the group, C. L. R. James, see Robinson, *Black Marxism*, 278–86. See also Glaberman, introduction; and G. Boggs, *Living for Change*, 107–11.

15 For the best scholarly account of James's political development to date, see Worcester, *C. L. R. James.*

16 Glaberman, introduction, xiv; Worcester, *C. L. R. James*, 143.

17 For a sense of the impact of James Boggs's *American Revolution* on younger black political and cultural revolutionaries, see Askia Touré's 1964 letter to Boggs responding to the book and mentioning his admiration and the admiration of Muhammad Ahmad and other East Coast activists for Boggs's work (James and Grace Lee Boggs Papers, series 1, box 2, folder 1, Walter P. Reuther Library, Wayne State University).

18 According to Grace Lee Boggs, James Boggs asked her to marry him more or less out of the blue. In a similar spirit, she immediately answered yes (*Living for Change*, 77–79).

19 Author's interview with Askia Touré.

20 G. Boggs, *Living for Change*, 95–97. For a more detailed account of the Boggses and their relationship to black activism in Detroit during the 1960s, see ibid., 117–41.

21 Author's interview with Grace Boggs.

22 For an example of Boggs's thinking on this subject during the period, see the 1963 essay "The Meaning of the Black Revolt in the U.S.A." in J. Boggs, *Racism and Class Struggle*, 9–18.

23 Roger Keeran estimates that the SWP and the WP had perhaps a couple of hundred members in the UAW between them at the time (*Communist Party*, 243)—though it should be noted that Keeran is far more sympathetic to the CPUSA than to the Trotskyists. By comparison, according to Keeran, the CPUSA had about 1,200 members in the auto and aircraft industries (247). On the other hand, according to Paul Buhle, *Labor Action* had a circulation in the tens of thousands (*Marxism in the USA*, 200). Martin Glaberman claims that the Detroit branch of the WP distributed 5,000 copies of each issue of *Labor Action* in Detroit alone during this period (*Wartime Strikes*, 79–80).

24 Worcester, *C. L. R. James*, 126–28.

25 Glaberman, introduction, xx; Worcester, *C. L. R. James*, 86; G. Boggs, *Living for Change*, 101. Chaulieu (Castoriadis), the editor of the French post-Trotskyist journal *Socialisme ou Barbarie* and a leader of a group by the same name, was not really a part of the Correspondence group. Rather it would be more accurate to say that he had ideas about "existing socialism," antivanguardism, and grassroots workers' control of the state that were congruent with those of James and the Correspondence circle. However, he had some differences with the views expressed in *Facing Reality*, even though C. L. R. James and Grace Lee (Boggs) left his pseudonym on the volume (apparently over his objections).

26 James, Lee, and Chaulieu, *Facing Reality*, 165.

27 Author's interview with Grace Boggs.

28 Author's interview with Dan Georgakas; Georgakas, "Frank Lovell." Even the Communist Left was represented, if indirectly, since the black former Communist and UAW organizer

Christopher Alston apparently spoke at the Debs Forum on occasion. According to a couple of people who had been CPUSA members in Detroit during the 1960s and 1970s to whom I spoke, Alston was not formally a member of the CPUSA during that period. Apparently he preferred not to be a member so he could participate in a wider range of organizations and activities—such as the Debs Forum. Nevertheless, he retained much of his earlier ideological orientation, remaining close to many still in the party and supporting many Communist initiatives (Dillard, "From the Reverend," 266).

29 Geschwender, *Class, Race*, 87–88; author's interview with Dan Georgakas; Peterson, "'Who Fails.'" Through much of its existence, *Speak Out* resembled *Correspondence* in the era between Johnny Zupan's departure from *Correspondence* and Grace Boggs's editorship; that is to say, it consisted largely of political philosophy and theory, especially the thought of James, with relatively little engagement with grassroots Detroit politics and culture (outside of the auto industry)—at least until the uprising of 1967.

30 Kelley and Esch, "Black like Mao," 16; author's interviews with Ernest Allen Jr.

31 For an account of the impact of the domestic Cold War on black Chicago cultural institutions, see Mullen, *Popular Fronts*, 181–200.

32 Author's interviews with John Bracey Jr., Sterling Plumpp, and Abdul Alkalimat.

33 Author's interview with John Bracey Jr.

34 Letters from Langston Hughes to Ishmael Flory, Oct. 7, 1959, and Oct. 24, 1961, Langston Hughes Papers, box 3, YU.

35 Author's interview with John Bracey Jr.

36 Ibid.; Amiri Baraka, "Black Marxists" (unpublished manuscript), *Black Power Movement, Part I*, reel 6; Danns, *Something Better*, 25–60; Andrews and Pickering, *Confronting the Color Line*, 105–49.

37 Flyer, John Henrik Clarke Papers, SC; program for Mar. 30, 1963, Amistad Society event, author's collection. Brown, for example, was one of the original signatories (along with James Baldwin, John Henrik Clarke, Richard Gibson, John O. Killens, Julian Mayfield, and Robert Williams) of the famous "Fair Play for Cuba" ad in the *New York Times*, Apr. 6, 1960.

38 For a sense of Margaret Burroughs's activities during the Popular Front, see Mullen, *Popular Fronts*, 75–105.

39 A small example of this work can be seen in a May 22, 1957, letter to W. E. B. Du Bois in which Margaret Burroughs outlined her successful efforts to sell Du Bois's novel *Ordeal of Mansart* in a writers' workshop to which she belonged. She reported that all the members of the workshop bought a copy (W. E. B. Du Bois Papers, reel 72, UMA).

40 Fuller, foreword, 19.

41 West, *Restoring Hope*, 168–69; author's interview with Haki Madhubuti.

42 Madhubuti, in a roundtable discussion at Conference on Amiri Baraka and the Academy at the Millennium, Howard University, Feb. 15, 2001; author's interview with Haki Madhubuti.

43 Burroughs, "She'll Speak to Generations," 130.

44 Author's interviews with Sterling Plumpp and Abdul Alkalimat.

45 Author's interviews with John Bracey Jr. and Abdul Alkalimat; flyer for AAHA Annual Celebration of the Emancipation Proclamation, Aug. 27, 1963, author's collection.

46 *Roosevelt Torch*, May 1963; author's interview with John Bracey Jr.

47 Dillard, "From the Reverend," 144–45.

48 Author's interviews with John Sinclair and Dan Georgakas.

49 Author's interview with Dan Georgakas.

50 Author's interviews with Herb Boyd and John Sinclair.

51 Georgakas and Surkin, *Detroit*, 110; author's interviews with Dan Georgakas, Woodie King Jr., and Ron Milner.

52 Author's interview with Ron Milner.

53 Author's interviews with Woodie King Jr. and Ron Milner.

54 King, *Black Theatre*, 17–18; Salaam, "Black Theatre," 649–51; author's interviews with Herb Boyd and Dan Georgakas.

55 Mullen, *Popular Fronts*, 44–74.

56 Fuller's politics in the 1940s are a bit murky. I have no evidence that he was ever connected to any Left organization during that period but rather seemed to be distancing himself from the Communist Left in some of his personal letters—though he did profess sympathy for the socialism of Norman Thomas in his correspondence and was an early and ardent admirer of Kwame Nkrumah (letter to Edward Boyd, Apr. 1, 1964, HFP, box 1, folder 6).

57 Such attempts were not unknown elsewhere. *Nite Life*, a commercial journal oriented toward culture and community news in North Philadelphia and distributed free in bars and stores, was a vehicle for radical politics, including pieces by Muhammad Ahmad and other RAM activists. The *Urbanite*, a somewhat similar, short-lived venture in New York in 1964, was more Old Left–bohemian and more literarily oriented in nature.

58 Author's interviews with Ron Milner and Woodie King Jr.; King, *Impact*, 137–44. After being introduced to Milner at a reception at Wayne State, Hughes almost immediately set to work attempting to get fellowships and other sorts of support for Milner, who was then writing a novel (Bontemps and Hughes, *Letters*, 453).

59 S. Smith, *Dancing in the Street*, 107–12. See also King, "On Langston Hughes," 12–13.

60 For an account of the South Side Community Arts Center and its relation to the Popular Front, see Mullen, *Popular Fronts*, 75–105. Danner was a member of the organizing committee of an Interracial South Side Cultural Congress in 1944. According to Mullen, Margaret Burroughs described the participants as "'progressive.' That meant being from Left wing to Communist" (101–2).

61 Letter from Hoyt Fuller to Margaret Danner, Oct. 18, 1959, HFP, box 3, folder 1. For a concise portrait of Danner's sense of rivalry with other black writers, particularly Gwendolyn Brooks, and her fears of conspiracies against her, see Boyd, *Wrestling with the Muse*, 159–60. Danner's fears, angers, obsessive crushes, and emotional fascinations also come across clearly in her letters to Hoyt Fuller in the HFP.

62 For example, the South Side Community Art Center refused to accept Burroughs's membership dues during the height of the McCarthy era even though she helped found the center—recalling the cooperation of the NAACP in the Cold War persecution of W. E. B. Du Bois (Mullen, *Popular Fronts*, 192). For some confirmation of Burroughs's participation, see also an Arts Associates press release in the HFP, box 3, folder 2.

63 Letter from Hoyt Fuller to Margaret Danner, Apr. 22 [no year], HFP, box 3, folder 1.

64 Letter from Hoyt Fuller to Margaret Danner, Oct. 18, 1959, HFP, box 3, folder 1. See also S. Smith, *Dancing in the Street*, 112–15.

65 J. Thompson, *Dudley Randall*, 24–25; Madgett, "Naomi Long Madgett," 204–5.

66 Madgett, "Naomi Long Madgett," 205. Among those accounts with which she takes issue is that of Dudley Randall in *Broadside Memories*, which represents Boone House as "an important cultural force in Detroit from 1962 to 1964," with "art exhibits, jazz sessions, and monthly poetry readings" (36). (Randall had already painted a similar picture of Boone House activities in a 1971 *Black World* interview; see Nicholas, "Conversation with Dudley Randall," 28). Madgett suggests that Randall misremembered, perhaps under some pressure from Danner. However, Madgett's own account of dates and events does not seem absolutely accurate — as one might expect in an autobiographical recollection. For example, she asserts that "contrary to several poorly researched, published reports," Robert Hayden had no connection to Boone House ("Naomi Long Madgett," 205). Yet Danner enthusiastically recounts a Hayden visit to Boone House (and the fact that he decided to include some of her poems in his 1967 anthology, *Kaleidoscope*) in an undated letter to Hoyt Fuller (HFP, box 3, folder 2). It is possible that Danner manufactured the visit — such an invention would not have been out of character for her. Still, it seems unlikely that she would lie to Fuller, who knew Hayden. Hayden's headnote to the Danner selections in *Kaleidoscope* (124) clearly indicates that he was familiar with Boone House. And writers other than Randall recollect that much went on at Boone House. Herb Boyd recalls going to workshops at Boone House featuring important artists, including one in 1965 where he met Sterling Brown (author's interview with Herb Boyd). Woodie King Jr. remembers seeing Langston Hughes there. King's introduction to Hughes (and his subsequent friendship with Hughes), largely through Danner and his friend Ron Milner (who also met Hughes via Danner) gave King an entrée to a wide range of older black artists in New York that stimulated King's career in New York (author's interview with Woodie King Jr.; King, *Impact*, 138). Milner, Boone House's first writer-in-residence, also agrees that much was going on there. He too remembers Hayden's visit, including escorting him to a cab when the program was over (author's interview with Ron Milner). In short, for a crucial period in the early and mid-1960s, Boone House does seem to have been a major center of black literary activity in Detroit. For an extremely useful account of Boone House and its importance to what she calls "the second renaissance in African American culture," see Boyd, *Wrestling with the Muse*, 105–13.

67 Pool, a frequent writer for the journal *Soviet Woman* and sometime contributor to *Freedomways*, was clearly active in the international Communist movement — though on what level is hard to say precisely. Pool's correspondence with such writers as Sam Allen, Chuck Anderson, Mari Evans, Shirley Graham Du Bois, and Sarah Wright includes fascinating documents of Cold War Left networking and political circumspection. In these letters, the correspondents cautiously come out of their political closets through the mention of various names in common (e.g., W. E. B. Du Bois, Shirley Graham Du Bois, David Du Bois, Walter Lowenfels), proclaiming Left political sympathies in ways that did not reveal too much at once either to the letters' recipients or any third party who might be reading the mail. Another common

feature was a request for referees so that the writers of the letters might be able to approach other cautious leftists who do not know them, again playing the game of Cold War striptease (Rosey E. Pool Papers, box 82-1, folders 6, 8, and 48, and box 83-3, folder 165, HU; Shirley Graham Du Bois Papers, box 17, folders 21 and 22, Schlesinger Library, Harvard University). See also Boyd, *Wrestling with the Muse*, 109–10.

68 Letters from Hoyt Fuller to Margaret Danner, Oct. 18, 1959, and July 28, 1960, HFP, box 3, folders 1 and 10; Madgett, "Naomi Long Madgett," 203–4; Pool, *Beyond the Blues*, 29.

69 In fact, Pool privately complained in the previously cited correspondence that the Bontemps anthology used much of her research and many of her contacts without any acknowledgment of her or her anthology.

70 This usage of "Nkrumahist" anticipated later applications of the term to a Left Pan-Africanism that comprehends both Marxism and cultural nationalism as seen in Turé, "Marxism-Lenin-ism and Nkrumahism." Though the subject is beyond the scope of this chapter, the fact that Fuller was gay or bisexual, which was widely known among Black Arts activists, complicates our sense of homosexuality and the Black Arts movement.

71 The size of *Negro Digest/Black World*'s readership is hard to figure exactly. Fuller used a figure of 180,000 in an interview published in *Black Books Bulletin* in the fall of 1971 ("BBB Inter-views")—though a figure of 35,000 had been claimed for 1968 in an official circulation state-ment in the November 1969 issue of *Negro Digest*. Fuller privately admitted to his assistant David Llorens that the real circulation of the journal in 1965 was around 40,000 (Hall, "On Sale," 202). While it is true that, as James Hall points out, the commercial success of *Negro Digest/Black World* was modest as compared with other Johnson Publications magazines, such as *Ebony* and *Jet*, it is worth recalling that even the lowest figure is a huge circulation for a cul-tural/intellectual journal. To put these numbers into perspective, *Partisan Review*, frequently touted as the most important post–World War II intellectual journal (and the center of many studies of the New York Intellectuals) had a circulation of about 15,000 at its zenith.

72 Author's interview with Kalamu ya Salaam.

73 Nicholas, "Conversation with Dudley Randall," 28. Fuller and Randall had both been English majors at Wayne State University in the late 1940s—and among the relatively few black stu-dents there at the time. However, when Fuller lists the names of black writers and intellectuals in Detroit doing interesting work in a 1962 letter to Myrtle Hall, he mentions Woodie King Jr., Ron Milner, and Edward Simpkins but not Randall, suggesting that Danner and the Detroit group played a major role in bringing Fuller and Randall back together in an intellectual and artistic sense (letter to Myrtle Hall, Oct. 28, 1962, HFP, box 1, folder 34).

74 For a discussion of Hayden and his work during this era, see Smethurst, *New Red Negro*, 188–94. Randall connected himself to the Left of the 1930s and 1940s, if sometimes obliquely in his poetry and prose. For example, in his reminiscences about the early days of Broadside Press, he states, "I admit that I am not well qualified to operate in a capitalistic society. I came of age during the Great Depression, and my attitude toward business is one of dislike and suspi-cion" (*Broadside Memories*, 28–31). As Melba Joyce Boyd notes, Randall's connection seems to have been more through his association with individuals active on the Left, such as his brother Arthur and Robert Hayden in the 1930s, his membership in Horace White's Plymouth

Congregational Church, and the Left trade union activism that characterized the Ford Rouge plant and the United States Post Office in Detroit where Randall worked as a young man than through any actual membership in a left-wing party (*Wrestling with the Muse*, 45–51).

75 For an extremely engaging study of Randall and the development of Broadside Press that mixes personal recollection, literary history, and close reading, see Boyd, *Wrestling with the Muse*. For another study of Randall and Broadside Press that includes many useful statistics and tables concerning titles published, sales figures, and so on, see J. Thompson, *Dudley Randall*. For a memoir of the early days at Broadside, see Randall, *Broadside Memories*, 23–28. For an examination of the early broadside series and its relation to other broadsides by Black Arts publishers, see J. Sullivan, *On the Walls*, 27–53.

76 For a discussion of the difficulties of research on the literary Left caused by Cold War anti-Communism that notes Walker's membership in the CPUSA and the Young Communist League (and her later denial of past Communist affiliation), see Wald, *Revising the Barricades*, 4.

77 Randall, *Broadside Memories*, 24–25. Danner and Randall's *Poem Counterpoem* (1966) was the first book of the press to appear.

78 Boyd, *Wrestling with the Muse*, 135–42. For a scene in which Randall explains the origins of his approach to book design, see Melba Joyce Boyd's film about Randall, *The Black Unicorn*.

79 Author's interview with Haki Madhubuti.

80 Author's interview with Abdul Alkalimat.

81 Author's interview with Haki Madhubuti. See also D. Smith, "Chicago Poets"; and Parks, *Nommo*.

82 Author's interviews with Ebon Dooley and Amiri Baraka. For a sense of Mor's performance style and poetry, see (or, more accurately, hear) his reading of "The Coming of John" on *Black Spirits*, a recording of the Black Arts poetry festival at Harlem's Apollo Theater produced by Woodie King Jr. for Motown's Black Forum label in 1972 — where, according to a conversation I had with Amiri Baraka, you can hear Neal and Baraka exclaim in wonder, "What's this shit?" I have to admit I am unable to pick up this exchange on the record, but Baraka's comment to me does say something about the deep impression that Mor made on him (author's interview with Amiri Baraka).

83 Author's interviews with Abdul Alkalimat, Sterling Plumpp, Ebon Dooley, and Haki Madhubuti; G. Brooks, *Jump Bad*, 11–12.

84 For a brief description of how Haki Madhubuti left one meeting of Brooks's workshop after a dispute, see Randall, *Broadside Memories*, 16. Boyd recalls this description and places it in the context of the genuine (and sometimes contentious) give-and-take between Brooks and the workshop members (*Wrestling with the Muse*, 168).

85 Author's interview with Haki Madhubuti. Brooks's first book with Broadside was the 1969 *Riot*.

86 Author's interviews with Nelson Stevens; Donaldson, "Rise and Fall"; M. Harris, "Urban Totems," 24–26; William Walker interview, June 12 and June 14, 1991, SI.

87 Author's interviews with Nelson Stevens.

88 Author's interview with Haki Madhubuti.

89 For an excellent examination of the AACM and its cultural politics, focusing on one of its most nationally prominent members, Anthony Braxton, see Radano, *New Music Figurations*. For a study that locates the AACM within a larger matrix of Black Arts institution building by jazz artists, see Porter, *What Is This Thing?*, 191–239.

90 For the best and really the only serious consideration of Cohran and the Affro-Arts Theater, see Semmes, "Dialectics of Cultural Survival."

91 Danns, *Something Better*, 81–83.

92 For an argument that the UNIA was relatively ineffectual in Cleveland due largely to the success of the political machine in absorbing leading Garveyites, see Stein, *World of Marcus Garvey*, 238–42. However, I would argue from the same evidence that such efforts to include Garveyites within the patronage system demonstrate the wide local appeal and influence of the UNIA.

93 Ottanelli, *Communist Party*, 42.

94 Keeran, *Communist Party*, 125–26.

95 M. Thompson, *National Negro Labor Council*, 39–42, 50–55.

96 L. Moore, *Carl B. Stokes*, 15.

97 Meier and Rudwick, *CORE*, 390.

98 Hutchinson, *Harlem Renaissance*, 195–96; Sporn, *Against Itself*, 151–52; Flanagan, *Arena*, 167–69.

99 For an account of black participation in the FAP, see Bright, "On Fertile Ground." For a recollection of the importance of the legacy of the Karamu-based FAP artists by Virgie Patton-Ezelle, a black Cleveland artist who attended classes at Karamu in the 1960s, see Morrow, "Interview," 166.

100 Askia Touré remembers a Black Arts meeting at which Himes appeared while visiting the United States. According to Touré, the assembled artists gave Himes a standing ovation as he entered, deeply touching him (author's interview with Askia Touré).

101 Atkins, "Invalidity," 32.

102 For accounts of the *Free Lance* group, see Nielsen, *Black Chant*, 54–59; and Johnson and Johnson, *Propaganda and Aesthetics*, 155–58.

103 Morrow, "Interview," 165; author's interviews with Nelson Stevens.

104 Author's interviews with Nelson Stevens. For an outline of Black Arts activities in Cleveland, see Redmond, *Drumvoices*, 381–84. For a short description of the problems of the early Black Arts movement in Cleveland, see N. Jordan, "News from Cleveland."

105 For a brief account of the Black Arts poetry scene in St. Louis and East St. Louis, see Redmond, *Drumvoices*, 398–401.

106 For short but valuable sketches of BAG and its history, see Lipsitz, "Like a Weed"; and Looker, "'Poets of Action.'" See also Wilmer, *As Serious as Your Life*, 222.

107 In Indianapolis, the Black Arts movement revolved around the poet, critic, and editor Mari Evans. Despite her efforts and the sometime participation of poet Etheridge Knight in local events, Evans complained bitterly about the smallness of the scene in Indianapolis (letters to Nikki Giovanni, Feb. 4, 1968, and Apr. 1969, Nikki Giovanni Papers, box 9, folder 1, BU). During her off-and-on residences in her hometown of Cincinnati, Nikki Giovanni often served

as a link between local black cultural activities and such institutions as Broadside Press and *Negro Digest*. For example, she provided Dudley Randall with information about possible outlets for Broadside in Cincinnati and helped promote Randall and Burroughs's anthology *For Malcolm* locally (letters from Dudley Randall, Apr. 23 and Apr. 30, 1967, Nikki Giovanni Papers, folder 7). Giovanni had close personal relationships with a number of the most important Chicago Black Arts activists, including Haki Madhubuti, David Llorens, and Carolyn Rodgers, and less close but important professional connections to Dudley Randall at Broadside Press and David Rambeau at Concept East Theatre in Detroit. While Giovanni knew and respected Baraka and other East Coast Black Arts activists, her links to the circles around OBAC, Third World Press, *Negro Digest*, and Broadside Press appear much deeper in the early Black Arts period — even when Giovanni moved to New York in the late 1960s. No doubt this early emotional and artistic engagement contributed much to Giovanni's bitter response to Madhubuti's somewhat condescending criticism of her work in his 1971 *Dynamite Voices* — and perhaps in some complicated way inflected Madhubuti's critique, given his early enthusiasm for Giovanni as an artist and as a person (letters from Haki Madhubuti, July 7, 1967, and undated, Nikki Giovanni Papers, folder 3).

108 Author's interview with Haki Madhubuti. Madhubuti wrote what is perhaps the classic cultural nationalist critique of Third World Marxism (also known as "revolutionary" Marxism, as opposed to the "revisionist" Marxism of the CPUSA), "Latest Purge." The publication of this essay in a 1974 issue of the *Black Scholar* provoked a firestorm of debate within Black Power.

109 For a sense of this ambivalence, see the testimony of John Taylor, a radical white worker at Chrysler's Eldon Avenue Gear and Axle Plant, in Georgakas and Surkin, *Detroit*, 90–102. For general histories of the LRBW, see ibid.; Geschwender, *Class, Race*; and the documentary film produced by the LRBW, *Finally Got the News*.

110 For an account of the relationship between the LRBW and the BPP in Detroit, see Geschwender, *Class, Race*, 140–42.

111 S. Smith, *Dancing in the Street*, 197–98; author's interview with Grace Boggs; Hunter, "1967."

112 Mullen, *Afro-Orientalism*. For a short history and description of the *Inner City Voice*, see Georgakas and Surkin, *Detroit*, 13–22.

113 For an account of the first Detroit Black Arts Convention, see Randall, "Report." For a short description of the 1967 convention, including the event where Randall presented *For Malcolm* to Bettye Shabazz, see Graham, "Black Poets."

114 Madgett, "Naomi Long Madgett," 207.

115 For an example of how Walker supported the Black Arts movement while offering critiques of what she saw as the movement's shortcomings, primarily a tendency toward sectarianism and a degree of cultural amnesia about earlier black writers and activists, see Giovanni and Walker, *Poetic Equation*. For the most influential Black Arts critique of Hayden, see Madhubuti, "On *Kaleidoscope* and Robert Hayden." In all fairness to Madhubuti, whose criticism of Hayden is sometimes taken as an example of narrow Black Arts aesthetic and ideological concerns, Hayden significantly provoked this antagonism, or at least its public expression, with his combative, anti–Black Arts introduction to *Kaleidoscope*.

116 For many useful tables giving a wide range of demographic information about the authors that Broadside Press, Third World Press, and Lotus Press published as well as many valuable statistics about the circulation of the publications of these presses, see J. Thompson, *Dudley Randall.*

117 Randall, *Broadside Memories*, 28.

118 Though Brooks was early on a part of the cultural nationalist circles of Chicago, which would include Third World Press, she initially published with Broadside after leaving Harper and Row.

119 For a consideration of Johnson that places him within the context of New Negro radicalism and early twentieth-century modernism, see Lorenzo Thomas, *Extraordinary Measures*, 11–44.

120 Danner, "Elevator Man," 86; G. Brooks, *Blacks*, 20.

121 Danner wrote to Rosey Pool, "My work ties the Negro to his African heritage, and I know I shall have to touch the soil of Africa and I will not feel complete until I do" (quoted in Pool, *Beyond the Blues*, 86).

122 Danner, "Sadie's Playhouse," 87.

123 For Randall's own account of his early study of "traditional" scansion and Hayden's sense that Randall was unusually concerned with it, see Melhem, *Heroism*, 76.

124 Danner and Randall, *Poem Counterpoem*, 6.

125 Ibid., 13. For a brief discussion of the relationship between "Sporting Beasley" and "We Have Not Forgotten," see Smethurst, *New Red Negro*, 91.

126 Randall, *More to Remember*, 66.

127 Ibid., 73.

128 The creation of Boone House was also in the spirit of a number of cultural projects of the civil rights movement. For example, as noted in the Chapter 6, the early repertoire of the FST was oriented toward such modern "classics" as *Waiting for Godot.*

129 Randall, *Broadside Memories*, 23.

130 Madhubuti's previously mentioned essay on Hayden's anthology *Kaleidoscope* ("On *Kaleidoscope* and Robert Hayden") is probably the most influential Black Arts critique of Hayden. For the most prominent Black Arts attack on the work of Tolson, see Fabio, "Who Speaks Negro?"

131 For a description of the artistic scene on Chicago's South Side, particularly with respect to jazz, see Radano, *New Music Figurations*, 77–99.

132 For Brooks's own account of her quasi-religious meeting with what she describes as "New Black," see G. Brooks, *Report from Part I*, 84–86.

133 OBAC Writers' Workshop, "Statement of Purposes," 47.

134 Third World Press, "Statement of Purpose," printed inside the cover of Third World Press books in the 1970s.

135 Melhem, *Heroism*, 172.

136 OBAC Writers' Workshop, "Statement of Purposes," 47.

137 Author's interview with Haki Madhubuti.

138 Jennifer Jordan, "Cultural Nationalism," 48–53.

139 Madhubuti, *Groundwork*, 42.

140 Ibid., 43.

141 Some critics, notably Jennifer Jordan, contest this, claiming that the cultural nationalist poets were writing for a college audience ("Cultural Nationalism," 41). However, Jordan offers no evidence for her claims about the audience for such poetry. It is not clear what she means by the term "college audience," other than implying that the Black Arts poets were largely condescending elitists who wrote about, but not to, "the people." After all, "regular" African Americans began to go to college in large numbers during the late 1960s and early 1970s, so that the distinction between campus and community was often not so obvious.

142 For an account of Broadside's difficulties in the late 1970s, see Boyd, *Wrestling with the Muse*, 258–63.

143 According to Julius Thompson, Madhubuti's Broadside Press books sold between 55,000 and 80,000 copies in 1968 and 1969 (*Dudley Randall*, 52). Kalamu ya Salaam claims 3 million for the circulation of Madhubuti's poetry and prose to date (*Magic of Juju*, 54). Melba Joyce Boyd gives a figure of 500,000 for the total number of copies of the 81 books (74 of which were poetry) that Broadside published between 1966 and 1975 (*Wrestling with the Muse*, 3–4). Presumably this figure does not include the broadsides and the tapes also issued by the press. Though reliable information about small press publishing of work by black authors is always hard to come by, Boyd convincingly claims that the number of titles published by Broadside during this period considerably exceeds the total of poetry titles by African American writers from all publishers between 1945 and 1965—and is far, far greater if one is only considering volumes by black poets with national distribution during 1945–65.

144 U. Perkins, untitled essay, 6.

145 Ibid., 6. Touré, "Crisis in Black Culture," 459.

146 Author's interview with Sterling Plumpp. Plumpp explained that he had been an avid listener to the blues and jazz since his childhood, but that it took him a long time to reinvent the music as a literary form in a way that satisfied him.

147 For a critique of what he considers a reductive and authoritarian "Black aesthetic" theoretical vanguardism, see D. Smith, "Black Arts Movement."

Chapter Five

1 Originally both letters in "Us" were uppercased. As with "ACT," the name "US" was not an acronym. Instead it referred to black people (or African people) as opposed to white people (them). The uppercasing of both letters was for the purpose of emphasis. However, opponents of Karenga and US claimed demeaningly that "US" in fact stood for "United Slaves," a claim some later commentators on the Black Power movement took to be literally true rather than a bitterly humorous critique by enemies of Karenga and the organization. As a result, US changed its name to Us so as to remove any suggestion of an acronym or confusion about the intended meaning. I generally use the current "Us" as the standard title for the group for the sake of consistency, except in quotations.

2 Salaam, *Magic of Juju*, 36.

3 Author's interviews with Askia Touré, Ed Bullins, Sonia Sanchez, and Maulana Karenga;

Marvin X, *Somethin' Proper*, 159–60. It is also worth noting that the BPP was itself far from unified ideologically in this regard. As Mumia Abu-Jamal points out, members of the New York chapter of the party, while not precisely cultural nationalists, could be considered "culturally informed." For example, the New York Panthers adopted African and Muslim names at the same time that Panthers on the West Coast ridiculed cultural nationalists, especially Maulana Karenga, for similar practices. The influences of Malcolm X, the NOI, the neo-African traditionalists of the Yoruba Temple, and the "culturally informed" revolutionary nationalism of RAM were felt in the New York chapter far more strongly than in the West Coast chapters of the BPP, despite the earlier association of some Oakland BPP leaders, particularly Bobby Seale and Huey Newton, with RAM. These cultural differences provided some of the ideological underpinnings for the split between the West Coast Panthers and the New York chapter in which the New York Panthers were denounced as "cultural nationalists" ("Life in the Party," 46).

4 For a discussion of the impact of the trade union movement, particularly the ILWU, the Marine Cooks and Stewards, and the Brotherhood of Sleeping Car Porters, on African American political organizing in Oakland before Black Power, see Self, "'Negro Leadership.'" For an account of Communist contributions to the growth of civil rights activity in Los Angeles County in the immediate postwar era, activity that would founder under the pressures of McCarthyism, see Sides, *L.A. City Limits*, 139–47.

5 Goodlet combined two somewhat marginal black papers, the *Sun* and the *Reporter*, in the late 1940s, forging the *Sun-Reporter* (and himself) into a major influence on San Francisco politics. Though Goodlet sometimes criticized the Communist Left, he supported many Left initiatives and events up until his death in 1997. He also remained publicly close to such prominent (and persecuted) black leftists as William Patterson, W. E. B. Du Bois, and Paul Robeson throughout the McCarthy era. For example, he was apparently instrumental in arranging sponsorship for a 1953 concert by Paul Robeson in San Francisco when venues practically everywhere were closed to the singer (Jenkins, *Union Movement*, 173).

6 Healey and Isserman, *Dorothy Healey Remembers*, 123–25.

7 Mitford, *Fine Old Conflict*, 121. Mitford served as executive secretary of the East Bay CRC. For her account of CRC activities in Oakland, Richmond, and other East Bay communities, see ibid., 98–138.

8 Author's interview with Askia Touré.

9 Of course, there had long been CPUSA clubs with a leadership and a membership that were overwhelmingly, if not entirely, black, especially in the South. And northern black neighborhoods, such as Harlem and Chicago's South Side, frequently had been national and district "concentrations" of the CPUSA, sometimes for many years. What made the Che-Lumumba Club unique (and controversial) within the CPUSA was its official designation as a black club, drawing charges of "nationalism" from James Jackson and other CPUSA leaders. There were apparently Latina/o members of Che-Lumumba also—though written and verbal recollections available to me differ somewhat on this point. For a brief description of the debate from a California CPUSA leader involved in the formation of the club, see Healey and Isserman,

Dorothy Healey Remembers, 208–9. For a description of the club by its best-known member, see A. Davis, *Angela Davis*, 188–93.

10 As noted elsewhere in this chapter, Bob Kaufman had a considerable history as a Left trade union activist in New York City (and perhaps in the South) before his relocation to the West Coast. Elaine Brown had some local reputation as a poet and singer before her rise to prominence in the BPP. (She contributed three poems/songs to the *Watts Poets* anthology, edited by Quincy Troupe and published by the Watts Writers' House of Respect.) Though she had not participated directly in the Left before her move west, her mother had been deeply involved in Popular Front trade union and cultural activities and sympathized with the CPUSA (and perhaps was a party member) in Philadelphia (E. Brown, *Taste of Power*, 322). Angela Davis, who entered the Black Power movement in San Diego and Los Angeles, had numerous contacts with the Communist Left as a young person in Birmingham and New York (where she went to a liberal-Left private high school, Elisabeth Irwin, and belonged to the Communist youth group Advance), mainly through her parents (who had been activists in the SNYC), before joining the CPUSA in Southern California in the late 1960s (A. Davis, *Angela Davis*, 82–113). Ethna Wyatt, one of the founders of BAW, came from a Left background in Chicago, where her stepmother was a member of the CPUSA (Marvin X, *Somethin' Proper*, 106).

11 Perhaps it is more accurate to say that the ILWU was a union in which the CPUSA remained a relatively legitimate political force, particularly in the Bay Area, rather than to say that the Communist Left dominated the national leadership of the union. While few if any of the national officers were CPUSA members after the 1940s, as far as I can tell, the ILWU did successfully challenge anti-Communist provisions of the Taft-Hartley Act (and of the Labor-Management Reporting and Disclosure Act of 1959) when it defended the election of an open Communist, Archie Brown, to the executive board of the longshore division's Local 10 in a case that began in 1961 and reached the Supreme Court in 1965.

12 Self, "'Negro Leadership,'" 97; B. Nelson, "'Lords of the Docks,'" 158–59. Of course, as Bruce Nelson points out, the decentralized nature of the ILWU that gave locals much autonomy allowed considerable latitude for discrimination against black workers. Local 8 in Portland, Oregon, was infamous within the ILWU for its longtime exclusion of African Americans in the face of considerable pressure from the union's national leadership. Despite a somewhat stronger Left presence in Los Angeles's Local 13 than in Local 8, there too the international union was unable (and to a certain extent unwilling) to directly intervene against the efforts of white and Chicano longshoremen to limit the number of black workers in the Port of Los Angeles — though it is possible that ILWU president Harry Bridges felt that open intervention would be counterproductive in a local known within the union as a center of anti-Bridges sentiment. The leader of the black dockworkers in Los Angeles, Walter Williams, despite much initial resentment over Bridge's refusal to publicly intercede with Local 13, apparently came to believe that Bridges worked privately (and effectively) in support of black dockworkers there. For an oral history of this struggle, see H. Schwartz, "Walter Williams."

13 Hilliard and Cole, *This Side of Glory*, 68. Hilliard also describes how he found work in the port through Left waterfront and West Oakland contacts (100–102).

14 Jenkins, *Union Movement*, 222–29.

15 For a recollection of the impact of the Left and the Negro Historical and Cultural Society on black cultural institutions in San Francisco during the 1950s and 1960s by Marc Primus, see Salaam, *Magic of Juju*, 131.

16 Barlow and Shapiro, *End to Silence*, 42–55.

17 Maynard, *Venice West*, 162–67.

18 Author's interview with Maulana Karenga.

19 Author's interviews with Ernest Allen Jr. It should be noted that the information provided by Ernest Allen Jr. is based not only on his recollections as a former Merritt College and UC-Berkeley student and a participant in the AAA and many other militant African American organizations in the 1960s and 1970s but also on his extensive research on the origins of the Black Power movement in the Bay Area.

20 Author's interviews with Ernest Allen Jr.; Tyson, *Radio Free Dixie*, 150–55.

21 Author's interviews with Ernest Allen Jr.

22 Gosse, *Where the Boys Are*, 218.

23 Author's interviews with Ernest Allen Jr.

24 Ibid. According to Ernest Allen Jr., Monsour denies making any such proposal, though the debate is clearly remembered by other participants in the group.

25 Author's interview with Marvin X.

26 Author's interviews with Ernest Allen Jr. and Marvin X; Marvin X, *Somethin' Proper*, 76–79.

27 Author's interviews with Ernest Allen Jr.; Marvin X, *Somethin' Proper*, 170–92.

28 Author's interviews with Ernest Allen Jr.

29 Author's interviews with Ernest Allen Jr., Askia Touré, and Muhammad Ahmad; Kelley, *Freedom Dreams*, 60–109.

30 Author's interviews with Ernest Allen Jr. and Marvin X; Johnson and Johnson, *Propaganda and Aesthetics*, 180–82; Marvin X, *Somethin' Proper*, 98–99.

31 Author's interview with Marvin X.

32 Ibid.; Marvin X, *Somethin' Proper*, 98–99; author's interview with Edward Spriggs.

33 Comments by Bullins in the 1978 documentary *Black Theatre*.

34 Lorenzo Thomas, "'Communicating by Horns,'" 293.

35 For a longer version of this consideration of Kaufman and his relation to the Popular Front and the Black Arts movement, see Smethurst, "Remembering When Indians Were Red."

36 NMU president Joe Curran, himself a former Communist, moved steadily to the Right in the postwar era. Left union activists, such as Ferdinand Smith and Blackie Myers, opposed him. Curran and his anti-Communist supporters swept union elections in 1947 amid accusations of strong-arm tactics by pro-Curran thugs and local and federal authorities. From 1948 to 1950, anti-Communist union officials expelled numerous leftists from the NMU. In 1950, the Coast Guard in cooperation with the NMU set up a program that screened out nearly 2,000 more sailors as "subversives," effectively removing the active influence of the Communist Left among merchant seaman. For an account of the virtual elimination of the Communist Left in the merchant marine, see Caute, *Great Fear*, 392–400.

37 Damon (as well as others) mentions the claim that Kaufman "became a communist labor

organizer in the South" after being banned from the merchant marine (*Dark End of the Street*, 33). It is not exactly clear what this means, though perhaps Kaufman played some role in the southern activities of a CPUSA-influenced organization, such as the CRC or the NNLC. Similarly, in his introduction to Kaufman's *Cranial Guitar*, David Henderson quotes George Kaufman as saying that his brother was an "area director" for the Wallace campaign in 1948 (9), but the area in question is not specified—and I have not as yet discovered it.

38 For recollections of Kaufman in New York by the prominent new thing jazz composer and musician Cecil Taylor, see Funkhouser, "being matter ignited," 28–31.

39 For the most reliable account of Kaufman's early life, see Damon, *Dark End of the Street*, 32–76.

40 Kaufman, *Cranial Guitar*, 105.

41 Schrecker, *Many Are the Crimes*, 375.

42 Kaufman, *Cranial Guitar*, 105.

43 Amiri Baraka, *Home*, 93.

44 Damon, *Dark End of the Street*, 68–71; Lorenzo Thomas, "'Communicating by Horns,'" 293–94.

45 Damon, *Dark End of the Street*, 69.

46 Hughes proclaimed the formal relationship of his sequence to bebop in the introductory note to *Montage of a Dream Deferred* in *Collected Poems*, 387. Ginsberg also claimed that the lineation and phrasing of the first section of "Howl" was based on bebop riffs (Allen and Tallman, *Poetics*, 318).

47 Kaufman, *Cranial Guitar*, 102.

48 Kaufman, *Solitudes*, 20; Douglass, *Narrative*, 13–14.

49 For a fairly recent (and extremely influential) example of the critical opposition of the aesthetics of bebop and those of the Popular Front, see Lott, "Double V," 603.

50 For a discussion of the debate among Left and liberal intellectuals in the late Popular Front, see Gennari, "Weapon of Integration." The most prominent pro-bebop artist associated with the Popular Front was, of course, Langston Hughes—though Hughes's enthusiasm for bebop did not cause him to reject older forms of jazz. For a brief and more grassroots view, see Mark Solomon's description of the surviving subculture of the Communist Left in the early 1950s, in which he mentions being one of a group of young leftists going to ask Charlie Parker to support W. E. B. Du Bois for the United States Senate on the Progressive Party ticket, as well as seeing Miles Davis at the seemingly unlikely venue of a Labor Youth League (a Communist youth group) dance (*Cry Was Unity*, xxvii). For that matter, in his autobiography, Dizzy Gillespie speaks of his own membership in the CPUSA and participation in the Communist cultural circuit as a musician during the 1940s (Gillespie, *Dizzy*, 80). While Gillespie claimed that his membership in the CPUSA was strictly one of access to employment opportunities, his homage to Paul Robeson later in the autobiography suggests that his relationship to the Harlem Left that Robeson embodied was more than one of professional expediency—a suggestion that is strengthened by Gillespie's public endorsement of a 1965 tribute to Robeson sponsored by *Freedomways*. This homage, as well as the mention of favorable discussions with Charlie Parker about the East Harlem congressman identified with the Communist Left, Vito Marcantonio, provides an interesting counterpoint to scholarly notions of the conscious

opposition of bebop musicians to Popular Front politics and aesthetics as embodied by Robeson.

51 For a discussion of Parker's relation to the modern European art music tradition and his sense of the aesthetic equality between European art music and contemporary jazz (though Parker did idealize the European tradition in some respects), see Woideck, *Charlie Parker*, 169–73, 203–8.

52 Kaufman, *Ancient Rain*, 37.

53 Kaufman, *Solitudes*, 42.

54 For example, when Césaire proclaims "Je sais le tracking, le Lindy-hop et les claquettes" (I can boogie woogie, do the lindy-hop, and tap-dance) in "Cahier d'un retour au pays natal," speaking of a performance of blackness for jaded white Europeans, there is much ironic humor but little of the ambiguity and sense of play that one might find in a similar line in a poem of Hughes (or Kaufman) (*Collected Poetry*, 58–59).

55 Lorenzo Thomas writes, "While the movement rejected mainstream America's ideology, deeming it inimical to black people, Black Arts poets maintained and developed the prosody they had acquired from Black Mountain and the Beats" ("Neon Griot," 309).

56 Lorenzo Thomas, "'Communicating by Horns,'" 294.

57 Author's interview with Ed Bullins.

58 Author's interview with Edward Spriggs; Salaam, *Magic of Juju*, 131.

59 Barlow and Shapiro, *End to Silence*, 43–49; author's interviews with Ernest Allen Jr. For an account of CORE's role in these demonstrations (albeit one that underestimates the participation of students), see Crowe, *Prophets of Rage*, 124–28.

60 Author's interviews with Edward Spriggs, Ernest Allen Jr., and Ed Bullins.

61 Author's interview with Edward Spriggs; Johnson and Johnson, *Propaganda and Aesthetics*, 182–84.

62 Salaam, *Magic of Juju*, 91; author's interview with Edward Spriggs.

63 Nearly everyone with whom I have spoken who knew Goncalves in the 1960s and 1970s agreed that he was very reclusive. Ernest Allen Jr. in particular suggested that it was this sort of personal detachment from the infighting between the BPP and other Black Arts and Black Power groups and individuals in the Bay Area that helped *JBP* survive longer than other institutions that either collapsed (like the Black House) or moved (like *Black Dialogue*) (author's interviews with Ernest Allen Jr.).

64 Barlow and Shapiro, *End to Silence*, 75–84; author's interviews with Marvin X and Sonia Sanchez. Giving San Francisco State (or Merritt College) a prior claim on the origin of black studies is debatable, since courses in Negro history, Negro culture, and so on had long been a feature of Left educational institutions, such as the California Labor School in San Francisco and Los Angeles, the Abraham Lincoln School in Chicago, and the Jefferson School in New York during the 1940s and 1950s. One might also ask how the unofficial seminars in African American folk culture and music that Sterling Brown gave at Howard for decades before the Black Power and Black Arts movements greatly differed in spirit from the noncredit course initially offered at San Francisco State. As John Bracey Jr. points out, one could even find accredited courses that would be at home now in any African American studies department

or program being offered at such institutions as Chicago's Roosevelt University long before the 1960s (author's interview with John Bracey Jr.). However, a plausible distinction can be drawn between these early forerunners of black studies and the courses offered at San Francisco State, Merritt College, Wayne State, and elsewhere in that the later classes were seen as part of the larger Black Power and Black Arts movements, giving them a different charge.

65 Barlow and Shapiro, *End to Silence*, 125.

66 Author's interview with Sonia Sanchez.

67 Barlow and Shapiro, *End to Silence*, 103; Amiri Baraka, *Autobiography*, 351–61.

68 Barlow and Shapiro, *End to Silence*, 168–324.

69 Author's interviews with Ed Bullins and Sonia Sanchez; Amiri Baraka, *Autobiography*, 351–53.

70 Author's interviews with Ed Bullins and Maulana Karenga.

71 Author's interview with Marvin X; Marvin X, *Somethin' Proper*, 109. Marvin X also claims that Sheridan warned him about Bullins for some unspecified reason — though this claim may be a retrospective result of Marvin X's long-standing feud with Bullins over the authorship of the play about Huey Newton, *Salaam, Huey, Salaam*.

72 Marvin X, *Somethin' Proper*, 110–18; author's interviews with Marvin X and Ed Bullins.

73 Author's interview with Ed Bullins. Marvin X makes the point, however, that while they may have been more open (or at least not as adamantly opposed) to white participation in the audience in theory, in practice he can remember very few white people at the BAW performances in the Fillmore (author's interview with Marvin X).

74 Marvin X, *Somethin' Proper*, 118–33; Amiri Baraka, *Autobiography*, 352–61; author's interviews with Ed Bullins and Marvin X.

75 This decline can also be seen in the newspaper *Black Panther*, which early on contained poetry by important Black Arts poets, such as Baraka, Sanchez, and Sarah Webster Fabio, but basically published only doggerel by BPP leaders by the end of the 1960s. For a short but interesting discussion of prosody in poetry published initially in the BPP press, in which challenges to mainstream notions of what formally constitutes "the poetic" mirror radical political challenges to mainstream society, see Bibby, "Insurgent Poetry," 138–43.

76 Author's interviews with Amiri Baraka and Maulana Karenga; Woodard, *Nation within a Nation*, 85.

77 Author's interviews with Amiri Baraka and Maulana Karenga; Amiri Baraka, *Autobiography*, 355–59; Woodard, *Nation within a Nation*, 107–27; Scot Brown, *Fighting for US*, 144–51.

78 Salaam, *Magic of Juju*, 108.

79 Blackwell, "Interview with Ntozake Shange," 134–35.

80 For a short memoir of the Chicano movement and the multicultural arts scene of the Mission District during the 1970s, see Herrera, "Riffs."

81 I. Reed, "Writer as Seer," 68.

82 For a short discussion of the cultural wing of the Asian American movement, see Ho, "BAMBOO," 251–56. It should also be noted that as in other areas and in other communities, CPUSA policies, particularly the support of Japanese American internment during World War II, and internal strife played a considerable role in the diminishment of the old Asian American Left.

83 Chin et al., *Aiiieeeee!*, x.

84 Ibid., ix.

85 See, for example, O'Toole, *Watts and Woodstock*, 79–95; Tapscott, *Songs of the Unsung*, 82; and Horne, *Fire This Time*, 10–22.

86 Written responses to author's questions by Jayne Cortez.

87 Porter, *What Is This Thing?*, 104–8.

88 Sides, *L.A. City Limits*, 151–58; O'Toole, *Watts and Woodstock*, 86–87.

89 Scot Brown, *Fighting for US*, 41; Spellman, *Black Music*, 109–10.

90 Horne, *Communist Front?*, 330–37.

91 Horne, *Fire This Time*, 6–7.

92 Sides, *L.A. City Limits*, 147–51.

93 Crowe, *Prophets of Rage*, 104–5. For a discussion of the anti-Communism of the NAACP and its West Coast branches during the McCarthy era, see ibid., 114–15.

94 For example, Tarea Pittman, regional secretary of the West Coast Region of the NAACP, sent a memo about a plan to reorganize the Los Angeles branch to Gloster Current, NAACP director of branches, dated June 1, 1962. In that memo Pittman claimed that the branch "was at the lowest prestige in its history." Pittman goes on to detail financial irregularities and membership problems, asserting that "Many organizations are coming to the front as civil rights advocates. If [the] NAACP continues to default as it has done in the past several years, it will be out of the running for good" (*Papers of the NAACP*, part 27, series D, reel 4).

95 "Comparative Analysis of the NAACP Branch Membership and Freedom Fund for the Years 1961 and 1962 in the Area Covered by the Sub-Regional Office," ibid.

96 For a brief but interesting account of the Los Angeles County NAACP and its work in the civil rights movement, albeit one that presents the NAACP as considerably stronger and more engaged in grassroots work in Los Angeles than I do, see Sides, *L.A. City Limits*, 158–67.

97 Crowe, *Prophets of Rage*, 121.

98 W. Ellis, "Operation Bootstrap," 75–84.

99 Author's interview with Maulana Karenga; written responses to author's questions by Jayne Cortez; Cortez, "Jayne Cortez," 35.

100 Author's interviews with Maulana Karenga and Ernest Allen Jr.; Scot Brown, "US Organization: African-American," 57–60.

101 Tapscott, *Songs of the Unsung*, 70–71.

102 Amiri Baraka, *Black Music*, 166; Spellman, *Black Music*, 108–9; Tapscott, *Songs of the Unsung*, 122.

103 During this period, Sun Ra was fond of prefacing his comments with "Speaking as a Jupiterian" (author's interview with Askia Touré). In contrast, Pan Afrikan Peoples Arkestra founder Horace Tapscott commented about the different trajectories of the two Arkestras: "While he was thinking in terms of space, of an ark traveling through space, I was thinking in terms of a cultural safe house for the music" (*Songs of the Unsung*, 83).

104 Tapscott, *Songs of the Unsung*, 82–83.

105 Written response to author's questions by Jayne Cortez.

106 Tapscott, *Songs of the Unsung*, 82–104.

107 Adler, "Arts Center Born"; Carter, "Watts"; Schulberg, introduction to *From the Ashes*, 16; written responses to author's questions by Jayne Cortez. The year 1964 also saw the first staging of James Baldwin's long-unproduced play, *The Amen Corner*, in Hollywood by a new black theater led by Frank Silvera, a successful stage and screen actor whose artistic roots lay in the FTP and the left-wing theaters of Boston and New York (and such Left arts organizations as the Committee for the Negro in the Arts). This successful production, which costarred Bea Richards, another veteran of the black Left in New York, traveled to New York City the next year. Silvera's Theatre of Being was not tied to a specific African American community in the manner of Studio Watts, the Watts Repertory Theatre, and the Compton Communicative Arts Academy, but it did provide black actors in Los Angeles a vital training ground.

108 Horne, *Fire This Time*, 185–87.

109 Author's interview with Maulana Karenga; Scot Brown, *Fighting for US*, 38–73.

110 Author's interview with Maulana Karenga; Scot Brown, *Fighting for US*, 81–85; Woodard, *Nation within a Nation*, 84–86.

111 For a sense of these debates and the divisions within the Los Angeles movement from someone who was sympathetic to John Floyd and his supporters, see A. Davis, *Angela Davis*, 158–67. For another take by someone who became a leader of the BPP in Oakland (though initially a co-worker of Floyd in the Black Congress), see E. Brown, *Taste of Power*, 106–31. For a discussion of the "underground" apparatus of the Black Panthers (and its relation to the splits within the party), see Umoja, "Repression Breeds Resistance," 3–15. For accounts of the UCLA shoot-out that draw heavily on Panther sources or, as Scot Brown points out, testimony by some questionable government informers, see Bush, *We Are Not*, 217; and Churchill, "'To Disrupt,'" 3–94. For a brief but relatively evenhanded account of the Panther-Us conflict within the Black Congress and the shoot-out, see Scot Brown, *Fighting for US*, 91–99. Brown's analysis of the ideological bases of the Panther-Us dispute is also very useful—though he does not quite get across the very personal nature of the BPP attacks on Karenga, such as the cartoons in the *Black Panther* depicting Karenga as a sort of walking egg, lampooning him as "Bamalama Karenga" (107–20).

112 Tapscott, *Songs of the Unsung*, 105–6.

113 Carter, "Watts," 14.

114 Ibid., 10.

115 John Outterbridge interview, Jan. 13, 1973, SI. For an account of Outterbridge and the founding of the Compton Communicative Arts Academy, see Willard, "Urbanization as Culture," 217–35.

116 Schulberg, introduction to *From the Ashes*, 3.

117 Ibid.; Gilbert, "From Watts," 18–20; author's interview with Budd Schulberg.

118 Gilbert, "From Watts," 25–26; author's interview with Budd Schulberg.

119 Author's interview with Budd Schulberg.

120 Ibid. The oscillation between cooperation and conflict on the part of Karenga and Jacquette reminds us that simple descriptions of the movement fracturing along lines of revolutionary nationalism/cultural nationalism or cultural nationalist/Marxist are inadequate. The Black Power and Black Arts movements in many areas were riven by debates, and sometimes physi-

cal conflict, between various groups and personalities. However, the history of the movements in Los Angeles was characterized by an unusually intense cycle of boom and bust in which coalitions initially united a broad range of organizations, as in the Freedom City movement (which sought to make Watts an independent municipality), the Temporary Alliance of Local Organizations (which included members of CORE, the NAACP, Us, SLANT, and the United Civil Rights Committee), and the Black Congress. The cycle continued with the rapid disintegration of these coalitions due to infighting among them, generally between Us and one or more of the other groups, particularly the BPP — often aided by FBI efforts to destabilize the Black Power movement by provoking competition and verbal and physical violence. After a period of time, a new attempt would be made to again unite the disparate Black Power and Black Arts organizations, often led by Us, and the cycle would repeat itself. For an account of Us and the rise and fall of these coalitions, see Scot Brown, "US Organization, Black Power."

121 Horne, *Fire This Time*, 202–4.

122 Schulberg, introduction to *From the Ashes*, 16–17; Hill, "Festival Hailed." Shriver pronounced the festival the epitome of the self-reliance and self-initiative the federal war on poverty was trying to promote. The participation of Shriver and various government and corporate sponsors in the festival points to how the political and cultural moment after the Watts uprising made large-scale, radical African American cultural initiatives possible in a way that would have been unimaginable a few years before. At the same time, the continuing dependence on this sort of support also opened the door, many participants later suggested, to the depoliticization of the movement.

123 For a high-profile example of this attention, see Gent, "N.B.C. to Broadcast."

124 Schulberg, introduction to *From the Ashes*, 13–14; author's interview with Budd Schulberg; Gilbert, "From Watts," 22; Fremont-Smith, "TV: NBC Documents."

125 J. Jackson, *Waiting in Line*, 116. For a review of Dolan's teleplay that praises it as a powerful if imperfect effort, see Gould, "TV: Experiment in Watts."

126 Author's interview with Budd Schulberg; J. Jackson, *Waiting in Line*, 116.

127 Schulberg, introduction to *From the Ashes*, 21; author's interview with Budd Schulberg.

128 Adams, "Watts Writers Move Ahead."

129 Schulberg, introduction to *From the Ashes*, 20–22; author's interview with Budd Schulberg; Semple, "Ghetto Described." A version of Scott's essay appears in Schulberg, *From the Ashes*.

130 Author's interview with Maulana Karenga; Scot Brown, *Fighting for US*, 134–35.

131 Troupe quoted in Horne, *Fire This Time*, 331.

132 Gilbert, "From Watts," 77–79.

133 Ibid., 27–28.

134 Ibid., 61–63.

135 McFarlane, "To Join or Not to Join," 1.

136 Ojenke, "Legacy of the Word," 20.

137 Lyle, "I Can Get It," 46.

138 Gilbert, "From Watts," 80–83; author's interview with Budd Schulberg.

139 For a sense of the way the political and the cultural merged in the Los Angeles Black Power movement (much like elsewhere) as well as how political conflicts inflected artistic events and

institutions, see Elaine Brown's description of a poetry reading organized by the Black Student Alliance of Los Angeles in *Taste of Power*, 122–25.

140 For a portrait of how the new antipoverty bureaucracy undermined the Watts Happening Coffee House, see ibid., 149–51. It should be noted that a number of scholars and former BPP activists have called Brown's memoir into question. For a summary of these critiques, see M. Perkins, *Autobiography as Activism*, 90–100.

141 For a discussion of the pachuco and the *vato loco* in Chicana/o literature, see Smethurst, "Figure of the *Vato Loco*."

142 Shange quoted in Salaam, *Magic of Juju*, 269.

Chapter Six

1 Amiri Baraka, "Black Arts Movement," 1; author's interviews with Amiri Baraka and Askia Touré; Salaam, *Magic of Juju*, 5.

2 For a discussion of the difficulty in reaching an audience beyond the region due to the parochialism of northern Black Arts activists and institutions, see Salaam, "Enriching the Paper Trail," 338–39.

3 Lorenzo Thomas, *Extraordinary Measures*, 209.

4 Kelley, *Hammer and Hoe*, 207–12; author's interview with Esther Cooper Jackson; D. Scott, "Interview with Esther Jackson."

5 Morgan, *Rethinking Social Realism*, 42–170; Hale Woodruff interview, Nov. 18, 1968, and William Walker interview, June 12 and June 14, 1991, SI. Catlett eventually came to have a sort of mentor/living treasure status with many Black Arts activists working in a range of genres and media, from the visual artists of OBAC to the writer Sonia Sanchez.

6 For a brief account of the importance of the People's Defense League and a longer treatment of the impact of the Left and Left ideas on the NAACP in New Orleans, see Fairclough, *Race and Democracy*, 46–73.

7 For an account of the Henry Wallace campaign in the South and its aftermath, see P. Sullivan, *Days of Hope*, 249–75.

8 Kelley, *Hammer and Hoe*, 225–29; author's interview with Esther Cooper Jackson; conversation with Stetson Kennedy, fall 1999.

9 Rogers, *Righteous Lives*, 101–5.

10 Honey, *Southern Labor*, 245–77; Painter, *Narrative of Hosea Hudson*, 352–60.

11 Baker, with a long history as an organizer with the NAACP, the SCLC, and SNCC, apparently never joined a particular Left political party but had close personal and working relationships with leftists of various affiliations, including Communists, Lovestonites (Baker attended the forums of former CPUSA national secretary Jay Lovestone's Communist Party [Opposition] in the 1930s), Trotskyists, Socialists, and independent radicals, especially when she worked at the WPA's Worker Education Project in New York during the Popular Front era. For a description of the ideological milieu of the Harlem Left in the 1930s and its impact on Baker, see Ransby, *Ella Baker*, 64–104. As Ransby points out, Baker's position during much of the civil rights era, like that of many "non-communist Leftists" in the movement, "straddled

the fence . . . leaning on the pragmatic side of condemning red-baiting without defending the rights of communists" (235). Baker, in fact, was a member of a New York NAACP committee that supervised the expulsion of Communists from the branch in the 1950s. Eventually, like King, Baker came to see this genuflection to what King called "our irrational obsessive anti-Communism" at a 1968 *Freedomways*-sponsored memorial meeting for W. E. B. Du Bois as destructive to the movement, perhaps, as Ransby suggests, through her close association with the much Red-baited Carl and Anne Braden.

12 For example, a sharp debate within the civil rights movement took place over SNCC's decision to use lawyers who were members of the National Lawyer's Guild, a Left-liberal organization that Communist lawyers helped found. Some CPUSA members or supporters remained active in the organization through the Cold War, since it refused to purge itself of Communists after the manner of the American Civil Liberties Union. As a result of a willingness to use any available and competent counsel, regardless of whether they were Lawyer's Guild members or not, SNCC received tremendous pressure from the NAACP, the UAW, and various anti-Communist liberals to change their decision. This sort of pressure was typical of the civil rights–Cold War era. What was atypical was SNCC's refusal to change its decision. Thus, this issue (and the issue of anti-Communism generally) became a landmark in SNCC's movement toward a more radical and ultimately nationalist position (Carson, *In Struggle*, 107).

13 Kelley, *Hammer and Hoe*, 229–30; Honey, *Southern Labor*, 288–89.

14 Author's interview with Sam Cornish.

15 For example, Tom Dent remembered the departure of progressive faculty members, such as L. D. Reddick and St. Clair Drake, and Left teachers, such as the visual artist Elizabeth Catlett, from Dillard University during the period ("Marcus B. Christian," 25). Interestingly, historically black schools in the North, such as Central State University, Howard University, and Lincoln University, were often havens for progressive or Left faculty.

16 Meier and Rudwick, *CORE*, 107–8; Harmon, *Beneath the Image*, 127–46; Jack Walker, "Sit-Ins in Atlanta," 64–76.

17 Dyson, *I May Not Get There*, 255–56.

18 Killens, "Artist," 63.

19 Ibid.

20 Author's interviews with Michael Thelwell and Muhammad Ahmad; Turé and Thelwell, *Ready for Revolution*, 147–49.

21 Author's interview with Muhammad Ahmad.

22 Amiri Baraka, *Autobiography*, 134.

23 Ibid., 109–10.

24 Salaam, "Enriching the Paper Trail," 329.

25 Murray, "Blueprint."

26 Thelwell, "Professor," 630.

27 Author's interviews with Muhammad Ahmad and Michael Thelwell.

28 Ibid.; Turé and Thelwell, *Ready for Revolution*, 114–16.

29 For an example of this linking of the new and the old radicalisms written a little after the high-water mark of the Black Arts and Black Power movements, see Killens, "Artist."

30　For an interesting, though somewhat circumscribed, discussion of the role that Killens and the Fisk writers conferences played in establishing what might be thought of (after Komozi Woodard) as the modern black cultural convention movement, see Gilyard, *Liberation Memories*, 113–37.

31　For an account of the 1966 Fisk conference, see Llorens, "Writers Converge." For a brief description of the Hayden-Tolson debate at the conference, see Farnsworth, *Melvin B. Tolson*, 297–98.

32　For a short description of the 1967 Fisk conference, see "On the Conference Beat."

33　Author's interview with Haki Madhubuti; Gilyard, *Liberation Memories*, 128. Killens also inaugurated a series of black writers conferences at Medgar Evers College, a campus of the City University of New York in Brooklyn, during a stint there as a writer-in-residence near the end of his career. The first conference took place in 1986 (Killens died in 1987) and is still held there every few years.

34　Author's interviews with Amiri Baraka and Michael Thelwell; Thelwell, "Professor." For the best account of the Dasein group and their work, see Nielsen, *Black Chant*, 59–77.

35　Author's interview with Michael Thelwell; Turé and Thelwell, *Ready for Revolution*, 133–35.

36　For accounts of civil rights and Black Power activities in a number of small southern cities, including Orangeburg (the location of South Carolina State), often in the words of participants in those struggles, see Dent, *Southern Journey*.

37　Redmond, *Drumvoices*, 375–81.

38　Harding, "History of the Institute," 145.

39　Ibid., 146–47. For another short history of the inception and early days of the IBW, see S. Ward, "'Scholarship.'"

40　Institute of the Black World, "Statement," 576.

41　Spellman, "Letter from Atlanta"; author's interview with A. B. Spellman.

42　Historian Robert Harris Jr. recalls attending a 1976 meeting of the National Committee of Concern over the Demise of *Black World* at John Henrik Clarke's apartment in New York City to discuss the creation of a new journal to replace *Black World* that helped lead to the founding of *First World* (comments of Robert Harris Jr., Modern Cultural Politics panel, Organization of American Historians annual meeting, Memphis, Tennessee, Apr. 3, 2003). Harris was the secretary of the steering committee of the national committee, which consisted almost entirely of African American academics, primarily from various institutions of the black studies movement. Haki Madhubuti remembers similar meetings in Chicago (author's interview with Haki Madhubuti). It is quite likely that others occurred elsewhere.

43　For an account of the black theater scene and its limitations in Atlanta during the Black Arts period, see Molette, "Atlanta."

44　Woodard, *Nation within a Nation*, xiii–xiv, 202–18. For an account of the forces leading to the formation and the decline of CAP, see ibid., 219–54.

45　Author's interview with Ebon Dooley; A. Reed, *Stirrings*, 1–52.

46　Amiri Baraka, "Black Arts Movement," 1–3; author's interview with Amiri Baraka; Stanford, "Revolutionary Action Movement," 109, 115.

47　For an account of the Atlanta Project, SNCC's first serious attempt to organize urban Afri-

can Americans, and the role the project played in moving SNCC in a nationalist direction, see Carson, *In Struggle*, 191–200.

48 Tyson, *Radio Free Dixie*, 150–54.

49 R. Williams, transcript of "Radio Free Dixie Broadcast," 4.

50 Tyson, *Radio Free Dixie*, 37–42, 68–71.

51 Fabré, "Free Southern Theatre," 56.

52 Dent, Schechner, and Moses, *Free Southern Theater*, 164–67.

53 To get a sense of these debates, see ibid., 111–34.

54 Myrick-Harris, "Behind the Scenes," 224.

55 For a short account of the early days of the FST, see Fabré, "Free Southern Theatre," 55–57; and Dent, Schechner, and Moses, *Free Southern Theater*, 3–62. Even after the move of the group to the Desire neighborhood, one of the poorest in New Orleans, the basic decision to be a black theater as opposed to an integrated one, and the departure of key white figures, especially Richard Schechner, some white theater workers, notably actor Murray Levy, continued to participate in the FST.

56 Salaam, "Enriching the Paper Trail"; author's interview with Kalamu ya Salaam.

57 For a discussion of Dent and his catalyzing role in Umbra, see Lorenzo Thomas, "Tom Dent."

58 Salaam, "Enriching the Paper Trail," 334.

59 For a sense of Dent's drive to connect with older African American writers in New Orleans, often in the face of some hostility or resistance, see Dent, "Marcus B. Christian." For a sense of black New Orleans in the Popular Front era, see Fairclough, *Race and Democracy*, 46–71. For a description of the repression of the New Iberia NAACP, see ibid., 87–99. It is worth noting that the repression that forced Lilly and others to flee New Iberia did not destroy the branch, even if it did damp down local militancy.

60 Lorenzo Thomas, *Extraordinary Measures*, 176; Kalamu ya Salaam, unpublished autobiographical statement, 1994, provided to the author by Salaam.

61 Salaam, "Enriching the Paper Trail," 334.

62 Letter from Tom Dent to Langston Hughes, Aug. 12, 1965, Langston Hughes Papers, box 50, YU.

63 Salaam, "Enriching the Paper Trail," 333–36, and autobiographical statement; J. Ward, "Southern Black Aesthetics."

64 Dent, "Beyond Rhetoric," 15.

65 Salaam, autobiographical statement, and "Enriching the Paper Trail," 336–38.

66 Salaam, autobiographical statement; author's interview with Kalamu ya Salaam.

67 Author's interview with Nayo Watkins. For example, Watkins mentions that her excitement at finding a broadside of her poem about black women, "Do You Know Me," in a rural Mississippi kitchen was greater than she felt about any journal publication. In fact, this is largely Watkins's attitude to this day as she devotes much of her artistic efforts toward working with local groups to create plays about local history and empowerment that have a great deal of meaning to those communities but not much interest for outside audiences (except as a model for how other areas and neighborhoods might create such theater).

68 Author's interview with Jerry Ward.

69 "History of SUDAN"; Lorenzo Thomas, "Neon Griot," 313.

70 Lorenzo Thomas, *Extraordinary Measures*, 209; Ahmos Zu-Bolton, letter to author, Oct. 27, 2000.

71 Salaam, "Enriching the Paper Trail," 339.

72 For an account of the conference, see Dent, "New Theaters."

73 Salaam, "Enriching the Paper Trail," 338–39.

74 SBCA bylaws, 1. Thanks to Jerry Ward for providing the author with copies of this and other SBCA materials.

75 SBCA conference list, 1972–76.

76 1982 flyer listing sites of SBCA conferences, 1972–82.

77 Author's interview with Jerry Ward.

78 Salaam, "Enriching the Paper Trail," 339, and autobiographical statement; author's interview with Kalamu ya Salaam.

79 Author's interview with Kalamu ya Salaam; Salaam, autobiographical statement.

80 Salaam, autobiographical statement.

81 Salaam, "Enriching the Paper Trail," 335.

82 Dent, *Magnolia Street*, 35.

83 J. Ward, "Southern Black Aesthetics," 147–48.

84 Salaam, "BLKARTSOUTH," 469.

85 Madhubuti wrote in a report to the inaugural CAP convention, "We must understand that this will be the decade of the Black critic. It will be his responsibility not only to define and clarify, but also to give meaningful direction and guidance to the young, oncoming writers" ("Dynamite Voices," 203).

86 Salaam, *Blues Merchant*, 3.

87 S. Henderson, *Understanding the New Black Poetry*, 64.

88 Salaam, *Blues Merchant*, 4.

89 Chapman, *Black Voices*, 382, 388.

90 Ibid., 378.

91 In fact, one could make the claim that the first proto–Black Arts institution in New Orleans was a jazz record label, All For One, founded in 1961 by Harold Battiste, a member of the NOI. Though lasting only a few years, All For One was a cooperatively owned black label that included such avant-garde jazz musicians as clarinetist Alvin Baptiste and drummer Ed Blackwell among its core members (Koster, *Louisiana Music*, 39–41).

92 Dent quoted in Salaam, "Enriching the Paper Trail," 335.

93 Ibid., 327.

94 Author's interview with Nayo Watkins.

95 Askia Touré interview, July 13, 1983, UPWSC.

Conclusion

1 Some of the most prominent leaders of the Black Power and Black Arts movements even attempted to find some middle ground between the two. For an example of such an attempt, see Turé, "Marxism-Leninism and Nkrumahism."

2 A. Reed, *Stirrings*, 1–52.

3 For a discussion of Mayfield's soundtrack summarizing claims the music functioned as a sort of "counter-narration" to the film (before going on to contest those claims), see Sieving, "*Super* Sonics." The implicit or explicit idea that Mayfield somehow fooled the filmmakers, or that the filmmakers did not realize what they were likely to get when they hired Mayfield, does in fact seem pretty dubious. A better way, perhaps, to view the movie is as an intentionally hybrid, Black Arts–influenced work on all levels rather than to attempt to set the soundtrack apart.

4 Author's interviews with Ebon Dooley and Edward Spriggs.

5 Amiri Baraka has, of course, recently received much notoriety for his contentious tenure as poet laureate of New Jersey from 2002 to 2004 that resulted in the abolition of the position by the New Jersey state legislature. What is less well known outside of Essex County, New Jersey, is the degree to which he and his wife, Amina Baraka, a dancer and poet who was a mainstay of early Black Arts efforts in Newark before her husband's return to his hometown in the mid-1960s, have been at the heart of the local arts scene for nearly forty years. When I interviewed Baraka at his home, I was struck by the stream of visitors and calls asking him to look at photographs for an exhibit, come to the opening of a play, and so on.

bibliography

Archival Sources

Amherst, Massachusetts
> University of Massachusetts–Amherst, W. E. B. Du Bois Library, Special Collections
>> W. E. B. Du Bois Papers

Atlanta, Georgia
> Clark Atlanta University, Woodruff Library, Special Collections
>> Hoyt Fuller Papers
> Emory University, Woodruff Library, Special Collections
>> Thulani Davis Collection of Black Periodicals
>> Louise Thompson Patterson Papers

Boston, Massachusetts
> Boston University, Mugar Library, Special Collections
>> Nikki Giovanni Papers
>> Rosa Guy Papers
>> Bob Kaufman Papers
> Northeastern University, Northeastern University Libraries, Archives and Special Collections
>> Elma Ina Lewis Papers
>> Elma Lewis School of Fine Arts Records
>> Museum of the National Center of Afro-American Artists Records
>> National Center of Afro-American Artists Records

Cambridge, Massachusetts
> Harvard University, Littauer Library
>> Labor Collection
> Harvard University, Schlesinger Library
>> Shirley Graham Du Bois Papers

Detroit, Michigan
 Wayne State University, Walter P. Reuther Library
 James and Grace Lee Boggs Papers

Gainesville, Florida
 University of Florida, George A. Smathers Libraries
 Special and Area Studies Collections

New Haven, Connecticut
 Yale University, Beineke Library
 Langston Hughes Papers
 James Weldon Johnson Collection

New York, New York
 New York Public Library, Main Research Branch
 Henry W. and Albert A. Berg Collection of English and American Literature
 New York University, Bobst Library, Tamiment Institute Library and Robert F. Wagner
 Labor Archives
 Harold Cruse Papers
 Schomburg Center for Research in Black Culture, New York Public Library
 John Henrik Clarke Papers
 Julian Mayfield Papers
 Larry Neal Papers
 Umbra Poets Workshop Oral History Transcripts

Providence, Rhode Island
 Brown University, John Hay Library
 Harris Poetry Collection
 Hay Broadsides Collection

Storrs, Connecticut
 University of Connecticut, Dodd Research Center
 Frank O'Hara Collection

Washington, D.C.
 Howard University, Moorland-Springarn Research Center
 Amiri Baraka Collection
 Rosey E. Pool Papers
 Smithsonian Institution, Archives of American Art
 Oral History Interviews

Interviews by the Author

Muhammad Ahmad, Aug. 20, 2002, phone interview
Abdul Alkalimat, July 18, 2001, phone interview

Ernest Allen Jr., May 23, 2001, and Aug. 28, 2002, Amherst, Massachusetts

Amina Baraka, June 30, 2000, Orono, Maine

Amiri Baraka, July 15, 2000, Newark, New Jersey

Grace Boggs, July 26, 2001, phone interview

Herb Boyd, June 29, 2001, phone interview

John Bracey Jr., July 13, 2001, Amherst, Massachusetts

Ed Bullins, July 23, 2001, Boston, Massachusetts

Sam Cornish, Oct. 17, 2003, Boston, Massachusetts

Jayne Cortez, summer 2002, answers to written questions

Ebon Dooley, Aug. 16, 2001, Atlanta, Georgia

Dan Georgakas, Aug. 24, 2001, Union City, New Jersey

Calvin Hicks, Feb. 13, 2002, Boston, Massachusetts

Esther and James Jackson, July 8, 2002, Brooklyn, New York

Maulana Karenga, Aug. 15, 2003, phone interview

Woodie King Jr., Jan. 3, 2004, New York, New York

Haki Madhubuti, Aug. 22, 2003, phone interview

Marvin X, Sept. 21, 2003, phone interview

Ron Milner, Dec. 4, 2003, phone interview

Sterling Plumpp, Aug. 11, 2001, phone interview

Kalamu ya Salaam, Apr. 23, 2000, New Orleans, Louisiana

Sonia Sanchez, Jan. 15, 2003, Philadelphia, Pennsylvania

Budd Schulberg, Mar. 9, 2002, phone interview

John Sinclair, Oct. 11, 2001, Cambridge, Massachusetts

A. B. Spellman, Dec. 28, 2000, Washington, D.C.

Edward Spriggs, Aug. 16, 2001, Atlanta, Georgia

Nelson Stevens, Sept. 19 and Dec. 4, 2002, Amherst, Massachusetts

William Strickland, Nov. 6, 2002, Amherst, Massachusetts

Michael Thelwell, Feb. 20, 2003, Pelham, Massachusetts

Lorenzo Thomas, Dec. 28, 1999, Chicago, Illinois

Askia Touré, Dec. 2, 2000, Cambridge, Massachusetts

Jerry Ward, Dec. 28, 2001, New Orleans, Louisiana

Nayo Watkins, Jan. 14, 2002, phone interview

Books, Chapters, Essays, Articles, Broadsides, Pamphlets, Dissertations, and Film and Video Documentaries

Abu-Jamal, Mumia. "A Life in the Party: An Historical and Retrospective Examination of the Projections of the Black Panther Party." In *Liberation, Imagination, and the Black Panther Party*, edited by Kathleen Cleaver and George Katsiaficas, 40–50. New York: Routledge, 2001.

Acosta-Belen, Edna. "The Literature of the Puerto Rican Minority in the United States." *Bilingual Review/La Revista Bilingue* 5.1–2 (1978): 107–16.

Adams, Val. "Watts Writers Move Ahead." *New York Times*, Oct. 9, 1966, sec. 2, p. 21.

Adler, Nancy. "Arts Center Born after Watts Riot." *New York Times*, Mar. 19, 1967, sec. 1, p. 92.

Adoff, Arnold, ed. *I Am the Darker Brother*. New York: Macmillan, 1968.

Algarín, Miguel. "San Juan/an Arrest/Maguayo/a Vision of Malo Dancing." In *Nuyorican Poetry: An Anthology of Puerto Rican Words and Feelings*, edited by Miguel Algarín and Miguel Piñero, 139–47. New York: Morrow, 1975.

Algarín, Miguel, and Miguel Piñero, eds. *Nuyorican Poetry: An Anthology of Puerto Rican Words and Feelings*. New York: Morrow, 1975.

Allen, Donald M., ed. *The New American Poetry*. New York: Grove, 1960.

Allen, Donald M., and Warren Tallman, eds. *The Poetics of the New American Poetry*. New York: Grove, 1973.

Allen, Ernest, Jr. "The New Negro: Explorations in Identity and Social Consciousness, 1910–1922." In *1915, the Cultural Moment*, edited by Adele Heller and Lois Rudnick, 48–68. New Brunswick: Rutgers University Press, 1991.

———. "Religious Heterodoxy and Nationalist Tradition: The Continuing Evolution of the Nation of Islam." *Black Scholar* 26.3–4 (Fall–Winter 1996): 2–34.

Altieri, Charles. *Enlarging the Temple: New Directions in American Poetry during the 1960s*. Lewisburg, Pa.: Bucknell University Press, 1979.

American Society of African Culture. *The American Negro Writer and His Roots: Selected Papers from the First Conference of Negro Writers March, 1959*. New York: American Society of African Culture, 1960.

Anderson, Elliot, and Mary Kinzie. *The Little Magazine in America: A Modern Documentary History*. Yonkers: Pushcart, 1978.

Andrews, Alan B., and George W. Pickering. *Confronting the Color Line: The Broken Promise of the Civil Rights Movement in Chicago*. Athens: University of Georgia Press, 1986.

Angelou, Maya. *The Heart of a Woman*. 1981. New York: Bantam, 1982.

Ashton, Dore. *The New York School: A Cultural Reckoning*. New York: Penguin, 1979.

Atkins, Russell. "Editorial Poem on an Incident of Effects Far-Reaching." *Free Lance* 7.1 (1963): 14–15.

———. *Here in the*. Cleveland: Cleveland State University Poetry Center, 1976.

———. *Heretofore*. London: Paul Breman, 1969.

———. "The Invalidity of Dominant-Group 'Education' Forms for 'Progress' for Non-Dominant Ethnic Groups as Americans." *Free Lance* 7.2 (1963): 19–32.

———. *Objects*. Eureka, Calif.: Hearse, 1964.

Baker, Houston, Jr. *Afro-American Poetics*. Madison: University of Wisconsin Press, 1988.

Bambara, Toni Cade. *The Black Woman: An Anthology*. New York: New American Library, 1970.

———. *The Salt Eaters*. New York: Random House, 1980.

Banner-Haley, Charles Pete T. *To Do Good and to Do Well: Middle-Class Blacks and the Depression, Philadelphia 1929–1941*. New York: Garland, 1993.

Baraka, Amina. "Coordinator's Statement." In *African Congress: A Documentary History of the First Modern Pan-African Congress*, edited by Amiri Baraka [LeRoi Jones], 177–79. New York: Morrow, 1972.

Baraka, Amina, and Amiri Baraka, eds. *Confirmation: An Anthology of African American Women.* New York: Morrow, 1983.

Baraka, Amiri [LeRoi Jones], ed. *African Congress: A Documentary History of the First Modern Pan-African Congress.* New York: Morrow, 1972.

———. "Afro-American Literature and Class Struggle." *Black American Literature Forum* 14.1 (Spring 1980): 5–14.

———. *The Autobiography of LeRoi Jones.* Chicago: Lawrence Hill, 1997.

———. *Black Art.* Newark: Jihad, 1966.

———. "The Black Arts Movement." Newark, 1994. Mimeographed.

———. *Black Magic: Collected Poetry, 1961–1967.* New York: Bobbs-Merrill, 1969.

———. *Black Music.* New York: Morrow, 1967.

———. *Blues People.* New York: Morrow, 1963.

———. *The Dead Lecturer.* New York: Grove, 1964.

———. *Eulogies.* New York: Marsilio, 1996,

———. *The Fiction of LeRoi Jones/Amiri Baraka.* Chicago: Lawrence Hill, 2000.

———. *Home.* New York: Morrow, 1966.

———. *The LeRoi Jones/Amiri Baraka Reader.* New York: Thunder's Mouth, 1991.

———, ed. *The Moderns: An Anthology of New Writing in America.* New York: Corinth, 1963.

———. *Preface to a Twenty-Volume Suicide Note.* New York: Totem, 1961.

Baraka, Amiri, and Amina Baraka. *The Music: Reflections on Jazz and Blues.* New York: Morrow, 1987.

Barlow, William, and Peter Shapiro. *An End to Silence: The San Francisco State College Student Movement in the 1960s.* New York: Bobbs-Merrill, 1971.

Bates, Beth T. " 'Double V for Victory' Mobilizes Black Detroit, 1941–1946." In *Freedom North: Black Freedom Struggles outside the South, 1940–1980,* edited by Jeanne F. Theoharis and Komozi Woodard, 17–39. New York: Palgrave, 2003.

"BBB Interviews Hoyt W. Fuller." *Black Books Bulletin* 1.1 (Fall 1971): 19–23, 40–43.

Bearden, Romare, and Harry Henderson. *A History of African-American Artists: From 1792 to the Present.* New York: Pantheon, 1993.

Benston, Kimberly. *Baraka: The Renegade and the Mask.* New Haven: Yale University Press, 1976.

———. *Performing Blackness: Enactments of African-American Modernism.* New York: Routledge, 2000.

Berger, Art. "Negroes with Pens." *Mainstream* 16.7 (July 1963): 3–6.

Berrigan, Ted. *The Sonnets.* New York: Grove, 1964.

Bibby, Michael. *Hearts and Minds: Bodies, Poetry, and Resistance in the Vietnam Era.* New Brunswick: Rutgers University Press, 1996.

———. "Insurgent Poetry and the Politics of the Poetic." In *Poetics/Politics: Radical Aesthetics in the Classroom,* edited by Amitava Kumar, 135–54. New York: St. Martin's, 1999.

Bigart, Homer. "4 in Youth Agency Retort to Marchi." *New York Times,* Jan. 5, 1965, 15.

Binder, Wolfgang, ed. *Partial Autobiographies: Interviews with Twenty Chicano Poets.* Erlangen, Ger.: Palm and Enke, 1985.

Biondi, Martha. *To Stand and Fight: The Struggle for Civil Rights in Postwar New York City*. Cambridge: Harvard University Press, 2004.

Black Museum History Committee. *Black Poets Write On: An Anthology of Black Philadelphia Poets*. Philadelphia: Black Museum History Committee, 1970.

The Black Power Movement, Part 1: Amiri Baraka from Black Arts to Black Radicalism. Editorial adviser, Komozi Woodard. Project coordinator, Randolph H. Boehm. Bethesda, Md.: University Publications of America, 2000. Microform.

The Black Power Movement, Part 2: The Papers of Robert F. Williams. Editorial adviser, Timothy Tyson. Project coordinator, Randolph H. Boehm. Bethesda, Md.: University Publications of America, 2001. Microform.

The Black Power Movement, Part 3: Papers of the Revolutionary Action Movement, 1962–1996. Editorial advisers, Muhammad Ahmad, Ernie Allen, and John Bracey. Project coordinator, Randolph H. Boehm. Bethesda, Md.: LexisNexis, 2002. Microform.

Black Theatre: The Making of a Movement. Directed by Woodie King Jr. San Francisco: California Newsreel, 1978. VHS.

The Black Unicorn: Dudley Randall and the Broadside Press. Directed by Melba Joyce Boyd. New York: Cinema Guild, 1996. VHS.

Blackwell, Henry. "An Interview with Ntozake Shange." *Black American Literature Forum* 13.4 (Winter 1979): 134–38.

Boggs, Grace Lee. *Living for Change*. Minneapolis: University of Minnesota Press, 1998.

Boggs, James. *The American Revolution*. New York: Monthly Review, 1968.

———. *Racism and Class Struggle: Further Pages from a Black Worker's Notebook*. New York: Monthly Review, 1970.

Bone, Robert. "Richard Wright and the Chicago Renaissance." *Callaloo* 9.3 (Summer 1986): 446–68.

Bontemps, Arna. *American Negro Poetry*. New York: Hill and Wang, 1963.

Bontemps, Arna, and Langston Hughes. *Letters, 1925–1967*. 1980. New York: Paragon House, 1990.

Boyd, Melba Joyce. "'Prophets for a New Day': The Cultural Activism of Margaret Danner, Margaret Burroughs, Gwendolyn Brooks, and Margaret Walker during the Black Arts Movement." *Revista Canaria de Estudios Ingleses* 37 (Nov. 1998): 55–67.

———. *Wrestling with the Muse: Dudley Randall and Broadside Press*. New York: Columbia University Press, 2003.

Branch, Taylor. *Parting the Waters: America in the King Years*. New York: Simon and Schuster, 1988.

Breman, Paul. "Poetry into the Sixties." In *The Black American Writer*, edited by C. W. E. Bigsby, 99–109. Deland, Fla.: Everett/Edwards, 1969.

———, ed. *Sixes and Sevens: An Anthology of New Poetry*. London: Paul Breman, 1962.

Bright, Alfred L. "On Fertile Ground: The African American Experience of Artists Associated with Karamu House." In *Yet Still We Rise: African American Art in Cleveland, 1920–1970*, edited by Ursula Korneitchouk, 23–32. Cleveland: Cleveland Artists Foundation, 1996.

Brooks, Cleanth. *The Well Wrought Urn: Studies in the Structure of Poetry*. New York: Reynal and Hitchcock, 1947.

Brooks, Gwendolyn. *Annie Allen*. New York: Harper and Row, 1949.

———. *The Bean Eaters*. New York: Harper and Row, 1960.

———. *Blacks*. Chicago: David, 1987.

———. *In the Mecca*. New York: Harper and Row, 1968.

———, ed. *Jump Bad: A New Chicago Anthology*. Detroit: Broadside, 1971.

———. *Maude Martha*. New York: Harper and Row, 1953.

———. *Report from Part I*. Detroit: Broadside, 1972.

———. *Riot*. Detroit: Broadside, 1969.

Brown, Elaine. *A Taste of Power: A Black Women's Story*. New York: Pantheon, 1992.

Brown, Patricia L., Don L. Lee, and Francis Ward, eds. *To Gwen with Love: An Anthology Dedicated to Gwendolyn Brooks*. Chicago: Johnson, 1971.

Brown, Scot. *Fighting for US: Maulana Karenga, The US Organization, and Black Cultural Nationalism*. New York: New York University Press, 2003.

———. "The Politics of Culture: The US Organization and the Quest for Black 'Unity.'" In *Freedom North: Black Freedom Struggles outside the South, 1940–1980*, edited by Jeanne F. Theoharis and Komozi Woodard, 223–54. New York: Palgrave, 2003.

———. "The US Organization: African-American Cultural Nationalism in the Era of Black Power, 1965 to the 1970s." Ph.D. diss., Cornell University, 1999.

———. "The US Organization, Black Power Politics, and the United Front Ideal: Los Angeles and Beyond." *Black Scholar* 31.3–4 (Fall–Winter 2001): 21–30.

Brown, Sterling A. "The Blues as Folk Poetry." In *Folk-Say, a Regional Miscellany: 1930*, edited by Benjamin Botkin, 324–39. Norman: University of Oklahoma Press, 1931.

———. *The Collected Poems of Sterling A. Brown*. Selected by Michael Harper. New York: Harper Colophon, 1980.

Bruce-Novoa, [Juan]. *Chicano Poetry: A Response to Chaos*. Austin: University of Texas Press, 1982.

———. *Retrospace: Collected Essays on Chicano Literature*. Houston: Arte Público, 1990.

Buhle, Paul. *Marxism in the USA: Remapping the History of the American Left*. London: Verso, 1987.

Bullins, Ed [Kingsley B. Bass Jr.]. *We Righteous Bombers*. In *New Plays from the Black Theatre*, edited by Ed Bullins, 19–96. New York: Bantam, 1969.

Burns, Ben. *Nitty Gritty: A White Editor in Black Journalism*. Jackson: University Press of Mississippi, 1996.

Burroughs, Margaret. "She'll Speak to Generations Yet to Come." In *To Gwen with Love: An Anthology Dedicated to Gwendolyn Brooks*, edited by Patricia L. Brown, Don L. Lee [Haki Madhubuti], and Francis Ward, 129–30. Chicago: Johnson, 1971.

Bush, Rod. *We Are Not What We Seem: Black Nationalism and Class Struggle in the American Century*. New York: New York University Press, 1999.

Carmichael, Virginia. *Framing History: The Rosenberg Story and the Cold War*. Minneapolis: University of Minnesota Press, 1993.

Carson, Claybourne. *In Struggle: SNCC and the Black Awakening of the 1960s*. Cambridge: Harvard University Press, 1981.

Carter, Curtis L. "Watts: The Hub of the Universe." In *Watts: Art and Social Change in Los Angeles, 1965–2002*, 9–20. Milwaukee: Haggerty Museum of Art, Marquette University, 2003.

Caute, David. *The Great Fear: The Anti-Communist Fear under Truman and Eisenhower*. New York: Simon and Schuster, 1978.

Césaire, Aimé. *The Collected Poetry*. Translated by Clayton Eshleman and Annette Smith. Berkeley: University of California Press, 1983.

Chapman, Abraham, ed. *Black Voices*. New York: New American Library, 1968.

Charters, Ann. *Kerouac: A Biography*. New York: Warner Books, 1974.

Childress, Alice, Paule Marshall, and Sarah Wright. "The Negro Woman in American Literature." In *Freedomways Reader: Prophets in Their Own Country*, edited by Esther Cooper Jackson, 291–98. Boulder: Westview, 2000.

Chin, Frank, Paul Jeffrey Chan, Lawson Fusao Inada, and Shawn Hsu Wong. *Aiiieeeee! An Anthology of Asian American Writers*. Washington, D.C.: Howard University Press, 1974.

Churchill, Ward. "'To Disrupt, Discredit and Destroy': The FBI's Secret War against the Black Panther Party." In *Liberation, Imagination, and the Black Panther Party*, edited by Kathleen Cleaver and George Katsiaficas, 78–117. New York: Routledge, 2001.

Clarke, John Henrik. "The New Afro American Nationalism." *Freedomways* 1.3 (Fall 1961): 285–95.

Clay, Steven, and Rodney Phillips. *A Secret Location on the Lower East Side*. New York: New York Public Library, 1998.

Cleaver, Kathleen, and George Katsiaficas, eds. *Liberation, Imagination, and the Black Panther Party*. New York: Routledge, 2001.

Cockcroft, Eva, John Weber, and James Cockcroft. *Toward a People's Art: The Contemporary Mural Movement*. New York: Dutton, 1977.

Coleman, Stanley R. "Dashiki Project: Black Identity and Beyond." Ph.D. diss., Louisiana State University, 2003.

Colon, Jesus. *A Puerto Rican in New York*. 1961. New York: International, 1982.

Cooney, Terry. *The Rise of the New York Intellectuals: Partisan Review and Its Circle, 1934–1945*. Madison: University of Wisconsin Press, 1986.

Cook, Mercer, and Stephen Henderson. *The Militant Black Writer in Africa and the United States*. Madison: University of Wisconsin Press, 1969.

Cook, William W. "The Black Arts Poets." In *Columbia History of American Poetry*, edited by Jay Parini and Brett C. Miller, 674–706. New York: Columbia University Press.

Corso, Gregory. *An Accidental Autobiography: The Selected Letters of Gregory Corso*. Edited by Bill Morgan. New York: New Directions, 2003.

Cortez, Jayne. "Jayne Cortez: In Her Own Words." In *Watts: Art and Social Change in Los Angeles, 1965–2002*, 35–37. Milwaukee: Haggerty Museum of Art, Marquette University, 2003.

———. *Pisstain Stairs and the Monkey Man's Wares*. New York: Phrase Text, 1969.

Countryman, Matthew J. "Civil Rights and Black Power in Philadelphia, 1940–1971." Ph.D. diss., Duke University, 1998.

Cronon, E. David. *The Story of Marcus Garvey and the Universal Negro Improvement Association*. 1955. Madison: University of Wisconsin Press, 1969.

Crouch, Stanley. "Lady Leo: Miss T." In *Watts Poets and Writers*, edited by Quincy Troupe, 76–77. Los Angeles: House of Respect, 1968.

Crowe, Daniel. *Prophets of Rage: The Black Freedom Struggle in San Francisco, 1945–1969*. New York: Garland, 2000.

Cruse, Harold. *The Crisis of the Negro Intellectual*. 1967. New York: Quill, 1984.

———. *The Essential Harold Cruse: A Reader*. Edited by Jelani Cobb. New York: Palgrave, 2002.

———. *Rebellion or Revolution*. New York: Morrow, 1962.

Damon, Maria. *The Dark End of the Street: Margins in American Vanguard Poetry*. Minneapolis: University of Minnesota Press, 1993.

Danner, Margaret. "The Elevator Man Adheres to Form." In *Beyond the Blues*, edited by Rosey E. Pool, 86–87. Lympne, U.K.: Hand and Flower, 1962.

———. "Sadie's Playhouse." In *Beyond the Blues*, edited by Rosey E. Pool, 86–87. Lympne, U.K.: Hand and Flower, 1962.

———. *To Flower*. Nashville: Hemphill, 1963.

Danner, Margaret, and Dudley Randall. *Poem Counterpoem*. Detroit: Broadside, 1969.

Danns, Dionne. *Something Better for Our Children: Black Organizing in Chicago Public Schools, 1963–1971*. New York: Routledge, 2003.

Davidson, Michael. *The San Francisco Renaissance: Poetics and Community at Mid-Century*. New York: Cambridge University Press, 1989.

Davis, Angela. *Angela Davis: An Autobiography*. New York: Random House, 1974.

Davis, Ossie. "Anti-Semitism and Black Power." In *Freedomways Reader: Prophets in Their Own Country*, edited by Esther Cooper Jackson, 207–9. Boulder: Westview, 2000.

———. "Purlie Told Me!" In *Harlem U.S.A.*, edited by John Henrik Clarke, 149–54. New York: Macmillan, 1971.

Davis, Ossie, and Ruby Dee. *With Ossie and Ruby: In This Life Together*. New York: Morrow, 1998.

Dawahare, Anthony. *Nationalism, Marxism, and African American Literature between the Wars: A New Pandora's Box*. Jackson: University Press of Mississippi, 2003.

De Jongh, James. *Vicious Modernism: Black Harlem and the Literary Imagination*. Cambridge: Cambridge University Press, 1990.

De Loach, Allen. *The East Side Scene: Anthology of a Time and Place*. Buffalo: University Press of the State University of New York at Buffalo, 1968.

Denning, Michael. *The Cultural Front: The Laboring of American Culture*. New York: Verso, 1996.

Dent, Thomas C. "Beyond Rhetoric toward a Black Southern Theater." *Black World* 20.6 (Apr. 1971): 15–25.

———. *Magnolia Street*. 1976. New Orleans: Privately printed, 1987.

———. "Marcus B. Christian: An Appreciation." *Black American Literature Forum* 18.1 (Spring 1984): 22–26.

———. "New Theaters across the South Join Hands." *Black World* 22.6 (Apr. 1973): 92–95.

———. *Southern Journey*. New York: Morrow, 1996.

———. "Umbra Days." *Black American Literature Forum* 14 (1980): 105–8.

Dent, Thomas C., Richard Schechner, and Gilbert Moses, eds. *The Free Southern Theater, by the Free Southern Theater*. Indianapolis: Bobbs-Merrill, 1969.

Dickstein, Morris. *Gates of Eden: American Culture in the Sixties*. New York: Basic Books, 1977.

Dillard, Angela. "From the Reverend Charles A. Hill to the Reverend Albert B. Cleage Jr.: Change and Continuity in the Patterns of Civil Rights Mobilizations in Detroit, 1935–1967." Ph.D. diss., University of Michigan, 1995.

———. "Religion and Radicalism: The Reverend Albert B. Cleage Jr. and the Rise of Black Christian Nationalism in Detroit." In *Freedom North: Black Freedom Struggles outside the South, 1940–1980*, edited by Jeanne F. Theoharis and Komozi Woodard, 125–52. New York: Palgrave, 2003.

di Prima, Diane. *Memoirs of a Beatnik*. 1969. San Francisco: Last Gasp, 1987.

———. *Recollections of My Life as a Woman: The New York Years: A Memoir*. New York: Viking, 2001.

Domini, John. "Ishmael Reed: A Conversation with John Domini." In *Conversations with Ishmael Reed*, edited by Bruce Dick and Amritjit Singh, 128–43. Jackson: University Press of Mississippi, 1995.

Donaldson, Jeff. "The Rise and Fall and Legacy of the Wall of Respect Movement." *International Review of African American Art* 15.1 (1998): 22–26.

Dorn, Edward. *The Collected Poems, 1956–1974*. Bolinas, Calif.: Four Seasons, 1975.

———. *Interviews*. Bolinas, Calif.: Four Seasons, 1980.

———. *Views*. Bolinas, Calif.: Four Seasons, 1980.

Douglass, Frederick. *Narrative of the Life of Frederick Douglass, An American Slave*. 1845. New York: Doubleday, 1989.

Drake, Sylvie. "'Iron Hand' in Opening at Watts Workshop." *Los Angeles Times*, Aug. 12, 1970, sec. 4, p. 14.

Duberman, Martin. *Black Mountain: An Exploration in Community*. New York: Dutton, 1972.

Dudziak, Mary L. *Cold War Civil Rights: Race and the Image of American Democracy*. Princeton: Princeton University Press, 2000.

———. "Josephine Baker, Racial Protest, and the Cold War." *Journal of American History* 81.2 (Sept. 1994): 543–70.

Dumas, Henry. *Play Ebony, Play Ivory*. New York: Random House, 1974.

Durem, Ray. *Take No Prisoners*. London: Paul Breman, 1971.

Durham, Richard. *Richard Durham's Destination Freedom: Scripts from Radio's Black Legacy, 1948–50*. Edited by J. Fred Macdonald. New York: Praeger, 1989.

Dyson, Michael Eric. *I May Not Get There with You: The True Martin Luther King Jr.* New York: Free Press, 2000.

Echols, Alice. *Scars of Sweet Paradise: The Life and Times of Janis Joplin*. New York: Henry Holt, 1999.

Elam, Harry, Jr. "Social Urgency, Audience Participation, and the Performance of *Slave Ship* by Amiri Baraka." In *Crucibles of Crisis: Performing Social Change*, edited by Janelle Reinelt, 13–35. Ann Arbor: University of Michigan Press, 1996.

Ellingham, Lewis, and Kevin Killian. *Poet Be like God: Jack Spicer and the San Francisco Renaissance*. Hanover: University Press of New England, 1998.

Ellis, William. "Operation Bootstrap: A Case Study in Ideology and the Institutionalization of Protest." Ph.D. diss., University of California–Los Angeles, 1969.

Ellison, Ralph. *Going to the Territory*. New York: Random House, 1986.

———. *Invisible Man*. New York: Random House, 1952.

———. *Shadow and Act*. New York: Random House, 1964.

Fabio, Sarah Webster. "Who Speaks Negro?" *Negro Digest* 16.2 (Dec. 1966): 54–58.

Fabré, Genevieve. "The Free Southern Theatre, 1963–1979." *Black American Literature Forum* 17.2 (Summer 1983): 55–59.

Fairclough, Adam. *Race and Democracy: The Civil Rights Struggle in Louisiana, 1915–1972*. Athens: University of Georgia Press, 1995.

Farnsworth, Robert M. *Melvin B. Tolson, 1896–1966: Plain Talk and Poetic Prophecy*. Columbia: University of Missouri Press, 1984.

Fass, Ekbert, ed. *Towards a New American Poetics: Essays and Interviews*. Santa Barbara: Black Sparrow, 1978.

Fax, Elton C. *Seventeen Black Artists*. New York: Dodd, Mead, 1971.

Ferguson, Karen. *Black Politics in New Deal Atlanta*. Chapel Hill: University of North Carolina Press, 2002.

Finally Got the News. Directed by Stewart Bird, Rene Lichtman, and Peter Gessner. New York: Icarus Films, 1970. VHS.

Flanagan, Hallie. *Arena: The Story of the Federal Theatre*. 1940. New York: Limelight, 1985.

Flores, Juan. *Divided Borders: Essays on Puerto Rican Identity*. Houston: Arte Público, 1993.

———. Foreword to *A Puerto Rican in New York*, by Jesus Colon, ix–xvii. New York: International, 1982.

Flowers, Sandra Hollis. *African American Nationalist Literature of the 1960s: Pens of Fire*. New York: Garland, 1996.

Foley, Barbara. *Radical Representations: Politics and Form in U.S. Proletarian Fiction, 1929–1941*. Durham: Duke University Press, 1993.

———. *Spectres of 1919: Class and Nation in the Making of the New Negro*. Urbana: University of Illinois Press, 2003.

Ford, Karen Jackson. "Making Poetry Pay: The Commodification of Langston Hughes." In *Marketing Modernisms: Self-Promotion, Canonization, Rereading*, edited by Kevin J. H. Dettmar and Stephen Watt, 275–96. Ann Arbor: University of Michigan Press, 1996.

Forman, James. *The Making of Black Revolutionaries*. 1972. Seattle: University of Washington Press, 1997.

Forrest, Leon. *The Furious Voice for Freedom: Essays on Life*. Wakefield, R.I.: Asphodel, 1994.

Foster, Edward. *Understanding the Beats*. Columbia: University of South Carolina Press, 1992.

———. *Understanding the Black Mountain Poets*. Columbia: University of South Carolina Press, 1995.

Fowler, Virginia C. *Nikki Giovanni*. New York: Twayne, 1992.

Frascina, Francis, and Serge Guilbault, eds. *Pollock and After*. New York: Harper and Row, 1985.

Fraser, C. Gerald. "Negroes Ask Role for Art in 'War.'" *New York Times*, Nov. 3, 1968, sec. 1, p. 43.

Freeman, Donald. "The Cleveland Story." *Liberator* 3.6 (June 1963): 7, 18.

Fremont-Smith, Eliot. "TV: NBC Documents 'The Angry Voices of Watts.'" *New York Times*, Aug. 17, 1966, 79.

French, Warren. *The San Francisco Poetry Renaissance, 1955–1960*. Boston: Twayne, 1991.

Friendly, Alfred, Jr. "Powell Says His Study Clears Antipoverty Program of Scandal." *New York Times*, Feb. 28, 1966, 11.

Fuentes, Luis. "The Struggle for Local Political Control." In *Historical Perspectives on Puerto Rican Survival in the United States*, edited by Clara E. Rodríguez and Virginia Sánchez Korrol, 133–42. 1980. Princeton: Markus Wieners, 1996.

Fuller, Hoyt W. Foreword to *Nommo*. In *A Literary Legacy of Black Chicago (1967–1987)*, edited by Carole A. Parks, 17–20. Chicago: OBAHouse, 1987.

———. "Harlem Writers Guild at the New School." *Negro Digest* 14.8 (June 1965): 56–59.

Funkhouser, Chris. "being matter ignited: An Interview with Cecil Taylor." *Hambone* 12 (1995): 17–39.

———. "LeRoi Jones, Larry Neal, *The Cricket* and JIHAD: Jazz and Poets' Black Fire." Paper presented at the National Poetry Foundation Conference, Orono, Maine, Summer 2000.

Gaines, Kevin. "The Cold War and the African American Expatriate Community in Nkrumah's Ghana." In *Universities and Empire: Money and Politics in the Social Sciences during the Cold War*, edited by Christopher Simpson, 135–38. New York: New Press, 1998.

Garcia, Mario T. *Memories of Chicano History: The Life and Narrative of Bert Corona*. Berkeley: University of California Press, 1994.

Garrow, David J. *Atlanta, Georgia, 1960–1961: Sit-Ins and Student Activism*. Brooklyn: Carlson, 1989.

Gates, Henry Louis, Jr. "Black Creativity: On the Cutting Edge." *Time*, Oct. 10, 1994, 74–75.

Gayle, Addison, Jr., ed. *The Black Aesthetic*. New York: Doubleday, 1971.

Gennari, John. "'A Weapon of Integration': Frank Marshall Davis and the Politics of Jazz." *Langston Hughes Review* 14.1–2 (Spring–Fall 1996): 16–33.

Gent, George. "N.B.C. to Broadcast Writings of Watts Negroes." *New York Times*, June 28, 1966, 91.

Georgakas, Dan. "Frank Lovell: The Detroit Years." In *Revolutionary Labor Socialist: The Life, Ideas, and Comrades of Frank Lovell*, edited by Paul Le Blanc and Thomas Barrett, 43–44. Union City, N.J.: Smyrna, 2000.

Georgakas, Dan, and Marvin Surkin. *Detroit: I Do Mind Dying*. New York: St. Martin's, 1975.

Geschwender, James A. *Class, Race, and Worker Insurgency: The League of Revolutionary Black Workers*. New York: Cambridge University Press, 1977.

Gibson, Kenneth A. "Speech." In *African Congress: A Documentary History of the First Modern Pan-African Congress*, edited by Amiri Baraka [LeRoi Jones], 18–21. New York: Morrow, 1972.

Gilbert, Derrick Ibrahim Mussa. "From Watts to Leinert Park: Two Generations of African-American Poetry Movements in Los Angeles." Ph.D. diss., University of California–Los Angeles, 1998.

Gillespie, John B. [Dizzy]. *Dizzy: To Be or Not to Bop*. New York: Quartet Books, 1982.

Gilyard, Keith. *Liberation Memories: The Rhetoric and Poetics of John Oliver Killens*. Detroit: Wayne State University Press, 2003.

Ginsberg, Allen. *Allen Verbatim: Lectures on Poetry, Politics, Consciousness*. New York: McGraw-Hill, 1974.

———. *Collected Poems: 1947–1980*. New York: Harper and Row, 1985.

———. *Howl and Other Poems*. San Francisco: City Lights Books, 1959.

———. *Journals Mid-Fifties, 1954–1958*. New York: HarperCollins, 1995.

Giovanni, Nikki. *The Selected Poems of Nikki Giovanni*. New York: Morrow, 1996.

Giovanni, Nikki, and Margaret Walker. *A Poetic Equation: Conversations between Nikki Giovanni and Margaret Walker*. Washington, D.C.: Howard University Press, 1974.

Gitlin, Todd. *The Sixties: Years of Hope, Days of Rage*. New York: Bantam, 1987.

Glaberman, Martin. Introduction to *Marxism for Our Time*, by C. L. R. James, xi–xxvii. Jackson: University Press of Mississippi, 1999.

———. *Wartime Strikes: The Struggle against the No-Strike Pledge in the UAW during World War II*. Detroit: Bewick, 1980.

Glueck, Grace. "A Very Own Thing in Harlem." *New York Times*, Sept. 15, 1968, sec. D, p. 34.

Gooch, Brad. *City Poet: The Life and Times of Frank O'Hara*. New York: Knopf, 1993.

Gosse, Van. *Where the Boys Are: Cuba, Cold War America, and the Making of the New Left*. New York: Verso, 1993.

Gould, Jack. "TV: Experiment in Watts." *New York Times*, Feb. 20, 1967, 75.

Graham, Le. "Black Poets at the Black Arts Convention '67." *Journal of Black Poetry* 1.6 (Fall 1967): 19–20.

Greenberg, Cheryl. *"Or Does It Explode?": Black Harlem in the Great Depression*. New York: Oxford University Press, 1991.

Griffin, Farah Jasmine. "Conflict and Chorus: Reconsidering Toni Cade's *The Black Woman: An Anthology*." In *Is It Nation Time?: Contemporary Essays on Black Power and Black Nationalism*, edited by Eddie S. Glaude Jr., 113–29. Chicago: University of Chicago Press, 2002.

Griffin, Junius. "2 in Youth Agency Are Communists, F.B.I. Check Finds." *New York Times*, Aug. 24, 1964, 1, 13.

Griffiths, David B. *Beach and Temple*. San Francisco International Scholars, 1998.

Guilbault, Serge. *How New York Stole the Idea of Modern Art: Abstract Expressionism, Freedom, and the Cold War*. Chicago: University of Chicago Press, 1983.

Haines, Herbert H. *Black Radicals and the Civil Rights Mainstream, 1954–1970*. Knoxville: University of Tennessee Press, 1988.

Hall, James C. *Mercy, Mercy Me: African-American Culture and the American Sixties*. New York: Oxford University Press, 2001.

———. "On Sale at Your Favorite Newsstand: *Negro Digest/Black World* and the 1960s." In *The Black Press: New Literary and Historical Essays*, edited by Todd Vogel, 188–206. New Brunswick: Rutgers University Press, 2001.

Hamalian, Linda. *A Life of Kenneth Rexroth*. New York: Norton, 1991.

Harding, Vincent. "History of the Institute of the Black World." In *Education and Black Struggle: Notes from the Colonized World*, edited by the Institute of the Black World, 145–48. Cambridge: Harvard Educational Review, 1972.

Harmon, David. *Beneath the Image of the Civil Rights Movement and Race Relations: Atlanta, Georgia, 1946–1981.* New York: Garland, 1996.

Harney, Steve. "Ethnos and the Beats." *Journal of American Studies* 25.3 (Dec. 1991): 363–81.

Harper, Phillip Brian. "Nationalism and Social Division in Black Arts Poetry." *Critical Inquiry* 19.2 (Winter 1993): 234–55.

Harris, Jessica B. "The National Black Theatre: The Sun People of 125th Street." In *The Theatre of Black Americans,* edited by Errol Hill, 283–91. New York: Applause Theatre, 1987.

Harris, Michael D. "Urban Totems." In *Walls of Heritage, Walls of Pride: African American Murals,* edited by James Prigoff and Robin J. Dunitz, 24–43. San Francisco: Pomegranate, 2000.

Harris, William J. *The Poetry and Poetics of Amiri Baraka: The Jazz Aesthetic.* Columbia: University of Missouri Press, 1985.

Hatch, James V. *Sorrow Is the Only Faithful One: The Life of Owen Dodson.* Urbana: University of Illinois Press, 1993.

Hayden, Robert. *A Ballad of Remembrance.* London: Paul Breman, 1962.

———. *Collected Poems.* New York: Liveright, 1985.

———, ed. *Kaleidoscope: Poems by American Negro Poets.* New York: Harcourt, Brace, 1967.

Haywood, Harry. *Black Bolshevik: Autobiography of an Afro-American Communist.* Chicago: Liberator, 1978.

Healey, Dorothy, and Maurice Isserman. *Dorothy Healey Remembers: A Life in the American Communist Party.* New York: Oxford University Press, 1990.

Henderson, David. Introduction to *Cranial Guitar* by Bob Kaufman, 7–28. Minneapolis: Coffee House Books, 1996.

Henderson, Stephen. *Understanding the New Black Poetry: Black Speech and Black Music as Poetic References.* New York: Morrow, 1973.

Hernandez, Carmen Dolores. *Puerto Rican Voices in English: Interviews with Writers.* Westport, Conn.: Praeger, 1997.

Hernton, Calvin. *The Coming of Chronos to the House of Nightsong.* New York: Interim Books, 1964.

———. "Umbra: A Personal Recounting." *African American Review* 27.4 (Winter 1993): 579–83.

Herrera, Juan Felipe. "Riffs on Mission District *Raza* Writers." In *Reclaiming San Francisco: History, Politics, Culture,* edited by James Brooks, Chris Carlsson, and Nancy Peters, 217–30. San Francisco: City Lights Books, 1998.

Hicks, Calvin L. *African-American Literary and Political Movements, 1960s, on New York's Lowereast Side.* New York: Cultural Dimensions, 1994.

Hill, Gladwin. "Festival Hailed in Watts by Shriver." *New York Times,* Aug. 15, 1966, 16.

Hilliard, David, and Lewis Cole. *This Side of Glory: The Autobiography of David Hilliard and the Story of the Black Panther Party.* Boston: Little, Brown, 1993.

"The History of SUDAN (in Texas?)." *Nkombo* 3.2 (Mar. 1971): 15–16.

Ho, Fred. "BAMBOO THAT SNAPS BACK! Resistance and Revolution in Asian Pacific American Working Class and Left-Wing Expressive Culture." In *Left of the Color Line: Race, Radicalism, and Twentieth-Century Literature of the United States,* edited by Bill V. Mullen and James Smethurst, 239–57. Chapel Hill: University of North Carolina Press, 2003.

Hobbs, Stuart D. *The End of the American Avant Garde*. New York: New York University Press, 1997.

Homberger, Eric. *American Writers and Radical Politics: 1900–1939*. New York: St. Martin's, 1986.

Honey, Michael. *Southern Labor and Black Civil Rights*. Urbana: University of Illinois Press, 1993.

Horne, Gerald. *Black and Red: W. E. B. Du Bois and the Afro-American Response to the Cold War, 1944–1963*. Albany: State University of New York Press, 1986.

———. *Black Liberation/Red Scare: Ben Davis and the Communist Party*. Newark: University of Delaware Press, 1994.

———. *Communist Front?: The Civil Rights Congress, 1946–1956*. Teaneck, N.J.: Fairleigh Dickinson University Press, 1988.

———. *Fire This Time: The Watts Uprising and the 1960s*. Charlottesville: University of Virginia Press, 1995.

———. *Race Woman: The Lives of Shirley Graham Du Bois*. New York: New York University Press, 2000.

Hudson, Theodore R. *From LeRoi Jones to Amiri Baraka: The Literary Works*. Durham: Duke University Press, 1973.

Hughes, Langston. *Ask Your Mama*. New York: Knopf, 1961.

———. *Collected Poems of Langston Hughes*. New York: Knopf, 1994.

———. "The Negro Artist and the Racial Mountain." In *African American Literary Theory: A Reader*, edited by Winston Napier, 27–30. New York: New York University Press, 2000.

———, ed. *New Negro Poets, U.S.A.* Bloomington: Indiana University Press, 1964.

———. *The Panther and the Lash*. New York: Knopf, 1967.

Hull, Gloria T., Patricia Bell Scott, and Barbara Smith. *All the Women Are White, All the Blacks Are Men, but Some of Us Are Brave*. Old Westbury, N.Y.: Feminist, 1982.

Hunter, Kim D. "1967: Detroiters Remember" (interview with Edward Vaughn). *Against the Current* 12.4 (Sept.–Oct. 1997): 20–21.

Hutchinson, George B. *The Harlem Renaissance in Black and White*. Cambridge: Harvard University Press, 1995.

———. "Jean Toomer and the 'New Negroes' of Washington." *American Literature* 63.4 (Dec. 1991): 683–92.

Ignatiev, Noel. "Antirevisionism." In *Encyclopedia of the American Left*, edited by Mari Jo Buhle, Paul Buhle, and Dan Georgakas, 48–51. New York: Garland, 1990.

Institute of the Black World. "Statement of Purpose and Program." In *New Black Voices: An Anthology of Contemporary Afro-American Literature*, edited by Abraham Chapman, 575–78. New York: New American Library, 1972.

Isserman, Maurice. *If I Had a Hammer*. New York: Basic Books, 1987.

Jackson, Blyden, and Louis Rubin Jr. *Black Poetry in America: Two Essays in Historical Interpretation*. Baton Rouge: Louisiana State University Press, 1974.

Jackson, Esther Cooper, ed. *Freedomways Reader: Prophets in Their Own Country*. Boulder: Westview, 2000.

Jackson, James Thomas. *Waiting in Line at the Drugstore and Other Writings of James Thomas Jackson*. Denton: University of North Texas Press, 1993.

James, C. L. R., Grace C. Lee, and Pierre Chaulieu. *Facing Reality*. 1958. Detroit: Bewick Editions, 1974.

Jarrell, Randall. *Poetry and the Age*. 1953. New York: Vintage, 1955.

Jenkins, David. *The Union Movement, the California Labor School, and San Francisco Politics, 1926–1988*. Berkeley: Regional Oral History Office, The Bancroft Library, University of California, 1993.

Joans, Ted. *Black Pow-Wow*. New York: Hill and Wang, 1969.

Johnson, Abby Arthur, and Ronald Maberry Johnson. *Propaganda and Aesthetics: The Literary Politics of African-American Magazines in the Twentieth Century*. Amherst: University of Massachusetts Press, 1979.

Johnson, Helene. "Poem." In *The Book of American Negro Poetry*, edited by James Weldon Johnson, 279–80. New York: Harcourt, Brace, 1931.

Johnson, James Weldon, ed. *The Book of American Negro Poetry*. New York: Harcourt, Brace, 1931.

Johnson, Thomas A. "Black Panthers Picket a School." *New York Times*, Sept. 13, 1966, 38.

Johnston, Percy. "Variations on a Theme by Johnston." In *Burning Spear: An Anthology of Afro-Saxon Poetry*, 46. Washington, D.C.: Jupiter Hammon, 1963.

Jonas, Steve. *Love, the Poem, the Sea and Other Pieces Examined*. San Francisco: White Rabbit, 1957.

Jones, Charles E., ed. *The Black Panther Party Reconsidered*. Baltimore: Black Classic, 1998.

Jones, Hettie. *How I Became Hettie Jones*. New York: Penguin, 1990.

Jones, LeRoi, and Larry Neal, eds. *Black Fire: An Anthology of Afro-American Writing*. New York: Morrow, 1968.

Jones, Meta Du Ewa. "Jazz Prosodies: Orality and Textuality." *Callaloo* 25.1 (Winter 2002): 66–91.

Jordan, Jennifer. "Cultural Nationalism in the 1960s: Politics and Poetry." In *Race, Politics and Culture: Critical Essays on the Radicalism of the 1960s*, edited by Adolph Reed Jr., 29–60. New York: Greenwood, 1986.

Jordan, June. *Things That I Do in the Dark: Selected Poetry*. New York: Random House, 1977.

Jordan, Norman. "News from Cleveland." *Journal of Black Poetry* 1.11 (Spring 1969): 61–62.

Joseph, Peniel E. "Where Blackness Is Bright?: Cuba, Africa, and Black Liberation during the Age of Civil Rights." *New Formations* 45 (Winter 2001–2): 111–24.

Kane, Daniel. *All Poets Welcome: The Lower East Side Poetry Scene in the 1960s*. Berkeley: University of California Press, 2003.

Karenga, Maulana. "Black Cultural Nationalism." In *The Black Aesthetic*, edited by Addison Gayle Jr., 31–37. New York: Anchor, 1972.

Kaufman, Bob. *The Ancient Rain: Poems 1956–1978*. New York: New Directions, 1981.

———. *Cranial Guitar*. Minneapolis: Coffee House Books, 1996.

———. *Golden Sardine*. San Francisco: City Lights Books, 1967.

———. *Solitudes Crowded with Loneliness*. New York: New Directions, 1965.

Keeran, Roger. *The Communist Party and the Autoworkers' Unions*. 1980. New York: International, 1986.

Kelley, Robin D. G. *Freedom Dreams: The Black Radical Imagination*. Boston: Beacon, 2002.

————. *Hammer and Hoe: Alabama Communists during the Great Depression*. Chapel Hill: University of North Carolina Press, 1990.

————. *Race Rebels: Culture, Politics, and the Black Working Class*. New York: Free Press, 1994.

Kelley, Robin D. G., and Betsy Esch. "Black like Mao: Red China and Black Revolution." *Souls* 1.4 (Fall 1999): 6–41.

Kelly, Robert, and Paris Leary, eds. *A Controversy of Poets*. Garden City: Doubleday, 1965.

Kent, George E. *Blackness and the Adventure of Western Civilization*. Chicago: Third World, 1972.

————. *A Life of Gwendolyn Brooks*. Lexington: University Press of Kentucky, 1990.

Kerouac, Jack. *Mexico City Blues*. New York: Grove, 1959.

Khajuka [Don Mizell]. "Boston's Elma Lewis." *Black Creation* 4.3 (Summer 1973): 39–40.

Killens, John O. "The Artist and the Black University." *Black Scholar* 1.1 (Nov. 1969): 61–65.

————. "Lorraine Hansberry: On Time." In *Freedomways Reader*, edited by Esther Cooper Jackson, 335–39. New York: Dodd, Mead, 1980.

King, Woodie, Jr. *Black Theatre Present Condition*. New York: National Black Theatre Touring Circuit, 1981.

————. *The Impact of Race: Theatre and Culture*. New York: Applause, 2003.

————. "On Langston Hughes." *Black Theatre* 3 (1969): 12–16.

Kofsky, Frank. *Black Nationalism and the Revolution in Music*. New York: Pathfinder, 1970.

————. Letter to the Editor. *Liberator* 6.2 (Feb. 1966): 21.

Koster, Rick. *Louisiana Music: A Journey from R & B to Zydeco, Jazz to Country, Blues to Gospel, Cajun Music to Swamp Pop, to Carnival Music and Beyond*. Cambridge, Mass.: Da Capo, 2002.

Labovitz, Sherman. *Being Red in Philadelphia: A Memoir of the McCarthy Era*. Philadelphia: Camino, 1998.

Lai, H. M. "A Survey of the Chinese American Left." *Bulletin of Concerned Asian Scholars* 4.3 (1972): 10–19.

Lenin, V. I. *Letters on Tactics*. Moscow: Progress, 1970.

Levine, Ira. *Left-Wing Dramatic Theory in the American Theatre*. Ann Arbor: University of Michigan Press, 1985.

Lewis, Barbara. "Ritual Reformations: Barbara Ann Teer and the National Black Theatre of Harlem." In *A Sourcebook of African-American Performance: Plays, People, Movements*, edited by Annemarie Bean, 68–82. New York: Routledge, 1999.

Li, David-Leiwei. "The Formation of Frank Chin and Formations of Chinese American Literature." In *Asian Americans: Comparative and Global Perspectives*, edited by Shirley Hune, Hyung Kim, Stephen Fugita, and Amy Ling, 221–23. Pullman: Washington State University Press, 1991.

Lipsitz, George. *A Life in the Struggle: Ivory Perry and the Culture of Opposition*. Philadelphia: Temple University Press, 1988.

————. "Like a Weed in a Vacant Lot: The Black Artists Group in St. Louis." In *Decomposition: Post-Disciplinary Performance*, edited by Sue-Ellen Case, Philip Brett, and Susan Leigh Foster, 50–61. Bloomington: Indiana University Press, 2000.

————. *Rainbow at Midnight: Labor and Culture in the 1940s*. Urbana: University of Illinois Press, 1994.

Llorens, David. "Writers Converge on Fisk University." *Negro Digest* 15.8 (June 1966): 54–68.

Locke, Alain, ed. *The New Negro: An Interpretation*. New York: Boni, 1925.

Looker, Ben. "'Poets of Action': The St. Louis Black Artists' Group, 1968–1972." *Gateway Heritage: The Quarterly Journal of the Missouri Historical Society* 22.1 (Summer 2001): 16–27.

Lorde, Audre. *The Black Unicorn: Poems*. New York: Norton, 1978.

Lott, Eric. "Double V, Double Time: Bebop's Politics of Style." *Callaloo* 11.3 (Summer 1988): 597–605.

Lowenfels, Walter, ed. *Poets of Today*. New York: International, 1964.

———, ed. *Where Is Vietnam?: American Poets Respond*. Garden City: Anchor, 1967.

Lowney, John. "Beyond Mecca: The Multiple Publics of Gwendolyn Brooks." Paper presented at American Studies Association annual meeting, Washington, D.C., 2001.

Lubiano, Wahneema. "Black Nationalism and Black Common Sense: Policing Ourselves and Others." In *The House that Race Built: Black Americans, US Terrain*, edited by Wahneema Lubiano, 232–52. New York: Pantheon, 1997.

Lyle, K. Curtis. "I Can Get It for You Wholesale." In *Watts Poets and Writers*, edited by Quincy Troupe, 44–48. Los Angeles: House of Respect, 1968.

Lyons, Paul. *Philadelphia Communists, 1936–1956*. Philadelphia: Temple University Press, 1982.

Madgett, Naomi Long. "Naomi Long Madgett." *Contemporary Authors Autobiography Series, Volume 23*, 193–213. Detroit: Gale Research, 1996.

Madhubuti, Haki [Don L. Lee]. "Amiri Baraka and the Millennium: A Symposium." Panel presentation at Howard University, Apr. 15, 2001.

———. *Black Pride*. Broadside, 1968.

———. "Black Writing." In *Jump Bad: A New Chicago Anthology*, edited by Gwendolyn Brooks, 37–39. Detroit: Broadside, 1971.

———. *Dynamite Voices*. Detroit: Broadside, 1971.

———. "Dynamite Voices." In *African Congress: A Documentary History of the First Modern Pan-African Congress*, edited by Amiri Baraka [LeRoi Jones], 200–211. New York: Morrow, 1972.

———. *Groundwork: New and Selected Poems from 1966 to 1996*. Chicago: Third World, 1996.

———. "The Latest Purge: The Attack on Black Nationalism and Pan-Afrikanism by the New Left, the Sons and Daughters of the Old Left." *Black Scholar* 6.1 (Sept. 1974): 43–56.

———. "On *Kaleidoscope* and Robert Hayden." *Negro Digest* 17.3 (Jan. 1968): 51–52, 90–94.

———. *Think Black*. Detroit: Broadside, 1967.

Major, Clarence. *The New Black Poetry*. New York: International, 1969.

———. *Symptoms and Madness*. New York: Corinth, 1971.

Malcolm X. *The Autobiography of Malcolm X*. New York, Grove, 1965.

———. *Malcolm X Speaks*. 1966. New York: Grove Weidenfeld, 1990.

Marable, Manning. *Black American Politics: From the Washington Marches to Jesse Jackson*. New York: Verso, 1985.

———. *Race, Reform and Rebellion: The Second Black Reconstruction in America, 1945–1982*. Jackson: University Press of Mississippi, 1984.

Martin, Tony. *Literary Garveyism: Garvey, Black Arts, and the Harlem Renaissance*. Dover, Mass.: Majority, 1983.

Marvin X. "The Black Ritual Theatre: An Interview with Robert Macbeth." *Black Theatre* 3 (1969): 20–24.

———. *Somethin' Proper*. Castro Valley: Black Bird, 1998.

Maxwell, William J. *New Negro, Old Left: African American Writing and Communism between the Wars*. New York: Columbia University Press, 1999.

May, Larry, ed. *Recasting America: Culture and Politics in the Age of the Cold War*. Chicago: University of Chicago Press, 1989.

Mayfield, Henry O. "Memoirs of a Birmingham Coal Miner, No. 1, 1964." In *Freedomways Reader*, edited by Esther Cooper Jackson, 21–25. Boulder: Westview, 2000.

Mayfield, Julian. "Into the Mainstream and Oblivion." In *The American Negro Writer and His Roots: Selected Papers from the First Conference of Negro Writers, March 1959*, 29–34. New York: American Society of African Culture, 1960.

Maynard, John A. *Venice West: The Beat Generation in Southern California*. New Brunswick: Rutgers University Press, 1991.

McCartney, John. *Black Power Ideologies: An Essay in African American Political Thought*. Philadelphia: Temple University Press, 1992.

McFarlane, Milton. "To Join or Not to Join." In *Watts Poets and Writers*, edited by Quincy Troupe, 1–10. Los Angeles: House of Respect, 1968.

McKennan Teresa. *Migrant Song: Politics and Process in Contemporary Chicano Literature*. Austin: University of Texas Press, 1997.

McNally, Dennis. *Desolate Angel: Jack Kerouac, the Beat Generation, and America*. 1979. Cambridge, Mass.: Da Capo, 2003.

Medina, Tony, Samiya A. Bashir, and Quraysh Ali Lansana, eds. *Role Call: A Generational Anthology of Social and Political Black Literature and Art*. Chicago: Third World, 2002.

Meier, August, and Elliott Rudwick. *CORE: A Study in the Civil Rights Movement, 1942–1968*. New York: Oxford University Press, 1973.

Melhem, D. H. *Gwendolyn Brooks: Poetry and the Heroic Voice*. Lexington: University Press of Kentucky, 1987.

———. *Heroism in the New Black Poetry: Introductions and Interviews*. Lexington: University Press of Kentucky, 1990.

Miller, R. Baxter. *Black Poets between Worlds, 1940–1960*. Knoxville: University of Tennessee Press, 1986.

Mishkin, Tracy. *The Harlem and Irish Renaissances: Language, Identity, and Representation*. Gainesville: University Press of Florida, 1997.

Mitford, Jessica. *A Fine Old Conflict*. New York: Knopf, 1977.

Mohr, Eugene V. *The Nuyorican Experience: Literature of the Puerto Rican Minority*. Westport, Conn.: Greenwood, 1982.

Molette, Barbara. "Atlanta." *Black World* 22.6 (Apr. 1973): 88–92.

Moore, Leonard N. *Carl B. Stokes and the Rise of Black Political Power*. Urbana: University of Illinois Press, 2002.

Moore, Richard B. *Richard Moore, Caribbean Militant in Harlem: Collected Writings, 1920–1972.* Edited by Joyce Moore Turner and W. Burghardt Turner. Bloomington: Indiana University Press, 1988.

Mootry, Maria, and Gary Smith, eds. *A Life Distilled: Gwendolyn Brooks, Her Poetry and Fiction.* Urbana: University of Illinois Press, 1987.

Morgan, Stacy I. *Rethinking Social Realism: African American Art and Literature, 1930–1953.* Athens: University of Georgia Press, 2004.

Morrison, Toni. *Sula.* New York: Knopf, 1973.

Morrow, Bruce. "An Interview with Virgie Patton-Ezelle." *Callaloo* 19.1 (Winter 1996): 163–71.

Mullen, Bill. *Afro-Orientalism.* Minneapolis: University of Minnesota Press, 2004.

———. *Popular Fronts: Chicago and African-American Cultural Politics, 1935–46.* Urbana: University of Illinois Press, 1999.

Murray, Pauli. "A Blueprint for First Class Citizenship." In *Reporting Civil Rights, Part One: American Journalism, 1941–1963,* 62–67. New York: Library Classics of America, 2003.

Myers, R. David, ed. *Toward a History of the New Left.* Brooklyn: Carlson, 1989.

Myrick-Harris, Clarissa. "Behind the Scenes: Doris Derby, Denise Nicholas and the Free Southern Theater." In *Women of the Civil Rights Movement: Trailblazers and Torchbearers, 1941–1965,* edited by Vicki Crawford, Jacqueline Anne Rouse, and Barbara Woods, 219–32. 1990. Bloomington: Indiana University Press, 1993.

Nadel, Alan. *Containment Culture: American Narratives, Postmodernism, and the Atomic Age.* Durham: Duke University Press, 1996.

Naison, Mark. *Communists in Harlem during the Depression.* Urbana: University of Illinois Press, 1983.

Neal, Larry. "The Black Arts Movement." In *The Black Aesthetic,* edited by Addison Gayle Jr., 272–90. New York: Doubleday, 1971.

———. *Black Boogaloo (Notes on Black Liberation).* San Francisco: Journal of Black Poetry, 1969.

———. "For Our Women." In *Black Fire: An Anthology of Afro-American Writing,* edited by LeRoi Jones and Larry Neal, 310–11. New York: Morrow, 1968.

———. *Hoodoo Hollerin' Bebop Ghosts.* Washington, D.C.: Howard University Press, 1974.

———. "New Space/The Growth of Black Consciousness in the Sixties." In *The Seventies,* edited by Floyd B. Barbour, 9–32. Boston: Porter Sargent, 1970.

———. Response to letter from Frank Kofsky. *Liberator* 6.2 (Feb. 1966): 21.

———. "The Social Background of the Black Arts Movement." *Black Scholar* 18.1 (1987): 11–12.

———. *Visions of a Liberated Future: Black Arts Movement Writings.* New York: Thunder's Mouth, 1989.

Neal, Mark Anthony. *What the Music Said: Black Popular Music and Black Public Culture.* New York: Routledge, 1999.

Nelson, Bruce. "The 'Lords of the Docks' Reconsidered: Race Relations among West Coast Longshoremen, 1933–1961." In *Waterfront Workers: New Perspectives on Race and Class,* edited by Calvin Winslow, 155–92. Urbana: University of Illinois Press, 1998.

Nelson, Cary. *Repression and Recovery: Modern American Poetry and the Poetry of Cultural Memory 1910–1945.* Madison: University of Wisconsin Press, 1989.

Nero, Charles. "Toward a Black Gay Aesthetic: Signifying in Contemporary Black Gay Literature." In *African American Literary Theory: A Reader*, edited by Winston Napier, 399–420. New York: New York University Press, 2000.

Ngugi wa Thiong'o. *Writers in Politics*. London: Heinemann, 1981.

Nicholas, A. Xavier. "A Conversation with Dudley Randall." *Black World* 21.2 (Dec. 1971): 26–34.

Nielsen, Aldon. *Black Chant: Languages of African-American Postmodernism*. New York: Cambridge University Press, 1997.

OBAC Writers' Workshop. "Statement of Purposes." *Nommo* 1.2 (Fall 1969): 47.

O'Hara, Frank. *The Collected Poems of Frank O'Hara*. New York: Knopf, 1971.

———. *Standing Still and Walking in New York*. Bolinas, Calif.: Gray Fox, 1975.

Ojenke. "Legacy of the Word." In *Watts Poets and Writers*, edited by Quincy Troupe, 17–20. Los Angeles: House of Respect, 1968.

Olson, Charles. *The Distances*. New York: Grove, 1960.

———. *The Maximus Poems*. New York: Jargon/Corinth, 1960.

———. *Projective Verse*. New York: Totem, 1959.

O'Neal, John. "Black Arts: Notebook." In *The Black Aesthetic*, edited by Addison Gayle Jr., 46–56. New York: Doubleday, 1971.

"On the Conference Beat." *Negro Digest* 16.9 (July 1967): 90–93.

Oppenheimer, Martin. *The Sit-In Movement of 1960*. Brooklyn: Carlson, 1989.

Oren, Michel. "A '60s Saga: The Life and Death of Umbra (Part I)." *Freedomways* 24.3 (1984): 167–81.

———. "A '60s Saga: The Life and Death of Umbra (Part II)." *Freedomways* 24.4 (1984): 237–54.

———. "The Umbra Workshop, 1962–1965: Some Socio-Literary Puzzles." In *Belief vs. Theory in Black American Literary Criticism*, edited by Joe Weixlmann and Chester J. Fontenot, 225–38. Greenwood, Fla.: Penkevill, 1986.

Osborne, Eddie. "Miami's Theatre of Afro Arts." *Black Creation* 4.3 (Summer 1973): 38–39.

O'Toole, James. *Watts and Woodstock: Identity and Culture in the United States and South Africa*. New York: Holt, Rinehart, and Winston, 1973.

Ottanelli, Fraser M. *The Communist Party of the United States: From the Depression to World War II*. New Brunswick: Rutgers University Press, 1991.

Padilla, Gennaro. "Myth and Comparative Cultural Nationalism: The Ideological Uses of Aztlan." In *Aztlan: Essays on the Chicano Homeland*, edited by Rudolfo Anaya and Francisco Lomeli, 111–34. Albuquerque: Academia/El Norte, 1989.

Painter, Nell. *The Narrative of Hosea Hudson, His Life as a Negro Communist in the South*. Cambridge: Harvard University Press, 1979.

Papers of the NAACP, Part 27: Selected Branch Files: 1956–1965, Series D: The West. Edited by John Bracey Jr., Sharon Harley, and August Meier. Project coordinator, Randolph H. Boehm. Bethesda, Md.: University Publications of America, 1999. Microform.

Parks, Carole A. *Nommo: A Literary Legacy of Black Chicago (1967–1987)*. Chicago: OBAHouse, 1987.

Perkins, David. *A History of Modern Poetry: Modernism and After*. Cambridge: Harvard University Press, 1987.

Perkins, Margo. *Autobiography as Activism: Three Black Women of the 1960s.* Jackson: University Press of Mississippi, 2000.

Perkins, Useni Eugene. Untitled essay. *Black Liberator* 1.9 (Oct. 1969): 6.

Peterson, Rachel. "'Who Fails on the Negro Question Is Weak on All': The Struggles of *Correspondence*, a 'Worker's Newspaper,' 1952–1963." Unpublished essay.

Plummer, Brenda Gayle. "Castro in Harlem: A Cold War Watershed." In *Rethinking the Cold War*, edited by Allen Hunter, 133–53. Philadelphia: Temple University Press, 1998.

———. *Rising Wind: Black Americans and U.S. Foreign Affairs, 1935–1960.* Chapel Hill: University of North Carolina Press, 1996.

———, ed. *Window on Freedom: Race, Civil Rights, and Foreign Affairs, 1945–1988.* Chapel Hill: University of North Carolina Press, 2003.

Pollenberg, Richard. *One Nation Divisible: Class, Race and Ethnicity in the United States Since 1938.* New York: Penguin, 1980.

Pool, Rosey E., ed. *Beyond the Blues.* Lympne, U.K.: Hand and Flower, 1964.

Porter, Eric. *What Is This Thing Called Jazz?: African American Musicians as Artists, Critics, and Activists.* Berkeley: University of California Press, 2002.

Prigoff, James, and Robin J. Dunitz, eds. *Walls of Heritage, Walls of Pride: African American Murals.* San Francisco: Pomegranate, 2000.

Primus, Marc. "The Afro-American Folkloric Troupe." *Freedomways* 6.1 (Winter 1966): 31–36.

Radano, Ronald M. *New Music Figurations: Anthony Braxton's Cultural Critique.* Chicago: University of Chicago Press, 1993.

Rampersad, Arnold. *The Life of Langston Hughes, Volume II: 1941–1967, I Dream a World.* Oxford: Oxford University Press, 1988.

Randall, Dudley. "The Black Aesthetic in the Thirties, Forties and Fifties." In *The Black Aesthetic*, edited by Addison Gayle Jr., 315–26. New York: Anchor, 1972.

———, ed. *The Black Poets.* New York: Bantam, 1971.

———. *Broadside Memories: Poets I Have Known.* Detroit: Broadside, 1975.

———. *Cities Burning.* Detroit: Broadside, 1968.

———. *More To Remember.* Chicago: Third World, 1971.

———. "A Report on the Black Arts Convention." *Negro Digest* 15.10 (Aug. 1966): 54–58.

Randall, Dudley, and Margaret Burroughs, eds. *For Malcolm: Poems on the Life and Death of Malcolm X.* Detroit: Broadside, 1969.

Ransby, Barbara. *Ella Baker and the Black Freedom Movement: A Radical Democratic Vision.* Chapel Hill: University of North Carolina Press, 2003.

"Reaction to *We Righteous Bombers*." *Black Theatre* 4 (1970): 16–25.

Redmond, Eugene B. *Drumvoices: The Mission of Afro-American Poetry: A Critical History.* Garden City: Anchor, 1976.

Reed, Adolph, ed. *Race, Politics and Culture: Critical Essays on the Radicalism of the 1960s.* New York: Greenwood, 1986.

———. *Stirrings in the Jug: Black Politics in the Post-Segregation Era.* Minneapolis: University of Minnesota Press, 1999.

————. *W. E. B. Du Bois and American Political Thought: Fabianism and the Color Line*. New York: Oxford University Press, 1997.

Reed, Ishmael. "The Writer as Seer: Ishmael Reed on Ishmael Reed." In *Conversations with Ishmael Reed*, edited by Bruce Dick and Amritjit Singh, 59–73. Jackson: University Press of Mississippi, 1995.

Reilly, Charlie. *Conversations with Amiri Baraka*. Jackson: University Press of Mississippi, 1994.

"Riot in Gallery Halts U.N. Debate." *New York Times*, Feb. 16, 1961, 1, 10.

Rivers, Conrad Kent. *Dust at Selma*. Cleveland: Free Lance, 1965.

————. *These Black Bodies and This Sunburnt Face*. Cleveland: Free Lance, 1963.

Robinson, Cedric J. *Black Marxism: The Making of the Black Radical Tradition*. 1983. Chapel Hill: University of North Carolina Press, 2000.

Rodgers, Carolyn. "Black Poetry—Where It's At." 1969. In *Nommo: A Literary Legacy of Black Chicago (1967–1987)*, edited by Carole A. Parks, 17–20. Chicago: OBAHouse, 1987.

Rogers, Kim Lacy. *Righteous Lives: Narratives of the New Orleans Civil Rights Movement*. New York: New York University Press, 1993.

Rosales, F. Arturo. *Chicano! The History of the Mexican American Civil Rights Movement*. Houston: Arte Público, 1996.

Russell, Mariann. *Melvin B. Tolson's Harlem Gallery: A Literary Analysis*. Columbia: University of Missouri Press, 1980.

Salaam, Kalamu ya. "Black Theatre—The Way It Is: An Interview with Woodie King Jr." *African American Review* 31.4 (Winter 1997): 647–58.

————. "BLKARTSOUTH/get on up!" In *New Black Voices*, edited by Abraham Chapman, 468–73. New York: Mentor, 1972.

————. "Blk Art South New Orleans." *Black World* 21.6 (Apr. 1972): 40–45.

————. *The Blues Merchant*. New Orleans: Nkombo, 1969.

————. "Enriching the Paper Trail: An Interview with Tom Dent." *African American Review* 27.2 (Summer 1993): 327–44.

————. *The Magic of Juju: An Appreciation of the Black Arts Movement*. Chicago: Third World Press, forthcoming.

Saldivar, Ramon. *Chicano Narrative: The Dialectics of Difference*. Madison: University of Wisconsin Press, 1990.

Salinas, Raúl. *Un Trip through the Mind Jail y Otra Excursions*. San Francisco: Editorial Pocho-Che, 1980.

Sanchez, Sonia. *A Blues Book for Blue Black Magical Women*. Detroit: Broadside, 1974.

————. *Homecoming*. Detroit: Broadside, 1968.

————. *homegirls and hand grenades*. New York: Thunder's Mouth, 1984.

————. *We a BaddDDD People*. Detroit: Broadside, 1970.

Schrecker, Ellen. *Many Are the Crimes: McCarthyism in America*. Boston: Little, Brown, 1998.

————. "McCarthyism and the Decline of American Communism, 1945–1960." In *New Studies in the Politics and Culture of U.S. Communism*, edited by Michael E. Brown, Randy Martin, Frank Rosengarten, and George Snedeker, 123–40. New York: Monthly Review, 1993.

———. *No Ivory Tower: McCarthyism and the Universities*. New York: Oxford University Press, 1986.

Schulberg, Budd, ed. *From the Ashes: Voices of Watts*. New York: New American Library, 1967.

———. "One Year Later: Still the Angry Voices (and Tears) of Watts." *New York Times*, Aug. 14, 1966, sec. 2, p. 13.

Schumacher, Michael. *Dharma Lion: A Biography of Allen Ginsberg*. New York: St. Martin's, 1992.

Schwartz, Harvey. "Walter Williams: The Fight for Black Equality on the L.A. Waterfront, Longshore Local 13, 1943–1970." *ILWU Dispatcher*, Feb. 1999, 6–7.

Schwartz, Lawrence H. *Creating Faulkner's Reputation: The Politics of Modern Literary Criticism*. Knoxville: University of Tennessee Press, 1989.

Scott, Della. "An Interview with Esther Jackson." *Abafazi* 9.1 (Fall–Winter 1998): 2–9.

Scott, Johnie. "The Ceremony of the Land." In *Watts: Art and Social Change in Los Angeles, 1965–2002*, 45–47. Milwaukee: Haggerty Museum of Art, Marquette University, 2003.

Scott, Saul. *Freedom Is, Freedom Ain't: Jazz and the Making of the Sixties*. Cambridge: Harvard University Press, 2003.

Self, Robert O. *American Babylon: Race and the Struggle for Postwar Oakland*. Princeton: Princeton University Press, 2003.

———. "'Negro Leadership and Negro Money': African American Political Organizing in Oakland before the Panthers." In *Freedom North: Black Freedom Struggles outside the South, 1940–1980*, edited by Jeanne F. Theoharis and Komozi Woodard, 93–124. New York: Palgrave, 2003.

———. "To Plan Our Liberation: Black Power and the Politics of Place in Oakland, California, 1965–1977." *Journal of Urban History* 26.6 (Sept. 2000): 759–92.

Sell, Mike. "The Black Arts Movement: Performance, Neo-Orality, and the Destruction of the 'White Thing.'" In *African American Performance and Theater History*, edited by Harry J. Elam Jr. and David Krasner, 56–80. New York: Oxford University Press, 2001.

———. "Ed Bullins as Editorial Performer: Textual Power and the Limits of Performance in the Black Arts Movement." *Theatre Journal* 53.3 (Oct. 2001): 411–28.

———. "Performing Crisis: Countercultural Theater and the '60s." Ph.D. diss., University of Michigan, 1997.

Semmes, Clovis E. "The Dialectics of Cultural Survival and the Community Artist: Phil Cohran and the Affro-Arts Theater." *Journal of Black Studies* 24.4 (June 1994): 447–61.

Semple, Robert B., Jr. "Ghetto Described at Senate Inquiry." *New York Times*, Dec. 10, 1966, 27.

Shange, Ntozake. *for colored girls who have considered suicide when the rainbow is enuf*. San Lorenzo: Shameless Hussy, 1975.

———. *Nappy Edges*. New York: St. Martin's, 1978.

Shockley, Ann Allen. *Loving Her*. Indianapolis: Bobbs-Merrill, 1974.

Sides, Josh. *L.A. City Limits: African American Los Angeles from the Great Depression to the Present*. Berkeley: University of California Press, 2003.

Siebers, Tobin. *Cold War Criticism and the Politics of Skepticism*. New York: Oxford University Press, 1993.

Sieving, Christopher. "*Super* Sonics: Song Score as Counter-narration in *Super Fly.*" *Journal of Popular Music Studies* 13.1 (Winter 2001): 77–91.

Silesky, Barry. *Ferlinghetti: The Artist in His Time.* New York: Warner Books, 1990.

Sillen, Samuel. Review of *The Negro Caravan, New Masses* 44.2 (July 14, 1942): 23–24.

Simon, Alvin. Letter to the editor. *Freedomways* 25.1 (1985): 48–50.

Singh, Nikhil Pal. "The Black Panthers and the 'Undeveloped Country' of the Left." In *The Black Panther Party Reconsidered,* edited by Charles E. Jones, 57–105. Baltimore: Black Classic, 1998.

Sitkoff, Harvard. *The Struggle for Black Equality, 1954–1980.* New York: Hill and Wang, 1981.

Sizemore, Barbara. "Sexism and the Black Male." *Black Scholar* 4.6–7 (Mar.–Apr. 1973): 2–11.

Smethurst, James. "'Don't Say Goodbye to the Porkpie Hat': Langston Hughes, the Left, and the Black Arts Movement." *Callaloo* 25.4 (Fall 2002): 1225–36.

———. "The Figure of the *Vato Loco* and the Representation of Ethnicity in the Narratives of Oscar Zeta Acosta." *MELUS* 20.2 (Summer 1995): 119–32.

———. *The New Red Negro: The Literary Left and African-American Poetry, 1930–1946.* New York: Oxford University Press, 1999.

———. "Remembering When Indians Were Red: Bob Kaufman, the Popular Front, and the Black Arts Movement." *Callaloo* 25.1 (Winter 2002): 146–64.

Smith, David Lionel. "The Black Arts Movement and Its Critics." *American Literary History* 3.1 (Spring 1991): 93–110.

———. "Chicago Poets, OBAC, and the Black Arts Movement." In *The Black Columbiad,* edited by Werner Sollors and Maria Diedrich, 253–64. Cambridge: Harvard University Press, 1994.

Smith, Judith E. *Visions of Belonging: Family Stories, Popular Culture, and Postwar Democracy, 1940–1960.* New York: Columbia University Press, 2004.

Smith, Richard Cándida. *Art, Poetry, and Politics in California.* Berkeley: University of California Press, 1995.

Smith, Suzanne E. *Dancing in the Street: Motown and the Cultural Politics of Detroit.* Cambridge: Harvard University Press, 1999.

Sollors, Werner. *Amiri Baraka/LeRoi Jones: The Quest for a Populist Modernism.* New York: Columbia University Press, 1978.

———. "Ethnicity." In *Critical Terms for Literary Study,* edited by Frank Lentricchia and Thomas McLaughlin, 288–305. Chicago: University of Chicago Press, 1987.

Solomon, Mark. *The Cry Was Unity: Communists and African Americans, 1917–1936.* Jackson: University Press of Mississippi, 1998.

Spady, James. *Larry Neal: Liberated Black Philly Poet with a Blues Streak of Mellow Wisdom.* Philadelphia: PC International and Black History Museum Umum, 1989.

———. "Muntu-Kuntu and the Philly Origins of the Black Arts Movement." *Philadelphia New Observer,* July 31, 1996, 14.

———. "The New Stylistics: Muntu-Kuntu and the Philly Origins of the Black Arts Movement." *Philadelphia New Observer,* July 24, 1996, 12, 24.

———. "Requiem: Do I Dare Disturb the Universe? The Artistic and Intellectual Life of Jimmy Stewart." *Philadelphia New Observer,* July 17, 1996, 15, 20.

Spellman, A. B. *The Beautiful Days*. New York: Poets, 1965.

———. *Black Music: Four Lives*. 1966. New York: Schocken, 1970.

———. "Letter from Atlanta." *The Cricket* 3 (1969): 1–7.

Spicer, Jack. *The Collected Books of Jack Spicer*. Los Angeles: Black Sparrow, 1975.

Sporn, Paul. *Against Itself: The Federal Theatre and Writers' Projects in the Midwest*. Detroit: Wayne State University Press, 1995.

Standing in the Shadows of Motown. Directed by Paul Justman. Santa Monica: Artisan Entertainment, 2002. DVD.

Stanford, Maxwell C. [Muhammad Ahmad]. "Revolutionary Action Movement (RAM): A Case Study of an Urban Revolutionary Movement in Western Capitalist Society." Master's thesis, Atlanta University, 1986.

———. "Revolutionary Nationalism and the Afroamerican Student." *Liberator* 5.1 (Jan. 1965): 13–14.

Stein, Judith. *The World of Marcus Garvey: Race and Class in Modern Society*. Baton Rouge: Louisiana State University Press, 1986.

Stern, Michael. "Arms Cache Laid to Small Group." *New York Times*, Mar. 19, 1966, 27.

Stewart, James. "The Development of the Revolutionary Black Artist." In *Black Fire: An Anthology of Afro-American Writing*, edited by LeRoi Jones and Larry Neal, 3–10. New York: Morrow, 1968.

Stone, Albert E. *The Return of Nat Turner: History, Literature, and Cultural Politics in Sixties America*. Athens: University of Georgia Press, 1992.

Stoper, Emily. *The Student Nonviolent Coordinating Committee: The Growth of Radicalism in a Civil Rights Organization*. Brooklyn: Carlson, 1989.

Sullivan, James D. *On the Walls and in the Streets: American Poetry Broadsides from the 1960s*. Urbana: University of Illinois Press, 1997.

Sullivan, Patricia. *Days of Hope: Race and Democracy in the New Deal Era*. Chapel Hill: University of North Carolina Press, 1996.

Szwed, John F. *Space Is the Place: The Lives and Times of Sun Ra*. New York: Pantheon, 1997.

Tachiki, Amy, ed. *Roots: An Asian American Reader*. Los Angeles: Asian American Studies Center, University of California, 1971.

Tapscott, Horace. *Songs of the Unsung: The Musical and Social Journey of Horace Tapscott*. Durham: Duke University Press, 2001.

Thelwell, Michael. "The Professor and the Activists: A Memoir of Sterling Brown." *Massachusetts Review* 40.4 (Winter 1999–2000): 617–38.

Theoharis, Jeanne F. "'I'd Rather Go to School in the South'; How Boston's School Desegregation Complicates the Civil Rights Paradigm." In *Freedom North: Black Freedom Struggles outside the South, 1940–1980*, edited by Jeanne F. Theoharis and Komozi Woodard, 125–51. New York: Palgrave, 2003.

Thomas, Lorenzo. "Alea's Children: The Avant-Garde on the Lower East Side, 1960–1970." *African American Review* 27.4 (Winter 1993): 573–78.

———. "Classical Jazz and the Black Arts Movement." *African American Review* 29.2 (Summer 1995): 237–40.

———. "'Communicating by Horns': Jazz and Redemption in the Poetry of the Beats and the Black Arts Movement." *African American Review* 26.2 (Summer 1992): 291–98.

———. *Extraordinary Measures: Afrocentric Modernism and Twentieth-Century American Poetry.* Tuscaloosa: University of Alabama Press, 2000.

———. "Neon Griot: The Functional Role of Poetry Readings in the Black Arts Movement." In *Close Listening: Poetry and the Performed Word,* edited by Charles Bernstein, 300–323. New York: Oxford University Press, 1998.

———. "The Shadow World: New York's Umbra Workshop and Origins of the Black Arts Movement." *Callaloo* 1 (1978): 53–72.

———. "Tom Dent and the Umbra Workshop." Paper presented at the American Studies Association annual meeting, Washington, D.C., 2001.

Thomas, Lundeana Marie. *Barbara Ann Teer and the National Black Theatre: Transformational Forces in Harlem.* New York: Garland, 1997.

Thompson, Heather Ann. *Whose Detroit?: Politics, Labor, and Race in a Modern American City.* Ithaca: Cornell University Press, 2001.

Thompson, Julius E. *Dudley Randall, Broadside Press, and the Black Arts Movement in Detroit, 1960–1995.* Jefferson, N.C.: McFarland, 1999.

Thompson, Mindy. *The National Negro Labor Council: A History.* New York: AIMS, 1978.

Tolbert, Emory J. *The UNIA and Black Los Angeles: Ideology and Community in the American Garvey Movement.* Los Angeles: Center for Afro-American Studies, University of California, 1980.

Tolson, Melvin B. *Harlem Gallery: Book I, The Curator.* New York: Twayne, 1965.

———. *Libretto for the Republic of Liberia.* New York: Twayne, 1953.

Touré, Askia [Rolland Snellings]. "The Crisis in Black Culture." 1968. In *Black Nationalism in America,* edited by John Bracey Jr., August Meier, and Elliott Rudwick, 452–62. Indianapolis: Bobbs-Merrill, 1970.

———. "Earth." In *Black Fire: An Anthology of Afro-American Writing,* edited by LeRoi Jones and Larry Neal, 327. New York: Morrow, 1968.

———. *Juju.* Chicago: Third World, 1970.

———. "We Are on the Move." In *Black Nationalism in America,* edited by John Bracey Jr., August Meier, and Elliott Rudwick, 445–51. Indianapolis: Bobbs-Merrill, 1970. Originally published as "Keep On Pushin': Rhythm and Blues as a Weapon," *Liberator* 5 (Oct. 1965): 6–8.

Troupe, Quincy, ed. *Watts Poets and Writers.* Los Angeles: House of Respect, 1968.

Turé, Kwame [Stokely Carmichael]. "Marxism-Leninism and Nkrumahism." *Black Scholar* 4.5 (Feb. 1973): 41–43.

Turé, Kwame, and Ekwueme Michael Thelwell. *Ready for Revolution: The Life and Struggles of Stokely Carmichael.* New York: Scribner, 2003.

Tyson, Timothy B. *Radio Free Dixie: Robert Williams and the Roots of Black Power.* Chapel Hill: University of North Carolina Press, 1999.

"Uhuru Day Rally Ends Festival." *Harambee,* Aug. 26, 1966, 1.

Umbra Poets. "The Umbra Poets." *Mainstream* 16.7 (July 1963): 7–14.

Umbra Workshop. "Foreword." *Umbra* 1.1 (Winter 1963): 3–4.

Umoja, Akinyele Omowale. "Repression Breeds Resistance: The Black Liberation Army and the Radical Legacy of the Black Panther Party." In *Liberation, Imagination, and the Black Panther Party*, edited by Kathleen Cleaver and George Katsiaficas, 3–19. New York: Routledge, 2001.

Valdez, Luis, and Stan Steiner, eds. *Aztlan: An Anthology of Mexican American Literature*. New York: Random House, 1972.

Van Deburg, William L. *New Day in Babylon: The Black Power Movement and American Culture, 1965–1975*. Chicago: University of Chicago Press, 1992.

Villareal, José Antonio. *Pocho*. New York: Doubleday, 1959.

Vincent, Theodore. *Black Power and the Garvey Movement*. New York: Ramparts, 1971.

Von Eschen, Penny M. *Race against Empire: Black Americans and Anticolonialism, 1937–1957*. Ithaca: Cornell University Press, 1997.

Wald, Alan M. "Culture and Commitment: U.S. Communist Writers Reconsidered." In *New Studies in the Politics and Culture of U.S. Communism*, edited by Michael E. Brown, Randy Martin, Frank Rosengarten, and George Snedeker, 281–306. New York: Monthly Review, 1993.

———. "Introduction to H. T. Tsiang." In *Into the Fire: Asian American Prose*, edited by Sylvia Watanabe and Carol Bruhac, 341–44. Greenfield Center, N.Y.: Greenfield Review, 1996.

———. "Marxist Literary Resistance to the Cold War." *Prospects* 20 (1995): 479–92.

———. *The New York Intellectuals: The Rise and Fall of the Anti-Stalinist Left from the 1930s to the 1980s*. Chapel Hill: University of North Carolina Press, 1987.

———. *Revising the Barricades: Scholarship about the U.S. Cultural Left in the Post–Cold War Era*. Pullman, Wash.: Working Paper Series, 2000.

———. *Writing from the Left: New Essays on Radical Culture and Politics*. New York: Verso, 1994.

Walker, Alice. *The Color Purple: A Novel*. New York: Harcourt, Brace, 1982.

Walker, Jack L. "Sit-Ins in Atlanta: A Study in the Negro Revolt." In *Atlanta, Georgia, 1960–1961: Sit-Ins and Student Activism*, edited by David J. Garrow, 59–94. Brooklyn: Carlson, 1989.

Walker, Joe. "Exclusive Interview with James Baldwin." In *Conversations with James Baldwin*, edited by Fred L. Stanley and Louis H. Pratt, 127–41. Jackson: University Press of Mississippi, 1989.

Walker, Margaret A. *This Is My Century: New and Collected Poems*. Athens: University of Georgia Press, 1989.

Ward, Brian. *Just My Soul Responding: Rhythm and Blues, Black Consciousness, and Race Relations*. Berkeley: University of California Press, 1998.

Ward, Jerry. "Southern Black Aesthetics: The Case of *Nkombo* Magazine." *Mississippi Quarterly* (Spring 1991): 143–50.

Ward, Stephen. "'Scholarship in the Context of Struggle': Activist Intellectuals, the Institute of the Black World (IBW), and the Contours of the Black Power Radicalism." *Black Scholar* 31.3–4 (Fall–Winter 2001): 42–53.

Warshow, Robert. *The Immediate Experience: Movies, Comics, Theatre and Other Aspects of Popular Culture*. 1962. New York: Anchor, 1964.

Washington, Mary Helen. "Alice Childress, Lorraine Hansberry, and Claudia Jones: Black Women Write the Popular Front." In *Left of the Color Line: Race, Radicalism, and Twentieth-Century*

Literature of the United States, edited by Bill V. Mullen and James Smethurst, 183–204. Chapel Hill: University of North Carolina Press, 2003.

———. "Desegregating the 1950s: The Case of Frank London Brown." *Japanese Journal of American Studies* 10 (1999): 15–32.

Watkins, Nayo. *I Want Me a Home*. New Orleans: Nkombo, 1969.

Watts, Jerry Gafio. *Amiri Baraka: The Politics and Art of a Black Intellectual*. New York: New York University Press, 2001.

———. *Heroism and the Black Intellectual*. Chapel Hill: University of North Carolina Press, 1994.

Watts: Art and Social Change in Los Angeles, 1965–2002. Milwaukee: Haggerty Museum of Art, Marquette University, 2003.

Weatherly, Tom. *Maumau American Cantos*. New York: Corinth, 1970.

———. *Thumbprint*. New York: Telegraph, 1971.

Wei, William. *The Asian American Movement*. Philadelphia: Temple University Press, 1993.

Welch, Rebecca. "Black Art and Activism in Postwar New York, 1950–1965." Ph.D. diss., New York University, 2002.

Werner, Craig. *Playing the Changes: From Afro-Modernism to the Jazz Impulse*. Urbana: University of Illinois Press, 1994.

West, Cornell. *Restoring Hope: Conversations on the Future of Black America*. Boston: Beacon, 1997.

Widener, Daniel. "Something Else: Creative Community and Black Liberation in Postwar Los Angeles (California)." Ph.D. diss., New York University, 2003.

Wilkins, Fanon Che. "'In the Belly of the Beast': Black Power, Anti-Imperialism, and the African Liberation Movement, 1968–1975." Ph.D. diss., New York University, 2001.

Wilkinson, Michelle Joan. "'In the Tradition of Revolution': The Socio-Aesthetics of Black and Puerto Rican Arts Movements, 1962–1982." Ph.D. diss., Emory University, 2001.

Willard, Michael Nevin. "Urbanization as Culture: Youth and Race in Postwar Los Angeles." Ph.D. diss., University of Minnesota, 2001.

Williams, Robert F. *Negroes with Guns*. 1962. Detroit: Wayne State University Press, 1998.

———. Transcript of "Radio Free Dixie" broadcast. *The Crusader* 4.8 (May 1963): 2–4.

Williams, William Carlos. *Paterson*. New York: New Directions, 1963.

Wilmer, Valerie. *As Serious as Your Life: The Story of the New Jazz*. Westport, Conn.: Lawrence Hill, 1980.

Woideck, Carl. *Charlie Parker: His Music and Life*. Ann Arbor: University of Michigan Press, 1996.

Woodard, Komozi. *A Nation within a Nation: Amiri Baraka and Black Power Politics*. Chapel Hill: University of North Carolina Press, 1999.

Woodford, John. "Testing America's Promise of Free Speech: *Muhammad Speaks* in the 1960s, A Memoir." *Voices of the African Diaspora* 7 (Fall 1991): 3–16.

Worcester, Kent. *C. L. R. James: A Political Biography*. Albany: State University of New York Press, 1996.

Wright, Jay. *The Homecoming Singer*. New York: Corinth, 1971.

Wright, Sarah. "The Lower East Side: A Rebirth of Vision." *African American Review* 27 (Winter 1993): 593–96.

Young Lords Party. "13-Point Program and Platform." 1970. In *We Took the Streets: Fighting for Latino Rights with the Young Lords*, by Miguel Melendez, 238–41. New York: St. Martin's, 2003.

"Youth Group Ruled a Communist Front." *New York Times*, Sept. 19, 1964, 10.

index

Abernathy, Sylvia, 213, 245

Abrams, Muhal Richard, 214, 240

ACT, 113, 195–96

Advance, 138, 140–42, 254

Affro-Arts Theater, 179, 215, 240, 352

African Blood Brotherhood, 109–10

African Liberation Support Committee (ALSC), 198, 303, 336, 339, 350–51

AFRI-COBRA, 144, 156, 179–80, 214, 220, 245

Afro-American Association (AAA), 167, 255, 260–62, 275, 282, 292, 296, 300, 344

Afro-American Folkloric Theater, 253, 264, 275

Afro-American Heritage Association (AAHA), 56, 182, 194–96, 199, 210

Afro-American Institute, 220

Ahidiana Collective, 300, 312, 351, 357, 363

Ahmad, Muhammad (Maxwell Stanford), 48, 52, 78, 93, 132–34, 165–71, 187, 193, 226, 319

Aiiieeeee! (Chin, et al), 7, 50, 287–90

Alabama A & M, 328, 336, 341

Algarín, Miguel, 12, 43, 172–76, 317

Alkalimat, Abdul (Gerald McWhorter), 210, 214, 337

Allen, Ernest, Jr. (Ernie Mkalimoto), 23, 72, 87, 100, 105, 193, 261–63, 285

Alston, Charles, 28, 143–44

Alston, Christopher, 195, 404–5 (n. 28)

American Dialog, 36, 122, 139–40

American Negro Theatre, 45, 110

American Society for African Culture (AMSAC), 120, 123

Amini, Johari (Jewell Lattimore), 85, 197, 227, 237, 245

Amistad Society, 196

Anaya, Rudolfo, 314–15

Angelou, Maya, 118, 121

The Angry Voices of Watts (documentary), 306–7, 309

Aptheker, Herbert, 125

Aquarian Center, 299–300

Art Associates, 206

Art Ensemble of Chicago, 214, 221, 282

Artistic Heritage Ensemble, 215

Artists Workshop, 201

Association for the Advancement of Creative Musicians (AACM), 13, 179, 210, 214–15, 221, 237, 240–42

Atkins, Russell, 6, 11, 39, 96, 219–20, 230, 244–45

Ayler, Albert, 69, 74, 105

Baker, Ella, 168, 423–24 (n. 11)

Baker, General, 192–93

Baldwin, James, 45, 46, 86, 111, 119, 128, 238, 306, 387 (n. 40)

Baltimore Afro-American, 128, 209

Bambara, Toni Cade, 87, 352, 371

Baptiste, Alvin, 349, 364

Baraka, Amina (Sylvia Robinson), 88–89, 176, 371, 428 (n. 5)

Baraka, Amiri (LeRoi Jones), 3–8, 11–12, 14, 20–22, 33, 37–39, 44, 48, 57–59, 62–66, 68–70, 72, 77, 79–84, 86, 94–96, 99, 100–101, 103, 105–6, 111, 118–19, 126, 130–41, 148, 150, 152, 164, 170–74, 176–77, 180, 191, 202–3, 211, 220, 223, 226, 240–41, 243, 249, 256, 264–66, 268–71, 276, 279–85, 300–301, 310–12, 317, 319, 329, 332–34, 338, 342, 345, 356, 361, 363, 371, 385 (n. 27), 386 (n. 38), 391 (n. 46), 428 (n. 5)

Barker, Danny, 347–49, 356, 364

Bass, Charlotta, 251, 293

Bearden, Romare, 127, 143

Bennett, Lerone, 196, 229

Benston, Kimberly, 6, 75, 90

Berger, Art, 35, 131, 141–43, 148–49, 308, 384 (n. 16)

Berrigan, Ted, 12, 136, 310

Berry, Abner, 116, 122

Berryman, John, 32, 230

Beyond the Blues (Pool), 207, 209, 229, 328

Biggers, John, 323

Black America, 12, 78, 92–93, 170

Black Artists Group (BAG), 179, 221–22

Black Arts Center, 352

Black Arts Movement: and the academy, 1–7; and alternative black avant-garde, 240–42, 244; and anti-Semitism, 4, 129–31, 242–43, 338–39; and Asian American movement, 1–2, 7, 42–43, 287–90; and Boston, 153–57; and Chicano Movement, 1–2, 6–7, 10, 41–42, 174–75, 286–87, 313–16, 353; and Cincinnati, 410–11 (n. 107); and Cleveland, 215–21; and East Bay Area, 256–63; and gender, 2, 84–89, 119–20, 143; and Harlem, 150–53,

177–78; and historically black colleges and universities, 326–42; and homosexuality, 85–86; and Houston, 352–53; and Indianapolis, 410 (n. 107); and jazz, 62–69, 74–76, 82–83, 165, 244, 269–72, 290–92, 296–98, 356, 360, 363–64; and Los Angeles, 290–313, 421–22 (n. 120); and Lower East Side, 132–50; and multiculturalism, 175–76, 285–90, 358–60; and New Orleans, 345–66; and Nuyorican writers, 1–2, 6–7, 10, 43, 172–76, 358; and Philadelphia, 158–71; and popular avant-garde, 58–76, 265–66, 363–64, 388–89 (n. 3); and R & B, 63–64, 68–69, 74–75, 150, 244; and San Francisco, 263–87; and St. Louis, 221–22; and textuality and performance, 89–99

Black Arts Repertory Theatre and School (BARTS), 8–10, 85, 92, 100–101, 131, 145–46, 150–53, 157, 170–71, 177, 215, 240, 263–64, 279–82, 284–85, 345, 352, 367

Black Arts/West (BAW), 240, 264–65, 281–82, 284, 367, 419 (n. 73)

Black Books Bulletin, 179, 238

Black Communications Project (BCP), 249, 279–80, 282–84, 367

Black Congress, 301

Black Dialogue, 13, 92, 248, 254, 256–57, 262–63, 265, 274–77, 281, 310, 316, 320

Black Fire (Jones and Neal), 3, 152, 171–72, 223, 310

Black House, 215, 240, 248–49, 280, 282–84, 367

Black Mind, 104–5, 152

Black News, 152–53

Black Panther Party for Self-Defense (BPP), 2, 4, 10, 33, 47, 57, 170, 172, 225, 248–49, 251, 253, 256–57, 262, 265, 277, 281–83, 300–302, 312–13, 414–15 (n. 3), 419 (n. 75)

Black Panther Political Party, 300–302

Black Scholar, 87

Black Students Union (BSU), 278–80, 288

Black Theatre, 70, 98, 151, 176, 284, 354, 365

Blake, J. Herman, 257–59
BLKARTSOUTH, 9, 312, 321, 340, 350–66
Boggs, Grace Lee, 19, 51, 186–92, 225–26
Boggs, James, 19, 51, 80, 150, 169, 186–92, 195, 225, 343
Bond, Jean Carey, 119, 121, 126–27
Bond, Julian, 140, 149, 329
Bontemps, Arna, 120, 207, 223, 228, 250, 253, 332
Boone House, 206–8, 211, 235–36, 407 (n. 66)
Bossiere, Carl, 281
Boyd, Herb, 201
Boyd, Malcolm, 203
Boyd, Melba Joyce, 6, 85, 212, 413 (n. 143)
Bracey, John, Jr., 194
Braden, Anne, 324
Braden, Carl, 324, 344
Branch, William, 53, 120–21
Braxton, Anthony, 214
Breitman, George, 53, 145, 192
Broadside Press, 6, 13, 47, 77, 93, 179, 197, 203, 209–10, 212, 224, 226–28, 235–39, 243, 310, 333, 413 (n. 143)
Brooks, Gwendolyn, 13, 29, 32, 38, 48, 73, 85, 193, 198–200, 205, 209, 211–12, 214, 223, 228–30, 237–38, 240, 245, 333–34
Brown, Abena Joan, 85, 245
Brown, Elaine, 2, 415 (n. 10)
Brown, Frank London, 196
Brown, James, 63, 74, 363, 390 (n. 29)
Brown, Lloyd, 45, 117, 120, 272
Brown, Marion, 133
Brown, Sterling, 24–25, 28, 30–32, 54, 61, 96, 109, 119, 126, 230–32, 238, 322, 328–30, 334
Brown Berets, 313
Bullins, Ed, 39, 57, 71–73, 100, 103, 107, 133, 151, 170, 202, 248, 254, 264, 274–75, 280–85, 291, 317, 390 (n. 24); *We Righteous Bombers*, 71–73, 87
Bulosan, Carlos, 28, 50, 51
Burley, Dan, 181

Burnham, Dorothy, 321–23
Burnham, Louis, 45, 120, 124–25, 128, 321–23
Burroughs, Charles, 48, 157, 193, 196–98, 200, 205, 224, 236
Burroughs, Margaret, 13, 22, 48, 85, 117, 127, 153–54, 157, 193, 195–200, 205–6, 208–10, 223–24, 227–28, 236, 328, 333, 348

Caldwell, Ben, 70
California Eagle, 250–51, 293
Carter, Alprentice, 282, 302
Castro, Fidel, 113
Catlett, Elizabeth, 28, 64, 127, 322–23
Cavalcade, 322
Center for Black Art, 336, 338
Central State University, 165–67, 326, 328
Césaire, Aimé, 169, 268, 273, 418 (n. 54)
Cherry, Don, 290–91, 297
Chew, Birdell, 306, 307
Chicago Defender, 27, 181, 183, 185, 193, 204
Chicago Mural Group, 214, 372
Childress, Alice, 45, 117, 119–20, 124
Chin, Frank, 3, 42–43, 289–90, 386 (n. 35)
Christian, Marcus B., 348
Civil Rights Congress (CRC), 45, 47, 110, 114, 161–62, 251, 293
Civil rights movement, 7, 257, 275–76, 293–96, 319–20, 342–50
Clarke, John Henrik, 45, 112, 117, 119–20, 125–26, 128, 148, 196, 228, 333, 369
Cleage, Albert, Jr., 80, 182, 185, 188, 192, 224–25, 403 (n. 12)
Cleaver, Eldridge, 170, 251, 282–83, 302
Cockrel, Kenneth, 192, 200–201
Cohran, Phil, 214–15, 240–41, 244
Cold War and McCarthyism, 7–8, 10–11, 29–38, 52, 114–32, 138–39, 161–63, 184–85, 193–94, 252–53, 257, 268–70, 323–26, 328–29
Coleman, Ornette, 62–63, 66–67, 74, 133, 270, 290, 292–93, 296–97
Collective Black Artists, 393 (n. 5)

Colon, Jesus, 50

Coltrane, John, 62, 65, 68, 74, 83, 99, 133, 159, 165, 241, 244, 270, 291, 296, 356, 363

Commentary, 30, 45, 131

Committee for a Unified Newark (CFUN), 80, 172, 240, 300

Committee for the Negro in the Arts, 45, 110, 196

Communist Party of the United States of America (CPUSA) and Communist Left, 15, 18–19, 94, 161–64, 188, 192, 201, 216, 225, 292–93, 343, 368; and African Americans, 44–49, 52–56, 114–32, 250–55; and Asian Americans, 49–51; and black bohemia, 138–47; and black community educational organizations, 193–200; and Che-Lumumba Club, 252, 414–15 (n. 9); and Chicana/os, 49–51; and the national question, 24–25, 53, 313; and Popular Front, 11, 26–38, 54–56, 61, 77, 109–10, 183–85, 216–18, 234–35, 266–74, 321–25, 385 (n. 22), 417–18 (n. 50); and proletarian/national counterculture, 24–25

Compton Communicative Arts Academy, 303

Concept East Theatre, 13, 106, 179, 202–4, 208, 236–37, 279

Congress of African People (CAP), 80, 88, 126, 157, 170, 198, 303, 336, 339–40, 350

Congress of Industrial Organizations (CIO), 160–61, 184, 216, 323. *See also individual unions*

Congress of Racial Equality (CORE), 116, 166, 217, 255, 275–76, 279, 294–96, 301, 319–20, 329, 345–46

Cook, Ann, 259

Cooks, Carlos, 117

Coordinating Council of Community Organizations (CCCO), 195–96

Cornish, Sam, 77, 326

Correspondence group and *Correspondence*, 19, 51, 187–92, 225–26

Corso, Gregory, 11, 37, 95, 385 (n. 27)

Cortez, Jayne, 85, 100, 103, 133, 140, 241, 291, 296–99, 308, 317, 320, 342, 371

Council on African Affairs, 115, 120

Countryman, Matthew, 4

Crawford, Bill, 48, 52, 163

The Cricket, 66, 101, 338

Crockett, George, 46, 184–85

Crouch, Stanley, 133, 291, 311, 317

The Crusader, 92–93, 170, 345

Cruse, Harold, 44, 48, 53–54, 76, 100, 103, 118–19, 122, 126–29, 131–32, 138, 142, 150, 153, 164–65, 167, 187, 195, 273, 369

Cruz, Victor Hernandez, 12, 43, 172, 174–75, 285–86, 358

Cultural Association for Women of African Heritage, 118

Cuney, Waring, 28, 60, 230, 273, 322

Daily Worker, 48

Damon, Maria, 43, 269, 416–17 (n. 37)

Daniels, Stan, 166, 169

Danner, Margaret, 85, 191, 193, 205–9, 223, 227–30, 235–38, 328, 333

Dasein group and *Dasein*, 47, 96–97, 330, 334

Dashiki Theatre Project, 320

Davis, Angela, 321, 415 (n. 10)

Davis, Benjamin, 109, 115, 122, 129, 138, 164, 184

Davis, Bill, 163

Davis, Eddie "Pork Chop," 116, 164

Davis, Frank Marshall, 24, 28–29, 31, 32, 35, 45, 73, 228, 234–35, 271, 273

Davis, Miles, 74

Davis, Ossie, 47–48, 53, 117, 128, 332, 346

Davis, Sallye, 321

Dawahare, Anthony, 23

Dee, Ruby, 53, 117

Delaney, Martin, 23

De Legall, Walt, 334

Denning, Michael, 28, 36, 196, 385 (n. 21)

Dent, Albert, 320, 324, 347

Dent, Tom, 12, 40, 92, 100, 112, 119, 127, 133–34, 136–37, 141, 146–48, 177, 320, 329, 342, 346–65

Derby, Doris, 345, 347

Detroit Black Arts Conventions, 226, 334

Detroit group, 205, 207–9, 228–37

Dillard, Angela, 201

Dillard University, 213, 320, 322, 347

di Prima, Diane, 12, 41, 136, 389 (n. 8)

Dodge Revolutionary Union Movement (DRUM), 183, 187, 225

Dodson, Owen, 328, 334

Dolan, Harry, 306–8

Dolphy, Eric, 290–91, 363

Donaldson, Jeff, 156–57, 214, 336, 340

Dooley, Ebon (Leo Thomas Hale), 319, 341, 370–71

Dorn, Ed, 12, 136

Douglas, Aaron, 28

Douglas, Emory, 282

Douglass, Frederick, 270

Douglass House/House of Respect, 8, 215, 279, 282, 306, 309–10, 312

Du Bois, Shirley Graham, 115, 117–18, 120–21, 124–26

Du Bois, W. E. B., 14, 31, 33, 44–45, 117–18, 120–21, 124–26, 199, 235, 247, 325–26

Du Bois Clubs, 254–55, 275, 292

Dumas, Henry, 100

Dunayevskaya, Raya, 186, 189–90

Durem, Ray, 8, 149

Durham, Richard, 181–82, 204, 387 (n. 41)

DuSable Museum (Ebony Museum), 13, 47, 56, 157, 196–97, 210, 224, 227, 236–37

The East (educational and arts center), 152–53, 176

Ebony, 204, 206, 208, 339

Eda, Eugene, 214

Elder, Lonnie, III, 118

Eliot, T. S., 27, 32, 229

Ellington, Duke, 63, 66, 157, 219

Ellison, Ralph, 76, 82, 111, 271

Elma Lewis School of Fine Arts (ELSFA), 154–57, 176

El Teatro Campesino, 7, 264

Epton, Bill, 145

eta Creative Arts Foundation, 13, 179, 242, 245

Evans, Mari, 126, 140, 153, 219, 328

Fabio, Sarah Webster, 85, 262, 278, 280, 282, 329, 352

Facing Reality group, 19, 51, 188–89, 192

Fair Play for Cuba, 20, 139–40, 145, 217, 258, 345

Fanon, Frantz, 164, 169

Fauset, Arthur Huff, 159–61

Fauset, Jessie, 159

Federal Art Project (FAP), 183, 218

Federal Theatre Project (FTP), 106, 160, 183, 217–18, 235, 345

Federal Writers Project (FWP), 28, 109, 160, 183, 218, 250, 322, 348

Feelings, Tom, 121, 126–27, 133, 144

Fields, Julia, 133

First World, 338–39, 425 (n. 42)

Fisk Black Writers Conferences, 48, 76, 156, 200, 209, 211–12, 226, 238, 326, 332–34

Fisk University, 326, 328–29, 332–34, 336, 341–42

Floating Bear, 136, 218

Flory, Ishmael, 47, 53, 114, 117, 187, 194–95, 199–200, 205

Floyd, John, 301

Foley, Barbara, 23, 382 (n. 15)

For Malcolm (Burroughs and Randall), 197, 209–10, 223–24, 226, 310, 333

Forman, James, 170

Frazier, E. Franklin, 109

Freedom, 45, 110, 114, 124–25

Freedom Now Party, 182, 191, 204, 403 (n. 8)

Freedomways, 12, 21, 45–47, 56, 92, 112, 115, 119, 121, 124–27, 141–43, 153–54, 160, 164, 196, 199, 316, 332

Free Lance, 47, 96, 218–21, 244

Freeman, Carol, 262–63

Freeman, Donald, 93, 166–69, 220

Free Southern Theater (FST), 92, 345–50, 357, 364, 367

From the Ashes (Schulberg), 248, 307–10, 316

Fuller, Charles, 64, 106, 163–64

Fuller, Hoyt, 76, 85, 92, 196, 204–10, 212, 214, 224, 229, 237, 240, 338–39

Gaither, Barry, 156–57

Garrett, Jimmy, 264, 278–79

Garveyism and UNIA, 8, 15, 23, 44, 109–10, 154–55, 157, 160, 168, 216, 234, 255, 292, 368

Gates, Henry Louis, Jr., 2, 58

Gayle, Addison, Jr., 92, 100, 150, 227, 357

Georgakas, Dan, 192, 200

Gibson, Kenneth, 17, 80

Gibson, Richard, 20, 145, 382 (n. 16)

Gilpin Players, 217

Gilyard, Keith, 334

Ginsberg, Allen, 11, 12, 35, 37–38, 42, 55, 97, 131, 136, 254, 311

Giovanni, Nikki, 3, 48, 85, 88, 100, 126–27, 133, 151–52, 332, 336, 387 (n. 46), 410–11 (n. 107)

Glaberman, Jessie, 186, 192

Glaberman, Martin, 186–87, 189–92, 225

Goncalves, Dingane Joe, 276–77, 320, 342, 418 (n. 63)

Gonzales, Rodolfo, 42, 76, 313

Goodlet, Carlton, 251, 414 (n. 5)

Govan, Oswald, 334

Graham, Donald Lee (Le Graham), 332, 336, 340

Gray, Jesse, 113–14, 164, 195

Group on Advanced Leadership (GOAL), 182, 191, 224, 403 (n. 8)

Guillén, Nicolás, 194

Guy, Rosa, 85, 118–19

Hall, James C., 6–8

Hamilton, Bobb, 133, 226

Hammonds House, 341

Hampton, Fred, 10

Hampton Institute, 213, 322

Hansberry, Lorraine, 45, 53, 81, 85, 117, 120, 124–25, 134, 264

Harding, Vincent, 337–38

Harlem as political and cultural landscape, 108–14, 150–53, 177

Harlem Quarterly, 114, 127

Harlem Renaissance. *See* New Negro Renaissance

Harlem Writers Guild (HWG), 112, 118–23, 129, 139, 141, 332

Harrell, Hugh, 127

Harrington, Ollie, 127

Harris, Robert, Jr., 425 (n. 42)

Harris, William, 5

Hayden, Robert, 13, 22, 32, 38, 76–77, 185, 209, 223–24, 227–28, 230, 232, 235–36, 267, 332–33

Haywood, Harry, 54, 116, 388 (n. 60)

Henderson, David, 12, 40–41, 100, 112, 126–27, 133, 136–37, 140–41, 147, 177, 241, 276, 285–86, 311, 317, 342, 346, 417 (n. 37)

Henderson, Stephen, 5, 76, 173, 245, 336–40, 362

Hernton, Calvin, 12, 40–41, 100, 112, 119, 126–27, 133, 136–37, 140, 147, 167, 276, 329, 336

Herrera, Juan Felipe, 286

Hicks, Calvin, 118–19, 134, 138–39, 142–43, 170

Hicks, Nora, 143

Highlander Folk School, 122, 323–24

Hill, Charles, 184

Hilliard, David, 2, 253

Himes, Chester, 111, 218

Honey, Michael, 325

Hooks, Robert, 103, 106–7

Hopkins, Donald, 259

Horne, Gerald, 122, 299, 305

House, Gloria, 85, 225

Howard University, 109, 326–31, 334, 336, 341–43

Hudson, Hosea, 321, 323

Hughes, Langston, 6, 8–9, 11, 13, 24–25, 27–
 29, 30, 32, 35, 37, 39, 42, 50, 54, 60–61, 69,
 82–83, 95–96, 111, 115, 117, 120, 135, 144, 148,
 157–58, 191, 194, 205, 207, 217, 219, 223, 227,
 230–31, 233–36, 238, 249–50, 253, 268–73, 321,
 348–49, 383–84 (n. 10), 395 (n. 33)

Inada, Lawson, 43
Ignatiev, Noel, 382 (n. 15)
Inner City Voice, 187, 192, 225–26
Institute for Positive Education, 179, 240, 300
Institute of the Black World (IBW), 336–39
International Longshoremen's and Warehouse-
 men's Union (ILWU), 49, 123, 250–54, 415
 (nn. 11, 12)

Jackson, Esther Cooper, 21, 85, 112, 115, 117,
 124–27, 142–43, 321, 323, 348, 395 (n. 26)
Jackson, James, 19, 21, 115, 118, 125, 143, 321, 323,
 395 (n. 26)
Jackson, James Thomas, 306
Jackson State University, 328, 335, 336, 341, 352
Jacquette, Tommy, 305
Jahn, Janheinz, 164
James, C. L. R., 15, 19, 150, 186, 188–92
Jarrell, Randall, 31, 384 (n. 11)
Jarrell, Wadsworth, 214, 336
Jeffers, Lance, 49, 310–11, 328
Jelliffe, Rowena, 217–18
Jelliffe, Russell, 217–18
Jihad Productions, 93, 101, 176, 240
Joans, Ted, 11, 39, 96, 133, 135, 265–66
Johnson, Christine, 46, 182, 195, 199
Johnson, Chuck, 192–93
Johnson, Ethel Azalea, 93, 168–69
Johnson, Helene, 60–61
Johnson, James Weldon, 14, 60, 203, 269, 361
Johnson-Forest group, 186–88
Johnson Publishing Company, 204, 208,
 242–43, 316, 338–39
Johnston, Percy, 97, 219, 334

Jonas, Steve, 39, 96, 135
Jones, Barbara, 214, 245
Jones, Hettie, 86, 130, 136
Jordan, Jennifer, 241
Jordan, Norman, 219–21, 370
Journal of Black Poetry (*JBP*), 13, 66, 77, 92, 218,
 248, 257, 263, 276–77, 310, 316, 365, 367

Kaiser, Ernest, 117, 127
Karamu House, 217–18, 220–21, 345, 354
Karenga, Maulana (Ronald Everett), Kawaida
 movement, and Us organization, 4, 16, 33,
 57–58, 66, 75, 79–80, 83–85, 87–89, 104, 150,
 177, 239–40, 248–49, 255–57, 281, 284–85,
 292, 295–96, 299–303, 305, 308–9, 312, 314,
 316–17, 353, 357, 362–64
Katherine Dunham's Performing Arts Training
 Center, 179, 222
Kaufman, Bob, 11, 35, 37, 39, 55, 96, 133, 135, 254,
 263, 265–74, 311, 416–17 (n. 37)
Kawaida movement. *See* Karenga, Maulana
 (Ronald Everett), Kawaida movement, and
 Us organization
Kelley, Robin, 325
Kelley, William Melvin, 332–33
Kenyatta, Jomo, 81, 97, 169
Kerouac, Jack, 11, 36, 37, 63, 385 (n. 21)
Kgositsile, Keorapetse, 100, 171, 226, 336, 340
Killens, John O., 45, 48, 117–21, 124, 127, 139,
 157, 196, 212, 226, 326, 328, 332–34, 336, 340,
 348
King, Coretta Scott, 337
King, Martin Luther, Jr., 124, 146, 294, 325–26,
 337
King, Woodie, Jr., 40, 100, 103, 105–6, 133, 157,
 202–6, 222, 236, 265, 358, 371
Kingston, Maxine Hong, 42–43, 386 (n. 35)
Koch, Kenneth, 42, 62
Kofsky, Frank, 74–75
Kulchur, 136, 140, 218, 276
Kuumba Workshop, 179, 200, 240, 245

Labrie, Aubrey, 260, 278

LaGrone, Oliver, 191, 206–7, 229, 234

La Mama theater, 106–7

Last Poets, 3, 100, 104, 151–52, 172

Lawrence, Carolyn, 245

Lawrence, Jacob, 28, 126, 144

Lawson, James, 117, 129

League of Revolutionary Black Workers (LRBW), 20, 170, 187, 192, 200–201, 224–25, 262

Le Sueur, Meridel, 24, 28, 31

Lewis, Elma, 85, 154–57

Lewis, Mary, 259–60, 278

Lewis, Samella, 213, 323

Liberation Books, 151–52, 176

Liberator, 12, 47, 66, 77, 85, 92, 121, 127–29, 131–32, 150, 171, 191, 275, 316, 397 (n. 55)

Lilly, Octave, 348–49

Lincoln, Abby, 85, 118

Linson, Rahsaan Connell, 352

Living Theater, 7, 91, 264, 281, 286, 345

Llorens, David, 226

Locke, Alain, 60, 159, 389 (n. 5)

Lorde, Audre, 41, 49, 81, 126

Los Angeles City College, 255–56, 274, 281, 292, 296

Lotus Press, 179, 213, 224, 226–27

Lowell, Robert, 32, 230

Lowenfels, Walter, 35, 131, 141, 143, 384 (n. 16)

Luciano, Felipe, 105, 172, 358

Lumumba, Mamadou (Ken Freeman), 262–63, 274

Lumumba, Patrice, 81, 97, 118, 124, 129, 261, 368–69

Lyle, K. Curtis, 311

Macbeth, Robert, 72, 103, 391 (n. 37)

Madgett, Naomi Long, 85, 126, 206–7, 226–27, 229, 233–34, 236

Madhubuti, Haki (Don L. Lee), 22, 33, 48, 76, 84, 86–87, 91–92, 126–27, 153, 156, 179, 197–200, 210–12, 219–20, 223–24, 226–27, 237, 239–43, 245, 300, 312, 319, 334, 336, 340, 361, 371

Mafundi Institute, 303, 308

Major, Clarence, 41, 77, 82, 94, 140, 152, 277

Malcolm X, 8, 47–48, 53, 76, 113–14, 116, 125, 131, 145–47, 162–66, 169, 182–83, 192, 209, 226, 255, 258–59, 261, 288, 333, 368–69

Malcolm X University, 335–36

Mallory, Mae, 219

Marcantonio, Vito, 30, 109

March on Washington (1963), 144, 149, 294

Market Place Gallery, 92, 112, 148

Marshall, Paule, 119, 139

Martin, Tony, 23

Marvin X (Marvin Jackmon), 5, 72, 98, 100, 151, 170, 248, 256, 261–64, 274–75, 280–85, 317

Masses & Mainstream (*Mainstream*), 31, 35–36, 120, 122, 139–40, 142

Maxwell, William, 23

Mayes, Clyde E., 311

Mayfield, Curtis, 150, 244, 370

Mayfield, Julian, 45, 53, 120–21, 138, 428 (n. 3)

McFarlane, Milton, 310

McKay, Claude, 35, 111, 126, 230

McKeller, Sonora, 306–8

Meloncon, Muntu Thomas, 352

Merritt College, 256, 258, 261–63, 274, 278, 281

Merriwether, Louise, 118

Mexican mural movement, 64–65, 218, 322–23

Michaux, Lewis, 121, 163–64

Michigan Chronicle, 185, 204, 206

Millay, Edna St. Vincent, 233–34

Miller, Loren, 251, 293

Milner, Ron, 40, 100, 103, 106, 202–3, 205–6, 222, 236, 265, 333, 371

Mingus, Charles, 291

Mitchell, Loften, 120, 332

Mitford, Jessica, 251

Mobilization for Youth (MFY), 105–6, 123, 138, 358

Modernism (Neomodernism), 11, 31–34, 37, 58, 94–95

Monk, Thelonius, 62, 66, 219

Monroe Defense Committee, 119, 139, 144–45, 148, 345

Monsour, Khalid (Donald Warden), 258–62, 296

Moore, Audley, 56, 122, 168–69, 195, 369

Moore, Cecil, 169

Moore, Isaac, 262

Moore, Richard, 48, 117, 121, 128, 195, 273

Mor, Amus, 69, 211, 409 (n. 82)

Moreland, C. K., 310

Morrison, Toni, 3, 334, 371

Mos Def, 3, 371

Moses, Bob, 47

Moses, Gilbert, 103, 345

Motown Records, 203, 205, 283–84, 390 (n. 28)

Muhammad, Elijah, 46, 116, 132, 181–83, 286

Muhammad Speaks, 27, 44, 46, 116, 143, 163–64, 181–82, 234, 387 (n. 40)

Mullen, Bill, 6, 225

Muntu group, 48, 64, 79–80, 131–32, 164–65, 171

Murphy, George, 128

Narcisse, Wendell, 351, 353

National Association for the Advancement of Colored People (NAACP), 26, 109–10, 115, 146, 160–62, 165, 169, 184, 255, 257–59, 261, 268, 293–96, 319, 323, 343–44, 347–48, 420 (n. 94)

National Black Political Convention, 126, 340

National Black Theatre (NBT), 79, 103–5, 151–52, 176

National Center of Afro-American Artists (NCAAA), 156–57, 176

National Maritime Union (NMU), 49, 266, 323–24, 416 (n. 36)

National Memorial African Bookstore, 56, 117, 121–22, 152, 163–64, 300

National Negro Congress (NNC), 160–61, 184, 321

National Negro Labor Council (NNLC), 45, 110, 114, 161, 216

Nation of Islam (NOI), 46, 79, 89, 116–17, 132, 151, 162–67, 181–83, 201, 224, 255, 286, 292, 314, 369

Neal, Larry, 3, 48, 58–59, 64–65, 68, 72, 77–79, 82–83, 90–93, 100, 108, 131–33, 150–53, 159–60, 163–65, 168, 170–71, 173, 208, 211, 223, 226, 243, 266, 312, 319, 329, 338, 356, 363

Negro Digest/Black World, 13, 86, 92, 150, 164, 179, 204, 207–10, 224, 237, 242–43, 275–76, 316, 333, 338–39, 348, 354, 356, 365, 367, 408 (n. 71), 425 (n. 42)

Negro Ensemble Company (NEC), 104, 106–7

Negro Historical and Cultural Society, 253–54, 274–75

Negro Story, 183, 200

Negro Students Association (NSA), 275, 278

Negro World, 23

Nelson, Cary, 37

New American Poetry (Allen), 7, 62, 135

New American Poetry and post-war bohemia, 11, 32, 34–44, 55–56, 61–62, 91–92, 94–97, 135–37, 200–204, 254, 263–74, 276, 285

New Black Voices (Chapman), 356

New Challenge, 183, 209

New Criticism, 29–34, 36, 37, 94

New Federal Theatre, 105–6

New Lafayette Theatre, 71–73, 79, 87, 103–5, 151–53, 176, 284

New Masses, 31, 139, 383 (n. 1)

New Negro Renaissance (Harlem Renaissance), 7, 23, 60–61, 108–10, 159, 217, 358

News and Letters group, 189, 192, 201

Newton, Huey, 47, 170, 251–52, 259, 261, 282–83

New York Intellectuals, 29–34, 36, 37

Nielsen, Aldon, 5, 12, 43, 96–97, 99, 133, 135, 177, 218, 385 (n. 25)

Nkombo, 92, 350–51, 353–54, 356, 360

Nkrumah, Kwame, 81, 124, 169, 261

Nonviolent Action Group (NAG), 96–97, 330, 334–35, 343

North Carolina A & T, 257, 329, 335–36

Northern Student Movement (NSM), 113–14, 337

Now!, 204

Nuyorican Poets Café, 172, 317–18

Obadele, Gaidi (Milton Henry), 182, 188, 225, 403 (n. 8)

Obadele, Imari (Richard Henry), 182, 188, 204, 225, 403 (n. 8)

O'Dell, Jack, 325

O'Hara, Frank, 12, 35, 37, 62, 95, 136

Ojenke (Alvin Saxon), 291, 308–9, 311

Olatunji, Babatunde, 157, 272

Olson, Charles, 12, 62

O'Neal, John, 140, 345, 356

On Guard for Freedom (OGFF), 113, 118–19, 132, 139–40, 146, 148, 150, 342

On the Town, 204

Oppenheimer, Joel, 136, 140

Oren, Michael, 133

Organization Alert, 163, 165, 168

Organization of Black American Culture (OBAC), 13, 156–57, 179, 197, 200, 210, 214, 227, 238, 240, 242, 245, 336–37, 341; Visual Arts Workshop, 90, 144, 179, 213–15; Writers' Workshop and *Nommo*, 210–13, 218

Organization of Young Men, 119, 140, 146, 167, 342, 345, 395–96 (n. 35)

Outterbridge, John, 291, 303

Pan Afrikan Peoples Arkestra, 291, 293, 297–99, 317, 420 (n. 103)

Parish, Norman, 214

Parker, Charlie, 75, 165, 244, 269, 271, 363

Partisan Review, 30, 45, 131

Patterson, Louise Thompson, 117, 250

Patterson, Raymond, 12, 92, 112, 133, 148

Patterson, William, 19, 47, 53, 117, 252

People's Defense League, 323, 348

People's Theatre, 322

Percikow, Henry, 141, 399 (n. 96)

Perkins, Useni Eugene, 244

Peterson, Rachel, 192

Pietri, Pedro, 43, 174

Piñero, Miguel, 12, 43, 172, 174–75

Pittsburgh Courier, 181

Plumpp, Sterling, 181, 237, 244, 319, 371

Pocho-Che collective, 286–87, 313

Pool, Rosey E., 207, 328, 407–8 (n. 67)

Postell, Tom, 133

Powe, Blossom, 310

Powell, Adam Clayton, Jr., 109, 113, 115, 301

Powell, Judson, 303

Priestly, Eric, 291, 308–9, 311

Primus, Marc, 253, 275

Progressive Labor Party (PL), 20, 51, 139–40, 145–46, 193, 225, 382 (n. 15)

Puppet Caravan Theatre, 322

Purifoy, Noah, 219, 291, 303

Rahman, Aishah, 118, 133

Rahman, Yusef (Ronald Stone), 68, 100, 171

Rambeau, David, 100, 103, 202–3, 236, 265

Randall, Dudley, 6, 76, 191, 197, 206–10, 212, 219, 223, 226–27, 229–36, 238, 243, 328, 333, 348, 408–9 (n. 74)

Randolph, A. Phillip, 14, 15, 291

Raphael, Lennox, 140

Redmond, Eugene, 133, 140, 222

Reed, Adolph, 341–42, 370

Reed, Ishmael, 12, 40, 100, 133, 136, 140, 143, 177, 223, 243, 285, 287–88, 352

Republic of New Africa (RNA), 79, 152, 224–25, 314

Revolutionary Action Movement (RAM), 18, 57, 78, 93, 128, 148, 166–71, 187, 190, 193, 220, 257, 262–63, 301, 320, 328, 342–45, 401–2 (n. 145)

Rexroth, Kenneth, 34, 35, 37, 384 (n. 15)

Rhythm, 338

Rivers, Conrad Kent, 210, 219, 229

Roach, Max, 191, 271

Robeson, Paul, 14, 27, 31, 33, 44, 110, 114–15, 117, 140, 155, 216, 267, 325

Rodgers, Carolyn, 85, 197, 212, 219, 227, 245, 361

Roosevelt University, 199–200

Rukeyser, Muriel, 27, 31, 38, 384 (n. 11)

Salaam, Kalamu ya (Val Ferdinand), 6, 9, 74, 86, 101, 127, 182, 208, 248, 286, 300, 319, 342, 349–58, 360–66, 371; *The Blues Merchant*, 362

Salinas, Raúl, 41, 174–75, 315

Sanchez, Sonia, 3, 58–59, 66, 68, 83, 85, 99–100, 133, 137–38, 151, 157, 173, 177, 191, 220, 223, 239, 241, 243, 249, 256, 270, 278–80, 282–85, 317, 319, 371

Sanders, Ed, 12, 136

Sanders, Pharaoh, 68, 83, 317

San Francisco Mime Troupe, 7, 264, 286, 345

San Francisco State College, 256, 274–81, 283–84, 288–89, 313

Schleifer, Marc, 138, 140

Schrecker, Ellen, 268

Schulberg, Budd, 30, 131, 248, 303–13

Schwartz, Delmore, 31, 32

Scott, Johnie, 306–8

Seale, Bobby, 170, 261–62, 282–83

Selective Patronage campaign, 166, 169

Self, Robert, 8

Self Leadership for All Nationalities Today (SLANT), 300–301, 305

Sell, Michael, 6, 64, 91–92

Sellers, Cleveland, 334–35

Shange, Ntozake, 106, 221, 285–86, 317–18, 371

Shepp, Archie, 119, 133, 138, 141–42, 147, 159, 281, 390 (n. 20)

Sheridan, Art, 254, 265, 275, 281

Sherman, Jimmy, 307

Shrine of the Black Madonna (Central Congregational Church), 184, 224, 226

Sides, Josh, 293

Silvera, Frank, and the Theater of Being, 421 (n. 107)

Simmons, Herbert, 309

Simon, Alvin, 140–41, 147

Simpkins, Edward, 206, 229

Sinclair, John, 200–201

Sirrah, Leumas, 306, 308

Sizemore, Barbara, 86–87

Smith, David Lionel, 6, 9

Smith, Welton, 275, 285

Smokehouse group, 144

Socialist Party (SP), 109, 166, 216, 325

Socialist Workers Party (SWP), 19–21, 51, 53, 122, 138–40, 144–47, 168, 182, 185–86, 188, 191–92, 201, 216–17, 225, 343, 368

Sollors, Werner, 5, 388 (n. 2)

Soulbook, 13, 67, 92, 170, 248, 256–57, 262–63, 274–76, 310, 316

South Carolina State University, 335

Southern Black Cultural Alliance (SBCA), 321, 340, 351–52, 354–55, 364–66

Southern Christian Leadership Conference (SCLC), 319, 325

Southern Conference Educational Fund (SCEF), 324, 344

Southern Conference for Human Welfare (SCHW), 324–25

Southern Negro Youth Congress (SNYC), 45, 115, 124, 321–23

Southern University, 320, 326, 335–36, 341

South Side Community Arts Center, 183, 193, 196, 200, 205, 220, 228, 235, 242

South Side Writers Group, 183, 200, 210

Spellman, A. B., 11, 39, 41, 59, 66, 83, 96, 119, 133, 136–37, 140, 148, 177, 208, 270, 276, 319, 330, 334, 336–38, 340, 365, 371

Spicer, Jack, 39, 254, 393 (n. 73)

Spiral group, 143–44

Spirit House, 101, 176, 240, 301

Spriggs, Edward, 133, 152, 220, 253–54, 274–75, 285, 317, 319, 338, 341, 370–71

Steinbeck, John, 27, 306–7

Stevens, Nelson, 220

Stewart, James, 48, 59, 64–66, 132, 164–65, 356

Stokes, Carl, 126, 216, 220

Strickland, William, 113, 337

Strong, Augusta Jackson, 124, 321, 323

Strong, Edward, 124, 161, 321, 323

Stuckey, Elma, 196, 229

Stuckey, Sterling, 76, 196

Student Nonviolent Coordinating Committee (SNCC), 47, 97, 123, 131, 166–68, 170, 196, 200, 279, 296, 301, 319–20, 324, 329, 331, 334–35, 342–43, 345–47, 424 (n. 12)

Student Organization for Black Unity (SOBU), 335–36

Students for a Democratic Society (SDS), 123, 166, 331, 382 (n. 15)

Studio Museum in Harlem, 102, 104, 151–53, 176, 254, 341, 393 (n. 4)

Studio Watts, 296, 298–99, 303, 305, 312, 317, 319, 352

Sudan Arts South/West, 321, 340, 351–53, 366

Sun Ra (Herman Blount), 62, 66, 74, 79, 83, 104, 132–33, 151, 170, 215, 241, 270, 281, 297, 325–26, 386 (n. 28), 420 (n. 103)

Talledega College, 323, 336

Tann, Curtis, 218

Tapscott, Horace, 291, 293, 297–98

Taylor, Cecil, 62, 66, 133, 219, 270, 386 (n. 28)

Teer, Barbara Ann, 85, 100, 103–5, 107

Theatre of Afro Arts, 321, 340, 351

Thelwell, Michael, 4, 319, 334

Third World Press, 13, 77, 93, 179, 197–98, 200, 213, 227–28, 238–43, 246

Thomas, Lorenzo, 6, 9, 12, 38, 40–41, 43, 68, 99, 100, 108, 116, 133–37, 141, 147, 177, 266, 269, 273–74, 276, 321, 347, 352–53, 365, 418 (n. 55)

Thompson, James, 133, 191, 206–7, 229

Tolson, Melvin, 13, 32, 209, 227, 230, 236, 267, 328, 332–33

Tonatiuh-Quinto Sol International, 313–14

Tougaloo College, 341, 345–46, 352

Touré, Askia (Roland Snellings), 12, 33, 59, 64, 68, 72, 83–84, 86–87, 93, 118, 126, 131–33, 142–44, 147, 150–52, 167, 171, 173, 177, 187, 226, 249, 256, 266, 279–80, 283–85, 317, 319, 338, 342–43, 356, 363, 365, 371

Troupe, Quincy, 40, 221, 223, 248, 254, 291, 308–11, 317

Turé, Kwame (Stokely Carmichael), 4, 17, 76, 330–31, 334, 343

Tyner, McCoy, 159, 164

UHURU, 167, 187–88, 190, 192–93, 200, 224–25, 262

Umbra, 12, 40, 142, 148–49

Umbra Poets Workshop, 5, 8, 12, 36, 40–41, 47, 79, 85, 91–92, 112, 126, 131, 137–38, 140–43, 146–49, 170, 206, 210–11, 264–65, 281, 287, 308, 346–47, 352, 357, 367

Underground Musicians Association/Union of God's Musicians and Artists Ascension (UGMA/UGMAA), 291, 298, 301, 312, 317

UNIA. See Garveyism and UNIA

United Automobile Workers (UAW), 183–85, 188

United Freedom Movement, 220, 275

United Nations demonstration against Lumumba assassination, 118, 129, 146, 397 (n. 56)

United Packinghouse Workers Union, 183, 199

University Center (Atlanta University), 322–23, 326, 336–41

University of California, Berkeley, 256–60, 328

Unstabled Coffeehouse, 201–2

Uptown Writers Group, 92, 148, 171

Us organization. See Karenga, Maulana (Ronald Everett), Kawaida movement, and Us organization

Valdez, Luis, 50, 264, 314–15
Van Deburg, William, 5
Vaughn's Bookstore, 224, 226, 300
Vibration, 220–21
Villanueva, Tino, 42, 315
Von Eschen, Penny, 181

Waddy, Marrianne, 278
Waddy, Ruth, 278
Waldman, Anne, 136
Walker, Alice, 2, 126, 371
Walker, Joe, 143, 387 (n. 40)
Walker, Margaret, 13, 22, 28, 32, 126, 209, 223, 227–28, 230–31, 236, 238, 311, 328, 332–33
Walker, William, 94, 199, 213–14, 323
Wall of Dignity, 213
Wall of Respect, 90, 93–94, 99, 180, 208, 213–14, 244, 323
Ward, Douglas Turner, 104, 107, 118
Ward, Jerry, 352, 355, 360, 370
Ward, Theodore, 117, 228–29, 264
Ward, Val Gray, 85, 156–57, 245
Warshow, Robert, 384 (n. 11)
Washington, Raymond, 356, 361, 363
Watkins, Nayo, 85, 350–51, 356, 361, 363–64, 371, 426 (n. 67)
Watson, Goldie, 161, 169
Watson, John, 201, 225
Watts, Daniel, 127–28
Watts, Jerry, 5, 386 (n. 38)
Watts Happening Coffee House, 303–5
Watts Poets (Troupe), 248, 310–11, 316
Watts Repertory Theatre, 299
Watts Summer Festival, 299, 305–6, 355, 422 (n. 122)
Watts Theatre Workshop, 306
Watts Towers, 218, 292
Watts Towers Arts Center, 303, 312
Watts Uprising, 248, 291, 294, 299, 303–4, 369
Watts Writers Workshop, 8, 47, 92, 150, 210, 248, 281, 303–13, 316–17, 367

Wayne State University, 200–201, 206–7, 209, 278
Weaver, Myrna, 245
Welch, Rebecca, 120
West, Don, 24, 28, 323–24
Weusi, Jitu (Les Campbell), 152
Weusi Group, 144
Whitman, Walt, 27, 31, 36, 42, 311
White, Charles, 28, 126–27, 157, 228, 322
White, Josh, 28–30, 115
Widener, Daniel, 6
Wilfred X, 182
Wilkerson, Doxey, 109, 116
Wilkinson, Michelle Joan, 10
Williams, Robert, 113, 121, 138, 146, 166, 169–70, 192–93, 228, 255, 258–60, 343–45, 368–69
Williams, William Carlos, 32, 34, 38, 42, 58, 94–95, 221
Wilmer, Valerie, 133
Wilson, John, 48, 64, 322
Wolcott, Brenda, 141, 143
Woodard, Komozi, 4
Woodruff, Hale, 28, 143, 322–23
Woods, James, 298–99
The Worker, 21, 122, 141–43, 190
Workers Party (WP), 19, 21, 51, 185–86, 188, 201
Wright, Jay, 41, 82, 133, 285, 317, 336
Wright, Richard, 27, 28, 45, 183, 228
Wright, Sarah, 85, 118–21, 138

Yardbird, 287–89
Yoruba Temple, 79, 132, 151, 168, 284
Young, Coleman, 46, 184–85
Young Lords Party, 172, 402 (n. 159)
Youth Organization for Black Unity (YOBU), 335–36
Yugen, 136, 218, 385 (n. 27)

Zu-Bolton, Ahmos, 336, 353